EARTH FROM ABOVE

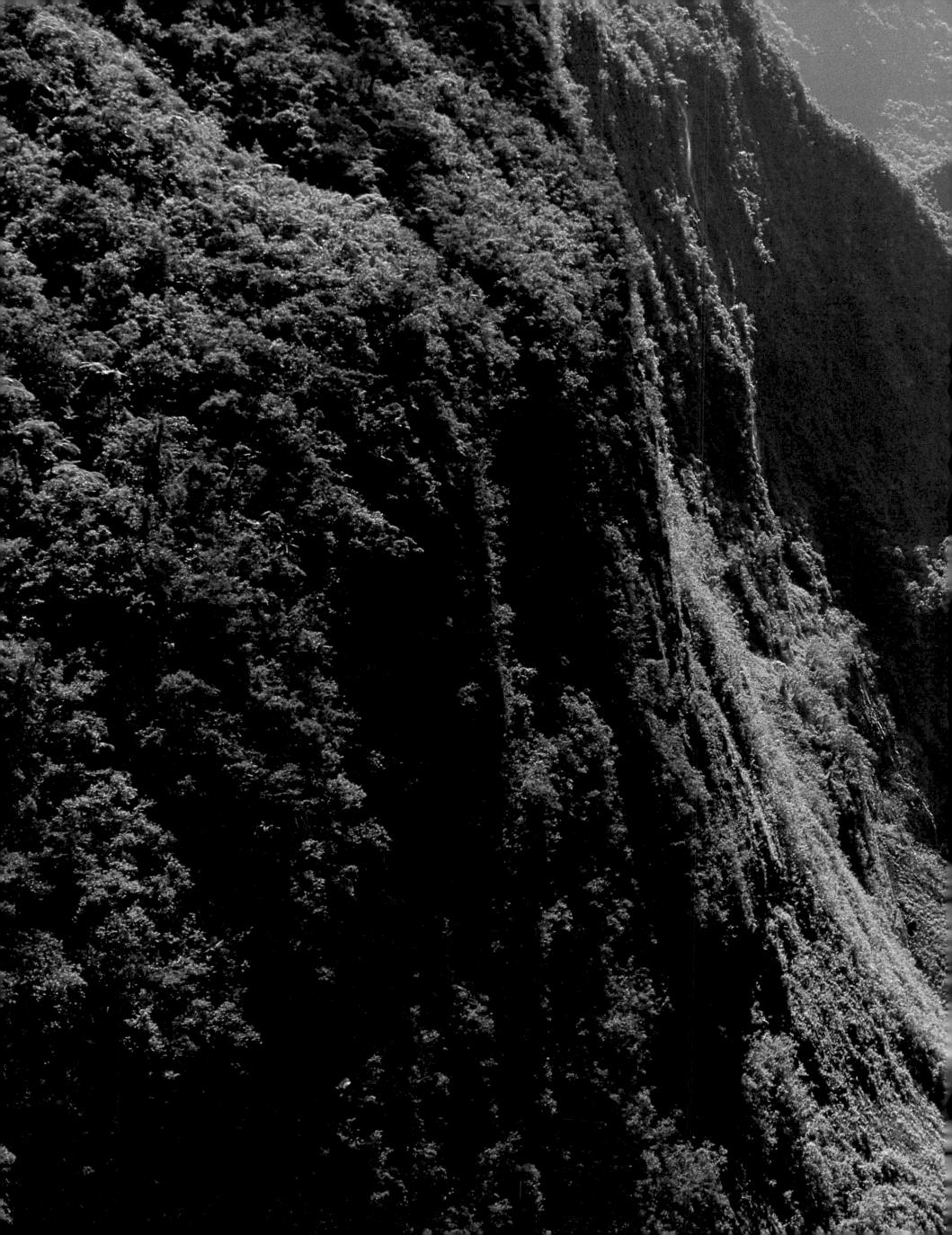

EARTH FROM ABOVE

Revised and Expanded Edition

YANN ARTHUS-BERTRAND

Essays by

Lester Brown

Edward Goldsmith

Hervé Le Bras

Jean-Marie Pelt

Jean-Robert Pitte

Christian Buchet

Laurence Roudart

Reiner Klingholz

Marcel Mazoyer

Anne Juillet-Leclerc

Bernard Fischesser

Christian Brodhag

Marie-France Dupuis-Tate

Maximilien Rouer

Translated from the French

by David Baker

HARRY N. ABRAMS, INC., PUBLISHERS

For Anne, Tom, Guillaume, and Baptiste.
With affection.

This vision of the world could not have been possible without the
aid of UNESCO, Fujifilm, Corbis, and Air France. I am grateful
for their confidence and friendship.

Editor, English-language edition: Nicole Columbus
Design Coordinator, English-language edition: Tina Thompson

Library of Congress Control Number: 2002105256
ISBN 0–8109–3495–7

Printed and bound in France
10 9 8 7 6 5 4

Harry N. Abrams, Inc.
100 Fifth Avenue
New York, N.Y. 10011
www.abramsbooks.com

Abrams is a subsidiary of

PREFACE

Yann Arthus-Bertrand has been part of my publishing life for twenty years. In 1979 I brought out his first book with Hachette Réalités. He and his wife, Anne, were just back from two years in Kenya, and his lion photographs caused a sensation. Not a year has passed since then without our publishing one or two books together. It has been a great experience, following his progress through the years, his combination of brilliance and hard work, as he traveled the globe in search of humanity and himself.

Maturity is a concept I can't really define, but I do know that with this book, Yann has reached the end of a journey in which he committed himself so fully as to win our respect. It has meant ten years of work, hundreds of thousands of photographs taken and miles traveled, stepping out of one airplane and into another, from country to country, juggling flight schedules all the way. But all of this would be nothing without his incomparable eye, which always finds the detail that makes a photograph better. His eye catches humanity in its finest light, without ever making concessions. His eye is always generous as well, as everyone is prompt to acknowledge.

But let there be no mistake: this book is not simply a series of photographs. It is the testimony of a citizen of the world at the dawn of the third millennium, who wants to show his vision of the earth, its beauty as well as its failures.

Behind his enthusiasm lies a certain anxiety. He worries about the transformation of this planet squeezed between demography and industrialization.

The texts accompanying his images are the counterpoint of his brilliant photographs. These are realistic texts, which sum up the state of our planet today.

Yet the book and the exhibitions accompanying it around the world are not an end in themselves; they are just the beginning. In each one of his projects during the past twenty years, Yann Arthus-Bertrand has always gone beyond the surface, beginning with the lions he tracked for two years, and continuing with other animals he has followed year after year. He has maintained strong continuity in his themes and his images.

Since its first publication, *The Earth from the Air* has become a unique phenomenon in the history of illustrated books, with total sales that are about to pass the two million mark and editions published in twenty different languages.

The free exhibition that started on the fence of the Luxembourg Gardens in Paris went on to countless cities and countries, where it has been seen by more than ten million visitors.

Unfazed by this enormous success, Yann pursues, as energetically as the day he started, his tireless quest for perfection. Each word has to be true and meaningful, each image must always reveal more. It is in that spirit that the text and legends of this new edition have been updated. Yann has taken ahold of the earth, but only to make it better understood and to share it with all who call it home.

Hervé de La Martinière

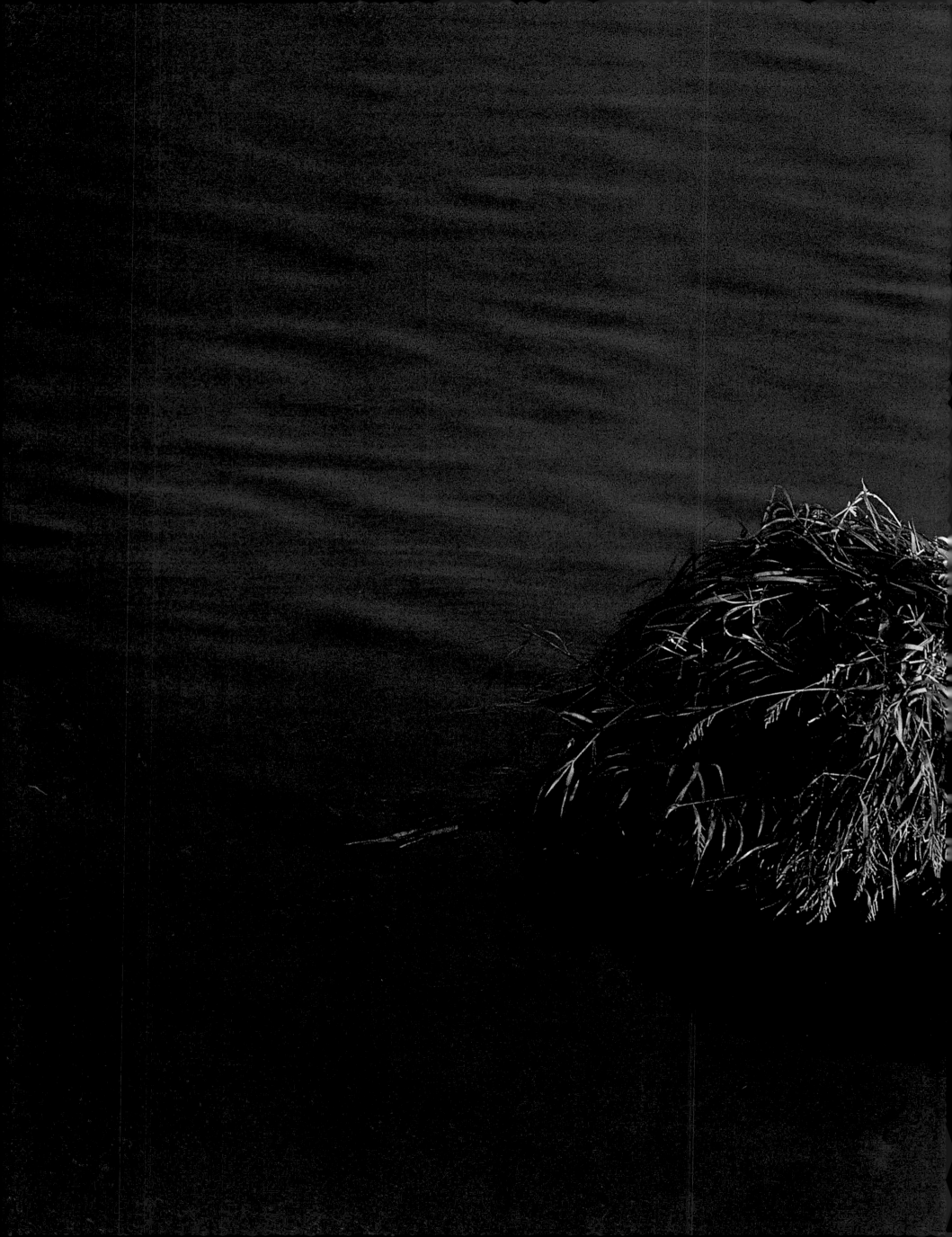

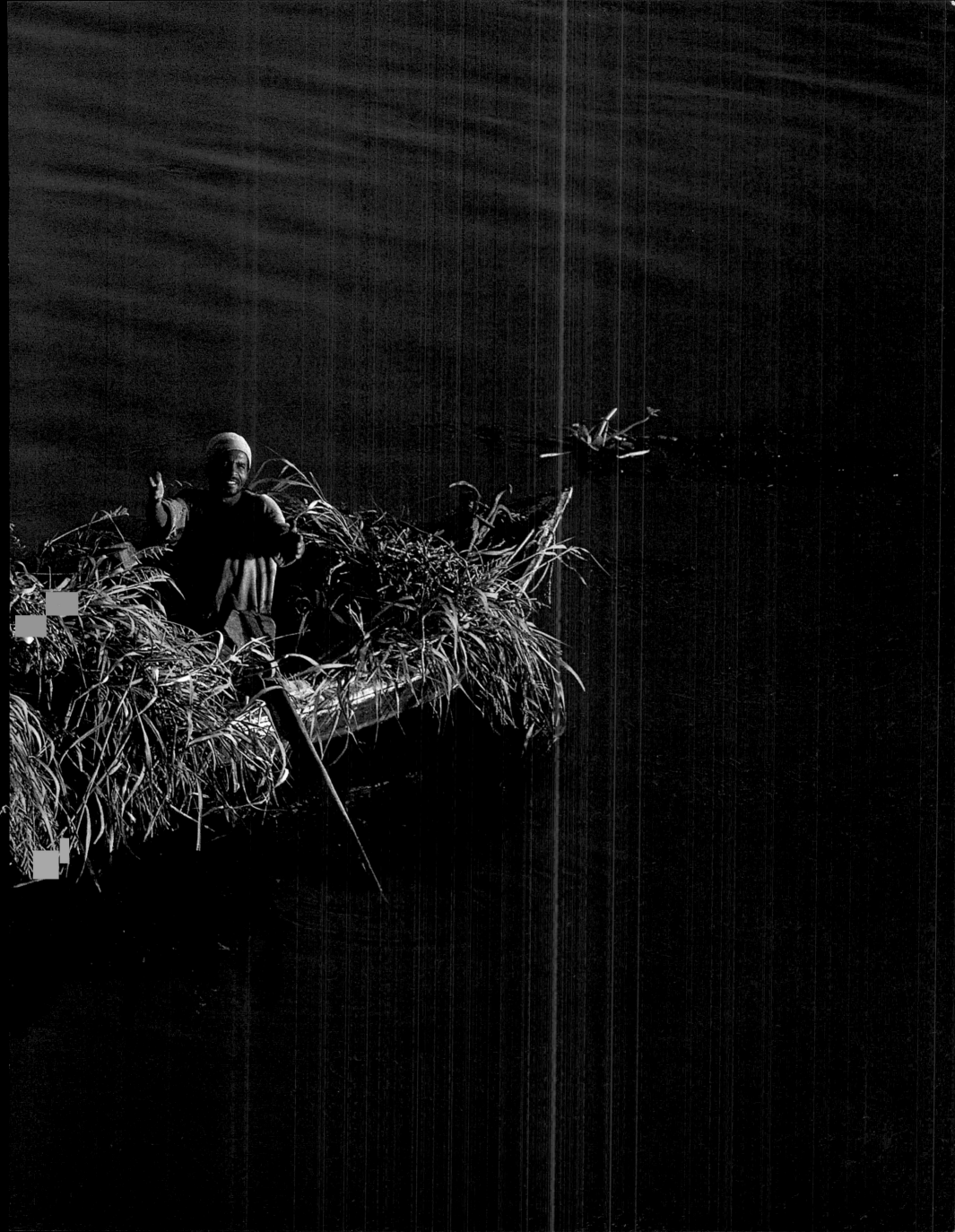

CONTENTS

Photograph captions written by Anne Jankéliowitch, Astrid Avundo, and Frédéric Marchand

Title page:
THE GORGES OF THE BRAS DE CAVERNE,
island of Réunion, France
(S21°01' E55°33')
Gorges created from volcanic fractures, like the bed of the Bras de Caverne river, make access to the center of the island of Réunion difficult. Some sites were explored only recently, such as the "Trou de Fer," a ravine of 820 feet (250 m) that was discovered in 1989. Because the island's center was protected from human encroachment, its tropical forests, with giant heather, ferns, and lichens, have been preserved, whereas the forests at low altitude have been converted to agricultural or urban use and have disappeared. More than 30 species of animals and plants, of which about two-thirds were endemic, have become extinct on the island in the past 400 years. Although blessed with great biological diversity, insular systems are generally more exposed to the risk of extinction of species than continents.

Previous spread:
BOAT ON THE NILE,
Egypt
(N31°08' E30°39')
The Nile, the world's longest river, runs from south to north through Sudan and Egypt for 4,140 miles (6,671 km). It is a communication route that carries both luxury floating hotels for tourists and modest craft bearing mostly forage and grain. Above all, the Nile is the main water resource for Egypt, providing 90 percent of the water consumed by the country. Although at one time the Nile's annual flood assured available water for only three to four months, the erection of the Aswan Dam in the 1960s made it possible to regulate the river's rate of flow and thus provide the country with water throughout the year by retaining a volume of water that is double the average annual flow of the Nile. However, the dam has caused ecological problems by depriving the river of the silt that fertilized the ground and offset marine erosion of the delta. Today the delta is receding at a rate of 100 to 650 feet (30 to 200 m) per year.

BUILDING AN ECO-ECONOMY

The goal of short-term profit causes many ecological disasters. Natural resources
continue to diminish because we do not take into account the costs of our actions on nature.
Can we devise an economic market guided by environmental indicators and not solely
by economic profit? The concept of the "eco-economy," based upon the real costs that
result from the degradation of the environment and the development of renewable energies,
reconciles economy with ecology.

In 1543 the Polish astronomer Nicolaus Copernicus challenged the view that the sun revolved around the earth, arguing instead that the earth revolved around the sun. This contention began a wide-ranging debate among scientists, theologians, and others. His alternative to the earlier Ptolemaic model, which placed the earth at the center of the universe, led to a revolution in thinking and a new worldview.

Today we need a similar shift in our worldview, this time in how we think about the relationship between the earth and the economy. Economists see the environment as a subset of the economy, whereas ecologists see the economy as a subset of the environment. The prevailing economists' view has created an economy out of sync with the ecosystems on which it depends.

Evidence that the economy is in conflict with the earth's natural systems can be seen in the daily news reports of collapsing fisheries, shrinking forests, eroding soils, deteriorating rangelands, expanding deserts, rising carbon dioxide levels, falling water tables, rising temperatures, more destructive storms, melting glaciers, rising sea levels, dying coral reefs, and disappearing species. These trends are taking a growing economic toll.

The example of China helps us to understand why our economy cannot take us where we want to go. China is the world's most populous country, with nearly 1.3 billion people, and since 1980 it has been the world's fastest-growing economy. In 1994 the Chinese government decided to develop an automobile-centered transportation system. Yet if the Chinese were to one day have one or two cars in every garage and were to consume oil at the U.S. rate, China would need over 80 million barrels of oil a day—more than the 74 million barrels per day the world now produces. Similarly, consider paper. As China modernizes, its paper consumption is rising. If the annual paper usage in China of 77 pounds (35 kg) per person were to climb to the U.S. level of 754 pounds (342 kg), China would need more paper than the world currently produces—there go the world's forests.

We are learning that the Western industrial development model is not viable for China: the natural resources do not exist for it to work. If the fossil-fuel-based, automobile-centered, throw-away economy will not work for China, then it will not work for India's 1 billion people, or for the other 2 billion people in the developing world. In a world with a shared ecosystem and an increasingly integrated global economy, it will ultimately not work for the industrial economies either. China demonstrates the urgency of building a new economy—an economy designed for the earth.

A SUSTAINABLE ECONOMY

An economy is sustainable only if it respects the principles of ecology; if it does not, it will decline and eventually collapse. Market forces, rather than ecological principles, have shaped today's global economy. Unfortunately, by failing to reflect the full cost—the social and environmental costs—of goods and services, the market provides misleading information to economic decision makers at all levels. An eco-economy will make markets work to the earth's advantage, enabling us to satisfy our needs without jeopardizing the prospects of future generations to meet their needs.

Ecologists understand the processes that support life on earth: the fundamental role of photosynthesis, the concept of sustainable yield, the role of nutrient cycles, the hydrological cycle, the sensitive role of climate, and the intricate relationship between the plant and animal kingdoms. They know that the earth's ecosystems supply services as well as goods, and that the former are often more valuable than the latter.

A sustainable economy respects the sustainable yield of the ecosystems on which it depends: fisheries, forests, rangelands, and croplands. A particular fishery can sustain a catch of a certain size, but if the annual demands on the fishery exceed the sustainable yield by even the smallest amount, the fish stocks will begin to shrink and will eventually disappear. As long as the harvest does not exceed the sustainable yield, it can be sustained in perpetuity. The same is true for forests and rangelands.

Nature also relies on balances. These include balances between soil erosion and new soil formation, carbon emissions and carbon fixation, and trees dying and trees regenerating. Nature

depends on cycles to maintain life. In nature there are no linear flow-throughs, no situations where raw materials go in one end and garbage comes out the other. In nature one organism's waste is another's sustenance. Nutrients are continuously cycled. Our challenge is to emulate these processes in the design of the economy.

THE BOTTOM LINE

Despite this long-standing body of ecological knowledge, national governments have expanded economic activity with little regard for sustainable yields or nature's fragile balances. Over the last half-century the sevenfold expansion of the global economy has pushed the demand on local ecosystems beyond the sustainable yield in country after country. Since 1950 the world fish catch has increased fivefold, global demand for paper has grown sixfold, and the world's herds of cattle and flocks of sheep and goats have doubled. These developments have had substantial and negative effects on fisheries, forests, and rangelands, and they have occurred because the market prices for goods and services do not include their social and environmental costs.

The services provided by ecosystems may sometimes be worth more than the goods, but their value needs to be incorporated into market signals if they are to be protected. Although calculating services is not a simple matter, any reasonable estimate is far better than assuming that the costs are zero, as is now the case. For example, a forest in the upper reaches of a watershed may provide services such as flood control and the recycling of rainfall inland that are several times more valuable than its timber yield. Yet the market does not reflect this, because the loggers who cut the trees do not bear the costs of the reduction in services.

To make matters worse, governments often subsidize environmentally destructive activities. For several decades the U.S. Forest Service used taxpayer money to build roads into national forests in order that logging companies could clear-cut forests. This not only artificially lowered the costs of lumber and paper, it led to flooding, soil erosion, and the silting of streams and rivers.

Relying on distorted market signals to guide investment decisions is ecologically devastating because markets, as currently structured, do not recognize the limits of natural systems. For example, when the climbing demand for water surpasses the sustainable yield of aquifers, the water tables begin to fall and wells go dry. The market says to drill deeper wells, and farmers engage in a competitive orgy of well drilling, chasing the water table further downward. On the North China Plain, where 25 percent of the country's grain is produced, this process is under way. In Hebei Province data for 1999 show that 36,000 wells, mostly shallower ones, were abandoned during the year as 55,000 new, deeper wells were drilled. In Shandong Province 31,000 were abandoned and 68,000 new wells were drilled.

In an eco-economy drilling additional wells would be banned as soon as a water table showed signs of falling. Instead of spending money to dig deeper wells, investments would be channeled into measures to boost water efficiency and to stabilize population in order to bring water use into balance with the sustainable supply.

USING THE TAX LEVER

Øystein Dahle, the retired vice president of Esso, the worldwide petroleum and petrochemical company, for Norway and the North Sea, observes, "Socialism collapsed because it did not allow prices to tell the economic truth. Capitalism may collapse because it does not allow prices to tell the ecological truth." The systemic change required to build an eco-economy necessitates a fundamental shift in market signals, so that they respect the principles of ecological sustainability. This means shifting taxes from income to environmentally destructive activities, such as carbon emissions and the wasteful use of water. By incorporating the environmental costs of goods and services into prices, we will enable prices to tell the ecological truth and help bring about the transition from a carbon-based economy to a hydrogen-based one.

Building an eco-economy in the time available will require rapid systemic change, and it will affect every facet of our lives: how we light our homes, what we eat, where we live, how we use our leisure time, and how many children we have. In an economic system where prices reflect true costs, the economically desirable and environmentally responsible choices will no longer diverge. An eco-economy will give us a world where we are a part of nature, instead of apart from it.

RESTRUCTURING THE ECONOMY

Instead of running on fossil fuels, an eco-economy will be powered by sources of energy that derive from the sun, such as wind and sunlight, and by geothermal energy from within the earth. It will be hydrogen-based instead of carbon-based. Cars and buses will run on fuel cell engines powered by electricity, produced with an electrochemical process using hydrogen as the fuel. This produces no climate-disrupting carbon dioxide or noxious health-damaging pollutants and emits only water vapor.

The energy economy will be essentially a solar/hydrogen economy, with various energy sources deriving from the sun used either directly for heating and cooling, or indirectly to produce electricity. Wind-generated electricity will be used to electrolyze water, producing hydrogen. This provides a means of both storing and transporting wind energy.

As fuels change, so will cities' transport systems—indeed, some already have changed. Instead of the noisy, congested, polluting, auto-centered transport systems of today, cities will have rail-centered transport systems; they will be bicycle- and pedestrian-friendly, offering more mobility, more exercise, cleaner air, and less frustration.

pp. 18–19
GRAND PRISMATIC SPRING, YELLOWSTONE NATIONAL PARK, Wyoming, United States
(N 44°26' W 110°39')

Situated on a volcanic plateau that straddles the states of Montana, Idaho, and Wyoming, Yellowstone is the oldest national park in the world. Created in 1872, it covers 3,500 square miles (9,000 km²) and contains the world's largest concentration of geothermic sites, with more than 10,000 geysers, smoking cavities, and hot springs. Grand Prismatic Spring, 370 feet (112 m) in diameter, is the park's largest hot pool in area and third-highest in the world. The color spectrum for which it is named is caused by the presence of cyanobacteria, which grow faster in the hot water at the center of the basin than at the periphery where the temperature is lower. Declared a Biosphere Reserve in 1976 and a UNESCO world heritage site in 1978, Yellowstone National Park receives an average of 3 million visitors per year. The continent of North America, which contains the five most visited natural sites in the world, is visited by more than 70 million tourists per year—one-tenth of world tourism in numbers, but one-fifth of world tourism in revenues.

pp. 20–21
ISLET IN THE SULU ARCHIPELAGO, Philippines
(N 6°05' E 120°54')

More than 6,000 of the 7,100 Philippine Islands are uninhabited and more than half are unnamed. This is true of this small isle of the Sulu Archipelago, a set of 500 islands that separate the Celebes and the Sulu seas. Legend has it that these scattered lands were pearls thrown down by giants after a dispute. More prosaically, the islands are of volcanic and coral origin, and their flora and fauna settled gradually over time, as is true of most island systems, borne here by marine currents, winds, migratory birds, and humans. This islet, lost in the blue immensity, reminds us that nearly 70 percent of the surface of our planet is covered by water, primarily saltwater. Most freshwater is imprisoned in polar glaciers, leaving less than 1 percent of freshwater (0.01 percent of all water) on the "blue planet" available to humans. The increase in the world population between 1950 and 2000 and in the quantity of water consumed brought a decline in available world water reserves from 22,000 to 8,900 cubic yards (from 17,000 to 6,800 m³) per inhabitant per year.

pp. 22–23
DROMEDARY CARAVAN IN THE DUNES near Nouakchott, Mauritania
(N 18°09' W 15°29')

The Sahara, the world's largest sand desert, covers 3.5 million square miles (9 million km²)—equivalent to the area of the United States—spread over eleven countries. Mauritania, which lies on its western border, is three-quarters desert and is thus particularly vulnerable to the phenomenon of desertification. Human activities such as excessive grazing, harvesting of firewood, and agricultural expansion are gradually destroying soil-retaining vegetation on the perimeters of the great dune ranges. This facilitates the advance of sand, which today endangers cities, including the capital, Nouakchott. In arid and semi-arid zones (which make up two-thirds of the continent of Africa), fragile arable lands deteriorate rapidly if farming and other exploitation become too intensive. In the past half-century, 65 percent of arable lands in Africa have suffered degradation, resulting in a drop in agricultural yield. In this vicious cycle, so difficult to break, poverty is both a cause and a consequence of the depletion of arable soil and the decline in agricultural productivity.

pp. 24–25
ELEPHANTS IN THE OKAVANGO DELTA, Botswana
(S 19°26' E 23°03')

The Okavango Delta, a vast humid zone in the heart of Botswana, has a rich and diverse fauna, including tens of thousands of elephants. Aggressively hunted for its ivory, the African elephant (*Loxodonta africana*), the world's largest land mammal, recently came close to extinction. Between 1945 and the end of the 1980s, the number of elephants dropped from 2.5 million to fewer than 500,000. In 1989 the Convention on International Trading of Endangered Species (CITES) declared a total interdiction on the international ivory trade. After Botswana, Namibia, and Zimbabwe were granted a partial, experimental lifting of the ban in 1997, 50 tons of ivory (5,446

tusks) were sold to Japan in 1999 for the sum of $5 million. The countries claimed that the proceeds were invested in conservation programs involving local communities. However, confirmed reports of a rise in hunting throughout the continent of the still endangered species proved that all controls were ineffective. Thus, the prohibition of the ivory trade was reinstated.

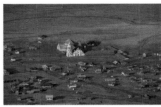

pp. 26–27
THE VILLAGE OF BACOLOR UNDER A LAYER OF MUD, the island of Luzon, Philippines
(N 14°59' E 120°39')

In 1991 the volcano of Pinatubo, on the island of Luzon in the Philippines, began to erupt after nearly six centuries of dormancy, projecting a 66 million-cubic-foot (18 million-cubic-meter) cloud of sulfurous gas and ash to a height of 115,000 feet (35,000 m) and destroying all life within a radius of 9 miles (14 km). In the days that followed, torrential rains from a hurricane mixed with ashes scattered over several thousand kilometers, causing devastating mudflows, which engulfed whole villages. Before the cataclysmic eruption on June 15, 1991, the evacuation of 60,000 people limited casualties to 875 dead and 1 million injured. Close to 600 million inhabitants of our planet live under the threat of volcanoes, but despite their force, volcanic eruptions are not the deadliest threat to humans. In the past fifteen years, 560,000 persons perished from major natural catastrophes (120,000 in 1998 and 1999 alone); 15 percent of the deaths were due to storms, 30 percent to earthquakes, and half to floods—a natural phenomenon that has become even more devastating as a result of human intervention in the environment.

pp. 28–29
RICE FIELDS IN THE SOUTH OF POKHARA, the Pahar region, Nepal
(N 27°49' E 84°08')

The Pokhara valley, in the Pahar region of central Nepal, is rich in fertile alluvial soil because of a network of running streams. The banks of the hills are covered by a mosaic of rice paddies in terraces of small embankments of earth. Eighty percent of the Nepalese population works in agriculture, and family-cultivated rice is the country's foremost agricultural product (4.2 million tons in 2001). At the end of the 1970s, the nation's farmers produced a small surplus, which enabled them to export some of their crops, particularly to Tibet. Today Nepal does not have the money to expand irrigation, and despite efforts to increase the area of cultivated land and to use more productive fertilizer and seeds, the country does not produce enough food for its own people and must import.

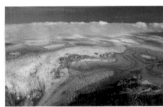

pp. 30–31
FOLGEFONNI GLACIER ON THE HIGH PLATEAUS OF SORFJORDEN, Norway
(N 60°14' E 6°44')

The Folgefonni glacier, hemmed in between two fjords, Hardangerfjorden and Sørfjorden, in southern Norway, is the third largest of the country's 1,500 glaciers, occupying an area of 83 square miles (212 km²). A plateau glacier typical of the regions with temperate climate, this flattened snowy cupola slides on a film of water formed between the rock and ice. In summer the partial melting of ice supplies the water of the fjords with silt and clay, giving them a very unusual green tint. Aside from seasonal variations, the volume of glaciers is constantly reduced because of the natural heating of the planet and the increase in the greenhouse effect. This theory on global warming caused international concern in 1992 at the Earth Summit in Rio de Janeiro, Brazil. An agreement signed at Bonn, Germany, in 2001, on the methods for applying the 1997 Kyoto Agreement, mandated that industrial nations reduce their greenhouse-effect gas emissions by 2010. But the United States, which has 5 percent of the world's population and emits one-quarter of greenhouse gases, refuses to participate in this global response to climatic change.

Captions to the photographs on pages 32 to 47 can be found on the foldout to the right of the following chapter

captions 18–31 captions 32–47

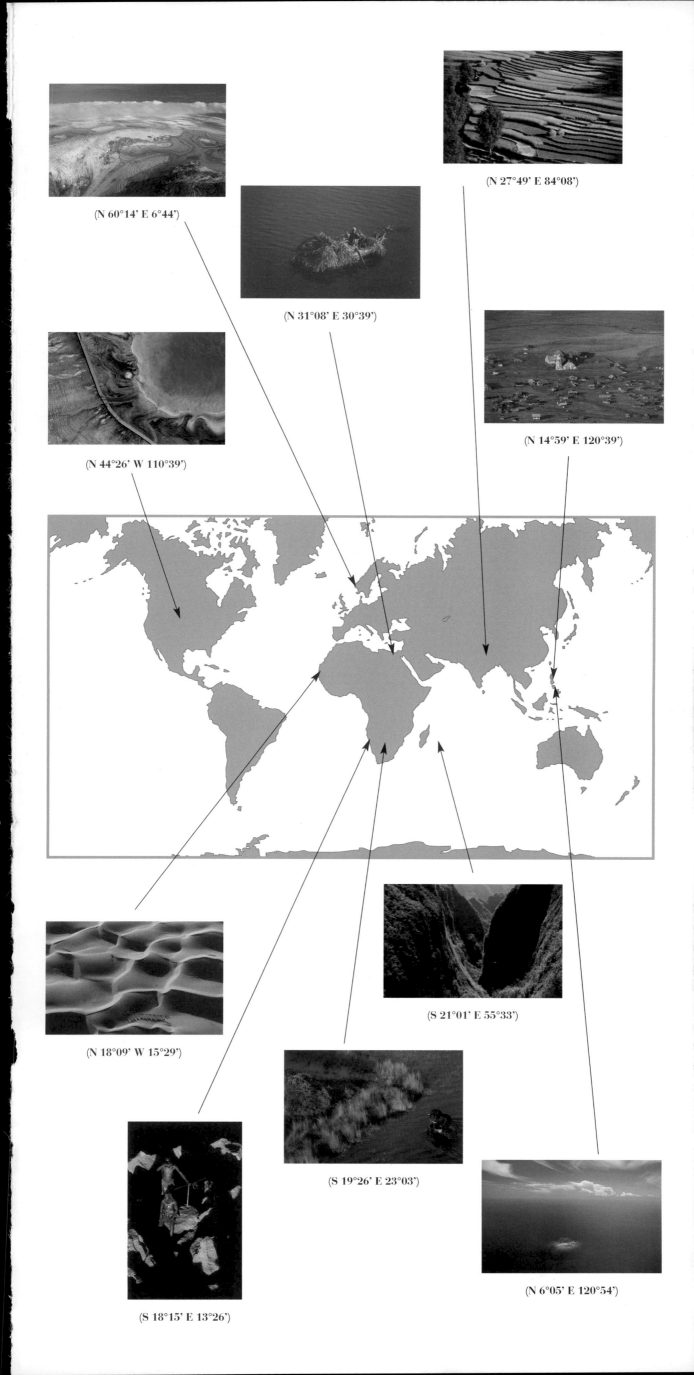

(N 60°14' E 6°44')

(N 31°08' E 30°39')

(N 27°49' E 84°08')

(N 14°59' E 120°39')

(N 44°26' W 110°39')

(S 21°01' E 55°33')

(N 18°09' W 15°29')

(S 19°26' E 23°03')

(N 6°05' E 120°54')

(S 18°15' E 13°26')

The materials sector of the eco-economy will look far different as well. Mature industrial economies with stable populations can operate largely by recycling the materials already in use. The materials loop will be closed, yielding no waste for the landfills.

In March 2001 the local destination for New York City's daily output of 12,000 tons of garbage was permanently closed. Now the garbage is hauled to distant sites, some of them more than 300 miles (480 km) away. Assuming a load of 20 tons of garbage for each of the tractor-trailers that are used for the long-distance hauling, some 600 rigs are needed to remove garbage from New York City each day. These tractor-trailers form a convoy nearly 9 miles (15 km) long, impeding traffic, polluting the air, and raising carbon emissions. What is happening in New York will occur in other cities if they also fail to adopt comprehensive recycling programs. Even a simple measure such as recycling all of the city's paper could shorten the daily convoy leaving the city by 187 tractor-trailers, or 2.8 miles (4.5 km).

In order to reverse deforestation, increasing paper recycling is essential. So, too, are developing alternative energy sources that will reduce the amount of wood used as fuel and boosting the efficiency of wood burning.

In the economy of the future the use of water will be in balance with supply. Water tables will be stable, not falling. The economic restructuring will be designed to raise water productivity in every facet of economic activity.

In this environmentally sustainable economy, harvests from oceanic fisheries will be reduced to the sustainable yield; fish farming will satisfy additional demand. A similar situation exists for rangelands. One of the keys to alleviating the excessive pressure on rangelands is to feed livestock the crop residues that are otherwise burned for fuel or for disposal. And the new economy will have a stable population. Over the longer term, the only sustainable society is one in which couples have an average of two children.

NEW INDUSTRIES, NEW JOBS

Building a new economy involves phasing out old industries, restructuring existing ones, and creating new ones. World coal use is already being phased out, dropping 7 percent since peaking in 1996. Some countries are making efficiency gains; it is being replaced by natural gas in countries such as the United Kingdom and China; and by wind power in still others such as Denmark.

The automobile industry faces a major restructuring as it changes power sources, shifting from the gasoline-powered internal combustion engine to the hydrogen-powered fuel cell engine. This shift will require both a retooling of engine plants and the retraining of automotive engineers and automobile mechanics.

The new economy will also bring major new industries, such as wind electricity generation, which promises to become the foundation of the new energy economy. In many countries wind will supply both electricity and, through the electrolysis of water, hydrogen. Together electricity and hydrogen can meet all the energy needs of a modern society.

There will be three new subsidiary industries associated with wind power: turbine manufacturing, installation, and maintenance. Manufacturing facilities will be found in both industrial and developing countries. Installation, which is basically a construction industry, will be more local in nature. Maintenance, a day-to-day activity, will be a source of ongoing local employment.

The robustness of the wind turbine industry was evident in 2000 and 2001: when high-tech stocks were in a free fall worldwide, sales of wind turbines were climbing, pushing the earnings of turbine manufacturers to the top of the charts. Continuing growth of this sector is expected for the next few decades.

The emergence of wind power will spawn another industry—hydrogen production. When wind turbines are in wide use, a large, unused capacity will exist during the night when electricity use drops. With this essentially free electricity, turbine owners can turn on the hydrogen generators, converting the wind power into hydrogen, the ideal fuel for the fuel cell engines that will replace internal combustion engines. Hydrogen generators will start to replace oil refineries. The wind turbine will replace both the coal mine and the oil well.

Changes in the world food economy will also be substantial. Some of these, such as the shift to fish farming, are already underway. Fish farming is likely to continue to expand simply because of its efficiency in converting grain into animal protein. This will create a need for aquatic ecologists, fish nutritionists, and marine veterinarians.

Another growth industry of the future is bicycle manufacturing and servicing. Because the bicycle is nonpolluting, frugal in its use of land, and provides the exercise much needed in sedentary societies, future reliance on it is expected to grow. Among industrial countries, the urban transport model pioneered in the Netherlands and Denmark, where bikes are featured prominently, gives a sense of the bicycle's future role worldwide.

Just as the last half-century has been devoted to raising land productivity, the next half-century will be focused on raising water productivity. Irrigation technologies will become more efficient. Urban wastewater recycling will become common. At present water tends to flow into and out of cities, carrying waste with it. In the future water will be used over and over, never discharged.

Restructuring the global economy will create not only new industries but also new jobs—indeed, whole new professions and specialties. As the wind industry grows, thousands of wind meteorologists will be needed to analyze potential wind sites, monitor wind speeds, and select the best locations for wind farms. Wind engineers will tailor designs to specific areas in order to maximize electricity generation.

Environmental architecture is another fast-growing profession. Environmental architects design buildings that are energy- and materials-efficient and that maximize natural heating, cool-

ing, and lighting. Buildings that are in harmony with the environment are hallmarks of an eco-economy.

In a future of water scarcity, watershed hydrologists will be in demand. They will understand the hydrological cycle, including the movement of underground water, and they will know the depth of aquifers and determine their sustainable yield.

As the world shifts from a throwaway economy, engineers will be needed to design products that can be recycled—from cars to computers. Computers contain a diverse array of materials, many of them toxic, which makes them difficult to recycle. A study by the Silicon Valley Toxics Coalition estimates that between 1997 and 2004, some 315 million computers will become obsolete in the United States alone. Each computer contains nearly 4 pounds of lead, meaning that the United States is facing the question of how to deal with 1.2 billion pounds of lead. If placed in landfills, lead can leach into aquifers and contaminate drinking water supplies. These same computers contain about 400,000 pounds of mercury and 2 million pounds of cadmium. Future recycling engineers will design products to be easily disassembled into components, and they will help to close the materials loop, converting the linear flow-through economy into a comprehensive recycling economy.

In countries with a wealth of geothermal energy, it will be up to geothermal geologists to locate the best sites either for power plants or for tapping directly to heat buildings. Retraining petroleum geologists to master geothermal technologies is one way of satisfying the likely surge in demand for geothermal geologists.

If the world is to stabilize its population sooner rather than later, far more family-planning midwives are needed in communities in developing nations, giving advice on reproductive health and contraceptive use. Another pressing need, particularly in developing countries, is for sanitary engineers who can design sewage systems not dependent on water, a trend that is already underway in some water-deprived countries. Washing waste away using water is a reckless use of a scarce resource better used for drinking, bathing, and irrigation.

Yet another area of expertise that is likely to expand rapidly as productive farmland becomes scarce is that of agronomists who specialize in multiple cropping and intercropping. This requires an expertise both in the selection of crops that can fit together well in a tight rotation in various locales and in agricultural practices that facilitate multiple cropping.

HISTORY'S GREATEST INVESTMENT OPPORTUNITY

Restructuring the global economy so that economic progress can be sustained represents the greatest investment opportunity in history. One major difference between the investments in fossil fuels and those in wind power, solar cells, and geothermal energy is that the latter will supply energy in perpetuity. These "wells" will not run dry. If the money spent on oil in one year ($756 billion in 2000) were invested in wind turbines, the electricity generated would be enough to meet one-fifth of the world's needs.

Investments in the infrastructure for the new energy economy include the transmission lines that connect wind farms with electricity consumers and the pipelines that link hydrogen supply sources with end-users. To a substantial degree, the infrastructure for the existing energy economy—the transmission lines for electricity and the pipelines for natural gas—can be used in the new energy economy as well. Existing urban pipeline distribution networks for natural gas can easily be converted to hydrogen.

In developing countries the new energy sources promise to reduce dependence on imported oil, freeing up capital for investment in domestic energy sources. Although few countries have their own oil fields, all have wind and solar energy. In terms of economic expansion and job generation, these new energy technologies are a godsend.

Investments in energy efficiency are also likely to grow rapidly simply because they are so profitable. In virtually all countries, industrial and developing, saved energy is the cheapest source of new energy. Replacing inefficient incandescent light bulbs with highly efficient compact fluorescent lamps offers a rate of return that stock markets are unlikely to match. Sometimes a simple measure can make a big difference. In Bangkok the city government decided that at 9 o'clock on a given weekday evening, all major television stations would show a large dial with the city's current use of electricity. When the dial appeared on-screen, everyone was asked to turn off unnecessary lights and appliances. As viewers watched, the dial dropped, reducing electricity use by 735 megawatts, enough to shut down two moderate-sized, coal-fired power plants.

A similar situation exists for tree plantations. An expansion of existing tree plantations by at least half, along with a continuing rise in productivity, is likely to be needed both to satisfy future demand and to eliminate one of the pressures that is shrinking forests. This, too, presents a huge opportunity for investment.

Building an eco-economy will not be easy, but everything that needs to be done is already being done by at least one country. As we look around the world, we catch glimpses of the eco-economy emerging in the wind farms of Denmark, the solar rooftops of Japan, the reforested mountains of South Korea, the bicycle-centered transport systems of the Netherlands, and the steel recycling mills of the United States.

Lester Brown

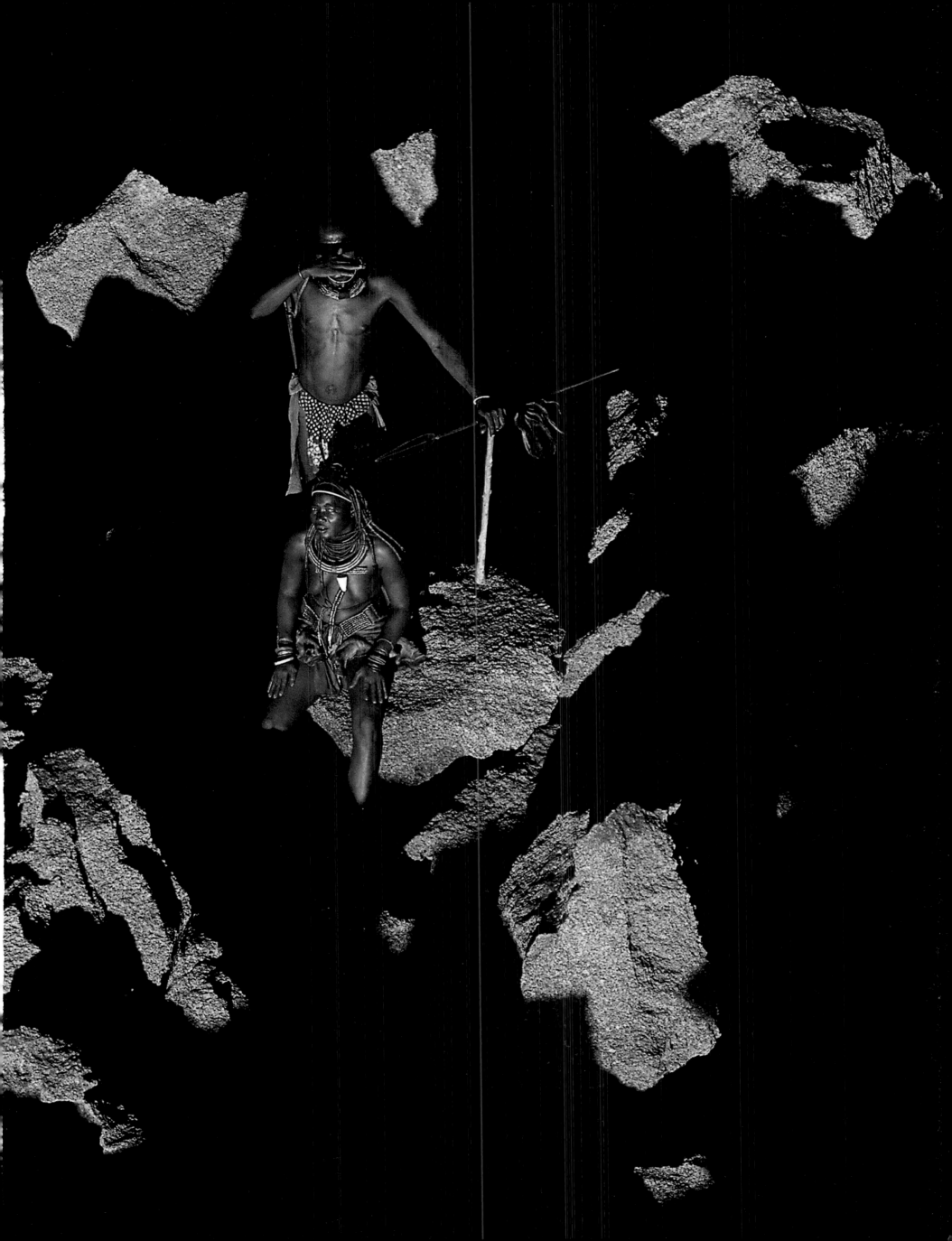

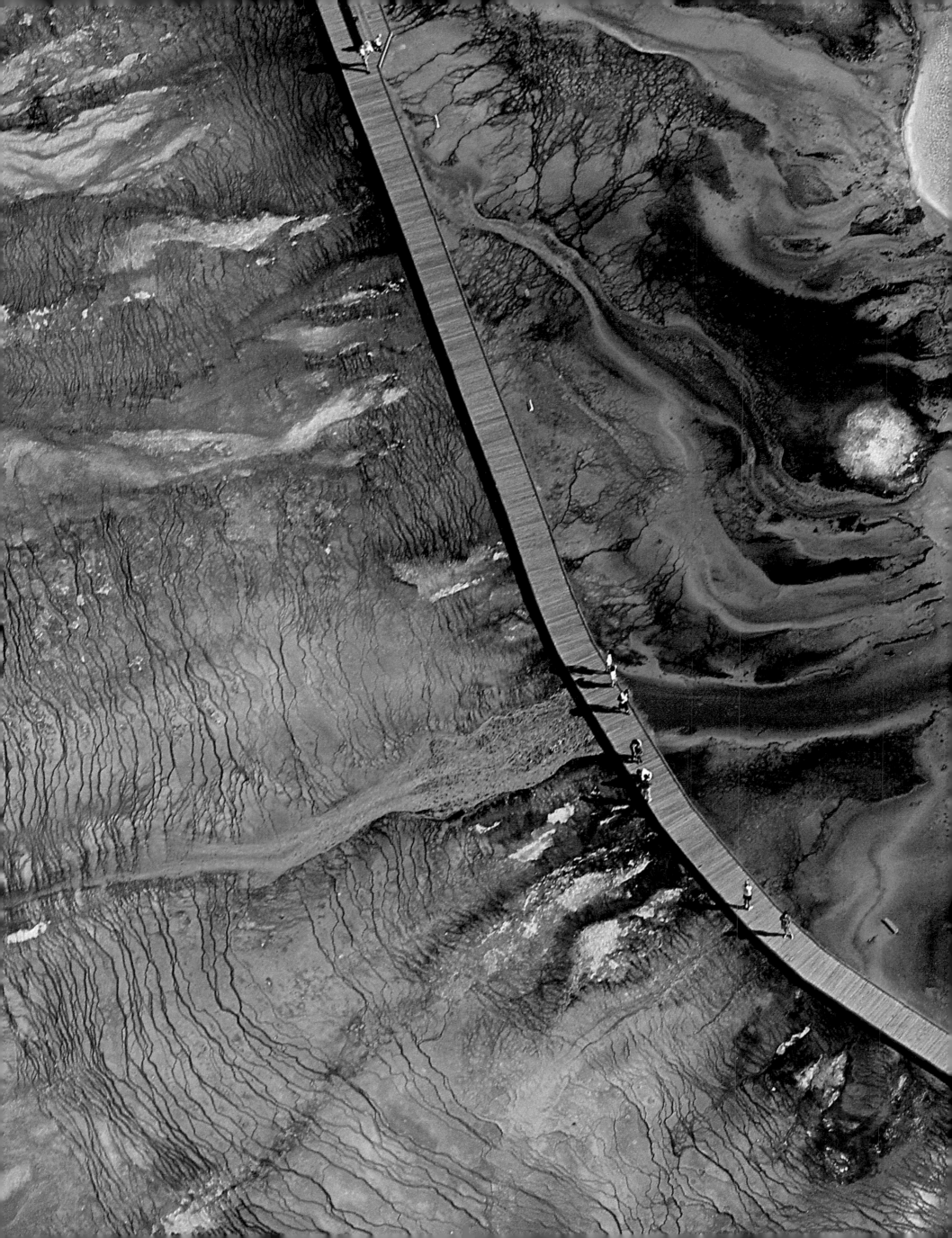

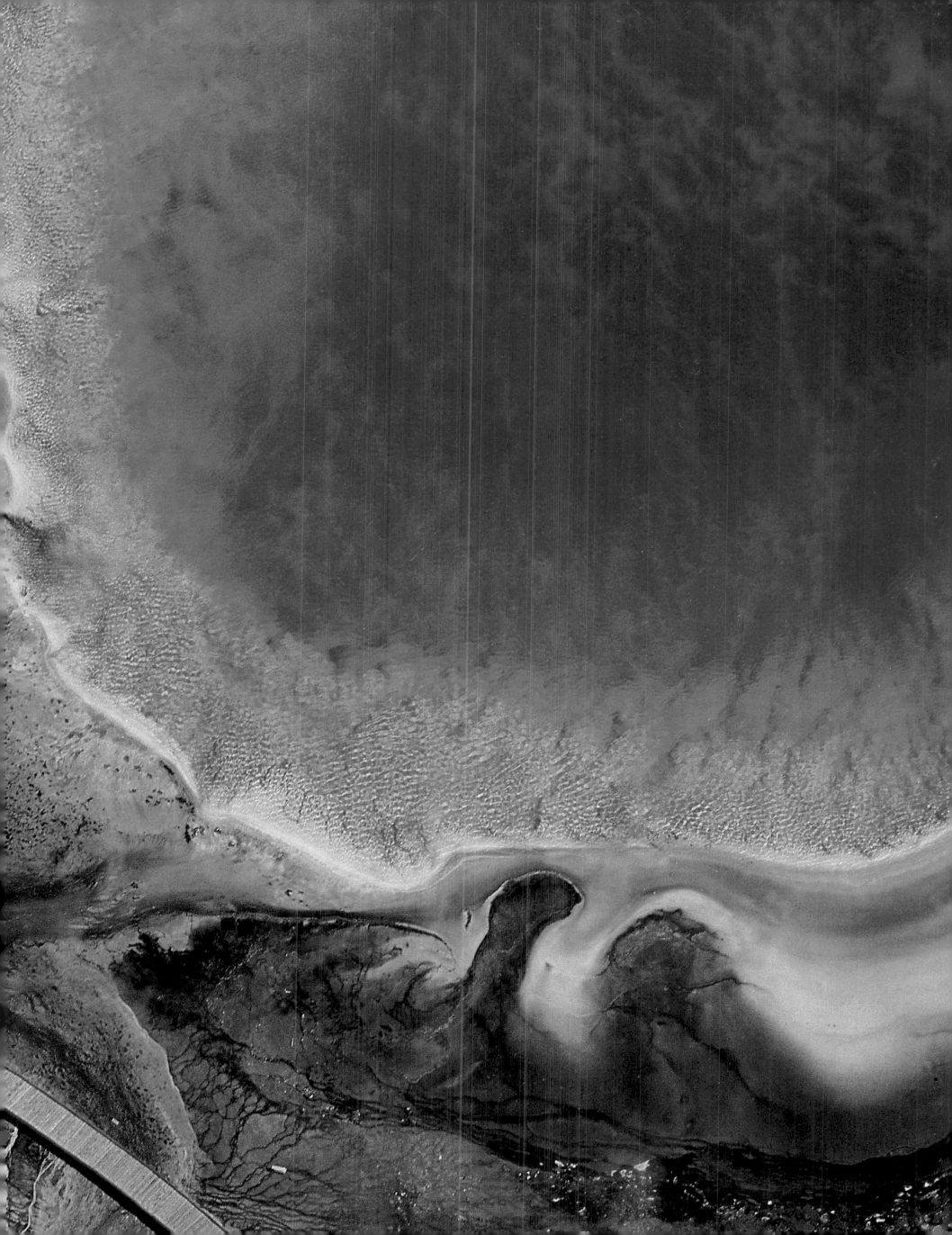

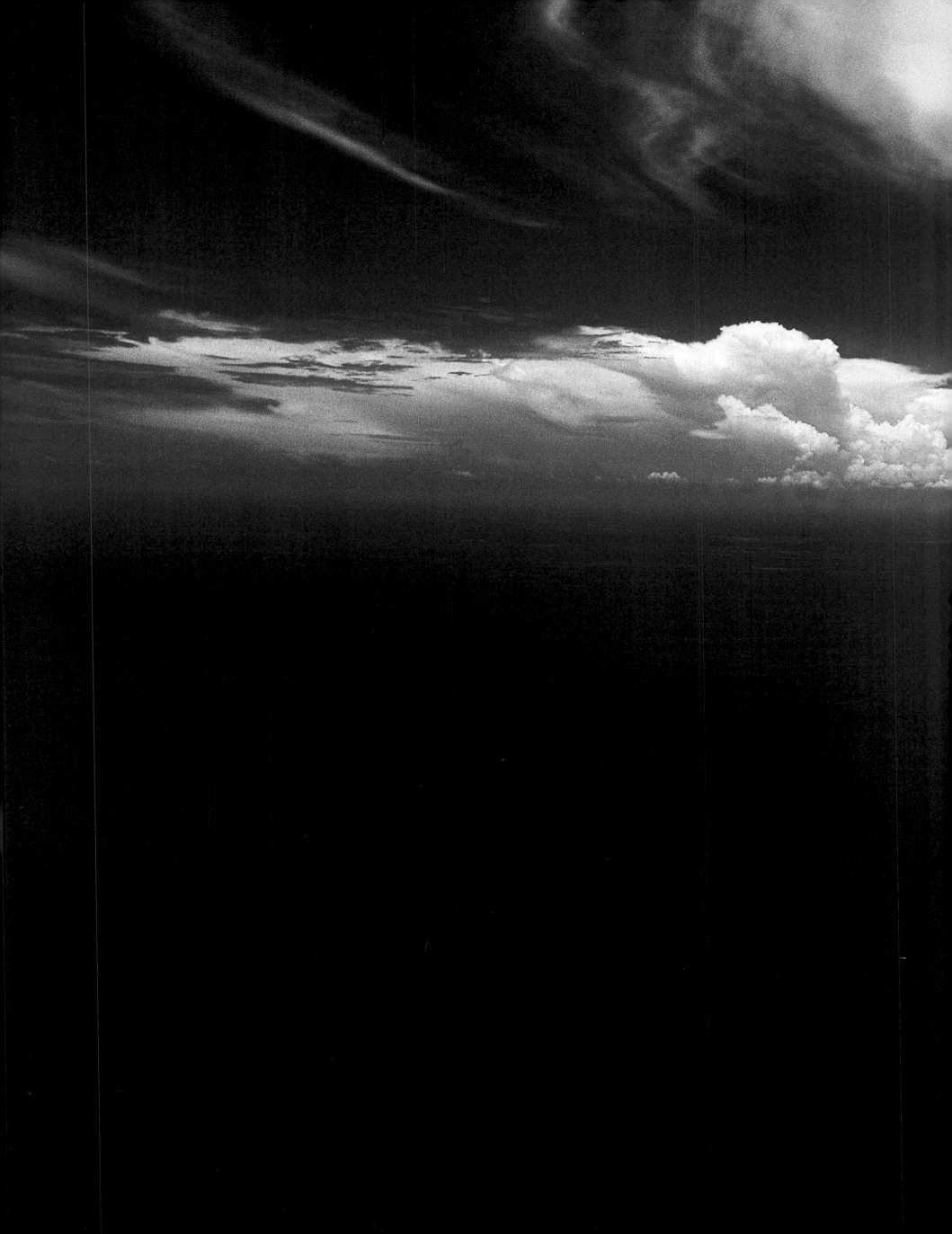

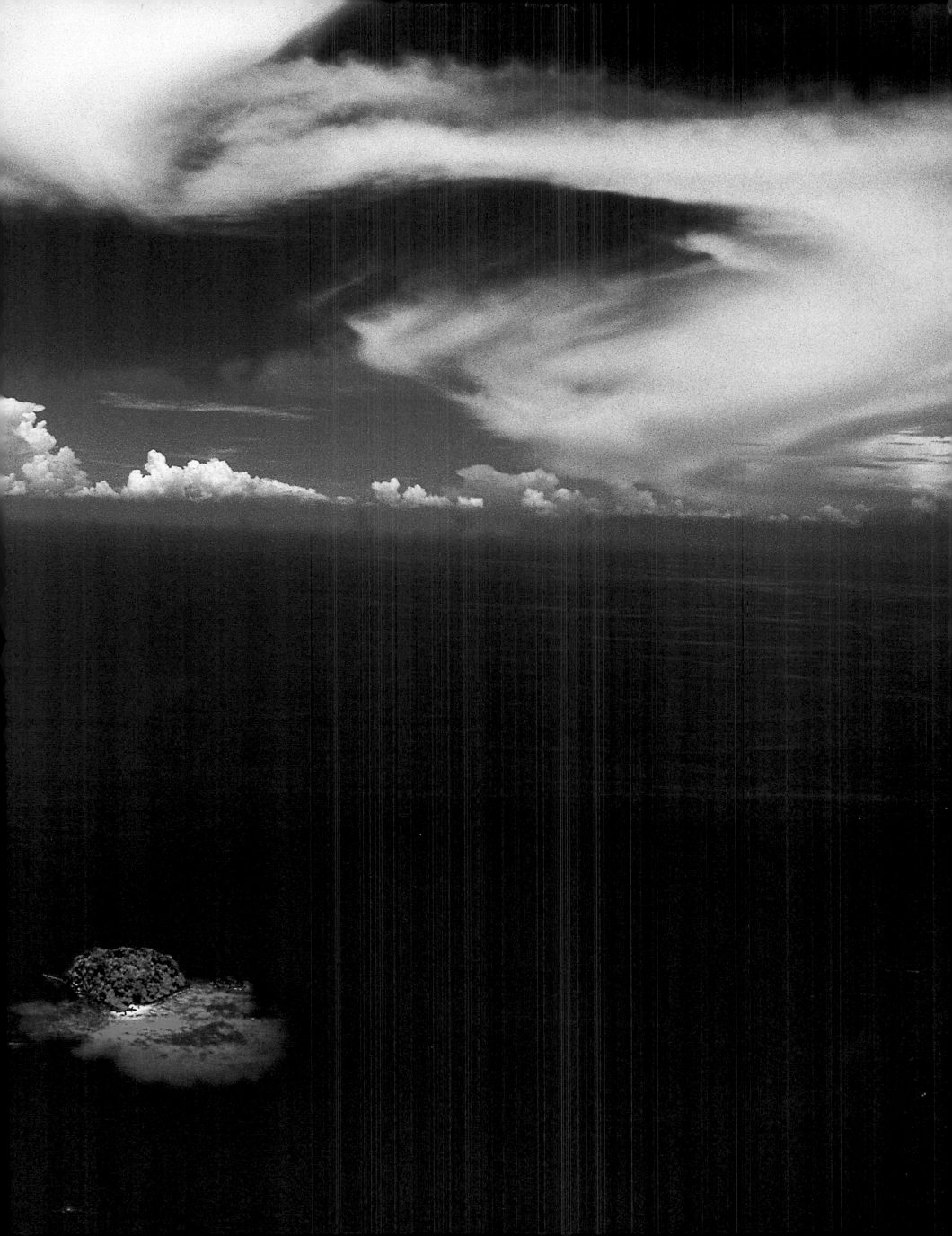

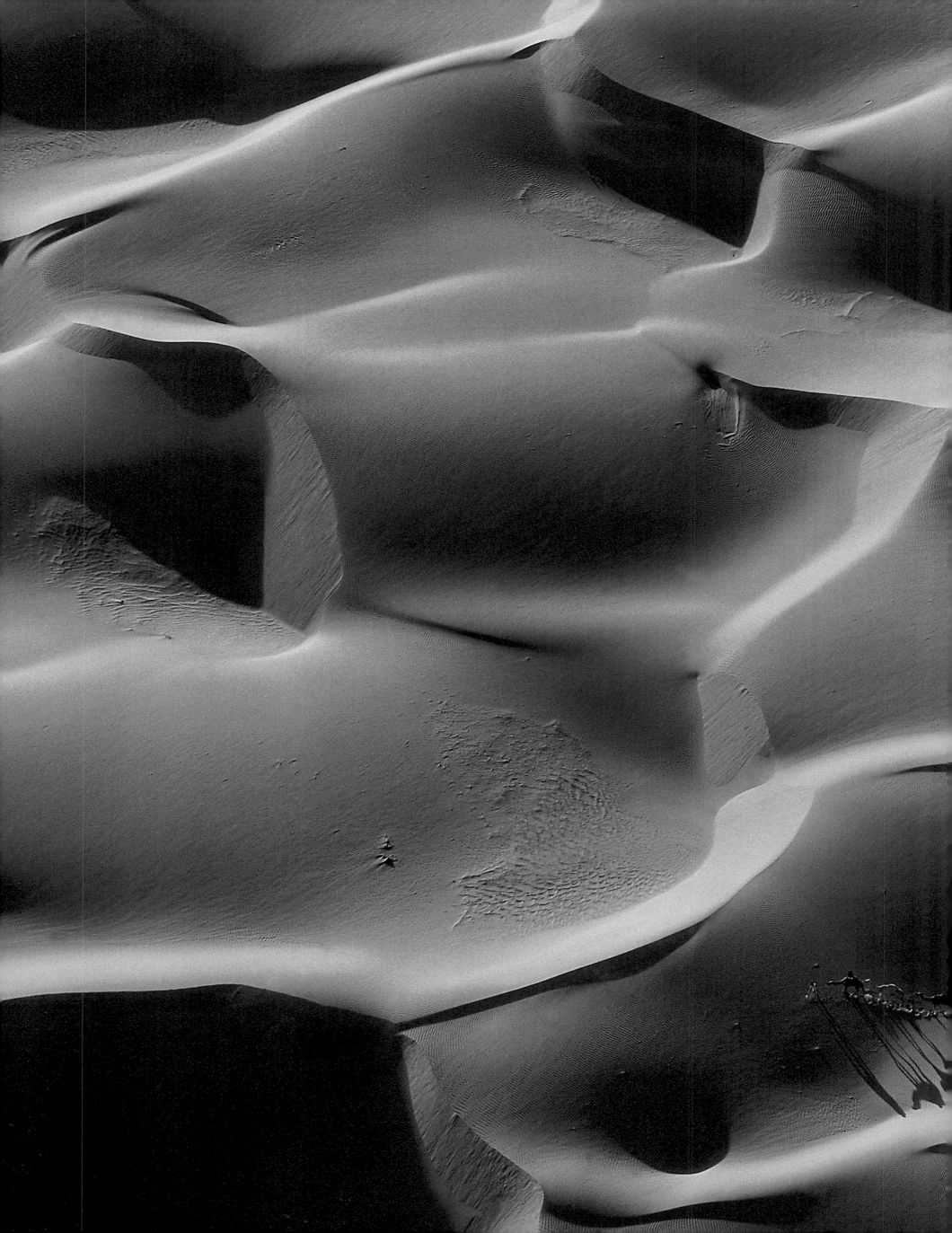

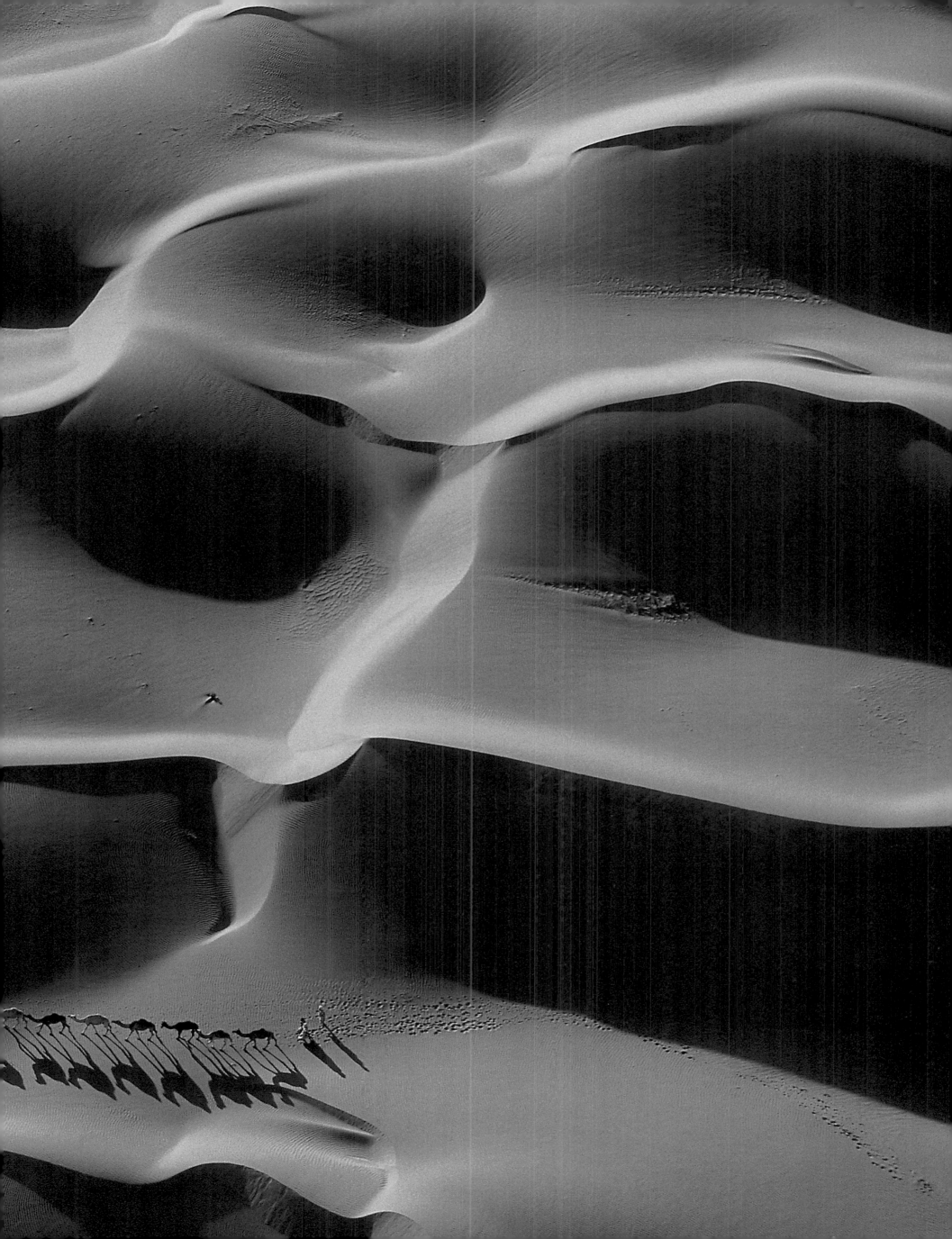

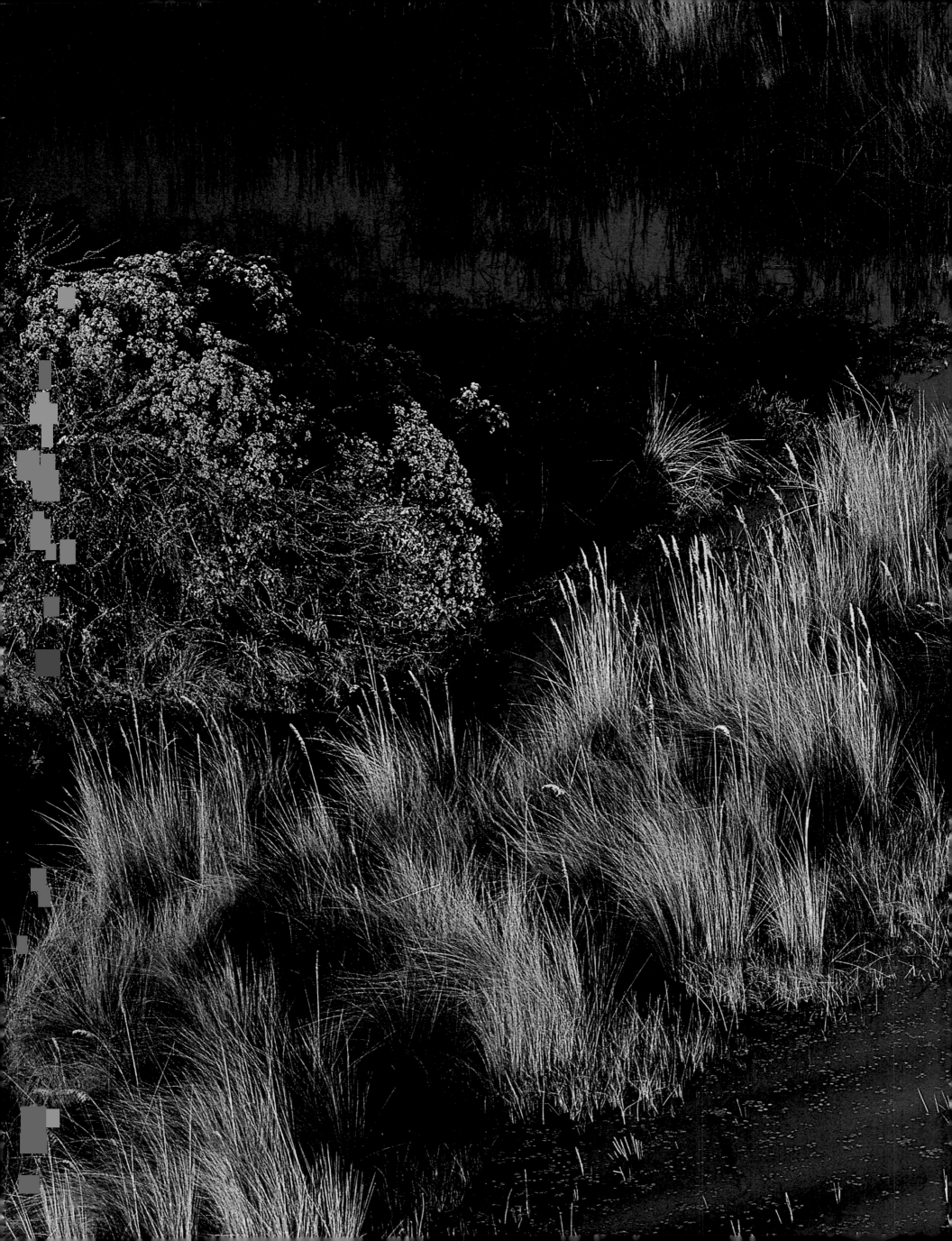

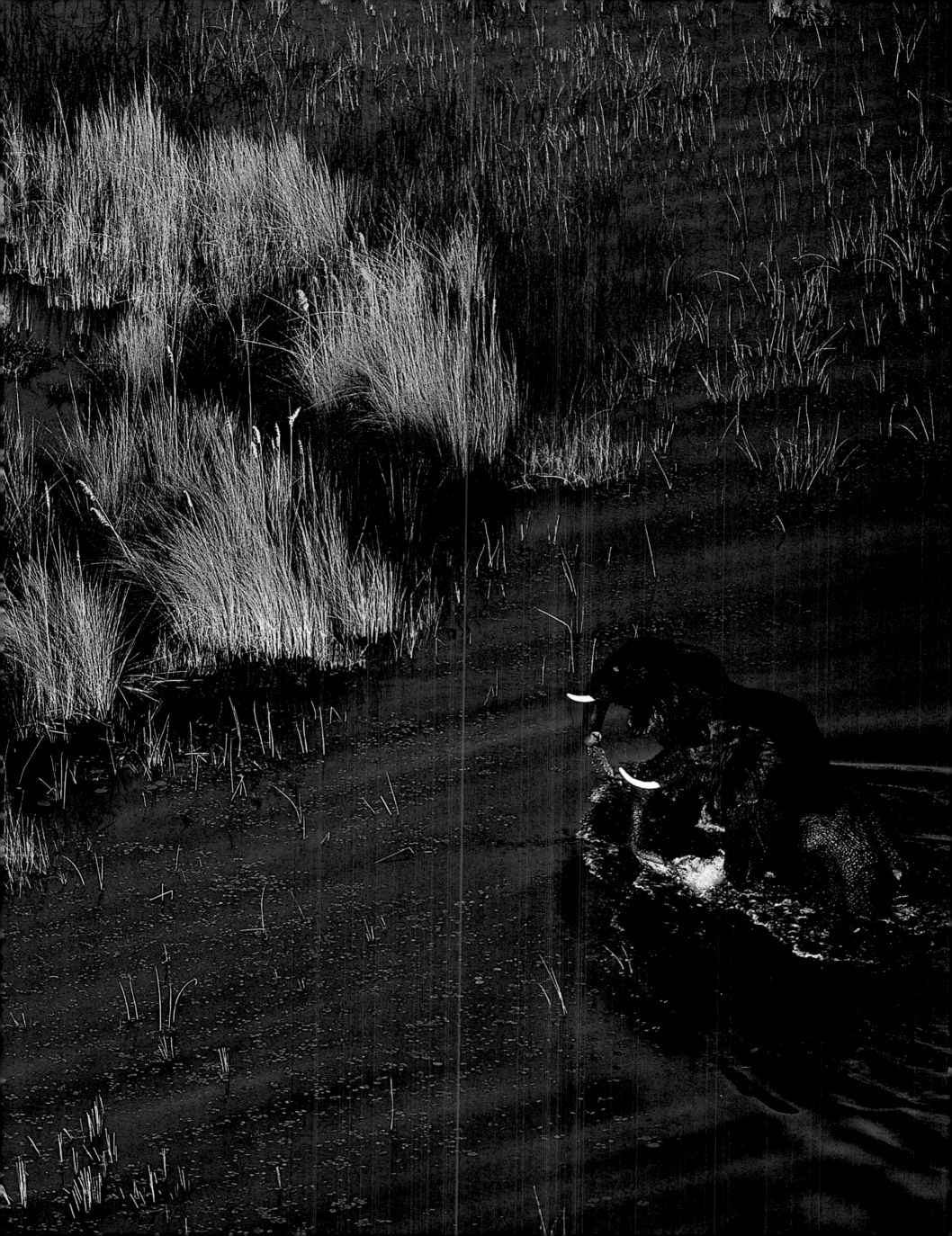

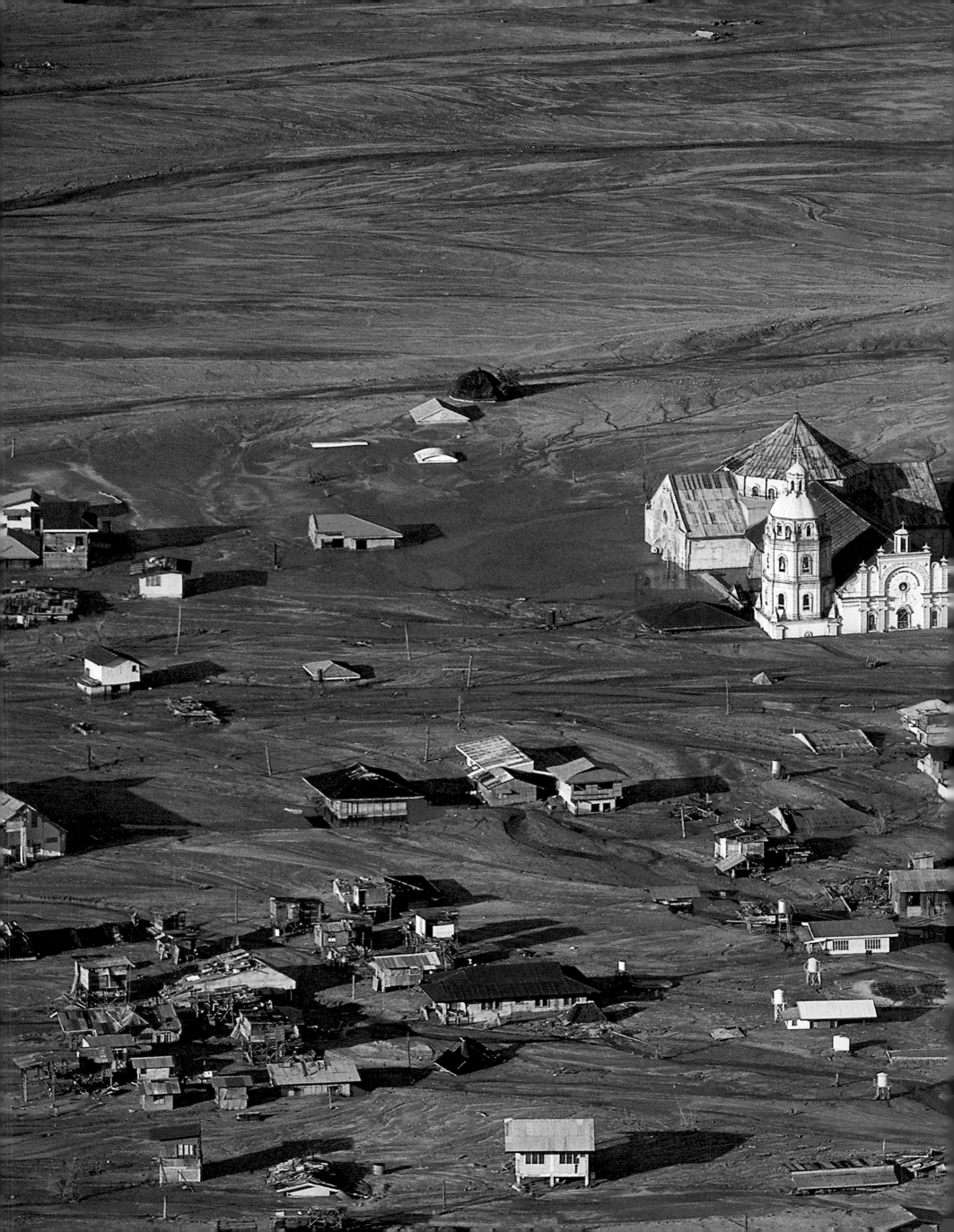

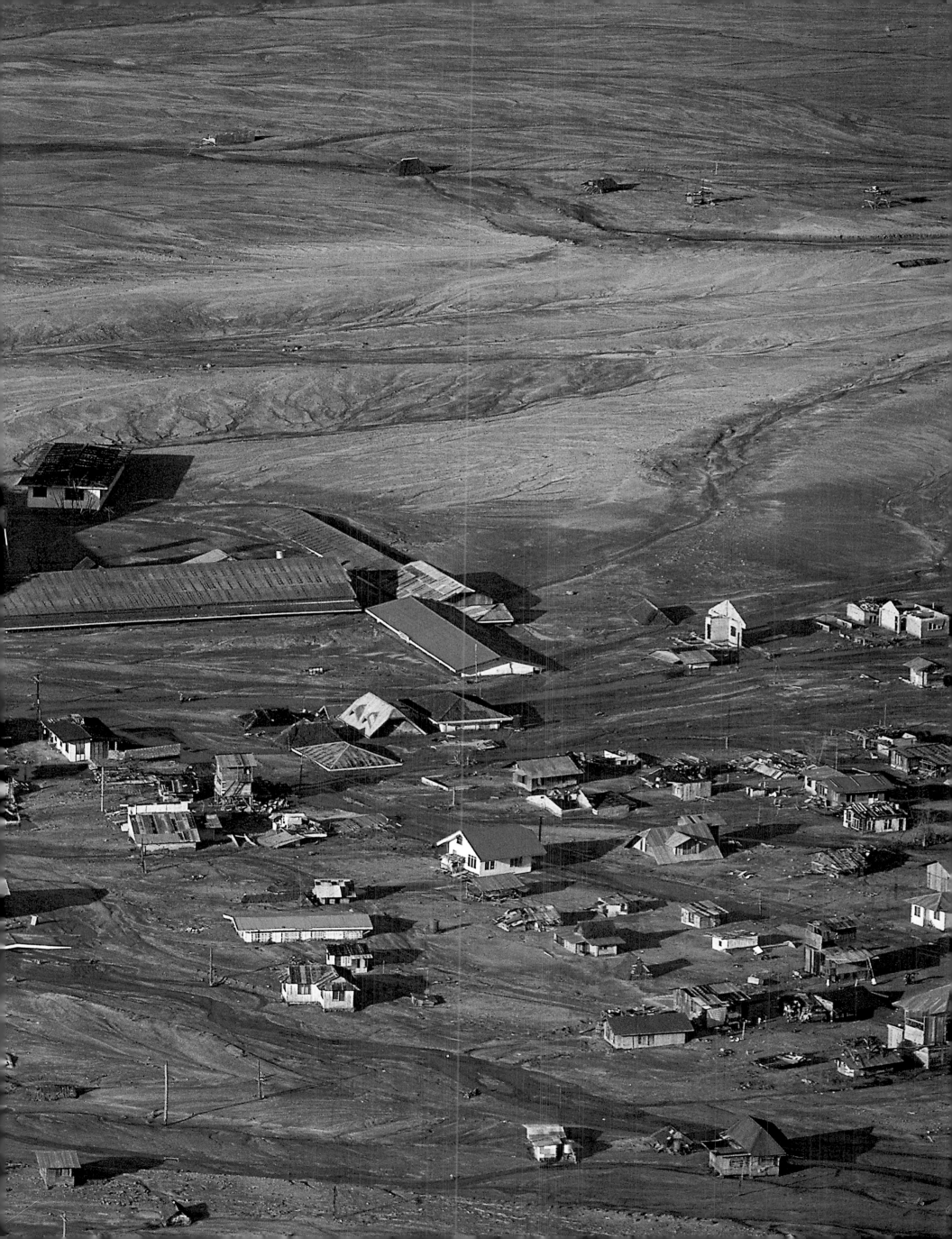

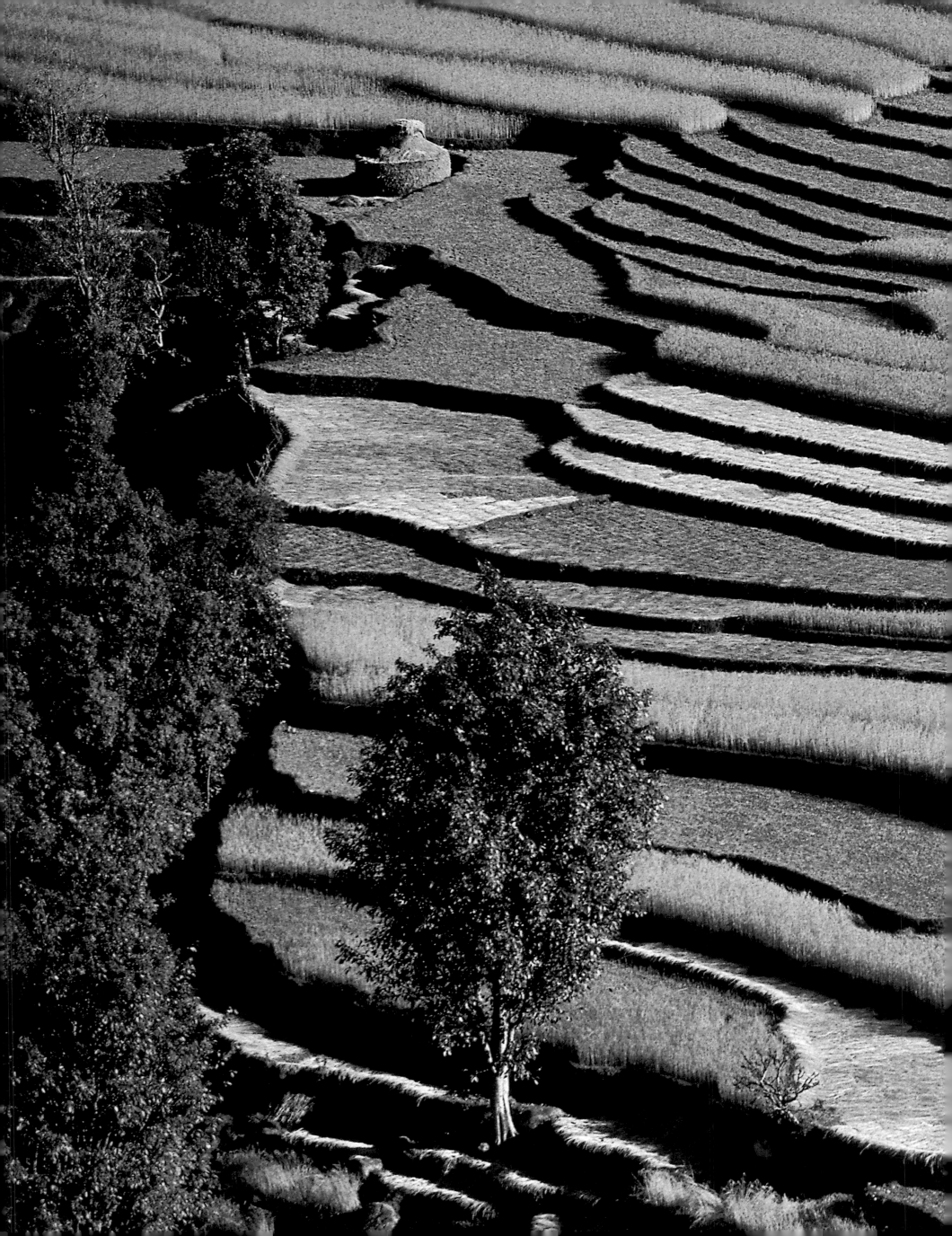

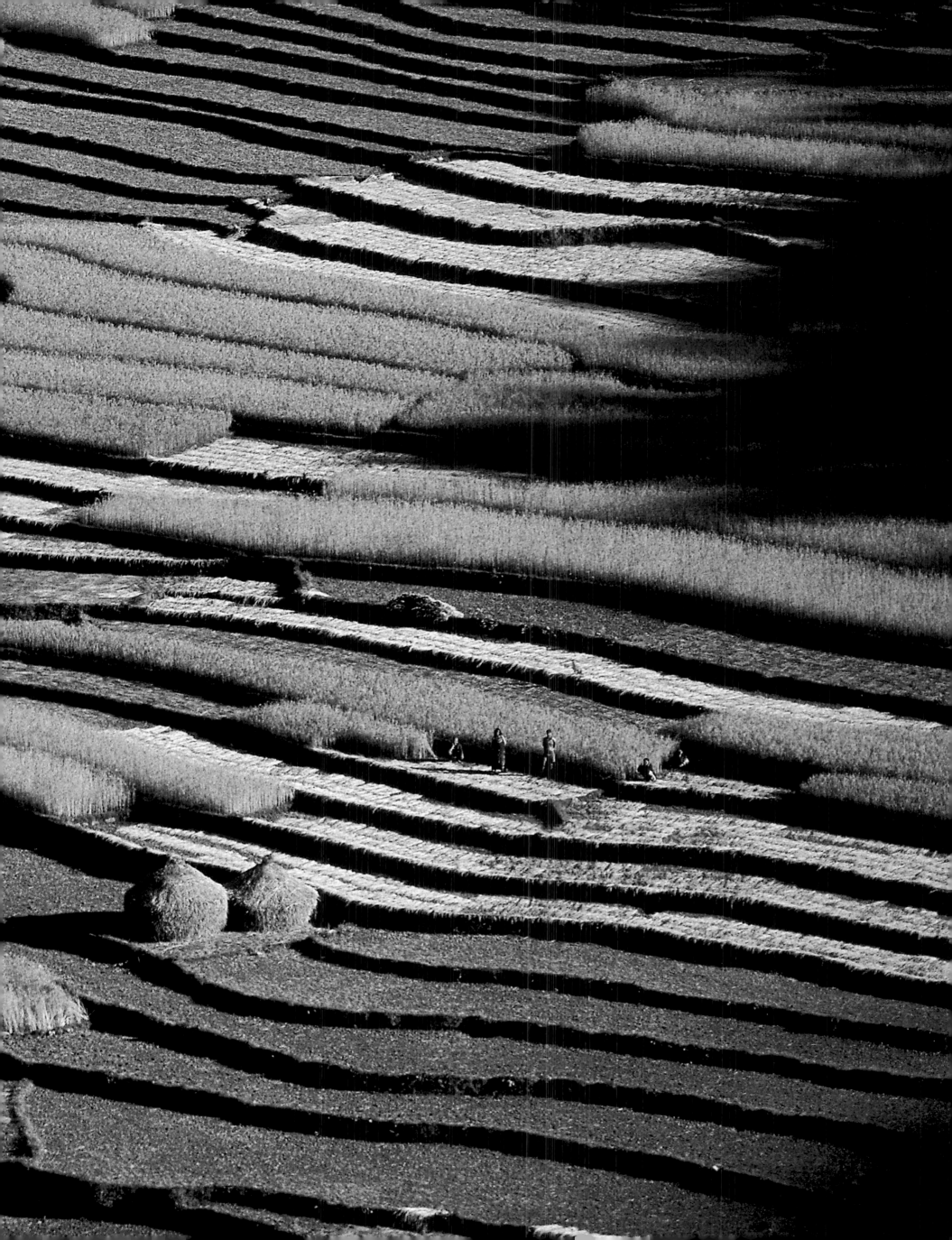

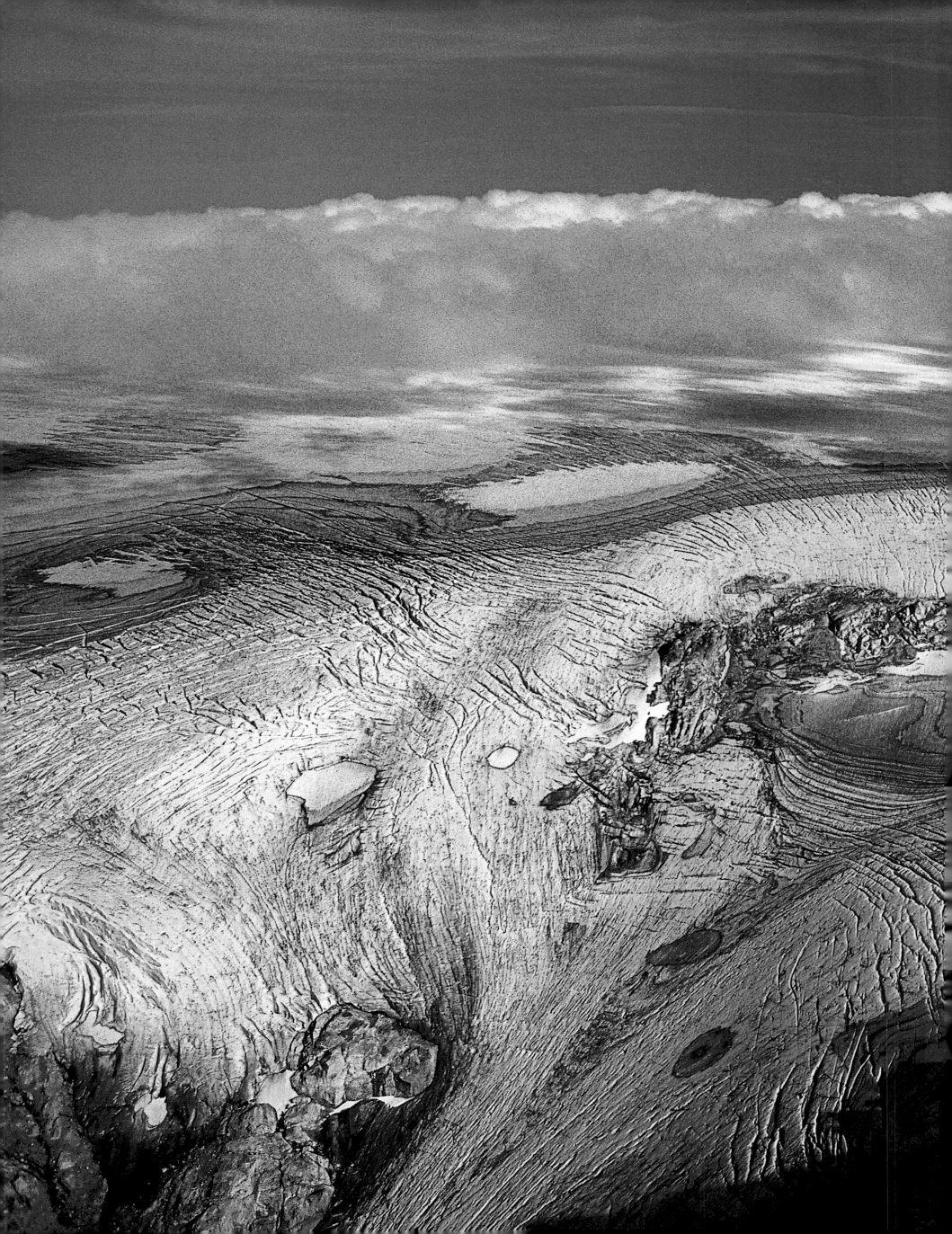

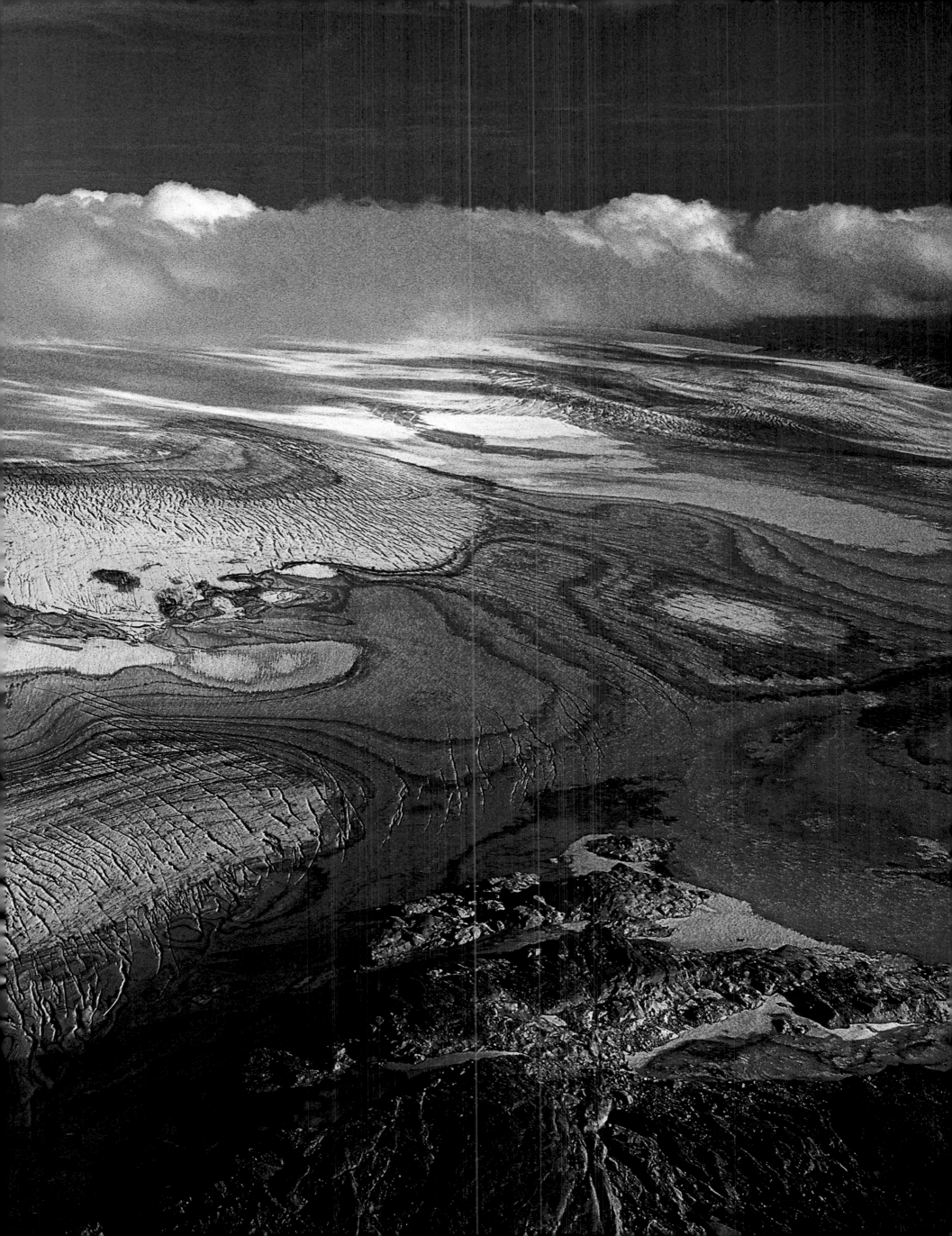

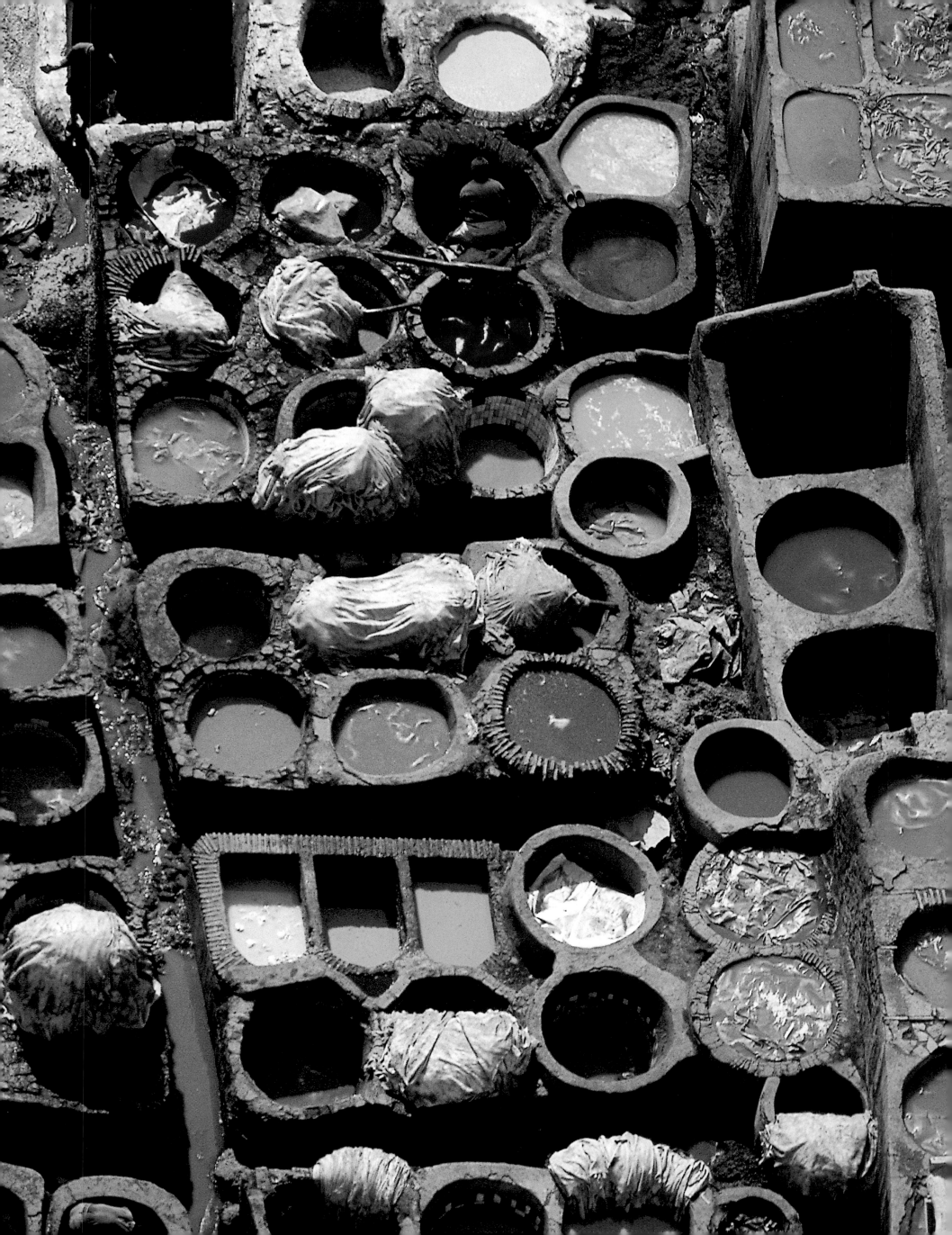

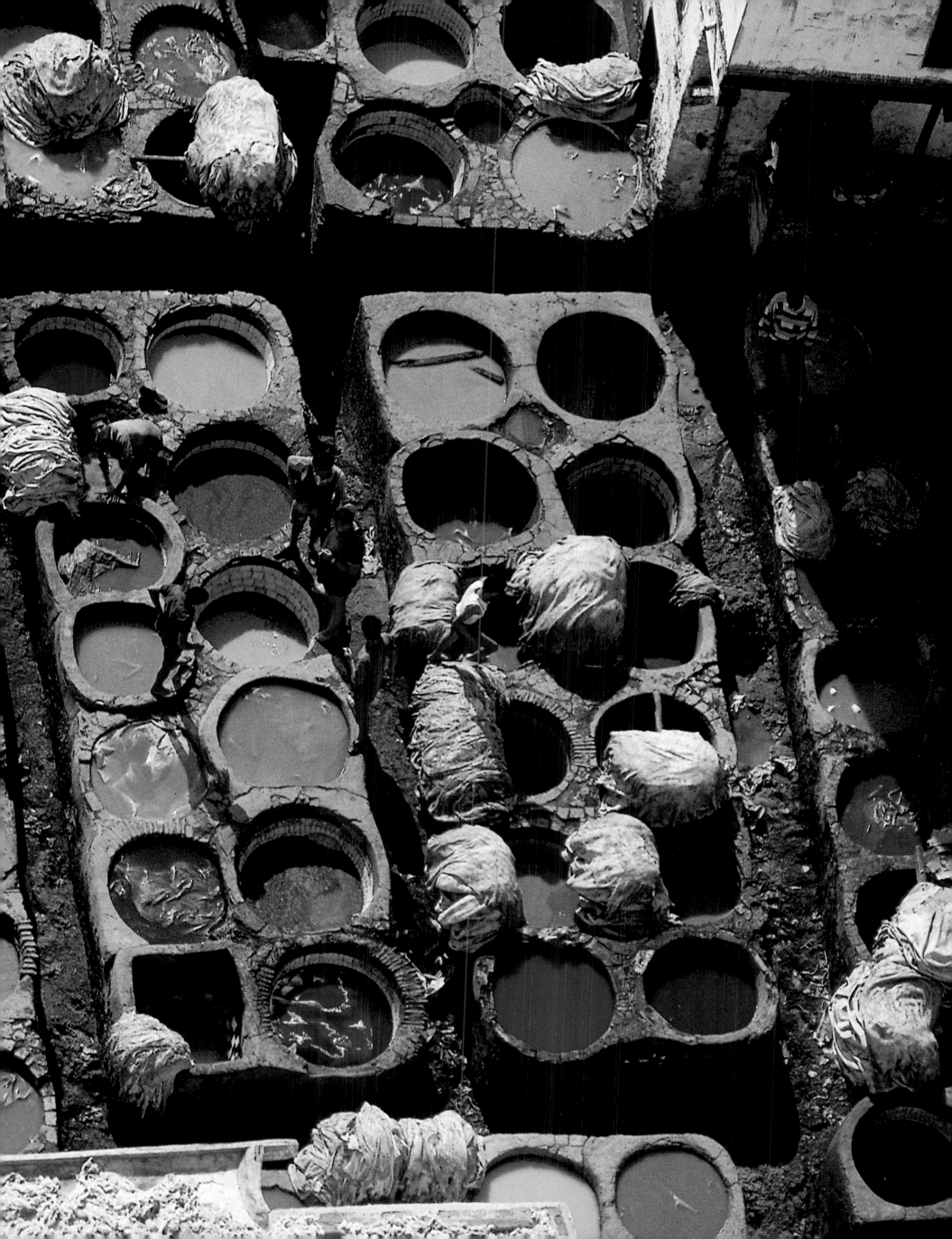

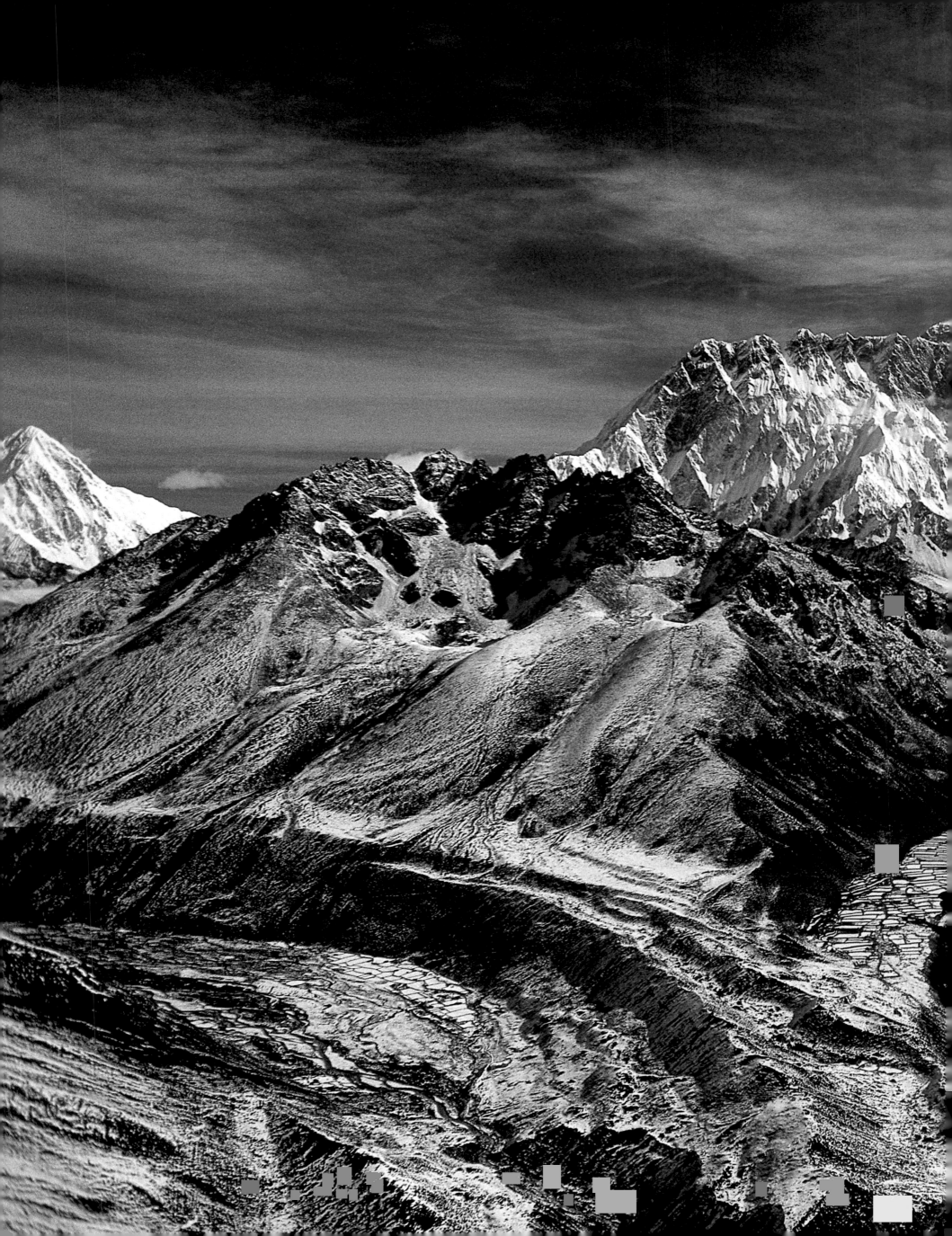

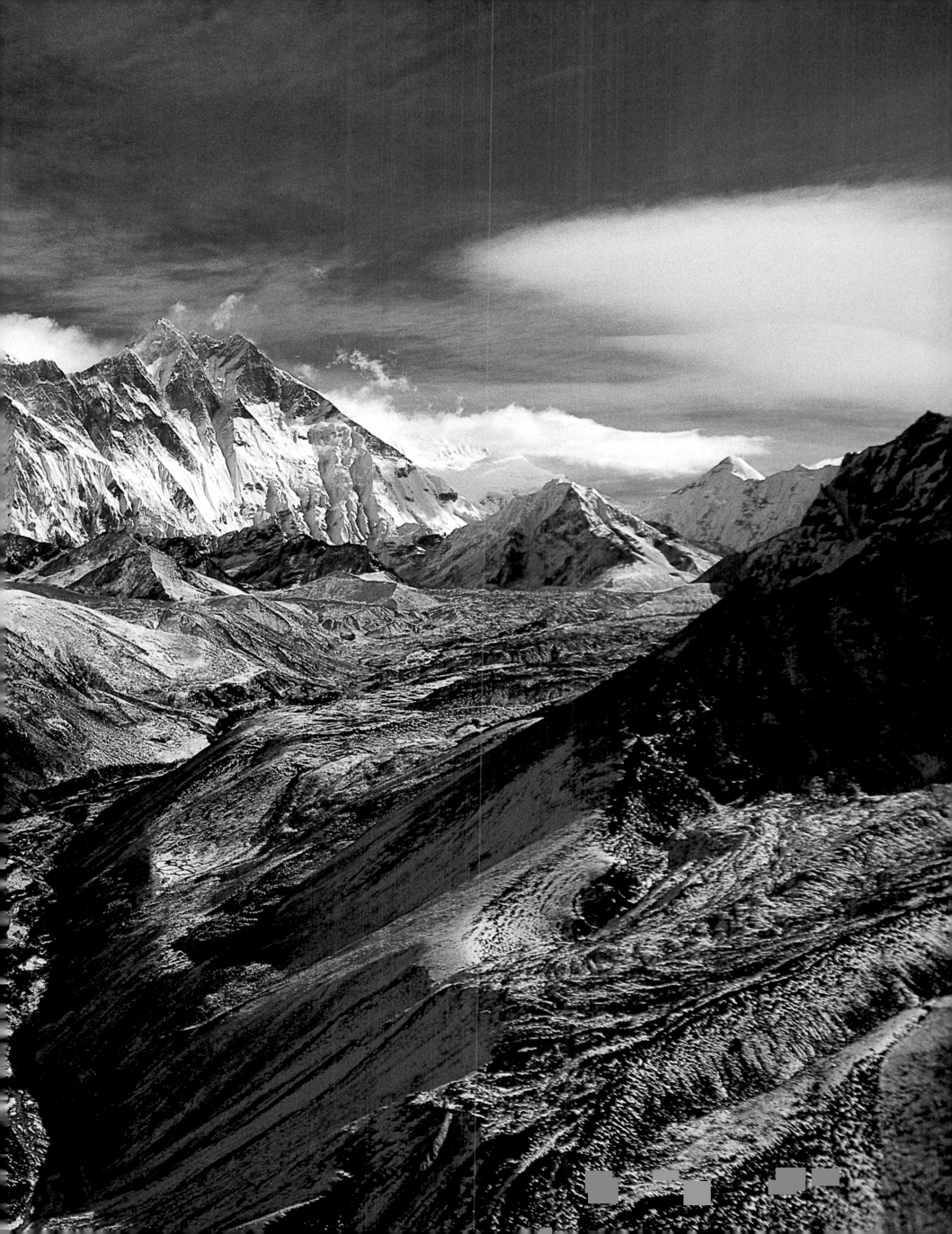

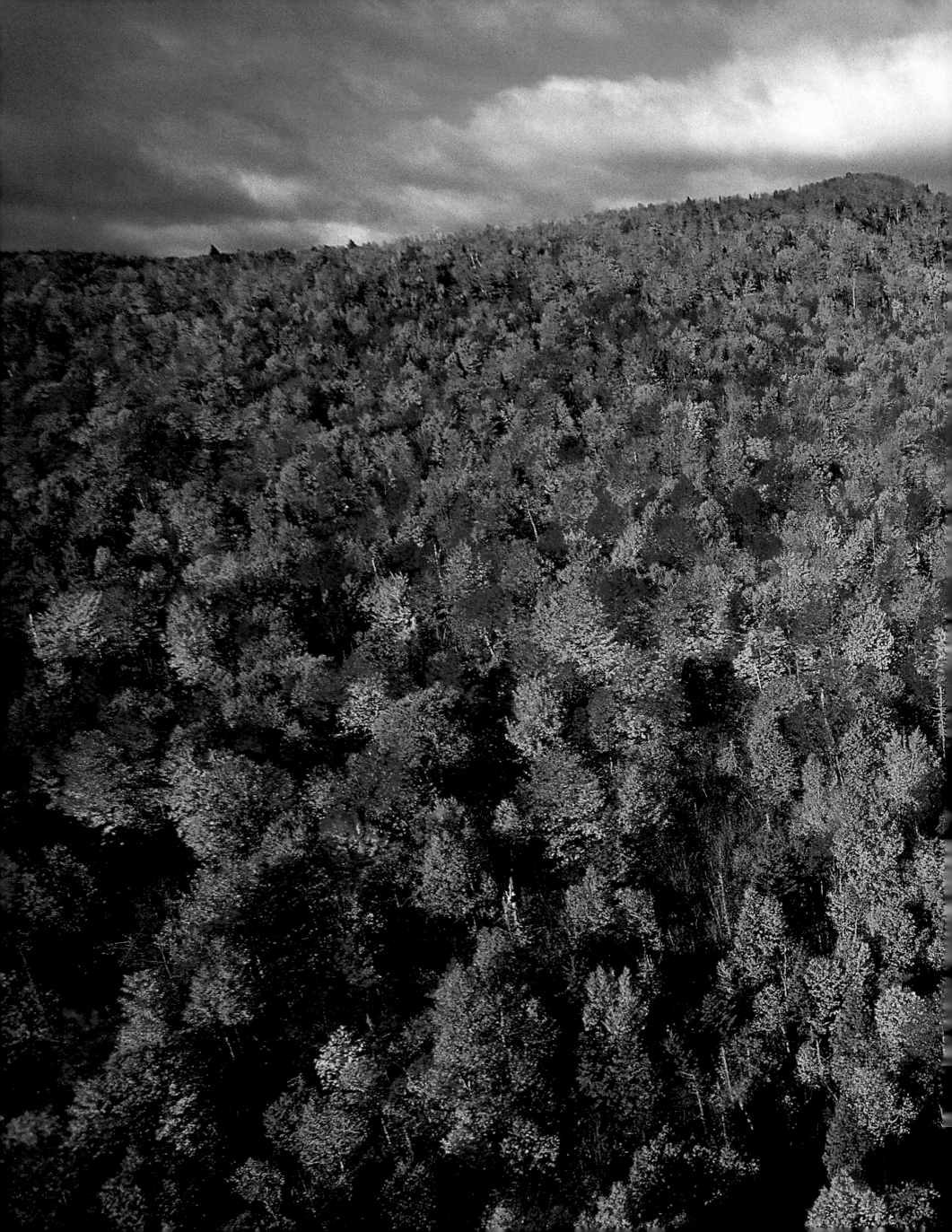

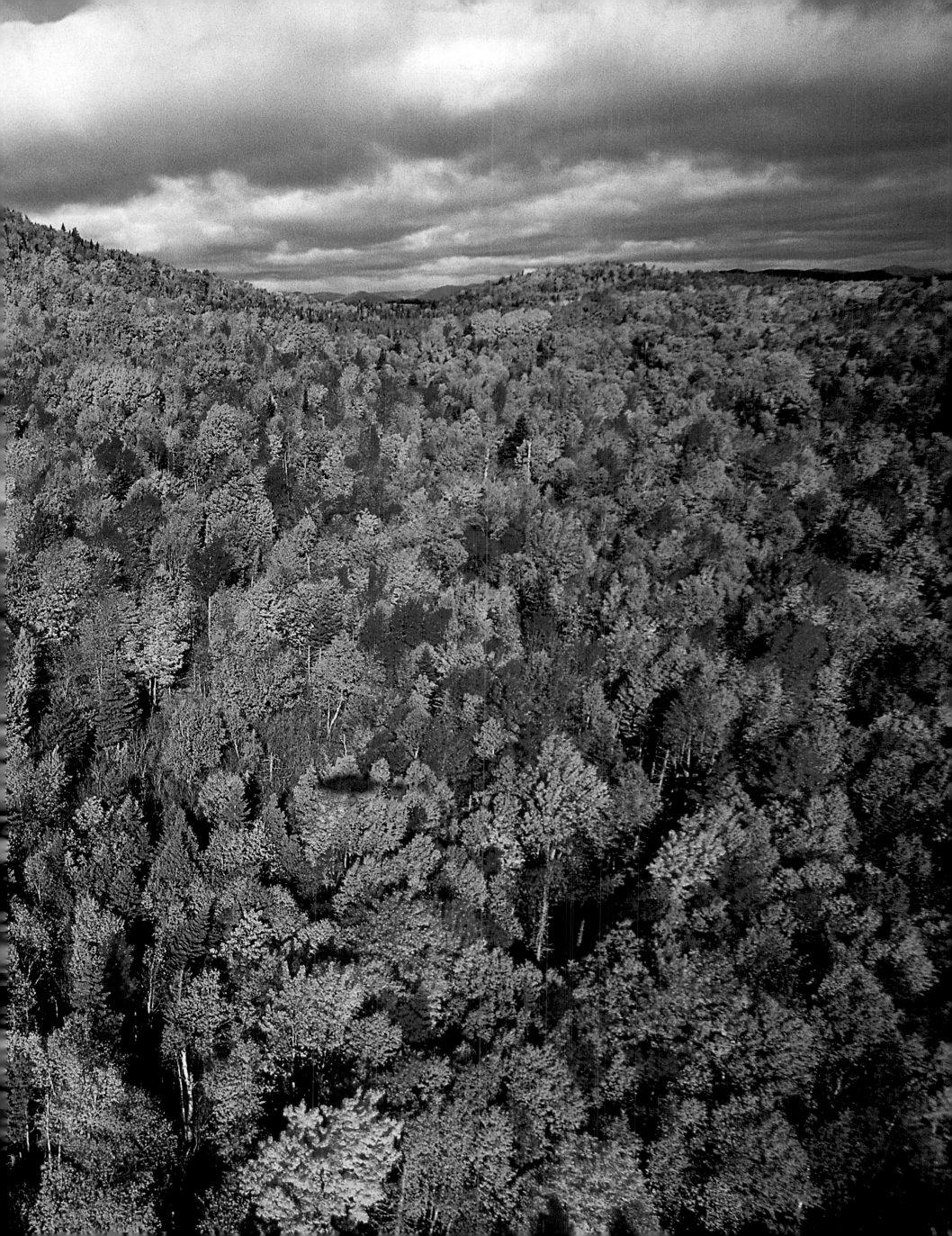

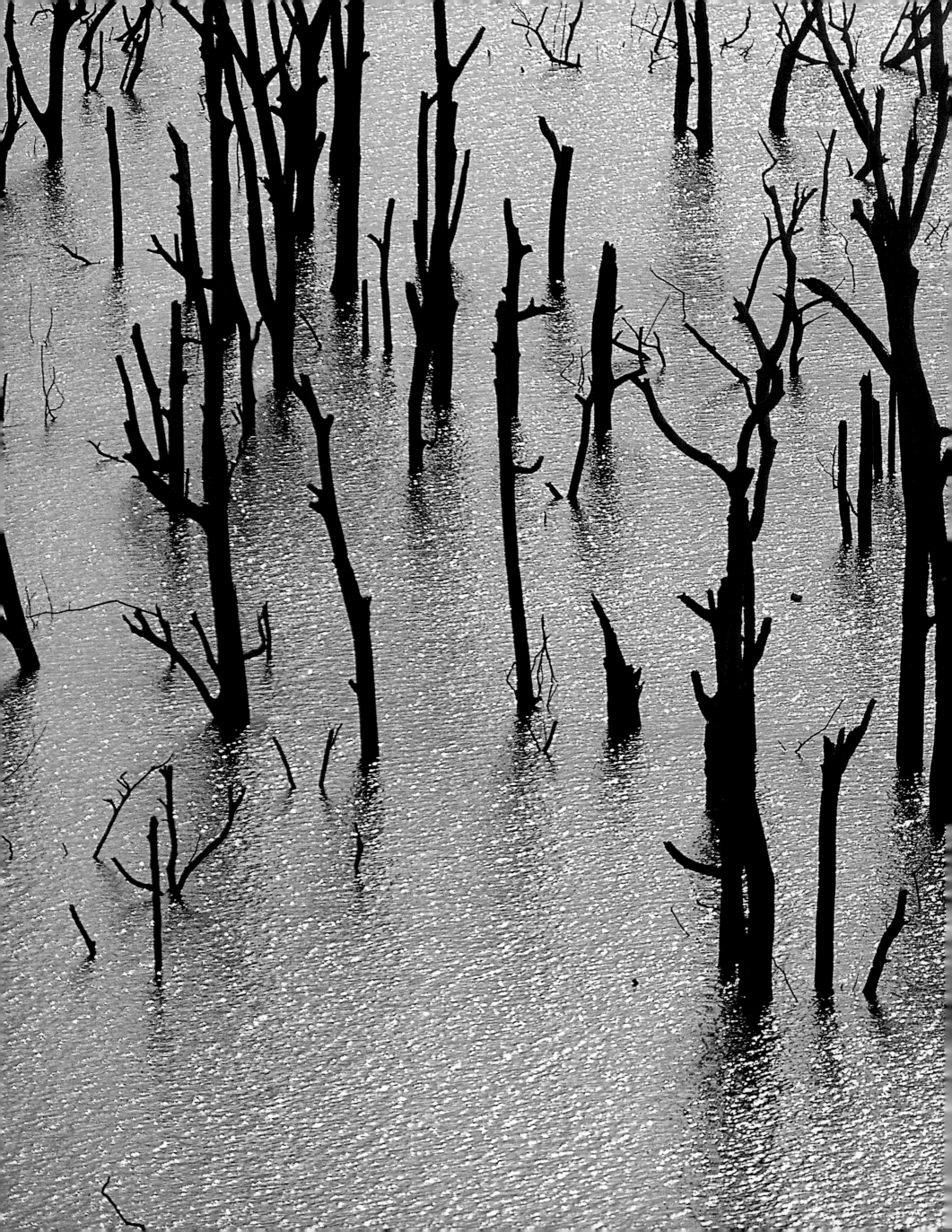

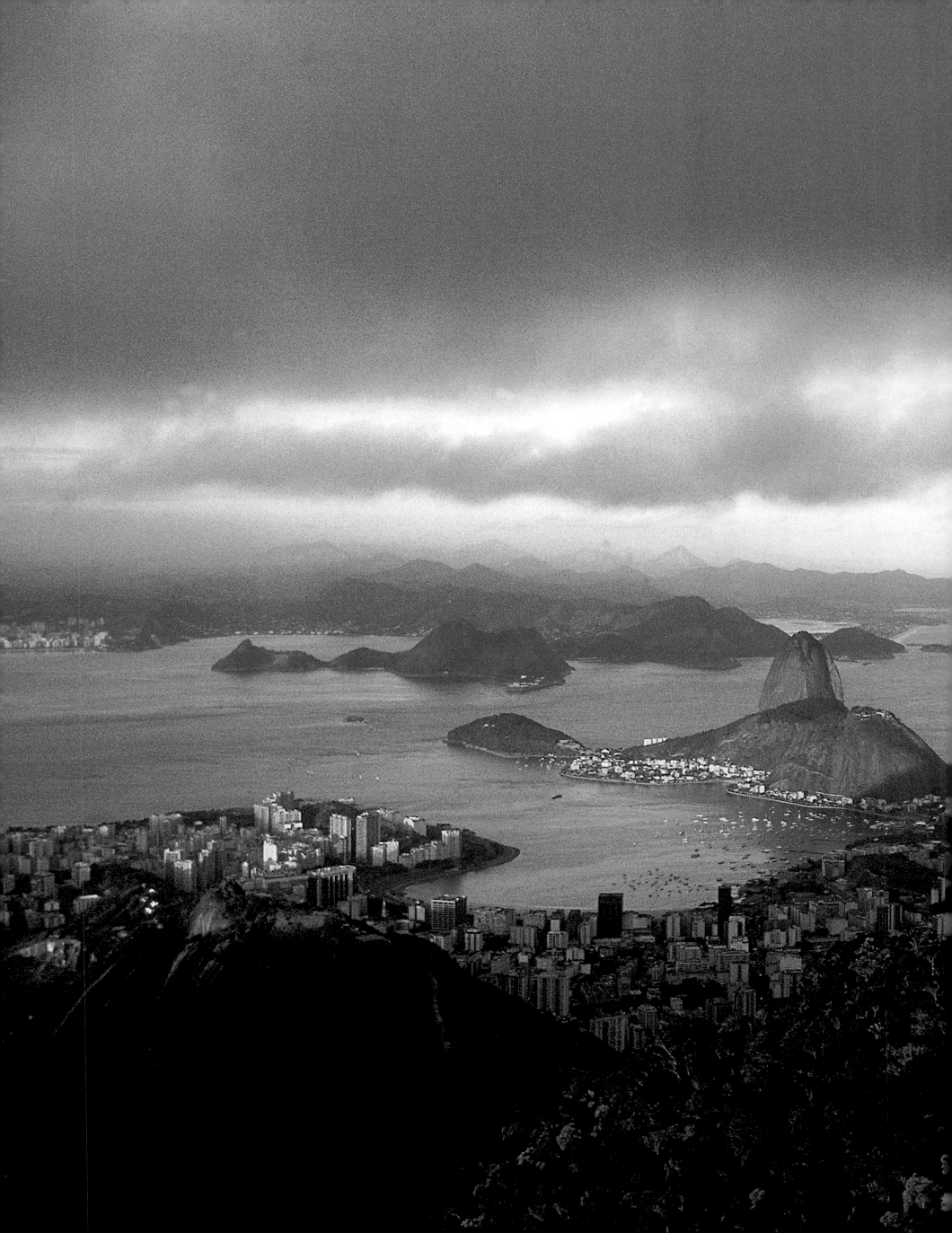

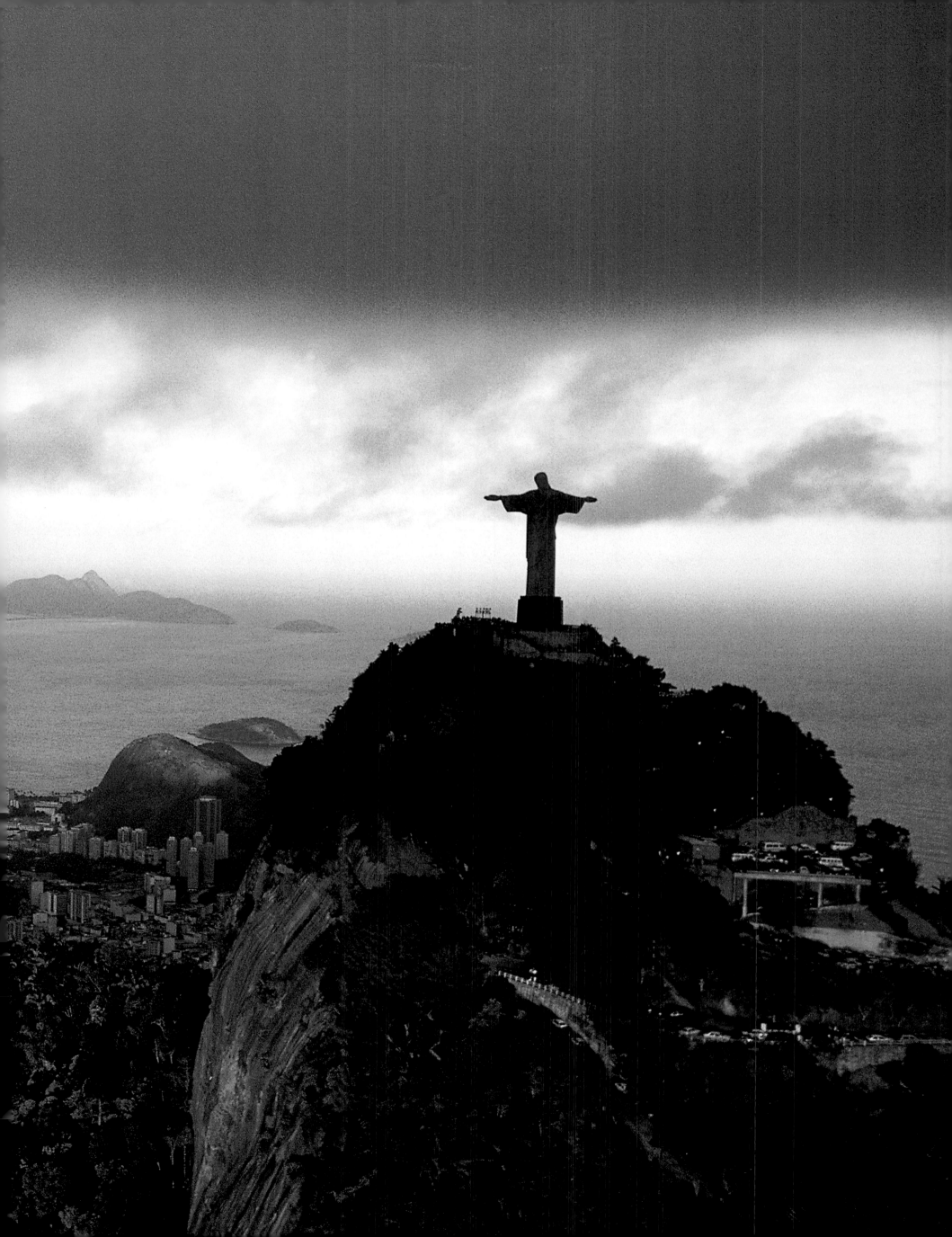

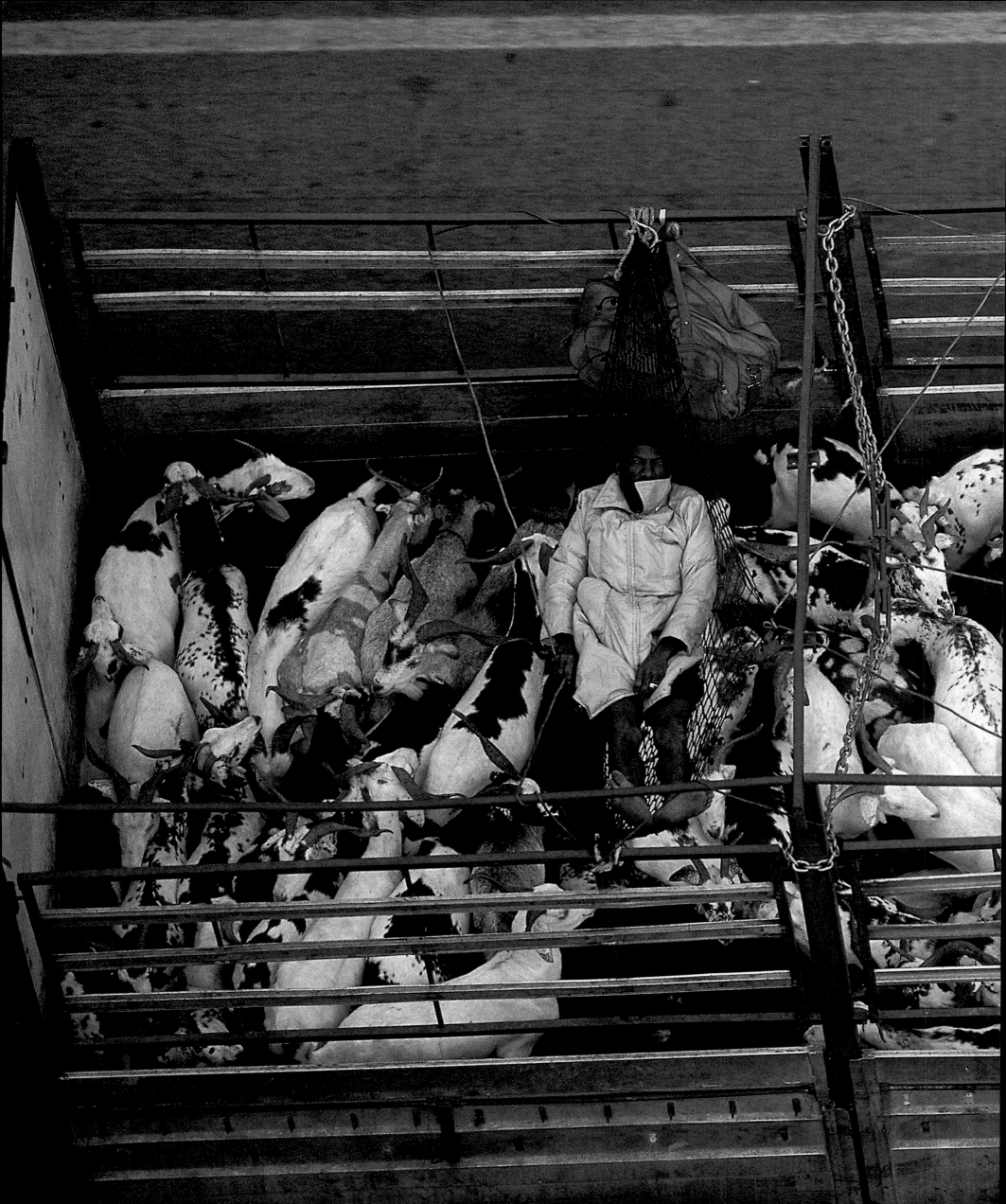

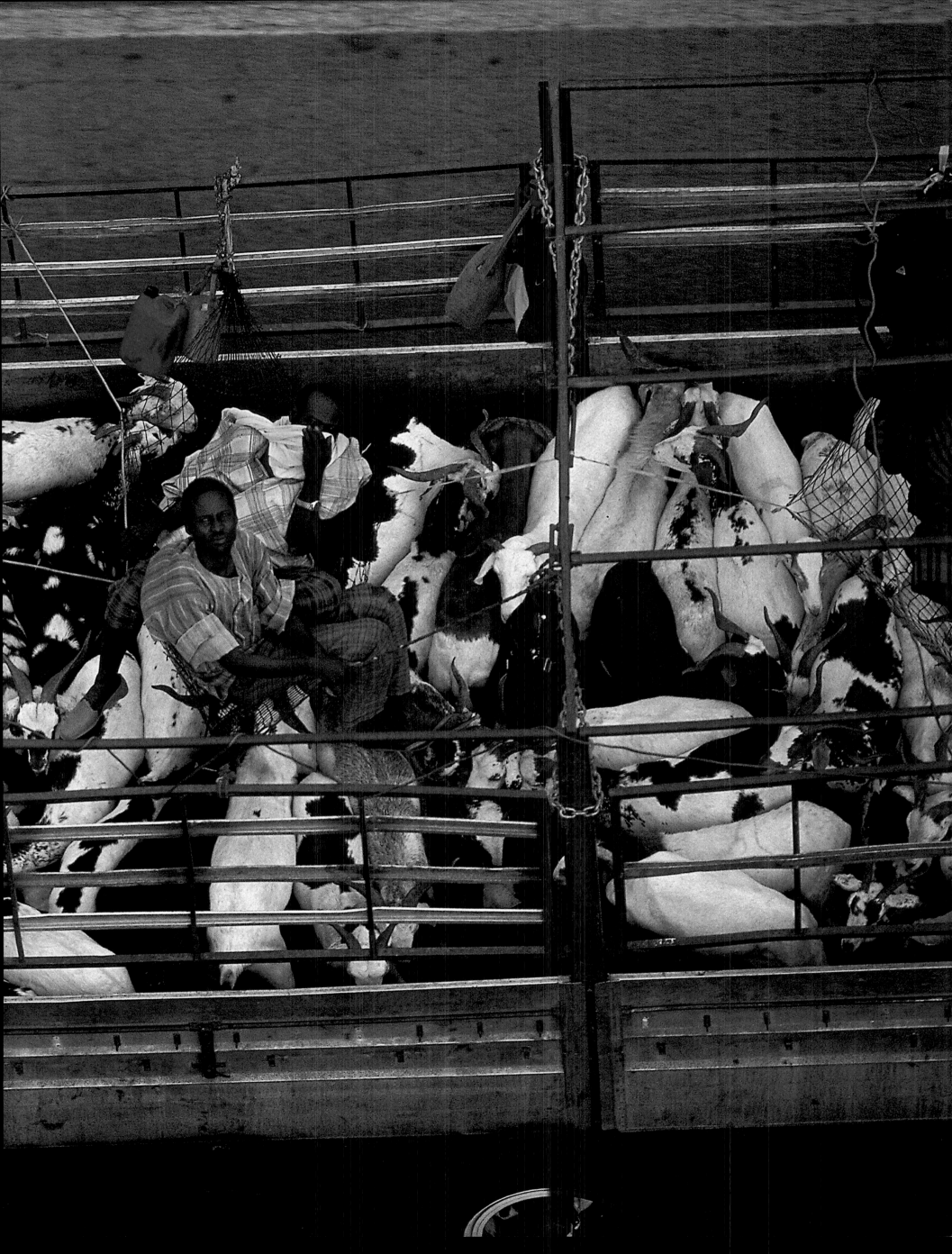

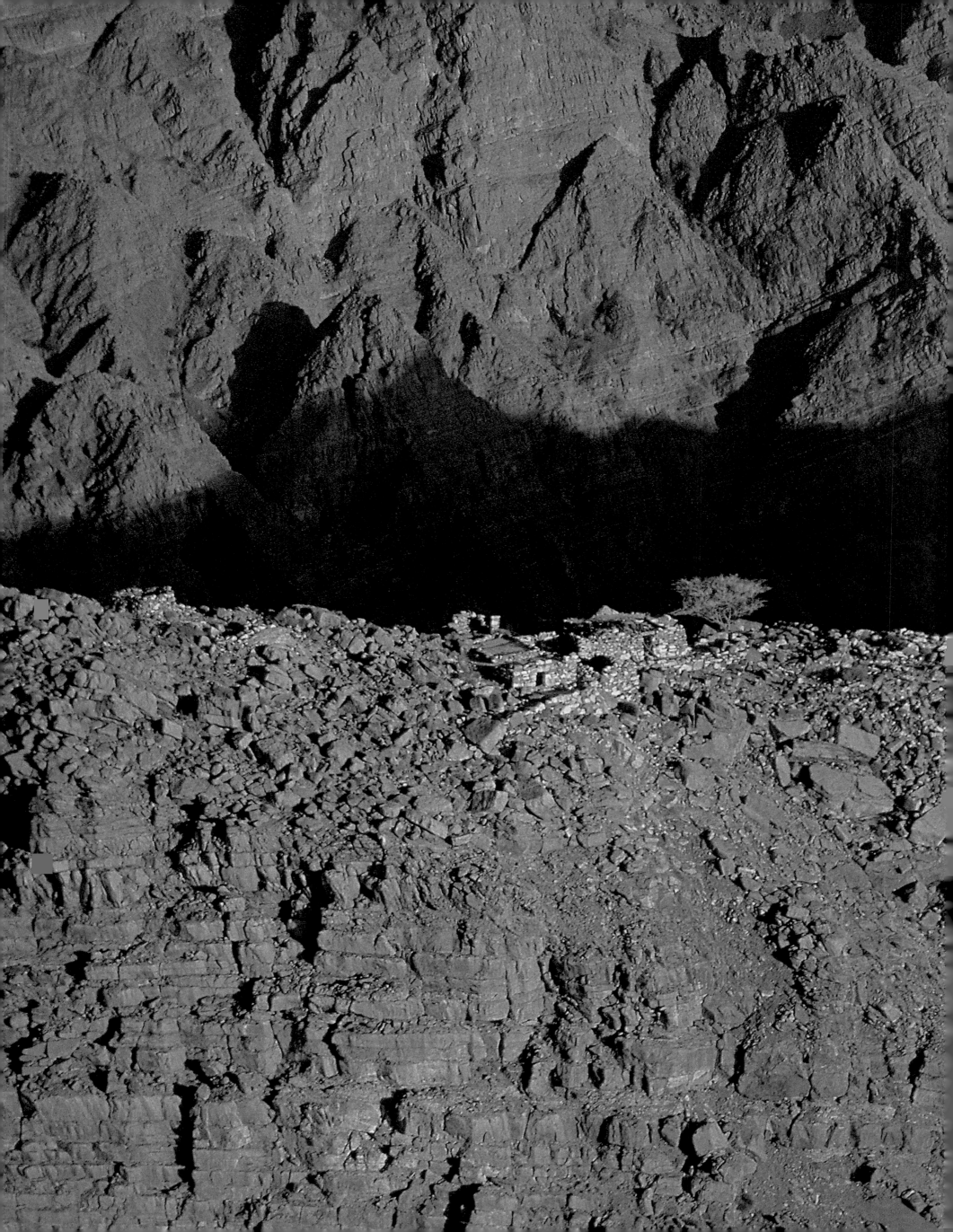

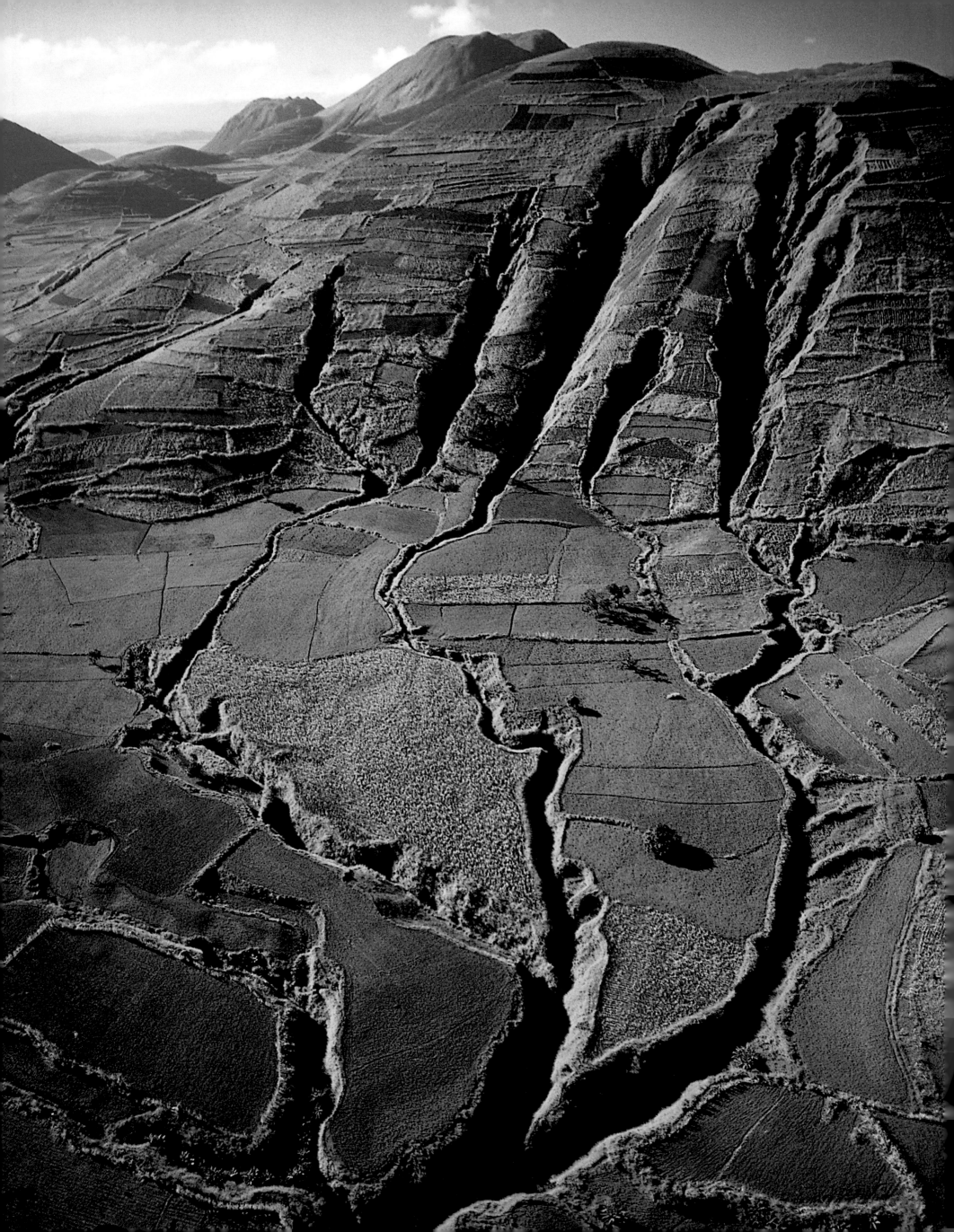

WORLD POPULATION AND THE ENVIRONMENT

In the space of a century, population patterns have changed. People have concentrated not only in cities but also along the shorelines, in the valleys of great rivers, and in metropolises. Observations on a finer scale show the complexity of the relationships between people and their environments. Political, economic, and social characteristics each play an important role locally, which on the global scale grow even greater.

In the Roman period the world was inhabited by about 250 million people. Not until the Renaissance, fifteen centuries later, would the population exceed 500 million. The 1 billion mark was reached much more quickly, around 1810; 2 billion by 1930; 4 billion in 1975. Today we number more than 6 billion. Growth has therefore proceeded at an accelerated pace that has justly been called, since the 1950s, a demographic explosion. However, since 1970 the growth rate has slowed: from 2 percent in 1975 to 1.2 percent today. According to the United Nations, this gradually accelerating decline could lead to a stabilization of the population at 8 billion by about 2040. The deceleration is as surprising and abrupt as the acceleration that preceded it. It is also unique for a living species in that it does not result from an increase in the death rate but rather from an increasingly effective control of fertility.

When rapid growth occurs within an animal population, it is referred to as a "disruption," to indicate clearly that the species has briefly escaped the control of the forces that maintain it in balance with its environment. In nature, order is restored by a strong death rate, which returns the population to its habitual level. Sometimes the environment is irremediably changed—as occurred with the introduction of dogs, rats, and rabbits in Australia and the Pacific islands—and a new balance is established between living species. The human situation is different. This species has invaded the entire world, to the point of global disruption. Our species thus avoids the sword of mortality. In fact, instead of a rise in the death rate, for the past fifty years we have experienced a dizzying drop in the death rate: the global life expectancy was 50 years in 1960; it rose to 60 years in 1980; and it is now 65.

Humans' relations with their surroundings are thus much more complex than those of other species. The first reason for this is the extreme heterogeneity of human populations, in terms of living standards, density, dietary habits, and consumption. To cite just a few examples, a Laotian emits as much greenhouse gas as a German, because of the deforestation and slash-and-burn farming common in Laos. Conversely, Bangladesh, which holds 120 million people squeezed onto

EROSION ON THE SLOPES OF A VOLCANO NEAR ANKISABE.
near Antananarivo, Madagascar
(S 19°04' E 46°39')
The origins of the Malagasy people are little known; the first residents apparently settled on the island a mere 2,000 years ago, arriving from Africa and Indonesia in successive waves of migration. For centuries the island has practiced traditional farming by slash-and-burn cultivation, known as *tavy*, which has been particularly devastating for the natural environment. Intensified overexploitation in recent decades, due to major demographic growth (the island's population has almost tripled in less than 30 years), has led to anarchic deforestation, wiping out more than 80 percent of the primary forest that once covered 90 percent of the island at the turn of the century; every year nearly 600 square miles (1,500 km²) of forest are destroyed. Deprived of vegetal cover, the humus and loose earth are stripped away by the rains, uncovering a layer of clay that is permanently infertile and digging networks of ravines, known as *lavakas*. Faced with the disappearance of arable land, the Malagasy peasants also exploit steep, hilly regions such as the sheer sides of mountains. As much as 65 percent of Africa's arable land is affected by various forms of soil degradation; 45 percent suffers the effects of erosion by water.

55,600 square miles (144,000 km^2) (slightly smaller than the state of Wisconsin), emits less greenhouse gas than the city of Chicago alone. The relationships between population density and environmental preservation are paradoxical. Twenty or thirty nomads pushing their herds to overgraze in the Sahel will seriously alter an ecosystem that is already fragile and contribute to the desert's encroachment, whereas several hundred residents per square mile in the rice fields of Java or the Philippines manage to live in a delicate balance with nature.

The second reason for the loss of contact between nature and humans is the means of production of material goods and food and their increasingly global nature. Local cultures, which maintain contact with the immediate environment, are profoundly changed by the current globalization. To understand, for instance, the pillaging of the Amazonian forest, we must first take into account Brazil's social system, in which poor peasants are constantly pushed into new lands on the "frontier," they become burdened with debt, and then sell the land back to large companies that finish the job of soil exhaustion through intensive farming. These companies are following the rules of the world market: sorghum and corn are harvested for livestock in North America, and coffee is sold to the entire world. We thus see how, in the final analysis, the social and political systems on the national or global scale are responsible for establishing—or, rather, upsetting—relations between people and their surroundings. These systems must be questioned in order to understand the current evolution of population, the death rate, and fertility.

We can point out four large classes of populations with highly defined traits and problems: Communist nations; subsaharan Africa; most developed countries; and emerging nations.

Current and past Communist countries show certain shared traits. Fertility is declining rapidly in these countries: 1.25 children per woman in Russia, Ukraine, and Belorus; 1.3 in Romania, Bulgaria, Hungary, and Lithuania; 1.5 in Cuba; 1.7 in China. The mortality trend in these countries is even more striking. Throughout the world the death rate is declining, yet their rates have often increased in the past 20 or 30 years: from 70 years in 1970, Russia's life expectancy has fallen to 66 years today. All of Eastern Europe has lost one year of life expectancy in the course of each of the past three decades. The same trend is seen in the other Communist regimes, such as North Korea and ex-Soviet Central Asia. Despite their economic success, the Chinese have gained only 3.5 years of life expectancy in 20 years, while their neighbors in India, Pakistan, and Thailand have gained 10. These poor performances have no obvious connection with economic level, climate, or population density. They probably are the more general expression of a profound disturbance in relations with the environment resulting from an arrogant productivism and the idea that

centralized technology can dominate nature. As for the declining fertility, aside from the imposed Chinese policy of only one child, it contradicts the notion of the proletariat (etymologically, the term comes from the Latin word for "progeny") and in ten years has caused (along with emigration) a reduction in the populations of Russia, Ukraine, and Belorus. These populations will have to deal with the severe consequences of a total contempt for ecological balances, including drying up the Aral Sea, the salinization of the lands of Central Asia, and the creation of gigantic nuclear wastecans.

Subsaharan Africa seems to be confronted by a "curse" of underdevelopment. Here is a vast area less populous than the world average: the Democratic Republic of Congo has 56 inhabitants per square mile, Gabon and the Central African Republic have 5 inhabitants per square mile. The region enjoys a nature that is often luxuriant and rich in abundant mineral resources, and yet the standard of living is declining, and the death rate is rising. Over the past several years, life expectancy has dropped by 10 years in Zambia and 15 years in Zimbabwe, primarily because of AIDS. At the same time, the birth rate in these same countries is declining slowly. These problems are the direct result of political troubles and the inability of governments to ensure the maintenance of services. In addition, the subcontinent has collided with the world economy, which after having upset its equilibrium twice, through the slave trade and then through colonization, has lost interest except to drain it of resources. The farmers of these countries are forced to extend the traditional modes of farming. The result is frequent ravages, such as the exhaustion and dispersal of fragile tropical soils because of increased burnings of the land.

The situation for the most developed countries, Europe, North America, and Japan, is obviously the opposite of those considered so far. Birth rates are low but stable (1.5 children per woman in Western Europe; 2 in North America; 1.35 in Japan) and the death rate, which has already fallen to levels considered impossible 30 years ago, continues to decline rapidly. The life expectancy in France rose from 72 to 78 years between 1975 and the present, in Japan it rose from 73.5 to 80.5 years, and in Germany from 71 to 77 years. This rise has meant 150,000 fewer deaths in France every year, which is a factor in demographic growth twice as great as immigration. Immigration from the southern hemisphere represents less than one-thousandth of the European population each year and, despite frequent public fears, should not increase as long as the demand for labor remains stagnant. The population of developed countries will thus continue to increase slowly, despite the low birth rate, and its impact on the global environment, which is already considerable, will grow. Eighty percent of greenhouse gas and chlorofluorocarbon emissions, responsible for the hole in the ozone layer, originate in developed countries.

(N 75°57' W 92°28')

(N 64°04' W 18°15')

(N 26°12' W 14°05')

(N 29°43' E 31°17')

(N 40°36' W 74°03')

(N 16°41' E 100°11')

(S 21°14' E 55°43')

(N 40°50' W 73°56')

(N 16°12' W 0°01')

**pp. 58–59
LANDSCAPE OF ICE,
Nunavut territory
(N 75°57' W 92°28')**

Nunavut is occupied by more than 20,000 Inuit, who represent 85 percent of the local population. The name means "our land" in the Inuit language, Inuktitut. The region was given the status of a territory in April 1999. This territory of archipelagos, water, and ice covers an area of 780,000 square miles (2 million km²), reaching to within 125 miles (200 km) of the Arctic circle. In the winter, when temperatures can go as low as –34° F (–37° C), the permanent ice floe at the center of the Arctic and the coastal ice floe formed by the freezing estuaries and bays link up, offering a landscape of continuous ice that can be traveled by dogsled and snowmobile. In the summer the ice floe breaks up, creating drifting platforms called packs. This seasonal release of the waters reopens the migratory routes of whales and other marine mammals and admits supply ships to the area. Over the past few years this event has occurred earlier and earlier; and in the summer of 2000 even the drifting packs disappeared. The Northwest Passage maritime route permits a link between Asia and Europe by way of the Nunavut Islands, providing an alternative to the Panama Canal.

**pp. 60–61
WORK IN THE FIELDS
BETWEEN CHIANG
MAI AND CHIANG RAI,
Thailand
(N 16°41' E 100°11')**

Rice plantations occupy nearly 15 percent of Thailand, dominating the country's landscapes as far as the valleys of the north, around the cities of Chiang Mai and Chiang Rai. Rice is generally harvested in small family farms in the traditional manner: it is beaten by hand in the fields before it is carried into the villages, where it is stored and then sold. Thailand is the leading exporter of rice in the world. Every year the country sells 6 million tons abroad, one-fourth of its annual crop. Nearly 120,000 varieties of rice exist throughout the world, but the expansion of modern commercial agriculture, which favors monoculture of cash crops (one crop only is grown on two-thirds of the rice fields of Southeast Asia) is gradually reducing this agricultural diversity. In China almost 3,000 local varieties of rice have been lost in the past thirty years. We are also losing a vital genetic potential for the improvement of cultivated plants, while increasing the risk of poor harvests because of the uniform vulnerability of crops to new illnesses and to ravagers. And yet rice constitutes the basic foodstuff for more than half of the earth's population, and Asia provides 92 percent of the annual harvest worldwide.

**pp. 62–63
DRYING DATES
IN A PALM GROVE
SOUTH OF CAIRO,
Nile Valley, Egypt
(N 29°43' E 31°17')**

Date palm trees are grown only in hot, arid areas with water resources, such as oases. Five million tons of dates are produced each year worldwide. Most of the production from the Near East and North Africa is intended for each country's domestic market and only about 5 percent is exported. Egypt, the world's second leading producer, after Iran, harvests more than 800,000 tons of dates each year, which are consumed locally at a rate of 22 pounds (10 kg) per person per year. These dates are habitually preserved in traditional ways. Fresh-picked, yellow or red depending on the variety, the dates slowly turn brown as they dry in the sun, protected from the wind and water by a small wall of earth and branches. They are then kept in baskets woven from palms. Although most of the dates produced go on the table, several derivatives (including syrup, flour, dough, vinegar, sugar, alcohol, and pastries) are made from the fruit manually or industrially.

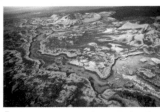

**pp. 64–65
LAKAGIGAR
VOLCANO CHAIN,
Iceland
(N 64°04' W 18°15')**

Lakagigar, in southern Iceland, still bears the scars of one of the most violent volcanic eruptions in recorded history. In 1783 two eruptive fissures, a total of 15 miles long (25 km), opened up on both sides of Laki volcano, vomiting 4 cubic miles (15km³) of molten rock that engulfed 225 square miles (580 km²) of land, the largest lava flow in human memory. A cloud of carbon dioxide, sulfur dioxide, and ash spread over the entire island and contaminated grazing land and surface waters. Three-fourths of the livestock was annihilated, and after a second eruption in 1785, a terrible famine decimated a fourth of the population (more than 10,000 people). The fissures of Lakagigar, crowned by 115 volcanic craters, are today closed up, and the streams of lava are covered by a thick carpet of moss. Iceland has more than 200 active volcanoes and has produced one-third of all discharges of lava occurring around the world in the course of the last 500 years.

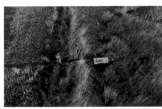

**pp. 66–67
PIROGUE ON THE
NIGER RIVER IN THE
GAO REGION,
Mali
(N 16°12' W 0°01')**

The Niger River, which has its source in the massif of Fouta Djallon in Guinea, is the third-longest (2,600 miles, or 4,184 km) river in Africa, after the Nile and the Zaire. Crossing through Mali for a length of 1,050 miles (1,700 km), it forms a large loop that rises to the southern border of the Sahara, watering major centers such as Timbuktu and Gao. The short rainy season stimulates the regeneration of aquatic plants, through which pass pirogues, a customary means of travel, transport, and trade among people living near the river. The Niger, subject to seasonal flooding, also irrigates nearly 2,000 square miles (5,000 km²) of land used for rice paddies and market gardens. It is the chief source of water for approximately 80 percent of Mali's population, who live by farming and herding.

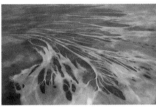

**pp. 68–69
SEBJET ARIDAL,
near Boujdour, Western
Sahara, Morocco
(N 26°12' W 14°05')**

The waters of the Lemnaider *oued* (an irregular river), which feed this *sebjet* (temporary salt lake) during periods of rain, have retreated, digging channels in the sand that fill up with salt deposits. Characteristic of arid zones of the Maghreb, the *sebjet* is located in southern Morocco in the heart of Western Sahara. This portion of desert, which spreads out for 1,500 miles (2,500 km) along the Atlantic Ocean and covers 100,000 square miles (252,000 km²), was formerly a Spanish colony but was reclaimed by Morocco in 1975. However, the Polisario Front (the popular front for the liberation of Saguia al-Hamra and Río de Oro in Western Sahara), proclaimed the independence of Western Sahara and took up arms. A democratic republic, the Saharawi Arab Democratic Republic (SADR), was created and admitted to the Organization of African Unity (OAU); although recognized by more than sixty nations, SADR is still not considered the official administrator of this territory by the United States and European countries.

**pp. 70–71
YANKEE STADIUM,
New York, United States
(N 40°50' W 73°56')**

Standing in the heart of The Bronx, in New York City, Yankee Stadium has a meticulously maintained grass lawn. This famous ballpark, home to the New York Yankees, holds 57,545 spectators at baseball games. The "national pastime" was born in the United States just before 1850 and was soon professionalized. Baseball was first included in the Olympic Games in 1992. This universal sporting event took place in Sydney, Australia, in 2000, with athletes from 196 countries participating in 28 disciplines. Although the Olympics brings together almost all the countries of the world, it does not erase the disparities between them: at the Sydney Games 1,658 medals were handed out, of which 1,271 (77%) were awarded to industrialized nations and 387 (23%) to developing nations.

Captions to the photographs on pages 72 to 87 can be found on the foldout to the right of the following chapter

captions 58–71 captions 72–87

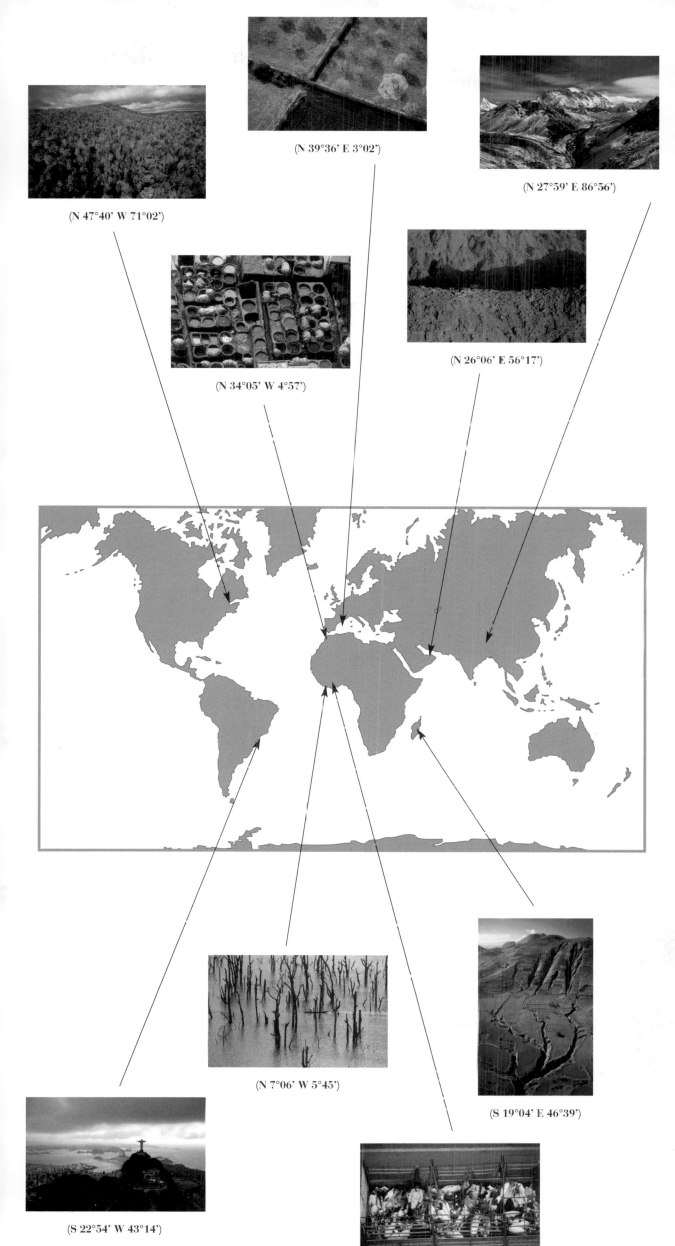

(N 39°36' E 3°02')

(N 27°59' E 86°56')

(N 47°40' W 71°02')

(N 34°05' W 4°57')

(N 26°06' E 56°17')

(N 7°06' W 5°45')

(S 19°04' E 46°39')

(S 22°54' W 43°14')

(N 6°35' W 5°01')

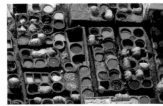

pp. 32–33
STUDIOS AND VATS
OF DYERS IN FEZ,
Morocco
(N 34°05' W 4°57')

The dyers' district of Fez, in Morocco, has kept its authenticity: for centuries the same ancestral techniques of dyeing have been used, passed down from one generation to another. Woolen or cotton fiber, as well as tanned hides of sheep, goats, cows, and dromedaries, are submerged in dye vats with ceramic surfaces, fullers, and stomped on by the craftsmen. The coloring is derived from natural pigments: poppy, indigo, saffron, date nuts, and antimony are used to obtain red, blue, yellow, beige, and black, respectively. The dyed materials are used to make the world-renowned carpets and leather objects that are the principal handmade Moroccan exports.

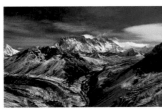

pp. 34–35
MOUNT EVEREST,
Himalayas, Nepal
(N 27°59' E 86°56')

In the massif of the Himalayas, which forms the boundary between Nepal and China, stands Mount Everest. Rising to an altitude of 29,028 feet (8,848 m), Everest is the highest point on the planet. In Nepali the mountain is called Sagarmatha, "He whose head touches the sky," and in Tibetan it is called Chomolongma, "Mother Goddess of the world." The name Everest comes from the British colonel George Everest, who in 1852 was assigned the task of drawing up a cartographic outline of India. Since the triumphant expedition by the New Zealander Edmund Hilary and the Nepalese sherpa Norgay Tensing on May 29, 1953, Everest has inspired more than 300 successful ascents and has claimed some 100 lives. But crowding has caused pollution problems, and the consumption of brushwood for campfires has stripped the slopes and exposed them to erosion. However, in the past ten years, new regulations, clean-up operations, the installation of solar panels, and the introduction of portable fuel for expeditions have helped reverse the degradation of this fragile high-altitude site, declared a national park in 1976, which is vital to the Sherpas.

pp. 36–37
AUTUMN FOREST IN
THE REGION OF
CHARLEVOIX,
Quebec, Canada
(N 47°40' W 71°02')

The hills of the Charlevoix region along the Saint Lawrence River in Quebec province are dominated by a mixed forest of deciduous trees and conifers. In 1988 UNESCO declared 1,800 square miles (4,600 km²) of this region a biospheric preservation site. The Quebec forest, boreal in the north and temperate in the south, covers nearly two-thirds of the province and has been exploited for lumber since the end of the seventeenth century. Today it contributes to the economic prosperity of Canada, which holds first, second, and third place in the worldwide production of newsprint paper, paper pulp, and timber, respectively. The Canadian forest has long been overexploited and has also been decimated by parasitic insects and acid rain, resulting in a considerable reduction in its total area. However, the forest today still covers almost 1 million square miles (2.4 million km²), and programs have been put in place for its preservation.

pp. 38–39
FISHER ON THE
LAKE OF KOSSOU,
near Bouaflé,
Côte d'Ivoire
(N 7°06' W 5°45')

The lake of Kossou, which spans 585 square miles (1,500 km²) in the center of Côte d'Ivoire, is an artificial reservoir designed to regulate the flow of the Bandama River and to facilitate the construction of a hydroelectric dam. The lake was built between 1969 and 1971, at the cost of 200 flooded villages and 75,000 displaced people, who benefited from reinstallation and development measures. In 2000 the world had a total of 45,000 dams greater than 50 feet (15 m) high (versus 5,750 of them in 1950), of which half are in China, where 90 dams higher than 190 feet (60 m) are under construction. Although dams can contribute prominently toward mastering floods and satisfying needs for energy and water, especially in developing countries where two-thirds of retained water are found, their ecological and social impact remains considerable: 40 to 80 million people in the world, often poorly compensated, have been displaced to make way for reservoirs. Better integration of the social and economic dimensions and a reduction of the resulting ecologi-

cal impact would help make dams a positive factor in human development and in the sustainable management of precious water resources.

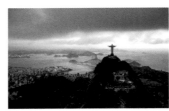

pp. 40–41
THE CORCOVADO
OVERLOOKING THE
CITY OF RIO DE
JANEIRO,
Brazil
(S 22°54' W 43°14')

Perched on a rocky 2,326-foot-high (705 m) peak called Corcovado, or "hunchback," the statue of Christ the Redeemer overlooks the Guanabara Bay and its famous "Sugarloaf," as well as the city of Rio de Janeiro. The city owes its name—which means "River of January"—to a misunderstanding by the first Portuguese explorers who dropped anchor in the bay, in January 1502, and thought they had arrived at the mouth of a river. The capital of Brazil from 1763 to 1960, Rio de Janeiro has developed into a megalopolis with a population of more than 10 million and spreading out over 30 miles (50 km). Christ the Redeemer of Corcovado is a reminder that Brazil has the largest Catholic population in the world, approximately 141 million (86 percent of the population). The more than 1 billion Catholics worldwide make up the largest denomination in Christianity, the world's most widely practiced religion, which has nearly 2 billion followers.

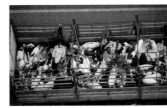

pp. 42–43
TRANSPORT OF GOATS
NEAR TOUMODI,
Yamoussoukro, Côte
d'Ivoire
(N 6°35' W 5°01')

These breeders travel in a truck's trailer, in the company of their goats, undoubtedly on their way to sell them at one of the many markets in the Yamoussoukro region, political capital of Côte d'Ivoire since 1983. Throughout West Africa the nomadic peoples of the Sahelian countries, particularly the Peuls, traditionally devote themselves to extensive raising of livestock, exporting a major share to the countries along the coast. For the past thirty years, improved roads in the region—especially in Côte d'Ivoire, where the surface area of paved roads has tripled—have greatly contributed to the development of commercial exchanges. Today new opportunities for exchange, information, and action between countries are available through communication via cellular phones and the internet, both of which are in full boom in the largest cities in Africa and the West.

pp. 44–45
HARVESTING
ALMONDS ON THE
ISLAND OF MAJORCA,
the Balearic Islands,
Spain
(N 39°36' E 3°02')

As in all Mediterranean countries, the ancient cultivation of almonds has remained traditional in the Spanish archipelago of the Balearic Islands. The almonds are generally gathered by shaking the tree branches over sheets spread out beneath. The low productivity of each almond tree (4.4 to 11 pounds, or 2 to 5 kg, of almonds per tree) is compensated for by the large area planted with trees; however, that area has diminished considerably because old trees have rarely been replaced. The almonds produced on these islands, which at one time made up the bulk of Spanish production, barely make up 3 percent today. Yet Spain remains the second-greatest almond producer in the world (after the United States), accounting for about 274,000 tons per year, nearly 78 percent of which are consumed by European countries in various forms: in confectionery and pastry (dried sweet almonds), as an aromatic agent (essence of bitter almond), or in cosmetics (sweet almond oil).

pp. 46–47
ISOLATED HOUSE IN
THE MOUNTAINS OF
THE MUSANDAM
PENINSULA,
Oman
(N 26°06' E 56°17')

Built out of mountain rocks, this house blends with the landscape and seems to oversee the valley, much as the Musandam Peninsula guards the Strait of Hormuz. Musandam, strategically placed on the trade route between the Persian Gulf and the Indian Ocean, served for a long time as a refuge for pirates and was coveted by both Persians and Arabs. Today it is part of the Sultanate of Oman, although it is 30 miles (50 km) away, enabling Oman to control maritime traffic, especially oil transport, and reinforcing the nation's position as guardian of the Persian Gulf. The Strait of Hormuz is a key element in the territorial conflicts between nations of the region, underlined by the Iran–Iraq conflict (1980–88) and the Persian Gulf War (1991).

The majority of populations from developing countries have both a very rapid decline in birth rate and a rapid rise in life expectancy. This is where the real fate of our planet is played out, now that the Chinese birth rate is at 1.7 children per woman. India, which has just passed the 1 billion population level, is an exemplary case among these emerging countries, which, despite great difficulties, are taking advantage of globalization. In thirty years India's birth rate declined from 5.7 to 3.3 children per woman, and life expectancy rose from 48 to 62 years. Mexico and Brazil (with a decline from 6 to 2.3 children per woman) and Indonesia (from 5.2 to 2.6 children) provide further examples of this extraordinary change. In the cities the birth rate is even lower: 1.8 children per woman in greater Cairo and in the federal district of Mexico City, which has a population of 22 million. But this success, the result of better education and women's rights as well as persistent economic development, has environmental risks as well. The rapidly growing middles classes are adopting a Western way of life—high meat consumption, intensive automobile usage—and cannot reduce the CO_2 and other greenhouse gas emissions that result. In addition, Western nations tend to utilize the skilled and low-cost workforce in developing nations to power their most dangerous and toxic factories, which are banned in most of the West. In Bhopal, India, on December 2, 1984, an accident in a dilapidated factory, owned by an American fertilizer production company, released toxic gases that killed 2,500 people.

From this summary we see how culture and global relationships affect a nation's relationship with the environment. Will Argentina, Venezuela, and Colombia join the group of former Communist countries in decline, or will they continue to grow as developing countries? These countries could be left behind by globalization, or could become integrated into it—but at what price? All eyes, meanwhile, are on China. When the populations of China and India each reach 1.3 billion and, in the year 2050, achieve the same standard of living, and thus of consumption, of North America, will they have the same CO_2 emissions and the same demand for meat (and thus for grains grown for dometic animals)? This is a just outcome in social terms, but it would be absolutely catastrophic for the environment.

One of the major faults in the preceding remarks on population is that they refer to states that are often immense, such as the 1 billion Indians or the 280 million Americans. Yet contact between humans and the environment occurs on a far narrower scale, on the level of communities. Unfortunately, local data are inferior to national data, because statistics remains an instrument of nations, which are primarily interested in their own functioning and survival as organized, centralized states. In an examination on a smaller scale, different problems appear. Population distribution in space, more than its total volume, becomes decisive. In one century the population distribution has been transformed. Since time immemorial the world had been characterized by a landscape populated but, only here and there, densely concentrated in cities. In 1700 Edo (the future Tokyo), with 800,000 inhabitants, was the largest city. Advances in transportation as well as in production allowed people to concentrate not just in cities but along coastlines, the valleys of great rivers, and in metropolises, urban blankets that can extend for more than 60 miles (100 km). The record for size is held by two Japanese urban areas, Kansai (comprised of Osaka, Kobe, and Kyoto) and Kanto (Tokyo and Yokohama), which each have a total population of 35 million. The region of all of Provence, in southern France, must be broken up to understand its population patterns: the coastline has 1,600 inhabitants per square mile (1,000 per km²); the next 6 miles (10 km) inland have 160 residents per square mile (100 per km²); and the next

**NEW YORK CITY MARATHON CROSSING
THE VERRAZANO NARROWS BRIDGE,
linking Staten Island and Brooklyn, New York City, United States
(N 40°36' W 74°03')**
Thirty thousand runners from around the world compete in the New York City Marathon, which passes through each of the five boroughs and is watched by millions of spectators. The total of the world's inhabitants numbered 1 billion two centuries ago, whereas today that number is 6 billion. Not long ago scientists were coming up with predictions as to when the world population would rise to the point of one person per square foot of earth's surface. But demographic growth is continuing to decrease, and today the hope exists that stabilization of the world population will occur within the next two centuries, at about 11 billion inhabitants. The challenge today is to achieve a population curve that is compatible with a truly sustainable development.

area has fewer than 16 people per square mile (10 per km²); whereas the region of Haute Provence has fewer than 3 inhabitants per square mile (2 per km²).

This new pattern of concentration creates pollution problems. In Los Angeles, for instance, the air at low altitude is trapped in the shoreline basin and does not get renewed, in the absence of wind, so pollution builds up and directly affects the climate. This also occurs in Alsace, in eastern France, and in the neighboring area of Baden, Germany, squeezed between the Vosges Mountains and the Black Forest. Athens also suffers low-altitude pollution; "nephos" is their term for the greenish cloud of pollution that blocks the atmospheric layer (known as "atmospheric inversion," because in theory warm air is supposed to rise) and masks nearly all sunlight over the city one day out of five. To make matters worse, these population densities are found in spaces that are often sensitive and ecologically important, such as ecotones (transitional areas between two different ecological systems), maritime coasts, and regions with complex hydrological systems of great rivers (which are popular locations for metropolises).

A century ago the German geographer Friedrich Ratzel published *Anthropogeography*, in which he stressed the importance of the links between a population and its territory. We started with some figures on global population, but to gain a better sense of the problems we face today we must observe environmental interaction on a local scale. In the final analysis, individual cultures play a critical role. Population numbers and technology are perhaps less decisive factors than the cultural traits that govern the relations between humans and their environment. Education, cultural diversity, and adaptability are more crucial than raw demographic numbers as we struggle to maintain a beautiful, diverse earth.

Hervé Le Bras

ERUPTIVE CONE OF PITON DE LA FOURNAISE,
island of Réunion, France
(S 21°14' E 55°43')
The Piton de la Fournaise ("Peak of the Furnace"), 8,600 feet (2,631 m) high, in southeastern Réunion, is the most active volcano on the planet after Kilauea in Hawaii. Active for the past 400,000 years, it erupts on an average of every 14 months; however, in the great majority of cases, the magma projections do not exceed the three zones of depressions, or caldeiras, that immediately surround it. On occasion, as in 1977 and 1985, more violent eruptions occur in which destructive streams of lava invade the wooded slopes and the residential areas of the island. Today 140 of the earth's 500 active volcanoes situated above sea level are monitored by scientists. A volcanic observatory was built near Piton de la Fournaise in 1979, making it one of the most closely watched volcanoes in the world.

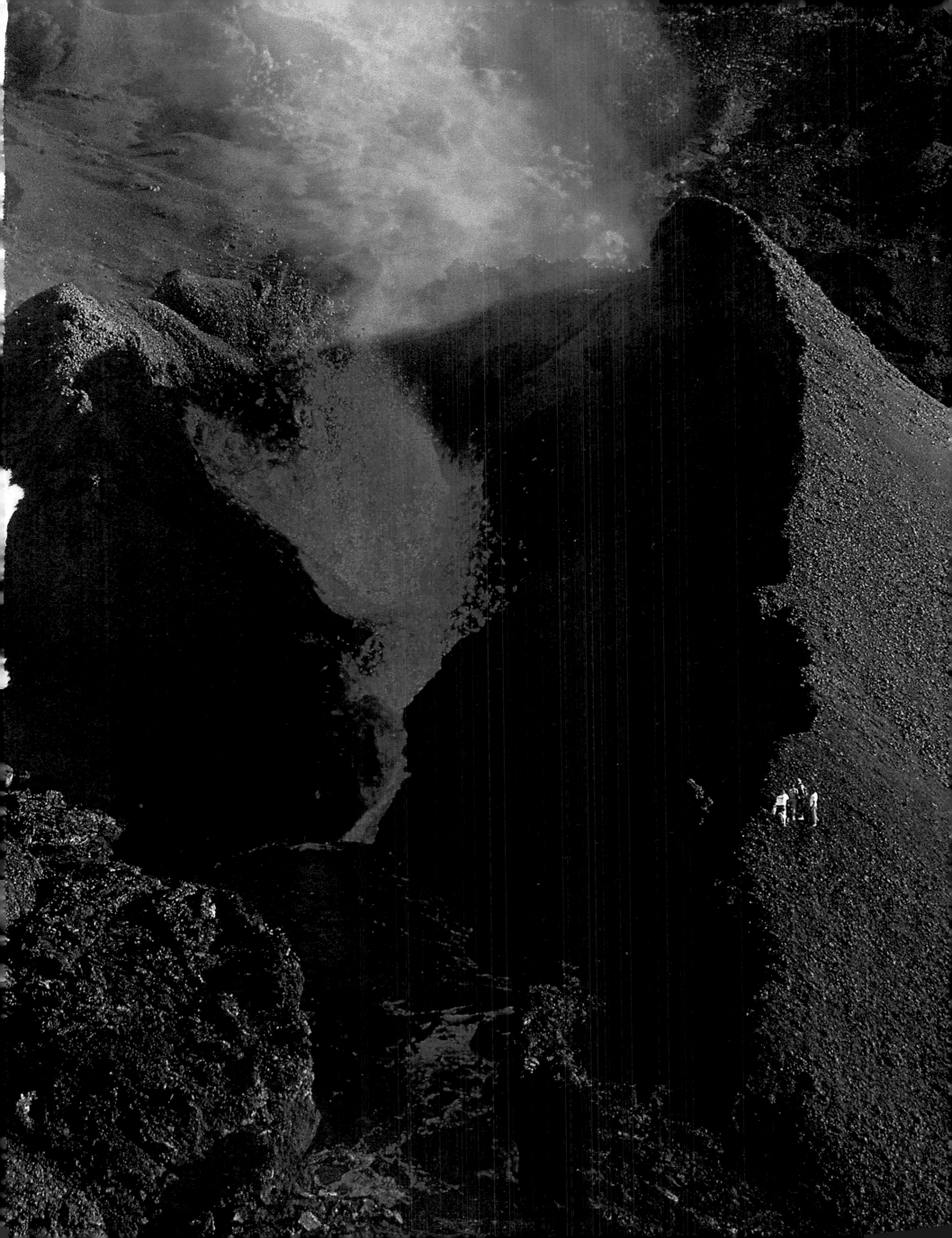

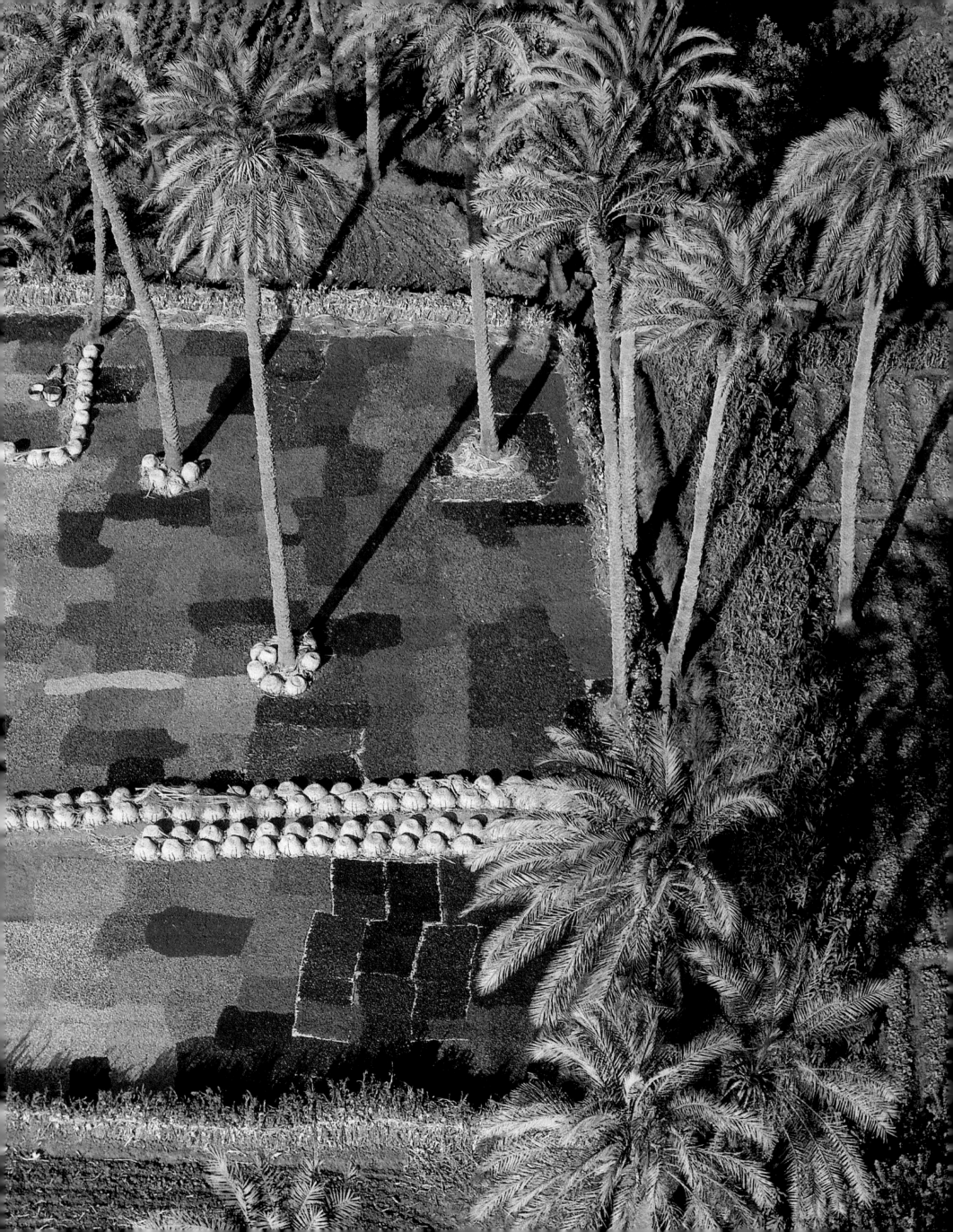

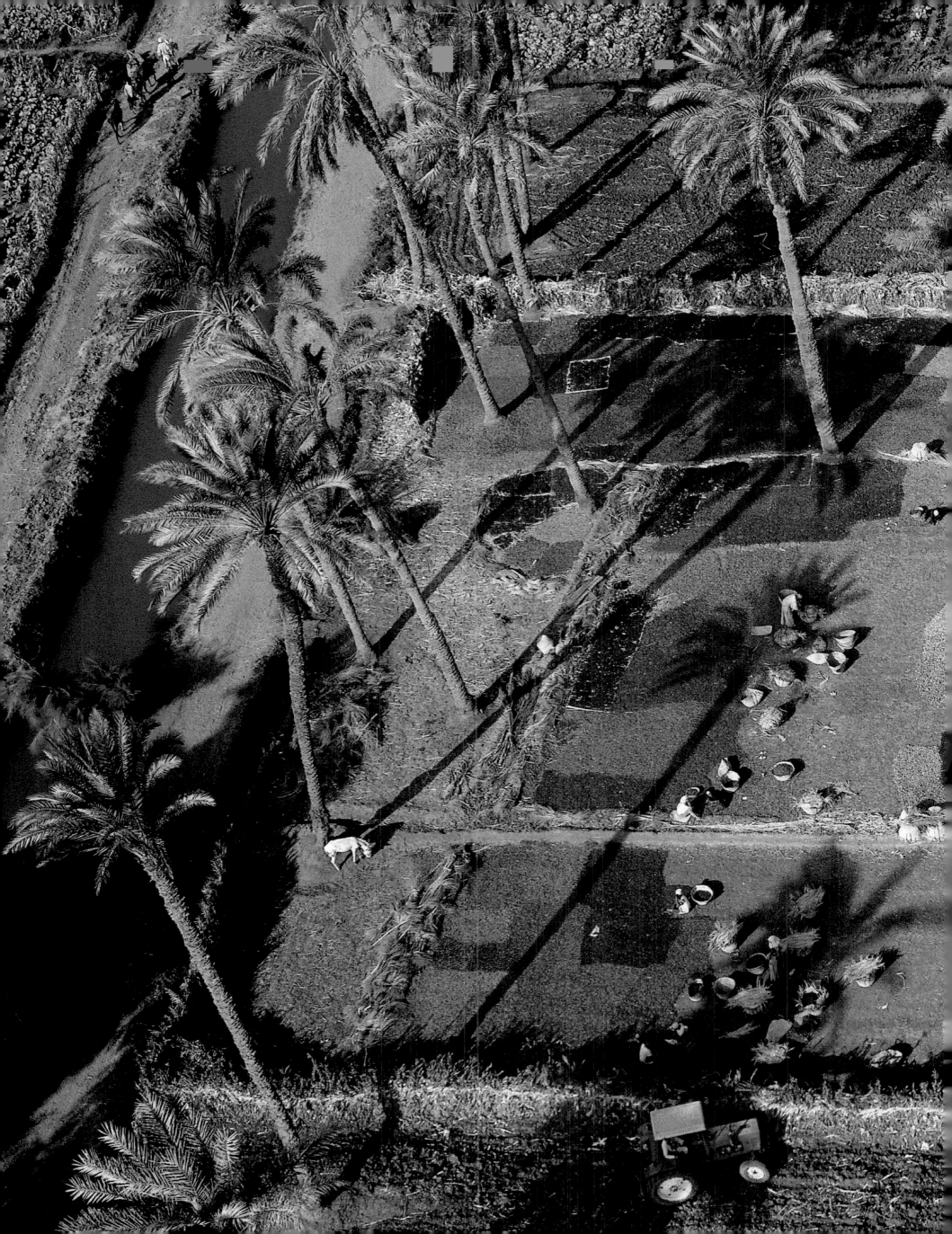

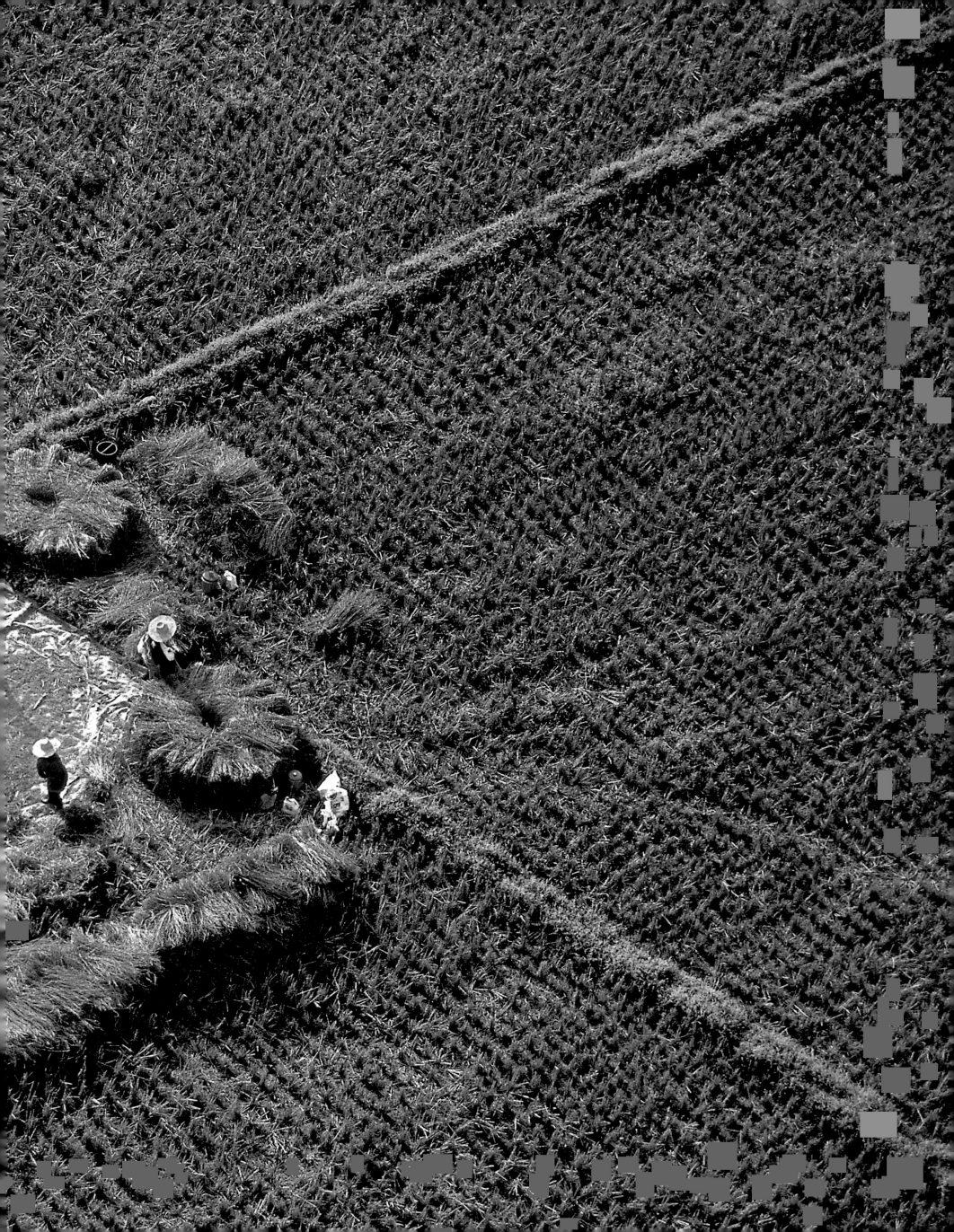

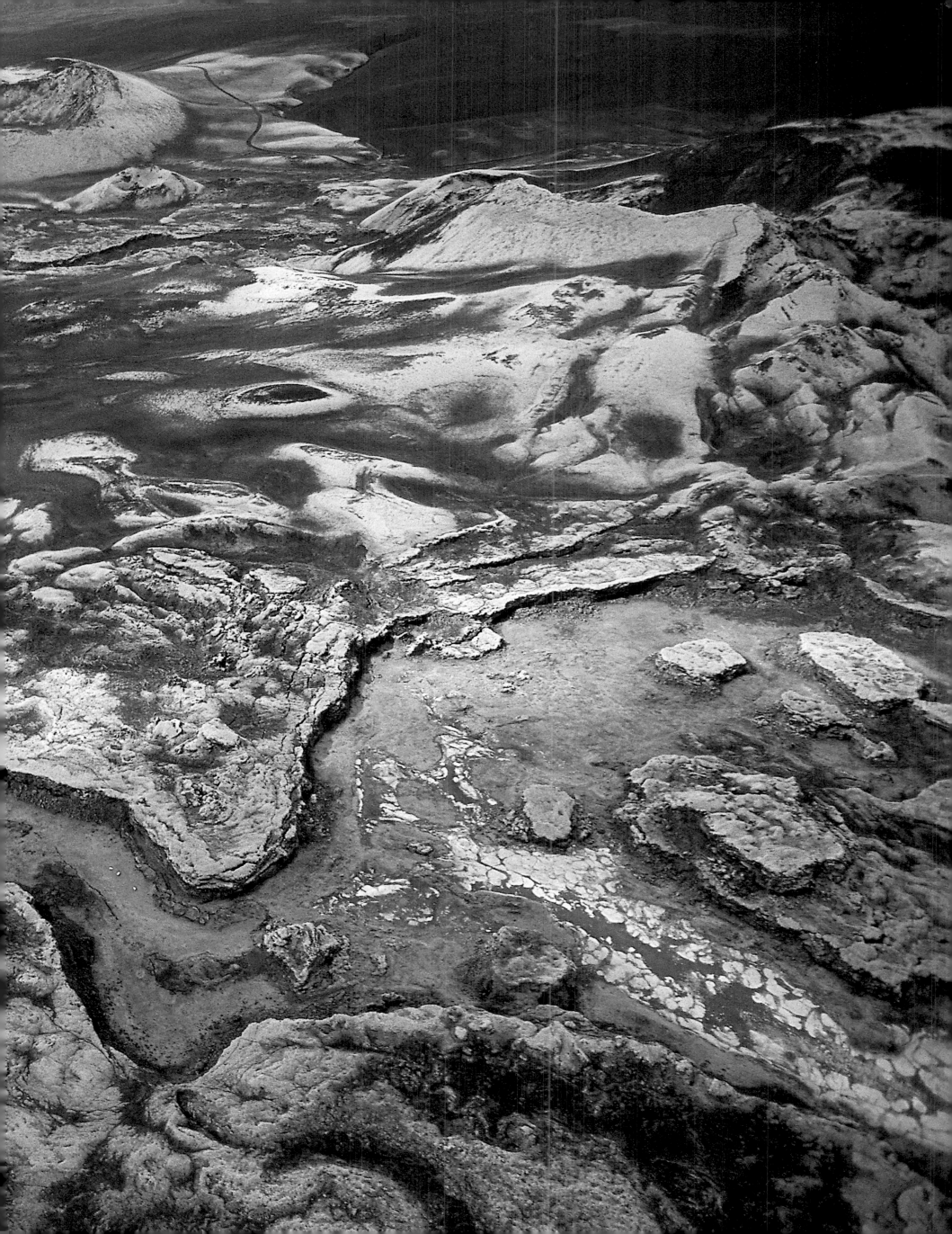

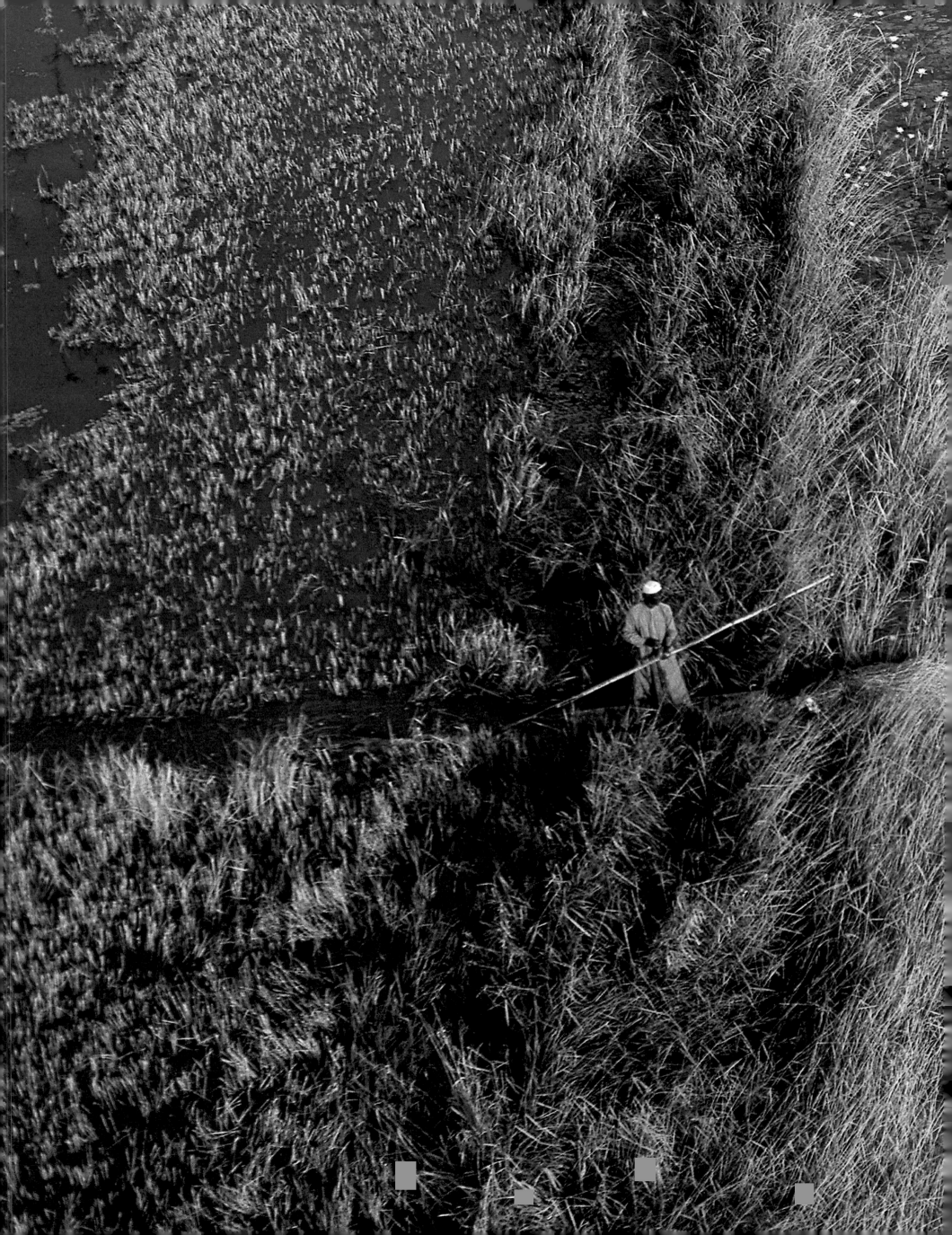

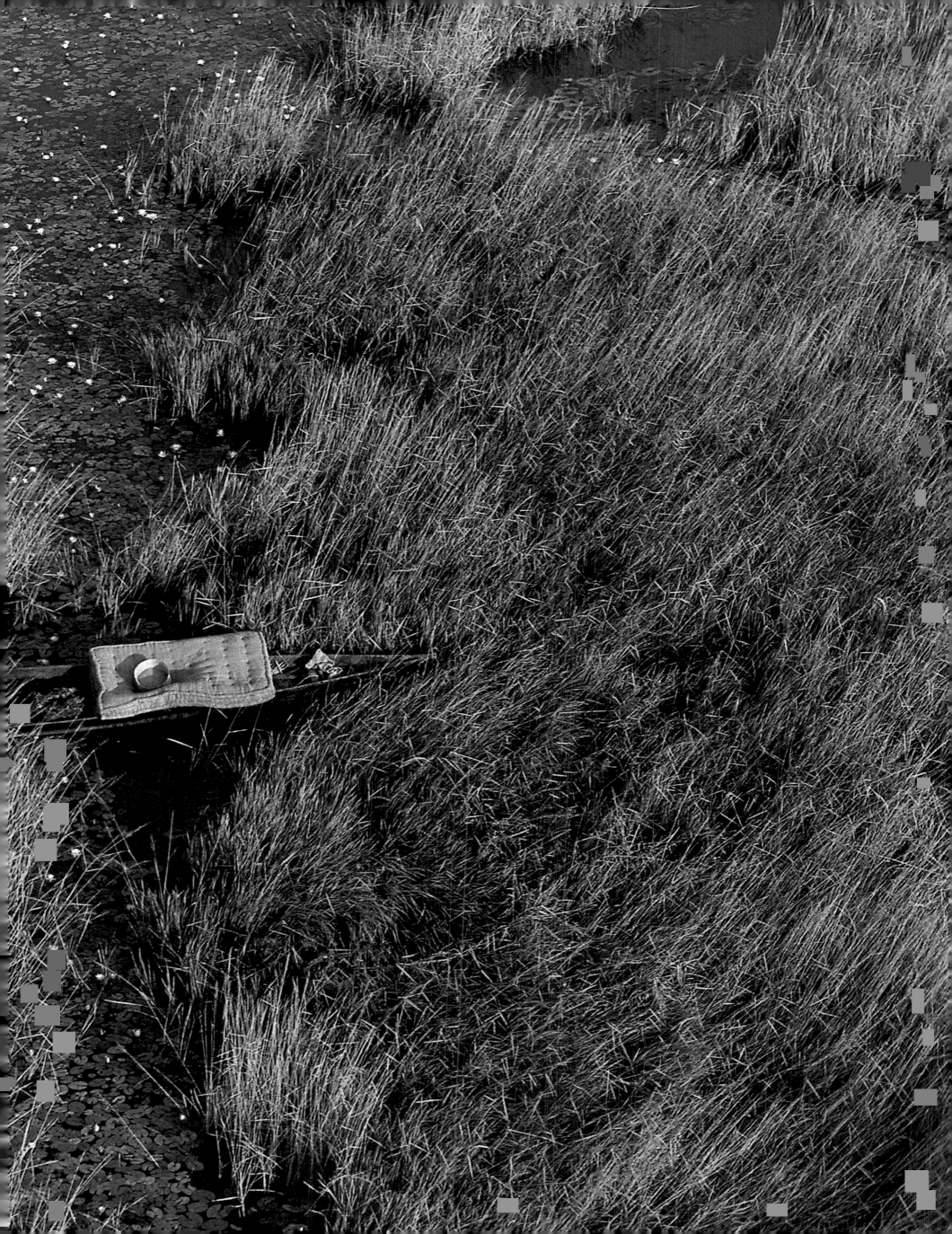

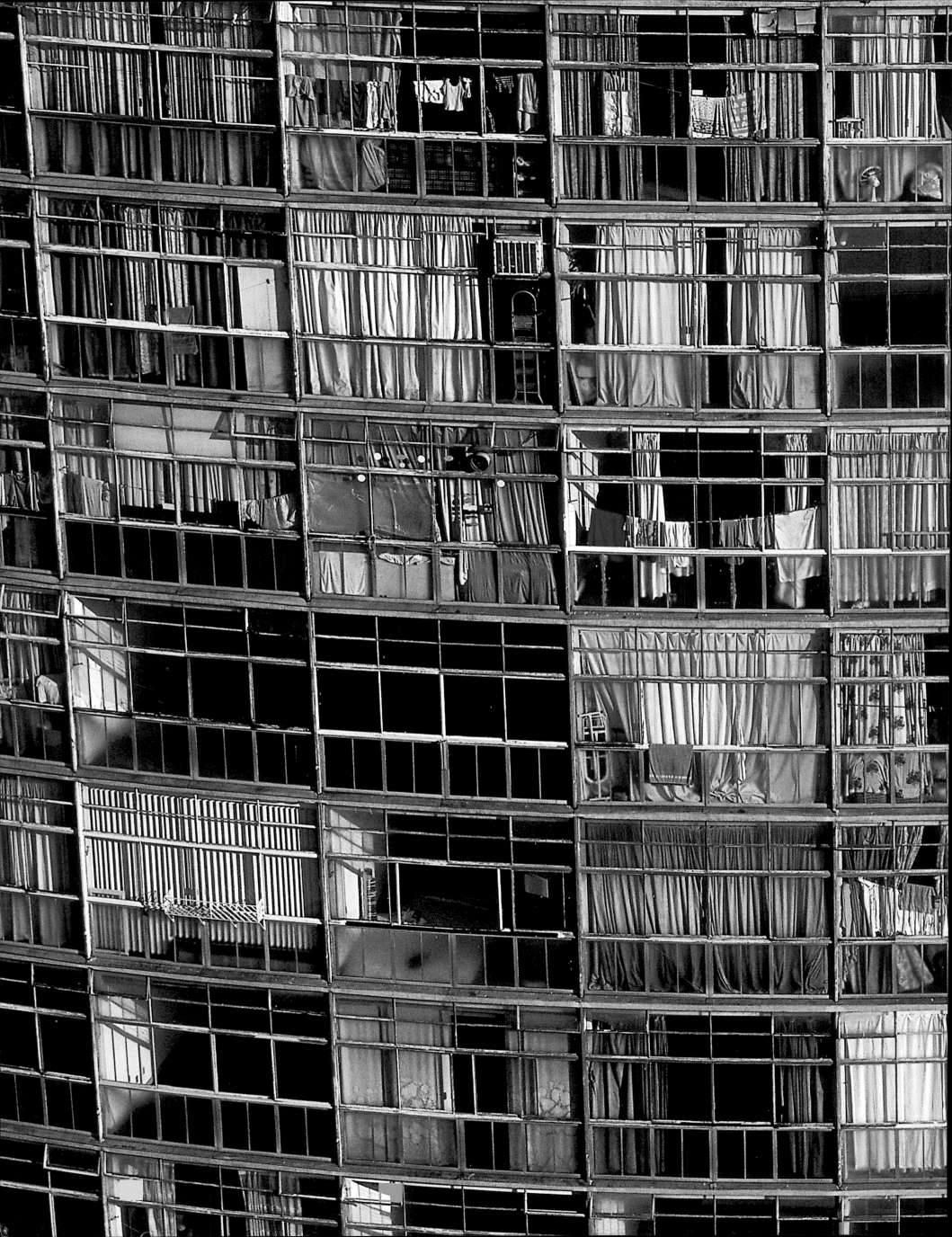

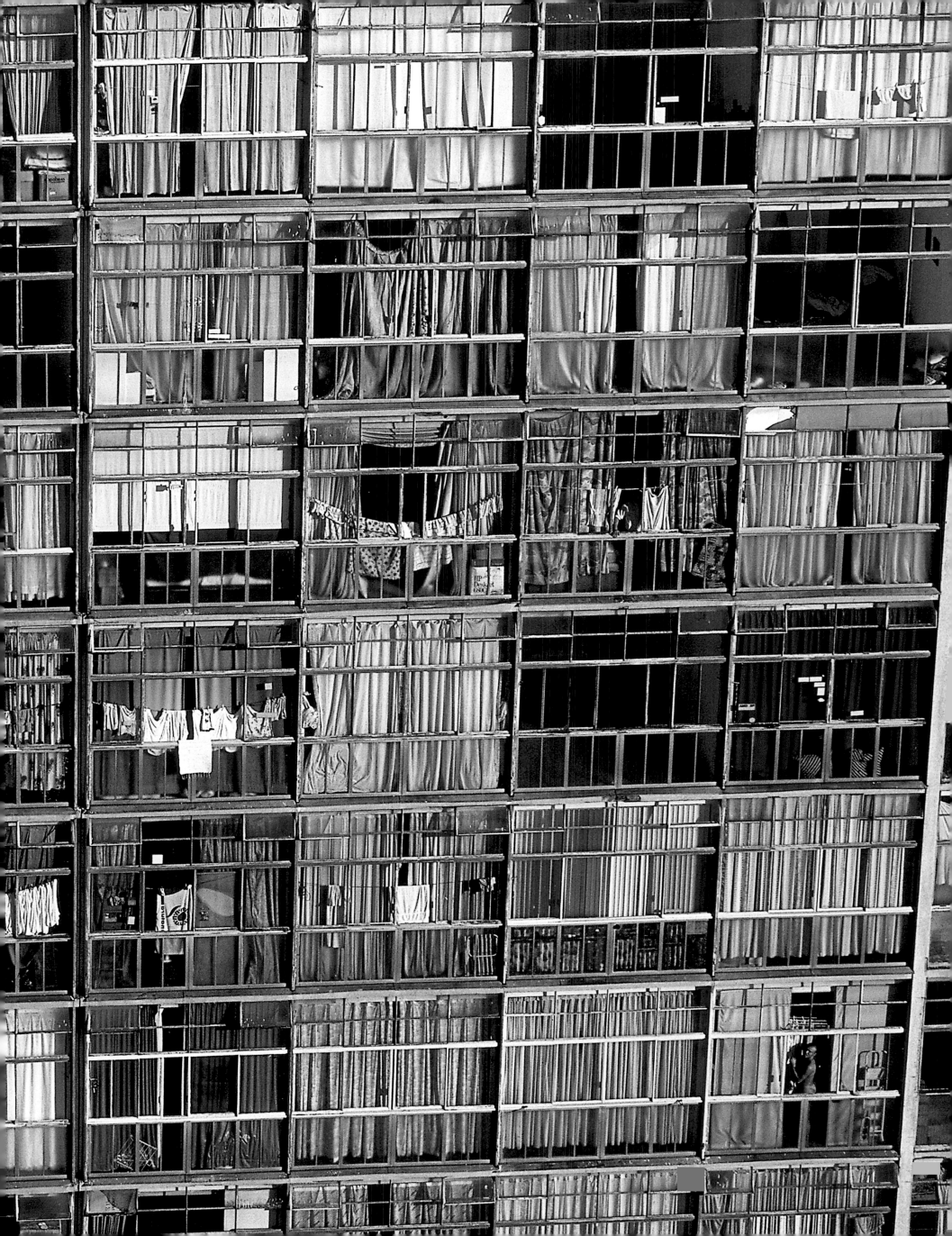

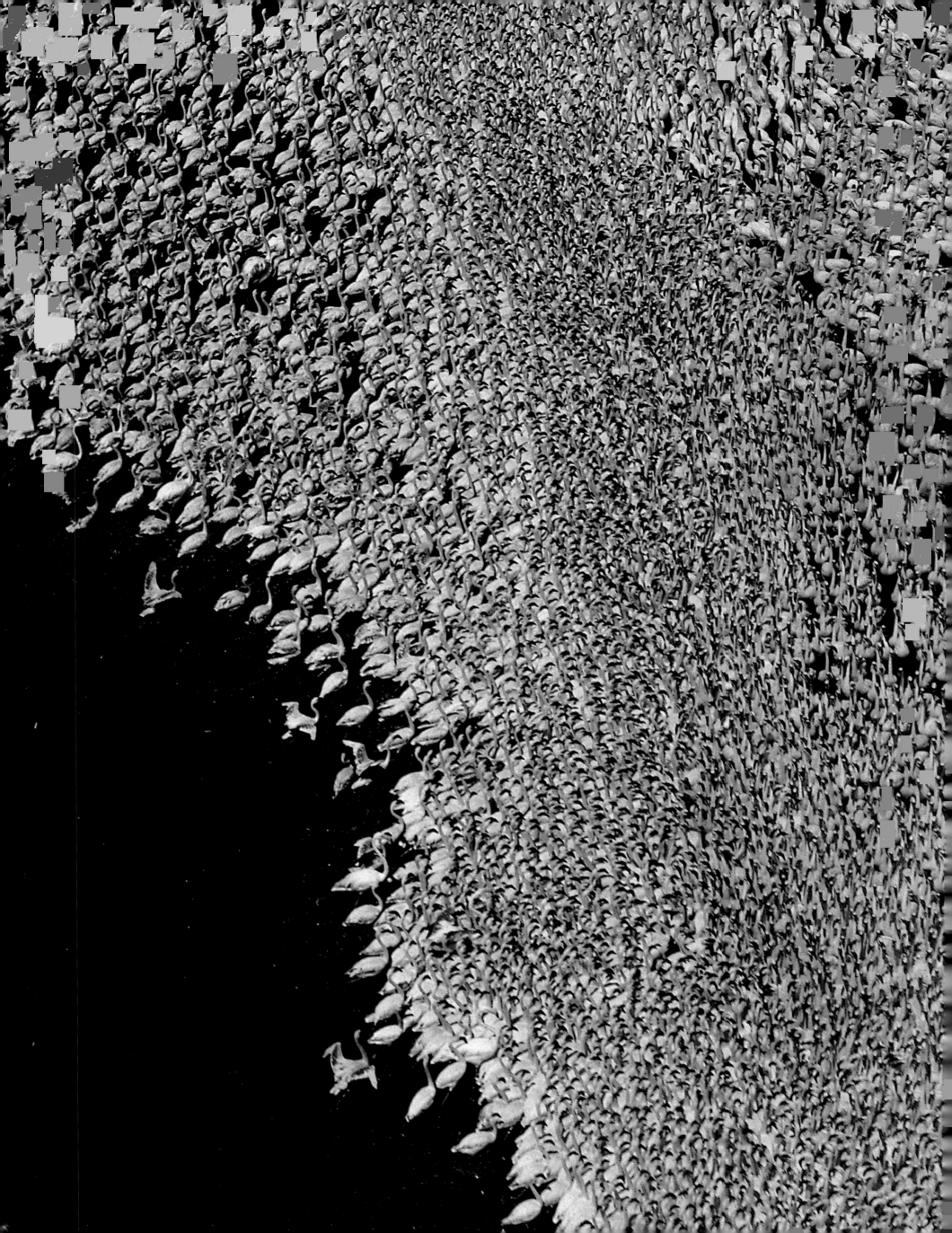

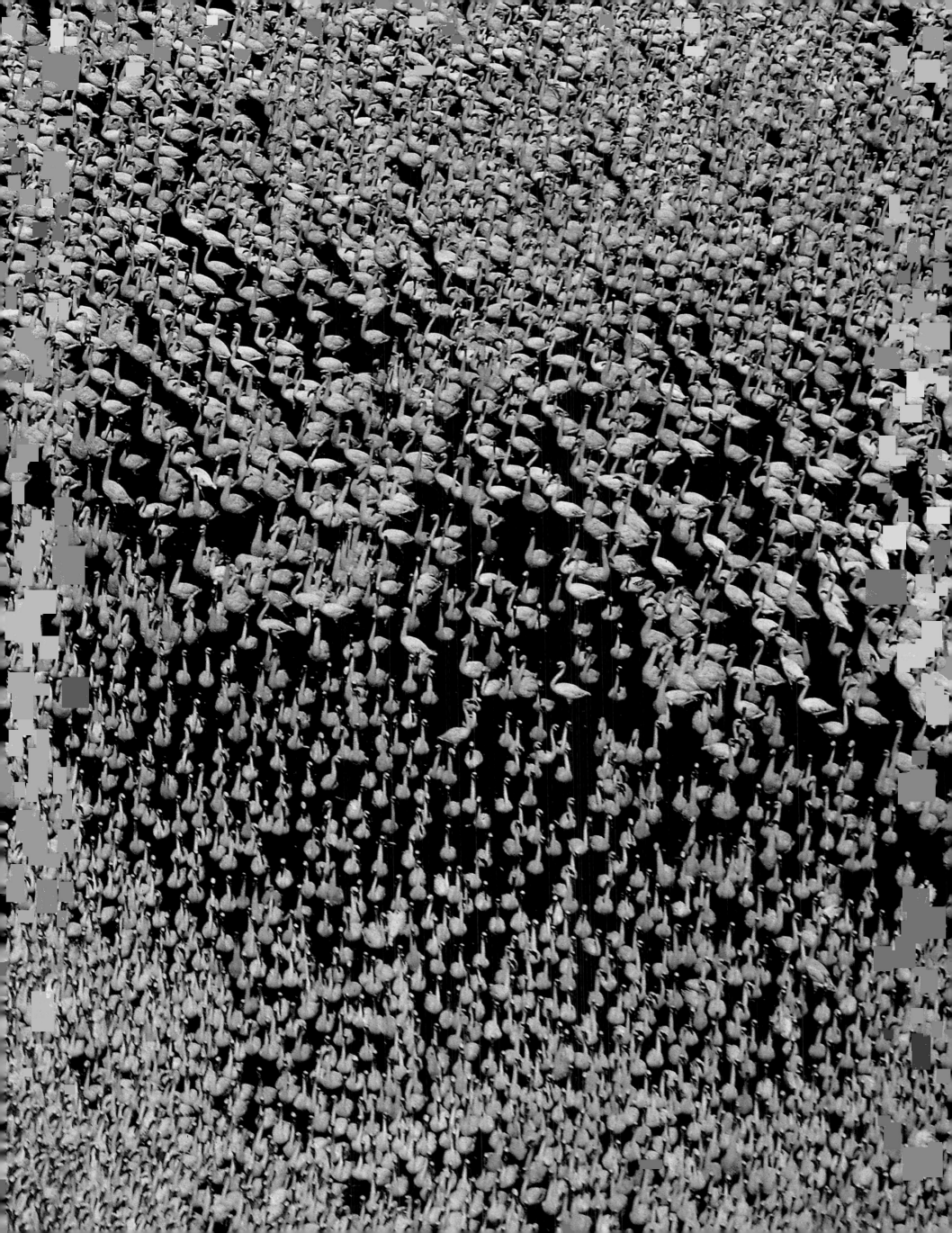

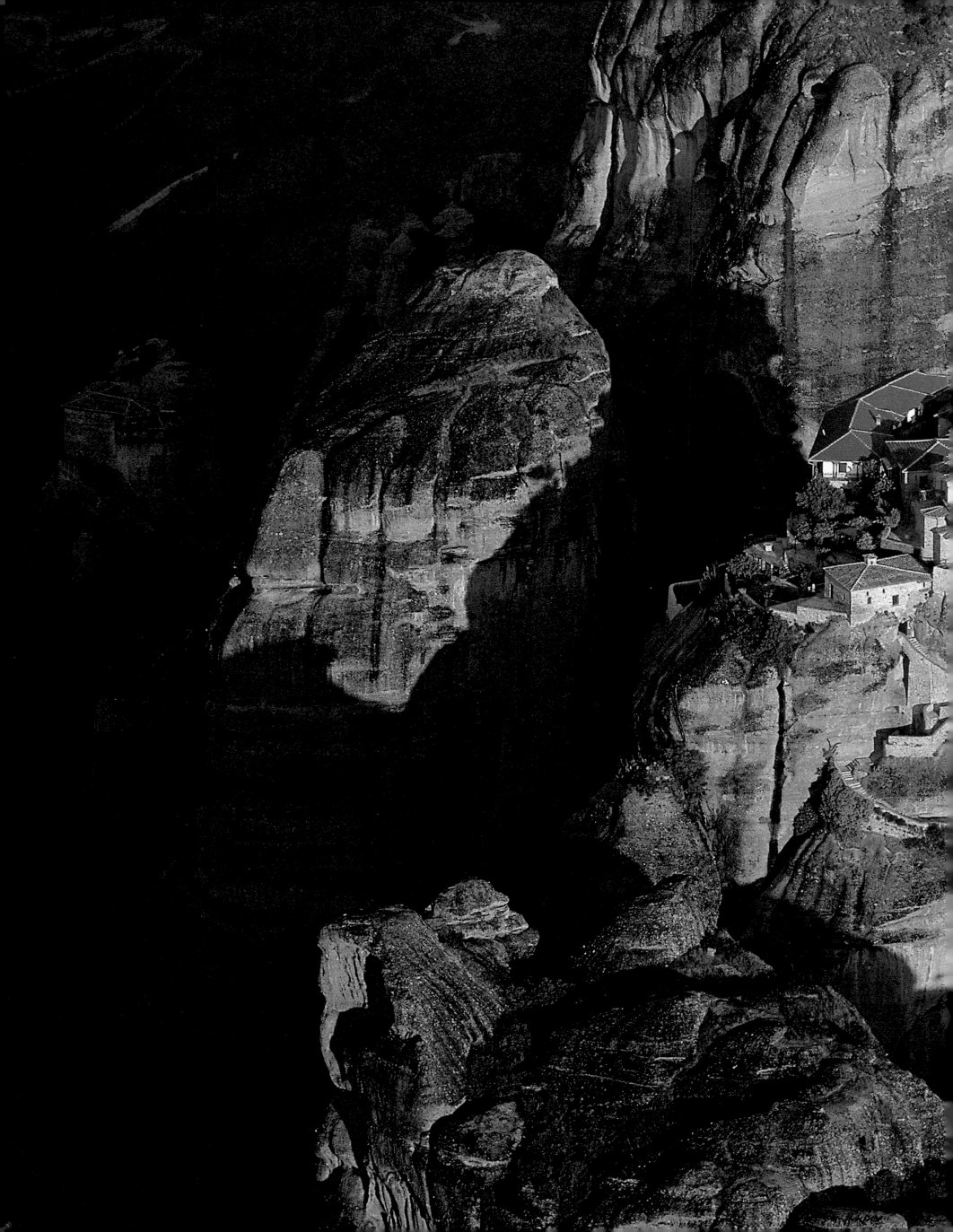

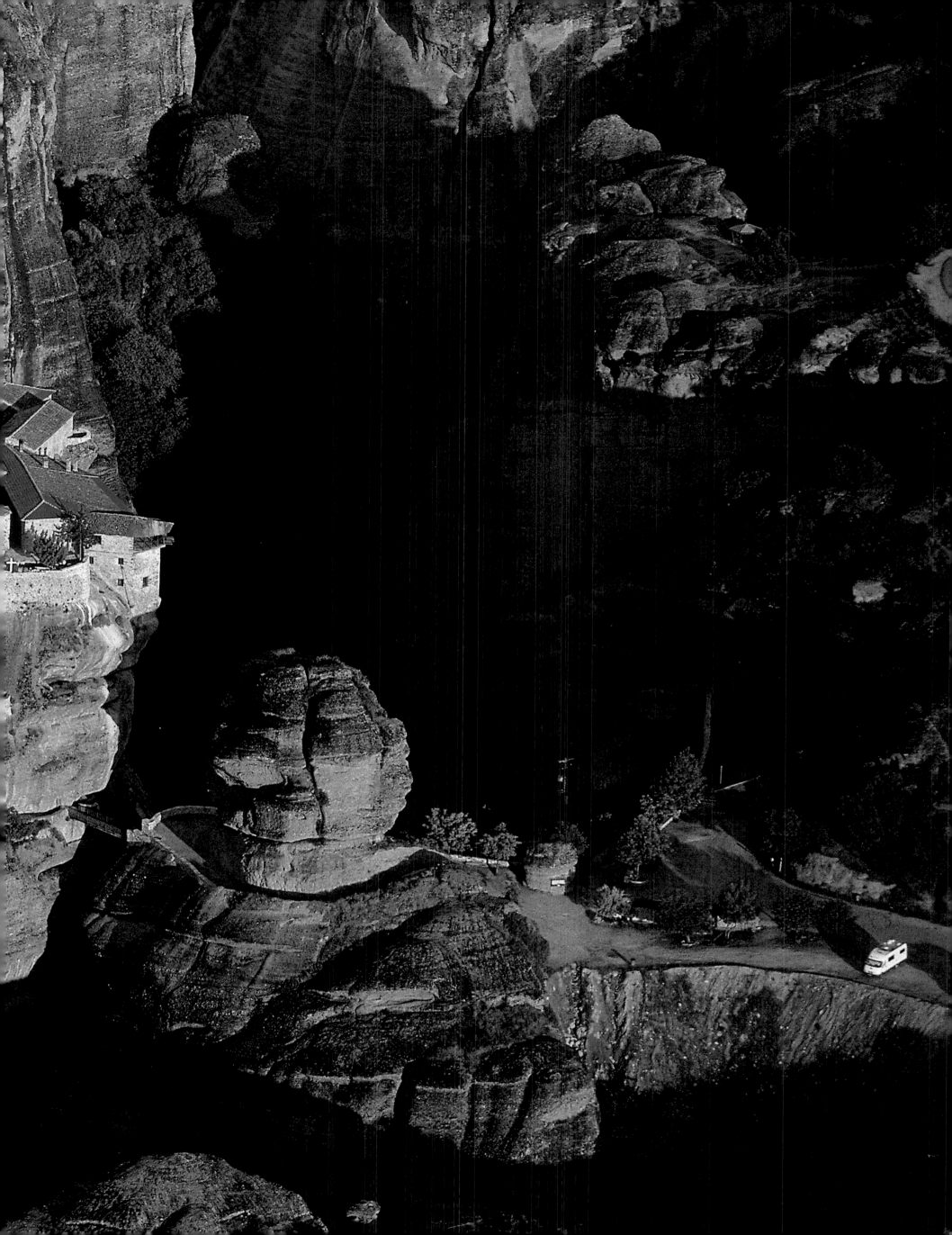

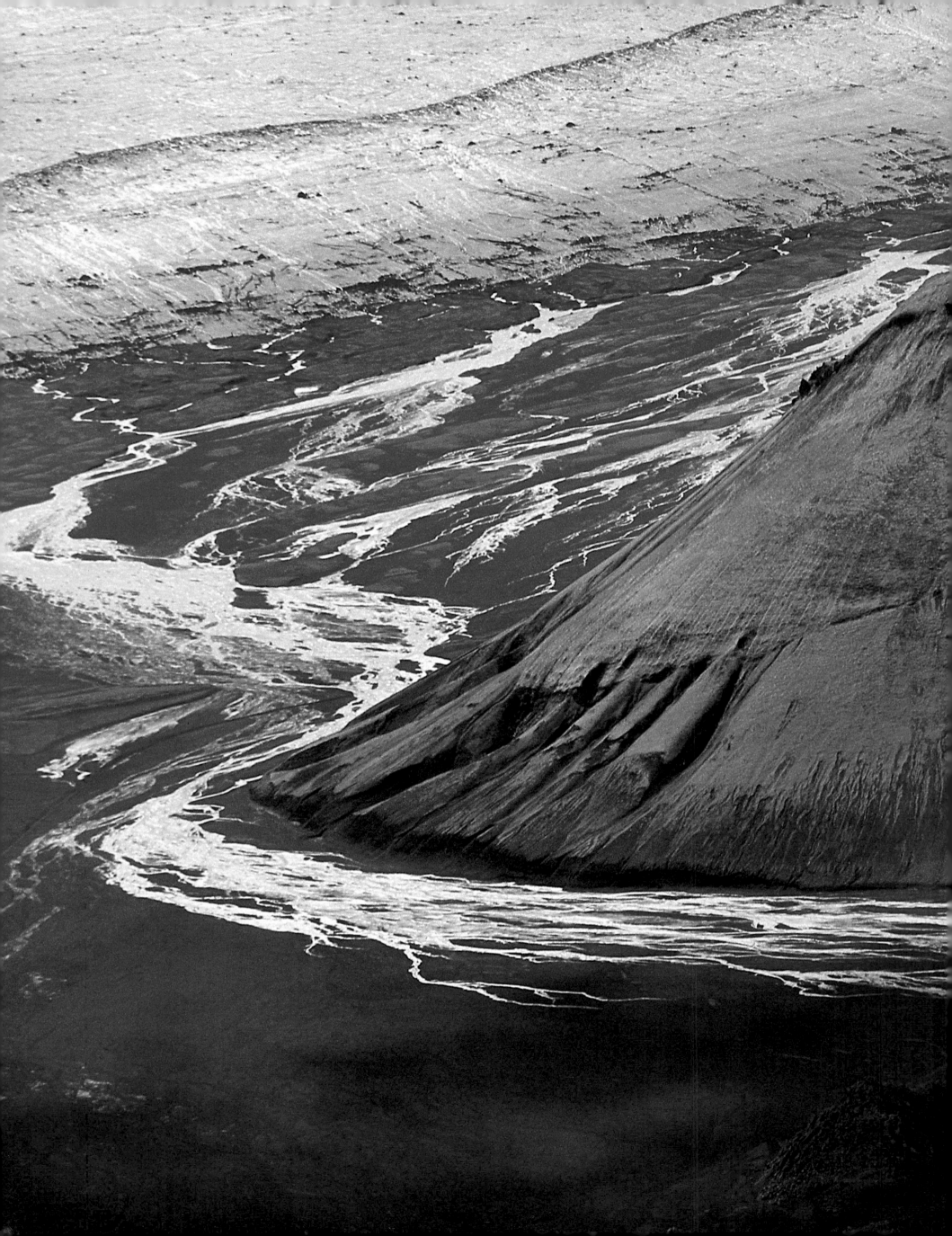

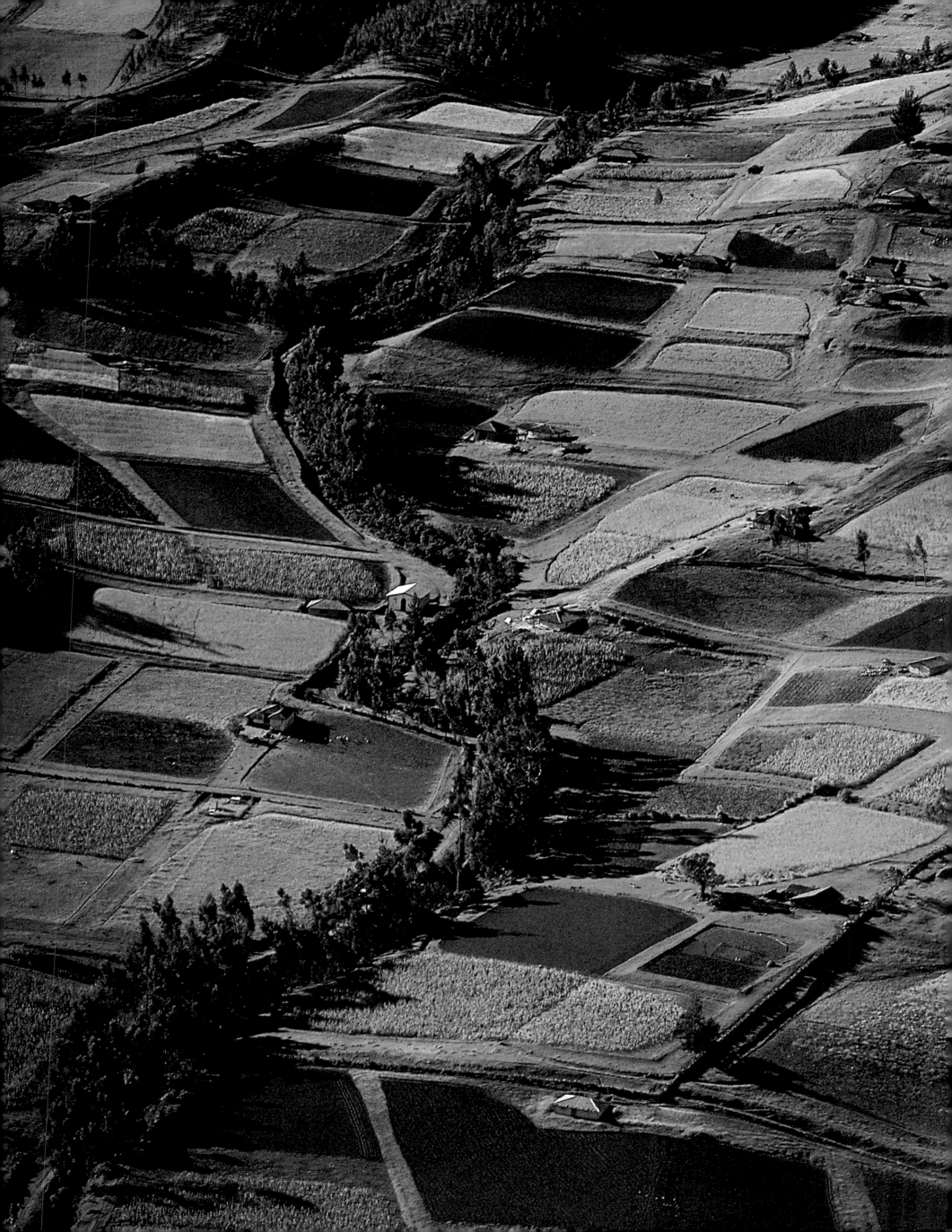

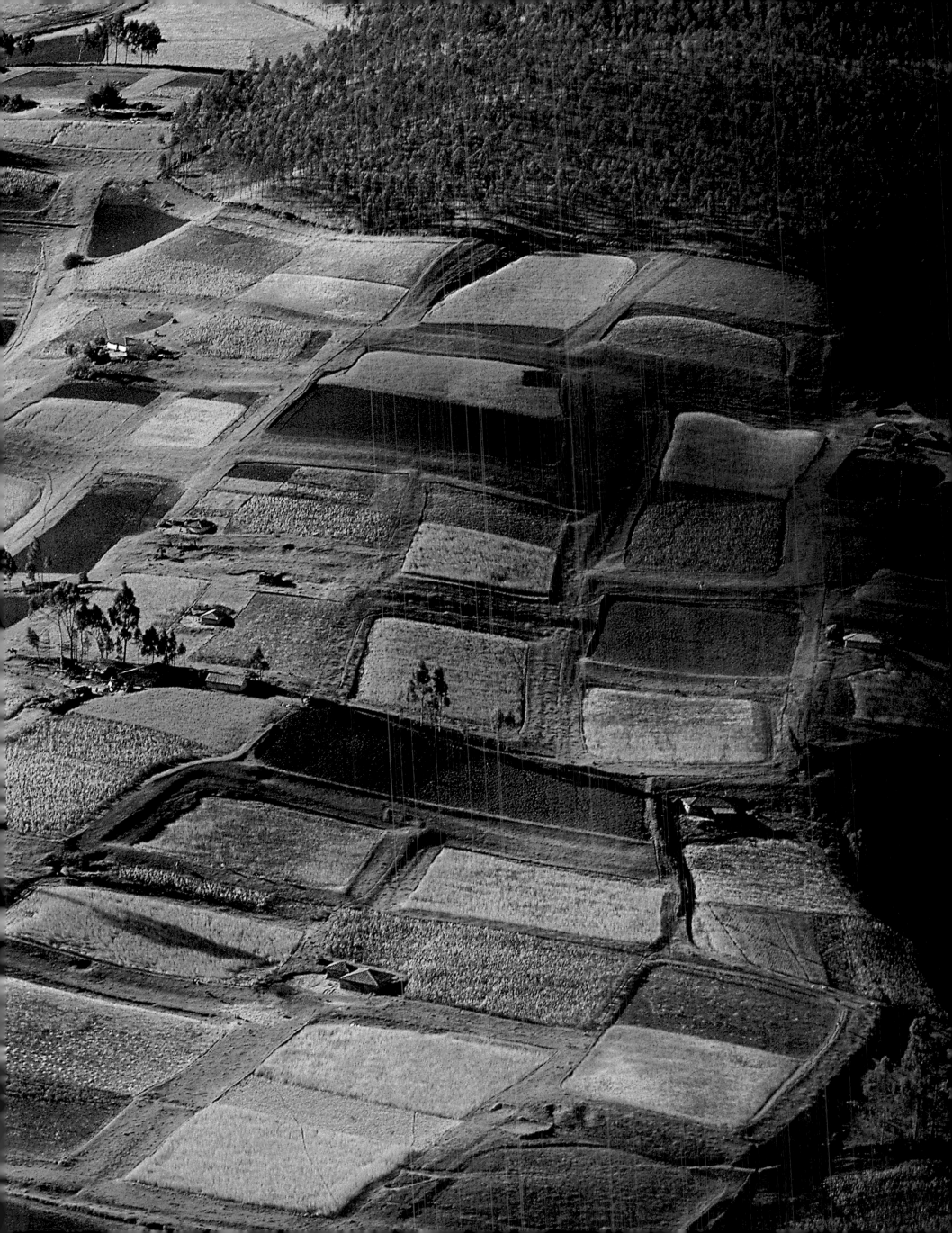

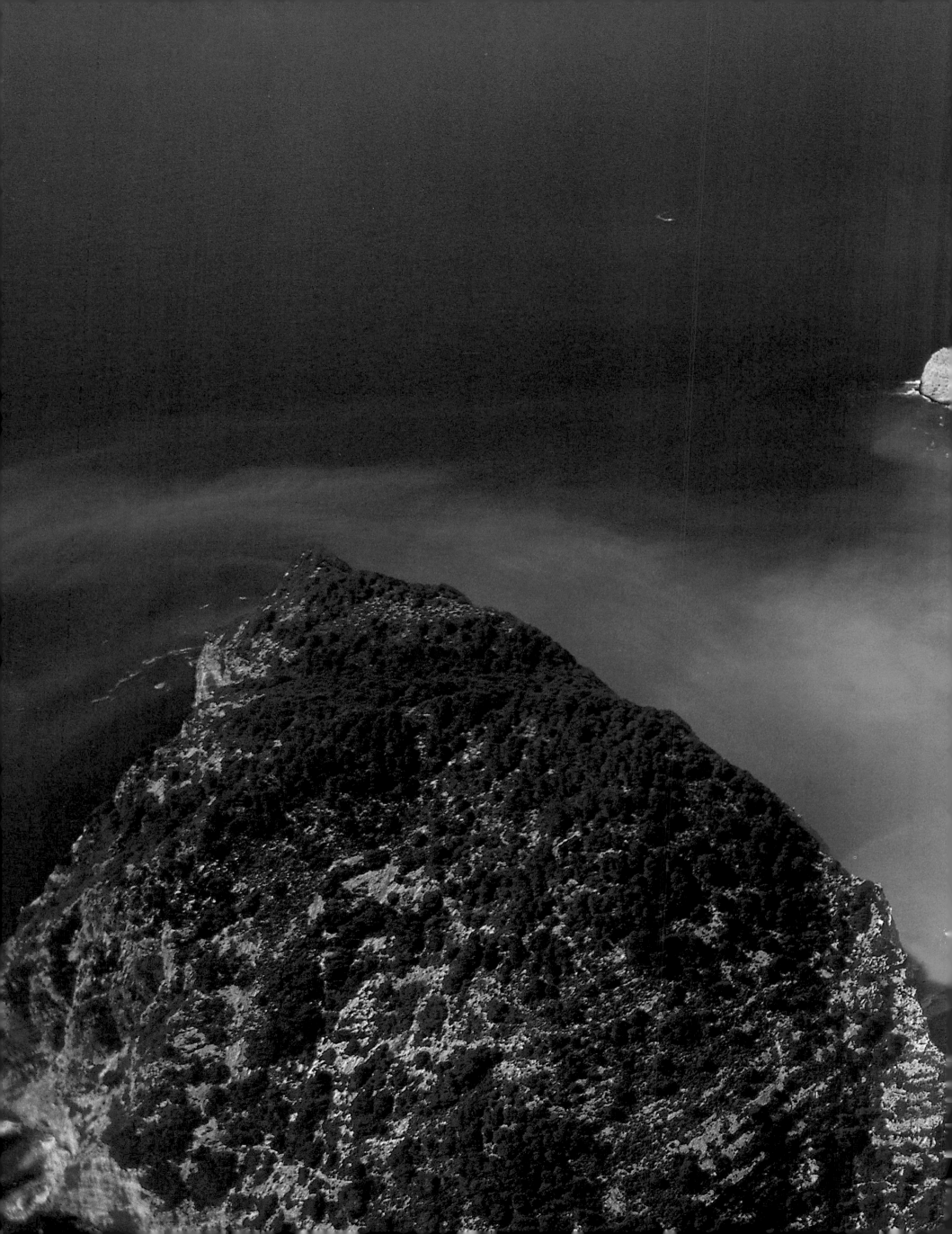

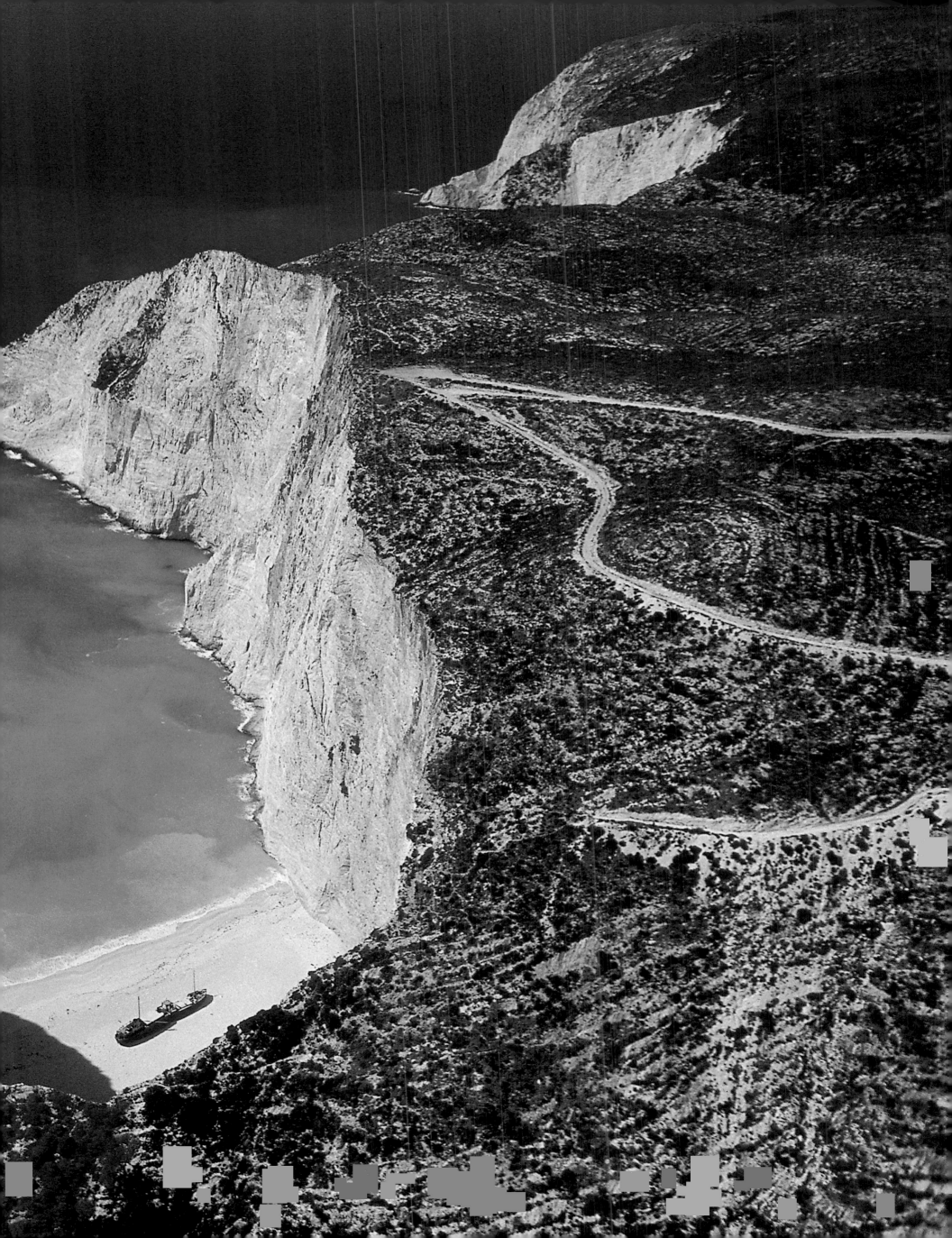

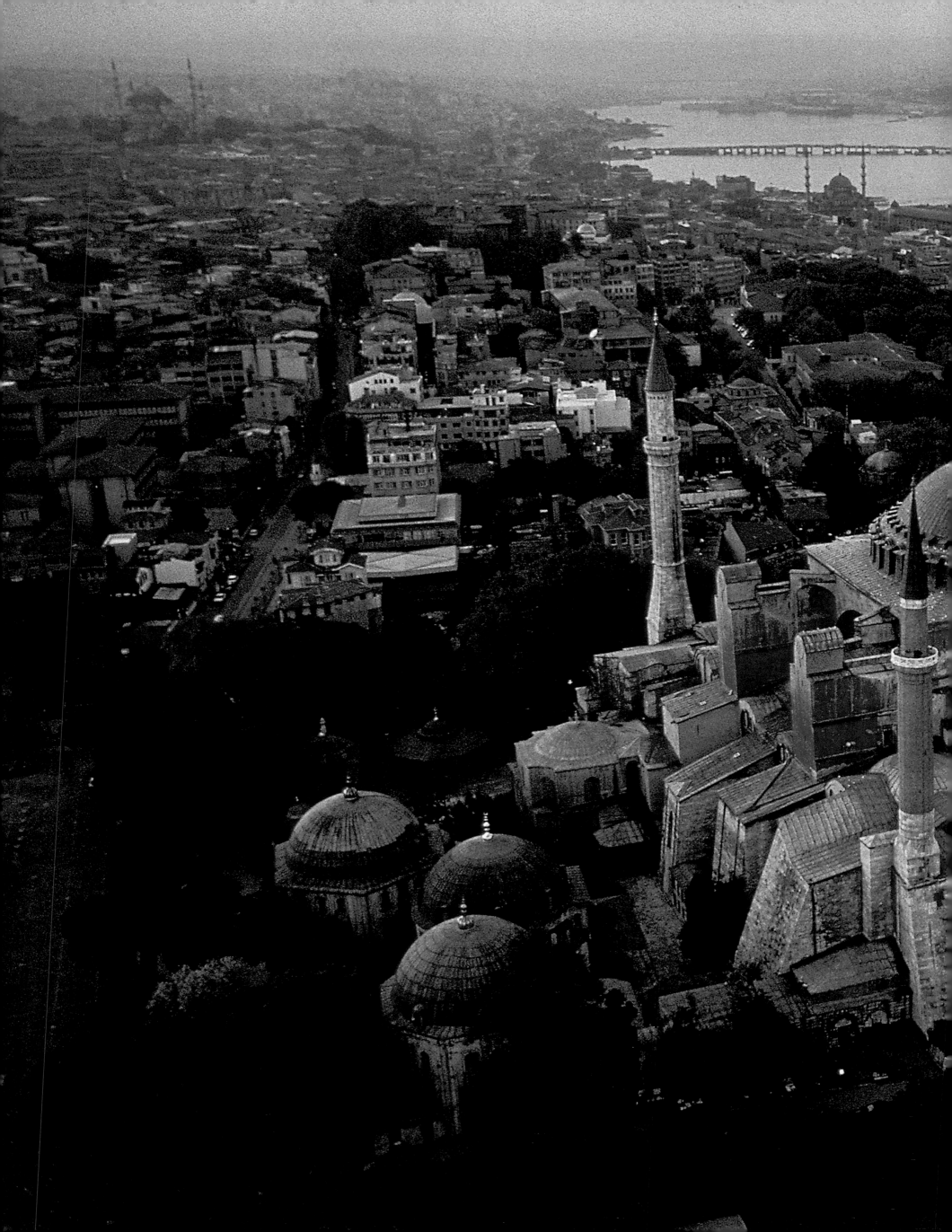

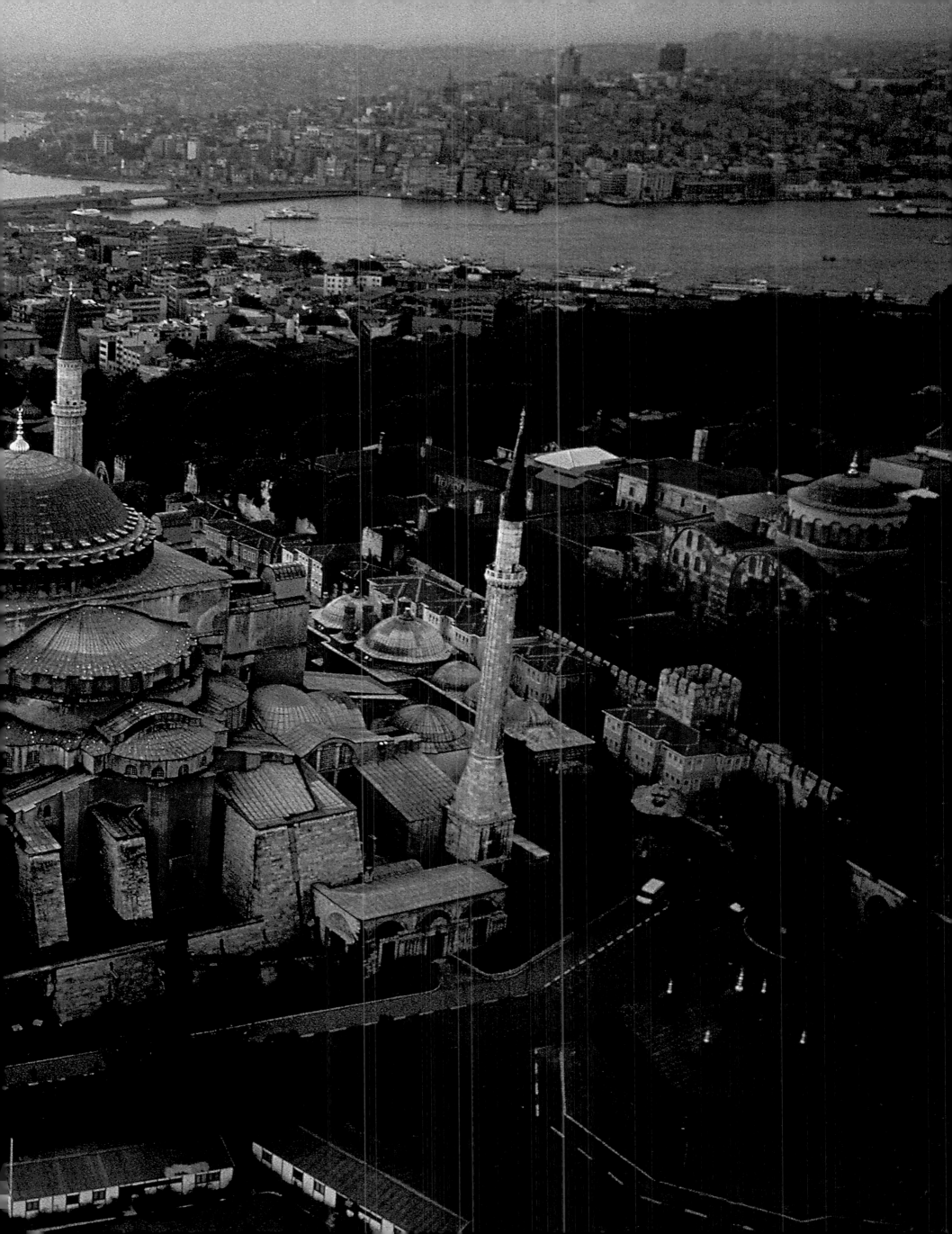

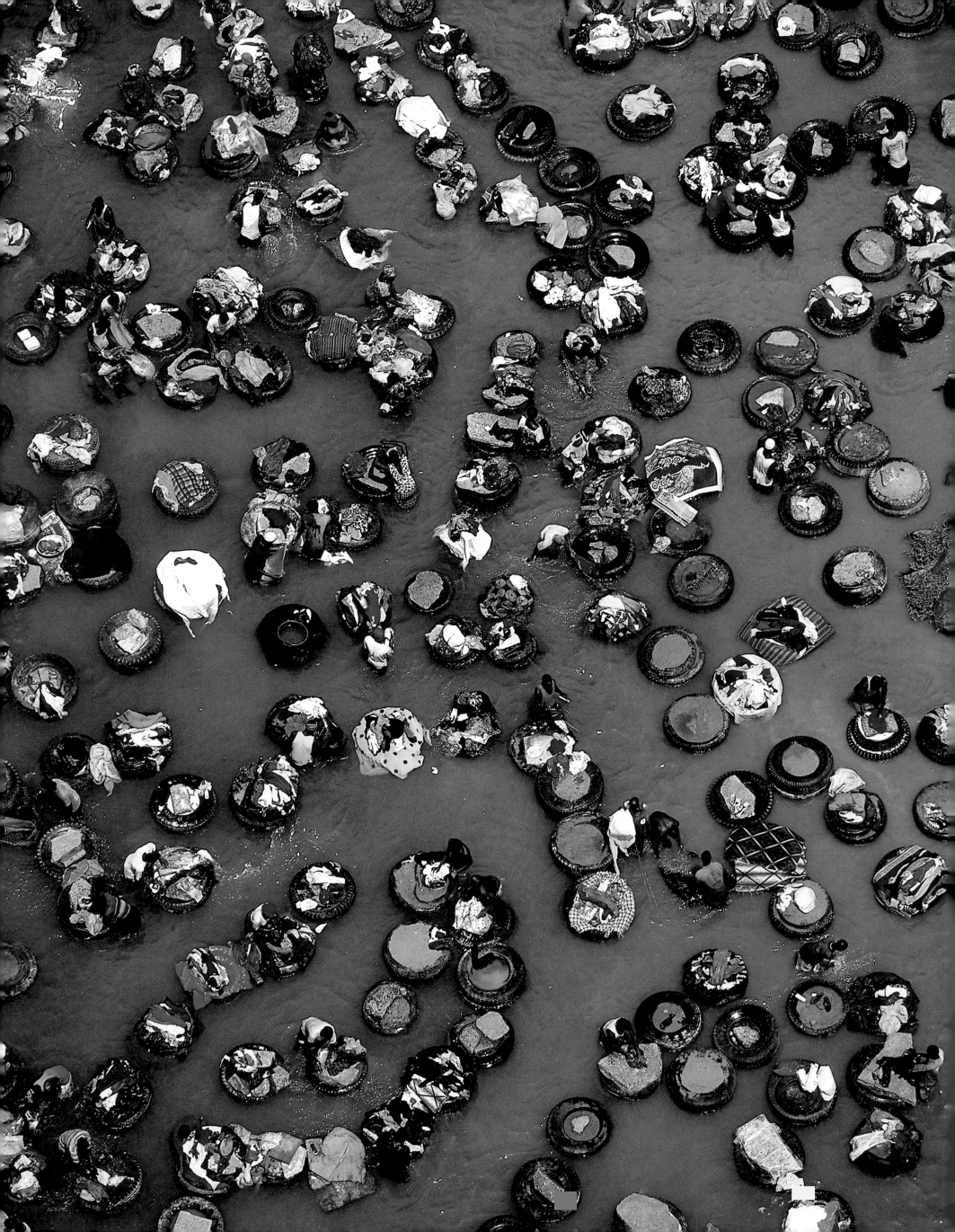

URBAN LANDSCAPES,
LANDSCAPES OF URBANISM

*Cities are home to half of the earth's 6 billion inhabitants. They have become difficult to avoid,
given the many advantages they offer and the attraction they exert. But the city is also
the victim of its success. The shantytowns and slums that house workers often have poor air
and water quality, hygiene, and safety. It is time for human beings to reclaim the urban space.*

The twentieth century was marked by the greatest revolution our planet has known since the arrival of human beings: the concentration of half of its population in these unlikely areas called cities. Cities are indeed unlikely, because all of human history has consisted of a territorial expansion of societies in the search for vegetable and animal nourishment, even to the extremes of the cold, hot, dry, or wet frontiers of our continents. Suddenly, such needs seem not to govern us, and cities have swollen to levels no one could have imagined a few decades ago. Thirty million are crammed into greater Tokyo; 25 million in and around New York, the heart of the megalopolis of the northeastern United States; more than 15 million around Mexico City, São Paulo, Osaka, Jakarta, Los Angeles, Bombay, and Manila. Ten or more additional metropolitan areas are near or above the 10 million mark. Before the nineteenth century only ancient Rome or Edo (Tokyo) exceeded a million in population. Then came the explosion.

It is indisputable that the reason for the success of cities is that they offer amenities. The industrial revolution and the subsequent service revolution occurred here, while the countryside has been increasingly reduced to its agricultural

WASHING LAUNDRY IN A CREEK,
Adjamé district in Abidjan, Côte d'Ivoire
(N 5°19' W 4°02')
In the neighborhood of Adjamé in northern Abidjan, hundreds of professional launderers, *fanicos*, do their wash every day in the creek located at the entrance of the tropical forest of Le Banco (designated a national park in 1953). They use rocks and tires filled with sand to rub and wring the laundry, washing by hand thousands of articles of clothing. Formerly a fishing village, Adjamé has been absorbed gradually by the metropolis of Abidjan, and it is now a working-class district. Abidjan is the economic and cultural center of the country, yet some parts of it are without running water or electricity. It has undergone staggering urban growth: its population has increased fiftyfold since 1950 and today it has more than 3 million residents, one-fifth of the national population. The city has seen a proliferation of dozens of small trades, such as these *fanicos*, which offer the only means of subsistence for the poorest groups.

and touristic functions. Exceptions exist, as in Germany, Belgium, Holland, Luxembourg, northwestern Italy, Japan, eastern China, and a few other regions of the world that have major industrial sectors within rural environments. But the population densities in these areas are among the highest in the world, and they cannot truly be described as rural—houses, roads, and factories are everywhere, interwoven among the fields.

It may seem paradoxical that this evolution has affected poor and rich countries alike; this is because, among poorer countries, country life is often precarious. The rural population is at the mercy of climatic irregularities that can destroy the chances for an adequate harvest. In the country, people are also subject to strong social pressures from family, ethnic group, religious community, and local leaders whether legitimate or criminal. In the city, despite its uncertainty, discomfort, and crowding, there is always some small deal to be made, some scraps from a wealthy table to be picked up. Even for those with minimal qualifications, work can be found, perhaps physically arduous work on a building site, or in health services, or temporary and illegal work if necessary, even degrading work at times, but bringing in a subsistence wage and a little something to send home to the family overseas or in the country. This was the growth process for London, Paris, and New York up to World War I and even beyond. The new arrivals, destitute, settled near train stations and ports, in the underdeveloped outskirts, in the slums. This is still happening in the gigantic, barely controlled urban sprawl of Mexico City, Rio de Janeiro, Calcutta, Manila, Lagos, and so many other cities in the southern hemisphere. Yet in times of peace and prosperity order seems to reign, and the city becomes welcoming, attractive, and intense.

CITY LIGHTS

Cities fascinate people. People of old in the fertile crescent and the great civilizations of the Mediterranean (Egypt, Israel, Greece, Rome), China and pre-Columbian America (Mexico, the Andes) established their gods in cities. In the shadow of the sacred, they developed politics, the art of governing the city, as well as commerce, art, the exchange of ideas, and social life. The high places at the heart of such cities as Jerusalem, the Acropolis and Agora of Athens, the seven hills of Rome, and the Temple of the Sun at Mexico City embody the permanence of this sense of space and of the world, this vertical bond between earth and heaven, between the profane and the sacred. With the possible exception of subsaharan Africa, which had scarcely any urban tradition before the colonial era, cities on all continents have preserved from ancient times their status as the center of the world. We need only think of the cathedrals, the forbidden cities of China and the Far East, the Imperial Palace of Tokyo where the emperor resides—with his modest constitutional title of "symbol" of Japan—or the model of the Plaza Mayor in Spain or Latin America. As soon as places take on meaning, speak to the heart and the mind, become enchanted, they are inhabitable. For as long as cities have been known (thanks to geomancy) as the hub of the cosmos, they have been sought out, loved, and embellished.

One of the most intense emotions felt by city dwellers is the give-and-take among all the members of the social body. A city that is livable and healthy lets rich mingle with poor, generation speak to generation, and all the professions collaborate. A city in equilibrium is a social elevator that offers an escape from the divisions of birth and inheritance and allows knowledge to spread as widely as possible. Rastignac, the ambitious young hero of Balzac's *Père Goriot*, shakes his fist at Paris, vowing to conquer or be conquered, summing up all the hopes ever inspired by cities. We find the same feeling in the Chinese peasant who arrives in Shanghai or Beijing after a grueling train journey, or the Indian from the altiplano who uses his last penny to get to Lima, or the African bushman who squeezes into, or hangs precariously onto, the ramshackle taxis and overfilled trucks, higher than they are long, to reach the Eldorado of his dreams, Dakar, Bamako, Nouakchott, Kinshasa, or Abidjan. Some take enormous risks to escape their country, Romania, Albania, Pakistan, or Turkey, and get to London, Paris, Dusseldorf, or Milan. They know it won't be easy, that they will have to put up with humiliation, indifference, or contempt on the part of those who have been there longer. They don't mind; they count on ethnic solidarity and will take advantage of humanitarian associations or official assistance. If necessary they work on the margins, even illegally, despite the known risk of passing a point of no return. Many succeed. The descendants of Italian *mafiosi* in Chicago have melted into American society. No one pays attention now to the family names of the children or grandchildren of Russians, Poles, Armenians, Spaniards, Italians, or Portuguese who arrived a century ago in Marseilles, Lyons, or Paris. A successful city is like a machine to integrate, not crush, personalities. Most cities still retain their eminent function as a place of welcome.

For anyone lacking regular or sufficient income, city life is hard, but humanitarian aids such as soup kitchens and shelters exist; in the countryside in poor countries they are not to be found. Despite the poverty, violence, and ignorance of shantytowns, *favelas*, camps of Gypsy wagons in Western Europe, and nomad tents in the cities of the Sahel, these places are the scene of true solidarity, a complicity, a sense of community among their residents. For most residents, they provide a difficult transition; people leave them as soon as possible, or do their utmost in order that their children can achieve a better status. The bottom line is unmistakable: people live longer in the city than on the farm. Because, no matter what, the city is more effective at providing subsistence and ongoing care.

Whether prosperous or poverty-stricken, cities are usually powerful stimulants for their residents. There is a continuous intermingling of so many people, goods, services, and ideas. The open-minded, responsible city dweller can find a wealth of intellectual and spiritual nourishment as well as economic ferment. The city dweller is constantly challenged to give the best, and even when beset by despair, to bounce back and move on.

TRADITIONAL VILLAGE,
north of Antananarivo, Madagascar
(S 18°48' E 47°28')
This village is a proto-city. Its form combines the most common ingredients in the evolution toward urbanism: interior gardens and bowers, aligned buildings, the plan of a central square, and even a borough just outside the city wall. In many civilizations the first towns were circular in shape with radial paths leading outward from the center.

pp. 98–99
WORKER RESTING ON BALES OF COTTON,
Thonakaha, Korhogo, Côte d'Ivoire
(N 9°28' W 5°36')

In the nineteenth century West Africa received its first cotton seeds of the *Gossypium hirsutum* variety, which originated in the British Antilles and remains the most widely cultivated kind of cotton in the world. Cotton production in West Africa was originally intended to serve only local needs. However, at the beginning of the twentieth century this raw material represented 80 percent of the world textile market, and the European colonial powers encouraged cotton production in order to break the export monopoly of the United States and Egypt. Harvested manually at a rate of 33 to 80 pounds (15 to 40 kg) per worker per day in tropical Africa, the cotton crop is then put through gins in order to separate fiber, seeds, and waste. One ton of cotton yields 880 pounds (400 kg) of fibers and 1,200 pounds (560 kg) of seeds, which are processed for human consumption (as oil) or for animals (cattle cakes). In northern Côte d'Ivoire, especially in the Korhogo region, cotton plantations, the main cash crop, take up 590,000 acres (240,000 hectares). The country's cotton output, nearly 300,000 tons, produced by more than 150,000 planters, is only a small fraction of world production; but nationally it counterbalances the agricultural domination in the south of the country, where the great plantations (cacao, palm oil, rubber, pineapple) are concentrated.

pp. 100–101
CLIFFS OF INISHMORE,
Aran Islands, County Clare, Ireland
(N 53°07' W 9°45')

Off the Irish coast, the Aran Islands—Inishmore, Inishmaan, and Inisheer—feature cliffs that rise to heights of 300 feet (90 m) and guard Galway Bay from the rough winds and currents of the Atlantic Ocean. Inishmore, the largest of the islands (9 x 2.5 miles, or 14.5 x 4 km), is also the most populous, with nearly 1,000 inhabitants. For centuries the inhabitants helped to fertilize the rocky soil of these islands by regularly spreading a mixture of sand and algae on the ground, intended to provide the thin layer of humus necessary for farming. To protect their plots of land from wind erosion, the islanders built a great network of windbreaking walls, a total of some 7,000 miles (12,000 km) in length, which lend these lands the appearance of a gigantic mosaic. The Aran Islands derive most of their resources from fishing, farming, and herding, and they attract a growing number of tourists to their many archaeological ruins.

pp. 102–103
FLOCK OF SCARLET IBIS NEAR PEDERNALES,
Amacuro delta, Venezuela
(N 9°57' W 62°21')

From the Llanos region to the Amacuro delta at the mouth of the Orinoco River, more than a third of the area of Venezuela is made up of humid zones, the habitat of choice of the scarlet ibis (*Eudocimus ruber*). These waders nest in large colonies in mangroves and move no farther than a few miles to seek food. Carotene derived from the shrimp, crabs, and other crustaceans they eat helps create the characteristic pigmentation of the species. The scarlet ibis's feathers, at one time used by native populations to make coats and finery, are now a component in the manufacture of artificial flowers. This bird, sought after for its flesh as well as its feathers, is endangered today; fewer than 200,000 survive, in Central and South America.

pp. 104–105
MARKET GARDENING IN THE VICINITY OF TIMBUKTU, Mali
(N 16°48' W 3°04')

In the arid region of Timbuktu in central Mali, market gardening has to contend with a sandy soil that is not especially fertile, in addition to difficult climatic conditions. Daytime temperatures can reach 120° F (50° C), and precipitation barely exceeds 6 inches (150 mm) per year. These sand gardens, consisting of a patchwork of tiny parcels of about 10 square feet, must use water very sparingly. They yield foods (including peas, fava beans, lentils, beans, cabbages, lettuce, and peanuts) intended mostly for immediate consumption. The growth of this type of gardening in Mali is a consequence of the severe droughts of 1973–75 and 1983–85, which decimated the livestock of the nomadic herdsmen in the northern areas, forcing some of them to settle in one place and adopt subsistence farming.

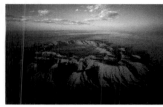

pp. 106–107
GOSSE'S BLUFF METEORIC CRATER, Northern Territory, Australia
(S 23°49' E 132°19')

Approximately 135 million years ago a meteorite fell on Australian soil, devastating more than 8 square miles (20 km²) in what is now the Northern Territory. Today a crater 3 miles (5 km) in diameter and 500 feet (150 m) deep remains, called Gosse's Bluff; it is known as Tnorala to the Aborigines. Meteorites of small size reach the earth's surface frequently, thousands of times each year. They are usually less than 3 feet (1 m) in diameter and cause no damage because they fragment and burn on entering the earth's atmosphere, reaching the ground as dust. The arrival of meteorites more than 33 feet (10 m) in diameter, which can cause serious damage, is rare. The largest of the roughly 150 craters of known impact was 125 miles (200 km) in diameter. One recent theory put forth to explain the massive extinction that killed off the dinosaurs 65 million years ago holds that it was the result of the devastating impact of an asteroid. The extinctions that we witness today, however, the greatest since that time, are the result of human action.

pp. 108–109
IRAQI TANK GRAVEYARD IN THE DESERT NEAR AL-JAHRAH, Kuwait
(N 29°26' E 45°24')

After Iraq invaded Kuwait on August 2, 1990, a coalition of twenty-eight countries headed by the United States (including the United Kingdom, France, Saudi Arabia, United Arab Emirates, and Egypt) launched Operation Desert Storm on January 17, 1991, with 760,000 troops, to force the occupation army to leave the emirate. Heavy aerial bombing prepared the way for a ground offensive that began February 24 and lasted a mere 100 hours. Iraq withdrew from Kuwait. The Gulf War reportedly caused thousands of casualties and cost $1 billion per day. The world budget for military expenditures for the year 2000 was more than $798 billion; the United States, western Europe, Japan, and Australia alone accounted for $517 billion. This same group of countries, which also make up the Aid and Development Committee, in 2000 provided public assistance for the development of the poorest nations to the tune of $53 billion, or roughly one-tenth of its global military expenditure.

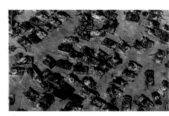

pp. 110–11
LANDSCAPE BETWEEN AS SAFAWI AND QASR BURQU', near Al Mafraq, Jordan
(N 32°32' E 37°34')

Benefiting from 19.5 to 23 inches (500 to 600 mm) of precipitation per year, northern Jordan presents a landscape of steppes combining sand and vegetation, as seen here between As Safawi and Qasr Burqu'. The country as a whole, however, is 80 percent desert and receives less than 4 inches (100 mm) of rainfall each year. The principal water source for this almost landlocked territory is the Jordan River, which gave its name to the country. The use of this waterway, which forms the western border with Israel and the West Bank, is a geopolitical stake in the region. Access to water sources is a problem for all countries of the Near and Middle East, especially those that control less than the entire course of a river, including its source and its outlet. The waters of the Tigris and Euphrates (Turkey, Syria, Iraq) and the Nile (Sudan, Egypt) hold similar importance. At present it is estimated that some ten conflicts in the world involve a dispute about water.

Captions to the photographs on pages 112 to 127 can be found on the foldout to the right of the following chapter

captions 98–111 captions 112–127

(N 16°48' W 3°04')

(N 9°57' W 62°21')

(N 32°32' E 37°34')

(N 53°07' W 9°45')

(S 18°48' E 47°28')

(N 9°28' W 5°36')

(S 23°49' E 132°19')

(N 25°24' E 30°26')

(N 29°26' E 45°24')

(N 63°50' W 19°12')

(N 37°54' E 20°39')

(N 39°46' E 21°36')

(N 48°48' E 2°07')

(N 41°00 E 28°59')

(N 0°17' W 78°41')

(N 5°19' W 4°42')

(S 23°32' W 46°37')

(S 0°17' E 36°04')

pp. 72–73
DETAIL OF A BUILDING IN SÃO PAULO,
Brazil
(S 23°32' W 46°37')

More than 5 million Paulistanos—residents of São Paulo, Brazil—live in working-class suburbs in crowded buildings known as *cortiços*. The workers' districts illustrate the changes that have taken place in São Paulo as it has grown from 250,000 inhabitants in 1900 to 26 million today. Now the largest urban center in Brazil and all of South America, this megalopolis occupies 3,100 square miles (8,000 km²), more than three times the size of greater Paris. It is home to 41 percent of Brazil's industry, provides half of manufactured goods in the country, and houses nearly 45 percent of the Brazilian work force. Yet since 1970 another type of residence has spread here in the country's most prosperous city: *favelas*, slums that today house 20 percent of Paulistanos. The increasing inequality between rich and poor is a problem throughout the nation and the entire continent.

pp. 74–75
GREATER FLAMINGOS ON LAKE NAKURU,
Kenya
(S 0°17' E 36°04')

Lake Nakuru has a surface area of 24 square miles (62 km²), which takes up one-third of the national park of the same name that was created in 1968. It shelters nearly 370 bird species, including the lesser flamingo (*Phoeniconaias minor*) and the greater flamingo (*Phoenicopterus ruber*), of which 1.4 million have been counted on the site. Like the other alkaline lakes scattered along the Rift Valley, its location on a rocky volcanic substrate, weak flow, intense evaporation, and average depth of 40 inches (1 m) give it a high soda content. These briny waters are favorable to the formation of blue-green algae, microorganisms, and small crustaceans, which provided the basic diet of flamingos. However, chemical products used in river farming and the water runoff from the nearby city of Nakuru have gradually polluted the lake waters. Since 1990 Lake Nakuru has been considered a wet zone of international importance.

pp. 76–77
METEORA MONASTERY,
Thessaly, Greece
(N 39°46' E 21°36')

Rising abruptly out of the plain of Thessaly in Greece, where the Pinios River emerges from the canyons of the Pindus range, the Meteora are narrow peaks of calcareous rock and sandstone sculpted by fluvial erosion in the course of the Tertiary era (between 65 and 5 million years ago). Between the fourteenth and sixteenth centuries, monks built twenty-four monasteries on these rocky heights, which rise 65 to 200 feet (200 to 600 m). For a long time these edifices remained inaccessible, approachable only by winches and ropes; finally, in 1920 stairways and bridges were installed, allowing tourists to visit the monasteries, which were declared a world heritage site in 1988. Most of these are in ruins today, and only four of them are still occupied by Orthodox Christian religious communities.

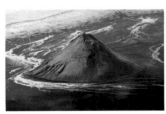

pp. 78–79
MAELIFELL,
bordering the Myrdalsjökull glacier, Iceland
(N 63°50' W 19°12')

Maelifell was created by one of the many eruptions under the Myrdalsjökull glacier in southern Iceland. It is a volcanic tuff, a cone made up of an accumulation of solidified ash and other volcanic material. Freed from the glacier about 10,000 years ago, Maelifell is now bathed by the rivers that flow from the glacier. Its perfect cone, rising to 650 feet (200 m) above the plain, is covered with grimmia, a moss that proliferates on cooled lava, which varies in color from silver-gray to luminous green, depending upon the soil's humidity. It is one of the few plants that have developed in Iceland, which has fewer than 400 observed vegetal species and only 25 percent of its land covered with permanent vegetation. Geologically very young, only 23 million years old, Iceland has more than 200 active volcanoes and many glaciers, which comprise nearly one-eighth of the area of the island.

pp. 80–81
VERSAILLES CHÂTEAU AT SUNSET,
Yvelines, France
(N 48°48' E 2°07')

In 1661 King Louis XIV of France selected the swampy site of Versailles, near Paris, for the construction of a palace that would take fifty years of labor. Erected in the heart of a plot of 2,000 acres, set off by sumptuous gardens, 34 pools, and 600 fountains, the château covers a surface area of 590,000 square feet (55,000 m²). For several years it was home to approximately 1,000 nobles and 4,000 servants, before it was pillaged during the French Revolution in 1789 and abandoned. Beginning at the end of the nineteenth century, it was gradually restored and refurnished. Declared a world heritage site by UNESCO in 1979, Versailles is now largely restored. The sixth most popular French tourist site, it receives more than 2.5 million visitors every year and helps keep France the most popular world tourist destination (receiving 75.5 million foreign visitors in 2000).

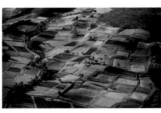

pp. 82–83
FIELDS NEAR QUITO,
Sierra region, Ecuador
(N 0°17' W 78°41')

Between the Western and the Royal cordilleras, or chains, of the Andes, the plateaus of Quito benefit from the humid, gentle climate of the sierra, which favors the cultivation of cereals and potatoes. Agriculture, which makes up only 12 percent of the gross national product, still supports nearly half of the population of Ecuador. Cultivated land comprises nearly one-third of the national territory, and it has been crucial in the country's history: the agrarian reforms of the 1960s and 1970s, which eradicated the dominance of the great haciendas of Spanish colonists, failed to solve the problem of unequal distribution of farmland. The best lots, those in the valleys and on the coasts, devoted to the export crops (bananas, sugarcane, cacao), remain in the hands of rich landholders, whereas small farmers share the land on upper plateaus, barely subsisting from their produce. Sixty-five percent of the population of Ecuador live in poverty, and 19 percent are unemployed.

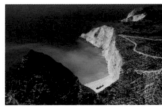

pp. 84–85
BOAT RUN AGROUND,
Zakynthos, Ionian Islands, Greece
(N 37°54' E 20°39')

Zakynthos, the southernmost of the Ionian islands and the second largest in area, is situated 10 miles (16 km) off the shore of the Peloponnesus. One part of the island features imposing chalky cliffs, lined with white gypsum, which have crumbled away—from the effects of erosion and several earthquakes, the most serious of which occurred in 1953—forming beaches of fine sand. These beaches are favorite egg-laying sites of loggerhead sea turtles (*Caretta caretta*). However, boat propellers, pollution, urbanization, and tourism have reduced the numbers of sea turtles that come to Zakynthos from nearly 2,000 at the end of the 1980s to fewer than 1,000 a decade later. Conservation measures and publicity campaigns since 1981 are just starting to bear fruit. A few endangered species, including sea turtles, become emblems and benefit from ambitious protection programs. However, one-fourth of the earth's mammal species and one-eighth of all bird species are threatened with extinction today.

pp. 86–87
HAGIA SOPHIA,
Istanbul, Turkey
(N 41°00 E 28°59')

Istanbul, formerly Constantinople, lies on both sides of the Bosporus Strait, which separates Europe and Asia. On the western bank lies Hagia Sophia, built between 532 and 537 A.D. during the reign of the Byzantine emperor Justinian. The basilica is crowned by a majestic cupola 100 feet (30 m) in diameter and rising 184 feet (56 m), a technical marvel at the time. After Constantinople fell to the Turks in 1453, Hagia Sophia was transformed into a mosque, and four minarets were added to it. In 1934 it became a museum, and most of its magnificent Byzantine mosaics have been restored. Christian for nine centuries, Muslim for more than 500 years, Hagia Sophia illustrates the contrasting destiny of Istanbul, the only city in the world that is divided between two continents. Christianity has 2 billion followers around the world, nearly twice the figure for Islam; this proportion could be reversed by the end of the twenty-first century.

This explains why the supreme human creations have come about in cities. This is true in the fields of the visual arts, literature, the sciences, and philosophy. The social environment favors them; so does the architectural, urban environment. No one can remain indifferent to the Parthenon of Athens, St. Peter's in Rome, Piazza San Marco in Venice, the Place de la Concorde in Paris, the pyramids of Cairo, or the cupolas of the Kremlin. Living close to them, no one can despair. Preindustrial civilizations had a vague sense of this, and thus in ancient times, even in the poor quarters of cities, attention was paid to beauty in Hindu and Buddhist temples, in Christian churches, mosques, public buildings, and the urban landscape in general. Their aim was not to offer consolation but to diffuse strong doses of creative feeling, to dispense the energy required for the only progress that mattered—that of the human spirit.

SHADOWS IN THE PICTURE

As living beings, diverse and fantastical, cities also bring great hardship to their inhabitants, whether powerful or poverty-stricken, although the latter of course bear more of the pain. The sudden piling up of immense crowds in tight spaces that have not been properly developed causes pollution of air and water. In most cities of wealthy countries, there is an awareness of these problems and an effort to solve them. Except for a few days each year, you can breathe fairly well in the great European and North American cities, because heating and cooking with wood and coal have been replaced. These cities have faucets that dispense drinkable water, even if it is not always free of odor and taste. Such is not the case in Russia, China, and surrounding countries, much less in countries of the southern hemisphere, where cities are covered in a thick cloak of pollution and water is both scarce and undrinkable, because of dangerous germs—although this does not prevent it from being drunk and used for every imaginable purpose. The Ganges is probably the most utilized river in the world, believed to purify and carry its worshippers to the gods, while in fact it gives them thousands of harmful bacteria.

While the city leaves no opportunity for boredom, it is also a place where people can waste a great deal of time. Distances in cities are not always great, but travel is often impeded by congestion. In most of the world's megalopolises, many residents spend two or three hours each day in public conveyances or in their private automobiles, amid noise and discomfort, accumulating pollutants in their lungs and bad moods that can affect the people around them. In wealthy countries, reduced working hours for wage earners has made possible a better distribution of commuting and periods of leisure or vacation. Everyone gains by this. In poorer countries, time spent in factories, studios, and shops has hardly decreased. Working

lives often begin before the age of ten and continue as long as health allows, because the concept of retirement has no meaning.

Space can also pose problems. Few of the world's city dwellers have sufficient living space. Conditions are good in America and in northern Europe or in the wealthy urban areas of poor countries, which house a tiny minority of citizens. Elsewhere, whether in individual or collective residences, crowding is the rule. In cases where the social organization of the family, the street, and the neighborhood teaches a city dweller, from an early age, to accept lack of privacy while respecting precise rules, order prevails. This is true of Japanese cities or Arab medinas with their low family homes; it applies as well to cities of Korea, China, or the northern Mediterranean, where multi-storied collective residences are the rule. Elsewhere, in the absence of habitual respect for one's neighbors, anxiety and insecurity predominate. For lack of anything better, many families occupy American or South African urban ghettos, the large French housing projects, or the shantytowns of cities in the southern hemisphere. According to the Report on the Situation of Human Habitats in the World, published in March 1996 by the United Nations Center for Habitats, at least 500 million city dwellers in the world are homeless or inadequately housed. The reasons are clear: between 1950 and 1990, industrialized countries have seen their population double and their per capita gross domestic product (GDP) triple. In the same period, the urban population of developing countries increased fivefold, while their per capita GDP grew by a factor of only 1.5. In the former Soviet Bloc countries and China, relative social discipline is still in force and the residents of the immense concrete districts favored by Communist regimes tolerate one another fairly well. When ethnic groups in a nation are poorly integrated, relations become tense, and violence can erupt at the slightest opportunity. This is now the rule in France in the approximately 200 large projects built in the 1960s and 1970s for the eternal happiness of their contemporaries, by architects who took Le Corbusier for a new Vitruvius and his Map of Athens for gospel. Sincerity and good intentions are no excuse; the road to Hell is paved with them.

A SOMEWHAT LESS GLOOMY FUTURE

No city exists without people's desire to live together and thus to soften the sharp edges that invariably occur in any society. The larger the city, the more difficult this process becomes. The less competent and honest the politicians, the lower the likelihood of finding humane solutions. As Jean Bodin used to say, the only form of wealth is in people. All we can do is second that opinion. Provided, of course, that people are educated, refined, responsible, concerned for the common

good—in a word civic-minded, attached to the *civitas*, the municipality for which our cities have served as a laboratory for thousands of years. This is a program for the urban policies of tomorrow. The human upheaval brought on by globalization is neither good nor bad in itself. It is unavoidable. Only human wisdom will make it a form of wealth and an opportunity, a means of exchange between different cultural experiences. If we accept this outlook, the city is an extraordinary experimental space.

We need to reinvent inviting neighborhoods and public spaces, like those once created by people all over the world. The Mediterranean street and town square have long been places of great social vibrancy. Why can't we invent contemporary versions of the same model, adapted to the different cultures of our planet, conducive to sharing and conviviality? The model for an ideal city does not exist; nor are there any ideal cities. Humans' living space is fragile. It is fragile in the countryside, in daily contact with the so-called natural environment. It is still more so in the city, where the environment consists of human material, the most sensitive but also the most difficult to sculpt.

Jean-Robert Pitte

ROAD INTERRUPTED BY A SAND DUNE,
Nile Valley, Egypt
(N 25°24' E 30°26')

Grains of sand, deriving from ancient river or lake alluvial deposits accumulated in ground recesses and sifted by thousands of years of wind and storm, pile up in front of obstacles and thus create dunes. These cover nearly a third of the Sahara, and the highest, in linear form, can attain a height of almost 1,000 feet (300 m). Barchans are mobile, crescent-shaped dunes that move in the direction of the prevailing wind at rates as high as 33 feet (10 m) per year, sometimes even covering infrastructures such as this road in the Nile Valley. Deserts have existed throughout the history of our planet, constantly evolving for hundreds of millions of years in response to climatic changes and continental drift. Twenty thousand years ago forest and prairie covered the mountains in the center of the Sahara; cave paintings have been discovered that depict elephants, rhinoceros, and giraffes, testifying to their presence in this region about 8,000 years ago. Human activity, notably the overexploitation of the semi-arid area's vegetation bordering the deserts, also plays a role in desertification.

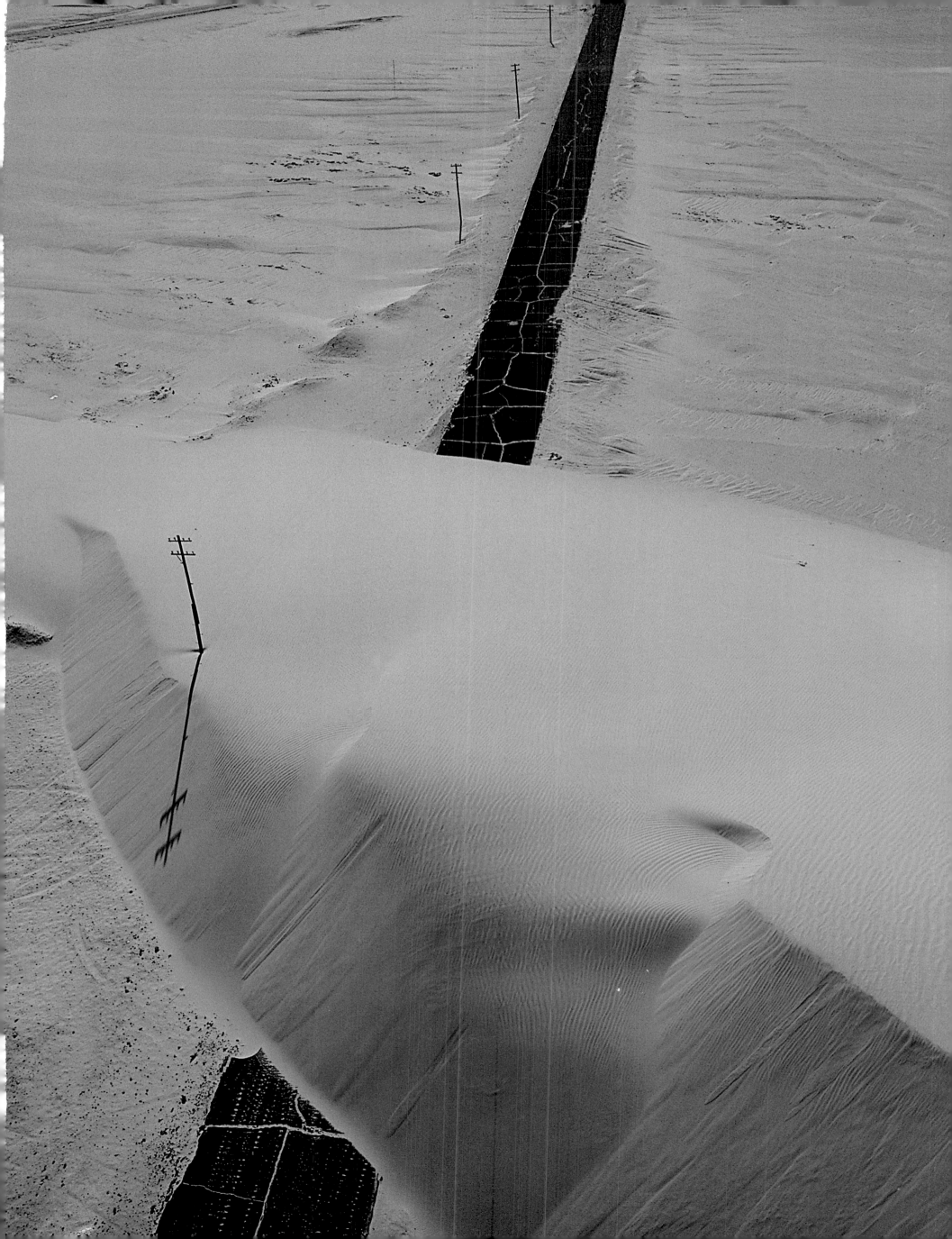

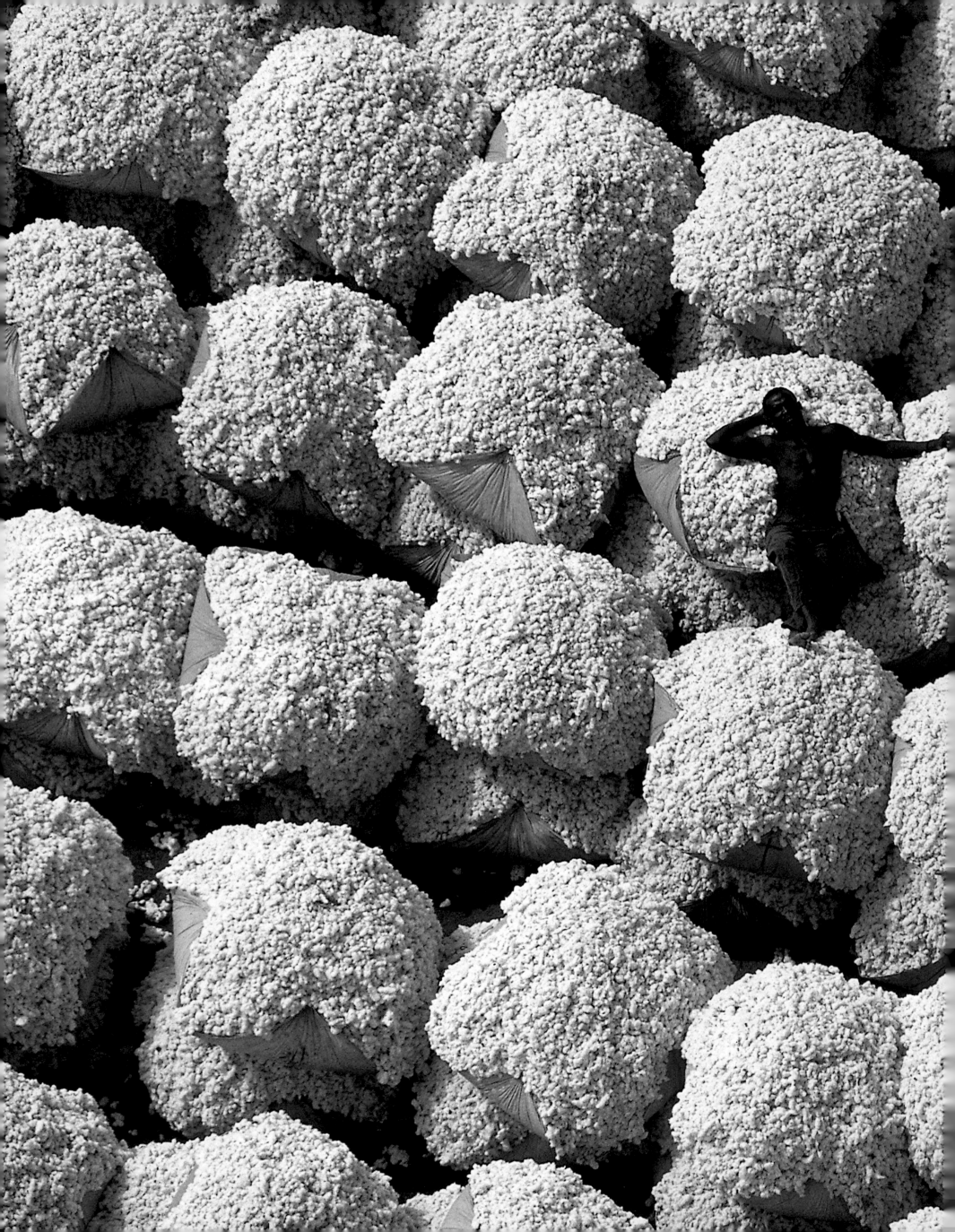

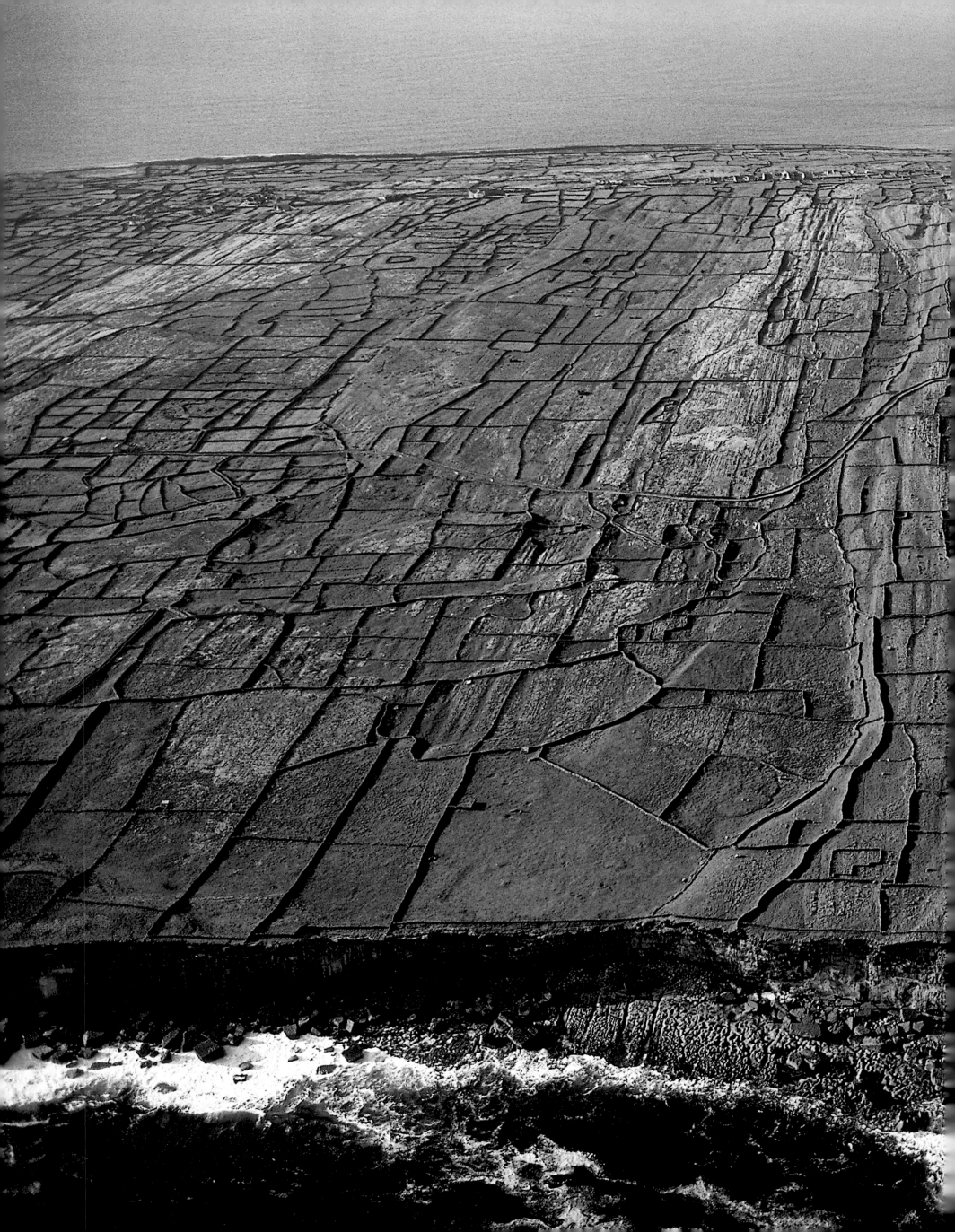

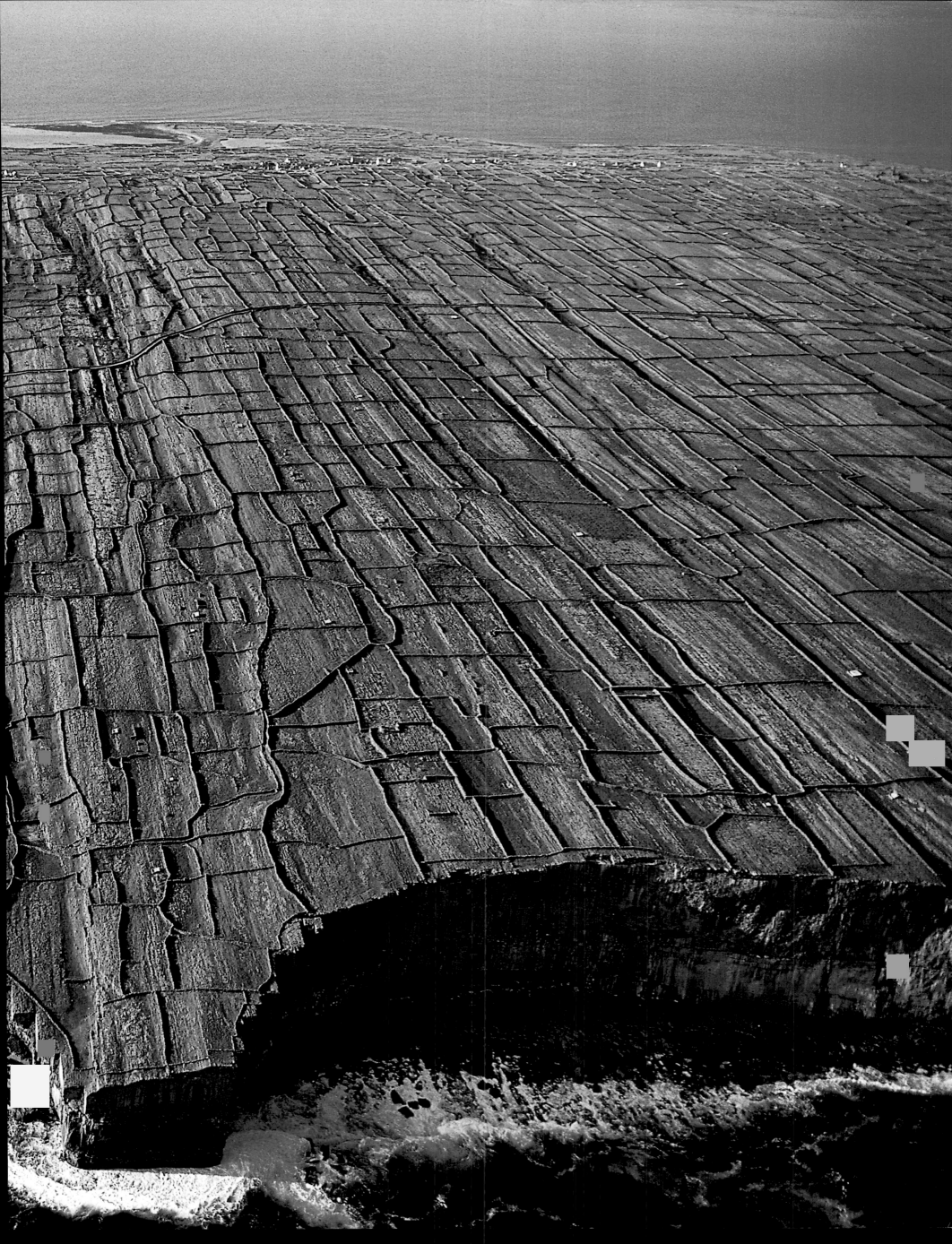

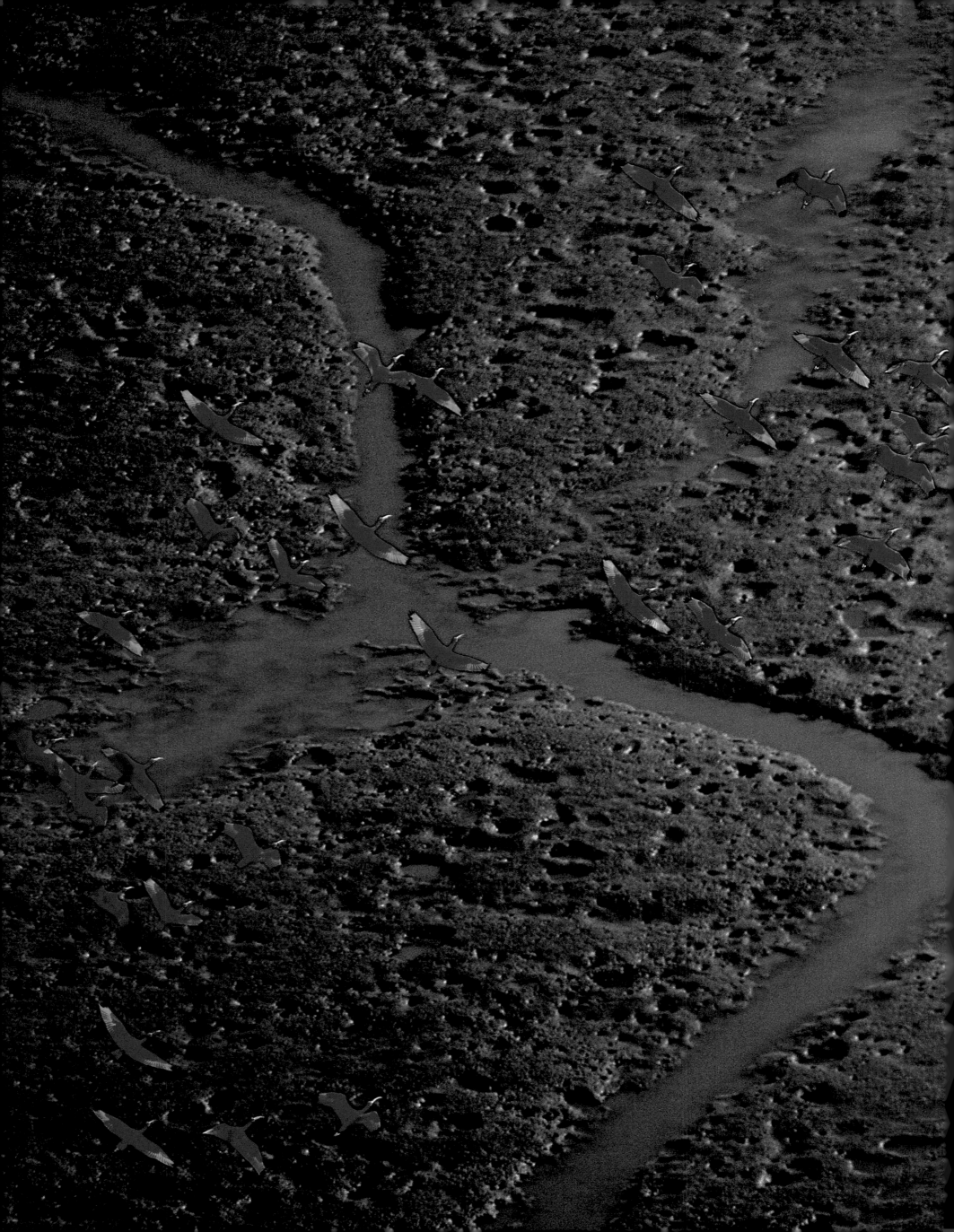

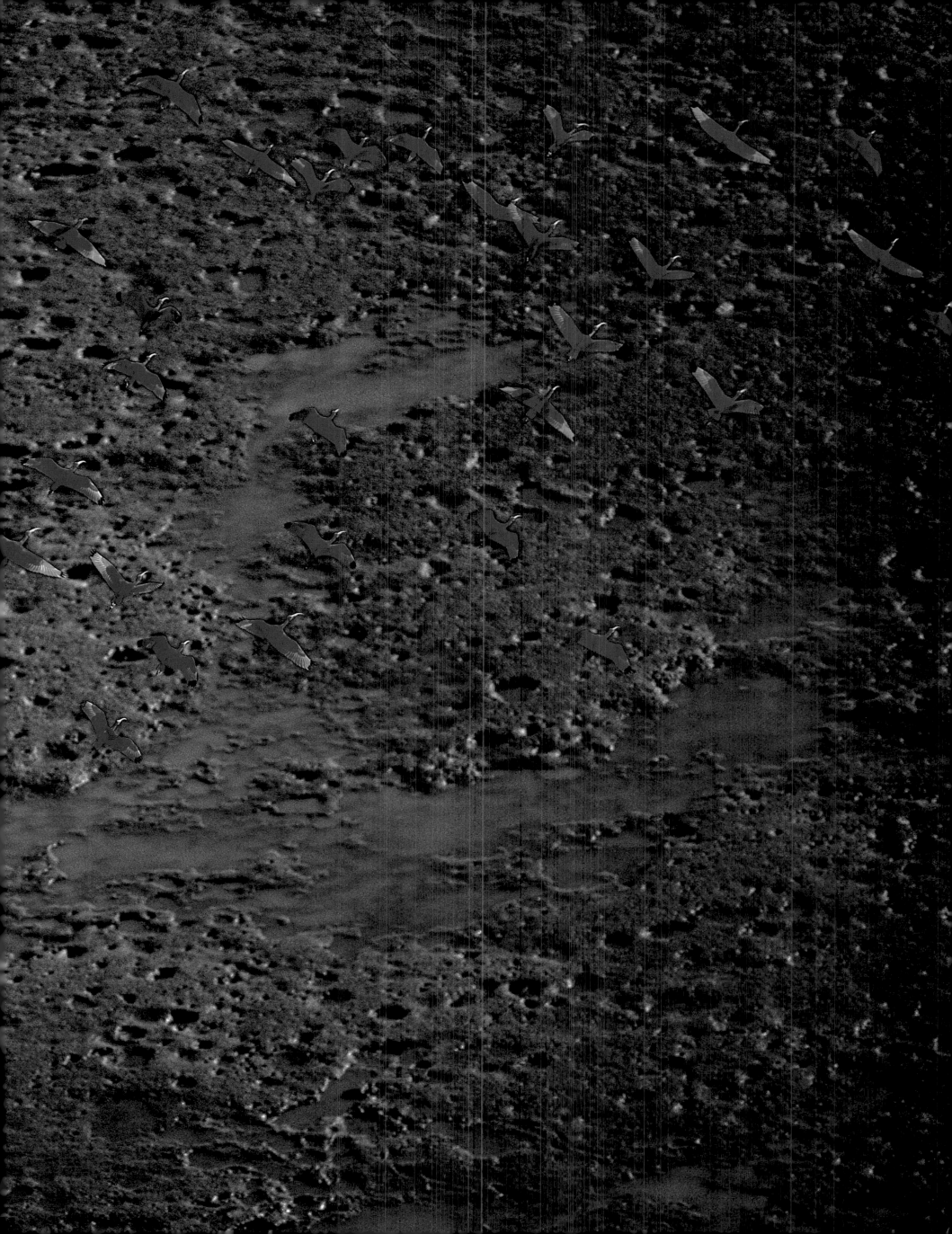

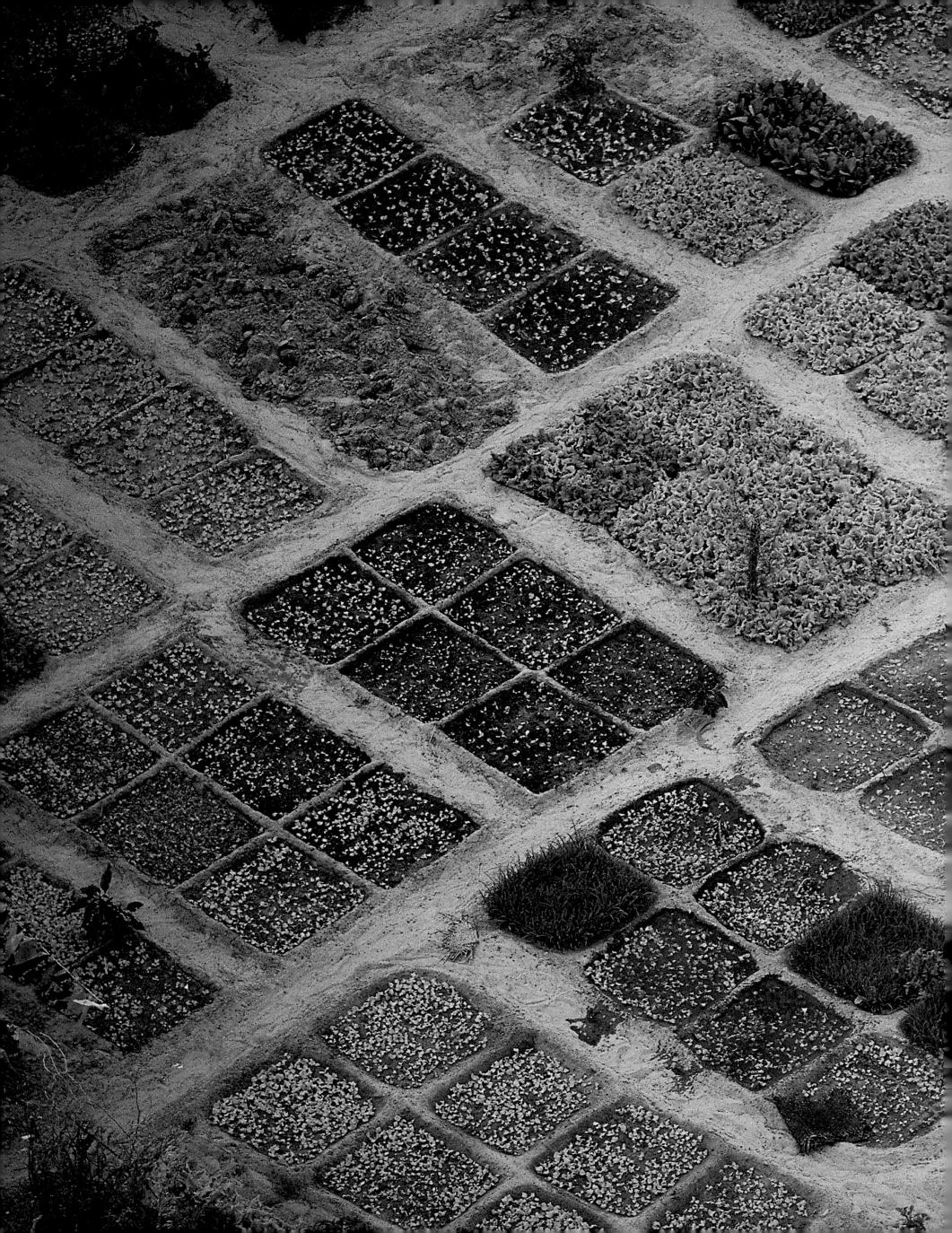

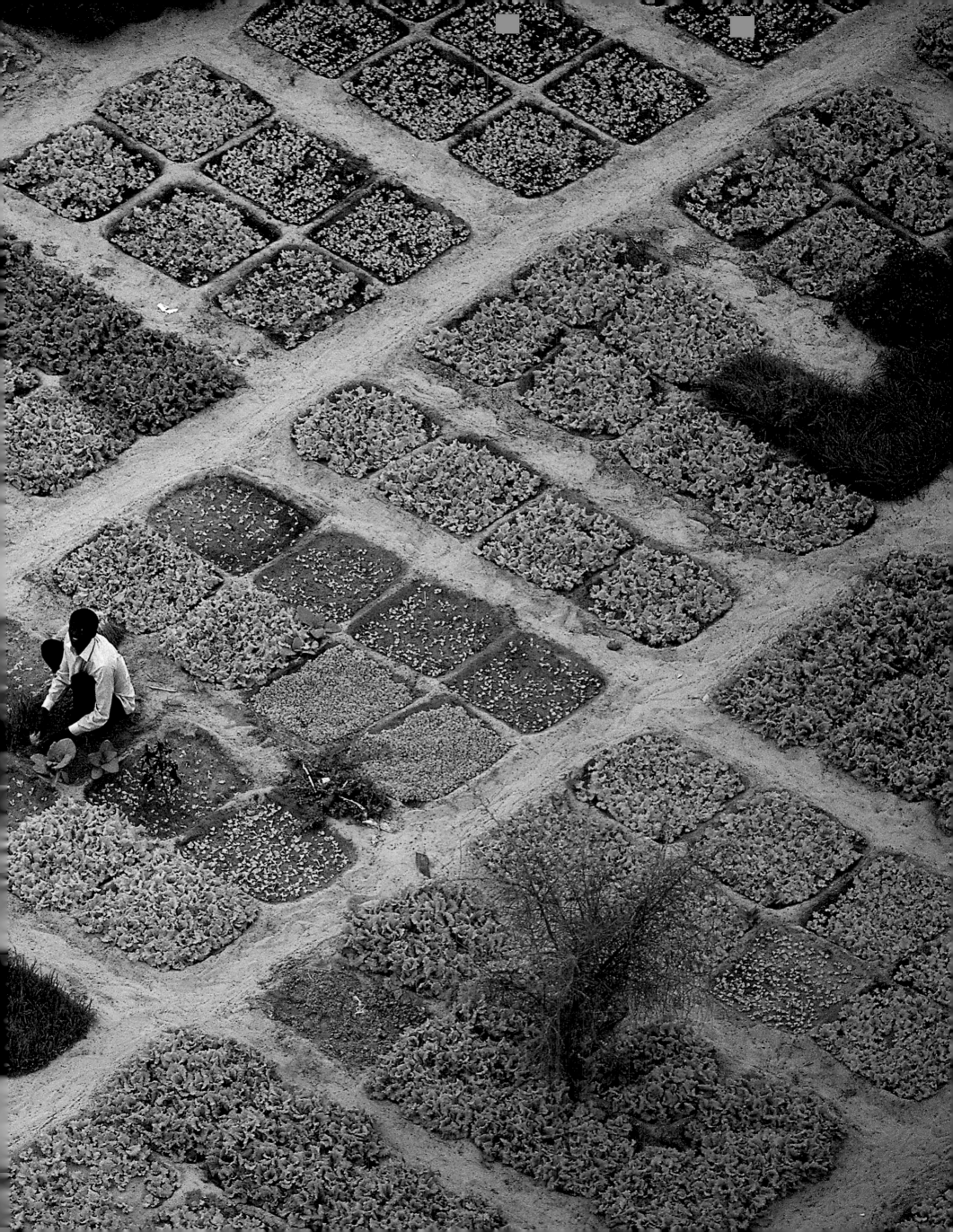

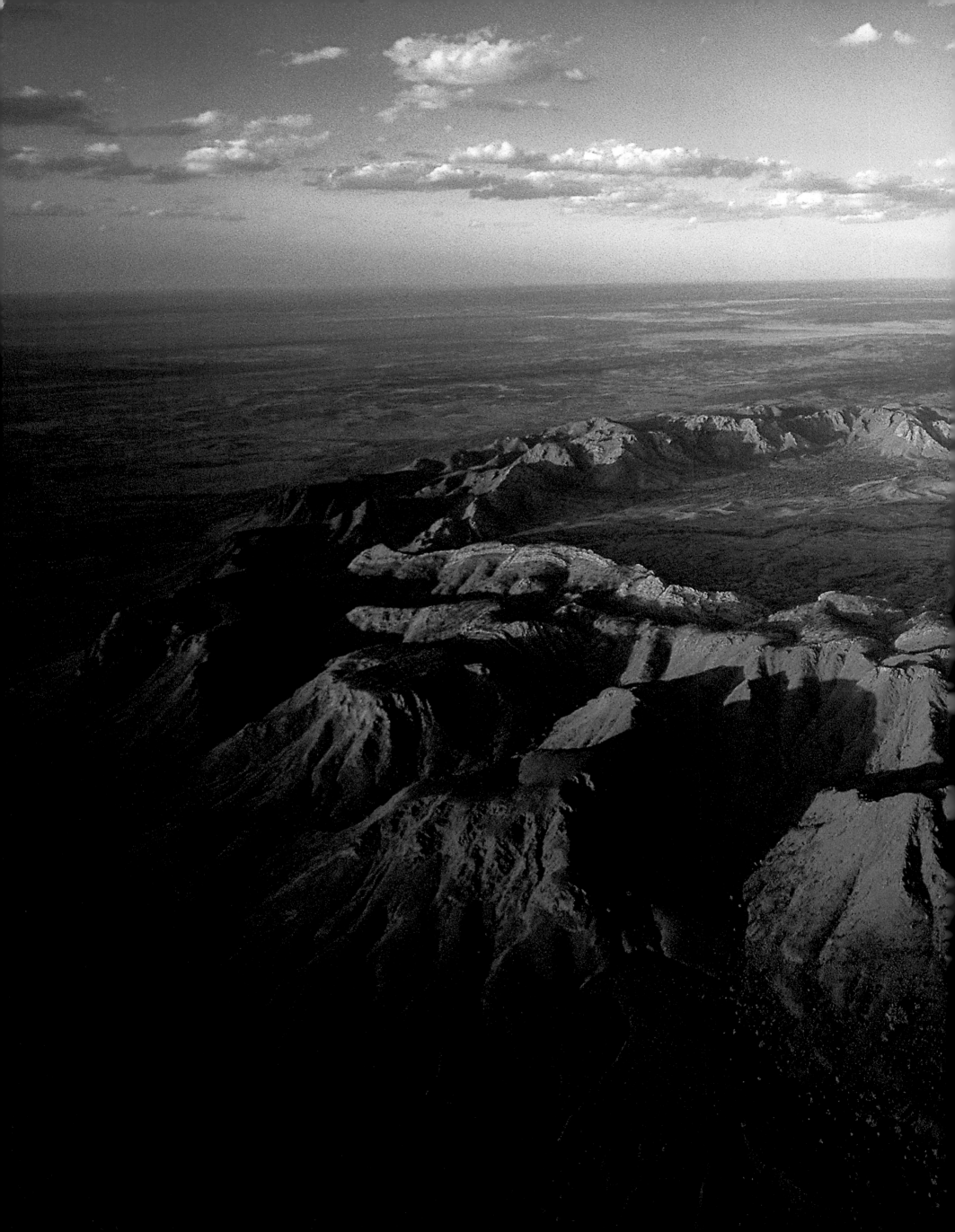

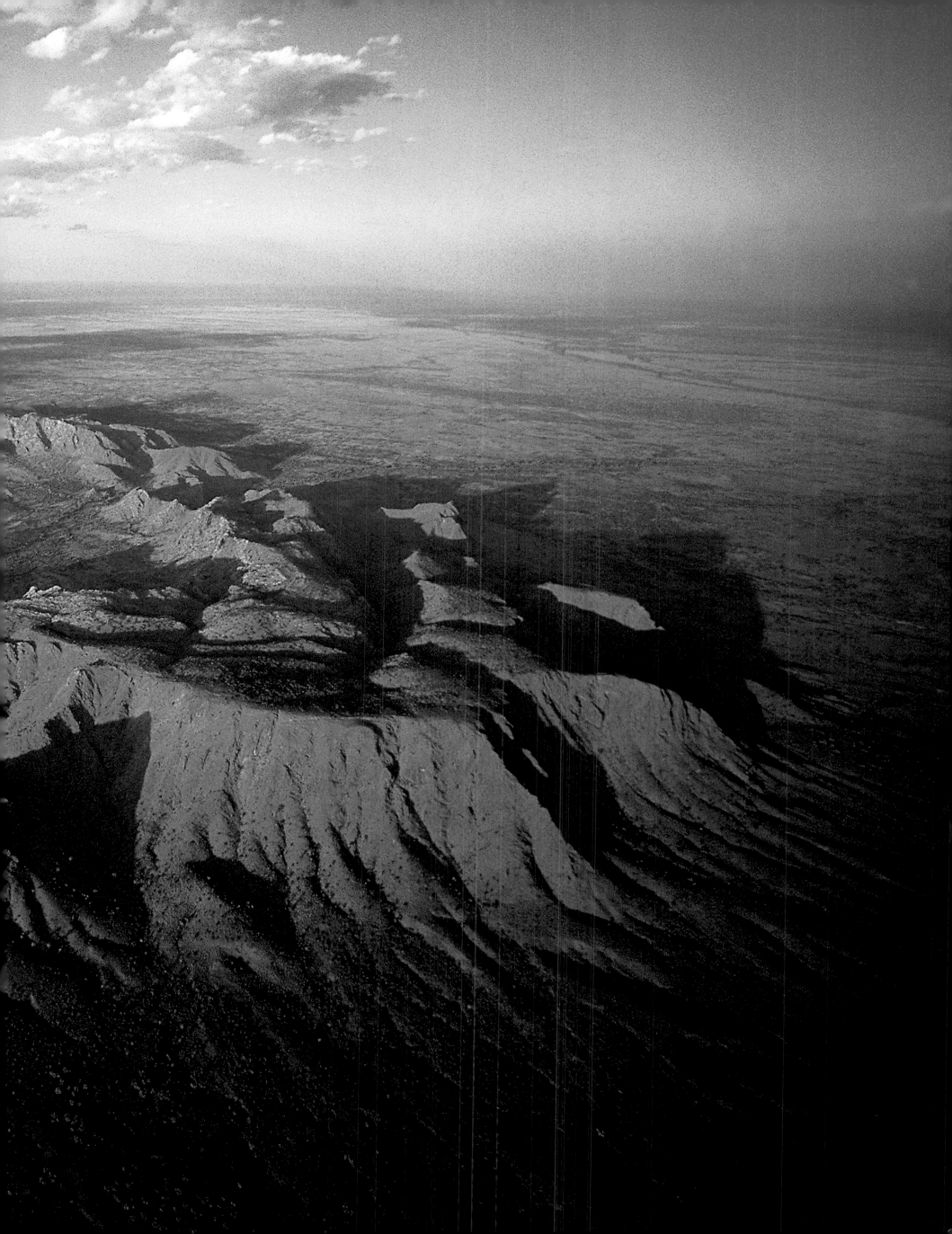

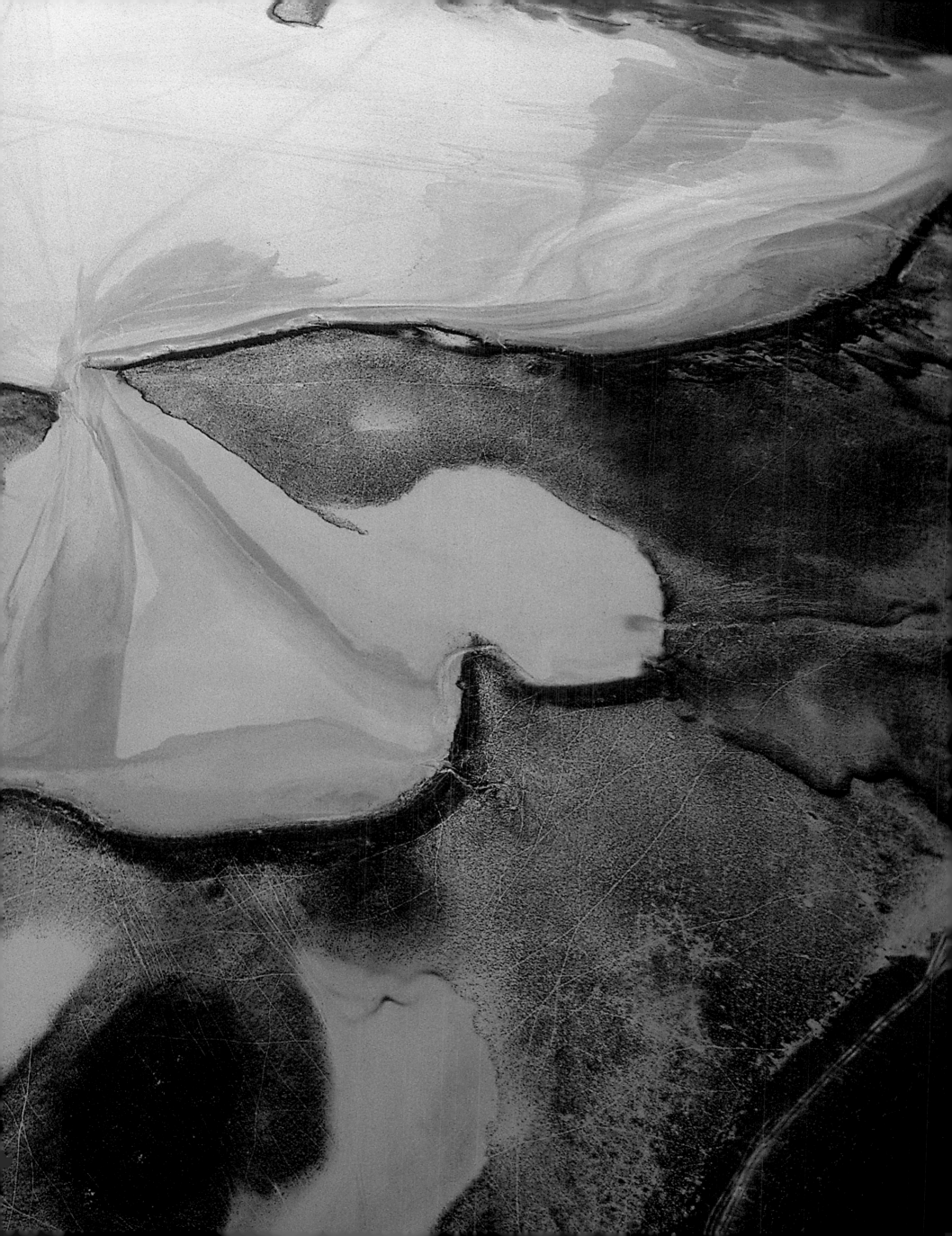

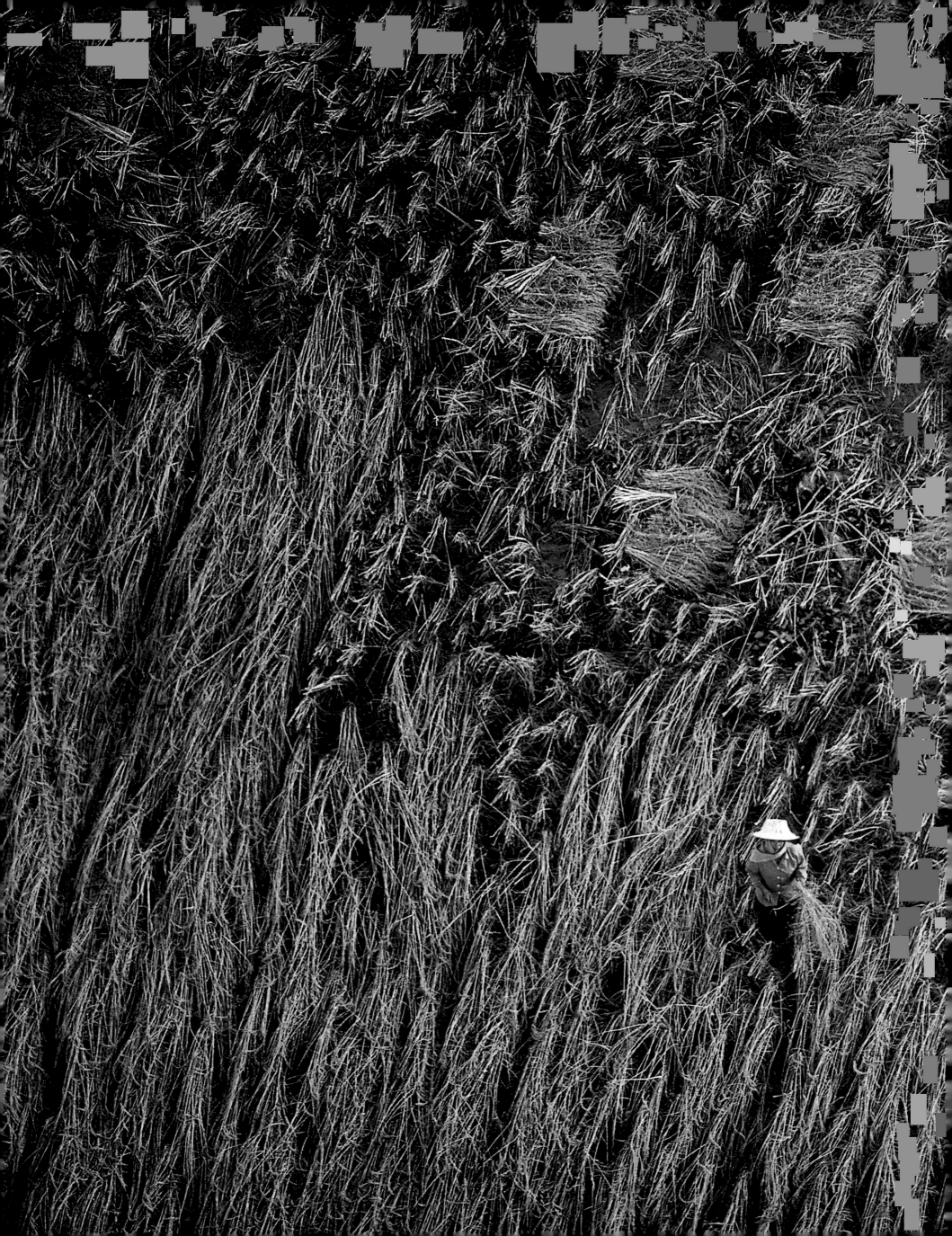

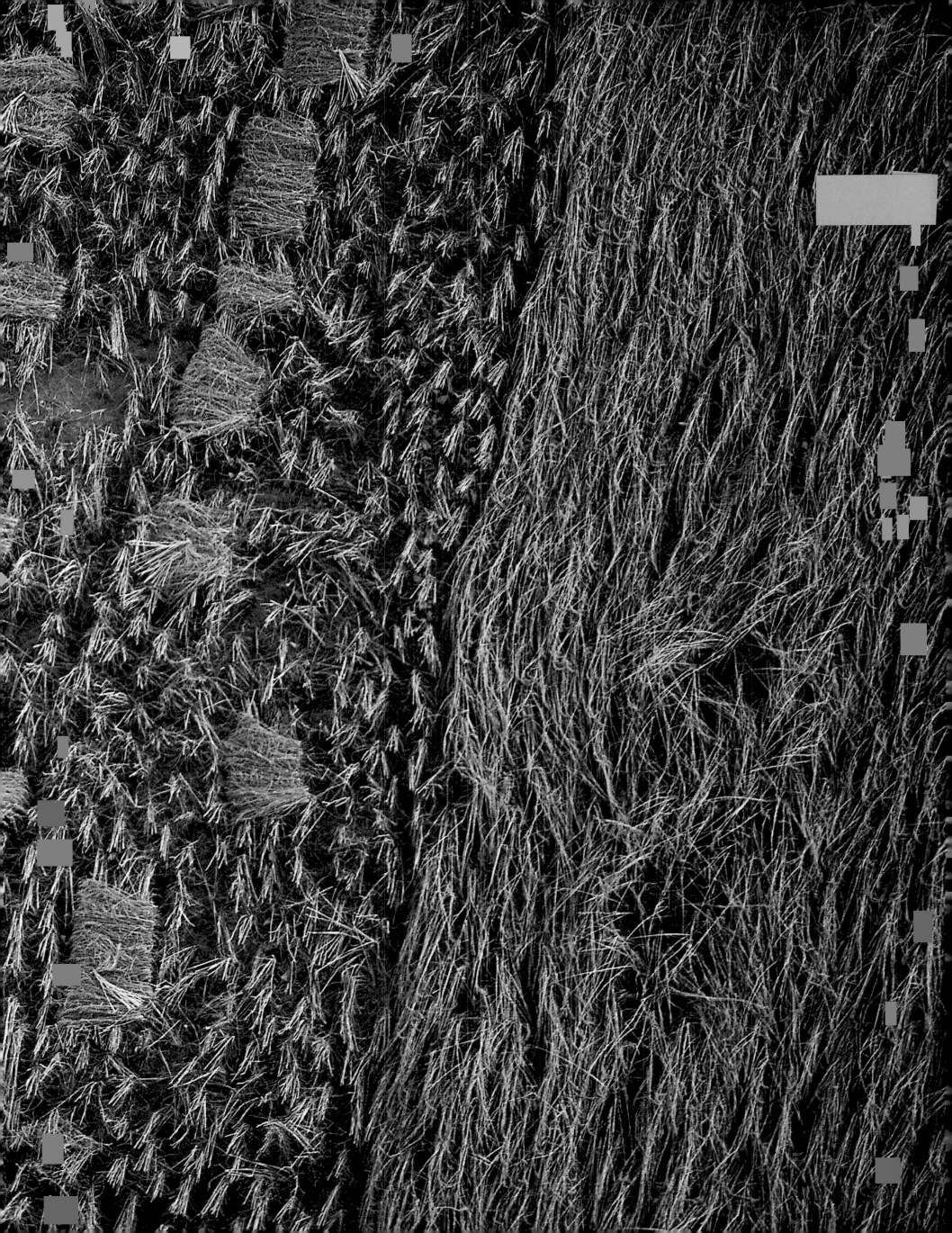

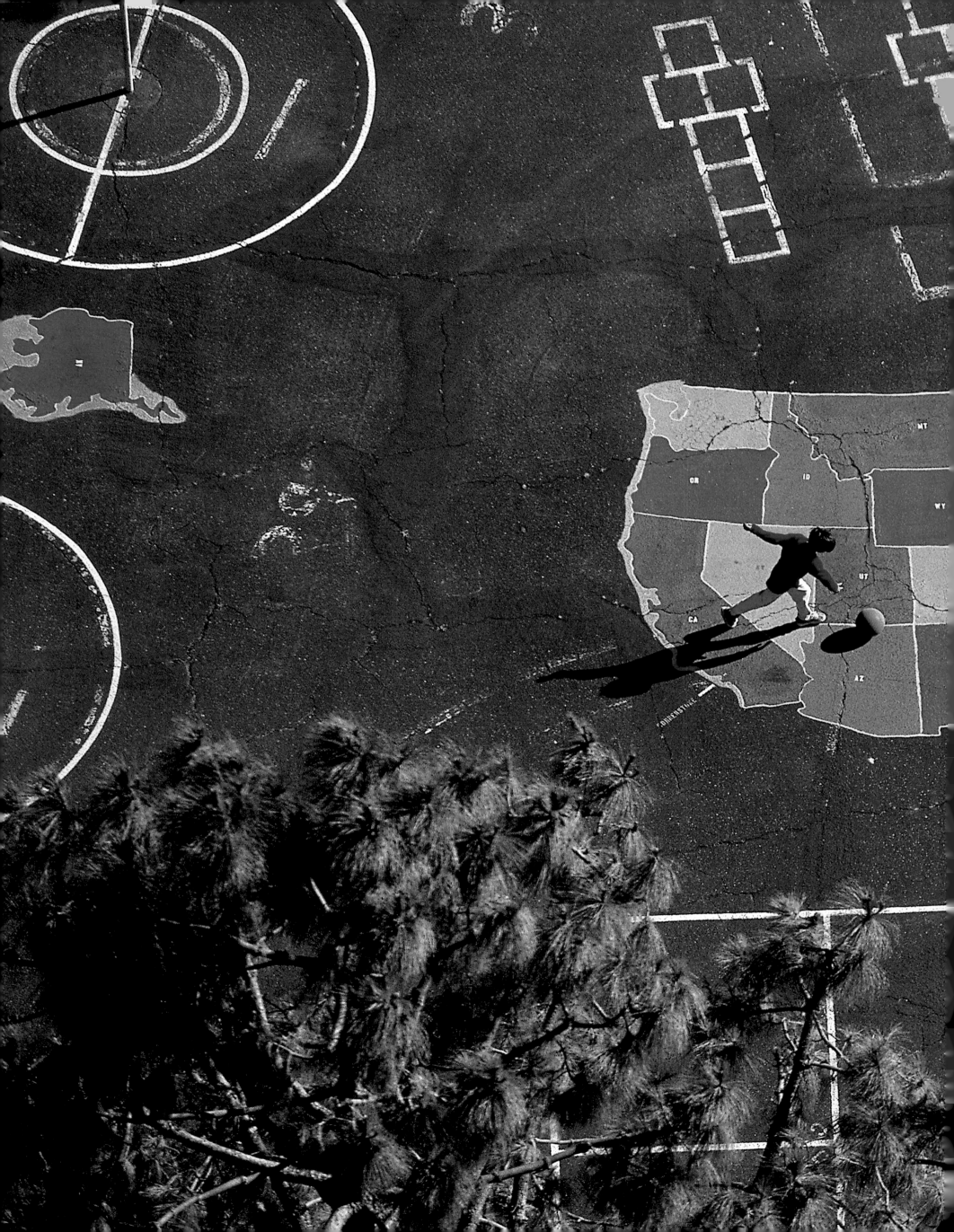

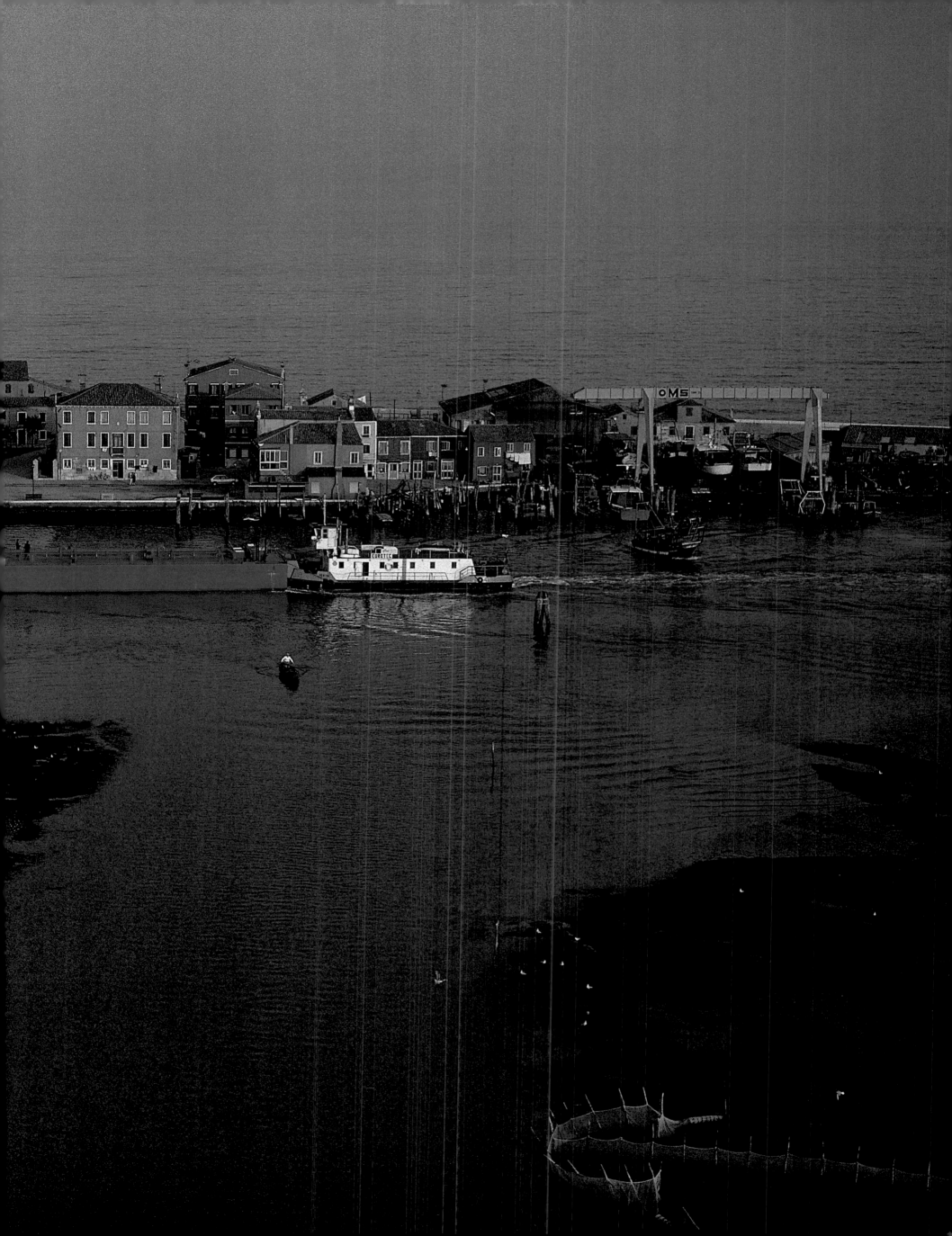

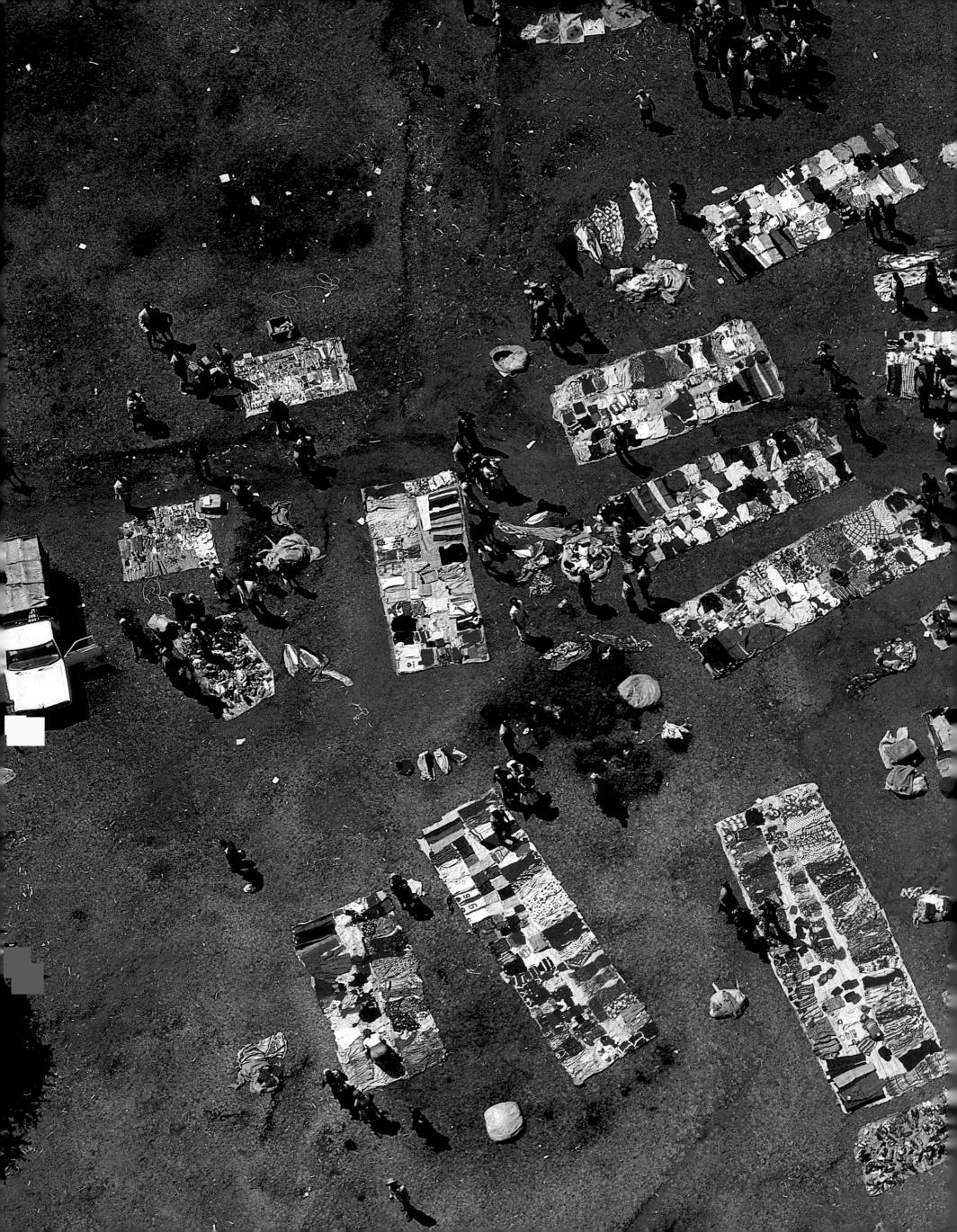

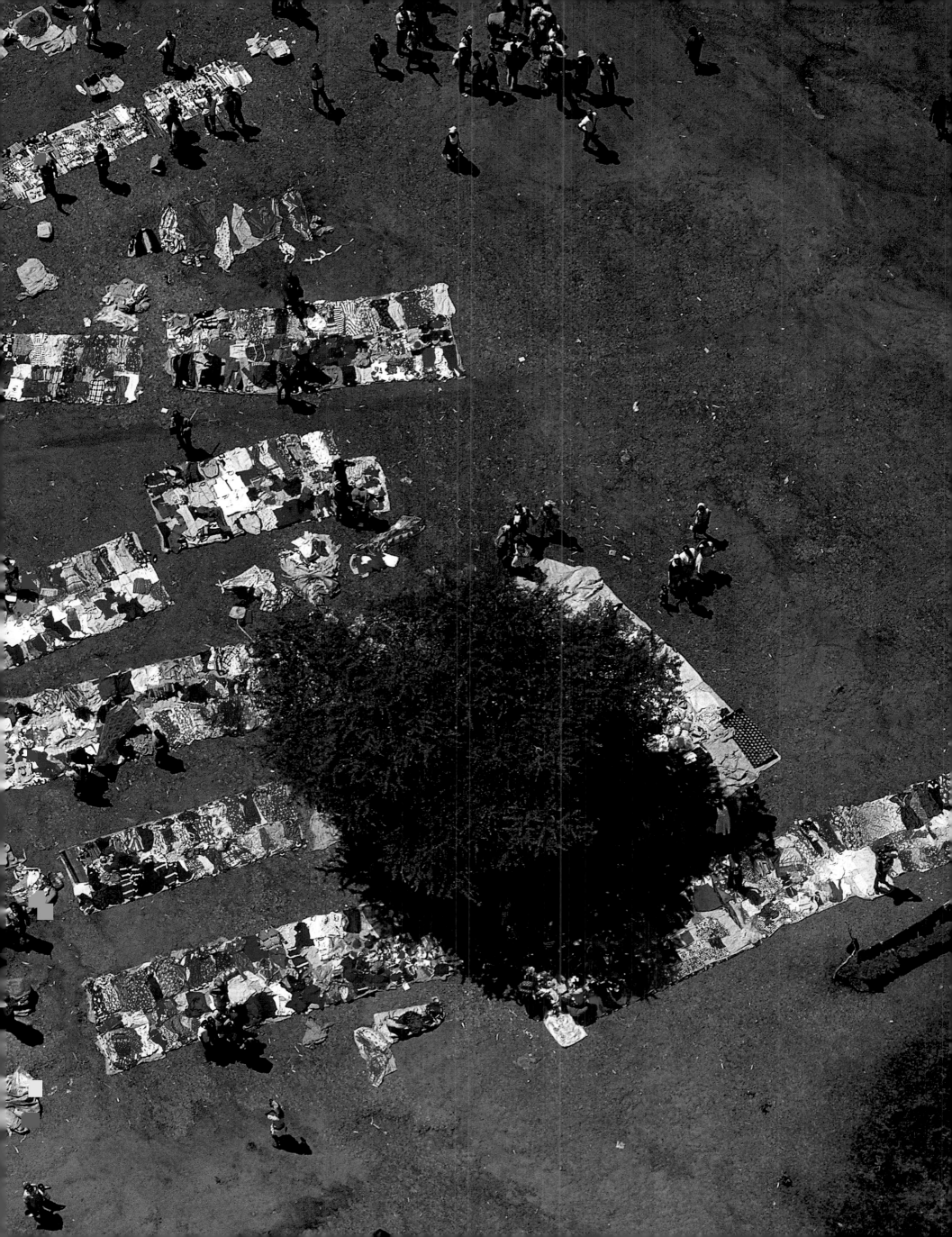

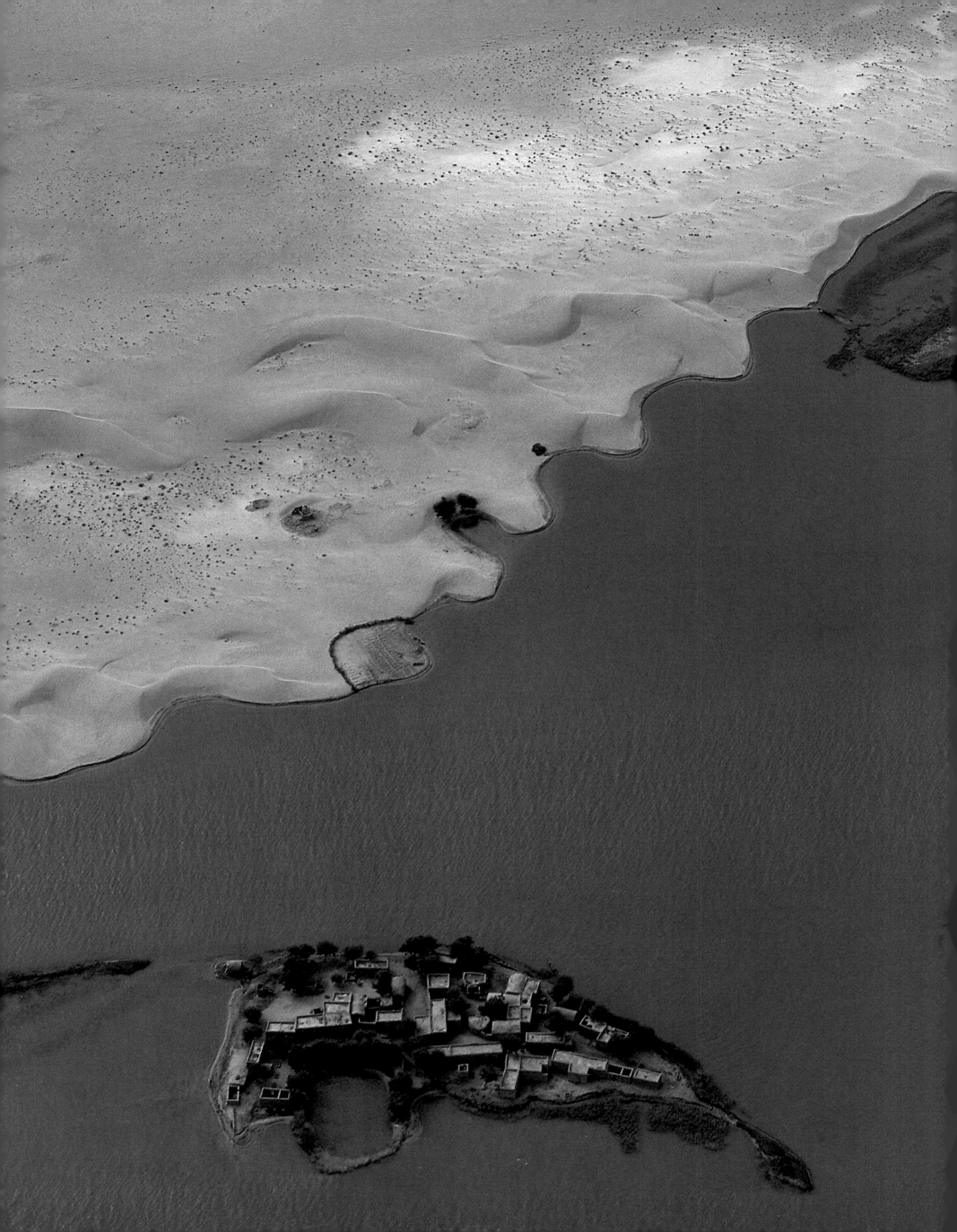

FARMERS OF THE WORLD: THE PRICE OF OUR FUTURE

Most poor farmers work with simple hand tools or even their bare hands.
Forced to compete against highly equipped, far more productive agro-businesses,
they are unable to advance, and they are impoverished, often to the point of hunger.
However, to feed the approximately 9 billion people expected on earth by 2050,
all of the world's forms of agriculture must be mobilized.

THE THOUSAND FACES OF FARMING

Seen from the sky, the earth is covered with water, swaddled in forests, lightly clad in savannas or veiled in steppes, and adorned with harlequin fields of a thousand or more crops: rice fields checker the valleys, climb the slopes, and ribbon the mountains; vegetable gardens nest in the hollow of tiny crevices; grains and legumes alternate their bright colors in a stream of patchwork fields; roots and tubers crowd together in profuse mounds. Round, rectangular, or elongated plantings, lined from the passage of tools and wheels, extend as far as the eye can see. Planted terraced fields and close rows of grape vines, tea and coffee plants climb and retain jagged contours. Olive, almond, and apple plantings protect grain fields. Proud date trees, scattered or aligned, protected by a low wall or a small sand dune, open their wide palms on vast oases as they do on the least suspicion of moisture. Varieties of beasts, roaming but guarded, enliven these calm landscapes: lambs crowd close to their shepherd; cows squeeze together to ford a stream; great dromedaries, tied together, file across the desert behind their driver; donkeys carry the packsaddle, pull the swing plow, or doze in the palm tree shade.

On the whole, however, very little equipment can be seen, and practically no tractors or large agricultural machinery. Most poor farmers are so poorly equipped that it is hard to believe they were able, for centuries, to model and remodel this earth, and constantly recompose these cultivated landscapes so filled with usefulness and elegance.

RESIDENCES ON AN ISLAND IN THE NIGER RIVER,
between Bourem and Gao, Mali
(N 16°30' W 0°12')
The Niger River winds south among the sands of the Sahara, creating a large loop in Mali called the "camel's hump" by locals. After the rainy season, during periods of high water from August to January, it floods vast expanses. Left above water are only a few small islets, called *toguéré*, which are sometimes inhabited. Although it occupies less than 15 percent of the Mali territory, the Niger River basin houses nearly 75 percent of the population, in addition to most of the country's metropolises. This river, which waters four countries in West Africa (Guinea, Mali, Niger, and Nigeria), takes its name from the Berber expression *gher-n-igheren*, which means "the river of rivers."

DIVERSE AGRICULTURES

Yet these images do not lie. At the beginning of the twenty-first century, the active agricultural population numbers 1.3 billion people worldwide, yet there are only 28 million tractors, or barely more than two tractors per 100 people working the fields. Farmers who have great motorized, mechanized capabilities are thus a tiny minority. The best equipped among them use four-wheeled motorized tractors of more than 200 horsepower and accessory machines, which are very expensive—costing an average of more than $200,000 per worker—and very effective. allowing a grain cultivator working alone to plant more than 500 acres (200 hectares).

Those who use animals are far more numerous: 400 to 500 million, or about one-third of the total. The best are horses or cattle, working plows or carts, equipment that can cost as much as $10,000, and which allows a grain cultivator working alone to cultivate about 25 acres (10 hectares).

The other two-thirds, approximately, of the world population working in agriculture and livestock, or 800 to 900 million people today. only have manual tools such as hoes, spades, machetes, knives, sickles, baskets, or pestles for clearing, plowing, sowing, weeding, harvesting, winnowing, transporting, and piling up grain. The best tools cost less than $100 and scarcely enable the cultivation of 2.5 acres (1 hectare) per worker.

In addition to these enormous inequalities of equipment and arable area per worker, there are inequalities of access to the most productive crops, to fertilizers and treatment products, which cause great disparities in yield per acre. For instance, the most productive grain varieties, resulting from advanced selections, can bring yields greater than 4 tons per acre, with an expenditure of $200 per acre for mineral fertilizers and treatment products. On the other hand, so-called domestic grains, which have not been subjected to any systematic selection and are still cultivated without fertilizers or treatment products, rarely reach a yield of more than 0.4 tons per acre in rain-watered agriculture and 0.8 tons per acre in irrigated agriculture.

Thus, the gross productivity of a peasant working with manual tools, without selected crops, fertilizers, or treatment products, can barely exceed 1 ton of equivalent grains (quantity of grain of the same caloric value) per worker per year, whereas the productivity of a farmer who is among those best supplied with mechanical, chemical, and biological resources exceeds 2,000 tons of equivalent grains per worker per year. The difference in productivity between the most productive and the least productive agriculture in the world today is therefore a ratio of 1 to 2,000!

AGRICULTURAL REVOLUTIONS

Before World War II this proportion was only 1 to 10. In the past century, the "modern agricultural revolution" occurred in developed countries. Motorization and mechanization became more effective (and costly), plant varieties and animal races grew ever more productive, and fertilizer, treatment products, and concentrated foods for livestock were used more intensely. These changes led to unprecedented levels of productivity. In developing countries, on the other hand, only an infinitesimal minority of very large agricultural companies, each with several hundred or thousand acres, employing poorly paid workers, had the necessary capital to take advantage of this revolution. But for the great majority of the peasants in these countries the corresponding monetary costs represent several hundred years of their labor.

As a result, the "green revolution," a variant of the agricultural revolution that does not include motorization and mechanization, spread much more widely in developing countries. This revolution consisted of the selection of highly productive varieties of rice, corn, wheat, soya, and a few large export crops, as well as wide use of fertilizers, treatment products, and, if appropriate, irrigation. Farmers capable of acquiring and profitably using these means of production were able to attain productivity levels of 10

tons of equivalent grains per worker per year for manual farming, or 50 tons for farming with draft animals.

At this time the modern agricultural revolution has aided only a few million farmers throughout the world, whereas the green revolution has helped about two-fifths of farmers. The one-third of world farm workers remaining, 400 million in number, representing more than a billion people to be fed, not only work with strictly manual tools but also without fertilizers or livestock feed, without product treatments or selected plant and animal varieties.

ECOLOGICAL CONSEQUENCES

These two agricultural revolutions contributed widely to the intense increase in the "useful fertility" of the ecosphere—the earth's capacity to produce crops useful to humans and to domestic animals. With the growth in the availability of food, the human population went from 2.5 billion people with an average of 2,450 kilocalories per day in 1950 to more than 6 billion with 2,700 kilocalories daily in the year 2000. Moreover, with the growing availability of fodder plants, the population of domestic animals and animal produce (eggs, milk, meat) advanced strongly, allowing considerable enrichment of the food ration of most residents of developed countries and of the wealthiest inhabitants of developing countries.

The modern agricultural revolution and the transportation revolution have led to the replacement of the former systems of vegetable and animal polyproduction with systems of production specialized in one or another type of agriculture or livestock. With the use of mineral fertilizers and tractors, farms were dispensed from maintaining livestock to produce manure and draw agricultural machinery; and because of the motorization of transport and the facilitation of exchange, farms have been freed from the obligation to provide all sorts of vegetable and animal products to supply the local market. In consequence, each farm was able to orient itself toward producing the simplified production combination that is most profitable to itself. This has meant a great deal of spatial redistribution and regrouping by region: grains here, weeded plants there, viticulture, fruit tree plantings, horticulture, timber, milk-producing cows or sheep, meat production in other places. These cultivated ecosystems thus involve a very reduced number of species, varieties, and domestic races, and the wild flora and

CENTER-PIVOT IRRIGATION.
Ma'an, Jordan
(N 29°43' E 35°33')
This self-propelled, center-pivot irrigation machine, invented by the American Frank Zybach in 1948 and patented in 1952, drills for water in the deep strata 100 to 1,200 feet (30 to 400 m) below the surface. A pivoting pipeline with sprinklers, extending about 550 yards (500 m), is mounted on tractor wheels and irrigates 195 acres (78 hectares) of land. The countries of the Near East and North Africa experienced the world's most rapid increase in grain imports in the 1990s. Production of 1 ton of grain requires about 1,000 tons of water, and these countries prefer to import grain to meet their growing needs rather than produce it domestically because of the scarcity of water. In fact, at the current rate of use in Jordan, subterranean water reserves could dry up before 2010. Underground water is already overexploited in the United States, India, and China. Watering technologies, however, waste less and respond better to plant needs, saving 20 to 50 percent of the water used in agriculture.

pp. 138–39
PATCHWORK OF
CARPETS IN
MARRAKECH,
Morocco
(N 31°32' W 8°03')

In addition to the countries of central Asia and certain countries in South America, major centers of carpet production are found in northern Africa (Algeria, Egypt, Tunisia, and Morocco). Morocco has succeeded in maintaining a tradition of manufacture within family units and cooperative craft workshops, although most productions is now automated. Carpets are traditionally woven of linen, a symbol of protection and happiness, with silk, cotton, and sometimes camel or goat hair. The colors and designs are characteristic of the production regions, and the High Atlas mountains, where Marrakech is located, offers the warmest hues, mainly red, orange, and yellow. Ninety percent of the High Atlas carpets are created in the cities of Tazenakht and Amerzgane, primarily by women workers. The Moroccan carpet, once reserved entirely for domestic local use, has gained a worldwide reputation and today enjoys a flourishing export trade.

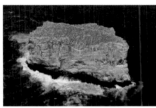

pp. 140–41
NORTHERN GANNET
COLONY,
Eldey Island, Iceland
(N 63°43' W 22°58')

Iceland, at the crossroads of the Arctic, North America, and Europe, hosts a varied population of birds: 70 species regularly nest there, and 300 others arrive for shorter periods. Eldey Island, 9 miles (14 km) south of the Icelandic coast, is a rocky peak 224 feet (70 m) high that has been declared a nature reserve. Each year it attracts one of the world's largest colonies of northern gannets (*Morus bassanus*), which includes more than 40,000 birds. They arrive on the island in January and February for nesting, and each couple gives birth to only one offspring. In September the birds depart to spend the winter off the coast of Africa. Like nearly one-fourth of the bird species of the Palearctic region, northern gannets migrate toward Africa covering more than 200 miles (300 km) a day and braving natural perils (opposing winds, predators) as well as threats resulting from human activity (destruction of their habitats, pesticides). In 1844 on Eldey Island the last two specimens of the great auk (*Alca impennis*), a once common species, were exterminated.

pp. 142–43
PALM TREES IN
THE MOUNTAINS
OF THE MUSANDAM
PENINSULA,
Oman
(N 26°06' E 56°16')

The limestone mountains that dominate the Sultanate of Oman are actually sea floors that have emerged from the water as a result of contact between the Arabian Peninsula and the ocean during major tectonic movements. Isolated at the extreme north from the rest of the country and separated by the United Arab Emirates, the Musandam Peninsula juts out into the Strait of Hormuz, which connects the Persian Gulf and the Gulf of Oman. The desolate heights bear little if any vegetation; nevertheless, on these mountains, which rise 6,500 feet (2,000 m) above sea level, the Shihuh villagers graze their herds following the rainy season. Here they also plant date palms, encircling the land with small stone walls. The walls not only protect the crops from hungry goats; they also help to retain water and limit erosion, by trapping the fertile silt during the rare but violent rains in winter.

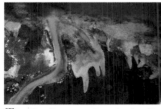

pp. 144–45
VILLAGE NEAR
PANDUCAN,
Philippines
(N 6°15' E 120°36')

The Panducan region, in the Pangutaran group of islands, is part of the Sulu Archipelago. The islands are home to the Tausug, "people of the sea currents," who number 400,000. Formerly smugglers, the Tausug now live from trade and fishing. They live in small hamlets of bamboo houses on stilts, scattered along the coasts fringed with coral. The Philippines are home to 9 percent of the world's coral reefs. These reefs have the greatest biological diversity, but they are also the most endangered: 70% of the coral reefs in the country are damaged. The practice of fishing using cyanide or explosives has had

devastating effects on the coral reefs and the marine fauna that depend on them. They are also choked by the sedimentary deposits that loosen from ground erosion. This damage is a grave concern to the many communities that depend on the health of the coral reefs for their livelihood.

pp. 146–47
WHITE HORSE
OF UFFINGTON,
Oxfordshire, England
(N 51°34' W 1°33')

This 365-foot-long (111 m) silhouette of a horse carved into the chalky side of a hill in the county of Oxfordshire, west of London, stands out clearly downhill from the ruins of the castle of Uffington. Its similarity to the designs on ancient coins suggests that it is the work of Celts in the Iron Age, around 100 B.C. Local tradition maintains that this stylized depiction is the image of a dragon, drawn in homage to Saint George, who, according to legend, killed the monster on a neighboring hill. But the most likely hypothesis is that this engraving was dedicated to the cult of the Celtic goddess Epona, who was usually depicted with the features of a horse. A dozen other white horses, carefully preserved, decorate hills in this region and neighboring Wiltshire, illustrating the age-old human desire to trace onto the landscape images of power and dreams.

pp. 148–49
BUNGLE BUNGLE
NATIONAL PARK,
HALLS CREEK,
Kimberley, Australia
(S 17°27' E 128°35')

In the heart of Bungle Bungle National Park (called Purnululu by the Aborigines), in western Australia, stands a series of sandy columns and domes approximately 330 feet (100 m) high. This labyrinth of gorges covers 310 square miles (770 km²). The rocks are made up of solidified sediment from the erosion of former mountains, fissured and raised from the force of motion of the earth's crust. Their tigerlike orange-and-black appearance is the result of alternating layers of silica and lichen. Known for centuries by the Aborigines, this site was revealed to the public only in 1982 and was declared a national park in 1987.

pp. 150–51
TEA CULTIVATION
IN THE PROVINCE
OF CORRIENTES,
Argentina
(S 27°50' W 56°01')

The fertility of the red soil and the regular rains of the Corrientes region create the ideal conditions for the cultivation of tea. In an effort to protect the soil against erosion, tea is planted along curved levels and protected from the wind by hedges. In Asia and Africa young shoots are harvested manually, but Argentinians use mechanical sowers, such as pushed tractors that dig the regular plantings. The tea cultivated here, a hybrid of the Indian Assam variety, yields a crop of 50,000 tons per year. Harvested in summer, it complements the large winter production of Maté tea, a type of holly, also known as "Jesuit tea." Today tea is cultivated in forty countries; India, China, and Sri Lanka alone provide 60 percent of the world crop.

Captions to the photographs on pages 152 to 167 can be found on the foldout to the right of the following chapter

captions 138–151 captions 152–167

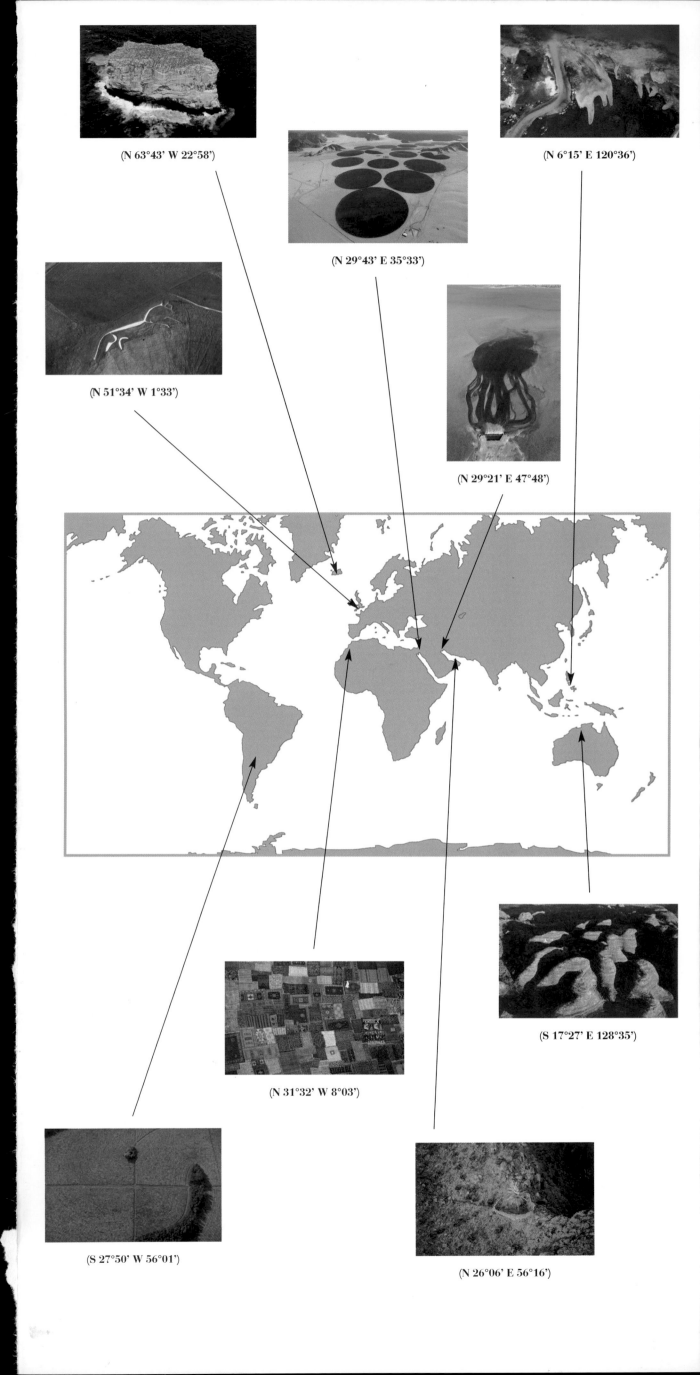

(N 63°43' W 22°58')

(N 29°43' E 35°33')

(N 6°15' E 120°36')

(N 51°34' W 1°33')

(N 29°21' E 47°48')

(S 17°27' E 128°35')

(N 31°32' W 8°03')

(S 27°50' W 56°01')

(N 26°06' E 56°16')

(N 33°50' W 118°20')

(N 45°22' E 12°20')

(N 4°16' E 73°28')

(N 43°15' W 2°58')

(N 19°32' E 99°43')

(S 18°50' E 15°32')

(S 2°11' E 38°25')

(N 16°30' W 0°12')

(S 1°14' E 34°48')

pp. 112–13
TOILING IN THE FIELDS IN THE REGION OF PHITSANULOK,
Thailand
(N 19°32' E 99°43')

Phitsanulok is located in the central plain of Thailand, which is fertile and enjoys a humid tropical climate, making it the rice bowl of the country. In an effort to increase its exports, Thailand has tripled the area of its arable lands in the past fifty years, creating cultivable spaces out of wooded areas. In the 1960s forests comprised half of the country, whereas today they cover only 28 percent. This accelerated deforestation has led to a disturbing degradation of the exposed soils, which after being uncovered are soon washed away by erosion. Although the phenomenon of deforestation linked to agriculture is common throughout Asia, it can be seen most strikingly in Thailand. In South Asia, which houses about 60 percent of the earth's population on 30 percent of the planet's land, available land resources are coming under considerable pressure.

pp. 114–15
YOUNG BASKETBALL PLAYER AT TORRANCE CORNERSTONE ELEMENTARY SCHOOL,
Los Angeles, California, United States
(N 33°50' W 118°20')

As symbolized by this student playing basketball in the courtyard of his Los Angeles school, sports are an integral part of the North American educational system. Athletic ability can often help students to win college scholarships. In the United States, where school is obligatory from age six to sixteen, 5.4 percent of the population goes on to college, one of the highest rates of university education in the world. But access to education remains very uneven around the world. Secondary education is available to only 5 percent of children in Africa, and primary school is far from universal: 110 million children (1 out of 5) in developing countries do not attend school. Today, at the dawn of the third millennium, one adult out of five can neither read nor write; of these approximately 900 million illiterate adults, 98 percent are found in developing countries, and two-thirds of them are women.

pp. 116–17
THE EYE OF THE MALDIVES,
atoll of North Mali, Maldives
(N 4°16' E 73°28')

The Eye of the Maldives is a faro, a coral formation on a rocky base that has sunk, concealing all but a ring-shaped reef that encircles a shallow lagoon. The lowest country in the world, with a high point not exceeding 8.3 feet (2.5 m), the Maldive archipelago would be the first territory to be submerged if the ocean level were to rise. Locally, dike projects have commenced. Its 26 large atolls include 1,190 islands, nearly 300 of which are inhabited either permanently or seasonally by tourists. After the construction of the first resort on the island of Kurumba in 1972, tourism in the Maldives expanded rapidly: 80 resorts exist today, and 300,000 tourists visit each year. Tourism is the world's leading industry. In 2000 the global total was almost 700 million tourists, and tourism yielded $476 billion in revenues. As tourism grows, it is essential to ensure that countries realize an economic advantage from tourism without destroying their natural and cultural heritage. The individual behavior of visitors is also a determining factor.

pp. 118–19
GUGGENHEIM MUSEUM BILBAO,
Bilbao, Basque country, Spain
(N 43°15' W 2°58')

The Guggenheim Museum Bilbao, inaugurated in 1997, is part of a program of urban renewal in this industrial city. Built at a cost of $100 million, the structure was designed by the California architect Frank O. Gehry, with the help of a computer program used in aeronautics. Its glass, steel, and limestone construction, partially covered with titanium, echoes the city's shipbuilding tradition. Encompassing a total area of 250,000 square feet (24,000 m²), the museum has 118,000 square feet (11,000 m²) of exhibition space divided among 19 halls, including one of the world's largest galleries (310 x 100 feet, or 130 x 30 m). This cultural attraction has raised the number of visitors to Bilbao from 260,000 to more than 1 million each year. By energizing the local economy (the gross industrial product of the Basque region grew fivefold), the museum has also brought new life to the city.

pp. 120–21
LAKE SHORE IN ETOSHA NATIONAL PARK,
Namibia
(S 18°50' E 15°32')

The salt deposits collected in the shoreline cavities of this lake in Namibia's Etosha National Park seem to form startling shapes of bizarre plants and animals when seen from the sky. Encompassing an area of 8,685 square miles (22,270 km²), this park is Africa's largest protected space. It surrounds a great basin of 2,340 square miles (6,000 km) covered with salt (*Etosha pan*), which transforms into a lake for a few weeks out of each year during the rainy season. Its water allows the growth of a blue-green algae, which attracts tens of thousands of flamingos. When the basin dries up, it is covered with grasses on which the park's great herbivores feed. Namibia has 20 national parks (13 percent of its territory), and environmental conservation is among the chief objectives in its constitution. Today the world includes about 13,000 protected areas, covering more than 5 million square miles (13.2 million km²), 8.8 percent of the earth's land; this is almost triple the area protected thirty years ago. Some of these areas, however, are protected in name only and are still exploited: agriculture is practiced in nearly half of them.

pp. 122–23
FISHING VILLAGE OF MALAMOCCO,
lagoon of Venice, Veneto, Italy
(N 45°22' E 12°20')

The lagoon of Venice is separated from the Adriatic Sea by a string of elongated islands, including the Lido, on which stands the fishing village of Malamocco. The historic city of Venice, which was built fifteen centuries ago, is made up of 118 islets. More and more frequently, the city is plagued by *acqua alta*, rising waters that regularly flood the city. This phenomenon has become more serious in the past thirty years, during which time the city has been flooded more than 100 times by more than 3 feet of water. In 1988, to preserve this tourist mecca (declared a world heritage site by UNESCO in 1987), an ambitious and costly plan known as Project Moses was launched: the three passes that link the sea and the lagoon are periodically sealed off by means of fifty movable dikes.

pp. 124–25
"TREE OF LIFE,"
Tsavo National Park, Kenya
(S 2°11' E 38°25')

This acacia is a symbol of life in vast expanses of thorny savanna, where wild animals come to take advantage of its leaves or its shade. Tsavo National Park in southeastern Kenya, crossed by the Nairobi–Mombasa road and railway axis, is the country's largest protected area (8,200 square miles, or 12,000 km²) and was declared a national park in 1948. Tsavo was already famous for its many elephants when, in the 1970s, more pachyderms fleeing drought entered the park. Consuming more than 440 pounds (200 kg) of vegetation daily, they seriously damaged the natural environment. Controversy surrounded the question of whether selective slaughter was necessary, but poachers put an end to the debate by exterminating more than 80 percent of the 36,000 elephants in the park. Tsavo's rhinoceroses, sought after for their horns (considered aphrodisiacs in Asia), suffered the same fate. The prohibition of international trading in ivory and rhino horns has enabled certain wild animal populations to increase in number. However, poaching and the disappearance of natural habitats remain disturbing threats.

pp. 126–27
MARKET NEAR THE NATURE RESERVE OF MASAI MARA,
Kenya
(S 1°14' E 34°48')

Between the nature reserve of Masai Mara and Lake Victoria in Kenya, near the village of Lolgorien, a small rural market is regularly held. Sedentary or nomadic Masai villagers of the region think nothing of traveling many miles to reach it. Presented on mats on the ground, the merchandise on sale is mostly used clothing from charitable associations—like many other goods in poor countries, they were donated by residents of wealthier countries. The gulf between rich and poor nations continues to grow: the gross national product (GNP) is approximately $17,000 per person in Europe, whereas it is only $340 per person in Kenya.

fauna, suppressed by treatment products, have been considerably impoverished. The use of strong doses of fertilizer and chemical-treatment products or the massive distribution of waste from great numbers of animals concentrated under one roof can cause, in some places, pollutions of surface and underground waters and sometimes an alteration in food products themselves (excessive nitrates in vegetables, pesticides on fruits, hormones and antibiotics in meat).

All of these problems are seen as well, to various degrees, in the areas of the green revolution, which have also experienced salination of bodies of water and of irrigated and poorly drained soils.

At the same time, replacing the majority of the workforce with machines has led to a large agricultural and rural exodus, resulting in population densities below 12 inhabitants per square mile (5 inhabitants per km^2) in some regions of the world; some regions, for lack of profitable production, have gone fallow and lost their population.

ECONOMIC CONSEQUENCES

In countries where these two revolutions have developed on a large scale, agricultural productivity gains have been so rapid and large that they have exceeded industry and services. The result has been a strong decline in real agricultural prices. Prices dropped by factors of two, three, or four, resulting in the impoverishment and then the elimination of a growing number of farms.

Moreover, some countries have been able to produce exportable surpluses at prices far below production prices of other countries. International exchanges of basic agricultural products only affect a small portion of world production and consumption (about 12 percent for grains, for example). These exchanges constitute markets in which, faced with a decline in demand, a handful of exporters engage in a war that leads to prices inferior to the lowest production costs available under normal conditions. At those prices, even producers that benefited from either of the preceding agricultural revolutions cannot hope to find their place in the market, or even to hold on there, unless they have supplementary competitive advantages. This is the case with the agro-exporting latifundias (large landed estates) of South America, South Africa, and Zimbabwe, and soon of Russia, Ukraine, and other countries, that are well equipped and have vast spaces at low cost as well as workforces that are among the least expensive in the world. At this kind of latifundia, an agricultural worker earning $1,000 per year can produce more than 1,000 tons of grain; therefore the cost of labor per kilogram of grain is less than one-thousandth of a dollar ($1,000 dollars per worker per year divided by 1 million kg per worker per year), and a ton of grain is exportable at about $70. This is the case, again, of American or European farmers, who live in wealthy countries that are concerned with their agricultural sovereignty, and thus farmers receive large public subsidies. In a few poor countries (e.g. Thailand and Vietnam) gains in productivity due to the green revolution are combined with salaries and revenues that are so low that the countries export rice even when they suffer from malnutrition.

For the vast majority of the world's poor farmers, international prices for basic subsistence goods are too low to allow them to live off their work and to renew their means of production, let alone to invest and get ahead. Because of the decline in transport costs and the growing liberalization of international agricultural trade, international prices tend to be imposed in all countries. This blocks countries' development, impoverishes the constantly renewed class of poor country people, and drives them to emigrate, thus increasing unemployment and serving to drive down wages.

To help explain this process of extreme impoverishment of the peasant class to the point of hunger, consider the example of a Sudanese, Andean, or Himalayan grain farmer who uses manual tools and produces 2,200 pounds (1,000 kg) of net grain (with seeds removed), without fertilizer or treatment products. Fifty years ago a grain farmer received the equivalent of $30 (in 2001 dollars) for 220 pounds (100 kg) of grain; thus he had to sell 440 pounds (200 kg) to replace his equipment, clothing, and so on, leaving 1,760 pounds (800 kg) for the modest feeding of four people. By depriving himself a little, he could even sell 220 pounds (100 kg) more to buy some new, more efficient tool. Twenty years ago he received the equivalent of just $20 (in 2001 dollars) for 220 pounds (100 kg); this meant he had to sell 880 pounds (400 kg) of grain to replace his equipment and would have only 1,320 pounds (600 kg) left to feed four people, inadequately in this case. Thus he could no longer buy new tools. Today he receives just $10 for 220 pounds (100 kg) of grain; so he would have to sell more than 1,320 pounds (600 kg) to replace his equipment, a clear impossibility because no one can feed four people on 880 pounds (400 kg) of grain. In fact, at this price he can neither completely replace his tools, cheap as they are, nor eat his fill and renew his work strength; he is therefore condemned to debt and to emigration to the under-equipped, under-industrialized shantytowns.

In addition, in former colonies (Latin America, South Africa, Zimbabwe) and former Communist countries (Ukraine, Russia), which did not experience any recent agrarian reform, most of these poorly equipped peasants are more or less deprived of land by the huge farms of several thousands or tens of thousands of acres. These minifundia peasants are obliged to seek day-to-day work on the great latifundias, for wages of $1 to $2 per day or else to move to the city slums.

HUNGER IN A RURAL ENVIRONMENT

Under these conditions, it is understandable that nearly three-fourths of undernourished humans on earth are poor rural people, who include, in a great majority, the peasants who have the worst equipment, worst location, and worst lodgings, as well as artisans and shopkeepers living in contact with them. According

to the Food and Agriculture Organization (FAO) of the United Nations, 840 million people in the world are now undernourished, which means that they are hungry nearly every day. They number about 800 million in developing countries, or nearly one person out of five.

Most of the hungry people in the world, then, are not urban consumers who purchase their food but peasants who grow and sell agricultural produce. It is clear, therefore, that development policies that consist of pushing forward the agricultural revolution and the green revolution into the most disadvantaged regions, and food policies that consist in supplying cities with surplus food at constantly lower prices, are useless in combating hunger.

AGRICULTURAL AND FOOD PERSPECTIVES FOR 2050

In the year 2050 our planet will have 9 billion people. To feed such a population adequately, without malnutrition or famine, the quantity of vegetal produce intended for feeding people and domestic animals must be more than doubled all over the world. It will have to be nearly tripled in developing countries, increased more than fivefold in Africa, and more than tenfold in several African countries.

To obtain such an enormous increase in vegetal production, agricultural activity will have to be extended and intensified in all regions of the world where that can be done on a sustainable basis. But the potential for growth in production offered by the modern agricultural revolution and the green revolution will encounter the problems already considered.

As for genetically modified organisms (GMO), the latest avatar of these two agricultural revolutions, they are no better equipped to bring about a miraculous restoration of the agricultural and food situation. Suppose that the creation of GMOs was not essentially a means of appropriating the genetic legacy of plants, and that the environmental and health risks that they can cause were relieved or nonexistent, and that the hopes and ambitions they feed could eclipse the reactions of fear and rejection they cause; even suppose that the development of GMOs that resisted crops' enemies and tolerated extreme climates and ungrateful soil was more rapid than the processes of classical selection. Despite all of this, the creation of GMOs is very expensive, and monitoring their ecological and digestive safety costs even more. It is so costly that research is basically oriented to suit the needs of the most prosperous producers and consumers. It is so expensive that the seeds of GMOs and the means of production necessary for them will be no more accessible to the poor peasants of disadvantaged regions than those of the green revolution.

To allow all the peasants in the world, in particular the poorest of them, to construct and exploit cultivated ecosystems on a sustainable basis that can produce a maximum of high-quality foodstuffs without environmental harm, there must be a halt to the war of international agricultural prices. An end must be put to the liberalization of agricultural exchanges that tends to align prices everywhere with those of the lowest price of surplus exporters. As we have seen, such prices impoverish and starve hundreds of millions of rural residents, which swell the ranks of the rural exodus, unemployment, and urban misery. Moreover, by excluding entire regions and millions of peasants from production, and by discouraging the production of those who remain, these prices keep agricultural production well below what would be possible with sustainable production techniques known to date. Such prices, which at the same time cause the under-consumption of foodstuffs and the under-utilization of agricultural resources, are thus doubly Malthusian. In addition, they impact negatively on the environment, health security, and the quality of produce.

On the contrary, it is necessary to ensure prices that are sufficiently high and stable to allow peasants to live in dignity from their work. For this purpose, it is necessary to organize international agricultural exchanges much more equitablly and effectively than they are today; every large country (such as China and India) or every group of countries having fairly similar agricultural productivities (such as West Africa, Southeast Asia, Western Europe, Eastern Europe, North Africa, and the Near East) ought in fact to be able to levy a variable customs duty on every bargain-rate agricultural import, sufficient to allow all peasants not just to survive but also to make progress. In addition, equitable international agreements would determine, product by product, an average sales price for international markets, as well as the quantity and price of exports granted to each country or group of countries. Of course, such a reorganization of the international exchanges will have to be accompanied, in each country, by specific measures: agrarian reforms, basic legislations guaranteeing to the greatest number of people access to the earth and security of tenure, differential taxation, orientation of public services of agricultural research according to the needs of peasants in impoverished regions, and many others. This is the price of the peasants' future. And of ours as well.

Laurence Roudart and Marcel Mazoyer

WASTE FROM A WATER DESALINATION PLANT IN THE SEA OF AL-DOHA, Jahra region, Kuwait
(N 29°21' E 47°48')

For a long time Kuwait depended upon imports from Iraq for its supply of drinking water, but today it has several seawater desalination plants that produce 75 percent of the country's water supply. These plants use a thermal process called mulit-stage flash distillation. The brine is rejected into the sea, where it mixes with the waters of the Persian Gulf, creating the shape of a tentacled monster. Thanks to 12,500 desalination plants in 120 countries, the earth's oceans furnish almost 3,700 million gallons (14,000 m³) of freshwater—less than 1 percent of the freshwater consumed in the world. Desalination plants require enormous amounts of energy and are expensive to operate and thus are available only to states that have considerable resources, particularly petroleum, such as those in the Arabian Peninsula. This area produces half of the world's desalinated water. At at time when the need for freshwater is a concern in a growing number of countries, Europeans use 150 to 250 liters of water per person each day; a toilet flush uses 6 liters. Less than 1 percent of this water, treated to make it potable, is actually drunk.

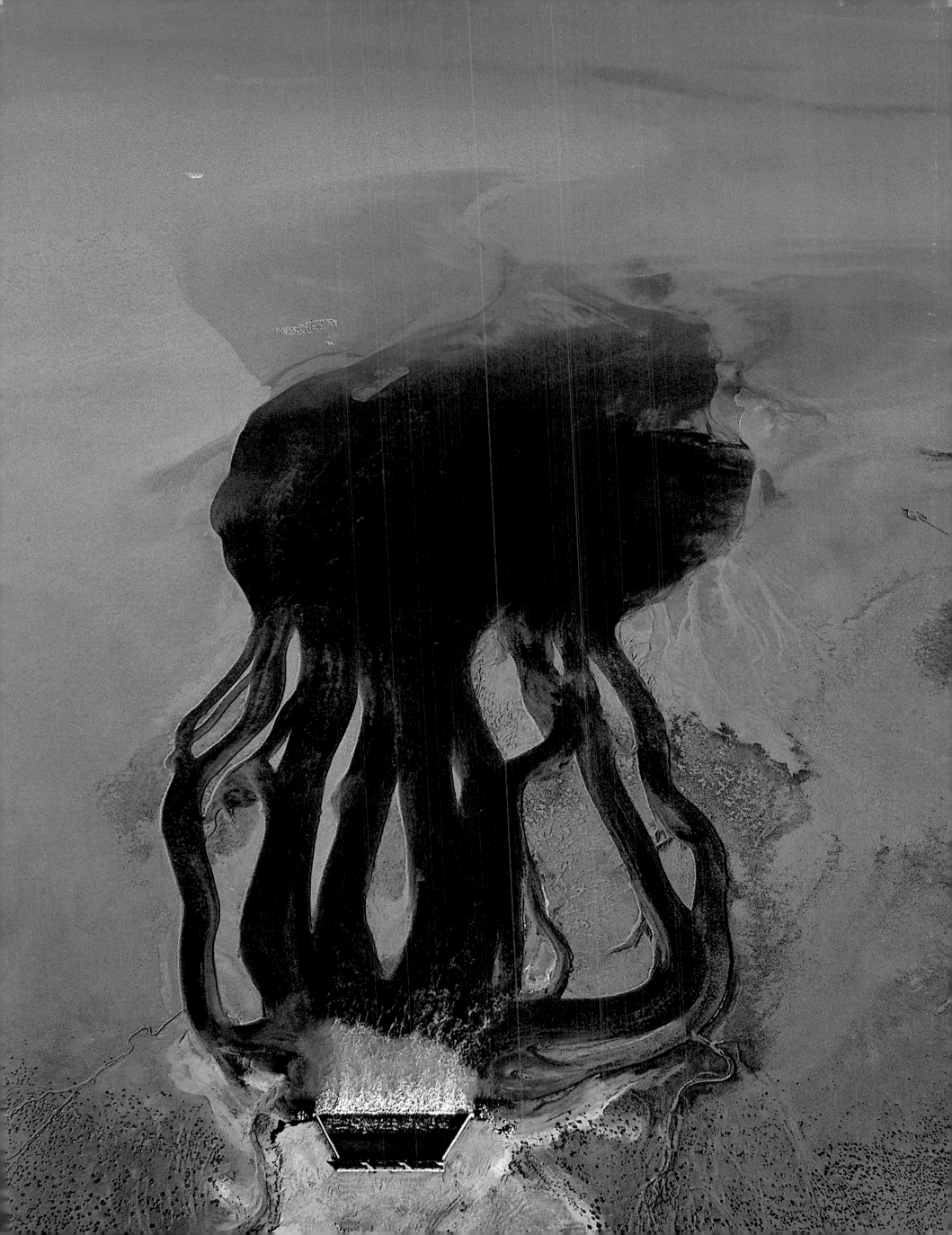

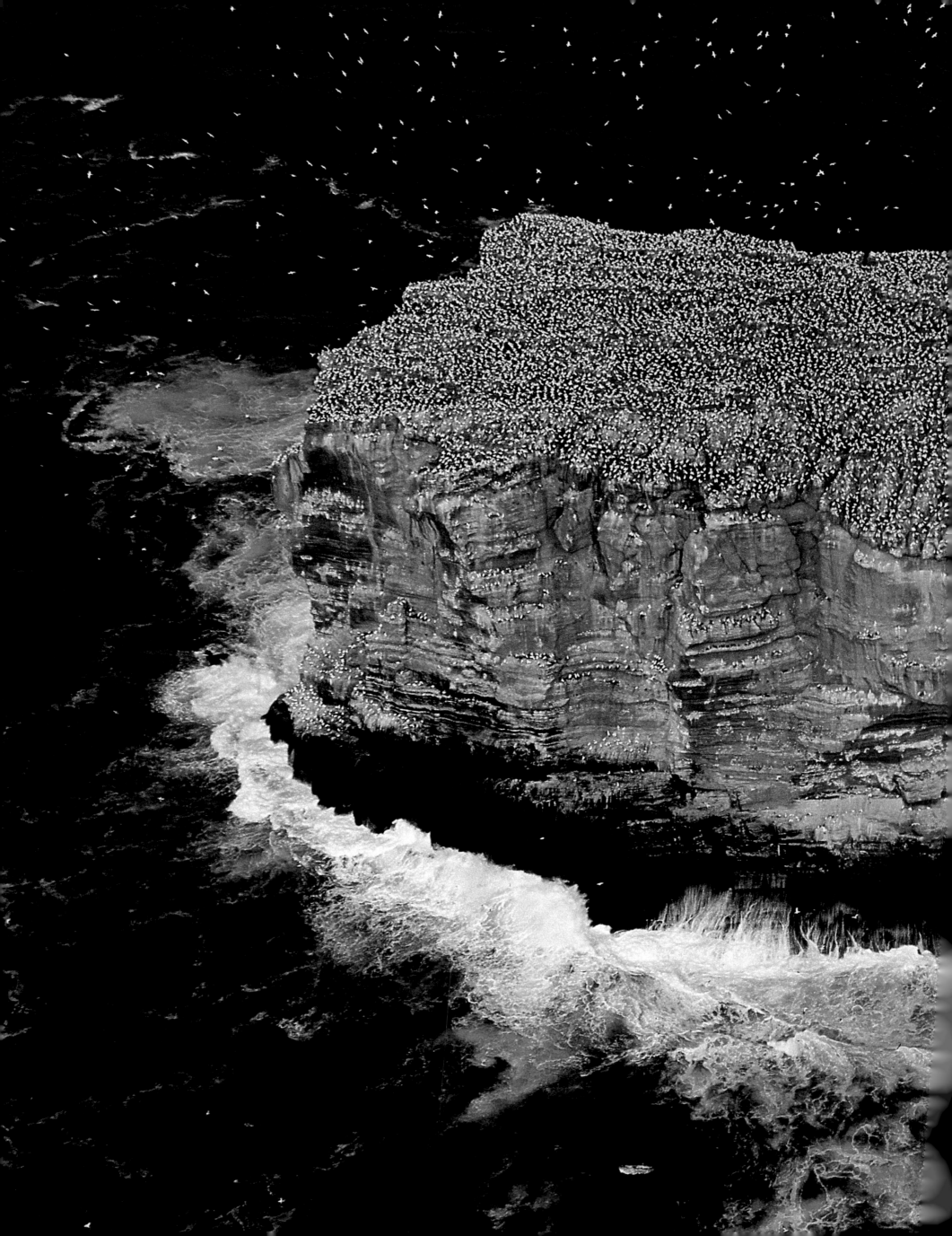

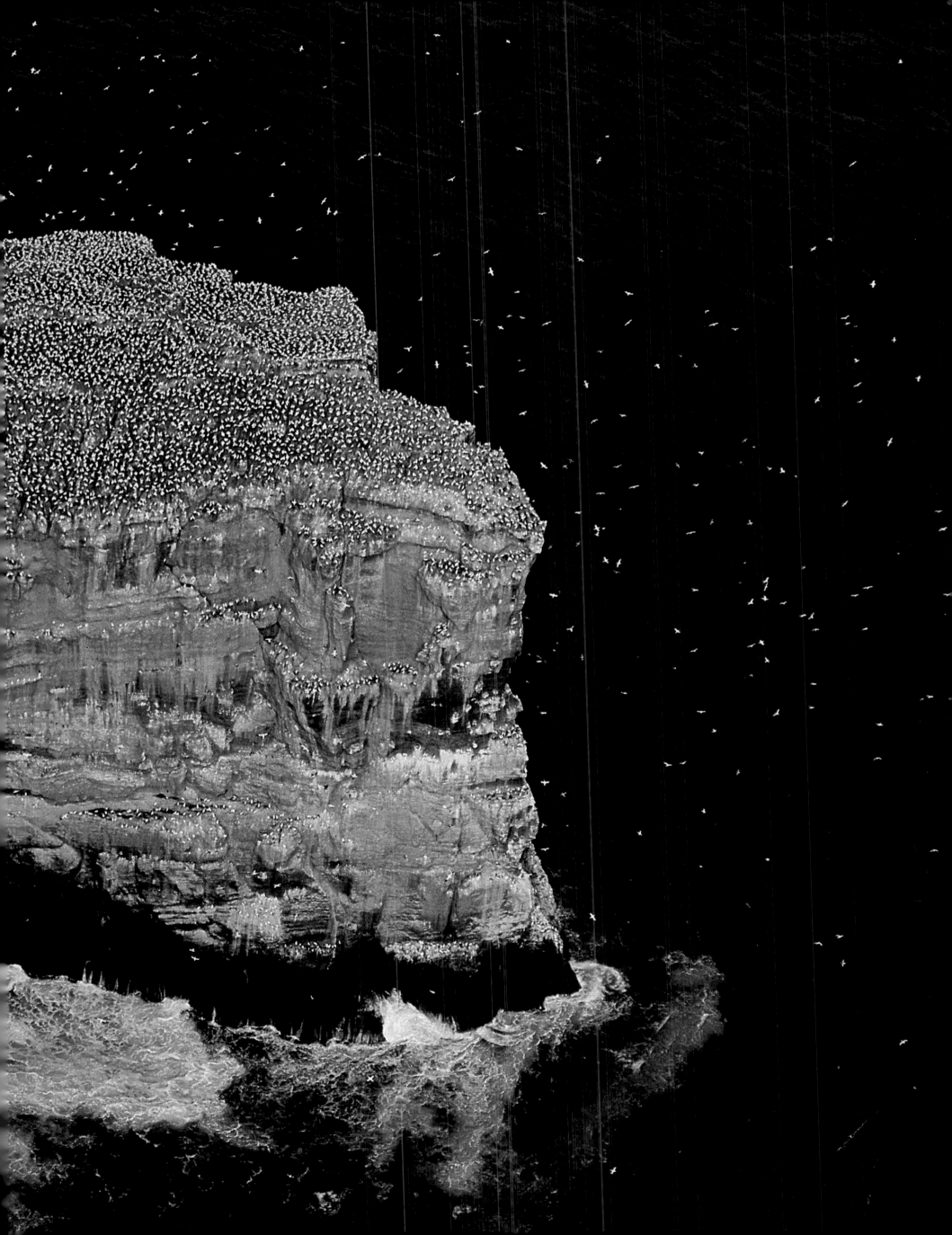

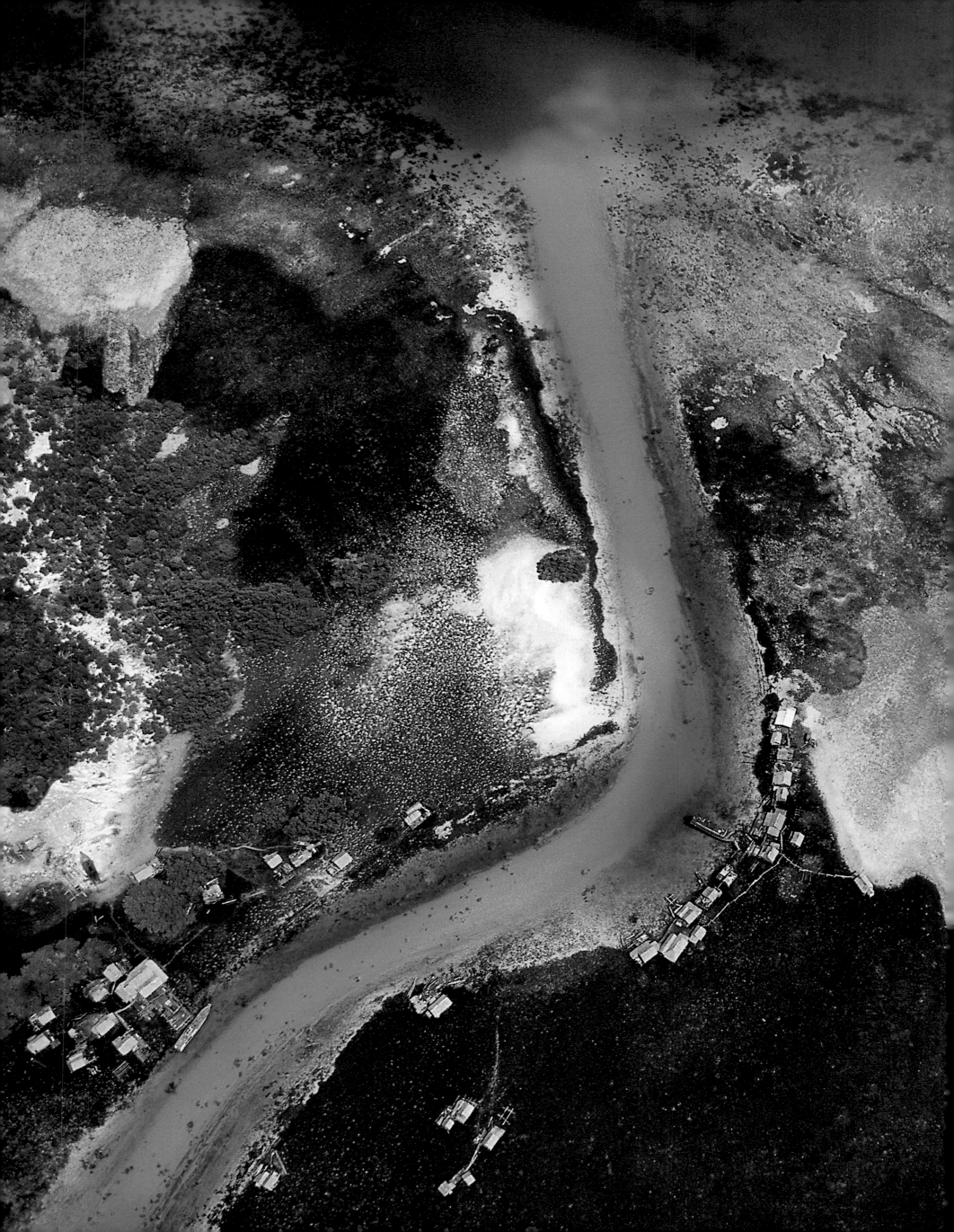

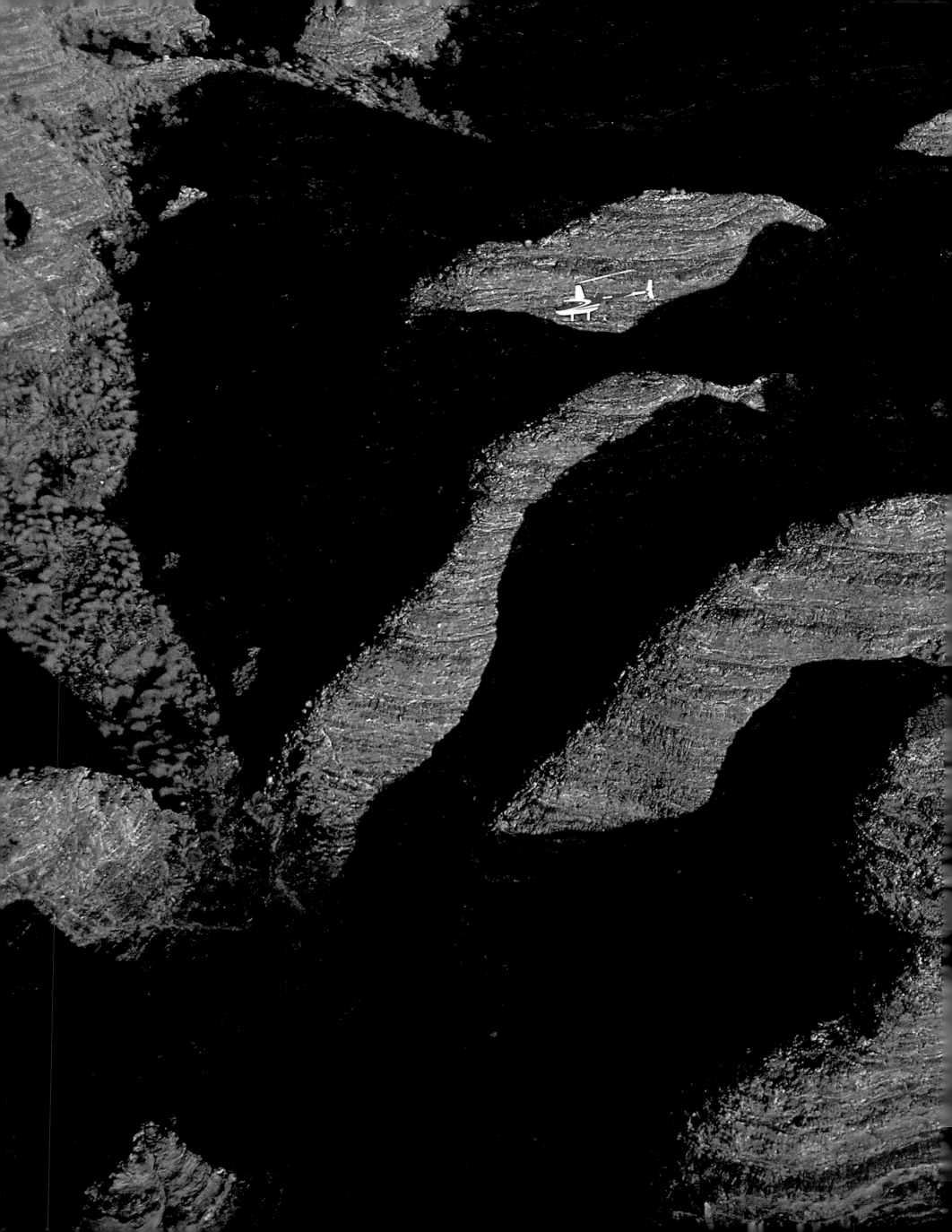

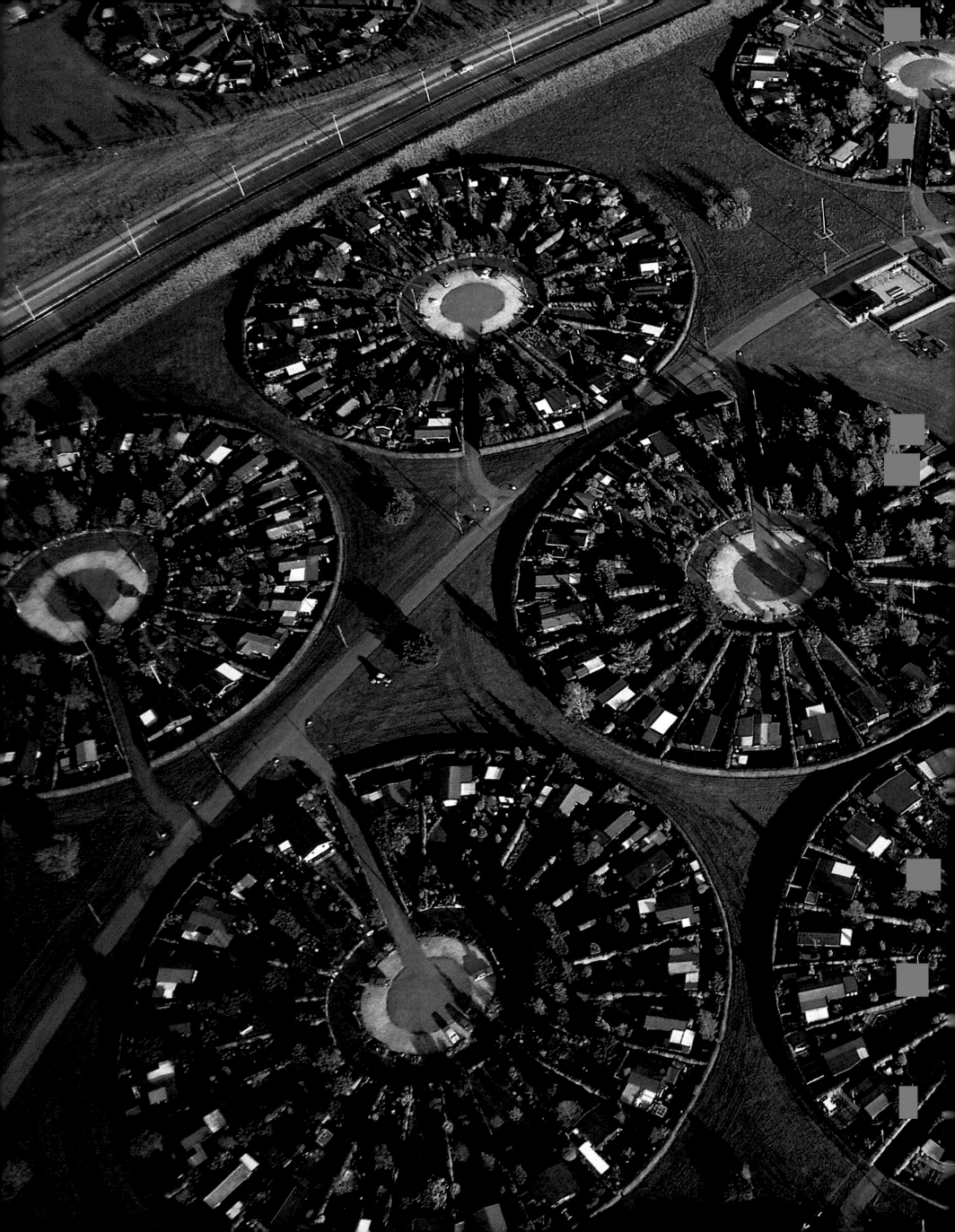

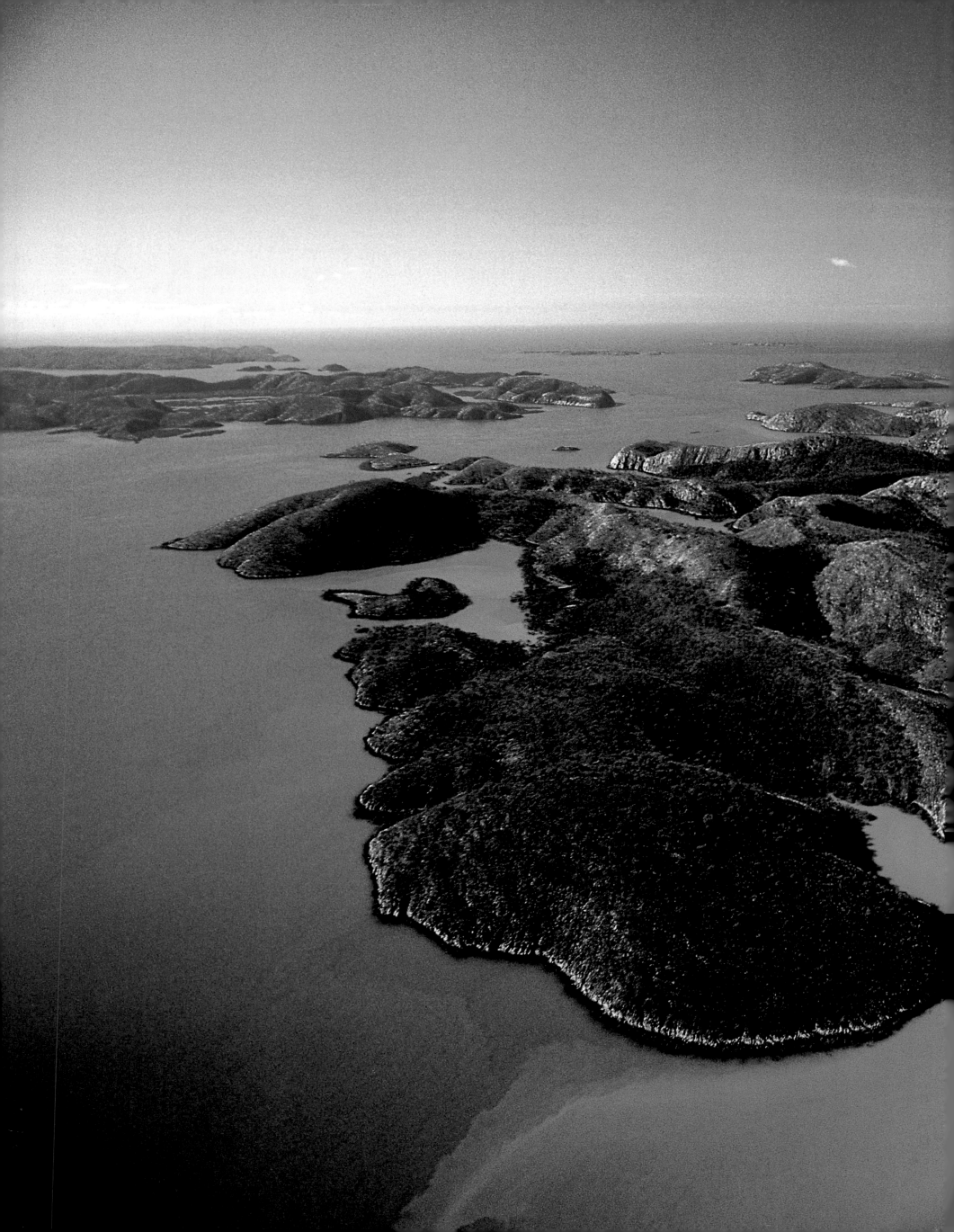

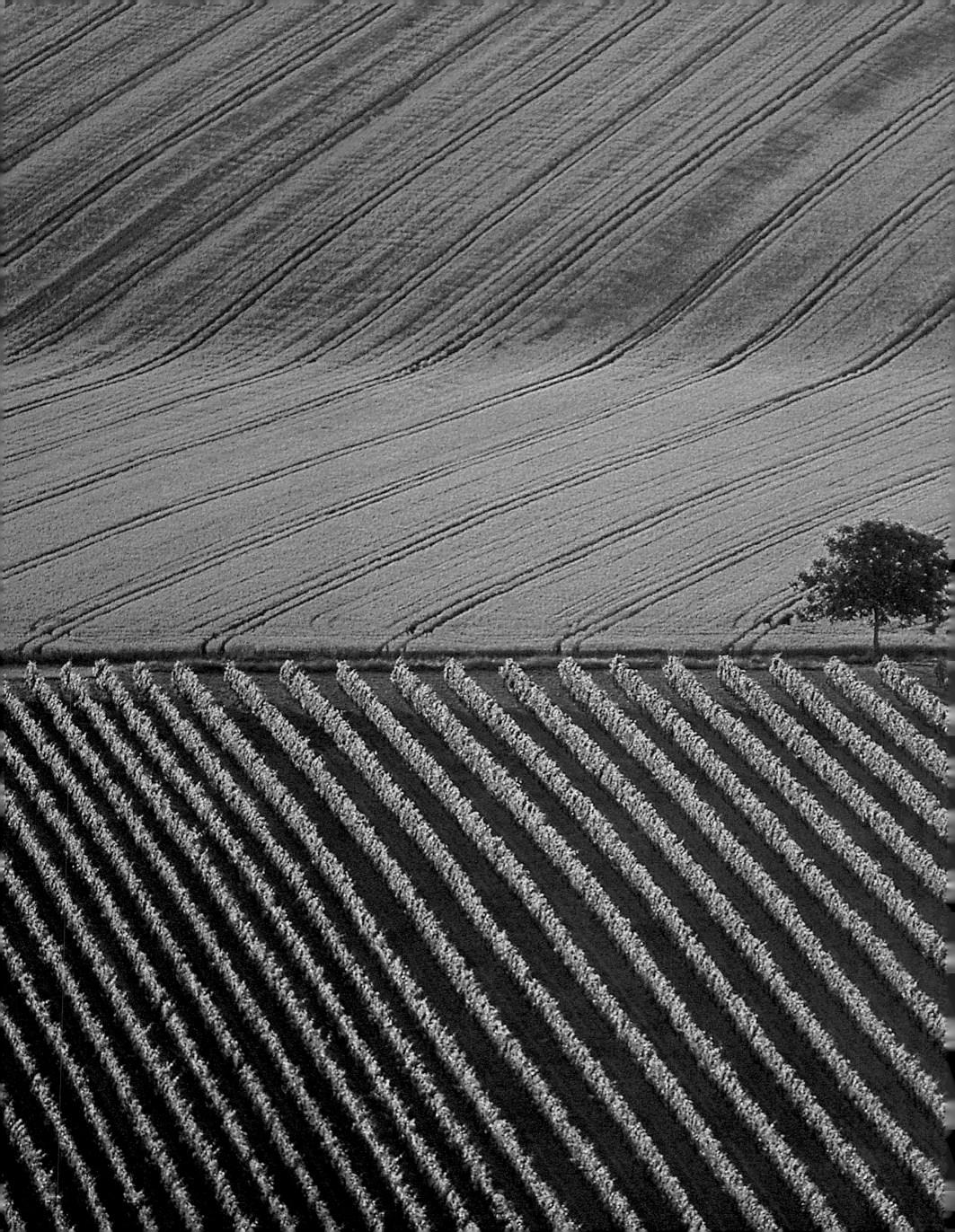

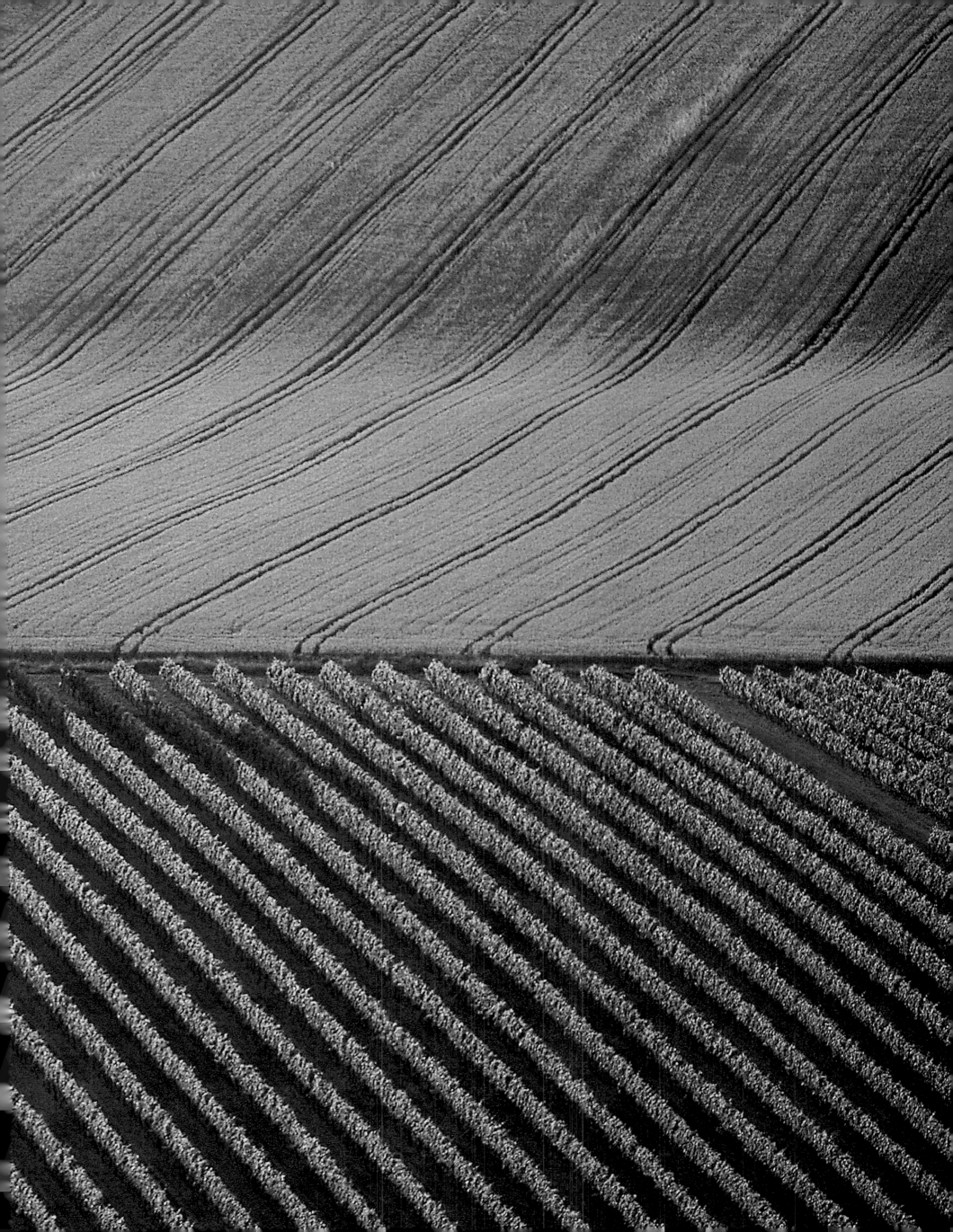

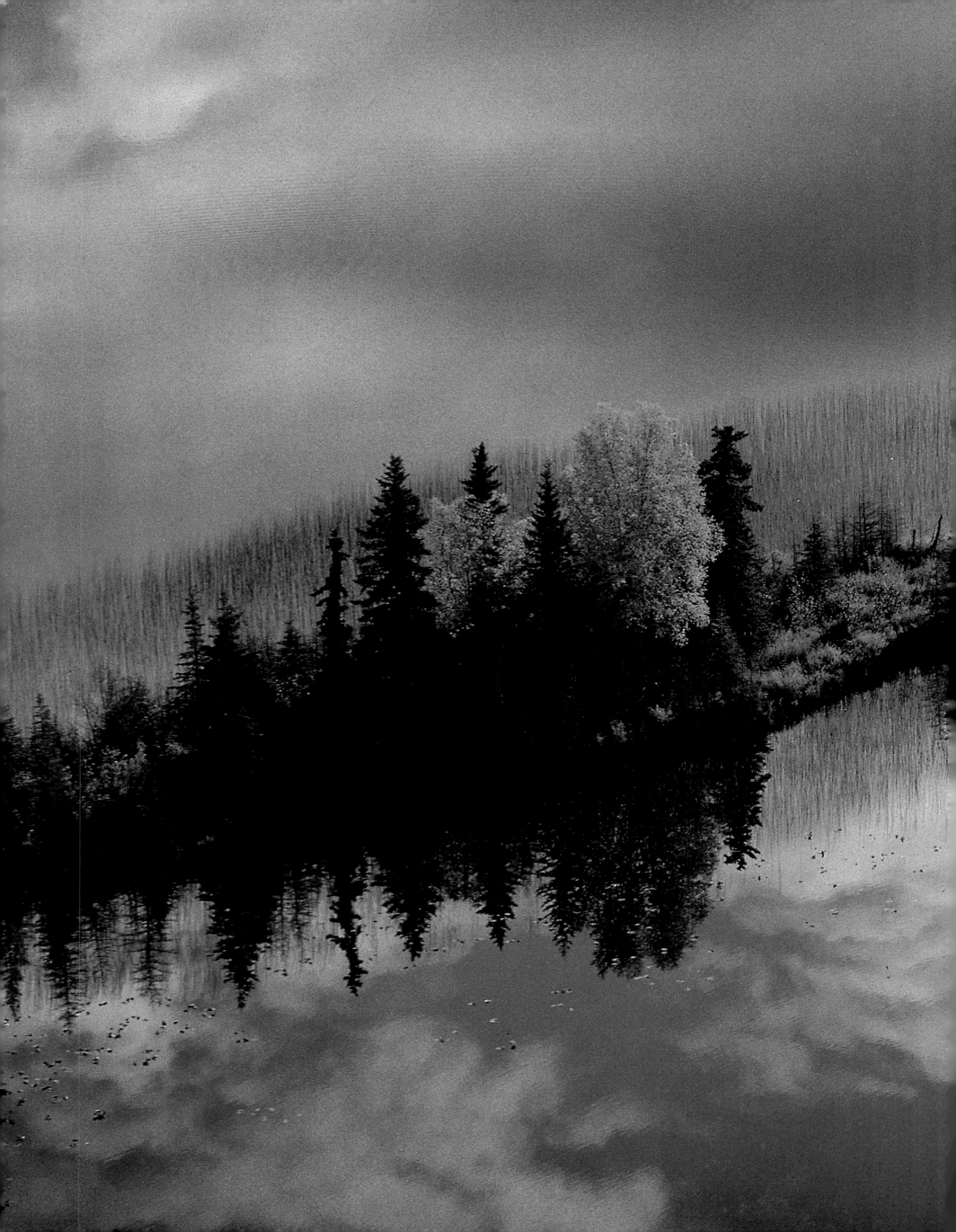

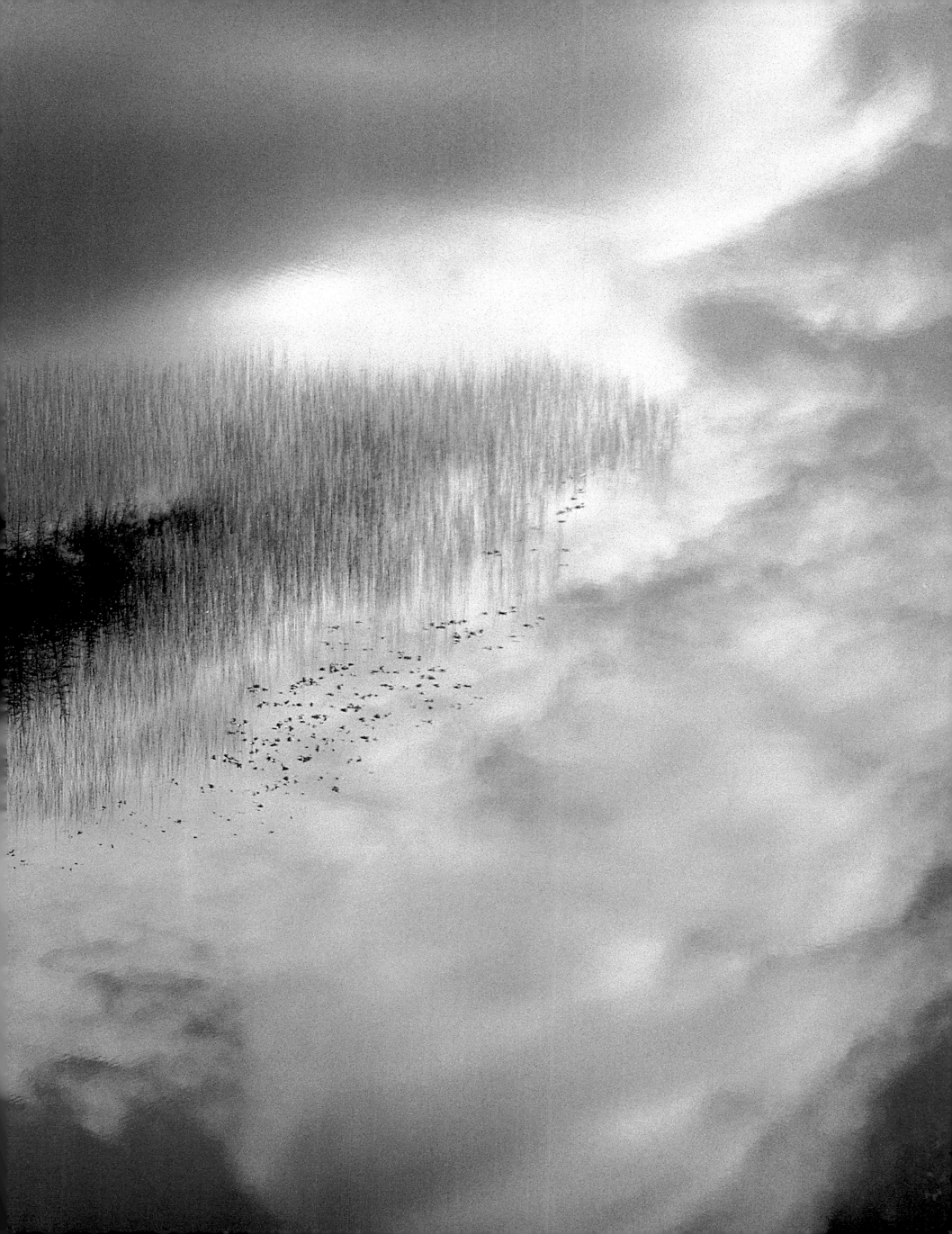

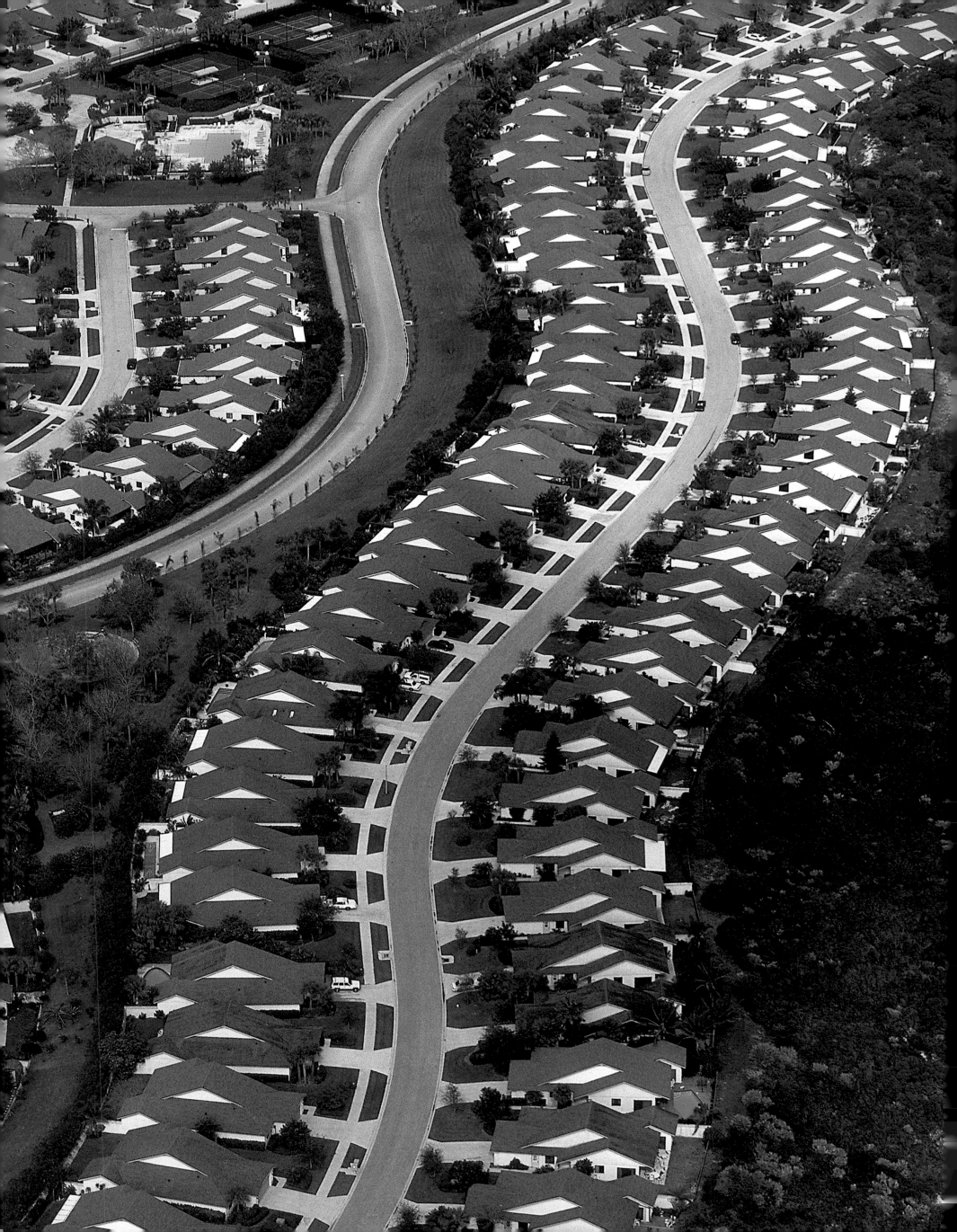

WATER: HUMANITY'S HERITAGE

We drink water every day, yet this natural need could become problematic in the future.
It already is for a large number of the earth's inhabitants who drink illnesses carried by
contaminated waters or must travel miles to obtain the precious fluid. The water available for
our use makes up less than one-thousandth of the planet's supply. The rest is contained in ice
or seawater or is drunk by the forests. Water is not abundant: it needs to be preserved.

Earth is a planet under the sign of water. This water, which covers nearly three-quarters of its surface, was given to earth at birth by the accumulation of successive waves of debris from comets encased in frozen water washed back from the depths of the cosmos. In a tumultuous clash of stones, ice, and water vaporized by incandescent masses from the entrails of the planet, the continents and the oceans took shape. A gas bubble, in which water vapor figured prominently, enveloped them in a kind of atmospheric glass, 25 miles (40 km) thick, which protected the earth from aggressive rays and meteorites and which trapped solar radiation by a greenhouse effect. Without this layer the average temperature of the planet would not exceed about -0.4°F (-18°C), and all its water would be solid ice.

A mighty storm gave rise to the water cycle, which for billions of years has been putting water molecules through an endless spiral. The sun is the machine that lavishes its energy on this mighty steam engine, whose boiler consists of the oceans and earth masses, while the cooler layers of the atmosphere provide the condensation system. Every year approximately 120,000 cubic miles (500,000 km³) of ocean water is charged to vapor. Most of this vapor, condensed at high altitudes, falls back on the oceans in the form of precipitation. The remainder, approxi-

mately 10,000 cubic miles (40,000 km³), is added to the exhalation from the rivers and lakes and from living beings. Trees, in particular, act as veritable living wicks and vaporize 200 to 400 times their weight in water each year of vegetation. All this atmospheric water, about 27,000 cubic miles (111,000 km³), is precipitated onto the emerged land mass. Two-thirds of it evaporates as soon as it falls; the balance is filtered into the soil or feeds the free waters, and finally every year the rivers return some 10,000 cubic miles (40,000 km³) of freshwater to the oceans. This is like the functioning of a purification and distillation plant working nonstop on a planetary scale, which propels water, from the earliest ages of the earth, through billions of lives for which it is indispensable. This is because the quantity of earth water has remained about level since the beginning: 339 million cubic miles (1.4 billion km³). It is a figure that defies the imagination, and yet if the earth were reduced to the size of an orange, this world water would amount to just a drop.

Two atoms of hydrogen, the primordial element present at the birth of the universe, linked to one atom of oxygen, an ash from inside a star—the water molecule is simple and minuscule, and yet its properties are exceptional, so that the most common liquid is also the most disconcerting. Water needs considerable quantities of energy in order to change its state. Before becoming vapor, it stores up a great deal of heat, which it frees upon condensation, and each molecule of water vapor in a cloud is a tiny aerial packet of energy. Because every evaporation releases cold, and every condensation gives off heat, water contributes to a permanent redistribution of solar energy on the globe, which it organizes and uses to regulate the climates. Water has a long "memory": oceans and earth engorged with water play the role of thermal regulators by storing up solar energy for years, even millennia. Unlike other substances, water dilates when solidifying. This fact has enormous consequences

PAVILIONS NEAR MIAMI,
Florida, United States
(N 26°24' W 80°11')
Famous for its beaches, Art Deco hotels, and luxury homes of movie stars, the city of Miami also contains residential suburbs with sober but comfortable pavilions. Built on former swampland that was dried up in the early twentieth century, these mushrooming cities meet the demand of a population that keeps growing. Miami is located in Dade County, a center of economic development, a place of refuge for exiles, and a favorite retreat for retirees. It has become the most densely populated region in Florida, with more than 2 million inhabitants. Florida was still largely wild at the beginning of the twentieth century but today, with a population of 14 million, it is the fourth-largest state in population. Its population has doubled in the past twenty years, and 85 percent live in urban areas.

for our environment, explaining the oceans, the lakes, the shattering of rocks, and our landscapes. Before it freezes, water achieves a maximum density at 39°F (4°C), and this strange trait makes cold waters sink. This fact, combined with the floating of ice, makes a body of water freeze on the surface and not down below. Otherwise all of the earth's waters would have long since turned to ice. The phenomenon is also at the origin of ocean currents, water turbulence, and its oxygenation.

Seen from the sky, water has a characteristic erosive signature. At the four corners of the earth we find, on every scale, the same organization and branching of streams and tributaries, the same meanderings, the same deltas, the same glacial valleys and alluvial plains. The hardest rock cannot resist the pressure that results from the freezing of water that has infiltrated it. Night after night, ice-filled crannies shatter the mountains and sculpt landscapes, which liquid water erodes and dissolves, because its corrosive power makes it a universal solvent. Each year the rivers carry toward the oceans 15 to 30 billion tons of muds and sediments: the flesh of continents. Fluid, capable of rising by capillary action into the slender sap conduits, is omnipresent, infiltrating everywhere, making the rain and fair weather, endlessly dissolving and carrying a thousand substances that it precipitates and distributes at will—all on the scale of the cell or the continent. Water is the great unifier of the planet, the bond that connects all living beings, even beyond the barrier of time. Dinosaurs drank this same water that we today put into bottles or use to cook our food.

EARTH IS A LIVING PLANET WOVEN FROM WATER

Life was born of and in water. When life crawled out of the sea onto land, each terrestrial organism preserved in itself,

in the form of sap, serum, or blood, a small internal sea as proof of a common marine origin.

Water determines the distribution of living beings on earth, who have evolved to economize water and fight off dehydration: from the camel's hump to the human kidney that cleans thousands of liters of blood daily. Every life form on land is confronted with the challenge of preserving this ancestral link with the liquid that no living cell can do without. From our birth to our death, water flows in the human body and constantly renews itself. Two-thirds water, a human being dies if more than 15 percent of it is lost. No one survives more than a week without drinking, and the loss of water is still more serious in hot climates. Thus, the history of humanity was determined by the quest for and conquest of water. The great civilizations were born from water and near water, and its mastery determined their grandeur, its mismanagement brought their decline and sometimes disappearance. Humankind grafted itself onto the water cycle and gradually put water to work, to its benefit. To water their plantings, people established the first canals and the first dams, then a multitude of hydraulic apparatuses each more ingenious than the last. Then they used water as a communication path and for transport, by channeling it. Well before Egyptian civilization, the Mesopotamians had already elaborated an astonishing system of dikes, canals, reservoirs, and dams, and six centuries before the birth of Christ, the Chinese had linked Beijing to Hangchu by a canal 1,000 miles (1,600 km) long.

We can read the history of a society's links with water in the landscape. Ditches testify to the ancient strategic importance of water; a canal bears witness to trade relations between the rivers, or to an ancient chain of crafts related to living water; an aqueduct tells of supplying a city with spring water. And all religions have always maintained complex relationships with water, a fundamental symbol that conveyed powerful myths.

Some countries with sufficient water resources have been able to develop an impressive technology linked to water. Having known the age of live water, whose energy drove the mills, then the age of stagnant water, whose humidity allowed the fermentation of the fibers required for the textile industry, they put water to work in steam engines. A decisive step was taken one day in 1880, when the mill wheel became an alternator and water power was converted into electric current. At that point water became fire and sun, providing heat and light. This

ARM OF LAKE MEAD,
Muddy Mountains, Nevada, United States
(N 36°19' W 114°24')
Damming up a canyon to accumulate water for a reservoir is generally considered beneficial, although some will deplore the loss of the natural landscape. Creating a lake out of the steppe is easier than preserving the water in a densely populated area. Today's societies are confronted with such choices, which are needed to improve living conditions for growing populations. In the future these dilemmas promise to be even more frequent and more painful.

pp. 178–79
DROMEDARY CARAVANS NEAR NOUAKCHOTT,
Mauritania
(N 18°09' W 15°29')

The dromedary, perfectly adapted to the aridity, is an important national livestock in Mauritania and all of the other countries bordering the Sahara. Its domestication several thousand years ago enabled humans to conquer the desert and develop trans-Saharan trade routes. The dromedary eats 25 to 50 pounds of vegetables a day and can survive without water for many months in the winter. In the summer, because of the heat and expended effort, the dromedary can last only a few days without drinking; by comparison, a human would die of dehydration within twenty-four hours. The reserve fat contained in its single hump helps in thermal regulation, allowing the dromedary to withstand the heating of its body without needing to perspire to cool down. The Maurs, the ethnic majority in Mauritania, raise the dromedary for its milk and meat as well as its skin and wool. In 2001 the country's dromedary livestock numbered about 1 million.

pp. 180–81
NEW OLIVE PLANTINGS,
Zaghouan, Tunisia
(N 36°24' E 10°23')

These olive groves at the foot of the 4,250-foot-high (1,295 m) Jebel Zaghouan in northeastern Tunisia are planted in curved embankments to retain water and limit erosion, which viewed from above look like the lines on a relief map. A symbol of peace, the tree is native to the Mediterranean basin, where 90 percent of the planet's olive trees grow. An olive tree can live as long as 1,000 years, producing 11 to 65 pounds (5 to 30 kg) of olives yearly. In the past its oil was used in small clay lamps, but it has been replaced by petroleum. Today we consume both table olives and olive oil, which is celebrated for its dietary and medicinal properties and also exploited in cosmetics. It takes 11 to 13 pounds (5 to 6 kilograms) of olives to produce a liter (a bit more than a quart) of olive oil. Tunisia produced 1 million tons of olives in 2000, doubling its 1997 crop and becoming the fourth-greatest producer, after Spain (4.2 million tons), Italy (2.8 million), and Greece (2 million). These countries are also the principal consumers of olive oil: 20 liters per capita each year in Greece, 15 liters in Spain and Italy, and just one-half liter in France.

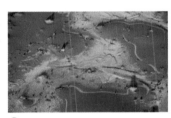

pp. 182–83
ORYX IN THE NAMIB DESERT,
Swakopmund, Namibia
(S 24°39' E 15°07')

On the Atlantic coast of southern Africa, the Namib Desert covers the entire 800 miles (1,300 km) of the Namibian shoreline and extends inland to a width of 62 miles (100 km), comprising one-fifth of the country's territory. Although its name, in the Nama language, means "place where there is nothing," its biological richness makes it a site unique in the world. The Namib has a secret: the humid air masses coming from the Atlantic condense on contact with the desert surface, which cools at night, enveloping the area in a thick morning fog nearly 100 days each year. This fog adds up to 1.2 inches (30 mm) of annual precipitation and constitutes the desert's main source of water and thus of life. When the orange-red sand is moistened, it allows many vegetal and animal species to subsist in the Namib Desert, such as an insect that specializes in capturing the water vapor. Only species that have evolved the characteristics most adapted to the extreme conditions of desert locations (aridity, harsh temperature, scarce food resources) can survive here, including this gemsbok (*Oryx gazella*), a type of oryx, a large African antelope.

pp. 184–85
ALGAE CULTIVATION IN BALI,
Indonesia
(S 8°43' E 115°26')

Algae was used exclusively as a fertilizer in antiquity and was incorporated in the form of ash into glass manufacture in the sixteenth century. Today 97 percent of algae production serves the food industry. Out of approximately 30,000 algae species known throughout the world, only a few dozen are exploited. They include carrageen (*Chondrus crispus*), also called Irish moss, from which is extracted a colloid used as a jelling, thickening, or stabilizing agent by the food, pharmaceutical, and cosmetic industries. In the Far East, the cultivation of this kind of red algae is an important source of revenue for coastal populations. Cuttings of algae are attached on submerged ropes, held taut between stakes, following the main current. Indonesia is the sixth-largest producer of red algae, a market dominated by the Philippines, which produces 600,000 tons per year (30 percent of global production). If all of the species of algae are combined, however, China is the leading producer and consumer.

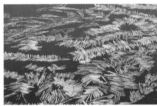

pp. 186–87
LEONA RIVER,
Santa Cruz province,
Argentina
(S 50°02' W 72°07')

In Patagonia, in the eastern part of Los Glaciares National Park, the Leona River starts at the southern end of Lake Viedma and winds for some 30 miles (50 km) through the rugged cordillera of the Andes. It empties into Lake Argentino, the largest in the country (608 square miles, or 1,560 km²), for which it is the main source. A subglacial river, the Leona is fed by blocks of ice broken off from glaciers, which are slightly turquoise in color because they are so ancient and dense. As they melt, these blocks give the waterway its characteristic milky-blue tint, which the Argentines call *dulce de glaciar*, "glacier cream." The color contrast is even more striking because the banks, subject to successive floods, are almost bare of all vegetation. The river was christened the Leona in 1877 by the Argentine explorer Francisco Pascasio Moreno, who during one of his expeditions in the region had been attacked by a female puma (*leona* is the Spanish word for "lioness"). Like most of the Patagonian waterways, the Leona offers a rich variety of fish, especially salmon and trout.

pp. 188–89
FLOATING WOOD DOWN THE AMAZON,
near the city of Manaus,
Amazonas, Brazil
(S 3°03' W 60°06')

In this region, where the density of vegetation precludes any other access to natural resources, rafting is the only way to transport wood. Logs are bound together and stored on the Amazon before being towed by barge to the sawmills. Brazil is the world's fifth-largest producer of industrial wood and the number-one producer of tropical woods, but this major economic resource has caused a disturbing deforestation of nearly 8,600 square miles (22,000 km²) each year. The Amazonian forest has already lost 15 percent of its original area, primarily as a result of the drying up of arable soils, mining activity, and exploitation for construction wood, fuel, and forest products. The per capita use of paper and cardboard, made of forest products, has nearly tripled since 1961, mainly because of consumption by wealthy countries: Europe, Japan, and North America, which represent only 19 percent of the world population, consume 63 percent of all paper and cardboard products.

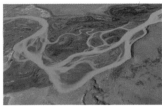

pp. 190–91
CULTIVATION OF YAMS IN NORTHERN TAGADI,
Bondoukou region,
Côte d'Ivoire
(N 8°43' W 2°39')

The yam, planted according to traditional farming techniques under mounds of earth, as in this field near Bondoukou in eastern Côte d'Ivoire, is grown for local consumption in most of the world's tropical countries. This starch- and protein-rich tuber is especially common in the northernmost part of Africa's forest regions, from Côte d'Ivoire to Cameroon. As the basic ingredient of one of the main Ivoirian dishes, *foutou* (a kind of thick puree), this starch is a staple in the diet of rural populations, as well as city dwellers, who now make up 51 percent of the national population. Côte d'Ivoire remains the third-largest African producer of yams (after Nigeria, which alone accounts for 70 percent of African production, and Ghana). In Africa as a whole, agriculture occupies more than 60 percent of the active population and provides 40 percent of the continent's revenues.

Captions to the photographs on pages 192 to 207 can be found on the foldout to the right of the following chapter

captions 178–191 ↓ captions 192–207 ↓

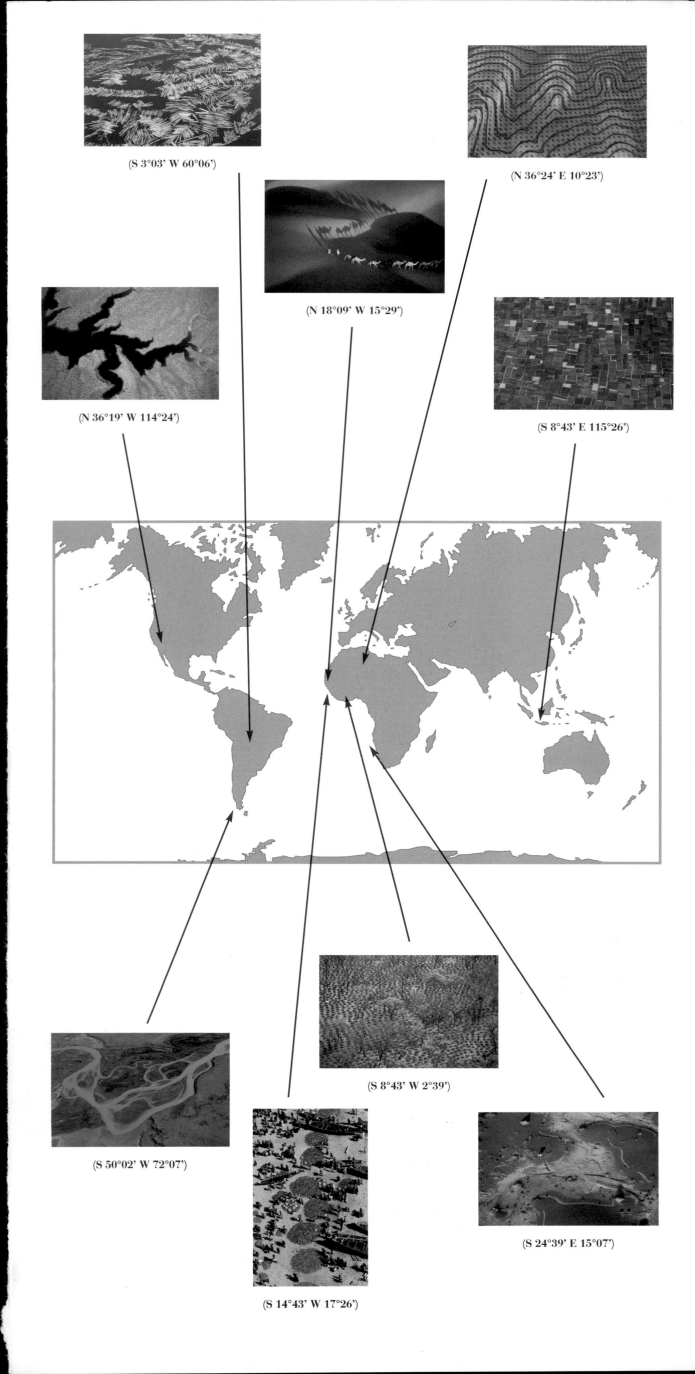

(S 3°03' W 60°06')

(N 36°24' E 10°23')

(N 18°09' W 15°29')

(N 36°19' W 114°24')

(S 8°43' E 115°26')

(S 50°02' W 72°07')

(S 8°43' W 2°39')

(S 14°43' W 17°26')

(S 24°39' E 15°07')

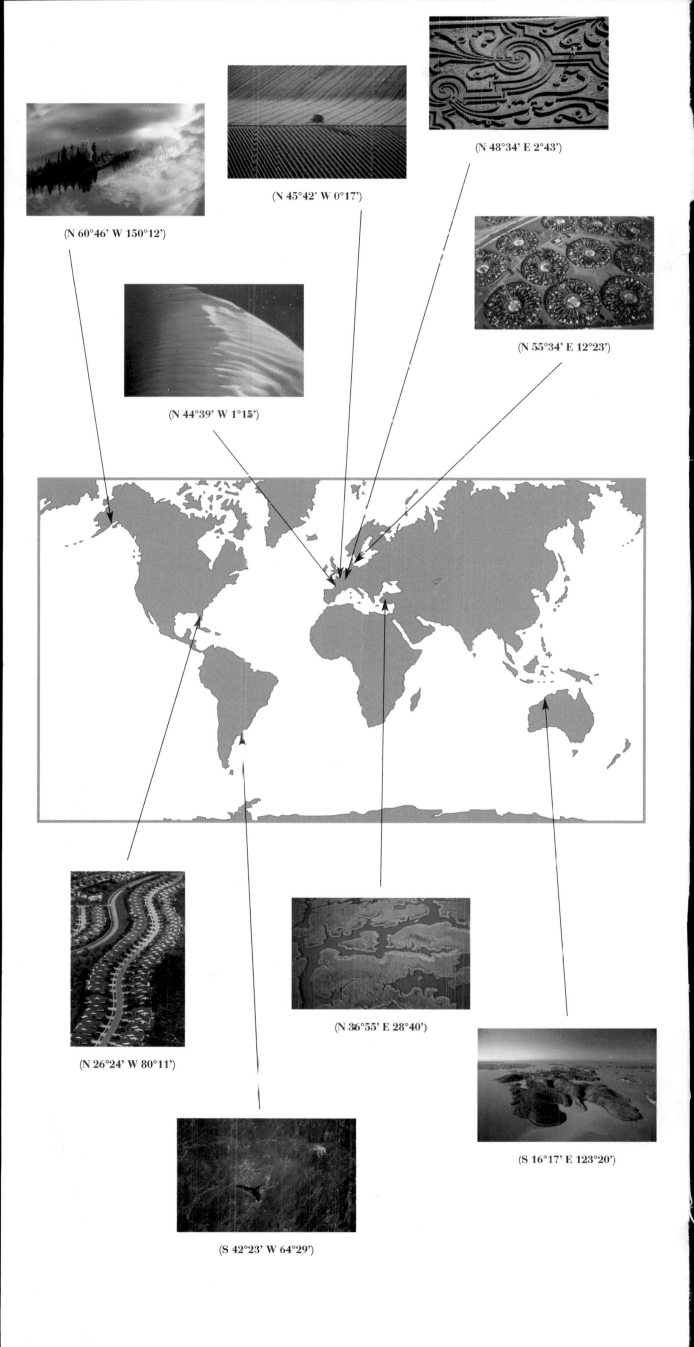

(N 60°46' W 150°12')

(N 45°42' W 0°17')

(N 48°34' E 2°43')

(N 44°39' W 1°15')

(N 55°34' E 12°23')

(N 26°24' W 80°11')

(N 36°55' E 28°40')

(S 16°17' E 123°20')

(S 42°23' W 64°29')

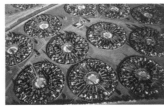

**pp. 152–53
HOUSING
DEVELOPMENT
IN BRØNDBY,
Suburb of Copenhagen,
Sjælland, Denmark
(N 55°34' E 12°23')**

To achieve a balance between space limitations, safety, and comfort, the houses in Brøndby, a suburb southwest of Copenhagen, are arranged in perfect circles in which each homeowner has a 4,500-square-foot (400 m) parcel of land with a garden leading to the house. This type of residential neighborhood is becoming increasingly familiar on the periphery of large urban centers that employ large numbers of people. Because of industrial expansion and demographic growth, the benefits of cities, and the growth typical of large centers, the world's urban population has increased by more than 13 percent in the past half-century. Nearly half of the world's population (45 percent) lives in a city today. In 2025 the world will have 25 megalopolises, each holding between 7 and 25 million residents, adding up to 1 billion more city residents than exist today. Three-quarters of this additional billion will be found in the southern hemisphere.

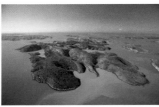

**pp. 154–55
BUCCANEER
ARCHIPELAGO,
West Kimberley,
Australia
(S 16°17' E 123°20')**

Thousands of uncultivated islands, including Buccaneer Archipelago, emerge from the waters off the jagged, eroded coasts of northwestern Australia. Because there is scant agricultural or industrial activity on the shoreline, the waters of the Timor Sea that surround these islands have remained relatively untouched by pollution. This has allowed fragile species such as the *Pinctada maxima* oyster to develop. Harvested in their natural setting, the sea floor, these mollusks are exploited for the production of cultured pearls. Australian pearls, which make up 70 percent of those produced in the South Seas, are twice as large (averaging a half-inch, or 12 mm, in diameter) as those of Japan and, according to experts, finer in appearance. Japan pioneered the pearl industry at the turn of the twentieth century and is the world's leading producer.

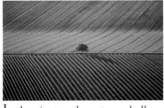

**pp. 156–57
AGRICULTURAL
LANDSCAPE NEAR
COGNAC,
Charente, France
(N 45°42' W 0°17')**

In the nineteenth century phylloxera, an aphid-like insect, ravaged the vineyards of Charente along with nearly half of all French vines. A major part of the grape stocks of this region was replaced by cereal plantings, which still predominate in the landscape. The vineyards were gradually restored around the city of Cognac, where the production of the liquor of the same name has steadily increased. Growing on chalky soil, the ugni blanc grape (known locally as saint-émilion) yields a wine that is distilled and aged in oak casks, giving rise to cognac. More than one billion bottles are currently aging. The trade name Cognac is reserved to this area alone, limited by legal decree since 1909, and is divided into six vintages. The Cognac region is home to more than 15,000 vineyards in an area of 350 square miles (900 km²), producing more than 190 million bottles of this prestigious beverage per year; more than 90 percent is exported, chiefly to the United States and Japan but also to other European countries.

**pp. 158–59
WOODED ISLAND
ON A LAKE ON
KENAI PENINSULA,
Alaska, United States
(N 60°46' W 150°12')**

Alaska, the largest of the fifty states in the United States, has an area of 600,000 square miles (1.5 million km²), equal to one-fifth of the entire country. Unlike most of the state, the Kenai Peninsula on the southern coast is protected from permafrost by a temperate maritime climate. It offers a landscape of forests and lakes with clear waters that reflect the sky, at least until winter temperatures freeze them over. The lakes' plentiful fish include rainbow trout, northern pike, and especially salmon, which swim upriver in the summer to the delight of the region's black bears and grizzlies. The salmon also attract sport and commercial fishing; 10 million of them are captured each year by the Alaskan food processing industry, which supplies half of the world's preserved salmon.

**pp. 160–61
GARDENS AT THE
CHÂTEAU OF
VAUX-LE-VICOMTE,
Maincy, Seine-et-
Marne, France
(N 48°34' E 2°43')**

The "Turkish carpets"—decorative gardens of boxwood hedges—of the château of Vaux-le-Vicomte are the work of the landscaper-architect André Le Nôtre. Designed for Nicolas Fouquet, minister of finance, the château was built in five years by approximately 18,000 workers. The garden, set off by several lakes and fountains, is 8,000 feet (2,500 m) long, which required the destruction of two hamlets. Fouquet invited the young king Louis XIV to visit in 1661; offended by the splendor of his subject's abode, the king ordered an investigation of Fouquet and had him arrested. Le Nôtre, for his part, was assigned the direction of the royal parks and gardens. He designed other gardens "à la française" for the châteaux of Saint-Germain-en-Laye, Saint-Cloud, and Fontainebleau, but his masterpiece remains the gardens of Versailles, the palace of the Sun King himself.

**pp. 162–63
MARSHLAND
IN KAUNOS,
Anatolia, Turkey
(N 36°55' E 28°40')**

These marshes lie downstream from Lake Köyceğiz, situated near the Aegean Sea and facing the island of Rhodes. At one time under the domination of Rhodes, ancient Kaunos now attracts many tourists to its ruined ramparts, tombs, and an amphitheater that seats 20,000. A beach at the edge of the marshland is home to the loggerhead sea turtle (*Caretta caretta*). In the 1990s steps were taken to protect these turtles from the effects of tourism, which is an important economic resource for the country. Turkey attracted 9.6 million visitors in 2000 (an increase of 40 percent over the previous year), a quarter of whom are Germans.

**pp. 164–65
WHALE OFF THE
VALDÉS PENINSULA,
Argentina
(S 42°23' W 64°29')**

After summering in the Arctic, whales return to the southern seas each winter to reproduce. From July to November, whales mate and bear their young along the coasts of the Valdés Peninsula in Argentina. This migratory marine mammal, of which there are eleven different types, was hunted for its meat and the oil extracted from its fat almost until extinction. Protective measures were adopted after international attention was focused on the problem in 1937. In 1982 a moratorium was declared on whale hunting for commercial purposes, and in 1994 the austral seas became a whale sanctuary; the Indian Ocean was established as a sanctuary fifteen years earlier. Despite these efforts it was estimated in 2001 that more than 21,000 whales have been killed since the enactment of the moratorium, mainly by Japan and Norway. After decades of protection, 7 of the 13 whale species, of which only a few thousand remain (10 to 60 times fewer than in the early twentieth century), are still endangered.

**pp. 166–67
NATURE RESERVE,
Arguin bank,
Gironde, France
(N 26°24' W 80°11')**

At the mouth of the Arcachon basin, between Cap Ferret and the Pilat dune (the highest in France, 350 feet, or 106 m, high), the Arguin bank shows through the waters of the Atlantic Ocean. The site is made up of a group of sandy islets that change form and position according to marine winds and currents on a relatively regular cycle of some eighty years, varying the area from 375 to 1,200 acres (150 to 500 hectares). It was declared a nature reserve in 1972. The Arguin bank serves as a place for short stops, hibernation, or nesting for many migratory bird species. It primarily hosts a colony of 4,000 to 5,000 couples of sandwich terns (*Sterna sanvicensis*), one of the three largest in Europe. Despite its protected status, the nature reserve is threatened by growing crowds of tourists and the development of oyster farming on its periphery. Mauritania has a protected area with the same name, the Arguin Bank National Park, which also receives many colonies of migratory birds.

water, whose turbulence fed electric power stations yesterday, serves to cool nuclear stations today.

It was only late in the game that cities cleaned themselves, installed gutters to evacuate soiled water and distribution networks to convey it, purified, to a faucet. The Europeans did not achieve running water and the bathroom until the nineteenth century. And it was only after Pasteur had demonstrated that we were drinking 90 percent of our illnesses that people committed themselves to real programs of decontamination and control of water. But while humans were becoming cleaner, they dirtied enormous quantities of water, and, making it their handmaid to drench, rinse, dissolve, dilute, heat, cool, transport, evacuate, or irrigate, they began to consume it in prodigious quantities. The sweat of an industrious civilization, water is sick and dirtied in countless ways.

EARTH IS A PLANET WITH DISEASED WATER

Driven by the demands of growth and by demographic explosion, humanity has indulged in an orgy of water wastage. Abusive deforestations and poor development practices, which defy natural filtration, have led directly to floods that each year cause 100,000 deaths all over the world, as well as to poor replenishment of running waters and ground water. Indirectly, this action contributes to the degradation of the climate. Each year the desert gains 15 million acres, while one-third of exposed land is already unsuitable to agriculture. The rivers in many places have been reduced to the condition of a canal; the 38,000 large dams that encumber them have changed their natural flow by more than 16 percent. These constructions can bring prosperity, just as they can generate serious problems by modifying the water equilibrium of entire regions.

In the past century the total area under irrigation throughout the world increased sevenfold, and it continues to grow. This area alone consumes 70 percent of freshwater used in the world, because of agriculture's enormous need for water; it takes 1,500 tons of water to bring one ton of wheat to maturity, and three times that for a ton of rice. In developing countries, where irrigation is vital, watered surfaces use almost all the water consumed. This is because agricultural irrigation is often poorly managed; three-fourths of the water evaporates and some gets lost in leaks. Irrigation is the principal cause of soil salination; ultimately, some 100 million acres are said to have been sterilized by excessive salt.

Since the 1960s water pollution has reached global proportions, becoming one of the most disturbing aspects of our civilization. Every year about 20 billion tons of various types of refuse ends up in the oceans—we are turning our rivers and oceans into garbage dumps. No one is spared; at Varanasi, the Ganges is transformed into a sewer, while the Great Lakes of North America are acidified by air pollution. The nature of the pollutants is as diverse as their source: heavy metals emitted by industry, which living beings concentrate in their organism; pesticides and nitrate fertilizers escaping from tilled fields to poison and asphyxiate the living waters; criminal leaks or expulsions of hydrocarbons—each year brings more sophisticated and more aggressive pollutants, requiring purification processes that grow more costly and elaborate all the time. We cannot continue to waste and soil freshwater without courting disaster; our habits must be changed, because water is no longer an inexhaustible resource. It is a legacy as rare as it is fragile, as indispensable as it is unevenly distributed.

It is illusory to believe that freshwater is abundant, because the earth's water is 97 percent saltwater, and of the remainder, three-quarters is immobilized in the form of ice or buried deep. The only available portion, a tiny fraction, represents less than one-thousandth of the earth's water. What we use up today represents one-tenth of the total annual flow of our rivers. From 1940 to 1990 global consumption increased fivefold while the earth's population doubled; it should increase by 4 to 8 percent per year if our usage does not change. Modern megalopolises, always thirsty, will fetch water from farther and farther away and drain the deep underground water resources. The agricultural demand for water in developing countries could double every twenty years. Water is one of the most poorly distributed natural resources, and the immutable sequence of its cycle, ignoring frontiers, masks cruel inequities. Fifteen percent of global freshwater resources is located in the Amazonian basin, which contains only 0.3 percent of the population, whereas 60 percent of the world land mass is in a situation of chronic water scarcity. While the privileged 9 percent of the world population consume nearly three-fourths of the available freshwater, half a billion people live in a state of deprivation in countries where water is used at a rate far ahead of its replenishment. It is predicted that in 2025, 1.5 billion people will lack a sufficient water supply. More than 2 billion people lack sanitary facilities, and illnesses carried by water kill more than 25 million per year in developing countries. Half of these victims are children. This squandering of water, these pollutions, and this runaway demand generate awesome tensions between countries—the wars of tomorrow might well be fought over water. Egypt is aware that eight African nations control the upper Nile Valley; Iraq and Syria know that Turkey can dam up the Tigris and Euphrates; and India is in constant discord with Bangladesh about the use of the Brahmaputra and the Ganges. Water has been decreed, justly, a world heritage. Humans, like all living beings, are the children of water, and water is their most precious commodity, one that they must now distribute and use better, wasting and polluting less. It is a matter of survival. Technology is already giving hope in the areas of seawater desalination; the mining of freshwater from submarine springs; the trapping of water from fog in desert countries; and new methods of irrigation by spraying and by drip, tech-

niques supported by computer that can economize as much as 70 percent of our water. Biologists are currently determining which food plants require the least amount of water.

To reduce the waste of water in industrial and domestic life, northern European countries are setting up chains of businesses that exchange their refuse, which can become raw material, and Japan puts laundry water through a simple treatment process for reuse in toilet tanks. Following the example of space shuttles, we are learning to recycle water on earth. It is also possible to improve the purification of our effluents and reduce pollution more effectively, starting at the product-manufacturing stage.

The water problem has to be addressed globally; on the level of everyday life, it concerns every one of us. On a planet that, seen from space, is blue and white, the colors of ocean and cloud, water has become the symbol of life. In the transparence of its perfect drop, it reveals in equal measure the concern for an uncertain future and the fragile gleam of hope that, at last, we may use it wisely.

Bernard Fischesser and Marie-France Dupuis-Tate

FISH MARKET NEAR DAKAR,
Senegal
(N 14°43' W 17°26')
The 435 miles (700 km) of the Senegalese coast benefit from a seasonal alternation between cool currents rich in minerals coming from the Canary Islands and warm equatorial currents. This makes the shoreline favorable to the development of rich and varied marine fauna. Eighty percent of coastal fishing is practiced from pirogues, dugout canoes of baobab or kapok trees, using lines or nets. But the fish also attract higher-speed European boats, to the detriment of the coastal countries. Nearly 400,000 tons of fish are caught annually, making it Senegal's chief economic resource. Most of the fish goes to the local market; tuna, sardines, and cod are sold right off the beach at the landing points of the pirogues. The Senegalese, like 1 billion residents of developing countries, depend on fish for 40 percent of the protein in their diet.

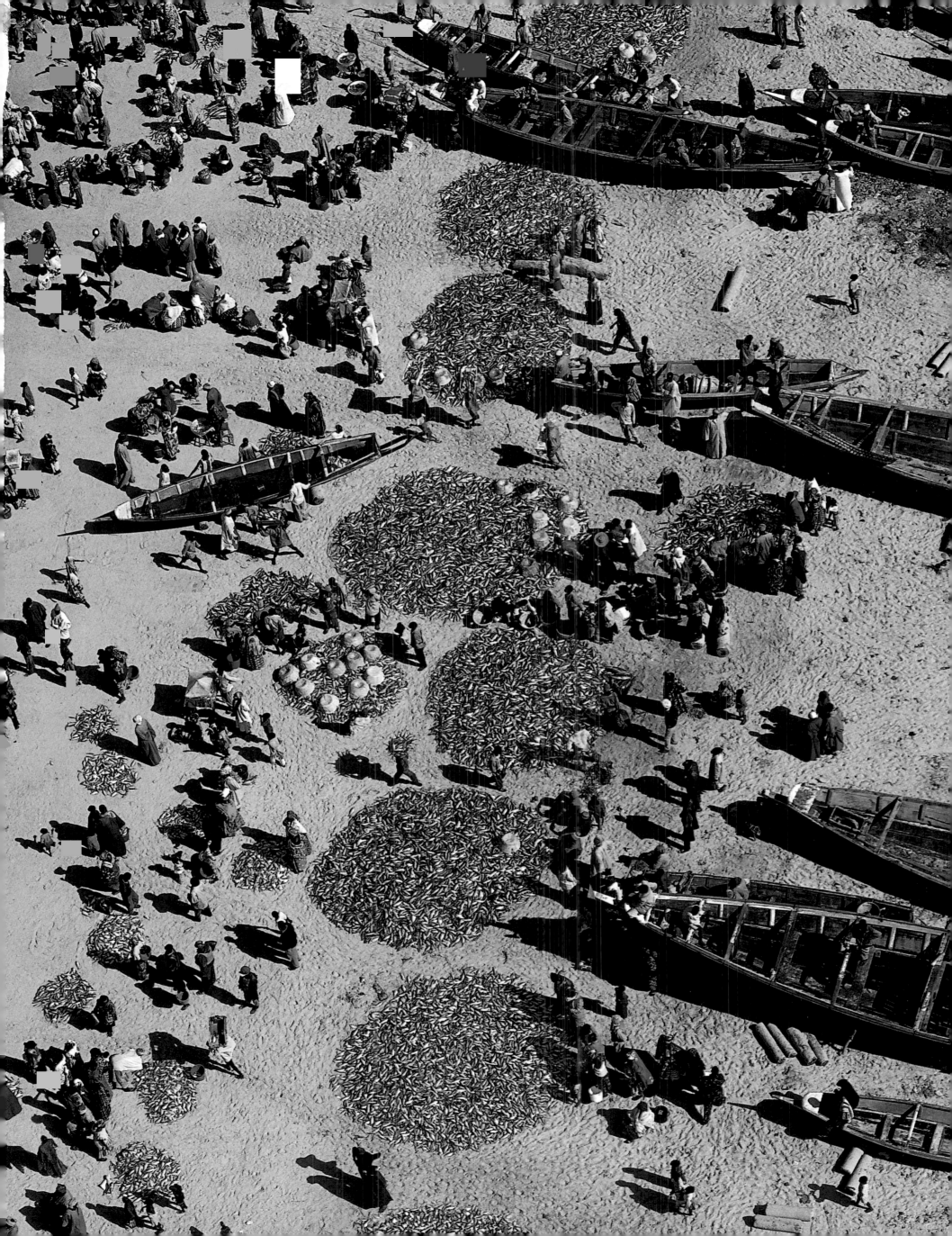

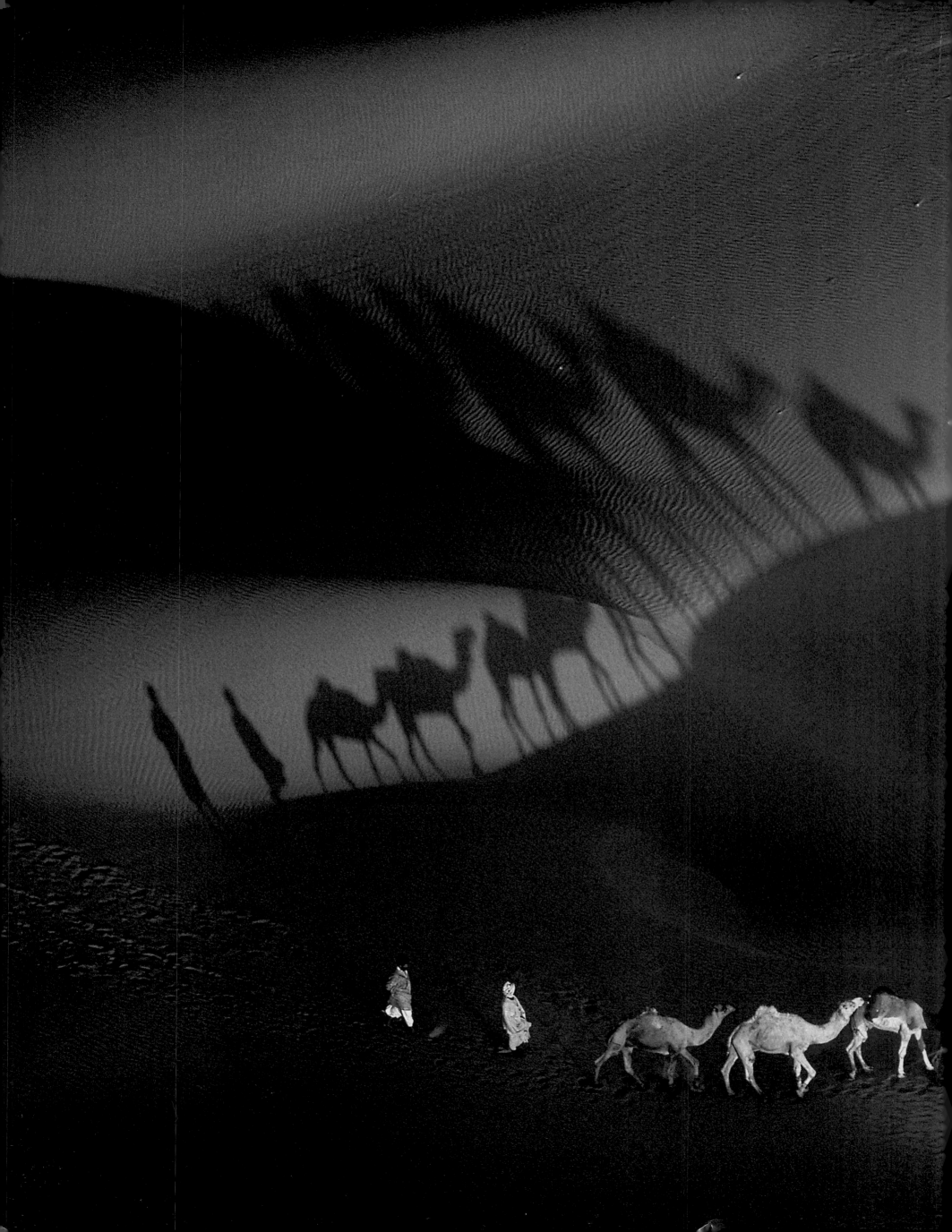

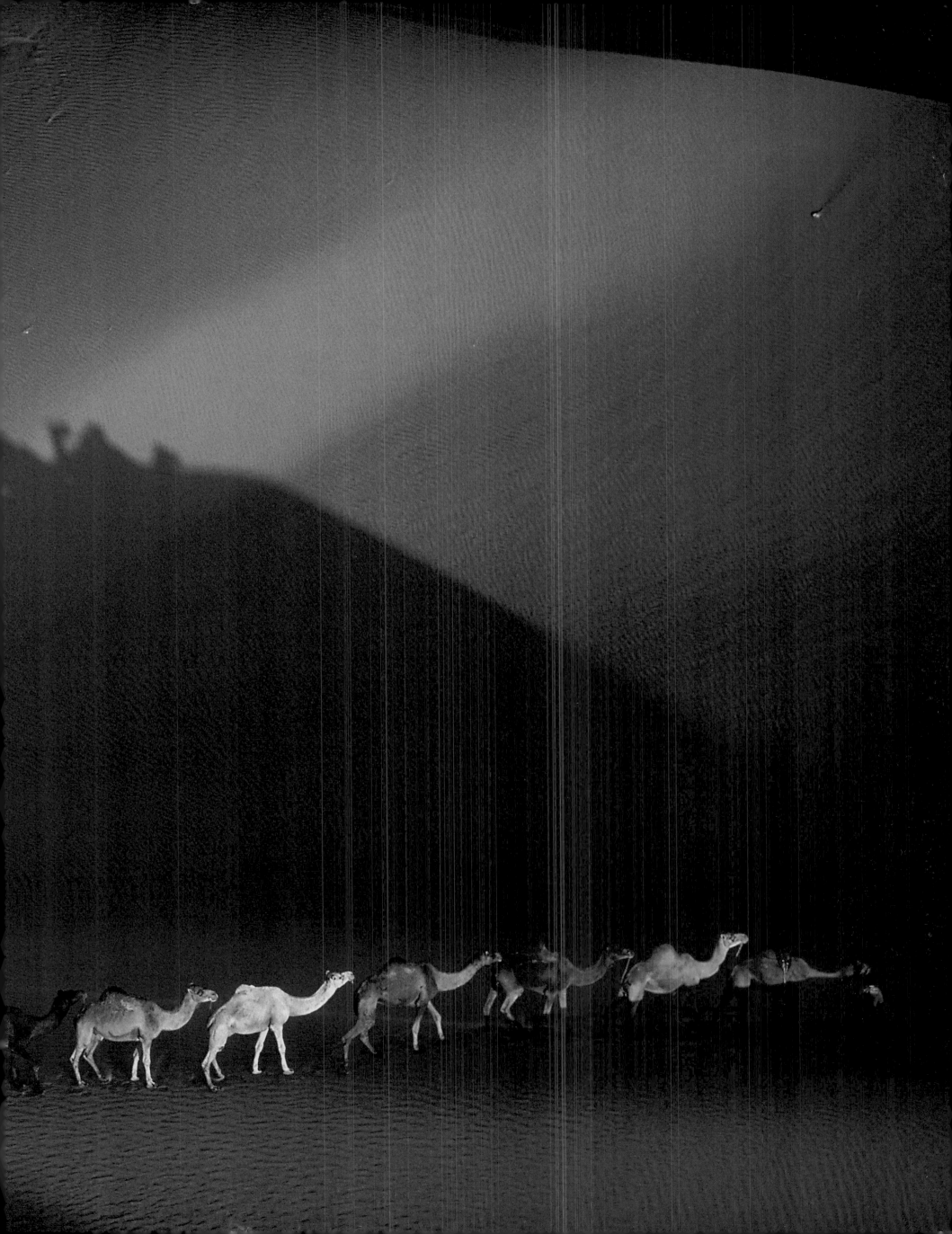

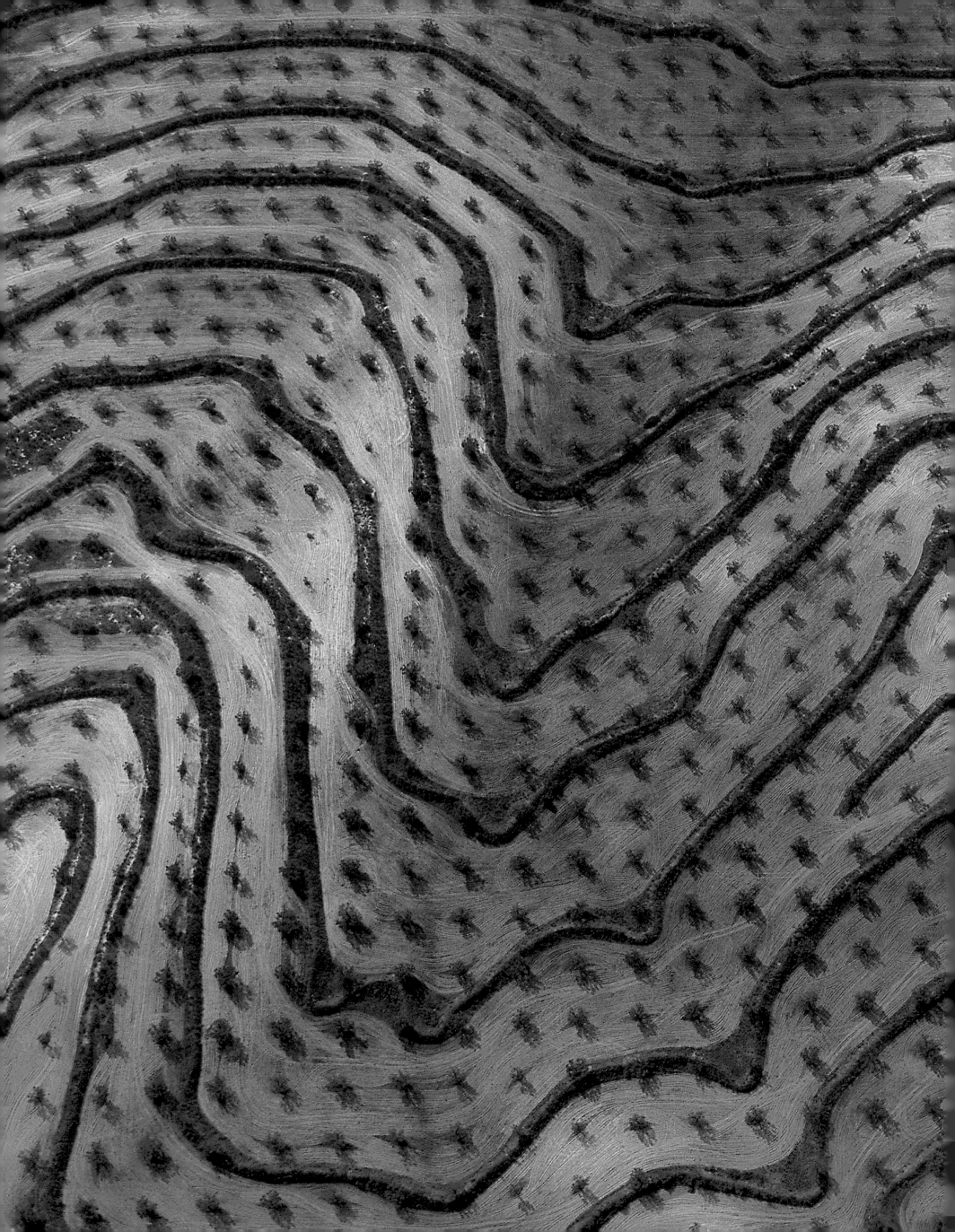

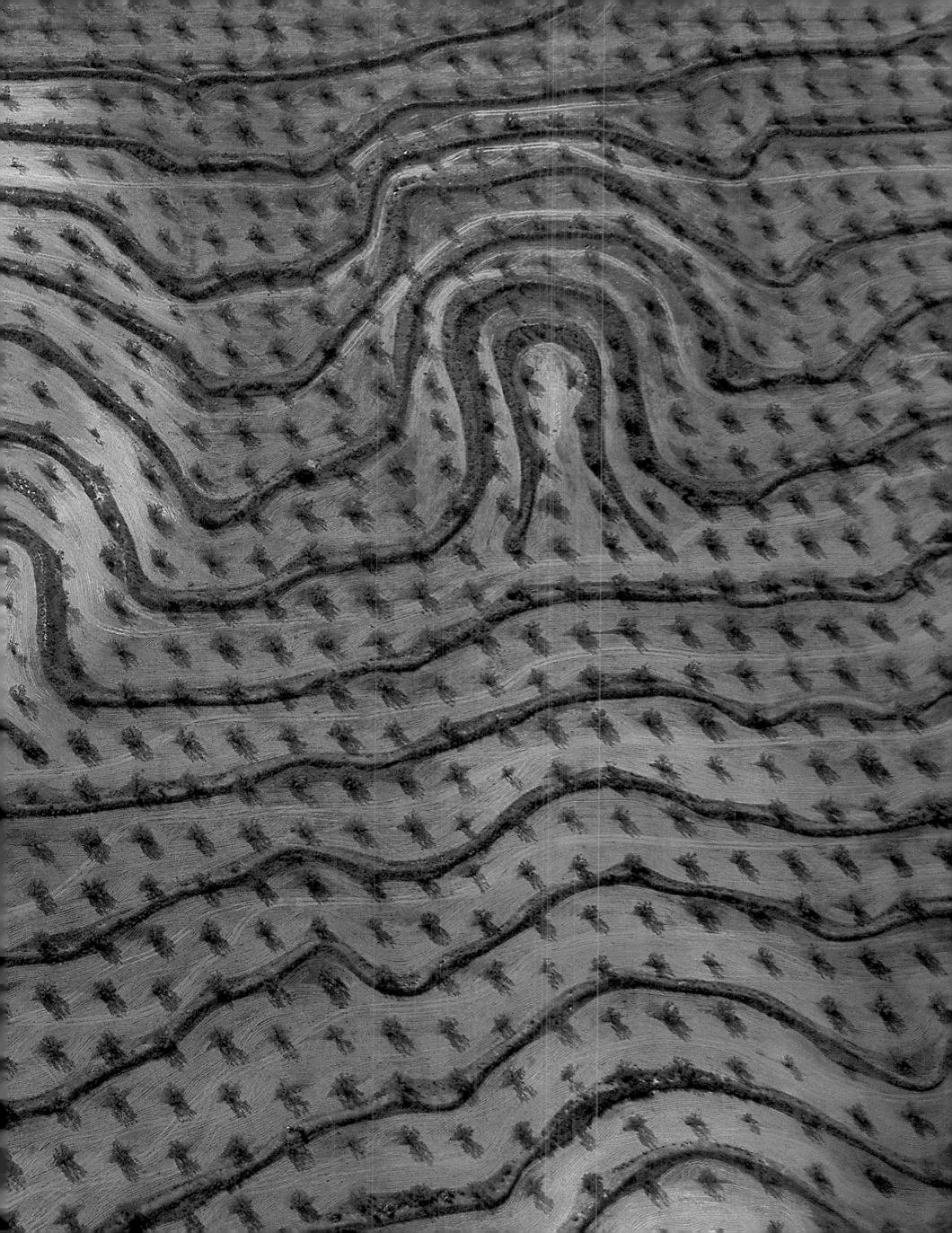

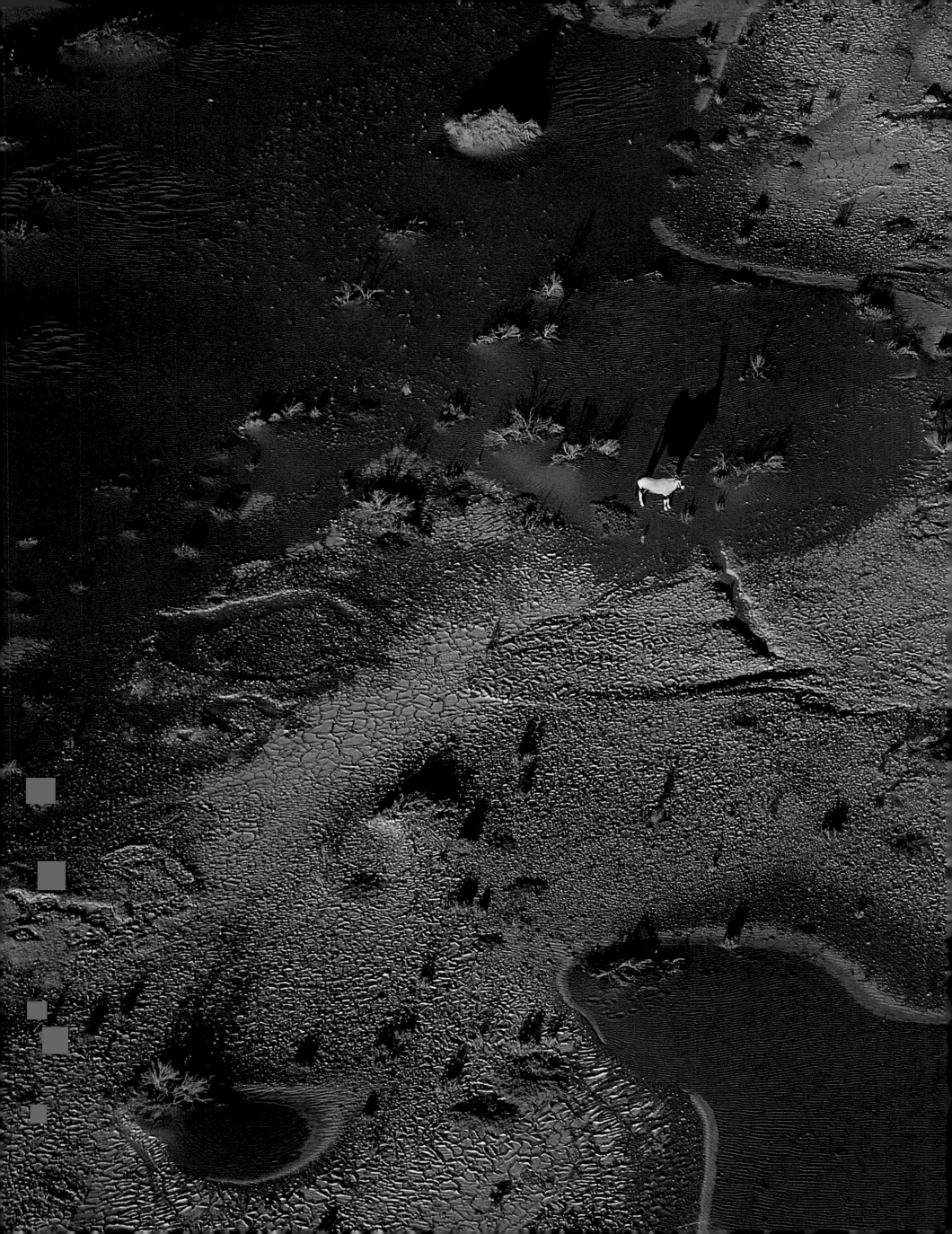

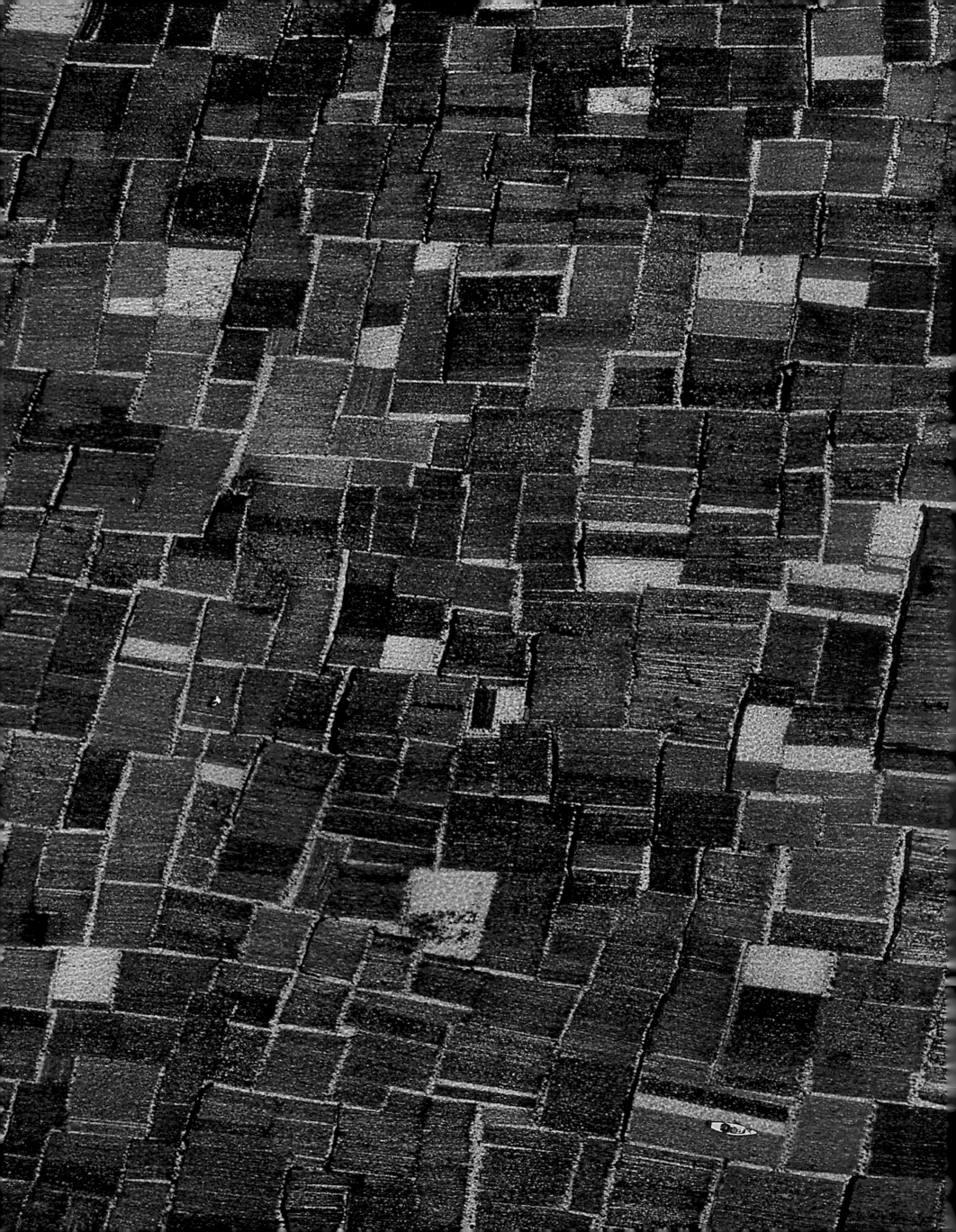

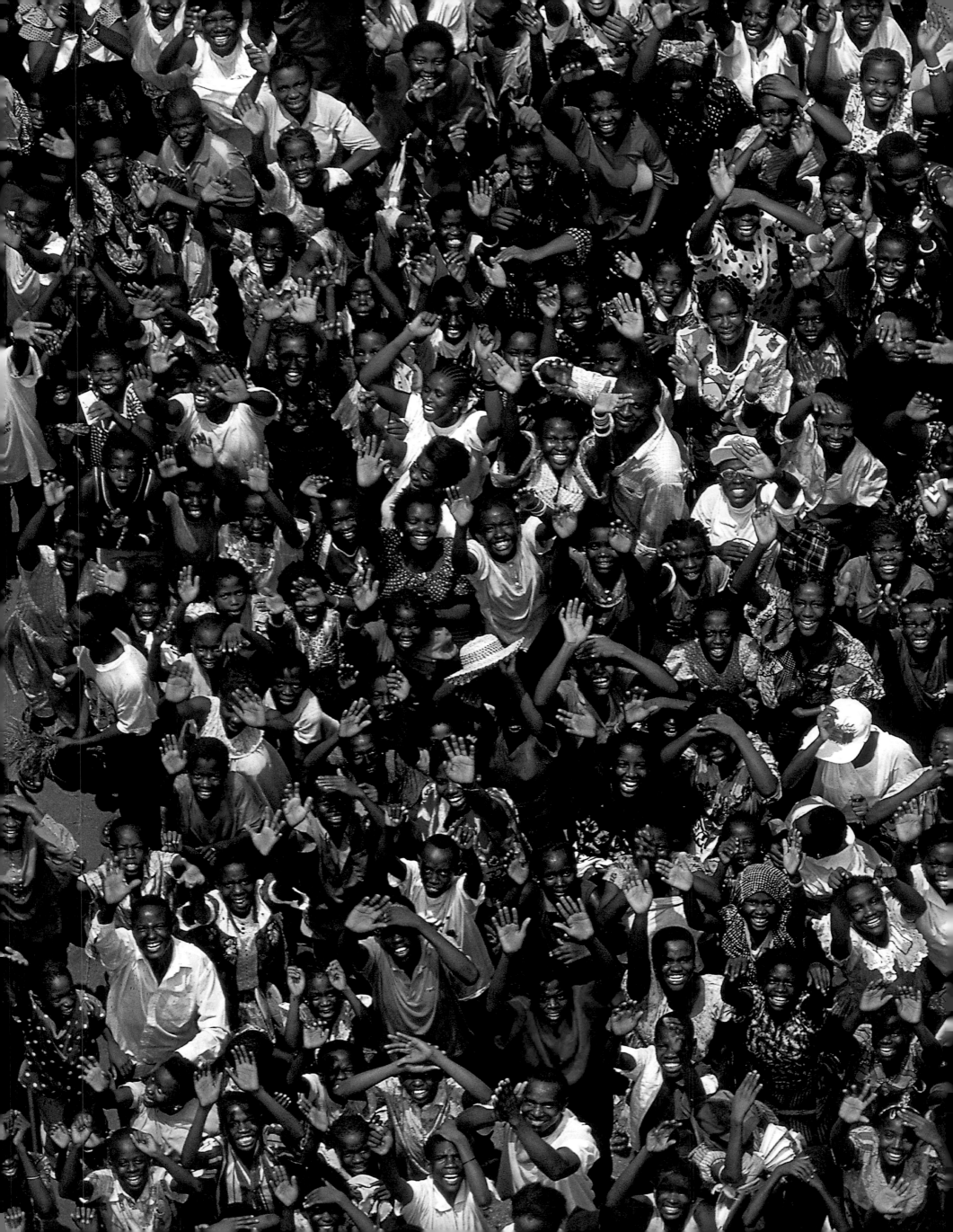

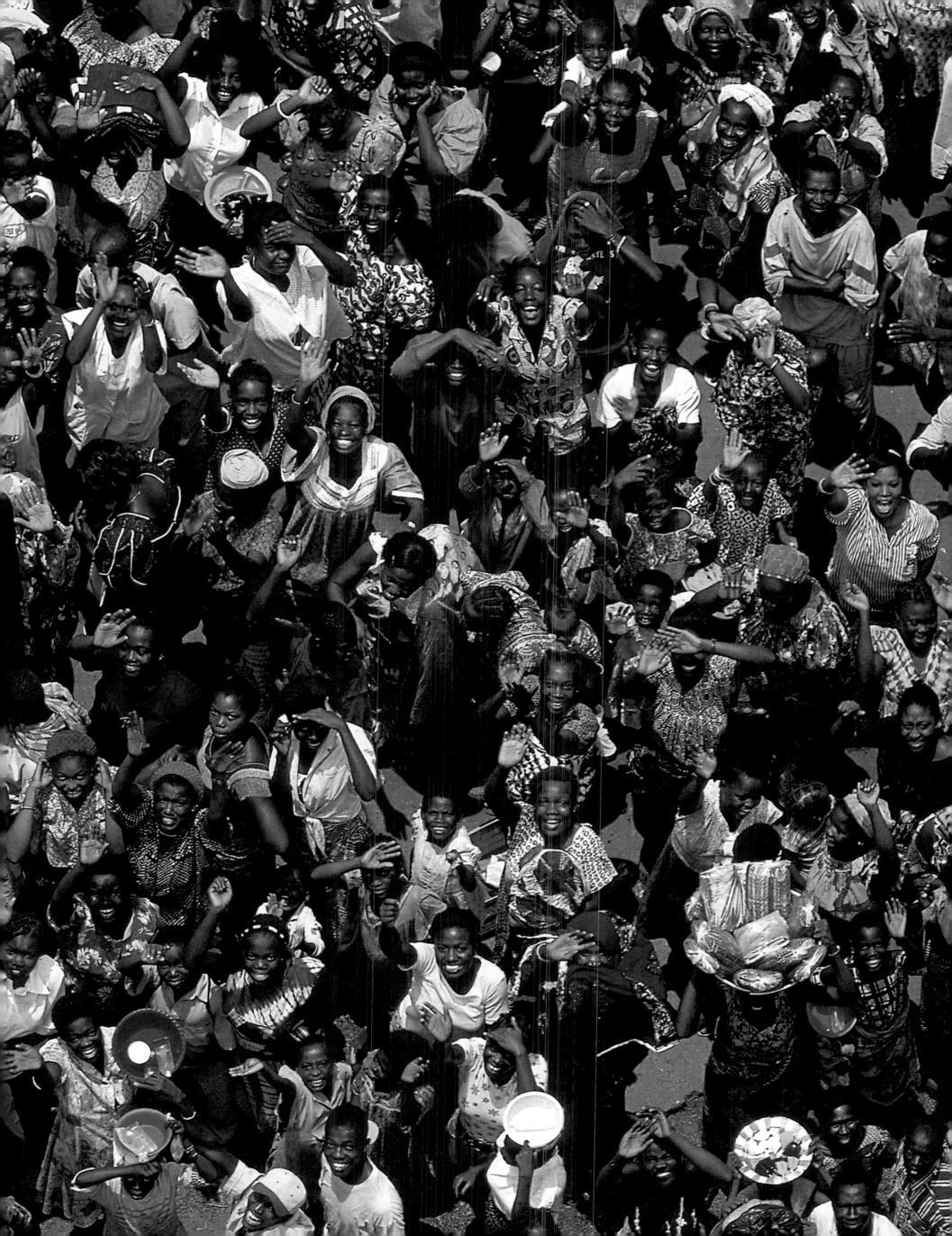

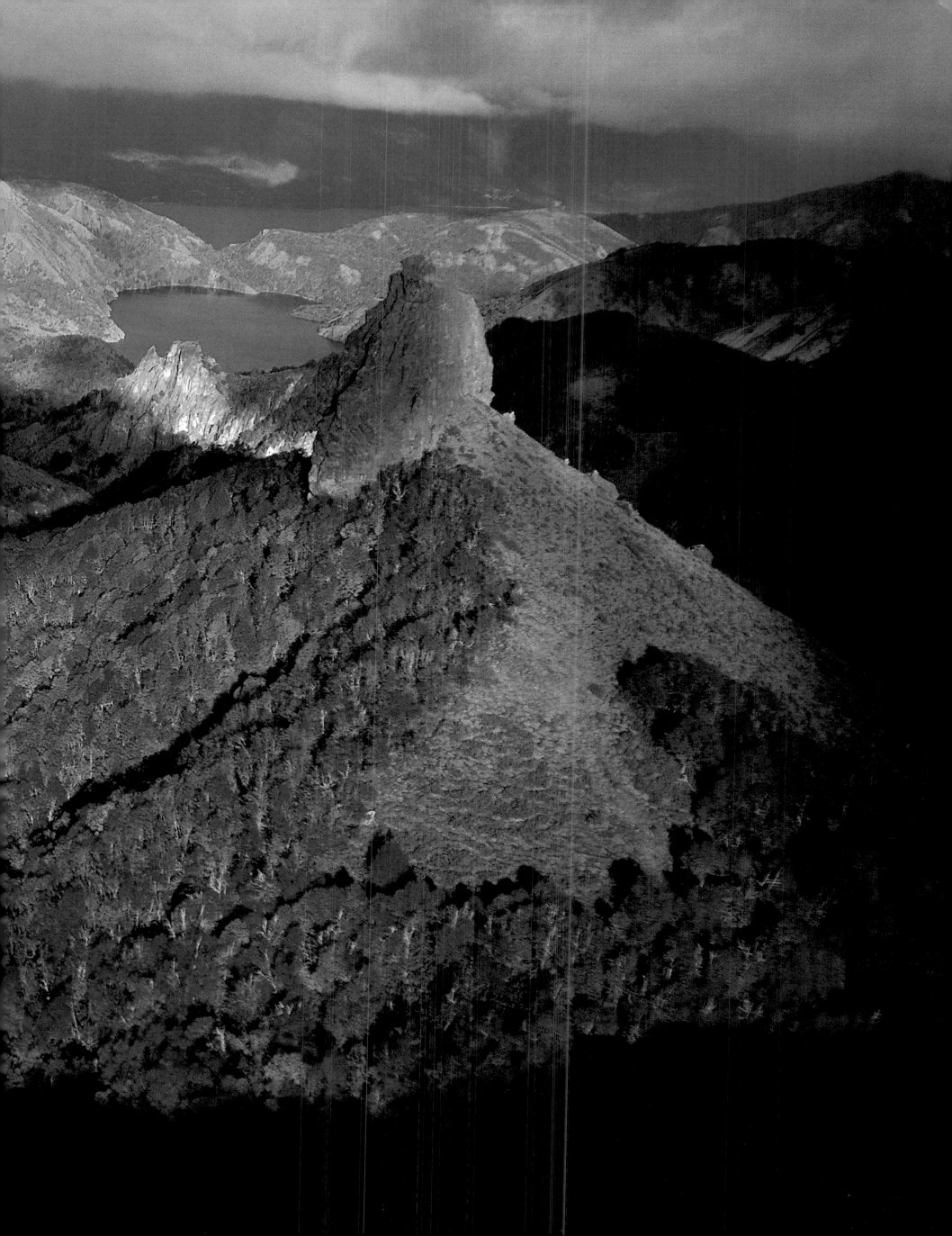

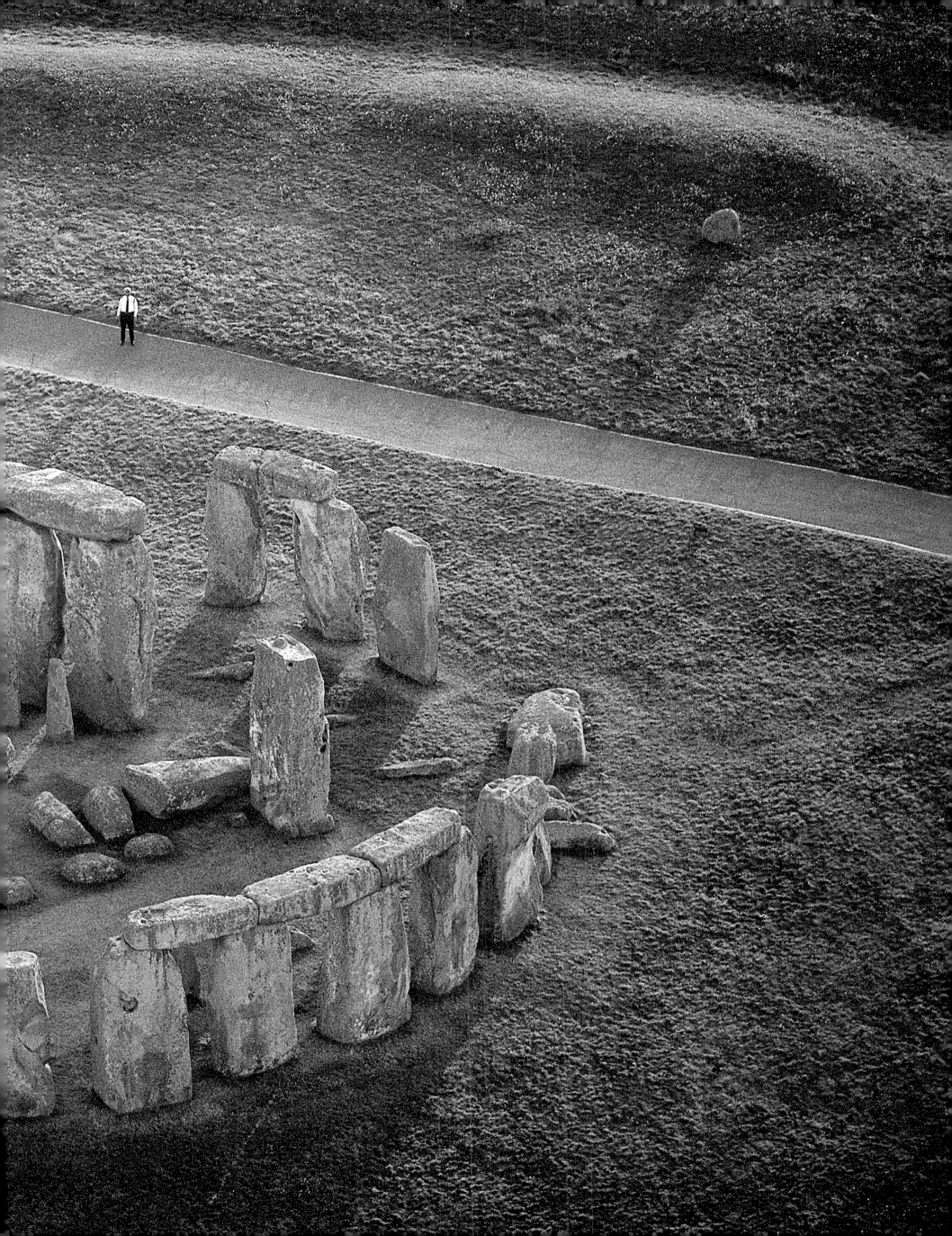

BIODIVERSITY:
A QUESTION OF SURVIVAL

Viewed alongside other living species, humankind stands apart. We managed to take advantage
of the earthly environment to reduce our mortality and increase our birth rate, and thus our
numbers constantly rise. Yet this mastery and exploitation of the environment has caused entire
species to perish, and others are in the process of disappearing. Will we learn to stop destroying life?
Every species plays its role in the global equilibrium of the environment to which we belong,
and we ignore this at our peril.

Encased in the huge Russian taïga, Lake Baikal, the greatest freshwater reservoir in the world, draws a long comma through the heart of Asia. At Irkutsk, the closest city, naturalists strive to count and identify the plant and animal species that inhabit the lake. No fewer than 2,600 species have been inventoried, three-quarters of which are specific to Lake Baikal and exist nowhere else on earth. Why so many entirely different species, when the lake might just as well contain only one—or none? But then we would no longer be on planet earth, where for nearly 4,000 years species have constantly diversified, feeding one another. We could imagine Lake Baikal functioning with one type of seal, which would feed on one species of fish, and this fish would subsist on a single crustacean species, which in turn would live at the expense of an algae produced by photosynthesis, occupying the base of this four-story ecological pyramid. The pyramid is purely theoretical, however, because in reality on each level below seals (only one freshwater seal exists, the nerpa) we can count numerous species of fish, shellfish, and algae. During the 60 million years of the lake's formation, biological evolution has constantly diversified and increased the numbers of species, in the process of life.

Not one environment exists, whether natural or artificial, forest or garden, steppe or cultivated field, where we fail to recognize at first glance different species, to every one of which scientists have given a name. The diversity of life is the guise in which nature appears to us, and the same applies within each species, including our own. In a crowd, no two faces are identical, except twins who share the same hereditary substance. In the same way, no two spotted cows, no two cats or oak trees are absolutely identical, even if these often minuscule differences

TOURISTS ON A BEACH AT FUERTEVENTURA,
near Corralejo, Canary Islands, Spain
(N 28°43' W 13°52')
Fuerteventura, the second largest of the Canary Islands, has the most expansive beaches of the entire archipelago. Taking advantage of one of many isolated inlets, these tourists are enjoying the pleasures of nudity and full-body tanning. No doubt inspired by the practice of local farmers, they have built a low wall of volcanic stone as protection from the winds from the Sahara that continually sweep the coast, to the great joy of wind surfers. Fuerteventura was selected as the site for the largest hotel complex in the world, but the island's shortage of freshwater, a problem for nearly 20 percent of the population of the archipelago, quickly caused the ambitious project to be dropped. Tourism nevertheless remains the chief industry of the Canaries, which receive 4 million visitors each year, 97 percent of whom come from Germany. Spain, the world's third most popular tourist destination after France and the United States, committed itself in 1995 to developing a sustainable form of tourism—better integrated into the local economy and less harmful to the environment.

appear more clearly within our own species. We can identify a face, but our eye is not practiced enough to distinguish between two spruce trees or two violets of the same species.

To recognize the species, describe their characteristics, and classify them—this is the job of natural scientists, who are unfortunately too rare; today they are replaced in our universities and research institutes by molecular biologists or geneticists, whose influence now rules biology. What a strange paradox, just when there is so much talk of preserving spaces and species. How can we protect them if we do not even know them?

In the fishermen's nets at Lake Baikal it is easy to identify the famous golomyanka, a strange carnivorous fish that feeds 50 percent on crustaceans and 50 percent on its own young. Stranger yet, these fish do not lay eggs in water as all other members of their genus do but give birth to larvae and then die. In addition to these oddities, they are perfectly transparent, to the extent that one could, it is claimed, read a newspaper through their bodies. But the fishers on Lake Baikal also eat plentifully of sculpin, omul, and many other fish, and they also eat seals. Birds, humans and seals, and fish are part of three large groups of vertebrates known on the planet today: 9,950 species of birds, 4,360 of mammal, and 25,000 of fish; in addition to the 7,400 species of reptile and 4,950 of amphibians (the last group is the most endangered). Yet these figures are modest when compared to the 270,000 species of flowering plants—including more than 50,000 species of treees—and the 950,000 insect species. Altogether, today some 1.75 million species have been identified. Our extremely approximate estimate of the total number of species in nature varies from the most modest figure of 10 million up to much higher figures

posited by others. After all, innumerable worms, arachnids, mollusks, algae, insects, and mushrooms are still entirely unknown to us.

This diversity is particularly great in intertropical forests, which alone contain a good half of all species on the planet. A northern forest of conifers has scarcely more than two species of tree per square kilometer, whereas a temperate zone forest of the eastern United States has as many as twenty, and an Amazonian forest has several hundred. Thus, it is no surprise that Brazil holds the record for the number of vertebrate species (6,100) and the number of higher plants (56,200). These records are nearly matched by the tropical forests of America and Southeast Asia, although the African forests have fewer species. It is important, however, not to confuse the notion of species with that of population, which indicates in a given area the number of individuals that belong to each of the known species. The human species today has more than 6 billion individuals, but we are far from being able to compute this number for each of the known animal or vegetable species. The most we can say is that by adding up all of the trees on the planet, we can count 500 trees per inhabitant.

This biological heritage, this biodiversity, is subject to continuous erosion, because of the constantly accelerating pace of human activity. In the tropical forests, we cut, burn, and flood hundreds of thousands of square miles each year to obtain timber and arable land, to build roads, to exploit petroleum concessions, or to create huge retaining basins for dams. The land lost in this manner each year is equal to the area of Belgium or the state of Maryland.

Scorched-earth farming, carried out by poor peasants on lands cleared by fire in order to exploit new arable surfaces, is not, as is sometimes claimed, the only predatory practice at the expense of forests. The big landowners often practice unacceptable timber exploitation, bulldozing hundreds of trees in order to find a few that are "of interest"; this ravages the forests, marginalizes native populations, and leaves the ground skeletal, disfigured, and unsuitable for farming. At the current rate all tropical forests could disappear within a half-century, along with the innumerable species they shelter.

DEFORESTATION IN AMAZONIA.
Mato Grosso do Norte, Brazil
(S 12°38' W 60°12')
The exploitation of the Amazonian rainforest epitomizes the destruction of the world's cultural and natural heritages by the expansion of an unjust, devastating economic system. In the final years of the twentieth century the phenomenon has only accelerated: the lands cleared by early 1999 altogether exceed 220,000 square miles (560,000 km²). Since 1993, in an attempt to ensure the survival of this resource, labels that identify the source of the wood have been used on some products, enabling consumers to purchase products derived from forests with sustainable methods of exploitation, which respect the rights of native populations and allow renewal of resources. These labels, although not yet pervasive, mark the beginning of the era of responsible, well-informed consumption.

**pp. 218–19
TSINGY OF BEMARAHA,
Morondava region,
Madagascar
(S 18°47' E 45°03')**

The strange mineral forest of Tsingy of Bemaraha stands on the western coast of Madagascar. This geological formation, called a karst, is the result of erosion, as acid rains have gradually dissolved the stone of the chalky plateau and carved out sharp ridges that can rise to heights of 95 feet (30 m). This nearly impenetrable labyrinth (*tsingy* is the Malagasy term for "walking on tiptoe") shelters its own unique flora and fauna, which have not been completely recorded. The site was declared a nature reserve in 1927 and a UNESCO world heritage site in 1990. Madagascar is a 230,000-square-mile (587,000 km²) fragment of earth produced by continental drift, isolated for 100 million years in the Indian Ocean off the coast of southern Africa, and has thus developed distinctive and diverse animal and plant species, sometimes with archaic characteristics. It has an exceptional rate of endemism: more than 80 percent of the approximately 12,000 plant species and nearly 1,200 animal species recorded are indigenous to the island only; but close to 200 Madagascan species are in danger of extinction.

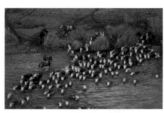

**pp. 220–21
FORDING THE
CHIMEHUIN RIVER,
Neuquén Province,
Argentina
(S 40°03' W 71°04')**

Patrolled by *gauchos*, this herd of Hereford cows crossing the Chimehuin river is returning to its home in the fields after seasonal migration to the high-lying pasturelands of the Andes cordillera. Partly covered by a thorny steppe, Neuquén is better suited for raising sheep than cattle, which remain a minority in the Patagonian region. Most of the country's bovine livestock live farther north, in the vast grassy plains of the pampa. These nearly 55 million cows consist primarily of breeds that originated in Great Britain or France. The world's fourth-largest producer, Argentina exports its beef products, famed for their fine flavor, throughout the world. Argentinians are the world's leading consumers of beef: nearly 145 pounds (65 kg) per person per year. Yearly per capita consumption is 100 pounds in the United States, 84 pounds in Australia, 14.3 pounds in the Philippines, and 9.3 pounds in China (double the consumption five years ago).

**pp. 222–23
AL-DAYR,
Petra, Maan region,
Jordan
(N 30°20' E 35°26')**

Jordan occupies a strategic position between the Mediterranean and the Red Sea. In the seventh century B.C. the Nabataeans, a people of merchant nomads, settled here. They carved a city out of the pink and yellow sandstone of the cliff in the southern part of the country and made it their capital. They called it Petra, the Greek word for "rock." Through the trade of rare products (incense from Arabia, spices from India, gold from Egypt, silk from China, and ivory from Nubia) and taxation of caravan routes, Nabataean civilization extended its influence far beyond the trans-Jordan region before it fell to the Romans in 106 A.D. Al-Dayr, standing at the top of the city, was built between the third and first centuries B.C. Because of its imposing stature (138 feet high and 148 feet wide, or 42 x 45 m), it dominates the approximately 800 monuments of Petra. Petra was declared a world heritage site by UNESCO in 1985, but a new threat has begun to menace the cliffs in the past few years: mineral salts dissolved in groundwater that reaches the base of the monuments become encrusted on the stone and make it fragile. Wind adds to the progressive degradation of the monuments.

**pp. 224–25
FISHING NETS IN THE
PORT OF AGADIR,
Morocco
(N 30°26' W 9°36')**

At Agadir, Morocco's leading fishing port, nets measuring several hundred feet in length are stretched out on the ground for repairs to be made before the next sea outing. Employing trawlers and small motorboats, 75 percent of Moroccan fishing remains a small-scale activity. The Moroccan waters, with 2,135 miles (3,500 km) of sea coast, are home to nearly 250 species of fish, notably sardines. The sardines swim along the shore to feed from the upwelling of the nutrient-rich lower waters. Sardines make up more than 80 percent of the catch and have made Agadir the world's leading sardine port. Since 1970 the world fishing output has doubled, reaching 126 million tons in 1999, mainly because of a spectacular increase in aquaculture: production through that means, which is now 20 percent of the world fishing total, has quadrupled in twelve years. As for the increase in captive fishing, made possible by a sixfold increase in the world fleet since 1970, it is now leading to a reduction in fishery resources: 11 of the 15 major fishing zones in the world are in decline.

**pp. 226–27
VINEYARDS,
region of La Geria,
Lanzarote, Canary
Islands, Spain
(N 28°48' W 13°41')**

Lanzarote, one of seven islands in the Spanish archipelago known as the Canaries, lies closest to the African continent. Agriculture is difficult because of the island's desert climate and the total absence of streams and rivers on its territory of 313 square miles (813 km²). Its volcanic origins, however, have provided the island with a fertile black soil made up of ash and lapilli over a substratum of fairly impermeable clay. Residents have developed a distinctive viticultural technique to adapt to these original natural conditions. Vine stocks are planted individually in the center of holes dug in the lapilli in order to draw on the accumulated moisture, shielded from the dry winds from the northeast and Saharan regions by low, semicircular stone walls. Spain's total wine production represents nearly 12 percent of the approximately 80 million gallons (300 million hectoliters) of wine produced worldwide each year, ranking third among producing countries after France and Italy.

**pp. 228–29
ORCHARD AMONG
THE WHEAT,
Salonica region,
Macedonia, Greece
(N 40°26' E 23°07')**

Subject to the continental climate, the fertile plain of Salonica, the largest in Greek Macedonia, is particularly suited to raising wheat and sometimes fruit trees. Because of the hilly terrain of the Greek peninsula, farms remain small and fragmented despite programs for grouping lands and farm cooperatives. Thirty-three percent of the country's ground area is cultivated, which is not sufficient to make Greek agriculture (16 percent of its GNP) truly competitive within the European Union. The widespread urbanization of the country during the 1970s caused the farm population to seriously decline; today it is only one-fourth of the active population, yet it remains the largest in Europe.

**pp. 230–31
HOUSE IN KEREMMA,
on Kernic cove at low
tide, Finistère, France
(N 48°39' W 4°13')**

On the English Channel coast of Brittany, this house was built in 1953 on a narrow spit of granite sediment that extends the dunes of Keremma and closes the Kernic cove almost entirely. Looking out on great expanses of sand at low tide, this thin dune is almost totally surrounded by water when the sea rises again. Rough ocean winds and the daily rise and fall of the tides (about 26 feet, or 8 m) are gradually eroding the fragile support for this isolated home. The house, which in 1983 stood nearly 150 feet (45 m) inland, by 1999 was just 6 feet (2 m) from the cliff edge overhanging the sea. It disappeared from the landscape in March 2000, when the inevitable erosion of the dune forced the owner to have it demolished before it could collapse. Installations by the shore conservation agency are trying to protect the Keremma dunes against the erosive action of the surf. Tides, daily shifts in the height of the coastal waters resulting from lunar and solar attraction, are typical of all the earth's seas, creating differences varying from just an inch (2.5 cm), such as in the Mediterranean Sea, to more than 52 feet (16 m) in the Bay of Fundy, an inlet of the Atlantic Ocean in Canada, which has the highest rises in the world.

Captions to the photographs on pages 232 to 247 can be found on the foldout to the right of the following chapter

captions 218–231 ↓ captions 232–247 ↓

(N 48°39' W 4°13')

(N 30°20' E 35°26')

(N 40°26' E 23°07')

(N 28°48' W 13°41')

(S 18°47' E 45°03')

(S 12°38' W 60°12')

(N 30°26' W 9°36')

(S 40°03' W 71°04')

(S 22°55' W 43°15')

(S 14°41' W 75°08')

(N 51°11' W 1°50')

(N 15°04' W 91°12')

(N 28°43' W 13°52')

(N 27°43' E 85°22')

(S 40°40' W 71°16')

(S 6°44' W 3°29')

(S 25°15' E 153°10')

(S 27°24' W 54°24')

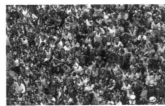

**pp. 192–93
CROWD IN
ABENGOUROU,
Côte d'Ivoire
(N 6°44' W 3°29')**

This colorful crowd, enthusiastically waving to the photographer, was photographed in Abengourou, in eastern Côte d'Ivoire. These children and adolescents remind us of the country's youthfulness; as in most of the African continent, 40 percent of the population is under 15 years of age. The country's birth rate is 5.1 children per woman, which is representative of the average for the continent (the world average is 2.8). Modernization and cultural and socioeconomic influences have gradually lowered the birth rate. The ravages of the AIDS epidemic in subsaharan Africa (home to 70 percent of the total 36.1 million people infected in the world) will have a severe impact on the region's demography: every day in Africa 6,000 people die of the AIDS virus and another 11,000 become infected.

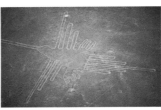

**pp. 194–95
OUTLINE OF A
HUMMINGBIRD
IN NAZCA,
Peru
(S 14°41' W 75°08')**

Two thousand years ago the Nazca people dug grooves in the desert earth of the Peruvian pampa, tracing impressive geometric figures and stylized depictions of plants or animals. This hummingbird, measuring about 320 feet (98 m), is among eighteen different silhouettes of birds in the area, which was declared a world heritage site by UNESCO in 1994. Beginning in the 1940s until her death in 1998, the German mathematician Maria Reiche was tirelessly involved in the recovery, maintenance, and study of these lines. Thanks in large part to her efforts, we can still admire what were probably devotional religious images. The Nazca Lines, the nearby burial complex, and other important archaeological finds are threatened today by *huaqueros*, tomb robbers, as well as by the influx of tourists, erosion, and industrial pollution.

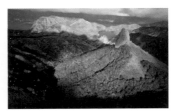

**pp. 196–97
BEECHES IN THE
MOUNTAINS OF
VILLA TRAFUL,
Neuquén province,
Argentina
(S 40°40' W 71°16')**

In the midst of Nahuel Huapí National Park in southwestern Neuquén province, Argentina, many high-lying—at average altitudes of 2,300 feet, or 700 m—glacial lakes of brilliant blue water are seen at the foot of mountains and rocky peaks of the Andes range. The region's humid climate favors the growth of southern beech trees (of the *Nothofagus pumilio* and *antarctica* varieties), which have spread over the mountainsides, enlivening them with flamboyant hues in autumn. Farther south, at steadily declining altitudes, the beech forests thin out, giving way to the steppe of Patagonia. The stretch of the Andes chain between Argentina and Chile, extending for approximately 3,100 miles (5,000 km), is the longest natural land frontier on the planet. It includes Aconcagua Mountain, the highest peak in the Western Hemisphere at 22,800 feet (6,960 m), which dominates the entire continent of South America.

**pp. 198–99
FARM LANDSCAPE,
northwest of Guatemala
City, Guatemala
(N 15°04' W 91°12')**

Guatemala City, the nation's capital, stands at an altitude of 4,920 feet (1,500 m) in a volcanic mountainous zone, and the valleys that surround it are covered with fertile lava. Half of the active population works in agriculture, the country's chief economic resource. The vast majority of farmers (90 percent) each own less than 17 acres (7 hectares) of land. Corn (the chief food staple) and coffee (which represents 50 percent of the nation's exports and of which Guatemala is ranked eighth in world production) are the main cash crops. Severely affected by Hurricane Mitch in 1998, then by several intense droughts, Guatemala, like the entire Central American isthmus, suffered in 2001 from a dramatic collapse in the price of coffee, which brought distress and famine to farmers and plantation workers. This series of calamities was not due to fate alone; economic policy of the 1990s, perpetuating social inequities and opposing democracy, also played its part.

**pp. 200–201
SAND DUNE IN
THE HEART OF
VEGETATION ON
FRASER ISLAND,
Queensland, Australia
(S 25°15' E 153°10')**

Fraser Island, off the coast of Queensland, Australia, is named after Eliza Fraser, who was shipwrecked on the island in 1836. At a length of 75 miles (120 km) and a width of 10 miles (15 km), it is the world's largest sand island. Yet on top of this rather infertile substratum, a humid tropical forest has developed in the midst of which wide dunes intrude, moving with the wind. Fraser Island has important water resources, including nearly 200 freshwater lakes, and has varied fauna such as marsupials, birds, and reptiles. Exploited for its wood since 1860, used for the construction of the Suez Canal, the island was later coveted by sand companies during the 1970s. Today it is a protected area and was declared a world heritage site by UNESCO in 1992.

**pp. 202–203
STONEHENGE,
Wiltshire, England
(N 51°11' W 1°50')**

Rising out of the Salisbury plain in southern England are the impressive remains of Stonehenge ("hanging stones"), built in several phases between 2800 and 1900 B.C. The monument was originally made up of about 125 monoliths arranged in four concentric circles, of which only the first two survive. These blocks of sandstone, weighing up to 30 tons and as tall as 23 feet (7 m), came from diverse regions, some even hundreds of miles away. The site was constructed so that the sun rises in the axis of the main doorway on the morning of the summer solstice. In addition to its role as an astronomical calendar, Stonehenge might have been the center of religious cults, of which we have lost all traces. Along with the site of Avebury, also in Wiltshire, Stonehenge was named a UNESCO world heritage site in 1986. These witnesses of European prehistory have survived through the ages, retaining part of their mystery.

**pp. 204–205
PLANTED FIELDS
ON THE BANKS OF
THE RIO URUGUAY,
Misiones province,
Argentina
(S 27°24' W 54°24')**

This province in northeastern Argentina, named for the Jesuit missions founded here between the sixteenth and eighteenth centuries, was originally covered with tropical forests. For nearly a century, however, European colonists deforested a major portion of the territory in order to exploit the red earth, which is rich in iron oxide and very fertile. Working along the contours of the land, leaving strips of grass between the furrows in order to reduce erosion, they developed various crops such as cotton, tobacco, tea, maté, sunflower, rice, and citrus. The farmers took advantage of the vast hydrographic network that waters this region between the Paraná and Uruguay Rivers, which is appropriately named Mesopotamia (the name means "between the rivers" in Greek).

**pp. 206–207
THE STUPA
OF BODNATH,
Buddhist temple,
Katmandu, Nepal
(N 27°43' E 85°22')**

The city of Bodnath is home to one of the holiest Buddhist temples in Nepal, especially venerated by the thousand Tibetan exiles who live in this neighboring country. The stupa, which is a reliquary in the form of a tumulus topped by a tower, holds a bone fragment of Buddha. At a height and width of 132 feet (40 m), the temple is one of the largest in Nepal. Everything in the architecture of this sanctuary is allegorical, representing the universe and the elements (earth, air, fire, and water). The Buddha's eyes are fixed on the four cardinal points; the various stages in the acquisition of supreme knowledge, Nirvana, are represented by the thirteen steps of the tower. On religious holidays the monument is decorated with yellow clay and hung with votive flags. In the number of followers (350 million, 99 percent of them in Asia), Buddhism ranks behind Christianity, Islam, and Hinduism. In Europe today Buddhism has 2.5 million adherents; in France the number rose from 200,000 in 1976 to 700,000 twenty years later.

Yet forests protect the soil, preventing water from rushing unrestrained into rivers, taking fertile silts with it and destroying fish resources. The underlayer of earth that is exposed as a result quickly becomes desertified, proving the truth of the maxim that the forest precedes humans and the desert follows them. The floods of the Ganges in Bangladesh and the Yangtze in China are the fatal consequence of the enormous deforestations in the hillside valleys of the Himalayas, particularly in Nepal, and in western China.

Now that we know the devastating cost, we can no longer massacre the forest. It is time to replenish it, to consider the planet a garden entrusted to humans to be managed with wisdom and care. In short, it is time to rebuild the garden of Eden, still fresh as a memory and a hope in our collective unconscious. This is a worthy project for future generations.

The respectful treatment of nature only benefits humanity. In the United States, for instance, agricultural techniques that were too intensive and used too many chemicals profoundly changed the ecology of the water for New York City. Proposals were made to build large treatment plants, until experts decided it would be better to restore the biodiversity that had originally been present in the environment, by radically changing agricultural practices. This was done, to the great benefit of greater New York, whose waters were purified by a simple biological process. Intensely farmed land, full of chemicals from fertilizers and pesticides, takes a heavy toll on diversity: first insects are killed, next butterflies, then wild herbs, and then perhaps tomorrow bees. When the hives disappear, the victims of pesticides, what will happen to the pollination process, on which the fertility of our fields and fruit trees depend? In India and Latin America more than one hundred species of wild plants are used as food or medicine; what will be left of these resources and knowledge if these plants are destroyed by the thoughtless use of chemicals or by competition from some genetically altered variety?

In a strange paradox, the cities, less subject to the spread of chemicals, are becoming true havens of biodiversity. In Germany, cities such as Berlin or Munich, with areas of 340 square miles (880 km²) and 115 square miles (300 km²), respectively, have been able to put into practice a fresh-air urbanism without excessive density. Thus, contrary to expection, they are richer in species than most of the rest of the country: 260 species of butterfly have been counted in a public park of 1.5 acres (6,000 m²) in the center of Munich.

Biodiversity is also a guarantee of endurance and of the good health of natural and cultivated areas. If disease strikes a forest devoted to the monoculture of a specific spruce, the entire forest will disappear. This occurred in nineteenth-century Ireland, which had devoted itself solely to the potato crop. Between 1845 and 1849 disease struck the potato fields and to-

tally ravaged them; famine followed, decimating entire families. In just a few years the Irish population lost 1.5 million: 1 million perished, and 500,000 emigrated to the United States. A similar catastrophe nearly occurred in Africa in the 1970s, when cassava crops were stricken with two serious cryptogamic diseases. The salvation in this case came from the hybridization of the cultivated cassava with a wild cassava species that was immune to the pathogenic fungus and had become rare in nature. The new variety proved resistant, and the specter of hardship and famine was dispelled.

Respect for biodiversity also means preservation of these many useful species, both nutritional and medicinal. Today an estimated 3,000 edible wild species are known; each of them, improved by selection and hybridization, could become a new nutrient tomorrow. The task of selecting the best, of achieving judicious combinations—this is basically the way master chefs create recipes, incorporating foods that are carefully selected and harmoniously combined: fruits and vegetables, meats and game, spices and condiments, great vintage wines. Luckily, monoculture has not yet taken over our delicate palates, so eager for fine, rich flavors. Europe's firm resistance to genetically modified plants is explained largely by this desire to preserve diversified foods that reflect biodiversity itself.

Protecting nature means protecting this very diversity. Consider the example of a plant that is increasingly consumed to combat rheumatism, devil's claw (*Harpagophytum procumbens*); it is native to Namibia, and its natural environment is overexploited today. In recent years there has been a push to buy products that are harvested organically, respecting the volume of the resource and the quantities that can be harvested without exhausting the natural habitat, allowing the *Harpagophytum* plants to renew themselves from year to year. This can be applied to all harvests.

The creation of parks, reserves, conservation areas, and international agreements is a multifaceted strategy for the necessary protection of nature as well as agriculture and culture in general. Every culture has its own nutritional and medicinal traditions, which must be preserved. This need has led today to agreements between the major laboratories of industrial countries and the developing countries, where genetic resources are found, in accordance with the decisions of the Rio de Janeiro Earth Summit of 1992. One aim of these agreements is to compensate the countries that provide these resources after they lead to a new medication, for example.

This prodigious "gene bank" of diverse species throughout the world ensures that the needs of human populations will be met. Protecting nature means recognizing our own links and membership in this environment that feeds, heals, and dazzles us. All of our technological devices, even the most sophisticated,

could vanish in an instant without decisively compromising the survival of humanity, because the first of all of nature's resources is the earth and its fruits. We are obliged to protect and love nature. In his 1968 book on condor protection, *Man and the California Condor*, the naturalist Ian McMillan explained his belief that the true importance of preservation was "as a cultural practice which developed and strengthened the human attributes needed in working out a new program for the welfare and survival of our own species."

<div align="right">Jean-Marie Pelt</div>

FAVELAS IN RIO DE JANEIRO,
Brazil
(S 22°55' W 43°15')
Nearly one-fourth of the 10 million Cariocas—residents of Rio de Janeiro—live in the city's 500 shantytowns, known as *favelas*, which have grown rapidly since the turn of the twentieth century and are wracked by crime. Primarily perched on hillsides, these poor, underequipped neighborhoods regularly experience fatal landslides during the heavy rain season. Downhill from the favelas, the comfortable middle classes of the city (18 percent of Cariocas) occupy the residential districts along the oceanfront. This social contrast marks all of Brazil, where 10 percent of the population controls the majority of the wealth while nearly half of the country lives below the poverty level. As a result of urban growth, approximately 25 million people in Brazil, and 600 million in the world, inhabit the slums of great metropolitan areas, where overpopulation and poor conditions threaten their health and their lives.

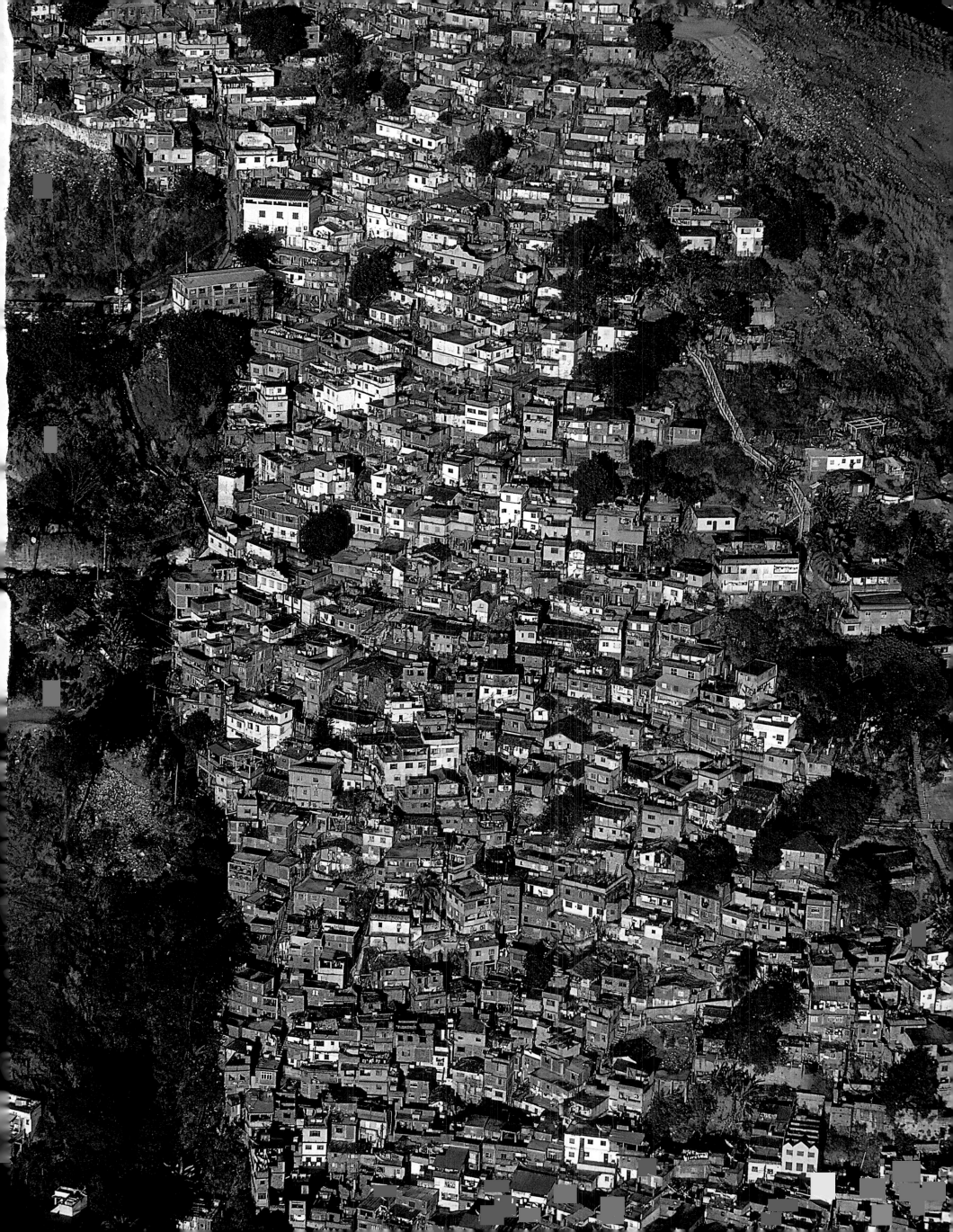

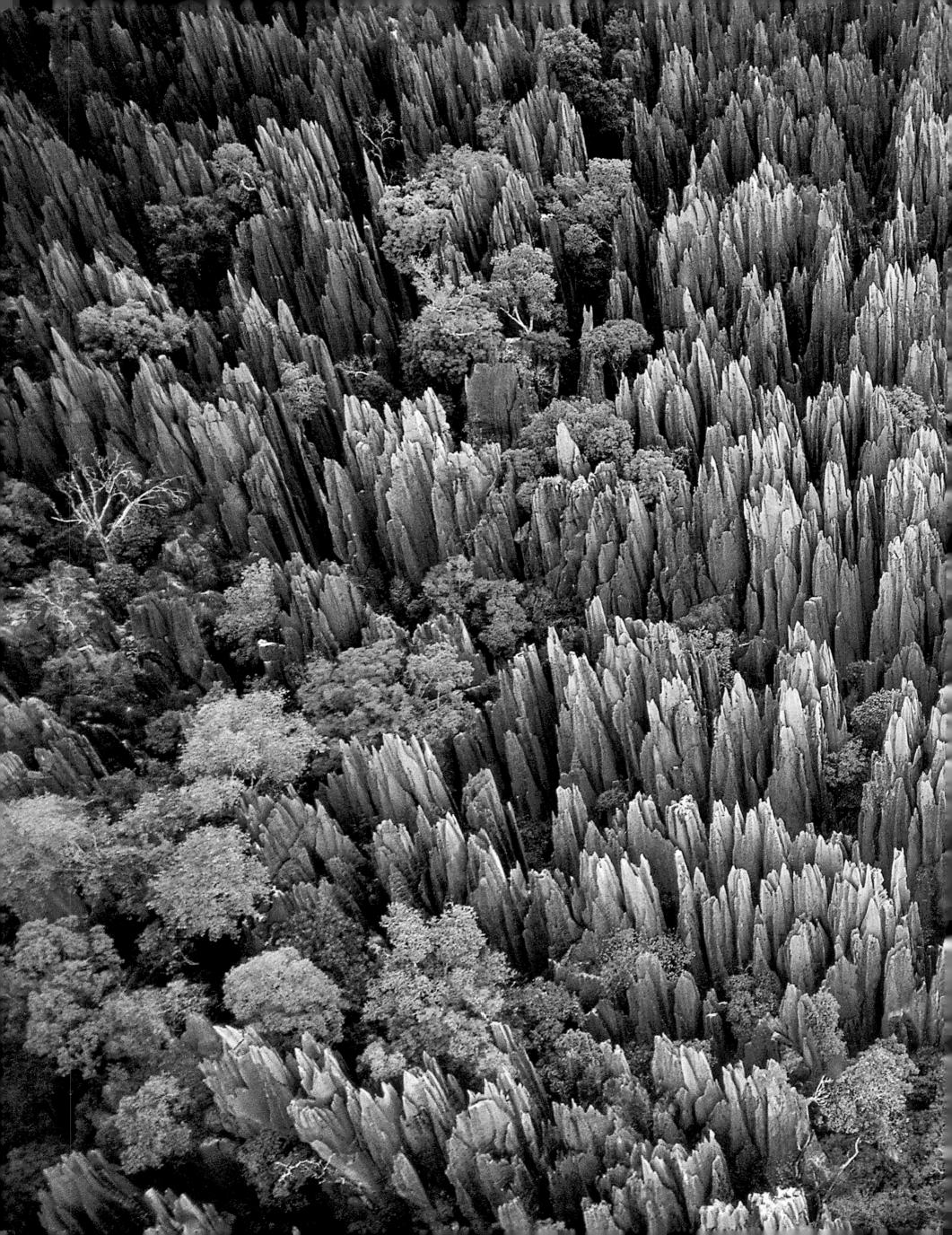

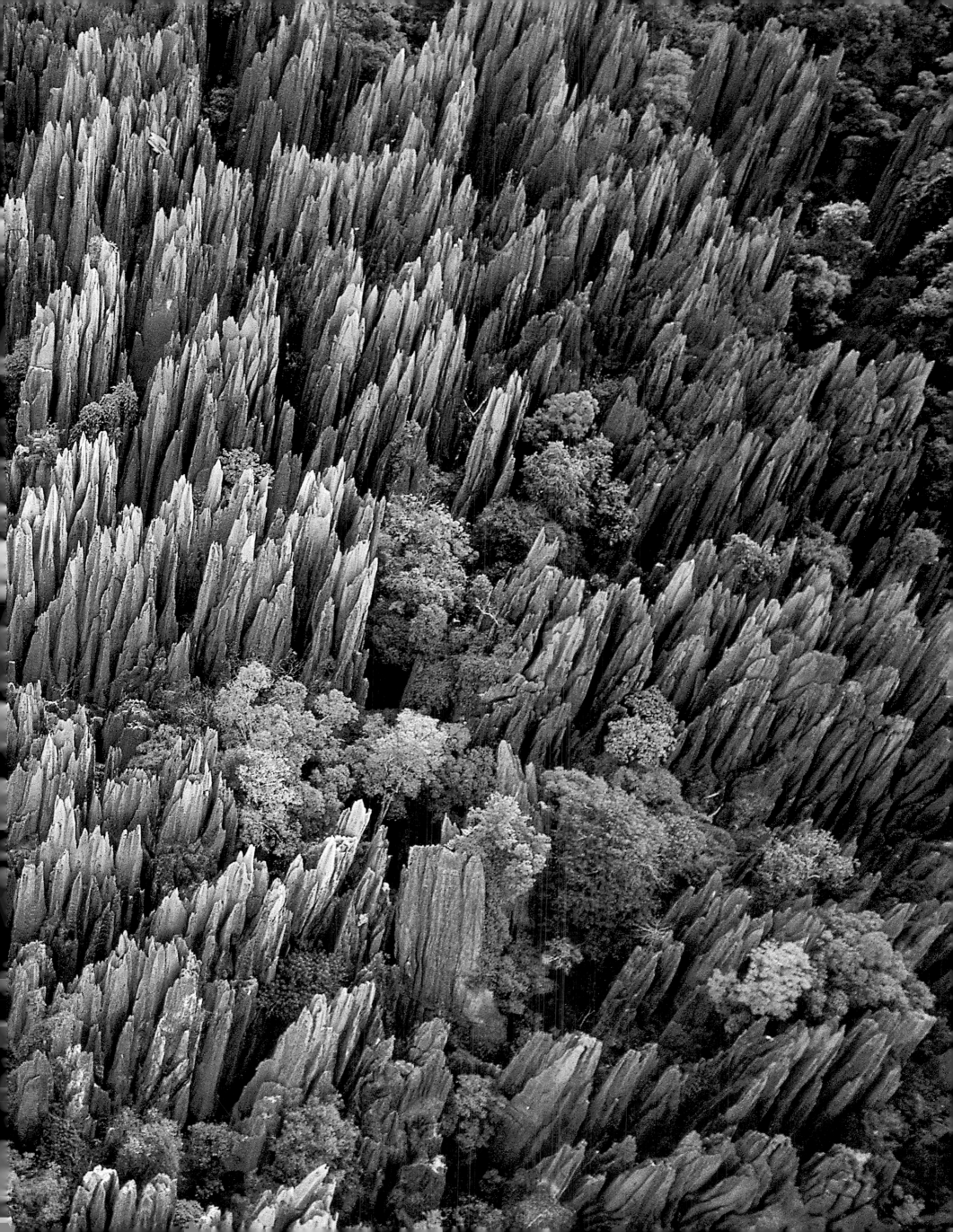

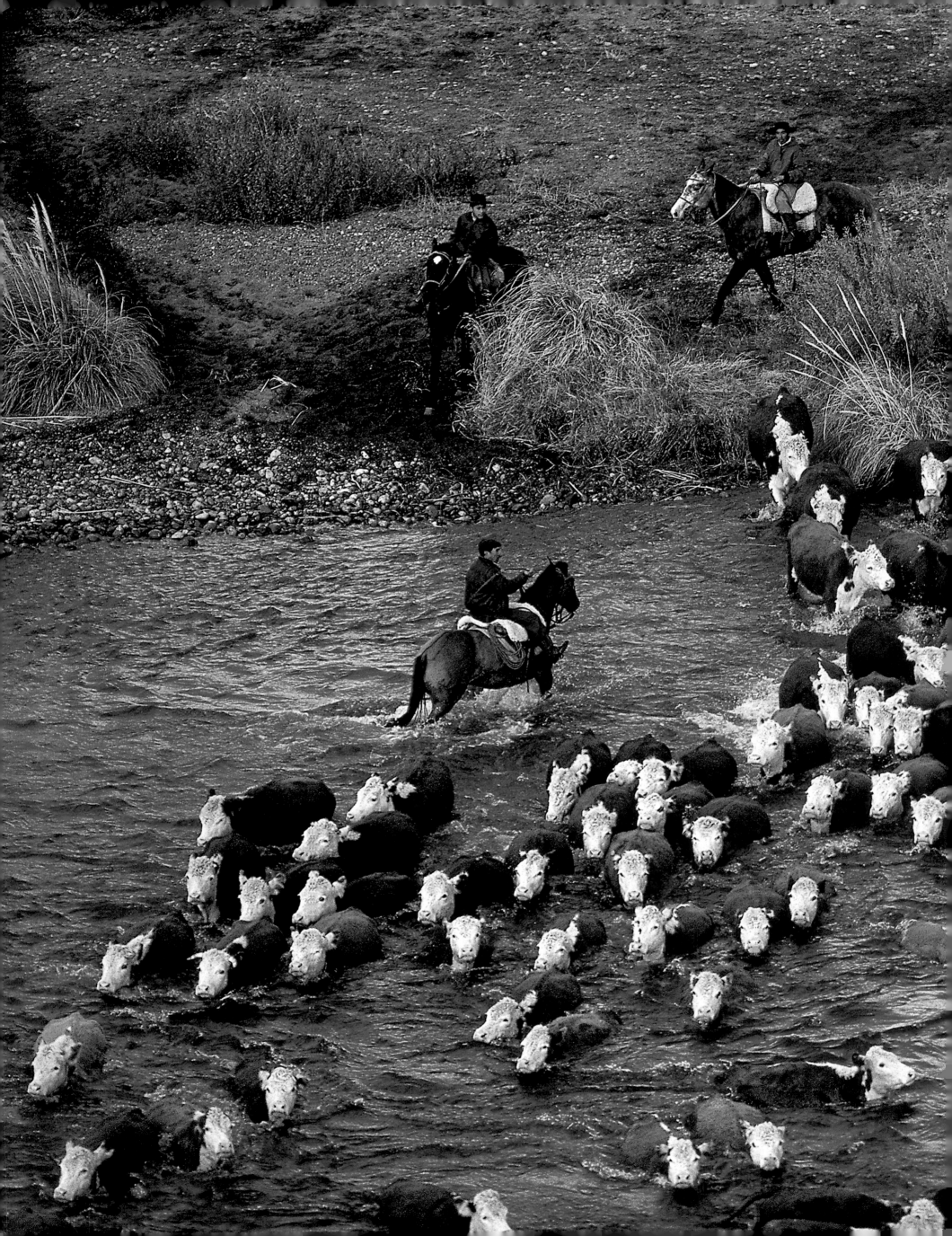

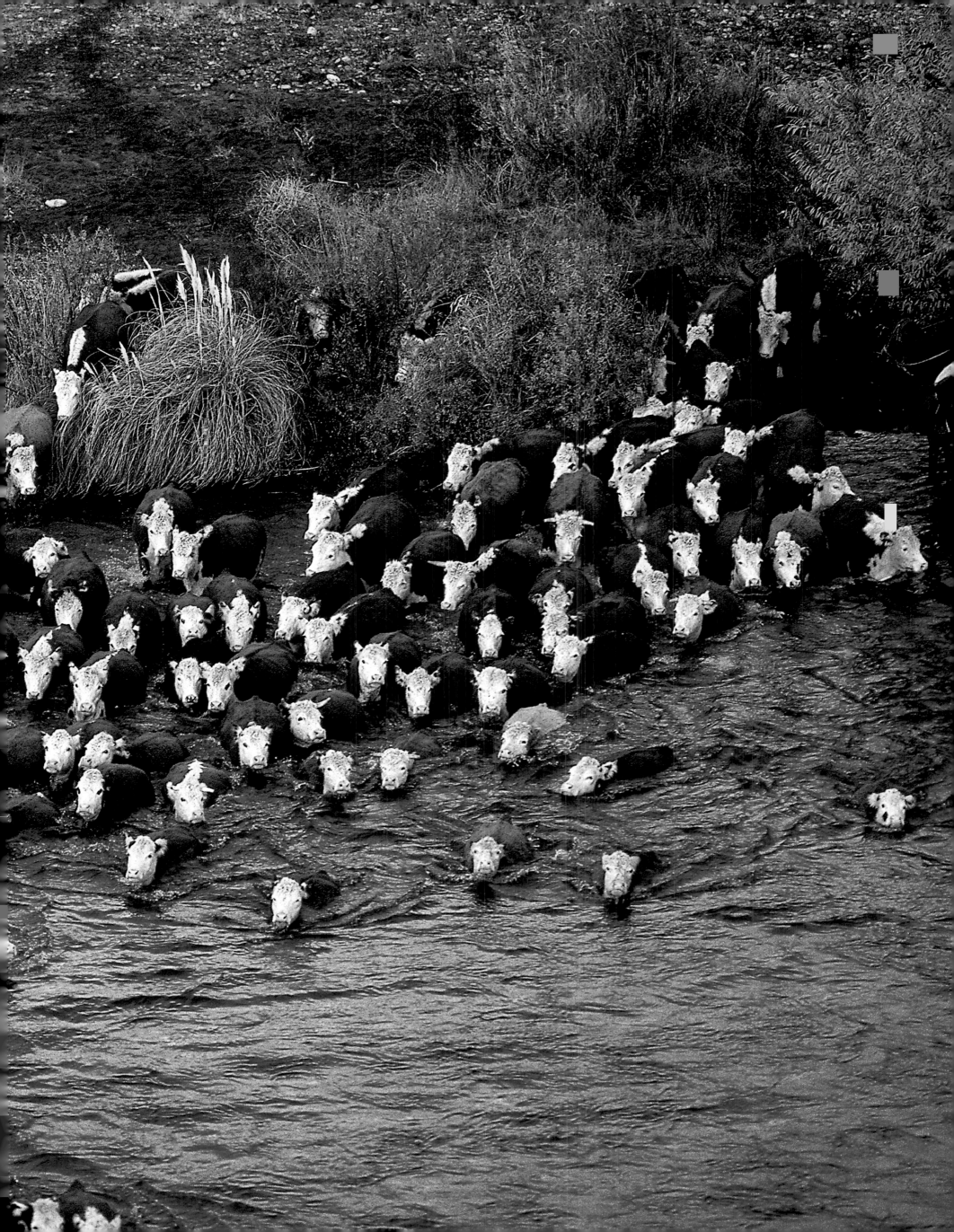

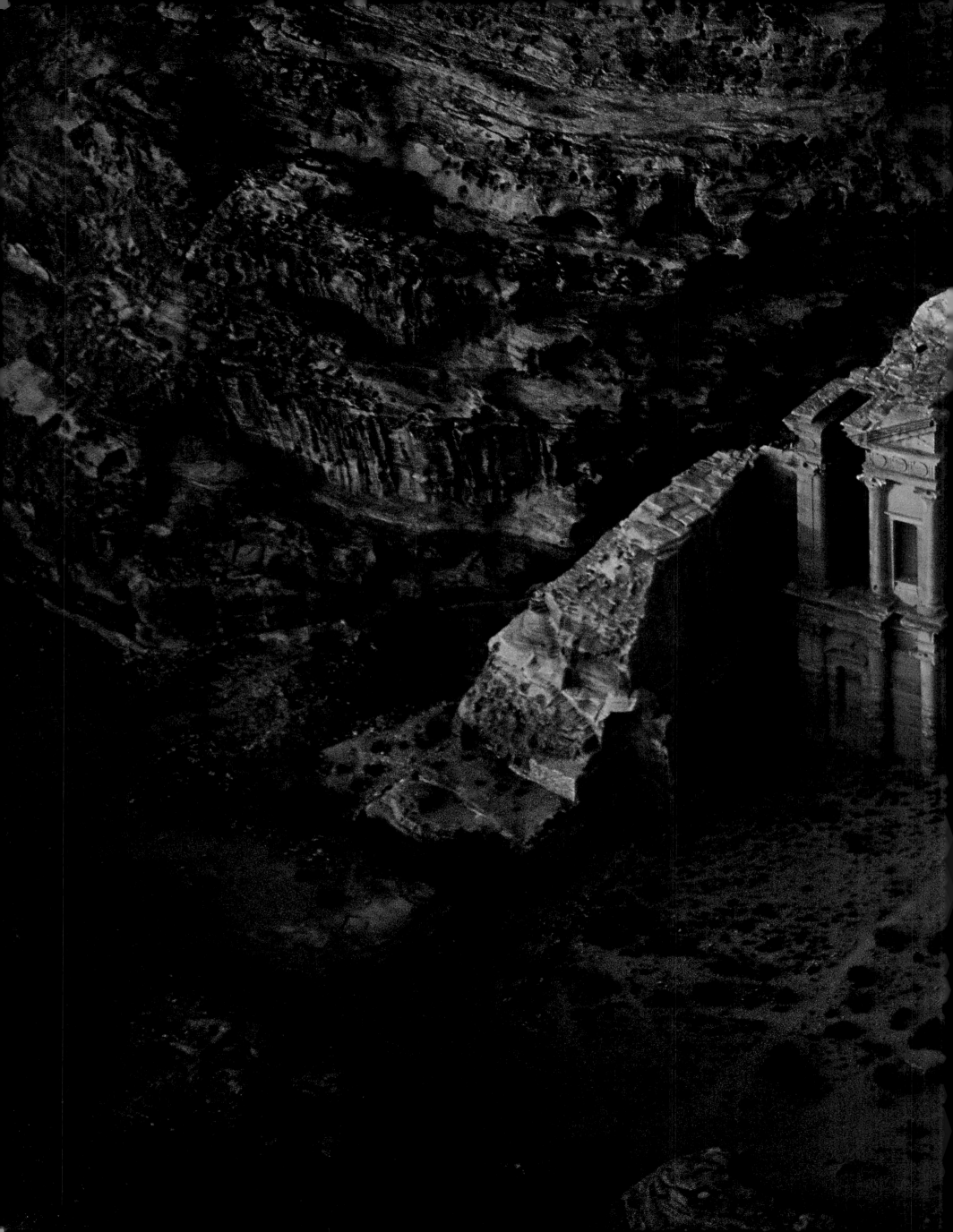

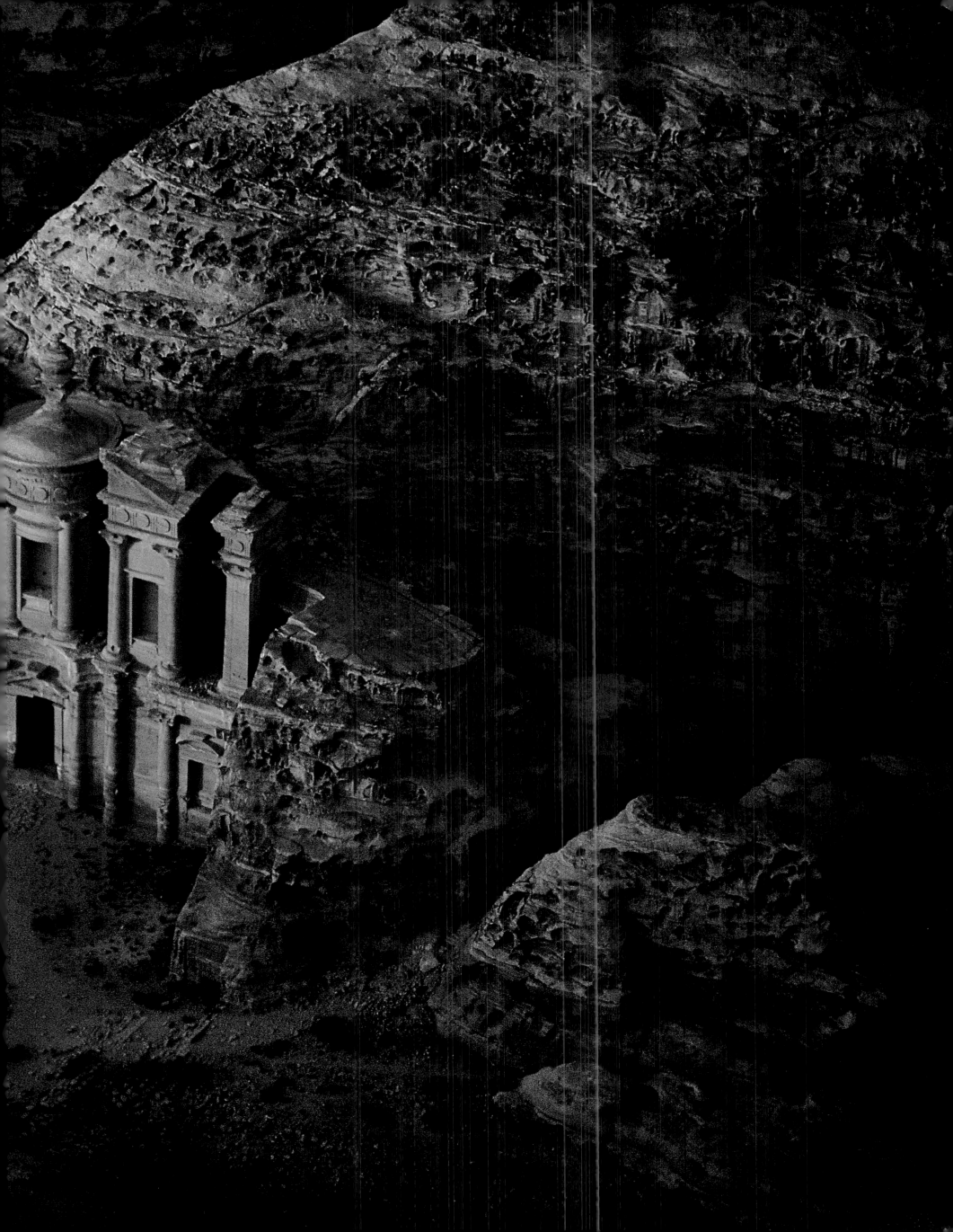

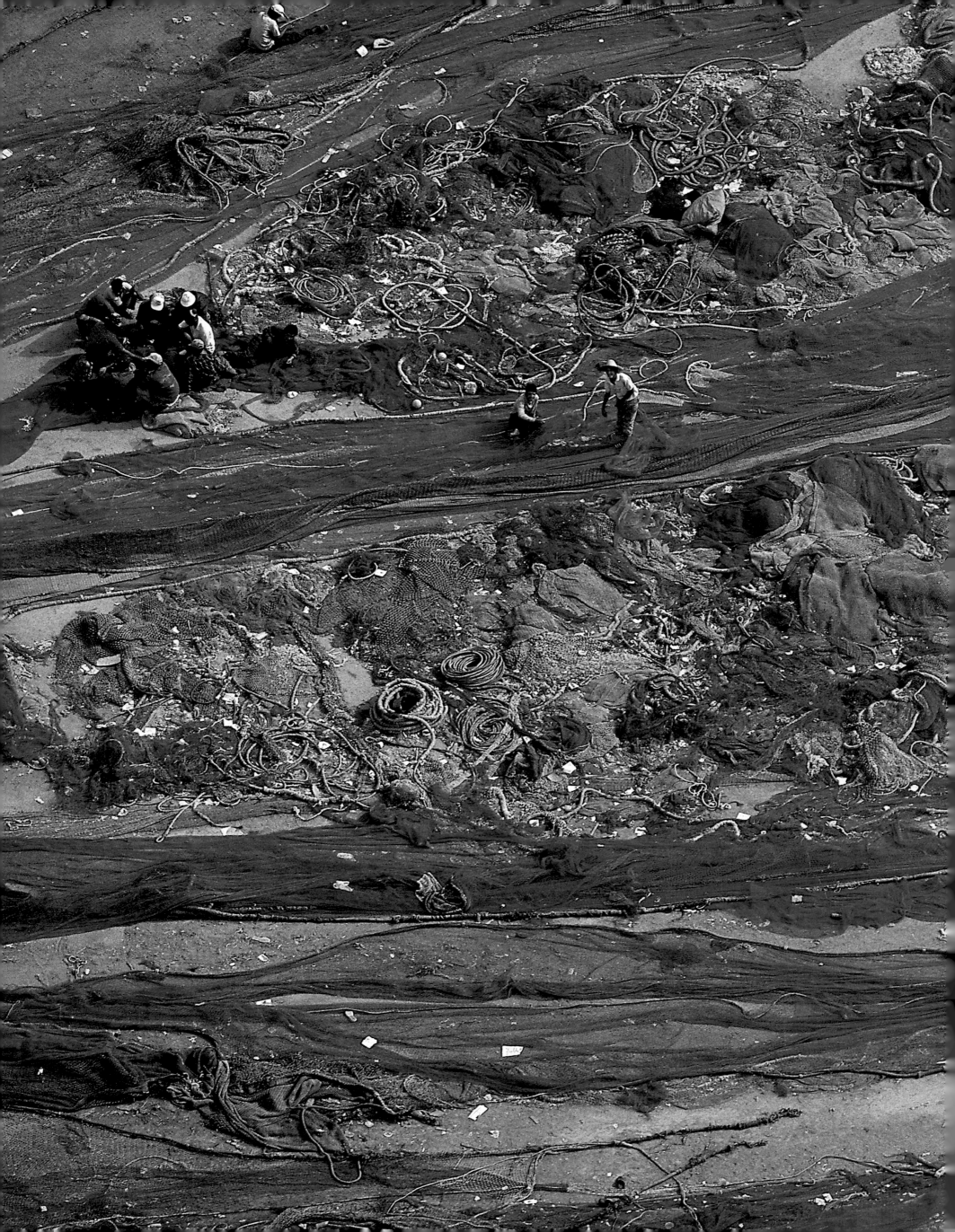

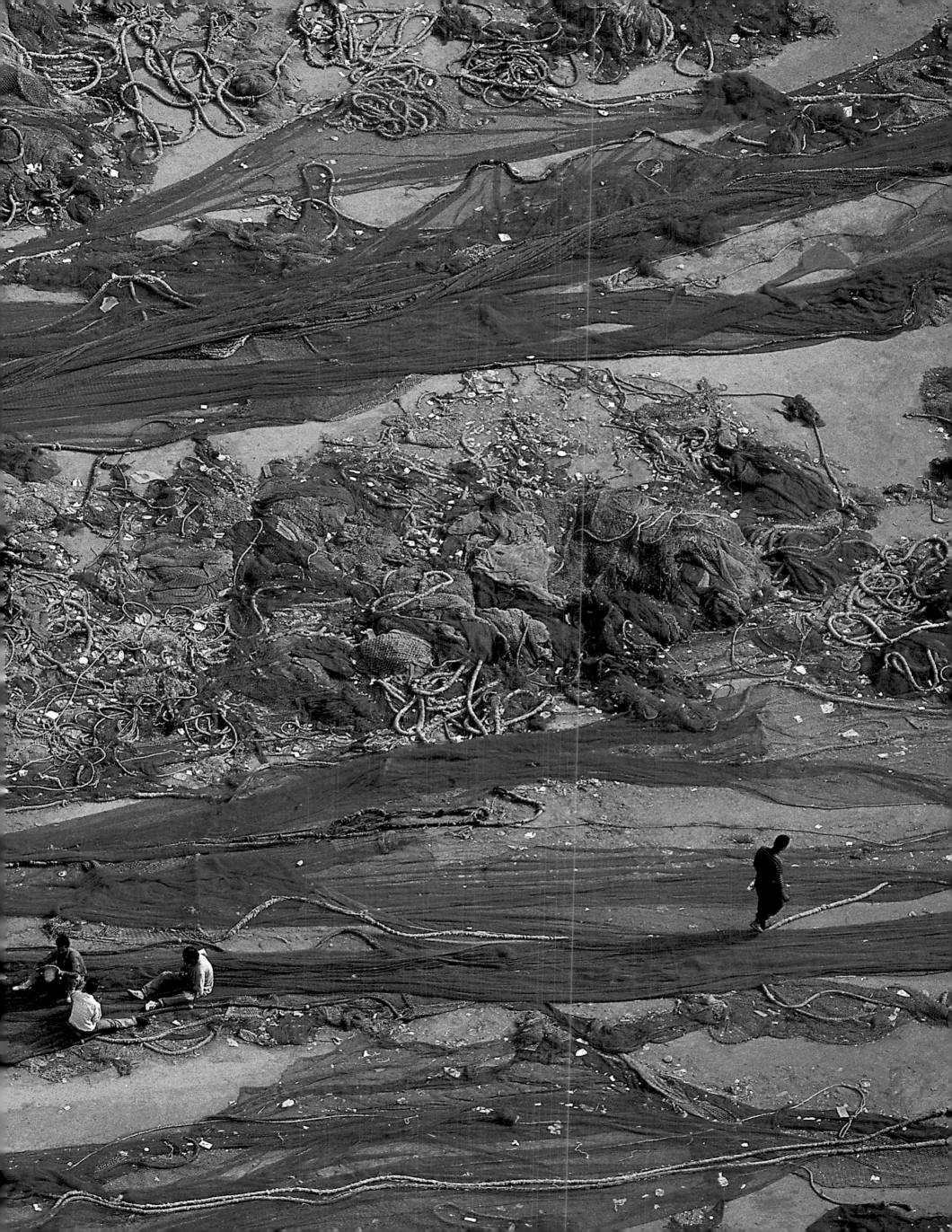

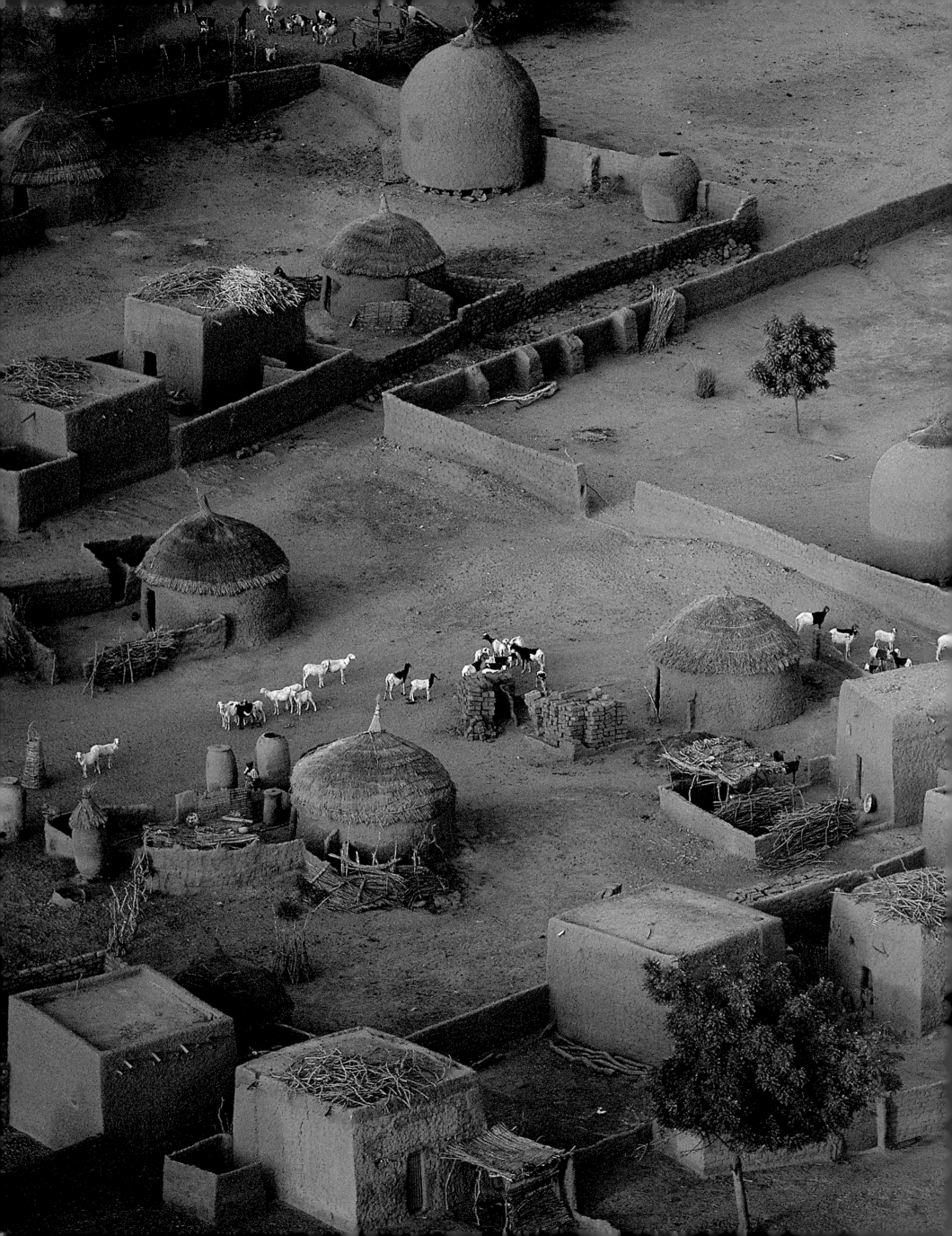

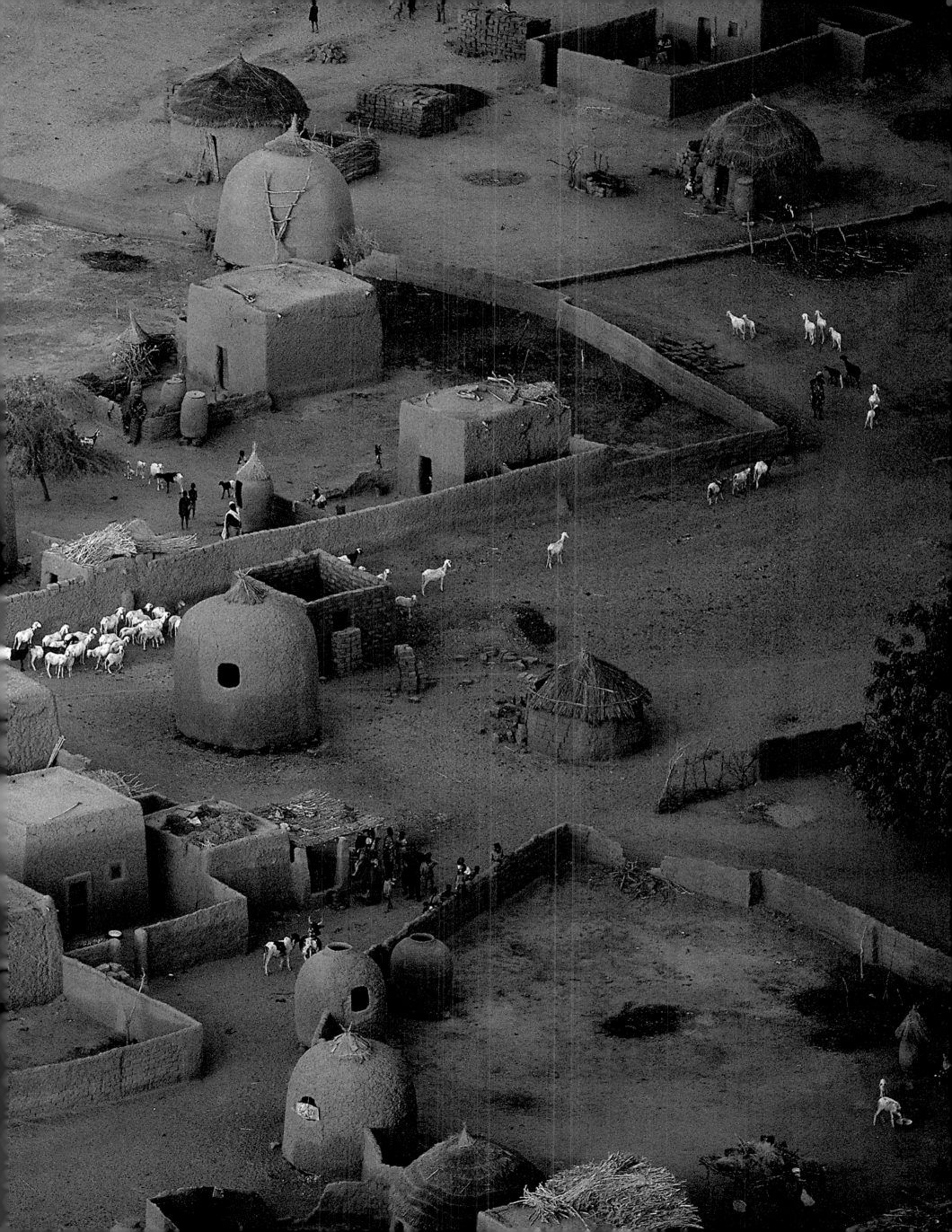

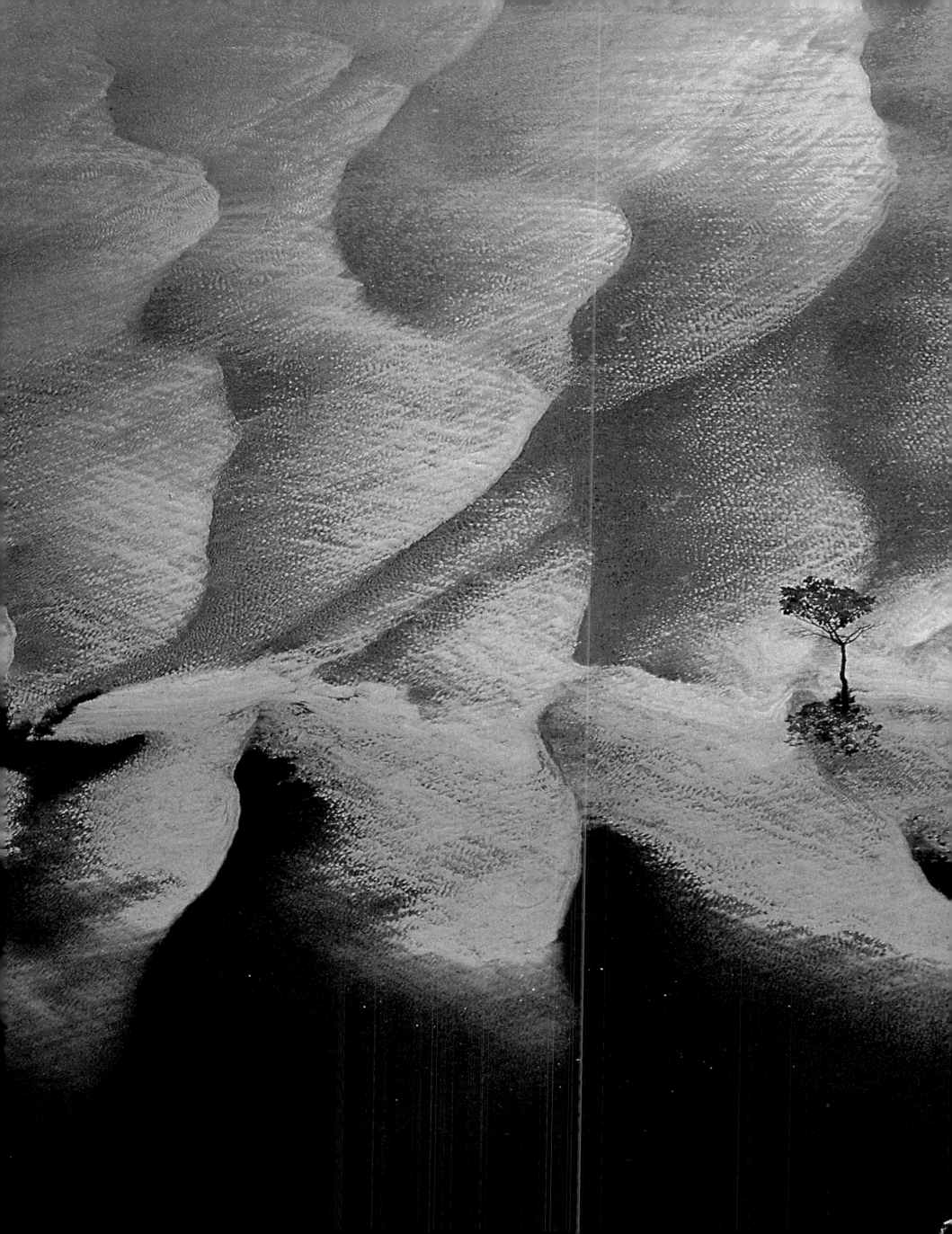

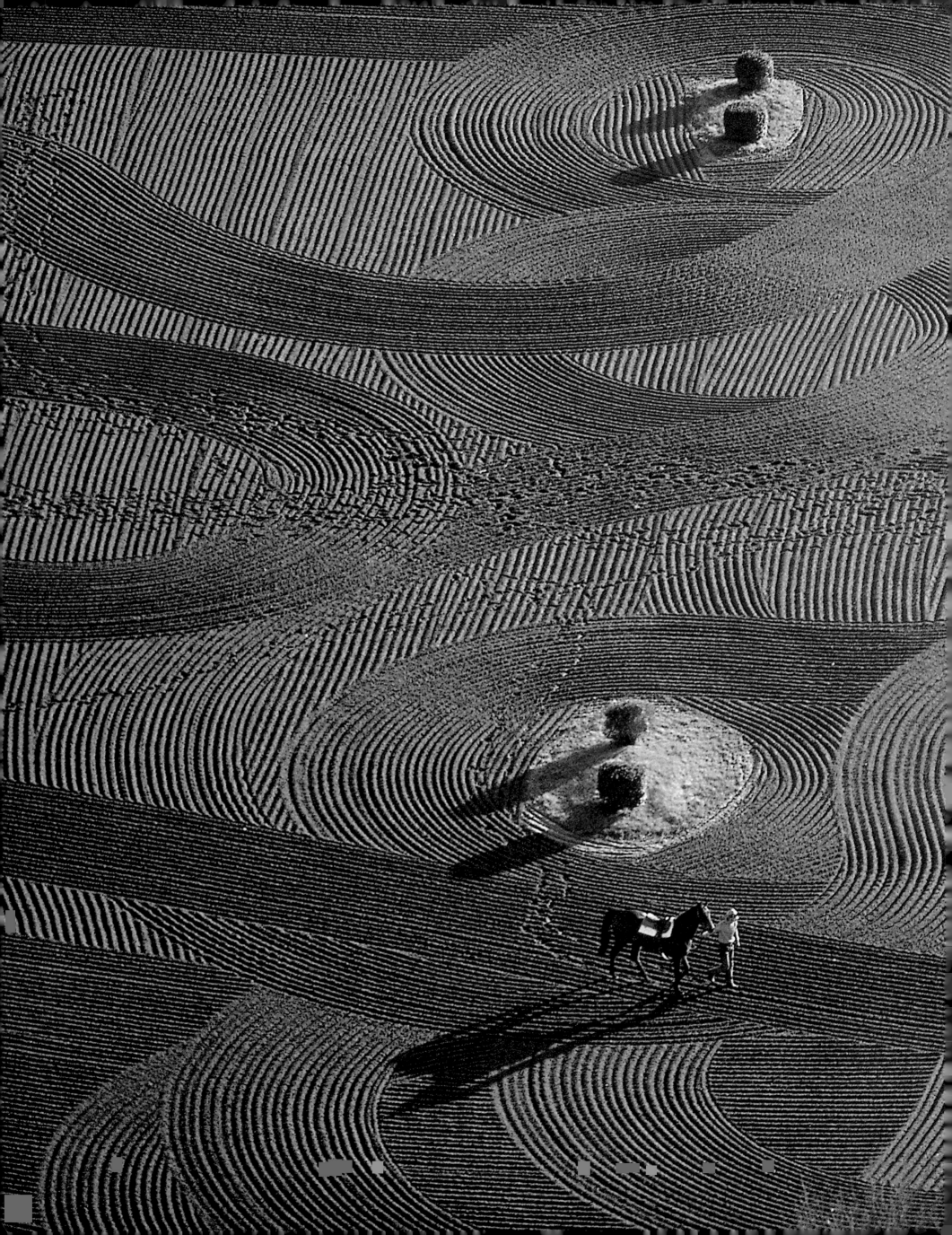

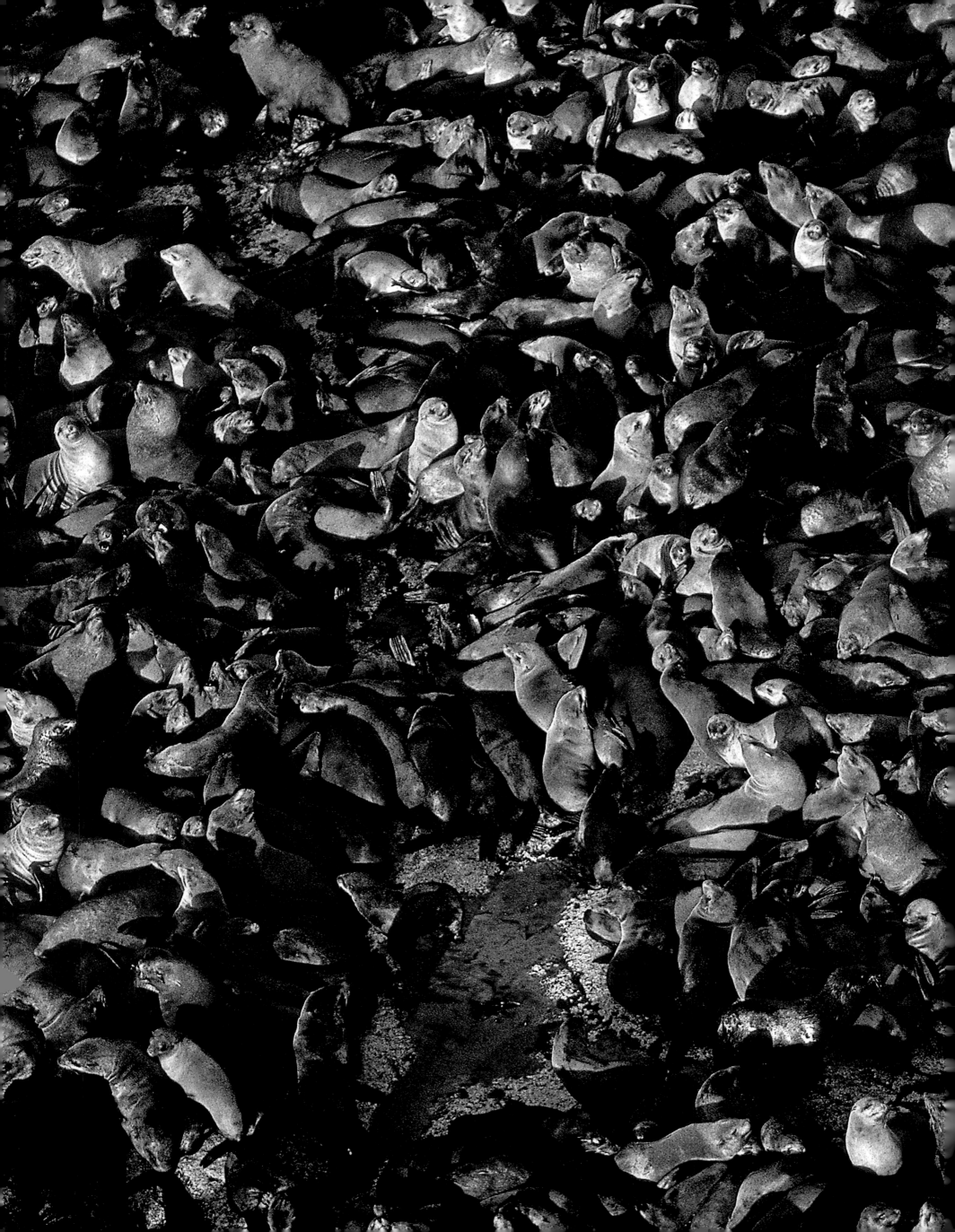

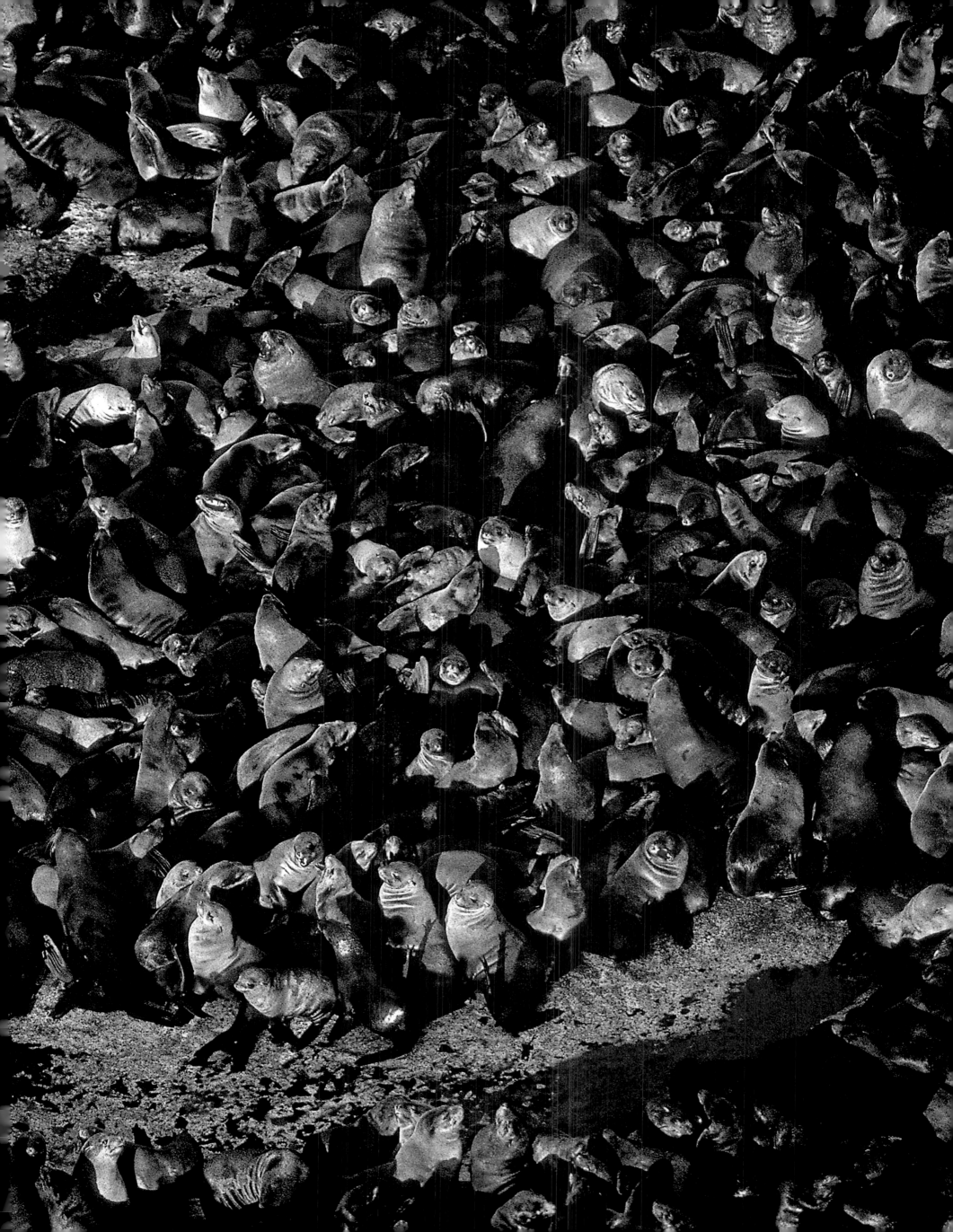

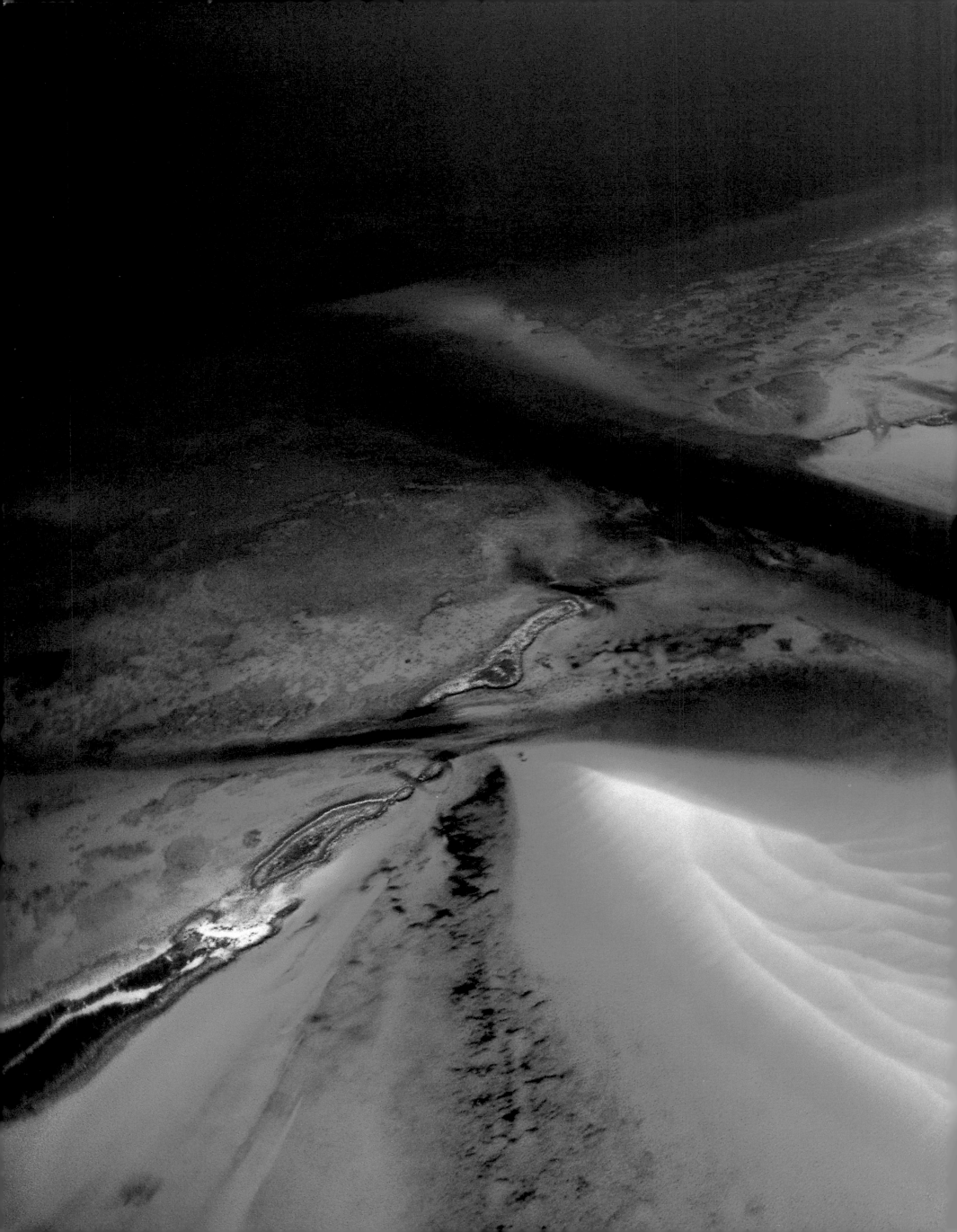

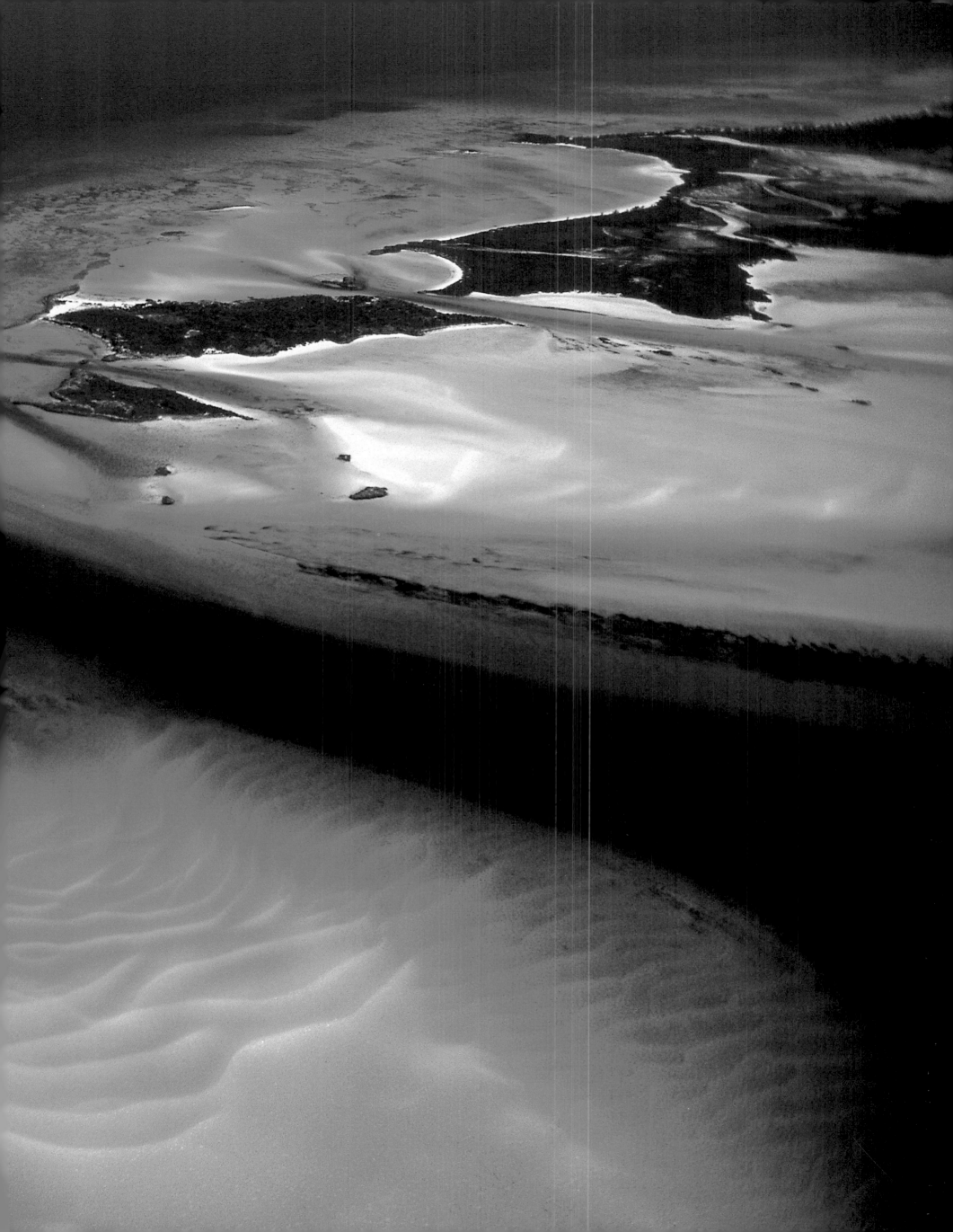

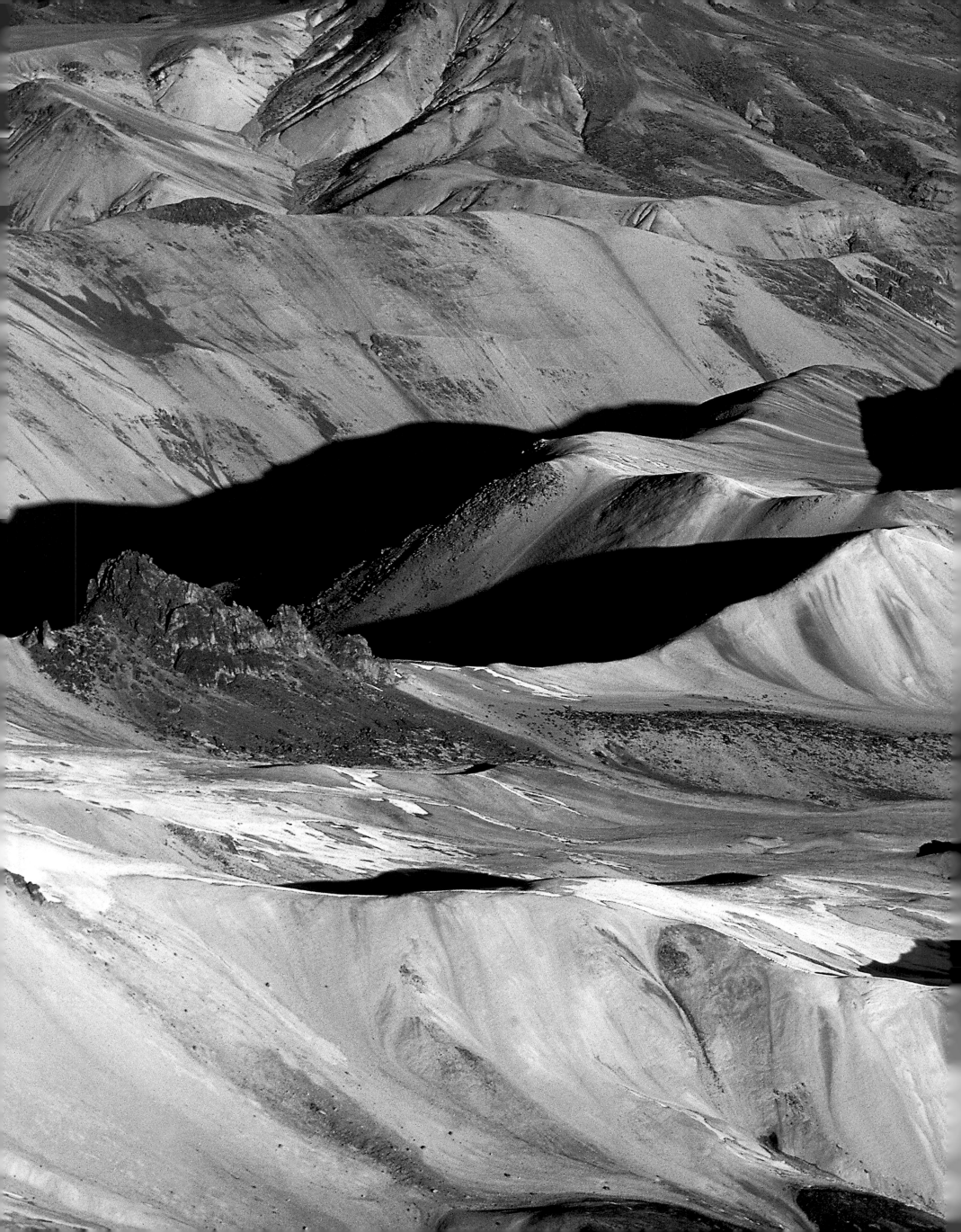

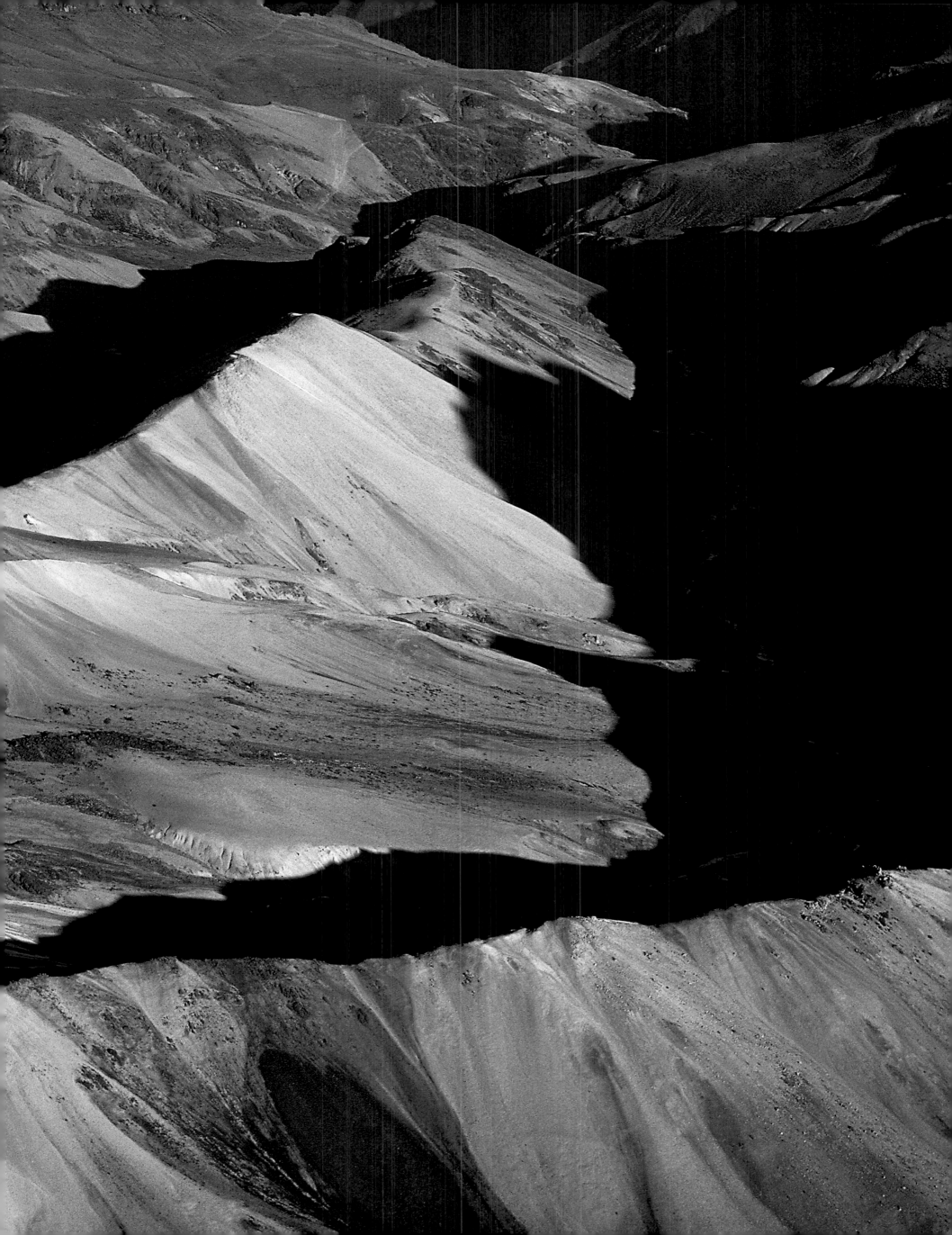

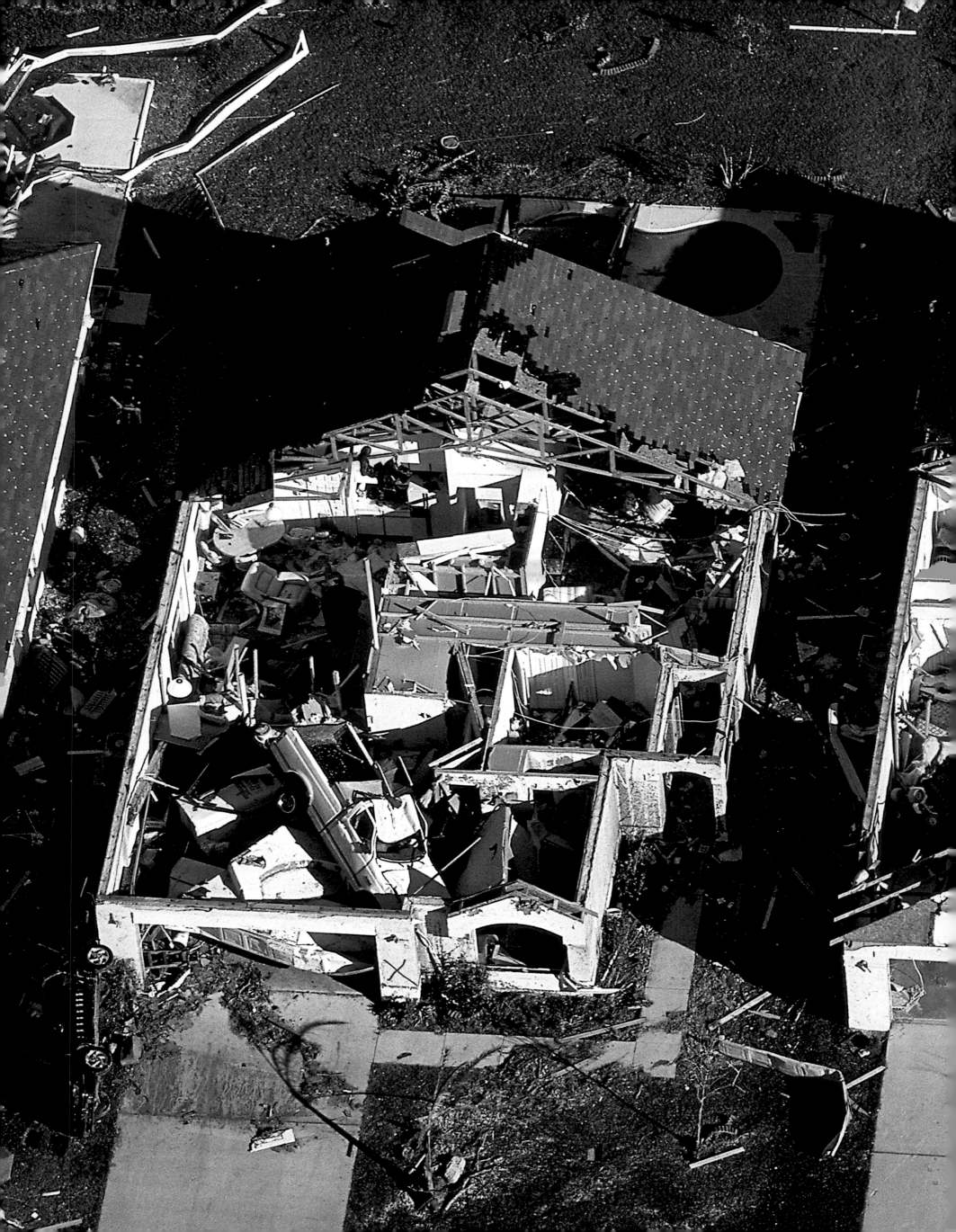

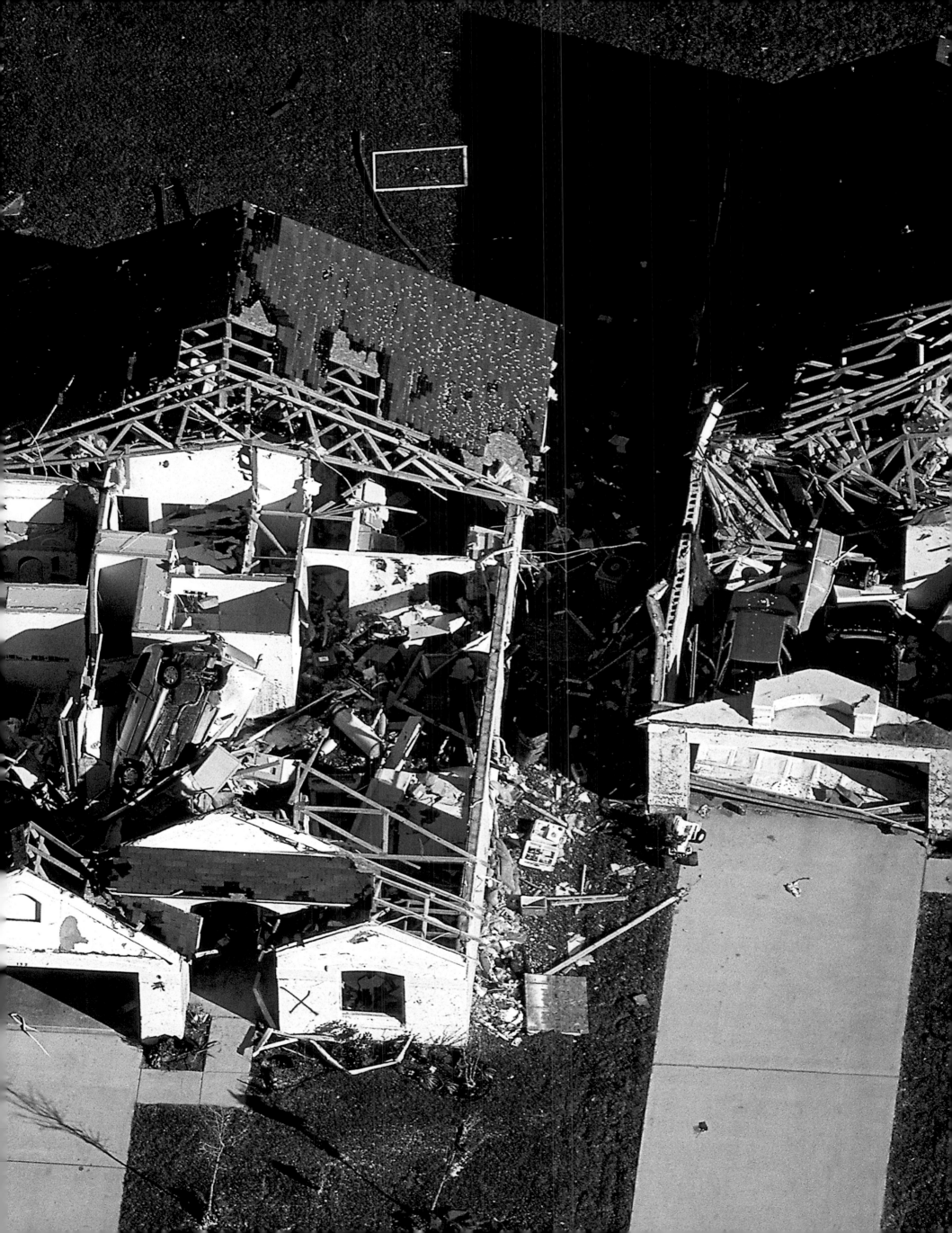

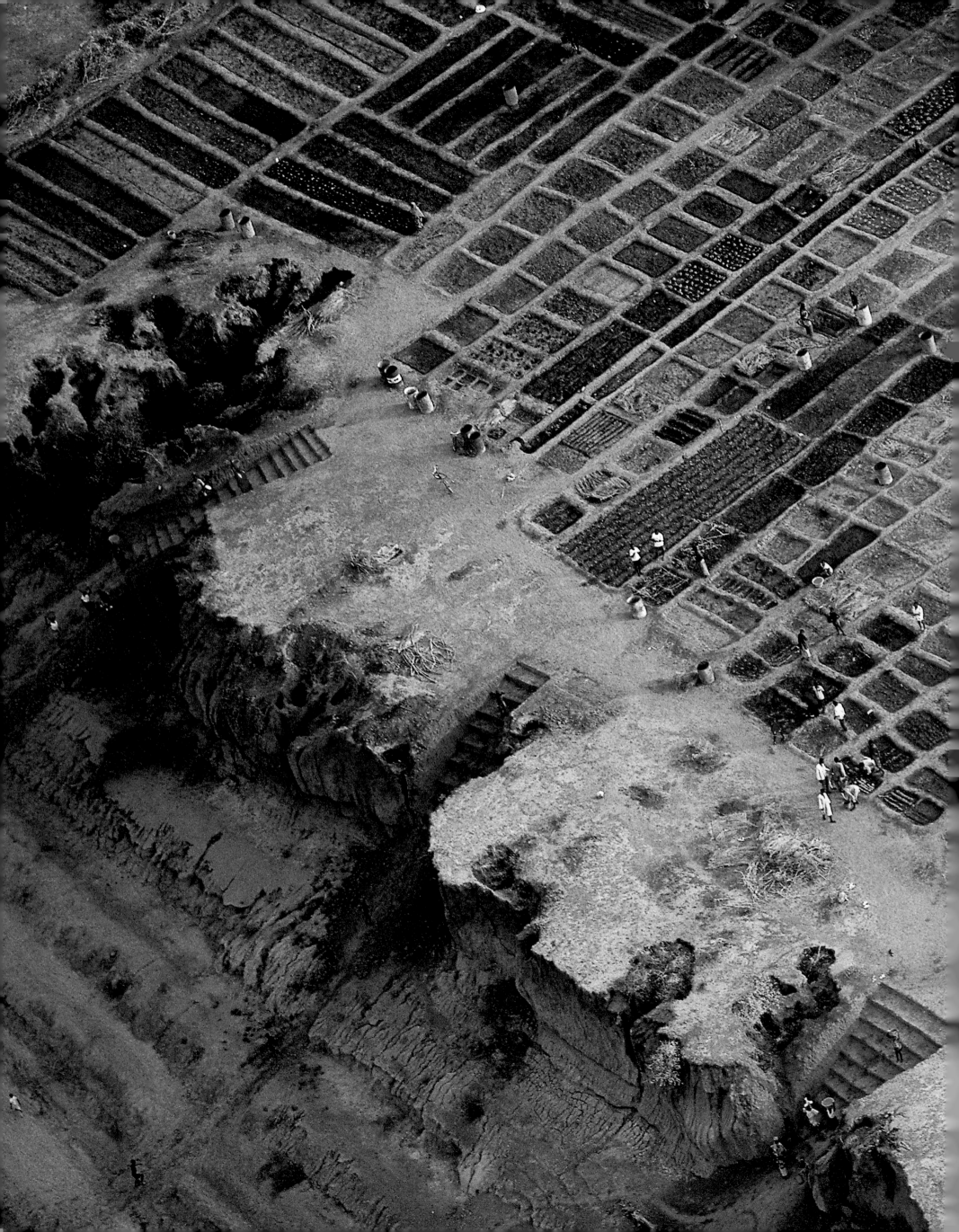

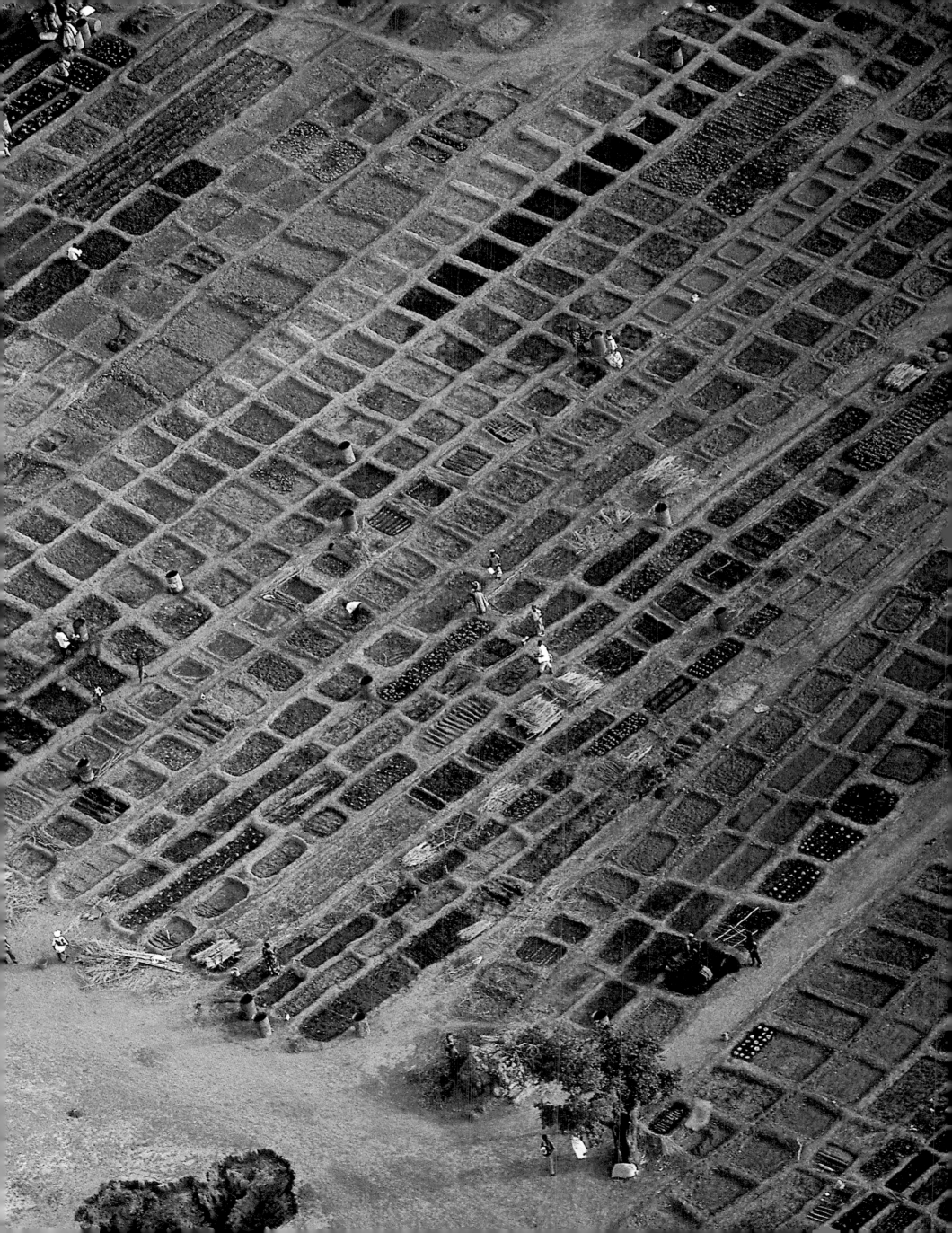

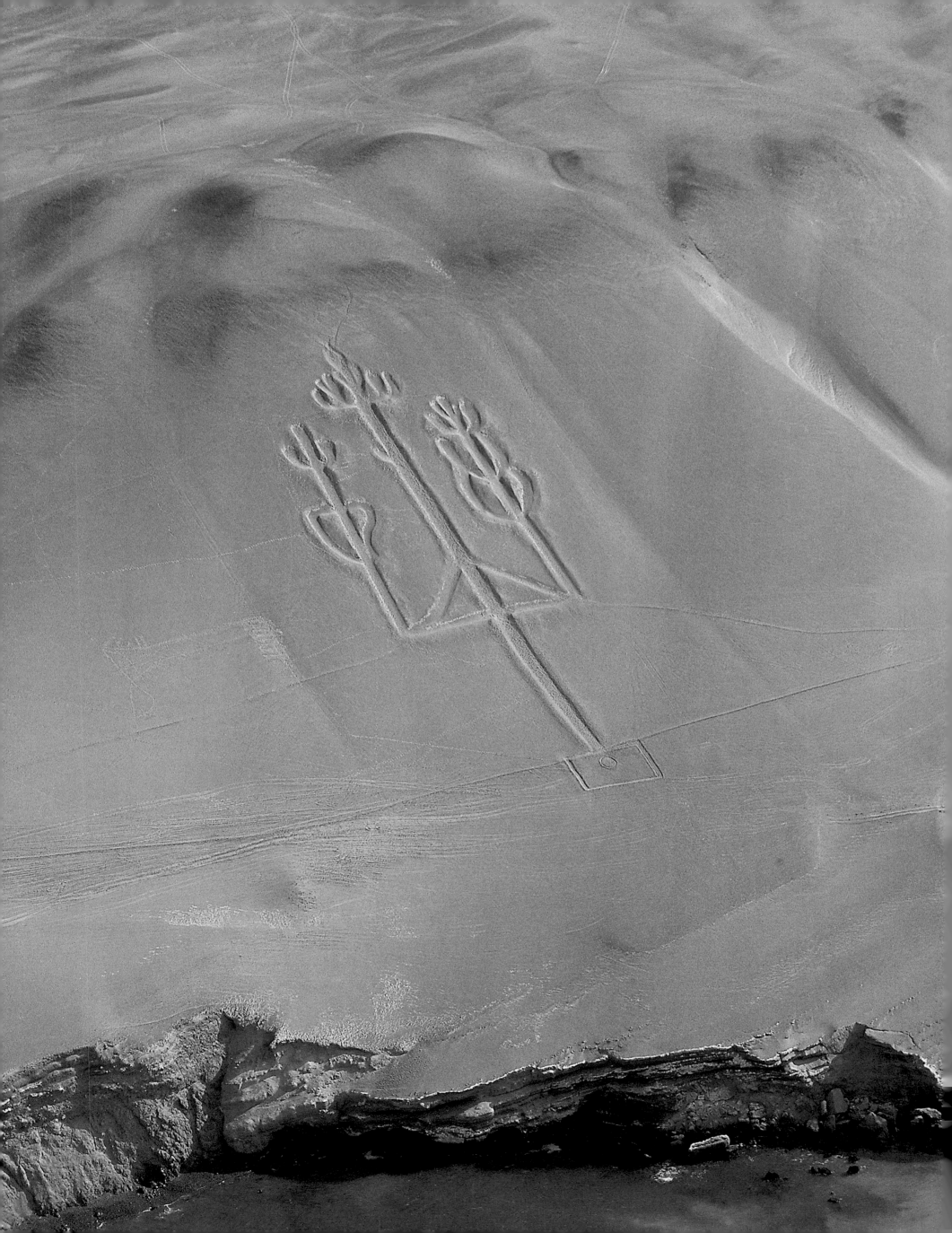

A PLEA FOR THE SEAS

*Long ago we thought the ocean was infinite. Observation from space and high-speed transmission
methods have given us a global perspective that offers compelling evidence. On the small space
allotted to humankind, people have soiled the finest thing the earth had to offer. It is not rare for sailors,
even far out at sea, to find plastic bags and other floating debris, in addition to polluted rivers.
We have become our own enemy. Standing at the top of the pyramid of the species, we face
a crucial choice: either absorb our own refuse or create less. The natural cycle,
which had seemed eternal, could come to a grinding halt.*

Several million years ago, before life washed up, still trembling, on firm ground, it had already probably racked up billions of years' worth of experience under the ocean's surface. That aquatic universe, the "primitive soup," was the setting for the origins of life. Is is also a great hope for the future: the great depths of the sea, still largely unknown, conceal astonishing biological and industrial resources. But the "world ocean"—called Pacific, Atlantic, or Indian depending on the continents on which it borders—although long considered infinite in scope, today is threatened by humans, who blithely soil and weaken that resource to which they owe their life. The blue immensity that covers 72 percent of our planet cannot continue to serve as the ultimate garbage can. Each of us bears a responsibility in the future of the earth, which depends in large measure on the fate of the seas and oceans.

The image of blue waves as far as the eye can see, which comes to mind when we think of the world ocean, does not conform to reality. The ocean is immense, but it is not a reservoir of unlimited life. Its living forces are concentrated essentially in the coastal zones, which are remarkable for their diversity, the wealth of life forms they shelter, and the crucial roles they play. But this living coastal fringe, the most shallow and accessible part of the sea to humans, is also the one most subject to commercial exploitation and most vulnerable to the polluting refuse of our rivers. Because these confined spaces are the source of 80 percent of marine species (river estuaries, in particular, serve as veritable sea "nurseries"), the attacks on them threaten the diversity of ocean life on a scale out of all proportion to their modest surface. Coastal wetlands, herbariums for algae or sea-grasses, silty estuaries, mangrove forests, or coral reefs, these natural lungs of marine biodiversity that alternate along the coastal zones according to the latitude and depth, are receding everywhere to a disturbing extent, overexploited or devoured by concrete. Nearly two-thirds of the wetlands of Europe and North America were destroyed in the course of the twentieth century, primarily in the final two decades, and it is estimated that 85 percent of Asian wetlands are on their way to extinction.

Half of the mangrove forests on the planet have been wiped out. These forests of mangrove that plant their feet in the mud along tropical coasts provide space for reproduction and shelter during the first stages of life for many species of fish and crustaceans. They also cushion the coastal environment against the impact of atmospheric disturbances such as storms or violent winds. Conversely, by trapping sediment carried by run-off waters from higher elevations inland, they contribute toward reducing the turbidity of the waters, thus protecting against invasions of algae and the coral reefs close to shore. Nevertheless, they are being cleared to make way for agricultural expansion and urbanization, and in many countries they provide the main source of firewood for coastal populations. In fifty years their area went from 1.1 million to 300,000 acres in the Philippines, from more than 750,000 to 475,000 acres in Thailand, and from 625,000 to 325,000 acres in Vietnam. In numerous islands of the Caribbean, as well as in the Indian and Pacific Oceans, they have disappeared. The hurricane that struck the coast of India in October 1999, causing a tidal wave reaching 30 miles (50 km) inland that claimed 10,000 victims, would have been less devastating if the mangrove forests had been able to play their role as protector of the shores.

Coral reefs, also common in tropical regions because they require a relatively high water temperature for their growth, are virtual reservoirs of biodiversity. They are estimated to contain

**CANDELABRA OF PARACAS PENINSULA,
Peru
(S 13°48' W76°24')**
Commonly referred to as the "Candelabra," this design is carved into the cliff of the Paracas Peninsula on the Peruvian coast. The geoglyph is 650 feet (200 m) high by 200 feet (60 m) wide, and it is speculated that it depicts either a cactus or the Southern Cross constellation. Although it is similar to the Nazca Lines that lie 125 miles (200 km) southeast, it is the product of an earlier civilization, that of the Paracas. A Paracas necropolis was discovered in the region, containing 429 mummified corpses, or funeral *fardos*. The Paracas, known for their textiles, embroidery, and pottery, were above all a fishing people; their civilization disappeared about 650 B.C. Visible from far out at sea, the Candelabra was a navigational landmark, as it still is today for boats cruising off the peninsula.

about 4,000 species of fish among the 800 species of coral that build the reefs. This natural barrier, teeming with life, also protects land from the assaults of the ocean. The good health of coral reefs is crucial in maintaining the richness of the oceanic fauna, which the reefs shelter during the reproductive phase of life. Today 70 percent of the coral on earth is threatened, either directly by human action or indirectly by climatic warming and pollution.

But the intertropical zone is not alone in receiving blows to its natural marine environments. Less visible than the direct destruction of the natural settings, another factor destroying oceanic life is threatening the oceans without any geographic distinctions: often invisible, highly dangerous for inland seas, the universal scourge of pollution is weakening our seas. Its effects on marine fauna and flora are becoming clearer with each new study. Beverage containers and other packaging abandoned on beaches represent a growing component in the problem of refuse. The ocean floor is littered with debris: a study conducted in the Gulf of Gascony showed, in an area extending down as far as 650 feet (200 m) below the surface, at least 50 million individual bits of refuse, 95 percent of it composed of plastic nondegradable materials. In addition to direct visual pollution, the damage to marine life is important. This debris kills birds that become caught in film composed of plastic material and drown, turtles and birds that often confuse plastic bags with jellyfish, and seals that ingest the material. Sixty-three percent of marine bird species and 35 percent of marine mammals are reportedly affected, to various extents, by this phenomenon. But humans are not satisfied just to toss their aluminum cans and their plastic bottles. The ocean also suffers from industrial pollution. In fact, two-thirds of marine pollution is derived from earth by way of the atmosphere and rivers, streams, and estuaries.

Air pollution, caused by gas emissions and industrial smoke effluents, is conveyed by rains and forms the main vehicle for several substances particularly noxious to the marine environment, including mercury and lead. Thirty percent of heavy-metal pollution from the atmosphere consists of lead. In the North Sea 20 percent of the lead deposits are conveyed by the atmosphere.

In many regions of the world today, rivers and streams have the sad appearance of actual open-air sewers. Río Bogotá in Colombia is so polluted that no form of life can survive in it, and its shores include no habitat. The river in turn is contaminating the Río Magdalena basin, which is itself making the Caribbean Sea unhealthy for several tens of miles around its mouth. In China 80 percent of industrial wastes are dumped into rivers without any treatment, causing pollution of more than half of the country's river network. The great Russian river, the Volga, alone carries 42 million tons of toxic waste. In developing countries it is estimated that 20 percent of aquatic species in rivers have disappeared in recent years, victims of these massive waves of pollution.

Organic substances such as PCBs (polychlorinated biphenyls) and dioxins, as well as some pesticides, pharmaceutical products, and industrial chemical products, also threaten the reproductive process, even at very low doses. More and more marine mammals, starting with dolphins, are found dead on the coastlines as a result of the collapse of their immune systems, caused by the toxic substances introduced into the ocean by our sewers and rivers.

Massive use of agricultural fertilizers, effluents from intensive crops, and the increased discharge of waste water with heavy doses of phosphate and ammonium introduce nutrients that can cause algae to proliferate. This can be either a microplankton, the source of the phenomenon known as "red tide," or macro-algae, which cause "green tide." These intense colonizations of a single species asphyxiate the marine environment, depriving it of oxygen and leading to numerous deaths of marine invertebrates and fish. Humans are not any safer, and their health can be directly affected by the consequences of the degradation of the oceans. Heavy metals accumulate in crustaceans, mollusks, and predatory fish, and are subsequently in-

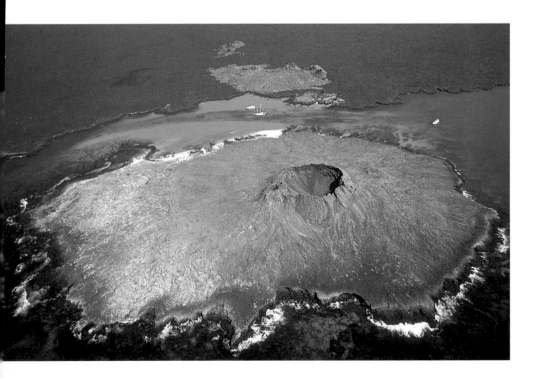

VOLCANO ON THE WEST COAST OF THE ISLAND OF SAN SALVADOR,
Galapagos Islands, Ecuador
(S 0°22' W 90°35')
The 19 islands that form the Galapagos Archipelago are of volcanic origin and rose from the waves of the Pacific Ocean 3 to 5 million years ago. Despite their lunar appearance, they offer exceptional biological diversity and are home to the richest colony of sea iguanas in the world and to the giant tortoise (*Geochelone elaphantopus*), which gave its name to the archipelago (*galapago* is the Spanish word for "tortoise"). Tourists have always responded to the magical charm of the place, and Darwin found inspiration here for his theory of the evolution of species. The Galapagos Islands were recognized as a national park in 1959 and became a UNESCO world heritage site in 1978. However, demographic growth, the introduction of exotic species, and the rise of tourism (although strictly controlled since 1998) threaten this natural evolutionary laboratory. The archipelago was miraculously spared significant ecological damage when 600 tons of oil were spilled by the tanker *Jessica*, which ran aground in January 2001, but other coastal areas were less fortunate.

pp. 258–59
PIROGUES ON THE
NIGER RIVER IN GAO,
Mali
(N 16°16' W 0°03')

The Niger is a major communication artery in Mali, linking trade between the region of Bamako, the capital city, and Gao in the north (a distance of 370 miles, or 1,400 km). However, ships of average size can travel the river only during high-water season between July and December; only boats with light draft can navigate the Niger all year long. The Bozo people, traditionally fishers, have become the "masters of the river" by handling local transports in their fishing boats. These large pirogues cruise back and forth in the port of Gao; although fragile in appearance, they can carry several tons of merchandise. In particular, they move great quantities of bourgou, a grass found in the waters of the river that is fed to the region's migratory livestock.

pp. 260–61
VILLAGE RAVAGED BY
HURRICANE MITCH
ON GUANAJA,
Islas de la Bahía,
Honduras
(N 16°30' W 85°55')

Originating south of Jamaica, Hurricane Mitch reached winds of 180 miles (288 km) per hour four days before striking Central America on October 30, 1998. Honduras, including the island of Guanaja, was battered for two days by destructive winds, torrential rains, and mudslides that wiped out entire towns, killing several thousand people and leaving more than 1 million injured or homeless. During the months following the disaster, the population also endured a shortage of drinking water and an outbreak of disease. Mitch, the most severe hurricane to strike Honduras since Fifi (in 1973), also destroyed 70 percent of the banana and coffee crops, the country's major export products, bringing economic chaos to a country that is already among the world's poorest.

pp. 262–63
VILLAGE IN THE
HEART OF RICE
FIELDS NEAR
ANTANANARIVO,
Madagascar
(S 18°57' E 47°31')

In the region of Antananarivo, the Merina people, a Malayo-Indonesian ethnic group, use traditional methods to cultivate their rice paddies in the plains surrounding the villages. Rice paddies now take up two-thirds of the country's cultivated area. Two types of rice growing are practiced on the island: wet cultivation on flooded terraces along the rivers, in the valleys; and dry cultivation on scorched earth on the steep slopes. Madagascar is among the world's leading consumers (about 264 pounds, or 120 kg, per capita per year) of rice, but it is not a major producer (producing 2.5 million tons, it ranks approximately twentieth in the world). For a long time the country has been importing rice of average quality while exporting a luxury variety. Rice, wheat, and corn are the three most consumed grains in the world.

pp. 264–65
DETAIL OF THE
THJORSA RIVER,
Iceland
(N 63°56' W 20°57')

The Thjórsá River, the longest river in Iceland, travels 143 miles (230 km) through terrain covered with lava. The river carries a good deal of organic and mineral refuse to the ocean, lending the Thjórsá its characteristic color. The island is covered with a vast network of unnavigable rivers, most of which derive from subglacial torrents, whose variable, tortuous routes make the construction of bridges and dams difficult. However, hydraulic energy makes it possible to satisfy 20 percent of the electricity needs, and its capabilities remain considerable, because only one-sixth of the hydraulic potential has been exploited. Iceland is also planning to use its sources of renewable energy (hydraulic and geothermal) to produce hydrogen, having made the pioneering decision to convert its entire economy to this new, nonpolluting fuel by the year 2030.

pp. 266–67
WORKING THE
FIELDS NORTH
OF JODHPUR,
Rajasthan, India
(N 26°22' E 73°02')

Rajasthan, the second-largest state in India in terms of area (133,500 square miles, or 342,240 km²), lies in the northwest region of the country. Sixty-five percent of the state is covered by sandy desert formations, and the scarcity of surface water is largely responsible for the low productivity of its soil. However, the construction of irrigation systems, which benefit 27 percent of arable lands in India, has aided in the development of agriculture. Millet, sorghum, wheat, and barley are cultivated here. The harvesting of these grains at the end of the dry season is a task that normally falls to women, who, even while working in the fields, wear the traditional *orhni*, a long, brightly colored shawl that is typical of the region. More than half of India's territory is devoted to farming, which produces one-fourth of the domestic national product. Each year the country harvests about 220 million tons of grains, more than one-tenth of world production, and it ranks second in the world in wheat and rice. But the old conflict between production increase and demographic growth is now also affected by declining subterranean water reserves; a severe drought in April 2000 affected 20 million people in Rajasthan.

pp. 268–69
GREAT BARRIER REEF,
Queensland, Australia
(S 16°55' E 146°03')

At a length of 1,550 miles (2,500 km) along the northeastern coast of Australia, with more than 400 types of coral, the Great Barrier Reef is the largest coral formation in the world. This rich, silent sanctuary of submarine life was declared a marine park in 1979 (comprising 15 percent of the world's protected sea surface) and a UNESCO world heritage site in 1981. The Great Barrier Reef harbors more than 1,500 species of fish and 4,000 mollusks, as well as such animals as the endangered dugong (sea cow) and six of the seven species of sea turtle. Coral formations, the world's only relief that is biological in nature, are polyps that live symbiotically with photosensitive algae, zooxanthellae, which contribute to the development of the calcareous skeletons of their hosts. The coral reefs are essential to the protection of the coasts and of ocean fauna. They are sensitive to the smallest increase in water temperature, which can cause them to whiten. This phenomenon, which was particularly noticeable in 1998 (during El Niño), caused the loss of thousand-year-old corals. Many of the affected coral colonies are starting to regenerate, but the growing frequency of the whitening phenomenon, which could result from global warming, is disturbing.

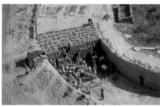

pp. 270–71
BRICKYARD
EAST OF AGRA,
Uttar Pradesh, India
(N 27°04' E 78°53')

Numerous brickyards have set up shop in the vicinity of Agra, a metropolis of 1.2 million in Uttar Pradesh, a state that comprises one-sixth of India's population. These small enterprises provide work in a region hard hit by unemployment, a problem throughout the country. In 1999 India ranked 144th in the world in gross domestic product per capita (adjusted accorded to buying power). Production of these terra-cotta bricks is particularly intended for urban centers; the rural population generally lives in housing made of adobe, a raw, claylike earth that is lower in cost but vulnerable to bad weather. The strong urban growth of the Agra area, where the population has increased by 50 percent in the past twenty years, points to a prosperous future for local producers of construction materials.

Captions to the photographs on pages 272 to 287 can be found on the foldout to the right of the following chapter

captions 258–271 captions 272–287

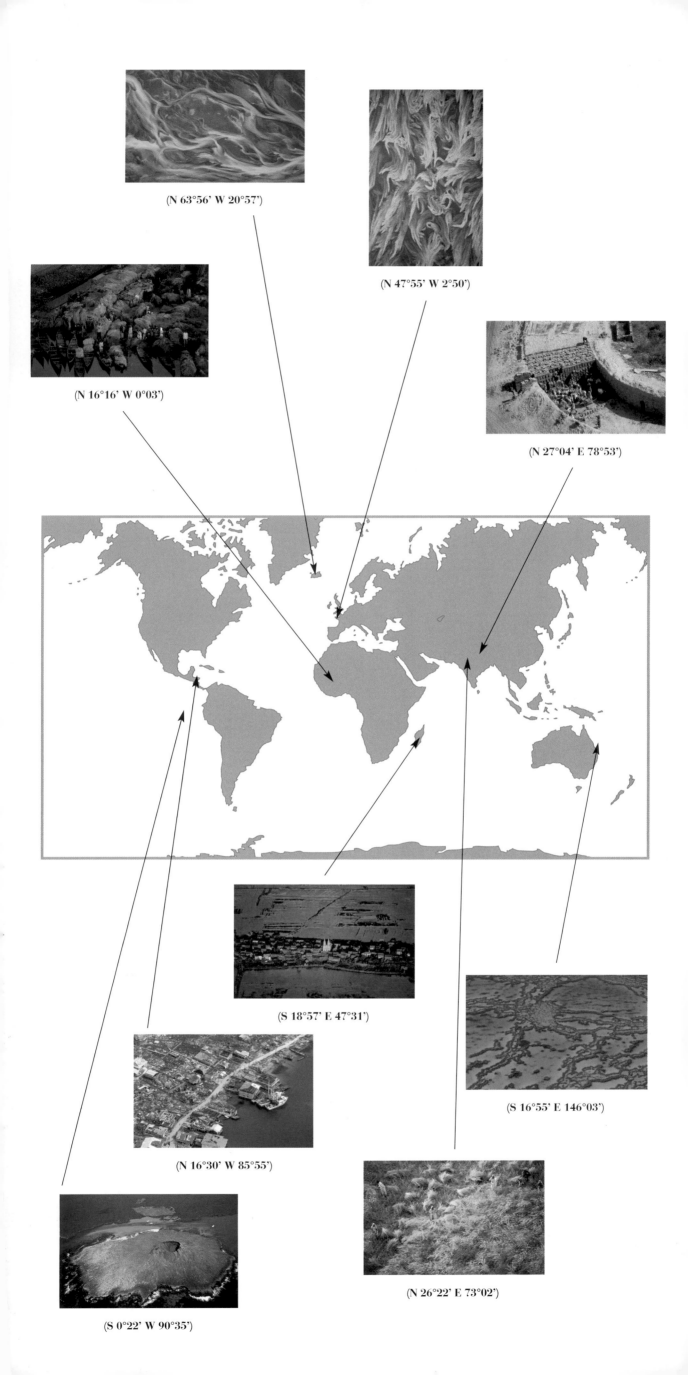

(N 63°56' W 20°57')

(N 47°55' W 2°50')

(N 16°16' W 0°03')

(N 27°04' E 78°53')

(S 18°57' E 47°31')

(S 16°55' E 146°03')

(N 16°30' W 85°55')

(S 0°22' W 90°35')

(N 26°22' E 73°02')

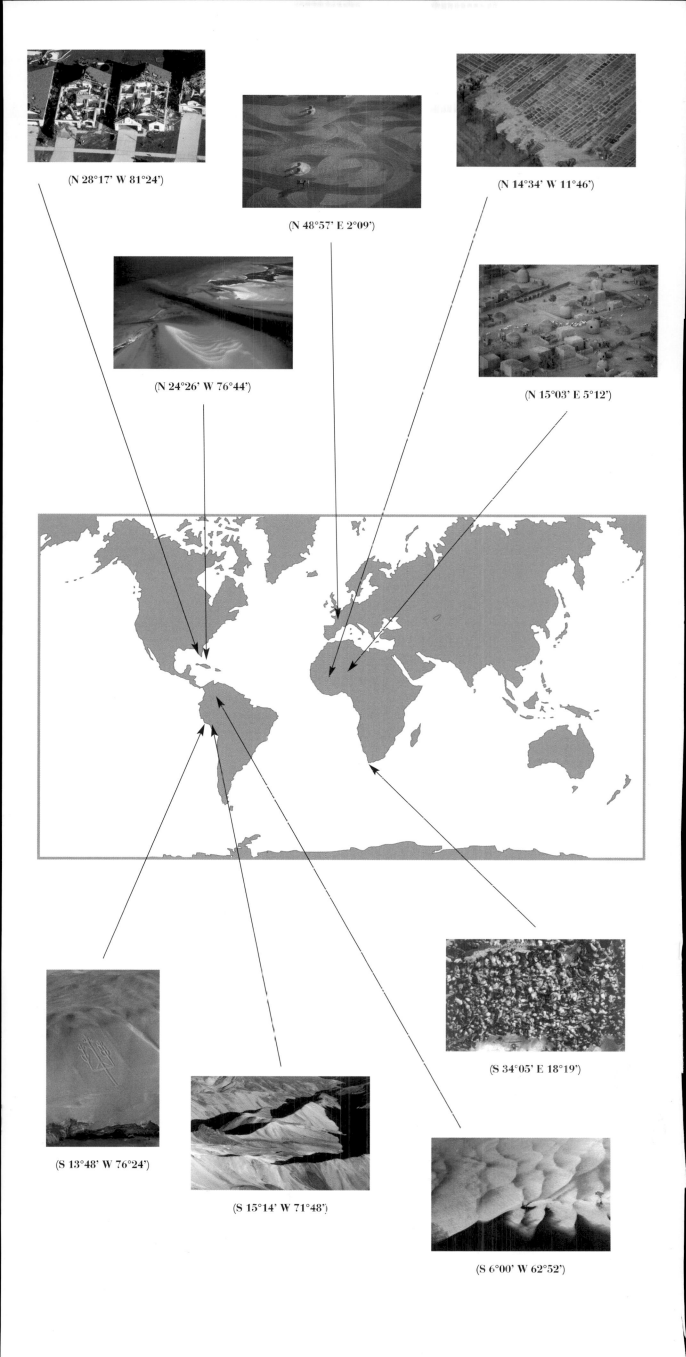

(N 28°17' W 81°24')

(N 48°57' E 2°09')

(N 14°34' W 11°46')

(N 24°26' W 76°44')

(N 15°03' E 5°12')

(S 34°05' E 18°19')

(S 13°48' W 76°24')

(S 15°14' W 71°48')

(S 6°00' W 62°52')

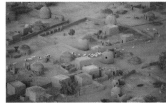

pp. 232–33
DETAIL OF A VILLAGE
NEAR TAHOUA,
Niger
(N 15°03' E 5°12')

This village near Tahoua, in southwestern Niger, shows typical Huasa architecture: cubelike houses of banco (a mixture of earth and vegetal fibers), alongside imposing ovoid-shaped grain storehouses. The Huasa people, who make up 53 percent of the country's population, are farmers, but they are most renowned for their artisanry and trade. The Huasa city-states in northern Nigeria have had commerce with numerous African countries for several centuries. Today the region of Tahoua is crossed by a road that leads northward, commonly called the "uranium route." A vein of uranium was discovered in 1965 in the ground below the Air Massif, and mines in the northern town of Arlit yield nearly 3,000 tons of uranium each year, or about 10 percent of the world output.

pp. 234–35
SAND BANK OF
THE RIO CARONI,
state of Bolívar,
Venezuela
(N 6°00' W 62°52')

The 425-mile-long (690 km) Rio Caroni flows northward through the Venezuelan state of Bolívar (commonly called Guayana), descending in a series of falls and meeting vast sandbanks on its way. The Caroni, along with the other waterways that cross Guayana, is rich in alkaloids and tannins from the degradation of dense forest vegetation. They are therefore grouped together under the general category of "black" rivers, as opposed to the "white" rivers that descend from the heights of the Andes carrying mud and silt; the waters of the black rivers are dark but clear, whereas the white rivers are murky. Before ending its course in the Orinoco River, the Caroni powers the Guri Dam (in service since 1986), which provides 60 percent of Venezuela's electricity. The Guri Dam is the world's second-largest dam in terms of hydroelectric power, with a capacity of 10,300 megawatts—the power of a French nuclear power plant is on the order of 1,000 megawatts. Hydraulic energy is developing in South America and already provides 50 percent of the power for ten countries.

pp. 236–37
TRAINING ARENA IN
THE HIPPODROME OF
MAISONS-LAFFITTE,
Yvelines, France
(N 48°57' E 2°09')

The hippodrome of Maisons-Laffitte, near Paris, boasts one of the largest equestrian training centers in France, with tracks and stables that accommodate close to 800 horses. In the training arenas—shown here is the Adam arena—the grooms exercise the young horses and prepare them for jumping obstacles before allowing them to run the practice rink and racetracks. The hippodrome of Maisons-Laffitte hosts more than 250 races each year, featuring a total of close to 3,000 contestants. Horse races account for a considerable portion of the gambling industry: more than $100 billion is bet on racehorses throughout the world each year; nearly half that sum, $44 billion, is placed by the Japanese.

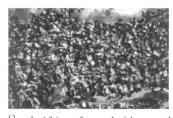

pp. 238–39
FUR SEALS ON A ROCK
NEAR DUIKER ISLAND,
province of Western
Cape, Republic of
South Africa
(S 34°05' E 18°19')

South African fur seals (*Arctocephalus pusillus pusillus*), gregarious by nature, gather on the coasts in colonies of several hundred, where they mate and give birth to their young. More comfortable in a marine setting than on dry land, these semi-aquatic mammals spend most of their time swimming through the coastal waters in search of the fish, squid, and shellfish that make up their diet. The species residing at the Cape of Good Hope, numbering some 850,000, is found only on the coasts of southern Africa, from Cape Cross (in Namibia) to the Bay of Algoa (in South Africa). Sea lions, of which there are 14 species, belong to the family of pinnipeds, which also includes 19 species of seal and one walrus variety; present in most seas, the pinnipeds have a total population of 50 million, 90 percent of which are seals.

pp. 240–41
ISLETS AND SEA
BEDS,
Exuma Cays, Bahamas
(N 24°26' W 76°44')

The archipelago of the Bahamas, which takes its name from the Spanish term *baja mar* ("shallows"), spreads out in an arc in the Atlantic Ocean, running 750 miles (1,200 km) from Florida to Santo Domingo. It consists of more than 700 islands (with a combined area of 5,500 square miles, or 14,000 km², of emerged land), 29 of which are permanently inhabited, plus a few thousand rocky coral islands called cays. Here Christopher Columbus first set foot in the Western Hemisphere, during his voyage in 1492. During the sixteenth and seventeenth centuries the Bahamas were a center of piracy. They became a British possession in 1718, which they remained until their independence in 1972. Today the country is a "fiscal paradise": there is no income tax. It derives its resources from banking (20 percent of the GNP) and tourism (60 percent of the GNP), which employs two out of three Bahamians. More than a thousand ships, or nearly 3 percent of the international commercial fleet, are registered with a Bahaman flag of convenience. The Bahamas have also become one of the centers for drug traffic (marijuana and cocaine) bound for the United States.

pp. 242–43
ANDES CORDILLERA
BETWEEN CUZCO AND
AREQUIPA,
Peru
(S 15°14' W 71°48')

The Andes Cordillera and its foothills cover one-third of the territory of Peru. In the country's southern region, between Cuzco and Arequipa, the mountains reach peaks of more than 20,000 feet (6,000 m), progressively giving way to the high Andes plateaus, situated between altitudes of 11,500 and 14,750 feet (3,500 to 4,500 m), known as Puna. The people who live here are one of the only sedentary populations that live at such a high altitude; the other example is in Tibet. The Andes Cordillera is a young formation, created 20 million years ago after upheavals of the earth's surface and accumulation of deposits of sandstone and granite. It extends over a length of 4,650 miles (7,500 km) along the Pacific coast of South America, crossing seven countries from the Caribbean Sea all the way to Cape Horn.

pp. 244–45
TORNADO DAMAGE IN
OSCEOLA COUNTY,
Florida, United States
(N 28°17' W81°24')

On February 22, 1998, a force-4 tornado (with winds of 185 to 250 miles per hour, or 300 to 400 km per hour) finished its course in Osceola County, after having devastated three other counties in central Florida. Several hundred homes were destroyed in its whirlwind, and 38 people were killed. This type of violent tornado, rare in Florida, is generally linked to the climatic phenomenon of El Niño, which causes strong meteorological disturbances all over the world about every five years. Major natural catastrophes are more frequent and devastating than ever before. Human activities have significantly disturbed natural sites, reducing their resistance and their ability to withstand the effects of extreme climatic events. People also aggravate these consequences by living in areas exposed to risks. The decade of the 1990s saw four times more natural catastrophes than occurred in the 1950s, and the economic losses thus caused in that decade totaled $608 billion, more than the costs for the four previous decades combined.

pp. 246–47
MARKET GARDENS
ON THE SENEGAL
RIVER NEAR KAYES,
Mali
(N 14°34' W 11°46')

In western Mali, near the frontiers of Senegal and Mauritania, the city of Kayes is a major ethnic and commercial crossroad. The Senegal River passes through the entire region, and many market gardens sit along its banks. The river is an important resource in this zone of the Sahel, and the waters are transported in containers by local women to provide for the manual watering of tiny parcels of land, which produce fruit and vegetables intended for the local market. The Senegal River, which begins at the confluence of the Bafing ("black river") and the Bakoy ("white river") rivers slightly upstream from Kayes, runs for 1,000 miles (1,600 km) across four countries. The hydraulic stations along its course allow the irrigation of only 234 square miles (600 km²) of farms, but its basin of 136,500 square miles (350,000 km²) provides water for nearly 10 million people.

gested by humans at the end of the food chain. The World Health Organization (WHO) has already counted some 250 million annual cases of gastroenteritis and respiratory ailments stemming from contamination through swimming in polluted waters. Pathogenic bacteria can survive in the sea for days, even weeks, and some viruses last for months, which explains how even in "moderately polluted" waters, according to the criteria of the European Union and the U.S. Environmental Protection Agency, the chance of contamination after just one swim has risen to 5 percent.

One type of human pollution that we hear about in the media is oil spills. The 1989 Exxon *Valdez* spill in Alaska was a catastrophe, and the 1999 *Erika* accident off the coast of Brittany in France was even more devastating. However, the 12,000 tons of hydrocarbons spilled by the *Erika* are just a drop of fuel in the garbage-can ocean. Every year about 6 million tons of various products are dropped into the world ocean. Accidental pollution, the result of the 115 to 120 annual wrecks by vessels of more than 300 tons, represents barely more than 150,000 tons or just 2.5 percent of total marine pollution.

Although seemingly less spectacular than the black tides that muck up the coastline for long periods, the pollution caused by the draining and cleaning of tanks by cargo ships on the high seas is nevertheless more serious. It adds up to eight to ten times greater in volume than the total damage caused by accidents and accounts every year for more than 1.2 million tons of hydrocarbons, accompanied by a whole range of detergents, chemical products, and various oils, dumped into the sea with near impunity—indeed, entirely legally: beyond the territorial waters or Exclusive Economic Zones, more than 200 miles (300 km) offshore, a certain amount of dumping is permitted.

Maritime traffic multiplied by 4.6 between 1970 and 1999 and will continue to grow. Although this development could help relieve highway transport, which has its own long-term harmful effects, there is no doubt that some action must be taken before the damage increases proportionately, turning a cause for concern into a crisis.

Another activity that might become one of the most serious of all threats for the future of the human race is fishing. Fish represent the main source of protein for more than 1 billion people all over the world. Humans take very little care of this gigantic "pantry"; our attitude is close to pillaging. Fish populations have been exploited beyond their safe biological limits. In fifty years the volume of fish caught globally has more than quadrupled, from 20 million tons in 1946 to more than 90 million tons today. In certain zones of the waters bordering Europe, 40 of the 60 main commercial species are exploited in conditions that endanger their future. Species that were once abundant are endangered today: bluefin tuna, cod, hake, monkfish, sole, and pollock, among others. Because overfishing is exhausting the traditional varieties, nations have begun catching other species, especially deepwater fish that are particularly vulnerable because of their weak fertility. To limit overfishing, regulations set a minimum fish size, requiring any smaller fish to be thrown back into the water, but the rejected fish rarely survive. Yet excessive fishing also gradually leads to a reduction of the size of the species.

Tomorrow humankind will be even more numerous—more of us eating, living in cities, on the coasts. The world population is expected to reach 8 billion by 2020 and 10 billion by 2050. Such growth threatens to cause an explosion of a situation that is already off balance.

Demographic growth will make the world ocean even more fragile as humanity concentrates along the coastline: 60 percent of the world's population today lives on a coastline 40 miles (60 km) wide, equal to just 15 percent of the emerged earth. This proportion could reach 75 percent in twenty years. Bangkok, Bombay, Buenos Aires, Cairo, Jakarta, Lagos, Los Angeles, New York, Shanghai, Manila, and Tokyo will increase their transformation into coastal "megacities," which will lead to problems in water quality. Pollutants, whether from agriculture, industry, or individuals, could reach dramatic levels. Demographic pressure can only aggravate health problems, which are already causing concern, stemming from the quality of bathing water as well as, more generally, all the problems cited above.

The situation is disturbing, but it is not hopeless. Ecological problems on this scale can be solved only by national and international regulation. The necessary global change, therefore, will have to be the result of political will. But such a will depends, in large measure, on the awareness of each individual. Citizens must be informed of the dangers that lie ahead and must demand a solution from their representatives. They must also keep themselves informed and adjust their own behaviors. The direct protection of marine biological diversity by the establishment of protected areas, a promising solution on the local level, remains very limited. It is difficult today to find more than a few protected marine areas (maritime "natural parks") in which growing efforts are being made to implement participatory management of the natural resources that concern local populations. It is urgent, above all, to create a global maritime environmental policy; at stake is the very credibility of all states that claim to provide legitimate protection of their citizens. The dangers can be contained if we show real determination in controlling fishing, safety of maritime shipping, gas emissions, and refuse from land.

Major advances have been achieved in the field of maritime security following the wreck of the *Erika*, but it is essential to go further, to become more effective and correct oversights. Individual nations must exert their controlling authority over the classification companies that inspect ships. In addition to the polluter-payer principle and the liability of the ship owner, charterer, and classification companies, we need to address the responsibility of the flag country. Inspections in port must be strengthened in order to ferret out the "garbage-can ships" that are often the source of polluting accidents. The

issue of dumping of cargo raises numerous problems. How can we claim that increasing the fines and sanctions will prove dissuasive when it is clear that less than 9 percent of proven infractions result in judicial prosecution? Satellite observation offers considerable opportunities for surveillance that, in Europe, have not yet had any judicial impact. On the other hand, establishing a coast guard would be a strong measure for the protection of the coastal waters against fuel dumping. It would also send a clear message regarding the determination to act on behalf of maritime security. What is required is a readjustment of the international norms authorizing dumping outside territorial waters, subject to certain levels, in order to keep pace with the exponential growth of maritime pollution.

To meet the growing demand for sea products, aquaculture seems to offer possibilities, as can be seen from its spectacular increase: from 10 million tons in 1984, its production reached 33 million tons in 1999, including 3 million tons of algae. But this growth must not occur at the expense of the natural environments and must be accompanied by strong measures for long-term management of stocks, or else we risk ending up with empty oceans bordered by intensive, artificially fed aquatic farms. Aquaculture can—and must—be conducted far out at sea. On an international level, it is urgent that we take measures to establish responsible, reasonable management of fisheries so as to ensure sustainable exploitation of these resources without exhausting the oceans. And this management must be imposed on nations. More concerned with their national economies, they struggle to respect these questions. It is essential for nations to grant subsidies for fishermen in an effort to avoid overexploitation of marine resources (and thereby to ensure the very future of the profession of fishing boat). One initiative of the WWF (World Wildlife Fund) is aimed at restoring to the consumer the ability to influence the great ecological balances. In several countries, discussions are under way to implement ecological certification of fish. The Marine Stewardship Council was instituted after a 1996 agreement between a large farm-produce company and the WWF. The certification of merchandise, which has equivalents in other fields (notably agricultural products that are labeled as organic and wood-derived products that are labeled by the Forest Stewardship Council), indicates that the product came from sustainably managed fisheries, exploited in economically viable and socially beneficial ways while preserving biological diversity and the marine environment. This label allows the consumer, by means of his or her purse, some authority over the conditions in which fishing is conducted. Numerous large English chains have long declared themselves in favor of this certification. Fish caught by trawlers, for example, would not be labeled, because that fishing technique is considered destructive of marine environments and insufficiently selective. As for the unloading of land refuse, in the past twenty years Europe has created a legislative and regulatory arsenal to protect its coastal areas. Applying it, however, has left something to be desired. Any real law about water has yet to be enacted, including the obligatory impact studies and follow-up for all activities and industries along the shore. Treatment capacities of the purifying plants are mostly inadequate in many parts of the globe. In the coastal cities of industrialized countries, at the height of the summer period, it is important to move rapidly toward stations for tertiary treatment integrating organic treatment that will allow pathogenic bacteria to be contained. Only 10 percent of the cities of the planet have water purifying stations and, according to the World Bank, nearly 1.5 billion people in the world have no access to drinkable water. "We drink 90 percent of our illnesses," Louis Pasteur once said, and it is confirmed by 250 million new cases of water-related ailments (trachoma, bilharziasis, cholera, typhoid, malaria, and others) that occur every year, killing 10 million people. Any environmental maritime regulations must provide a water policy.

Of course, no miraculous solutions can be found. Instead, we must combine micro-solutions, and those just outlined are not enough. The sea and the ocean floor will soon be at the very heart of the major economic and scientific stakes. Drilling to great depths can open new perspectives, and the development of marine biotechnology is only beginning. In hydrothermal springs, those oases of the deep, new forms of life are being discovered that can show us the great alchemy of the origins of life. Every day we come closer to understanding the central role played by the world ocean in regulating global climates. How irresponsible, then, to ruin this space, which houses 80 percent of biodiversity and promises to become the new Eldorado—it is irresponsible in economic as well as ecological terms. It is imperative that a marine policy create the outline for what could well become a "New Frontier."

Christian Buchet

ALGAE IN THE GULF OF MORBIHAN,
France
(N 47°55' W 2°50')
For more than a century, oyster farms have been the privileged sites for the introduction of "exotic" species. In the 1920s an epidemic decimated *Crassostrea angulata*, the most widely exploited oyster species in France, after a Japanese species, *Crassostrea gigas*, was introduced—and, involuntarily along with it, some thirty species of animals and algae that today live in the waters of the English Channel and the Atlantic Ocean. One example is the Sargasso (*Sargassum muticum*), a brown algae, seen here in the Gulf of Morbihan, where it has become a part of the local flora. It was feared that there might be a galloping invasion, but this species, while becoming abundant, seems to have found its place in the ecosystem. Nevertheless, its proliferation and gigantism, capable of disturbing aquaculture and causing competition to the detriment of local species, require careful watching.

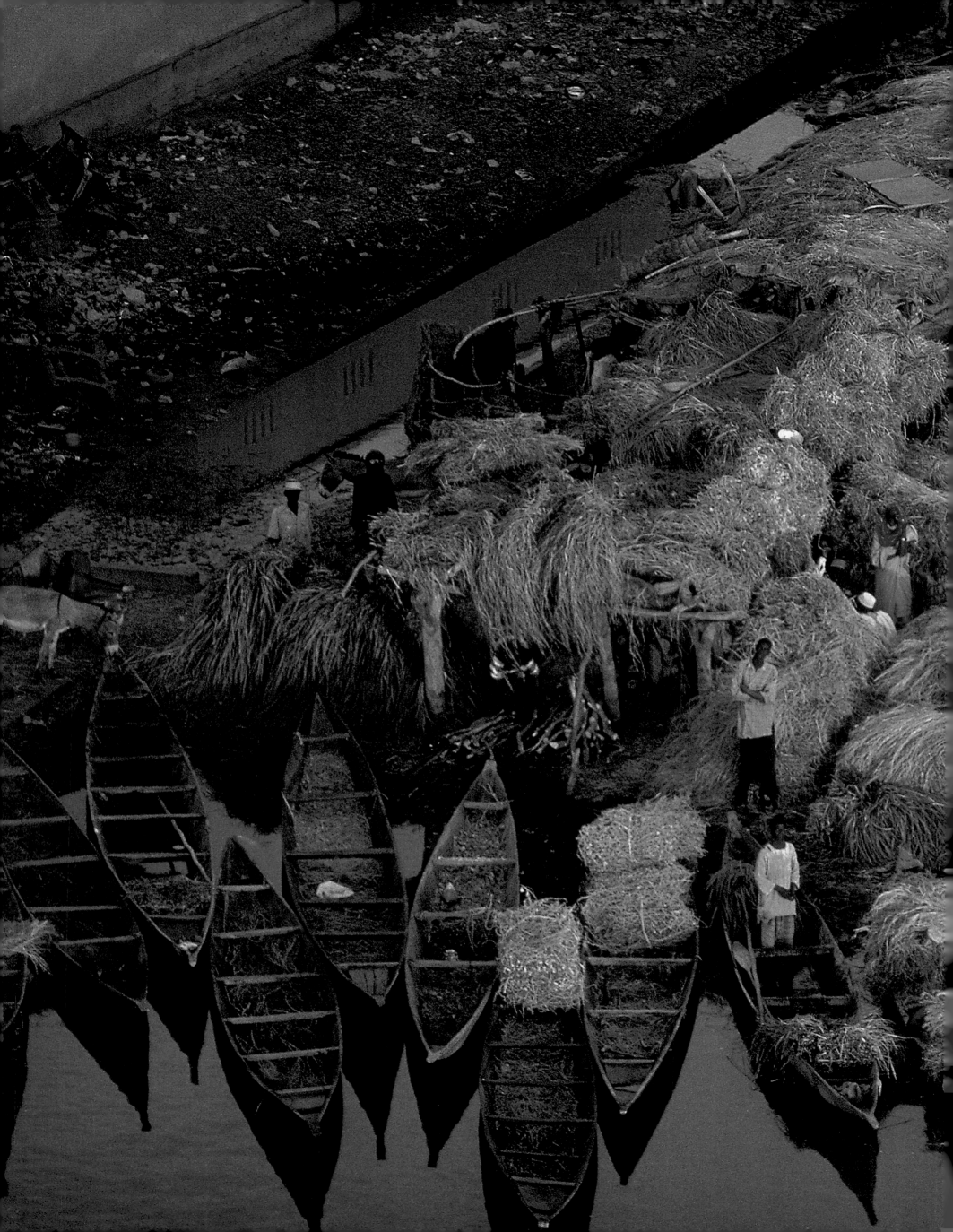

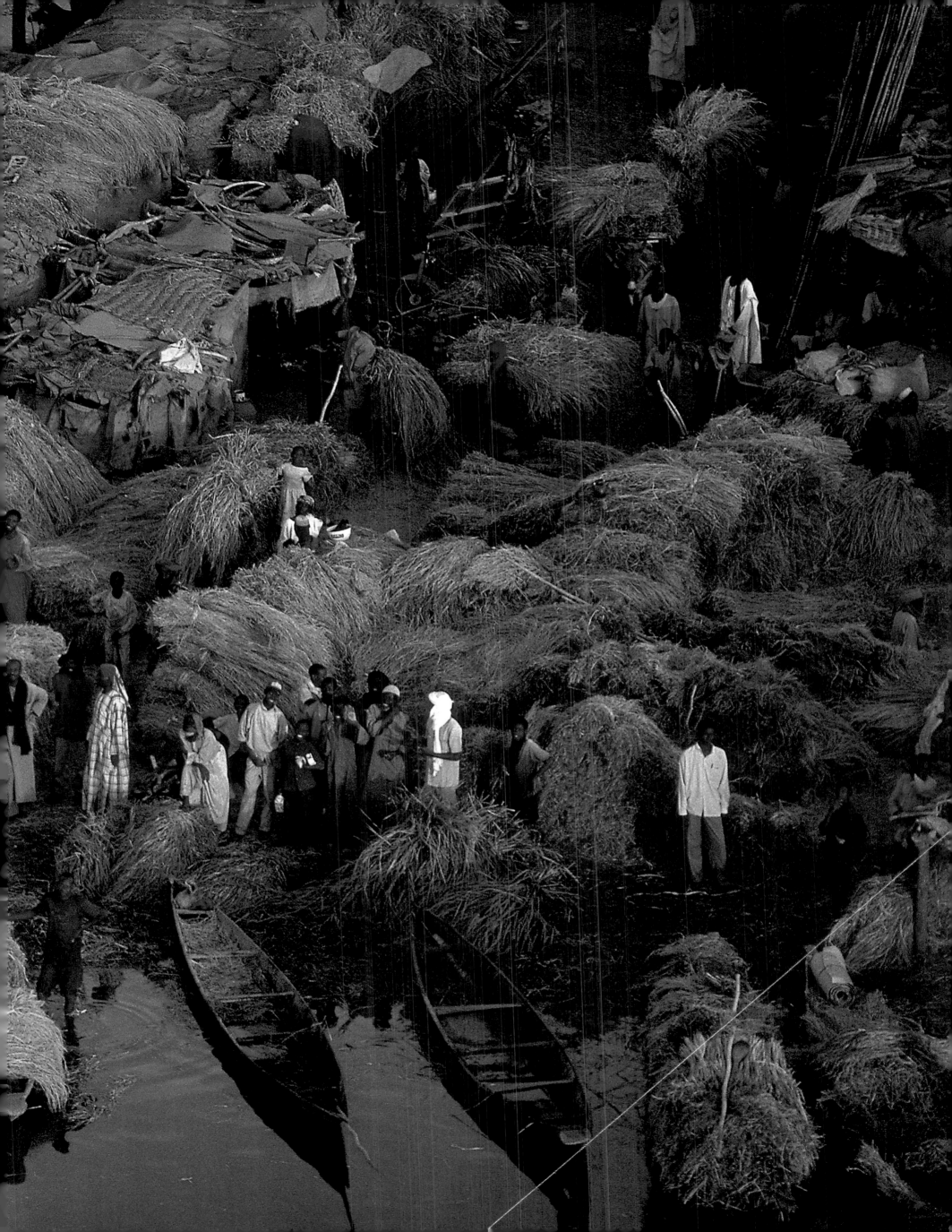

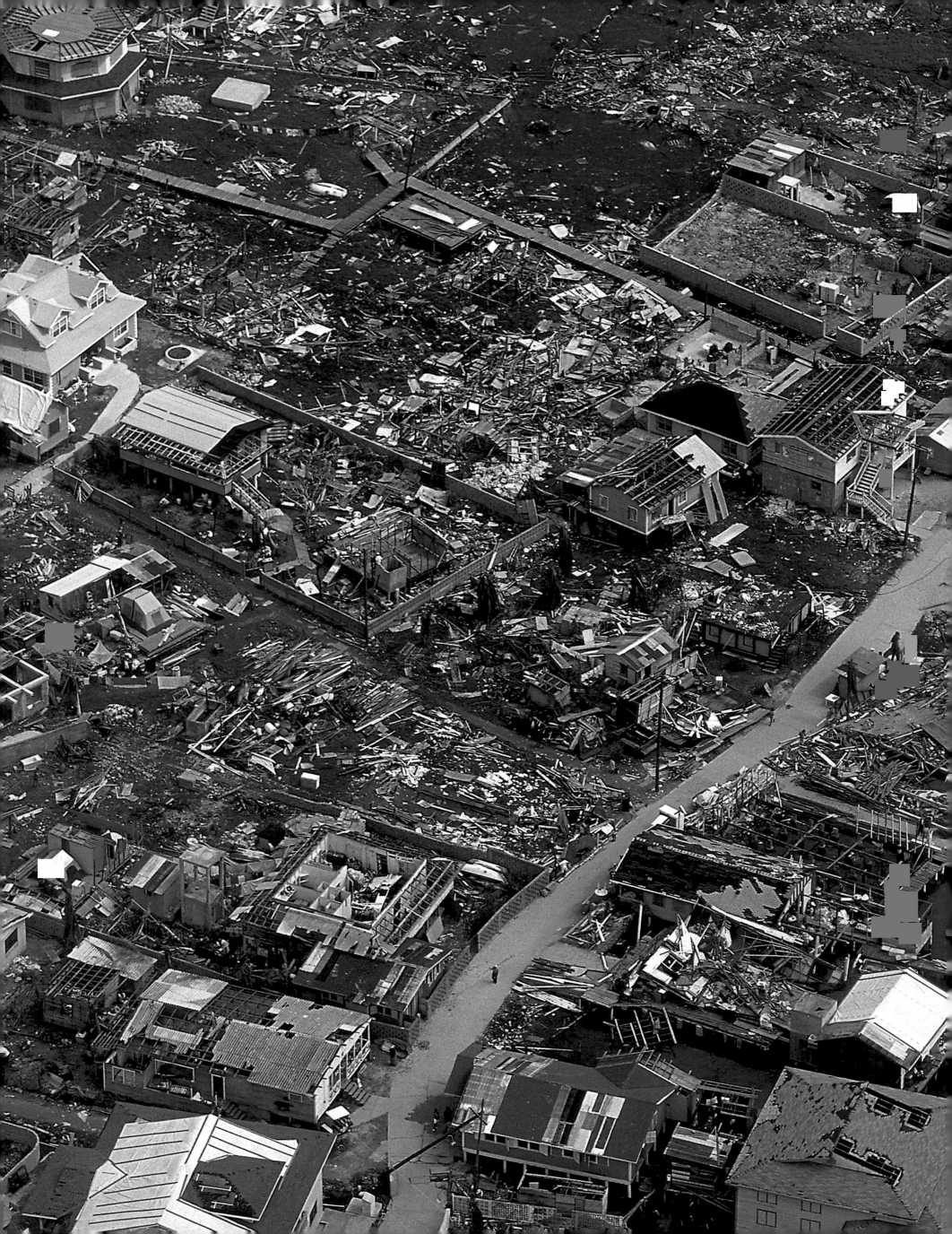

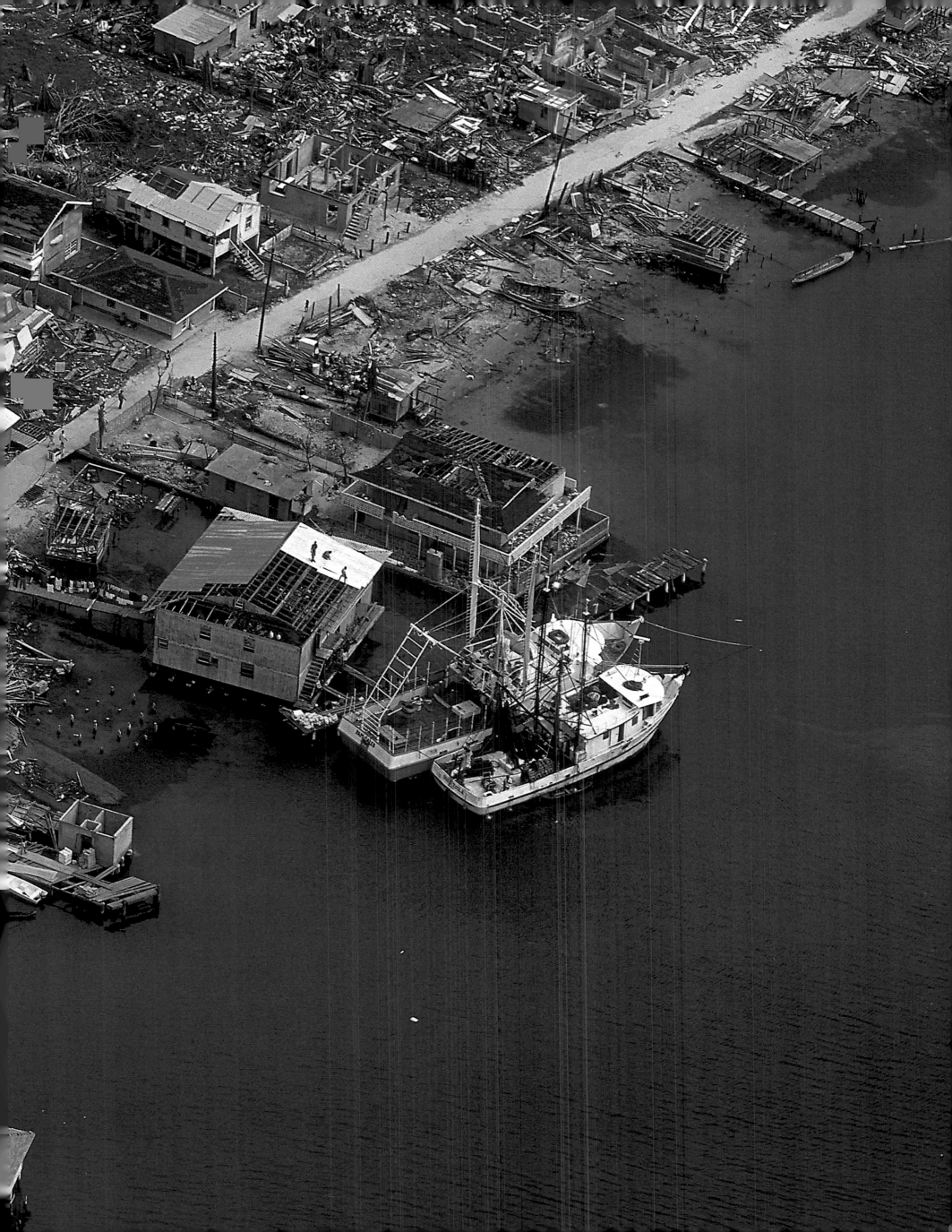

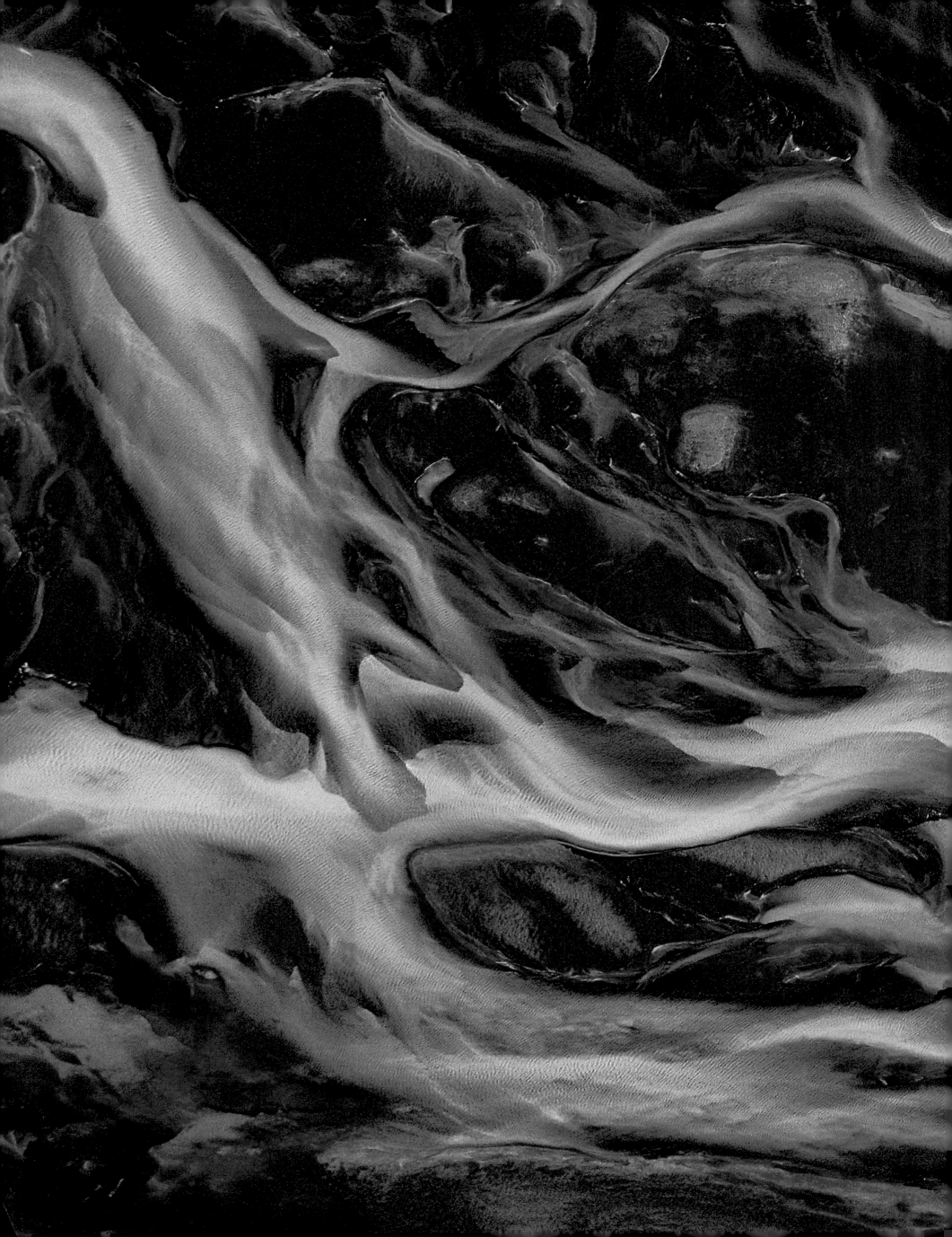

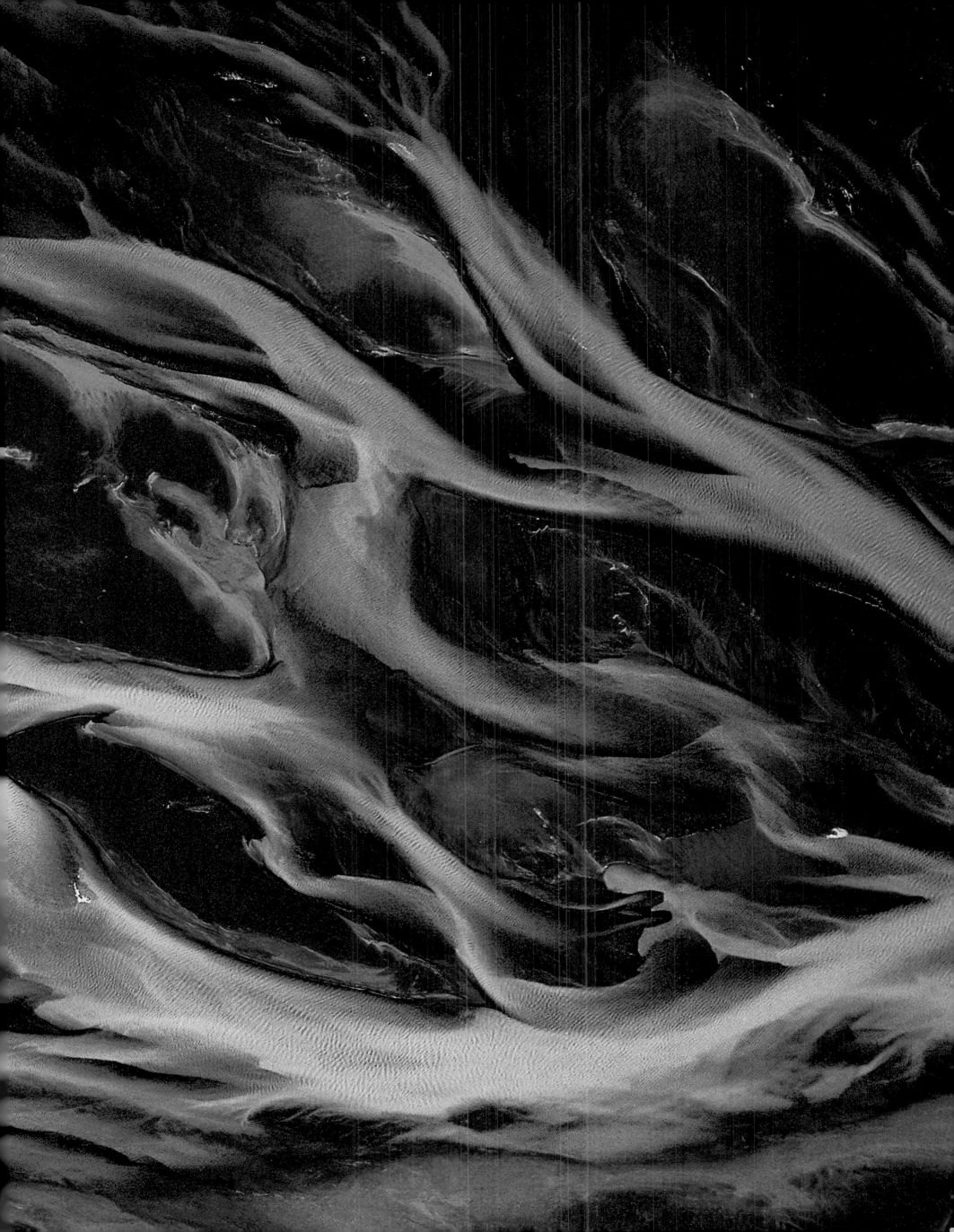

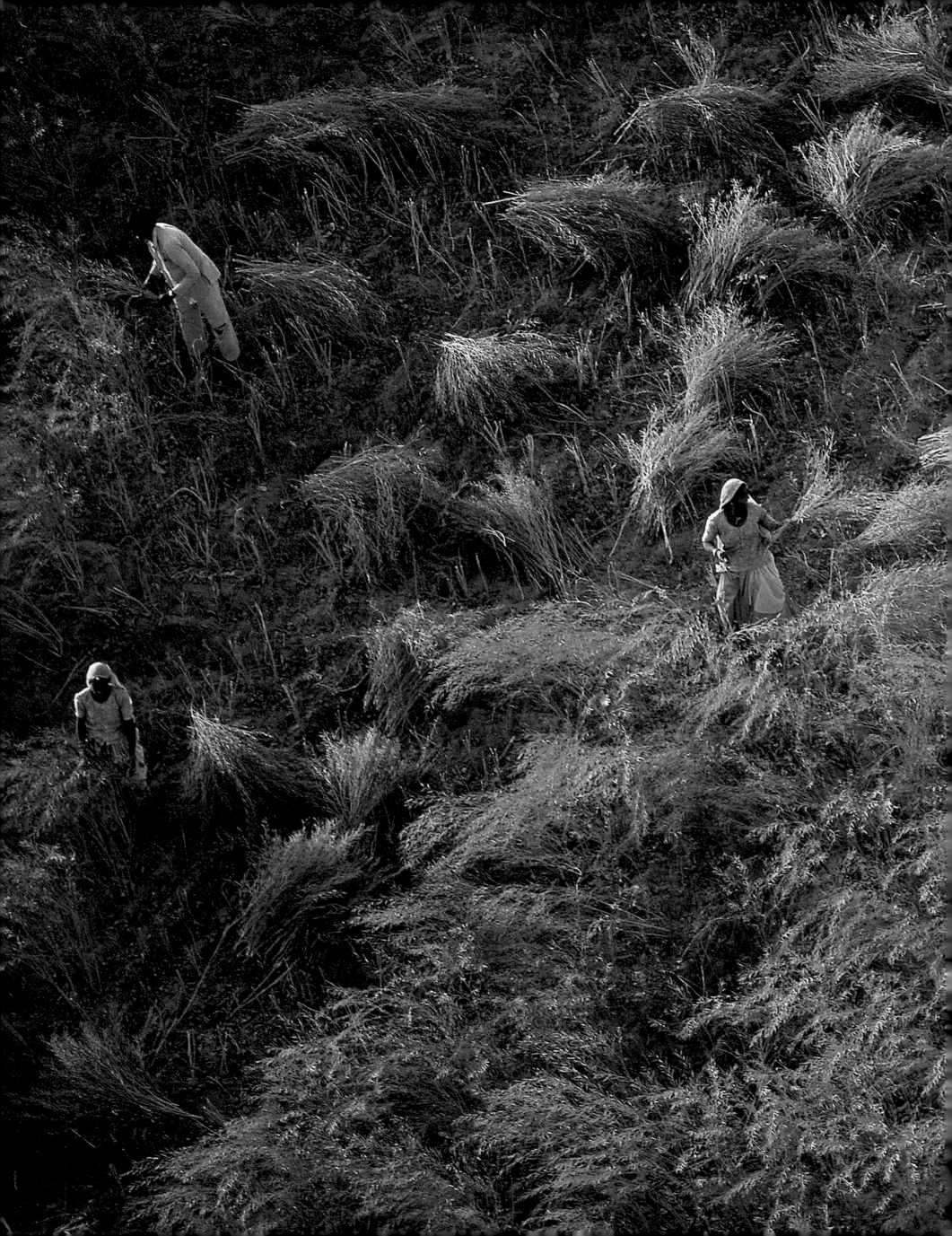

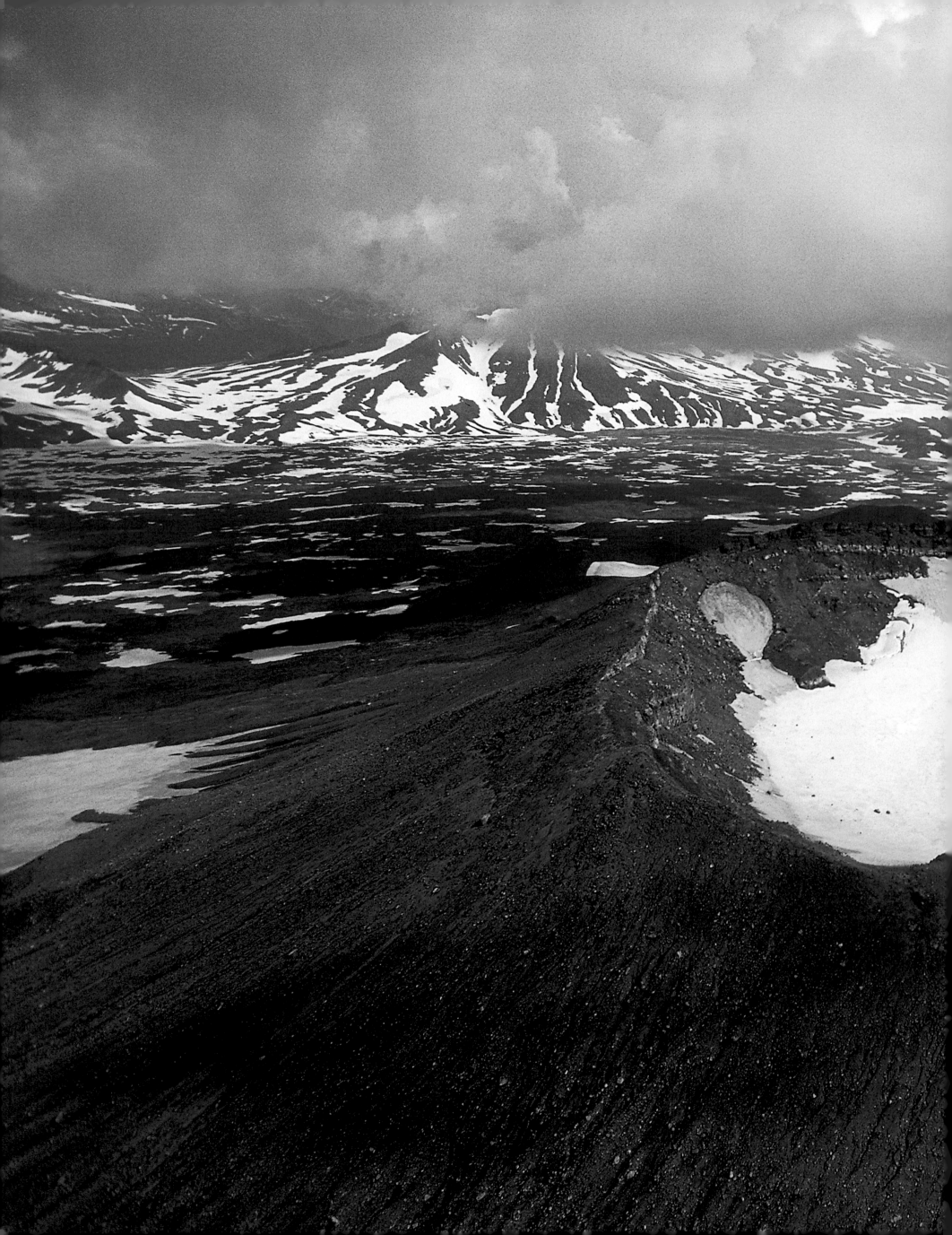

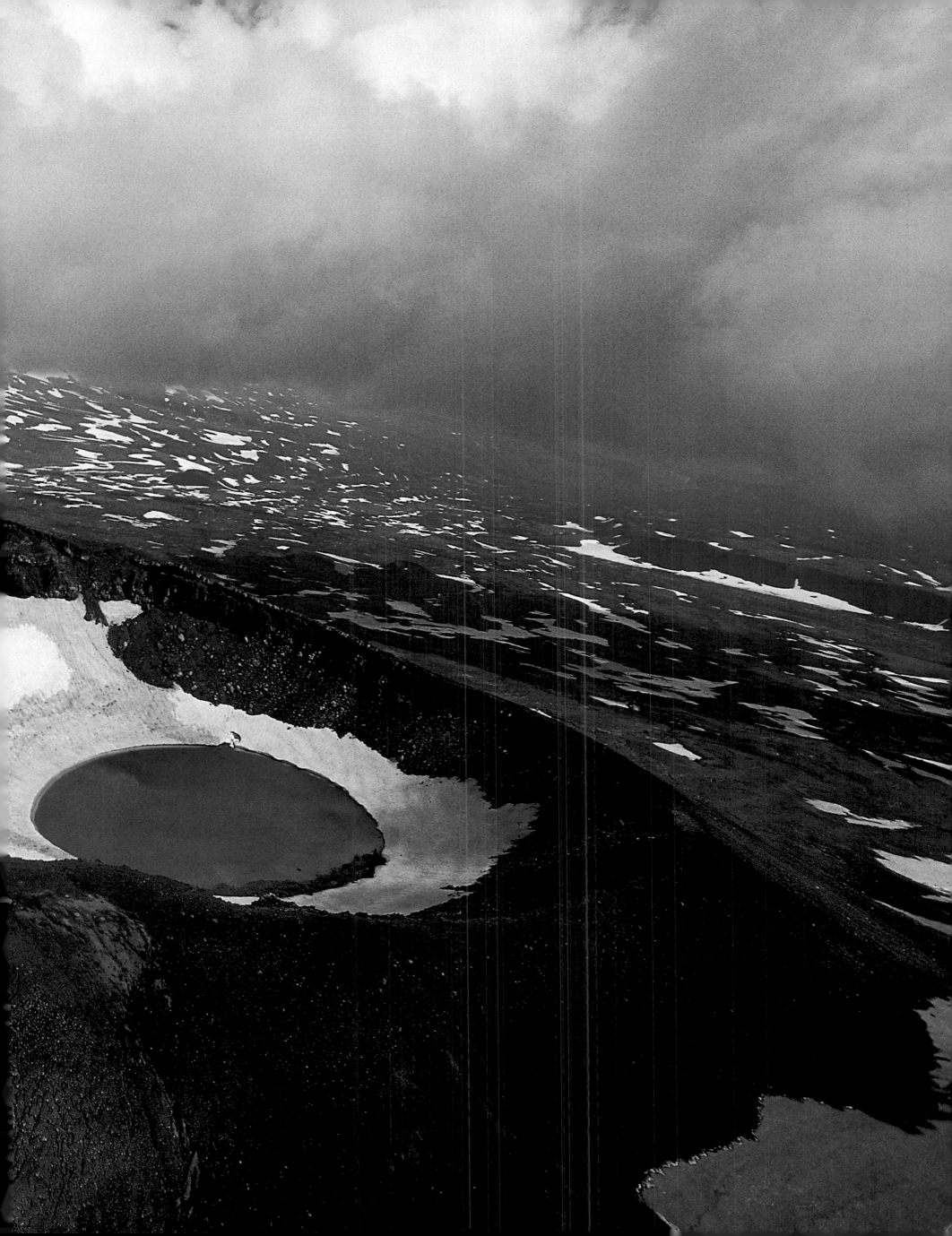

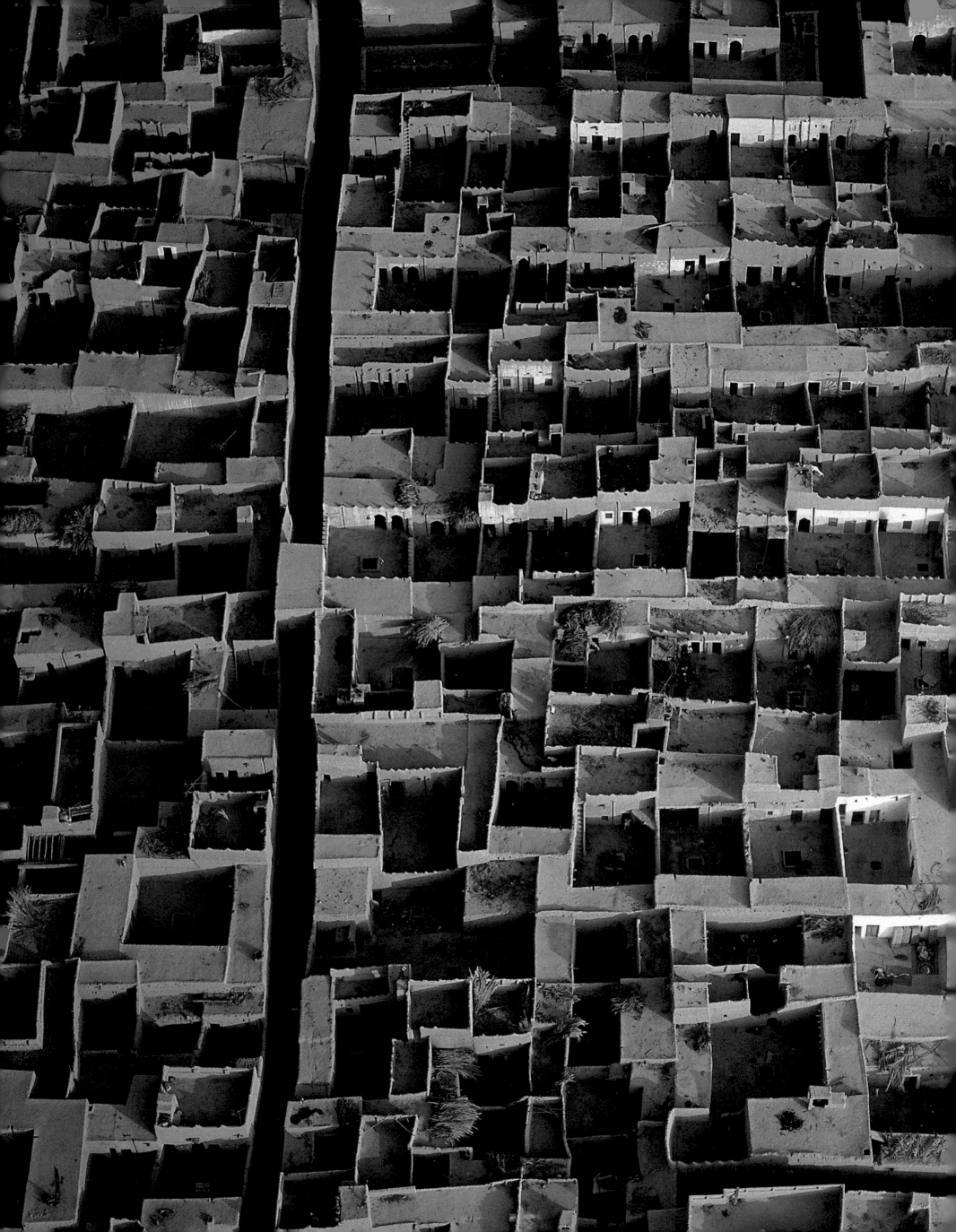

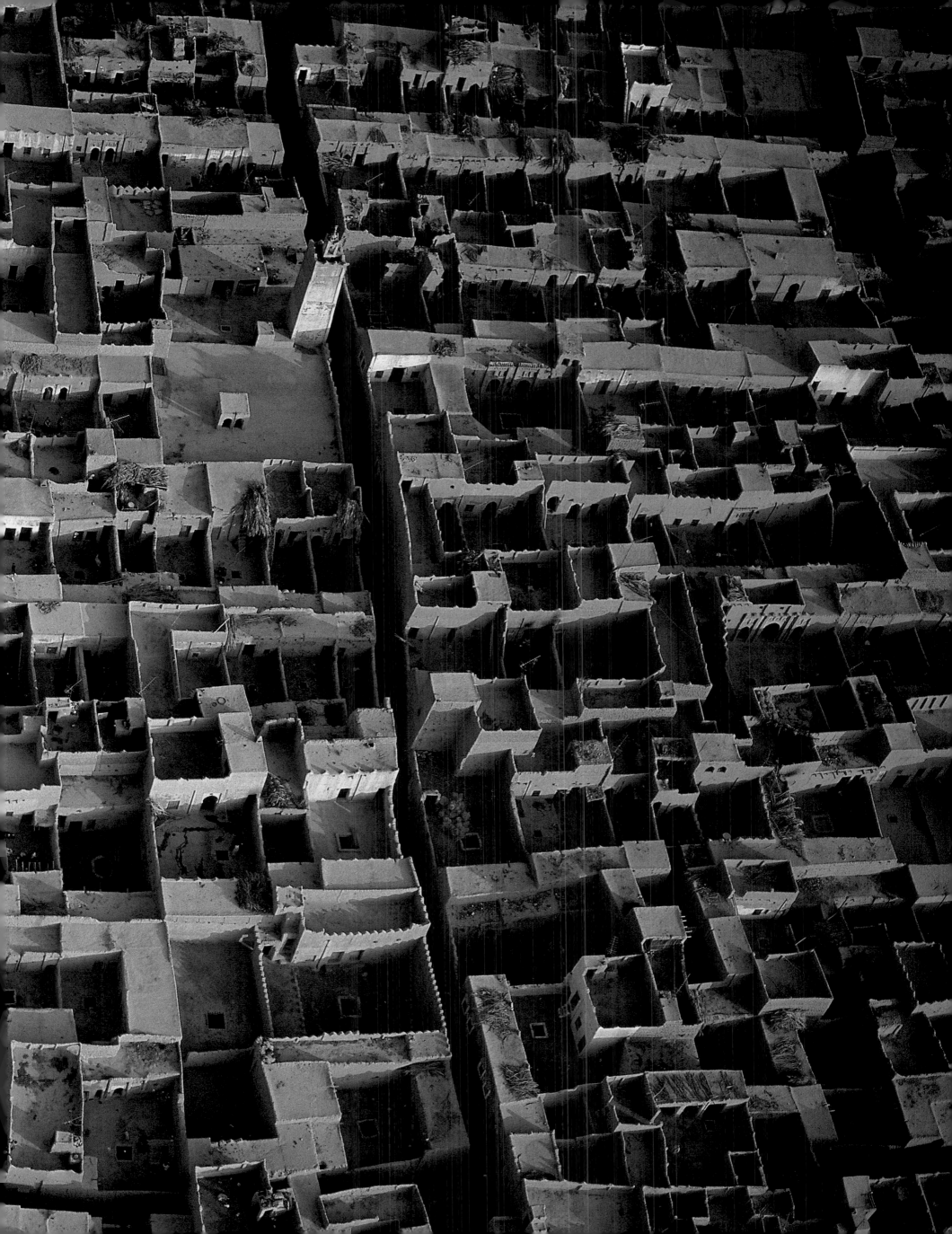

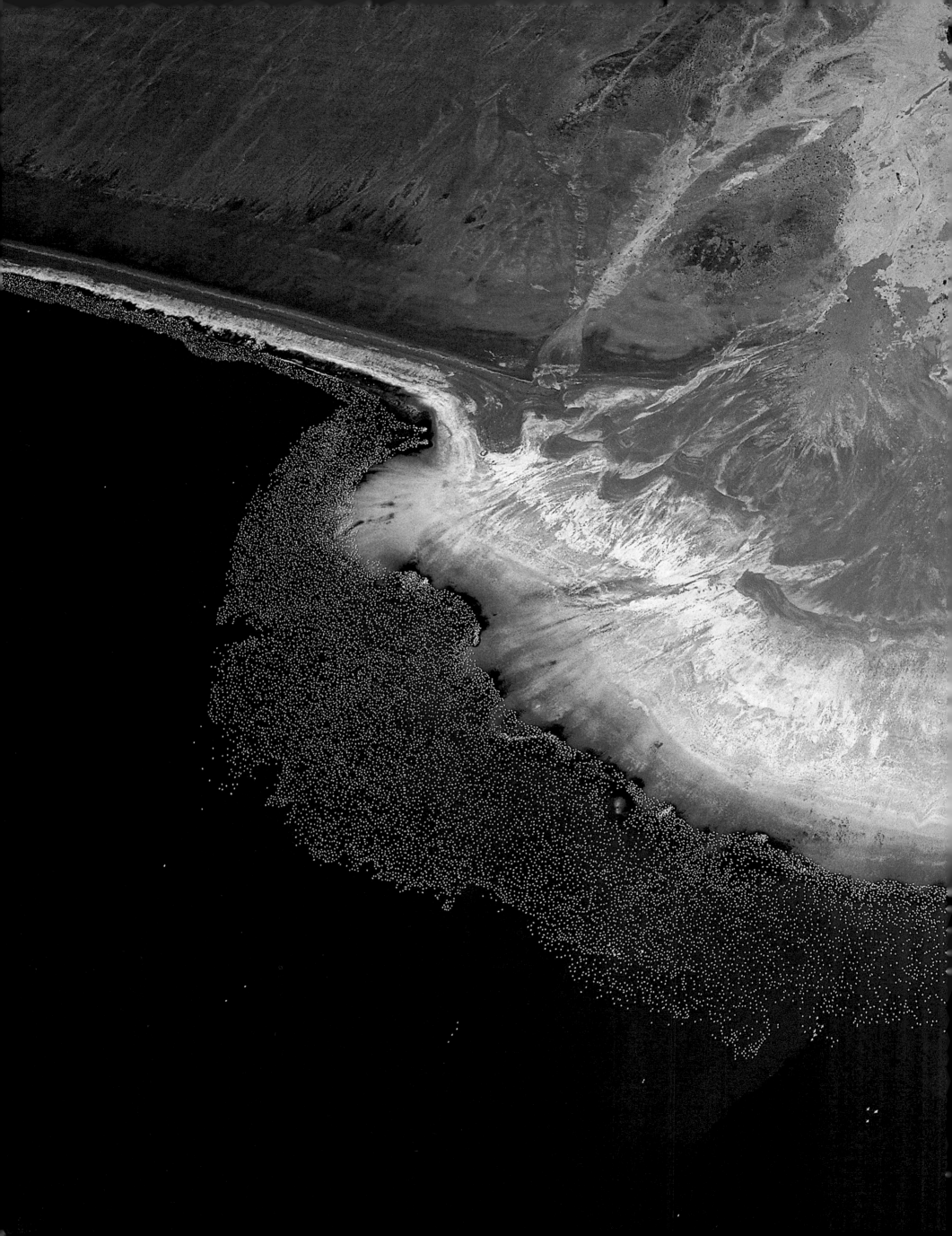

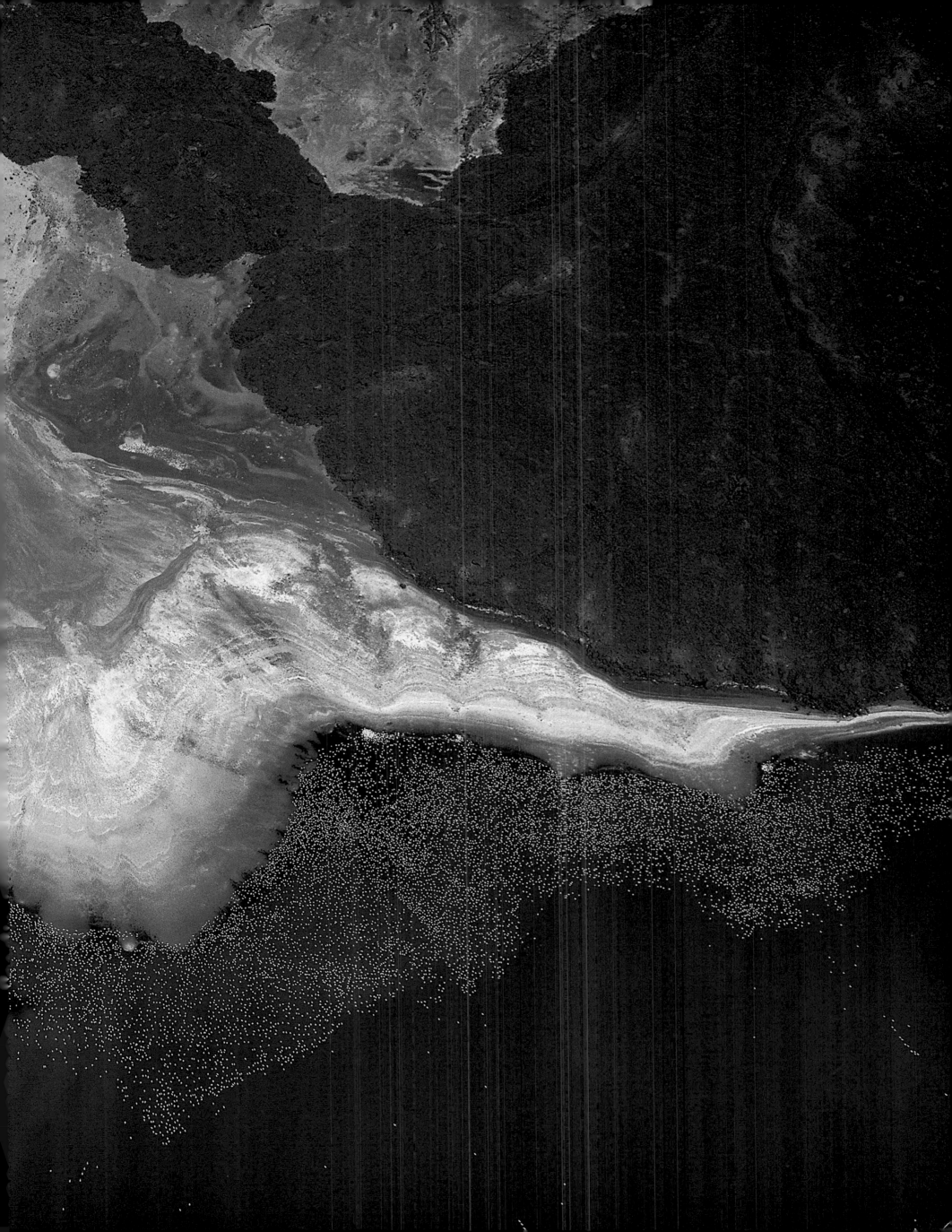

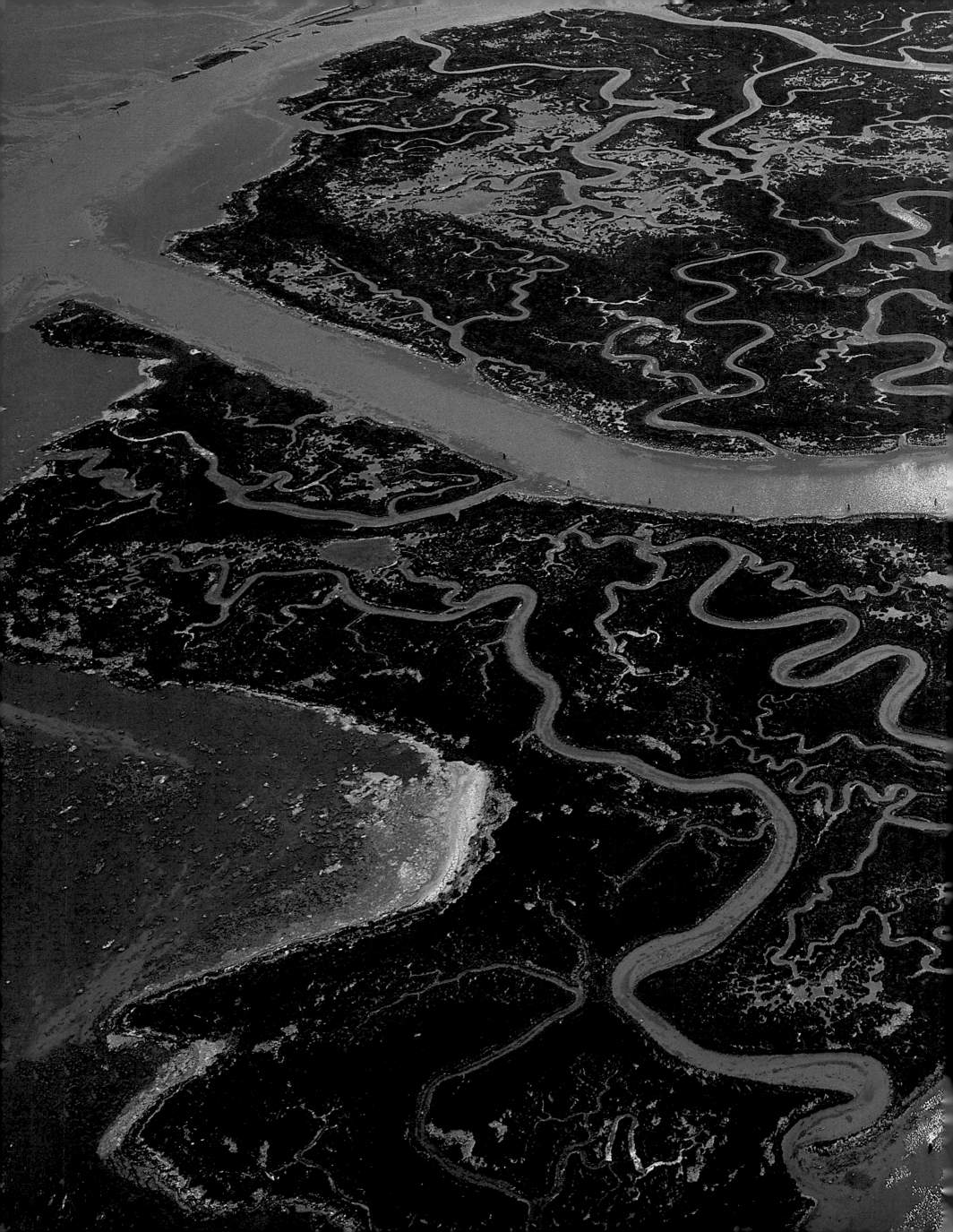

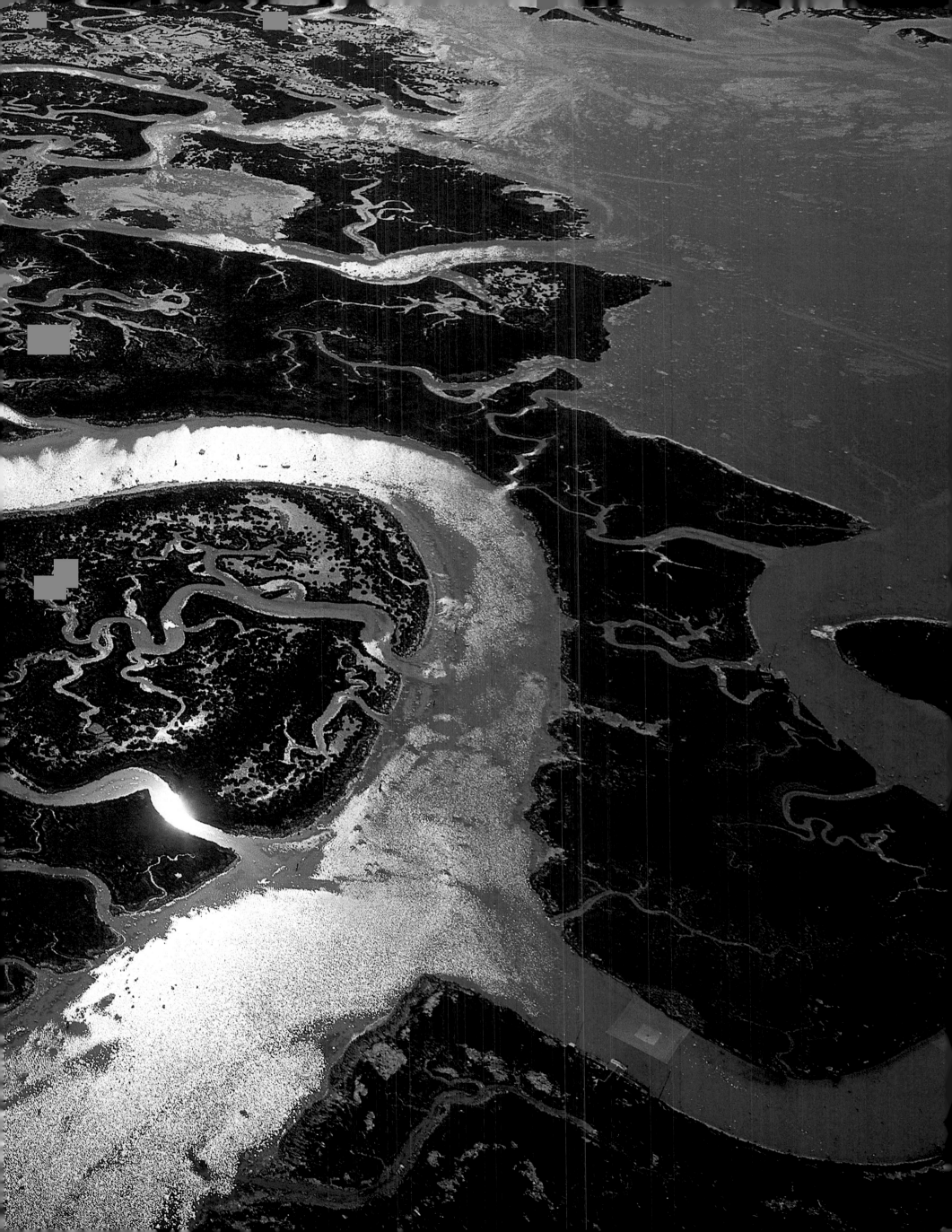

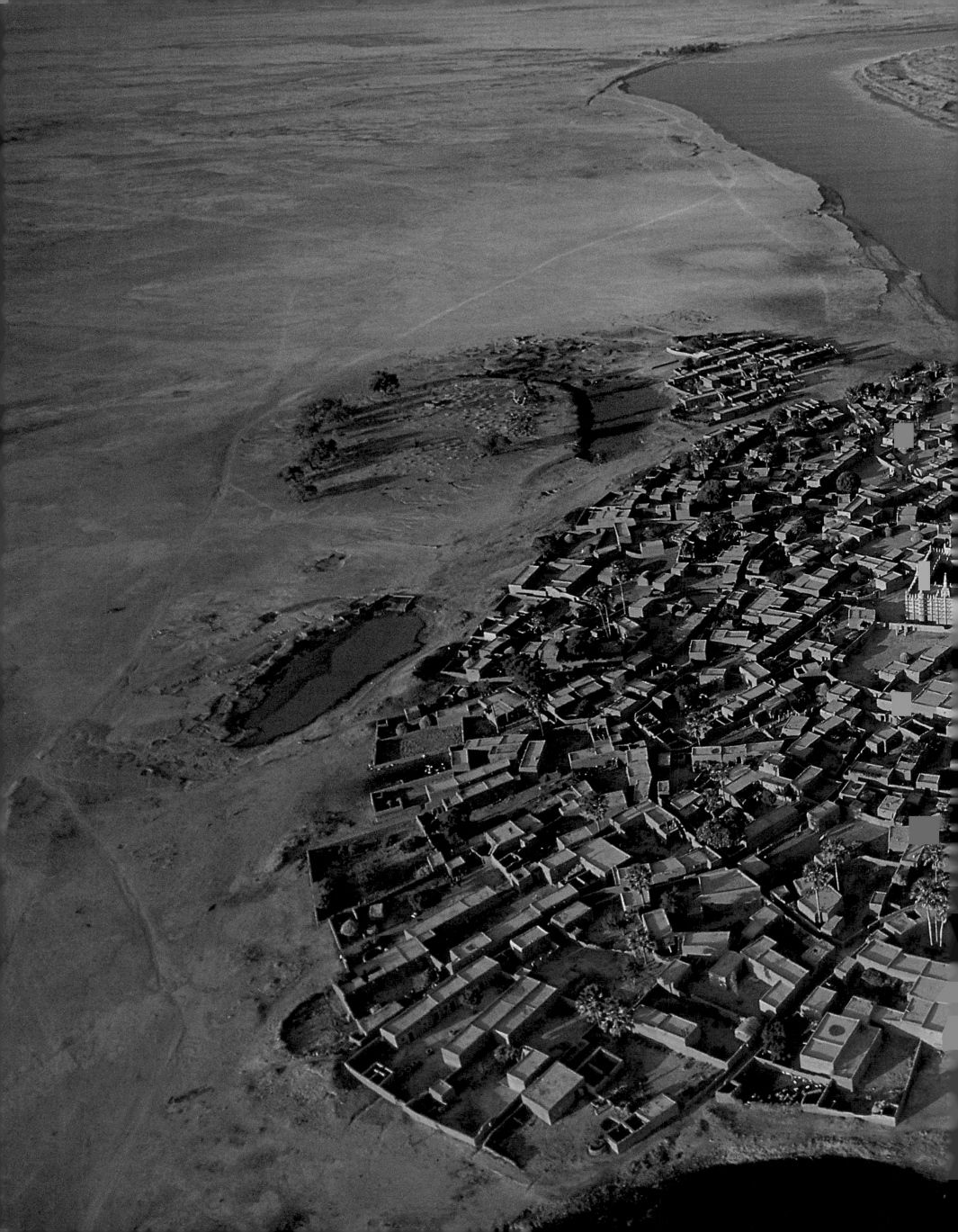

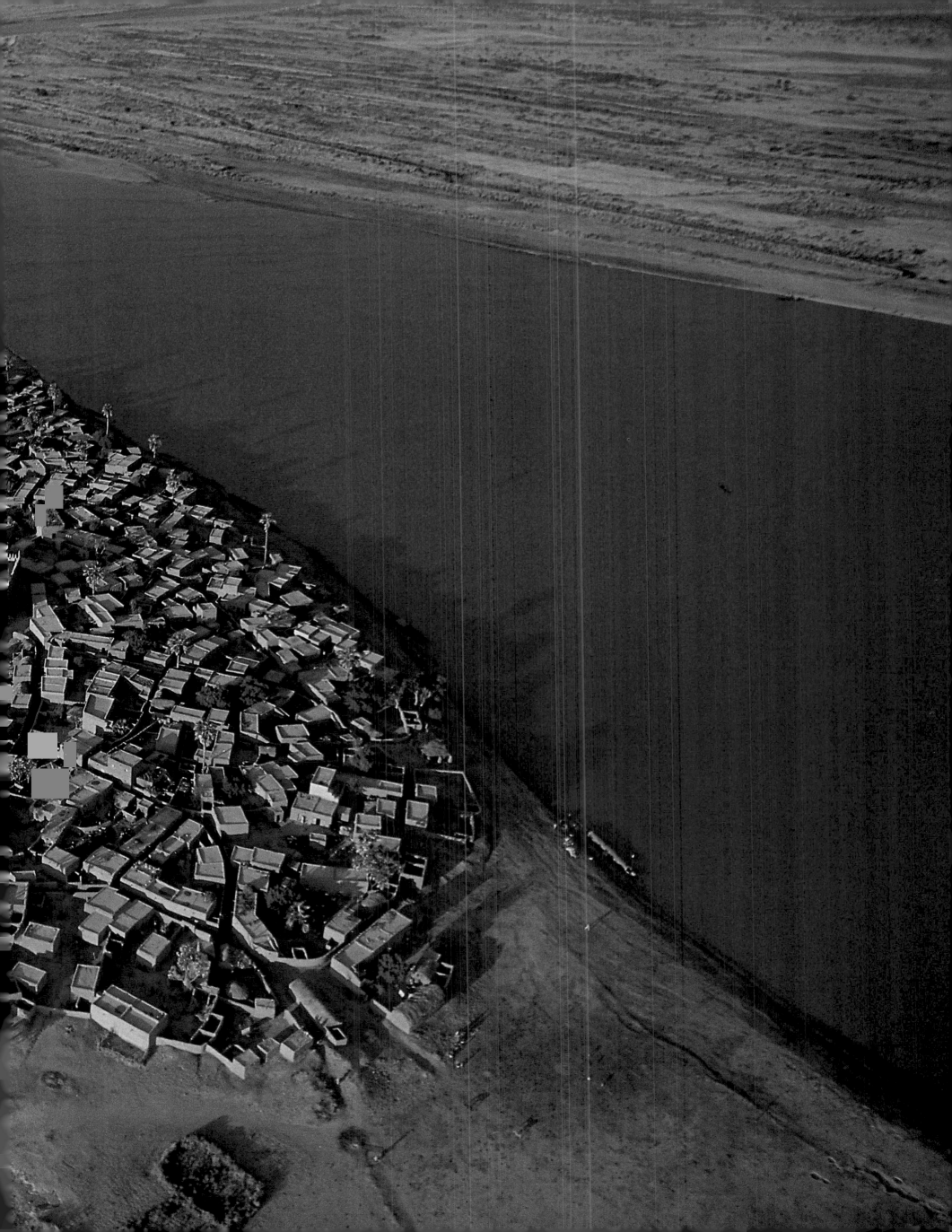

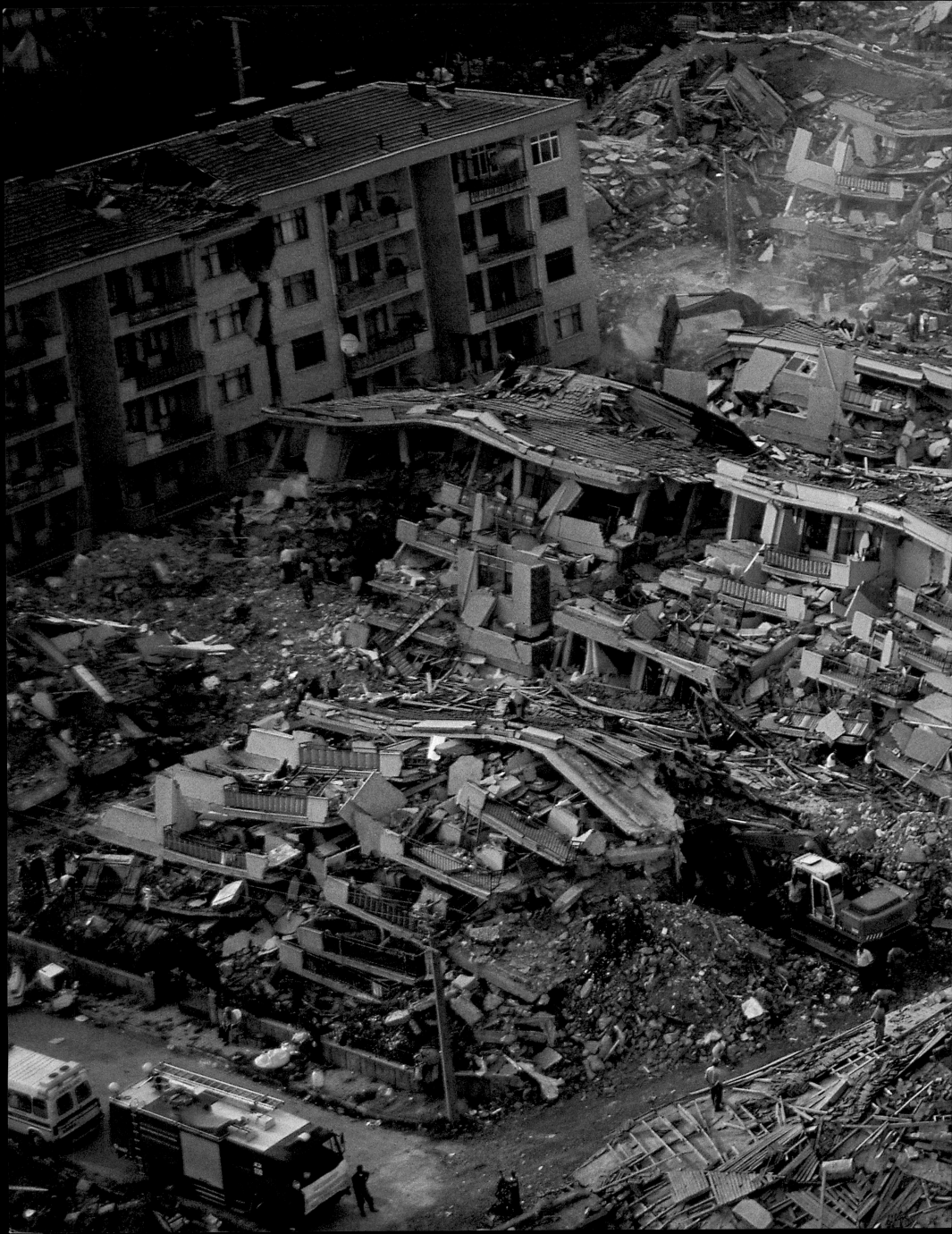

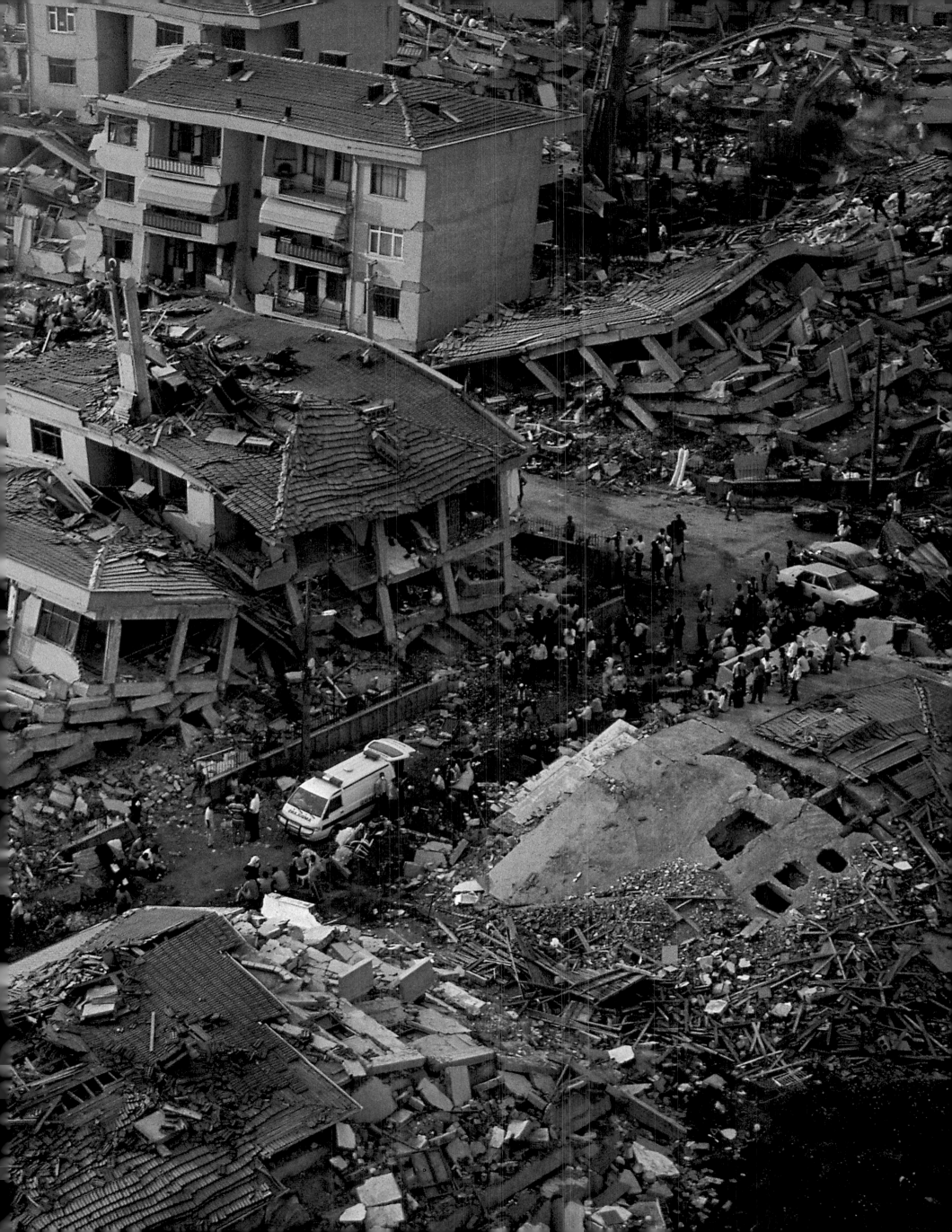

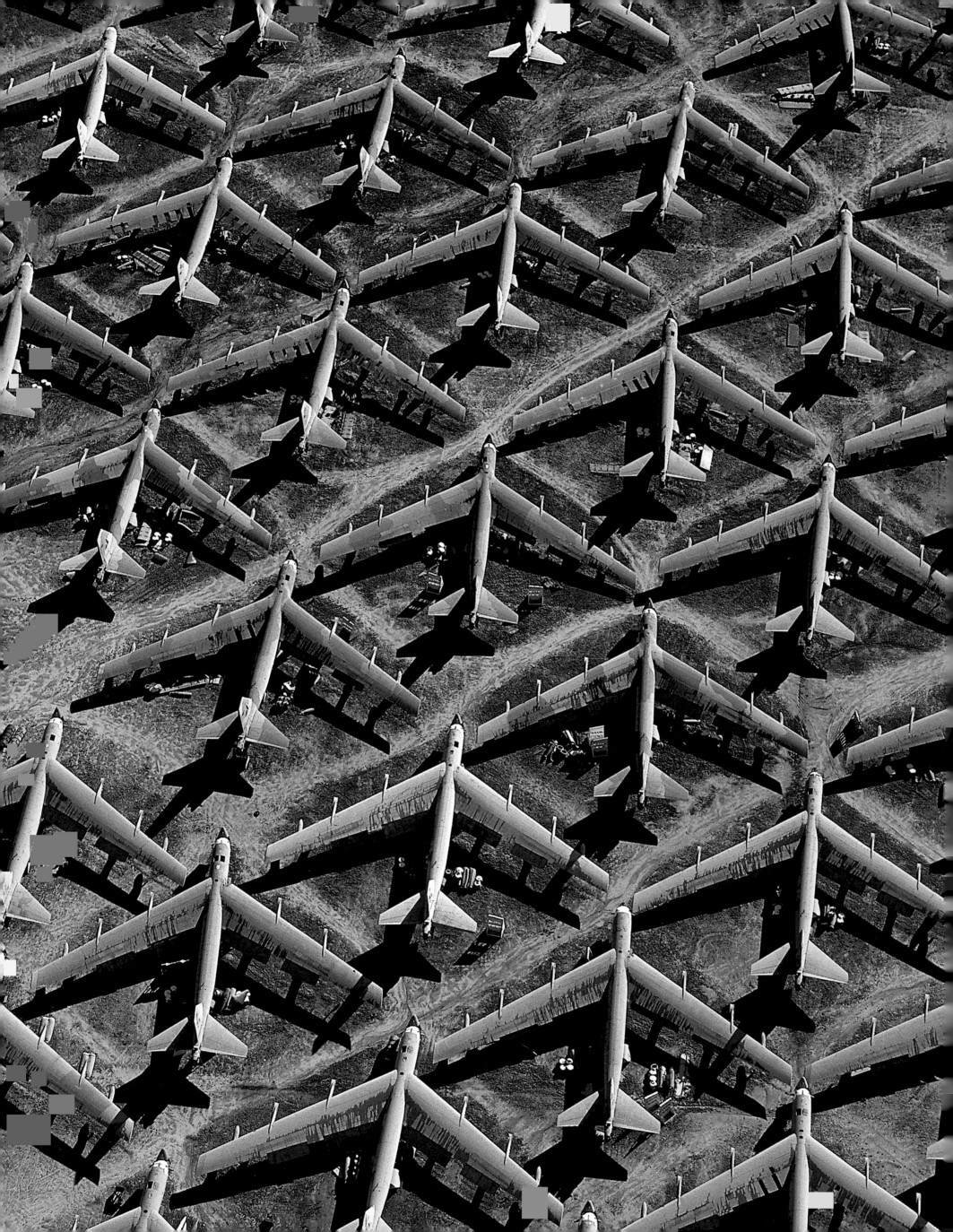

CHANGING CLIMATES

*It took a long time for humankind to understand that life on earth originated in
a succession of improbable events. How long will it take us to understand that the survival
of life depends upon fragile equilbriums that our actions are permanently upsetting?
The immediate gravity of the greenhouse-gas crisis has awoken us to the threat
that we pose to the naturally harmonious system in which we live.*

The view of the earth from space is of a sphere blue with the oceans that cover much of its surface, blue like the water and the skies that typify our planet. Humanity owes its existence to particular conditions and to an evolution that is still mysterious, and humanity survives thanks to a subtle balance with the elements that surround it. Life on earth developed in line with natural fluctuations and showed a fantastic capacity to adapt. But humans, driven by the call of progress, the urge to improve their living conditions, and the desire for power and money, modified their environment irreversibly.

The first environmental problem caused by industrial development that was discussed was global warming. Industrial activity began to accelerate in the mid-nineteenth century, yet the reality of global warming is still denied in some quarters. How reliable are the numbers? Could this just be a natural evolution in the earth's climate? Estimating temperature change, from the start of the industrial revolution to our own time, both on land and in water, is no simple matter. Indeed, it has involved comparing values recorded in the last century with current

figures, estimated with the help of more refined instruments. Can we truly compare temperatures taken in a bucket on the deck of a boat in the early twentieth century with measurements taken directly today? In addition, all cities have meteorological stations, but urban growth has quickly encircled these sites, and the thermometer fluctuations over recent centuries mainly reflect climbing temperatures linked to the city's life. And measurements have been far more numerous in the densely populated northern hemisphere than in the south.

However, after taking all of this into account and exercising every conceivable precaution, scientists today evaluate the average global increase in the earth's temperature since the beginning of the twentieth century at 1.1° F (0.6° C). The latest investigations have shown that part of the increase recorded between 1910 and 1945 can be attributed to natural variations in solar radiation, but the changes recorded since 1975 are no doubt due to human activity. The 1990s were the hottest decade in 1,000 years, with a record set in 1998. The melting of one part of the glaciers is a direct consequence of the higher temperature, but the changes do not occur uniformly; a major melting of ice was observed at the North Pole but not at the South Pole, where the ice distribution remained unchanged. This melting is also seen in mountain glaciers, in the Alps as well as the tropics: the glaciers of Kilimanjaro, New Guinea, and the Andes are disappearing.

This change is due to the release of greenhouse gases into the atmosphere. Carbon dioxide gas (CO_2), the largest in terms of quantity, results from the combustion of carbon or petroleum, reserves of carbon residing in the ground for millions of years. Industrial activity also emits nitrous oxide or methane; the

B-52 AT DAVIS–MONTHAN AIR FORCE BASE NEAR TUCSON,
Arizona, United States
(N 32°11' W 110°53')
Hundreds of B-52 Stratofortress bombers are stored at Davis–Monthan Air Force Base in the Arizona desert. These planes, whose flying days are probably over, are nevertheless preserved for spare parts. After its first test flight in Seattle, Washington, in 1952, this plane was heavily used during the Vietnam War (1963–75), and a modernized version was flown in the Gulf War (1991). The last models saw action during the 1999 bombardments in the Balkans and in Afghanistan in 2001. Since the Gulf War the United States has played a major role in world conflicts, and it has a tremendous voice in international institutions such as NATO. However, military power is just one of the many facets of American life, from trade to culture, with influence that extends across the planet today.

latter can also be produced by farming and raising of livestock. These gaseous components act like a lid placed on top of the atmosphere, which retains the radiation emitted by the surface of the earth as it reflects solar rays. This imprisons heat close to the earth's surface. The greenhouse effect is part of the natural climatic system. Without it, the earth's temperature would be 17.6° F (−8° C); with the greenhouse effect, the earth warms to a global average of 59° F (15° C). Observations of air bubbles trapped in ice show that the concentration of greenhouse gases was only 280 ppm (parts per million: 280 m³ of greenhouse gas in 1 million m³ of air) before the industrial revolution, whereas it is now at 365 ppm, a level not reached for more than 20 million years!

The dynamic that links the presence of these gases to global warming has been tested by mathematical models, in which meteorologists have expressed in equations the physical processes that determine climate. Scientists recently realized that the measured increase was not only a response to the greenhouse effect and that other factors also had to be taken into account. Sulfate aerosols, another effect of industrial activity, cause a temperature reduction and counteract the greenhouse effect. The climatic effects of other gases are more complex. Take the example of ozone: a hole in the ozone layer was observed at high levels of the atmosphere, especially above the Arctic; this can lead to a drop in temperature. But industrial activity also emits ozone into the atmosphere, which contributes to the greenhouse effect. The bottom line can thus be hard to calculate.

The consequences of the temperature increase are many: for instance, in tropical oceanic zones, evaporation is reinforced as a result. Water vapor present in the atmosphere, in turn, contributes to warming, but its effect remains very difficult to calculate. Moreover, the ocean also plays a determining role by

reducing global warming: it can in fact store up a great quantity of carbon dioxide. The ocean acts as an intermediary in the heat exchanges between different points on the globe, in the form of rains accumulated in the warmest zones, which are then carried to the poles. During the twentieth century, precipitation has been less abundant in subtropical zones at latitudes between 10 and 30 degrees, but it has increased in quantity in the highest latitudes of the northern hemisphere, where strong precipitation was shown to be frequent in recent decades. On the other hand, some tropical zones of Asia and Africa have experienced severe droughts.

El Niño, the greatest climatic disturbance on a global scale, which essentially affects the Pacific Ocean but has repercussions throughout the world, is certainly affected by the greenhouse effect. In 1982–83 and 1987–88 severe temperature aberrations and unprecedented precipitation and droughts had direct consequences on the countries of the Pacific Rim. The biological equilibrium was also disturbed. In 1997 fires routinely set by Indonesian farmers and the timber companies could not be extinguished as usual in early July when the summer monsoon serves to douse the flames naturally. People watched helplessly as a great part of the primeval forest that still survived in Borneo was destroyed.

The polar bear is directly threatened by the quick transformation of its biotope in the Arctic. Nevertheless, not all extinctions of living species can be attributed to the harmful effects of human activity; the geological ages also knew their share of great natural catastrophes. It is essential that the aforementioned numerical models reproduce as faithfully as possible the changes recorded during the past century, because these same tools are used to determine the climatic conditions that await future generations. One of the few things we know with certainty is the increase in greenhouse-gas concentrations. Climatologists are now capable of simulating the complex interactions between the ocean and the atmosphere, which, as we have seen, are intimately linked. We must take into account the fact that the phenomena affecting the atmosphere are much more rapid than those existing in the ocean; sulfate aerosols released into the atmosphere by industries, which can cause a reduction of the greenhouse effect, have a limited lifetime, because rain wipes them out quickly; but carbon dioxide trapped in the

GUANAJA RAVAGED BY HURRICANE MITCH,
Islas de la Bahía, Honduras
(N 16°30' W 82°55')
The year 1998 was marked by Hurricane Mitch, one of the most violent storms of the twentieth century. It struck with particular force in Central America, in Honduras and Nicaragua. In addition to harming tens of thousands of victims (the precise number will never be known), Mitch caused economic and ecological damage estimated in the billions of dollars. It is estimated that the hurricane set back the region's economic development by twenty years. Many meteorologists have associated the violence of Mitch with that of other climatic episodes that were particularly brutal at the end of the twentieth century, such as El Niño/La Niña and the great floods in China. Global warming is only one of the outcomes of human activities that have affected planetary climates; we are also witnessing a growth in extreme weather conditions, such as droughts, storms, and hurricanes.

pp. 298–99
ASHES OF A TREE IN BOUNA,
Côte d'Ivoire
(N 8°49' W 4°07')

In northwestern Côte d'Ivoire, in a region covered with shrub savanna and clear forest, this tree—downed by wind or lightning—was slowly consumed in a brushfire. Frequent in West Africa, these fires can spread through as much as 30 percent of the entire brush each year, most of them set off by traditional farming, herding, or hunting techniques. The ashes that result from the fire act as an organic, natural fertilizer, stimulating the quick regeneration of foraging plants and pastures. In addition, with taller grasses eliminated, the approach and hunting of game are facilitated. But many brushfires are set off late in the dry season and become uncontrollable, destroying the arborial stratum little by little and accelerating the process of erosion. This is particularly serious in Côte d'Ivoire, where 3.1 percent of the forest is destroyed each year, the highest rate of deforestation in Africa. Nearly 90 percent of the wood exploited in West Africa is consumed in the form of firewood and charcoal; at least 90 percent of the population depend on it for their fuel supply. Throughout the world, wood remains the primary energy source for 2 billion people who are without access to other sources, such as electricity.

pp. 300–301
TERRACED FIELDS,
near Sheikh Abdal,
Somalia
(N 9°59' E 44°48')

Although this region is plagued by malnutrition and is among the poorest in the world, it is unusual to see melons and tomatoes growing in terraced plots in a mountainous area such as this. Farming is generally reserved to the scarce arable land in the flat regions. The annual rainfall is only about 15 inches (400 mm) and occurs between two dry seasons. The water is stored in reservoirs (*hafir*) and transported to micro-irrigation systems. As in neighboring Yemen, on the other side of the Red Sea, the cultivation of food crops is in stiff competition with that of khat (*Catha edulis*), a stimulant of the *Celastrceeae* plant family. Most men, starting at the age of 18, chew the leaves as often as three times a day. Consumption of this plant, which costs $2 or $3 a bunch, is at the heart of a considerable market.

pp. 302–303
VILLAGE OF ARAOUANE,
north of Timbuktu, Mali
(N 18°54' W 3°33')

In the Saharan portion of Mali, 168 miles (270 km) north of Timbuktu, the village of Araouane stands on the great caravan route, once heavily traveled, linking the north of the country with Mauritania. Araouane's numerous wells, which contributed to its ancient prosperity, still attract nomad campers to its periphery. Little by little, however, its fortlike houses, in which the absence of windows testifies to the permanent struggle against heat and sand, are being swallowed up by the sand dunes driven by the winds, which are erasing the village. The Sahara is the largest warm desert on earth, extending for 3.5 million square miles (9 million km²), in eleven African countries. It consists of not only sand but also regs (gravel plains from which wind has eroded the sand), large stony plateaus (tassilis and hamadas), and high mountain ranges (Ahaggar, Aïr, Tibesti); these ranges take up 20 percent of its area. Scattered throughout this hostile, rigorous environment, the towns and villages of the Sahara contain 1.5 million people.

pp. 304–305
SUBAQUATIC VEGETATION IN THE LOIRE RIVER NEAR DIGOIN,
Saône-et-Loire, France
(N 46°27' E 3°59')

The Loire, 628 miles (1,012 km) long, has its source in the Ardèche in southeastern France and crosses a large portion of the country before reaching the Atlantic Ocean in the west. This waterway, considered the last wild river in France, is subject to an irregular system of floods and low waters of considerable scope. In the summer certain areas of the Loire become narrow trickles that ripple among sandbanks; the shallow waters sometimes reveal subaquatic plants, as seen here near Digoin. In winter its tides can cause major flooding of towns and villages along its banks. In all regions of the world, floods are growing

more frequent and more violent than before. In the past fifteen years 560,000 people have perished in natural catastrophes, half of them during floods. Deforestation, drying of wet zones, alteration of the natural course of earth's rivers (half of which have at least one large dam), and habitation of zones at risk are examples of human actions that contribute to aggravating the consequences of floods.

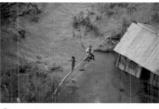

pp. 306–307
FLOODED HOUSES SOUTH OF DHAKA,
Bangladesh
(N 23°21' E 90°31')

Covered by a vast network of 300 waterways, including the Ganges, Brahmaputra, and Meghna Rivers, which descend the slopes of the Himalayas to the Bay of Bengal, Bangladesh is a delta plain that is subject to seasonal monsoons. Between June and September huge rains sometimes cause the rivers to overflow their banks and inundate nearly half of the territory. Accustomed to this natural cycle, part of the country's population live permanently on *chars*, ephemeral river islands made of sand and silt deposited by the rivers. In 1998, however, two-thirds of the country remained under water for several months following the worst flood of the century, which claimed 1,300 lives and left 31 million Bangladeshis homeless. Among the most densely populated territories on earth, with 360 inhabitants per square mile (922 per km²), Bangladesh is also one of the poorest countries: 32 percent of the population live on less than $1 per day. The rising sea level, partially caused by climatic warming, will only aggravate the difficulties of this country, which might see a considerable portion of its rice fields permanently flooded.

pp. 308–309
SHANTYTOWN OF GUAYAQUIL,
Guayas, Ecuador
(S 2°13' W 79°54')

With a population of 2 million, Guayaquil, Ecuador, has half a million more inhabitants than Quito, the capital. The prosperity of this great industrial and commercial port, which controls 50 percent of the country's exports and 90 percent of its imports, has attracted a growing number of migrants from the neighboring countryside. One-fifth of the population of Guayaquil today live in shantytowns in swampy areas, made up of houses on poles. These poverty-stricken areas, where the ground is artificially composed of debris accumulated by the tides, has no sanitation and is subject to disturbing health problems. In recent decades the population of Latin America has undergone the world's highest degree of urbanization: the number of city dwellers has risen from 41 percent of the total population in 1950 to 77 percent in 2000. On all world continents, 1 million people are added each week to the urban population, which reached 47 percent of the total in 2000.

pp. 310–11
SMALL BOAT CAUGHT IN WATER HYACINTHS ON THE NILE,
Egypt
(N 29°43' E 31°17')

The water hyacinth (*Eichhornia crassipes*) was first reported at the beginning of the twentieth century in the Nile delta in Egypt and in the province of Natal, South Africa. It is an invasive aquatic plant that originated in Brazil, where it develops moderately in its natural habitat. Introduced to Africa as an ornamental plant, in less than a century it spread to more than 50 countries around the world. An obstruction to navigation, this species can block agricultural irrigation canals and turbines in hydroelectric dams. Its thick vegetal carpet, which can double in area in twelve days, causes eutrophication, which is an increase in nutrients in the water—this in turn encourages the growth of still more aquatic plant life, which reduces the oxygen content of deep waters and leads to the asphyxiation of underwater life. No effective means of destroying this invader has been found to date, but organic defense methods could serve to limit its proliferation. Only 1 percent of introduced species cause major ecological and economic losses, but their presence remains the second cause, after the destruction of natural habitats, of the disappearance of species in the world.

Captions to the photographs on pages 312 to 327 can be found on the foldout to the right of the following chapter

captions 298–311 captions 312–327

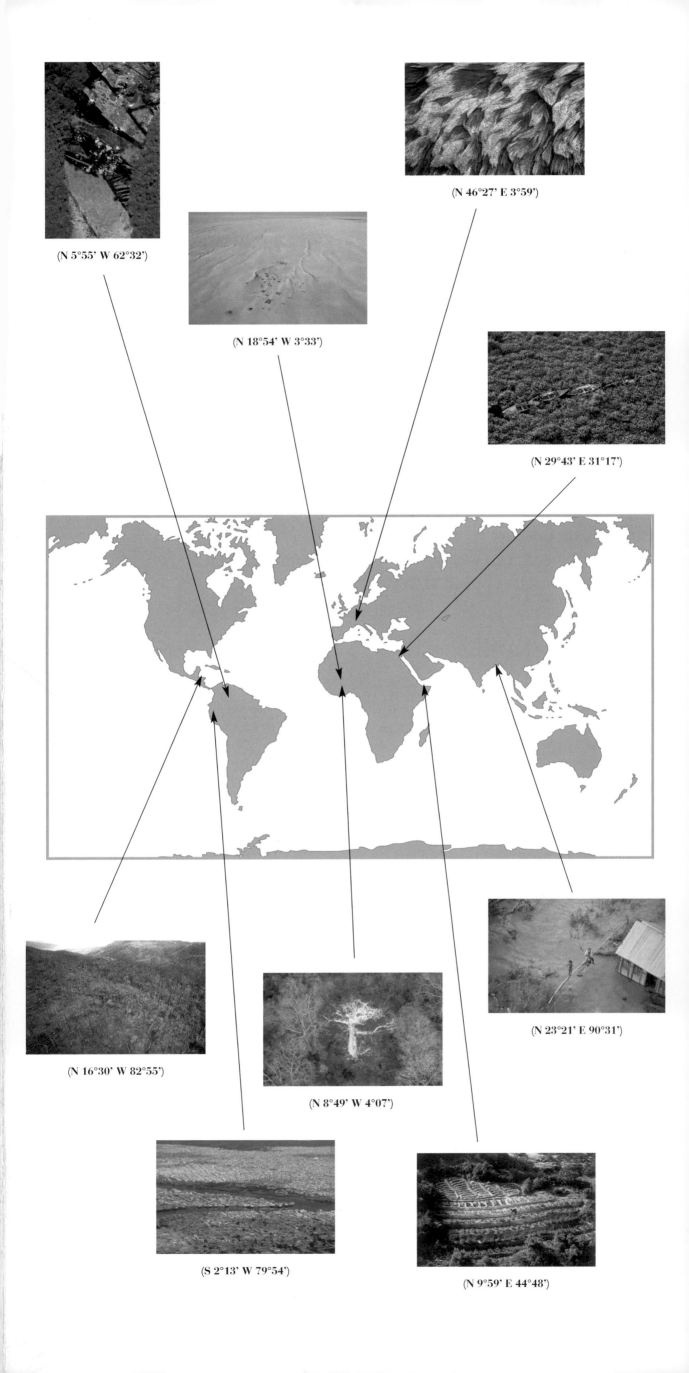

(N 5°55' W 62°32')

(N 46°27' E 3°59')

(N 18°54' W 3°33')

(N 29°43' E 31°17')

(N 16°30' W 82°55')

(N 23°21' E 90°31')

(N 8°49' W 4°07')

(S 2°13' W 79°54')

(N 9°59' E 44°48')

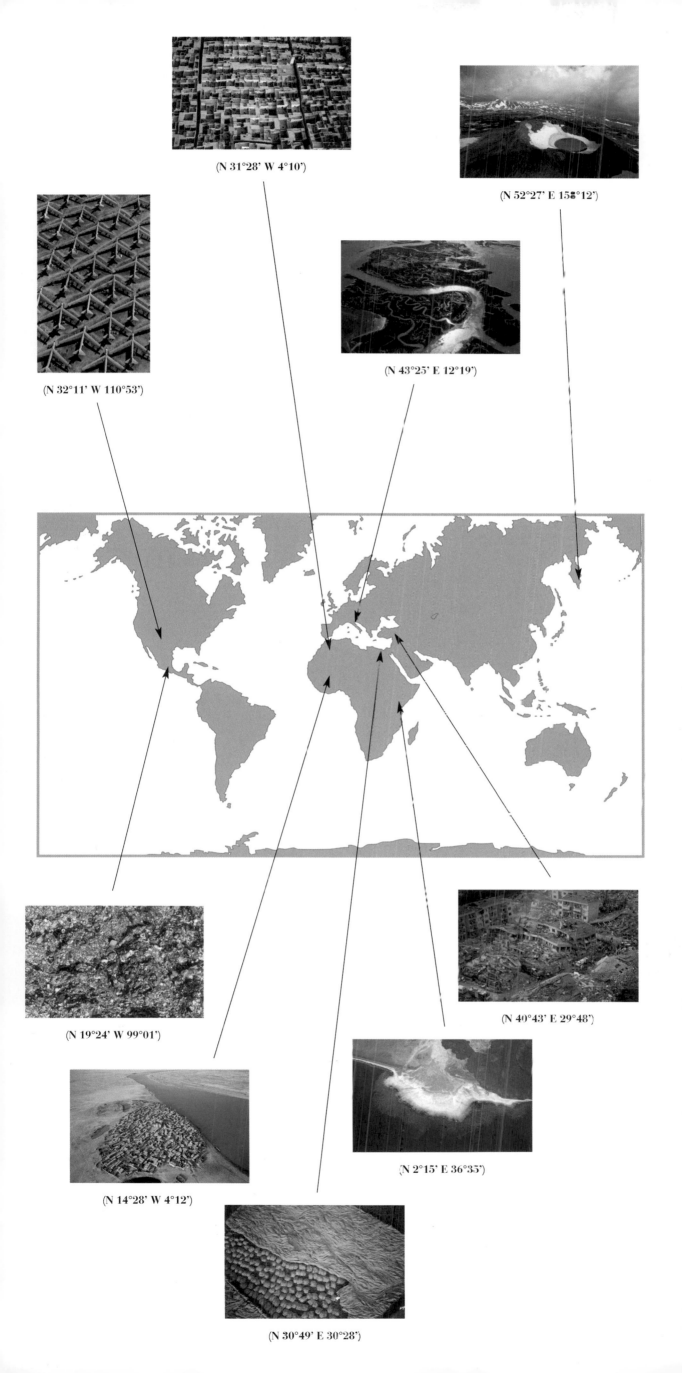

(N 31°28' W 4°10')

(N 52°27' E 158°12')

(N 32°11' W 110°53')

(N 43°25' E 12°19')

(N 19°24' W 99°01')

(N 40°43' E 29°48')

(N 14°28' W 4°12')

(N 2°15' E 36°35')

(N 30°49' E 30°28')

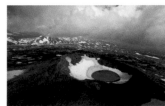

pp. 272–73
LAKE IN A CRATER
OF MUTNOVSKY
VOLCANO,
Kamchatka Peninsula,
Russia
(N 52°27' E 158°12')

Located in southern Kamchatka in Siberia, Mutnovsky is actually made up of two juxtaposed volcanoes. It rises to a height of 7,622 feet (2,324 m) and has two crater lakes at its summit. In the past 150 years this volcanic pair has experienced fifteen eruptions, the most recent of which occurred in 1961. Today its activity is limited to the emission of sulfurous gases or wisps of smoke at 1100° F (600° C). Created less than 1 million years ago, Kamchatka Peninsula is geologically quite young. It is located on a subduction zone, where the Pacific tectonic plate submerges under the Eurasia plate. The peninsula has 160 volcanoes, of which 30 are active, which were declared a world heritage site by UNESCO in 1996. An estimated 1,400 volcanoes in the world are capable of erupting at any time; 60 percent of them are located on the rim of the Pacific Ocean, called the "fire belt."

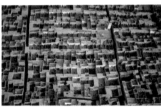

pp. 274–75
VILLAGE IN THE
RHERIS VALLEY,
Er Rachidia region,
High Atlas Mountains,
Morocco
(N 31°28' W 4°10')

Fortified villages are frequent along the valley of the Rheris, as they are on most rivers of southern Morocco, inspired by the Berber architecture built to protect against invaders. Today, with the threat of raids now gone, the close clustering of dwellings, small windows, and roofs covering houses and narrow streets serve the purpose of protecting occupants from heat and dust. The flat, connecting roofs also provide a place for drying crops. Perfectly integrated into the landscape, the houses are usually built out of adobe clay and chalk found in the area. Hardy in appearance, these buildings are actually fragile because they are made of brittle materials. Half of the buildings constructed fifty years ago are in ruins today.

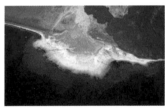

pp. 276–77
GREATER FLAMINGOS
ON THE EDGE OF
LAKE LOGIPI,
Suguta Valley, Kenya
(N 2°15' E 36°35')

The whiteness of crystallized natron (a sodium carbonate) on the black volcanic shore of Lake Logipi contrasts with the blue-green algae that proliferates in the alkaline, brackish water. Seen from the sky, this part of the shore suggests the shape of a giant oyster. The tiny pearl dots that surround it are flamingos, congregating where the freshwater reemerges. These birds seek nourishment in shallow lake waters rich in algae and small crustaceans, which give flamingos their characteristic color. Immense colonies of greater flamingos travel from lake to lake in the Rift Valley, guided by annual rain patterns that modify the concentration of soda and thus affect food supply. They deserted the region during the harsh drought that afflicted East Africa for almost five years, finally ending in 1998. At the beginning of that year heavy rains caused by El Niño encouraged lesser flamingos and greater flamingos to return to the Rift Valley, where nearly 3 million of them, more than half of their entire world population, live today.

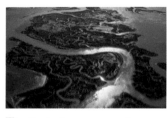

pp. 278–79
LAGOON OF VENICE,
Veneto, Italy
(N 45°25' E 12°19')

The Venice lagoon, extending over 195 square miles (500 km²) between the Italian coast and the Adriatic Sea, is Italy's largest wet zone. A place where freshwater and saltwater meet, this marsh of silt, clay, and sand is especially rich in nutritive elements that favor the development of a multitude of aquatic species and attract many birds. The lagoon is threatened today by urban and industrial pollution, particularly hydrocarbons and heavy metals. It also holds a major concentration of phosphates and nitrates deriving from agriculture that encourage the proliferation of a green algae, *Ulva rigida*. This algae causes eutrophication, reduction of the oxygen content of the water, which is fatal to fish. In industrialized nations the nitrate concentration of continental waters has doubled—even quintupled in some countries—in the past thirty years.

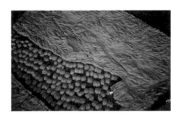

pp. 280–81
WHEAT BEING
BUNDLED INTO
SHEAVES BY A
FELLAH IN THE
NILE VALLEY,
Egypt
(N 30°49' E 30°28')

The *fellahin*, Egyptian peasants of the Nile Valley, have used the same ancestral agricultural methods for centuries, working the fields with a hoe, harvesting the wheat with a scythe, and carrying the sheaves on the back of a donkey or camel. The Nile Valley stretches like a fertile ribbon from the south to the north of Egypt. It is home to the world's densest farming population; only 3 percent of Egyptian territory is made up of arable land, and the entire area of 13,000 square miles (33,000 km²) is irrigated, making Egypt the most irrigated country in Africa. Fertilizers have aided in the increase of wheat production, a gain of 50 percent between 1990 and 2000, but it still provides for less than half of the country's rapidly growing population. Egypt is among the world's largest importers of grains, importing 9.6 million tons in 1999.

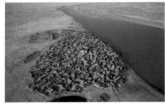

pp. 282–83
REFUSE DUMP IN
MEXICO CITY,
Mexico
(N 19°24' W 99°01')

Household refuse is piling up on all continents and will pose a critical problem for major urban centers, like the problem of air pollution resulting from vehicular traffic and industrial pollutants. With some 20 million residents, Mexico City produces nearly 20,000 tons of household refuse a day. As in many countries, half of this debris is directed to open dumping. The volume of refuse is increasing on our planet as a result of population growth and economic growth. An American produces more than 1,500 pounds (700 kg) of domestic refuse each year, about four times more than a resident of a developing country and twice as much as a Mexican. The volume of debris per capita in industrialized nations has tripled in the past twenty years. Recycling, reuse, and reduction of packaging offer solutions to the pollution problems caused by dumping and incineration, which still absorb 50 percent and 35 percent, respectively, of the annual volume of household garbage in France.

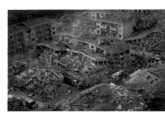

pp. 284–85
VILLAGE ON THE
BANKS OF AN ARM OF
THE NIGER RIVER,
Mopti region, Mali
(N 14°28' W 4°12')

As it crosses Mali, the Niger River divides up into branches, forming a vast interior delta in the plain of Massina. Flowing at 230,000 cubic feet (7,000 m³) per second, the river is a great boon to the residents of this dry region, the majority of whom live on the riverbanks. Living at the rhythm of the seasonal floods that occur from August and January, they practice river trade, fishing, herding, and farming. The Mopti region has become not only a major commercial center but also a crossroads where the diverse populations of the region meet: Bozo fishermen, nomadic Peul shepherds, Bambara farmers as well as the Songhai, Tuareg, and Dogon. The nation is 90 percent Muslim, and the mosque is usually the main building of each town or village, overlooking the landscape from an impressive height.

pp. 286–87
EARTHQUAKE AT
GÖLCÜK,
on the coast of the Sea
of Marmara, Turkey
(N 40°43' E 29°48')

The earthquake that struck the region of Izmit on August 17, 1999, at 3:02 a.m., registered 7.4 on the Richter scale (9 is the maximum). Its epicenter was at Gölcük, an industrial city with a population of 65,000. The official death toll was at least 15,500 people, many buried in rubble while they slept. The partial or total collapse of 50,000 buildings led to outrage against building contractors, who were accused of disregarding earthquake-proof construction codes. Southern and northern Turkey are sliding along the North Anatolian fault at an average relative speed of 1 inch (2.5 cm) per year, but the motion actually occurs quite abruptly, in the form of earthquakes—the earth moved nearly 10 feet (3 m) in less than a minute during the Izmit earthquake. Regions bordering tectonic plates, such as the trans-Asian zone running from the Azores to Indonesia by way of Turkey, Armenia, and Iran, are particularly exposed to seismic risk. Although they are rarer than storms and floods, earthquakes claimed 169,000 victims throughout the world between 1985 and 2000.

ocean will take several hundred years to return into the atmosphere. Physical mechanisms are put in place based on current observations as well as on past climatic variations. The study of the glacial cycles of the past million years reveals the climatic variations caused by the position of the planets in relation to the sun. Paleoclimatologists have shown that according to this mechanism, we are at the end of an interglacial age and that a harsher climate will prevail in about 6,000 years, lasting several tens of thousands of years.

This scenario does not take human action into account, and thus its short-term predictions are uncertain. A valid forecast would require the inclusion of several factors. First, it is essential to know estimated quanties of greenhouse gases in future years. Industrial emissions are expected to increase; forecasts state that in 2100 the concentration of carbon dioxide will reach 540 ppm to 970 ppm, or 90 to 250 percent more than the 280 ppm that existed in 1750. This estimate includes the reduction by the ocean and the stockpiling by the earthly biosphere through reforestation. The wide gap between the predictions is because of the different scenarios they assume with regard to population evolution, globalization of the economic system, and usage of fossil carbons for energy. Thus, the expected average increase in global temperature for the next century ranges between 2.7° and 8.1° F (1.5° and 4.5° C). The continents will heat up more quickly than the oceans, and the higher and medium latitudes will be more affected than the tropical and equatorial zones.

Whatever scenario we entertain, the distribution of temperature increases is the same. The contradiction already noted in the course of the past century between the northern and southern hemispheres will persist. Whereas the north can expect a rise of 14.4° to 18° F (8° to 10° C) by the century's end, it will amount to only 10.8° to 14.4° F (6° to 8° C) in the south. Europe and North America, as well as northern Africa, will experience the greatest change in temperture. Central and South America, subsaharan Africa, southern Asia, and Australia will undergo little change. In France the expected rise averages between 3.6° and 7.2° F (2° and 4° C). Ski resorts at average altitudes will experience curtailed tourist seasons because they will have only one to two months of snow cover. Winter sports lovers will be interested in the changes in oceanic circulation in the northern Atlantic. At present, the Gulf Stream conveys warm waters to the northern Atlantic, bringing us more clement temperatures than might be expected at these latitudes. This marine current aids in the circulation of the global ocean, but it could undergo a major slowdown as a direct consequence of warming and a new precipitation pattern. Global warming could thus cause local cooling in Western Europe. It is not expected, however, that this circulation will become completely stalled over the coming century. Dilation of the volume of the ocean waters is a direct consequence of rising temperature, which has already triggered a rise of sea level of between 4 and 8 inches (10 and 20 cm) since the start of the twentieth century. In addition, this phenomenon will be magnified by the melting of ice. Sea level is thus expected to rise by 4.5 to 30 inches (11 to 77 cm) by the end of the twenty-first century. The contour of the coastlines will be considerably altered: some land masses, such as the great deltas, will disappear from the globe, and coastal erosion will accelerate. Cliff collapses, like those already seen on the French coast, could become widespread.

Globally, water vapor, evaporation, and precipitation will increase in summertime as in winter. Rainfall will be more abundant in the medium and high latitudes of the northern hemisphere. However, whereas this change will strike all of North America, only the northern and eastern areas of Europe will be affected, as well as nearly all of Asia. In Australia, Central America, and South Africa drought will predominate.

Abundant precipitation and the global rise in temperature are not the only signs of the coming changes; it is now a proven fact that extreme events will be more frequent. This means that severe heat spells and days of violent rainfall will be more numerous, as periods of intense cold grow increasingly rare. We understand the effect of torrential rains on zones that are habitually dry, for instance along the coast of South America, during the passing of El Niño, when floods and mudslides assume terrible proportions. In 1998 the dunes of the Sechura Desert in Peru were completely drenched for several months; flooding caused two lagoons to merge and thus created, in the middle of the desert, Peru's second-largest lake.

These forecasts will lead to global changes, but the much more abrupt human modifications will also disturb the balance of the climatic system. The cloud cover that maintains the humidity required for development of the high-altitude forest of Monteverde in Costa Rica is disappearing. These clouds, gathering their humidity above the forest that occupied the plain downhill from it, have risen and reached the mountains. Runaway deforestation, which has destroyed more than 80 percent of the plains forest, is endangering not just the vegetal cover but also the fauna and flora that used to inhabit it.

Coral reefs are subject to multiple disturbances caused by human activity. In Papeete, Tahiti, galloping urbanization threatens its lagoon, and numerous tropical islands are affected by emissions of waste water. But the coral is also endangered by global changes. One of the chief causes of the whitening of coral is the rise in temperature, which causes the expulsion of the algae that live in symbiosis with it. The increased CO_2 concentration of the atmosphere is also affecting the chemical equilibrium that promotes the building of coral skeletons. Coral reefs were able to adapt to the increase of nearly 390 feet (120 m) in sea level during the major thaw some 15,000 years ago. However, by the year 2100 the formation of calcium carbonate, of which the reefs are composed, could be reduced by 22 percent; the impressive adaptability shown by these organisms for several million years will be helpless against this change.

Faced with such threats, researchers all over the world, specialists in climate change, periodically pool their knowledge

in order to improve the precision of their forecasts. When the climatic conditions are established, the sociologists and economists draw their conclusions on how society will be affected. In addition to all of the direct effects already discussed, they think about the productivity of natural systems, the water cycle, and air quality as well as the productivity of agriculture, the raising of livestock, and the evolution of illnesses. They strive to evaluate the impacts of these changes, the degree of vulnerability of various societies, and the adaptive capacities that can be summoned. These considerations quickly reveal the inequalities associated with the level of socioeconomic development of each country.

Even the most optimistic scenario foresees no stabilization of the quantity of carbon dioxide in the atmosphere for another 200 years, assuming a reduction of industrial emissions to the 1990 levels. It seems certain, then, that the changes noted during the twentieth century are moderate compared to those to be expected in coming centuries. Humans long ago chose to live dangerously when they started playing with fire 600,000 years ago.

Anne Juillet-Leclerc

RIVER ON THE AUYAN TEPUÍ.
Gran Sabana region, Venezuela
(N 5°55' W 62°32')
The Gran Sabana region in southeastern Venezuela is a wide plain covered with savannas and dense forest, interrupted by imposing mesas of sandy rock known as tepuis. The mesa of Auyan Tepuí, or "devil's mountain," covers 275 square miles (700 km²) and rises to 9,675 feet (2,950 m). The Río Carrao zigzags across Auyán Tepui and, at its edge, plunges in a steep waterfall. The Salto Angel waterfall is the world's highest free-falling waterway; at a height of 3,210 feet (979 m), it is fifteen times higher than Niagara Falls. Rich in gold and diamond ore, the Gran Sabana region and its many waterways have attracted prospectors since 1930—towns such as Icabaru, which was made famous by the discovery in 1942 of a diamond of 154 carats, or El Dorado, whose name alone conjures up the age of the conquistadors.

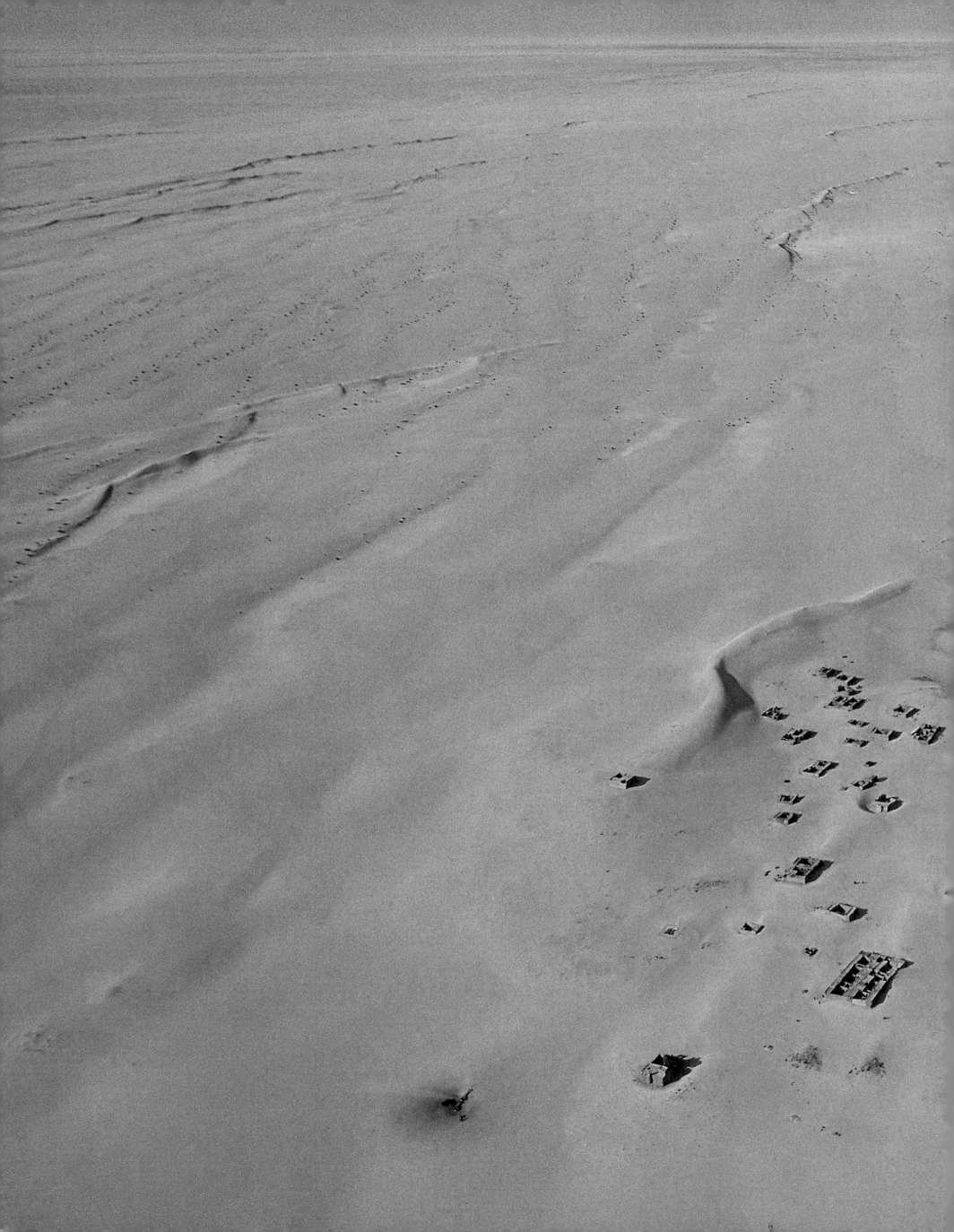

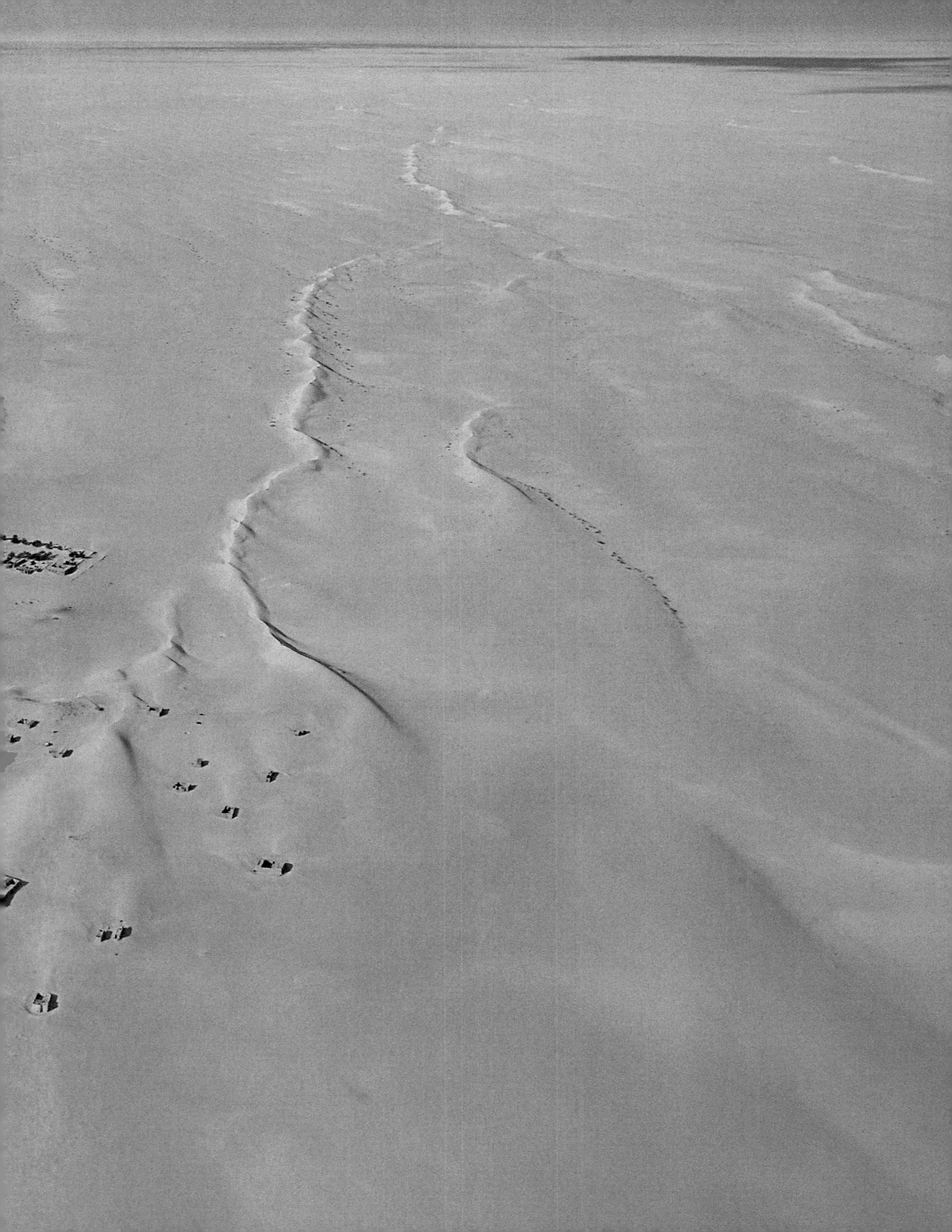

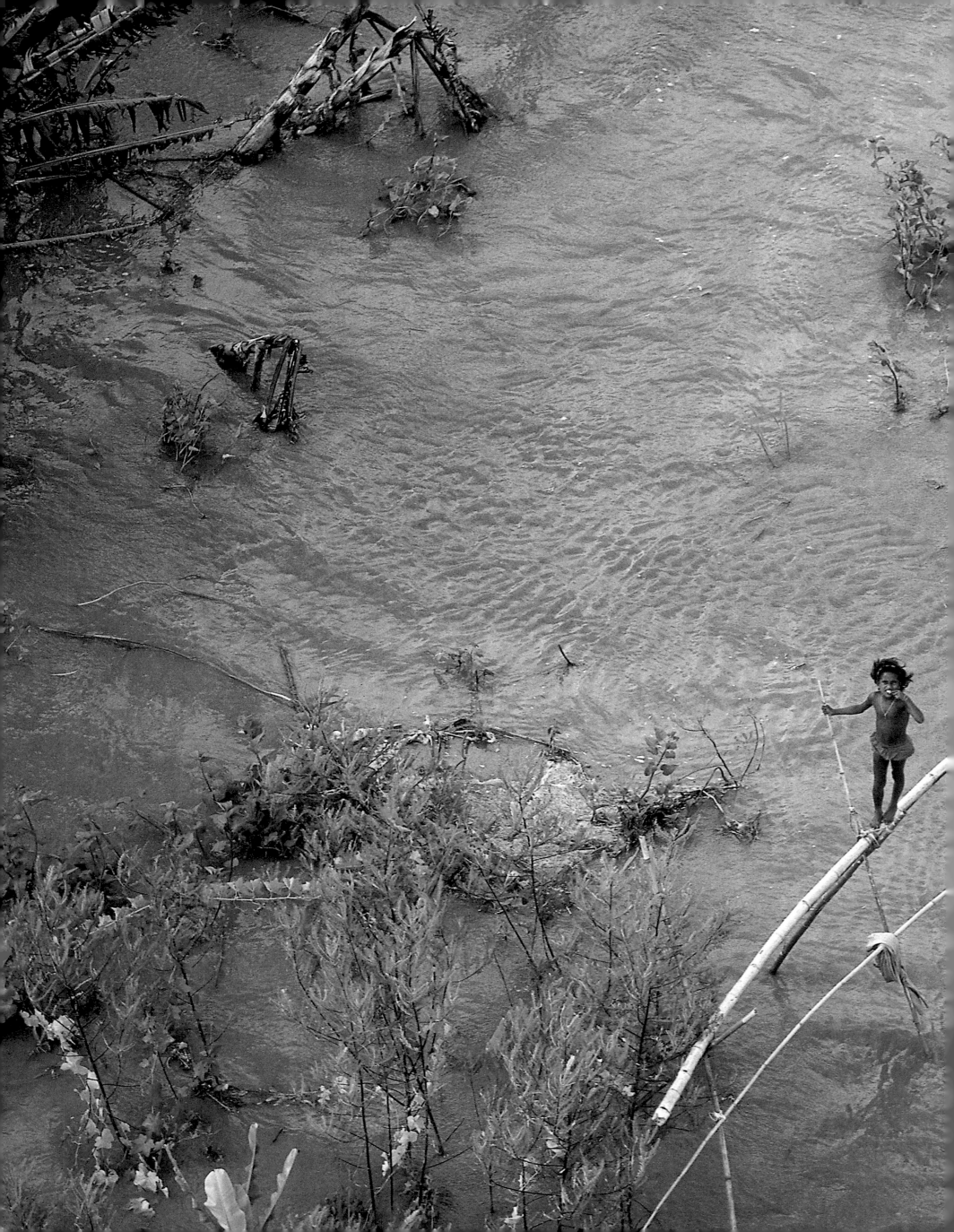

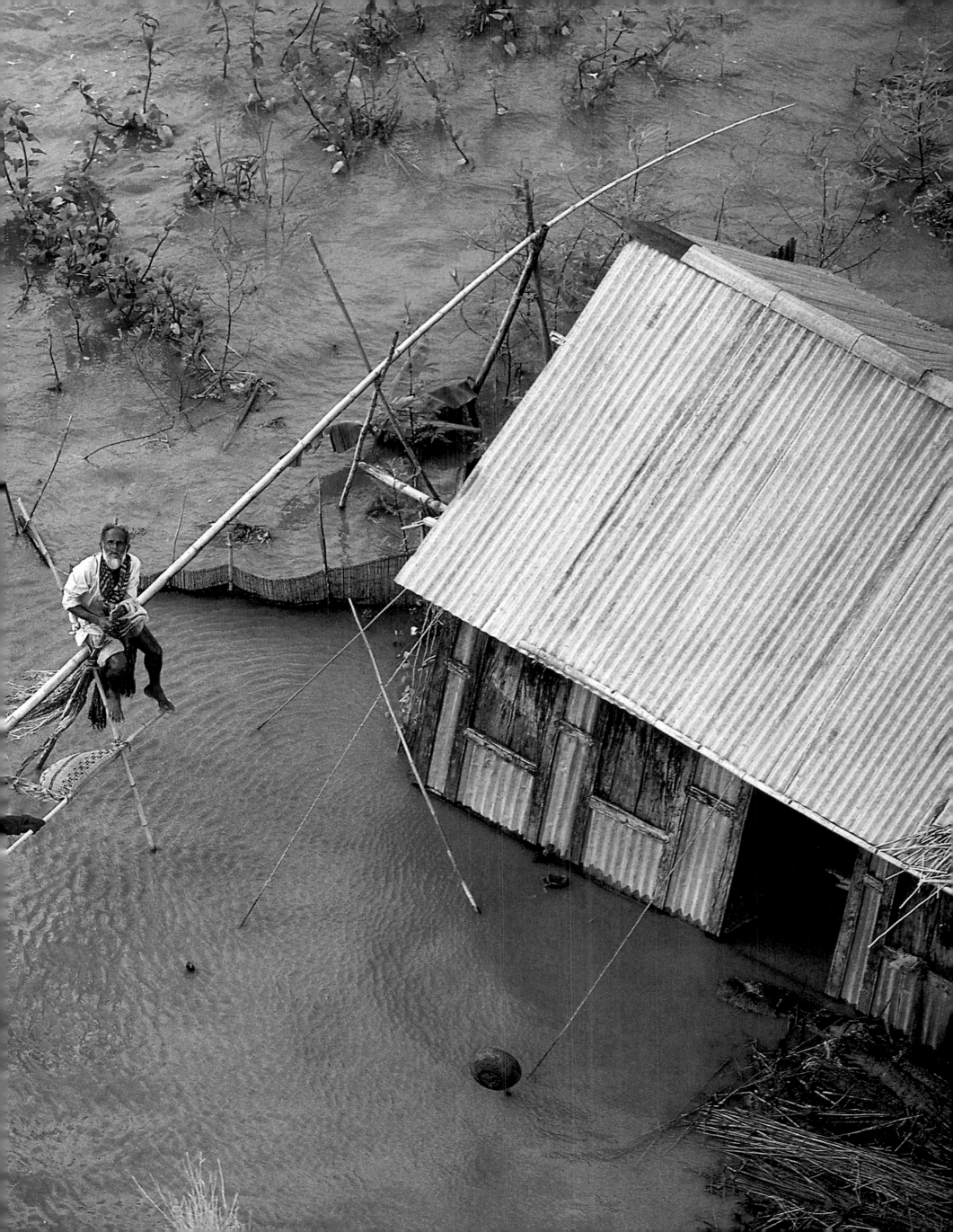

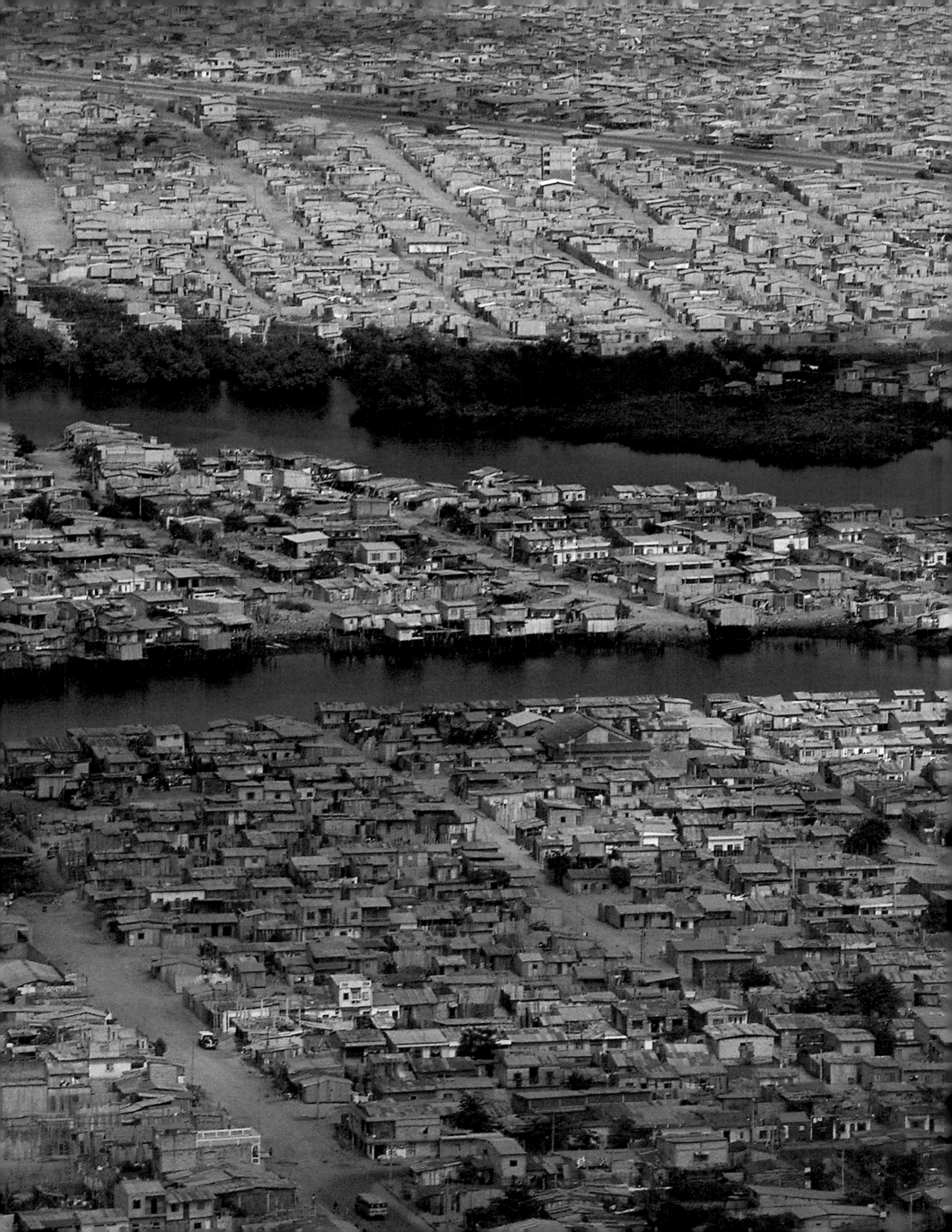

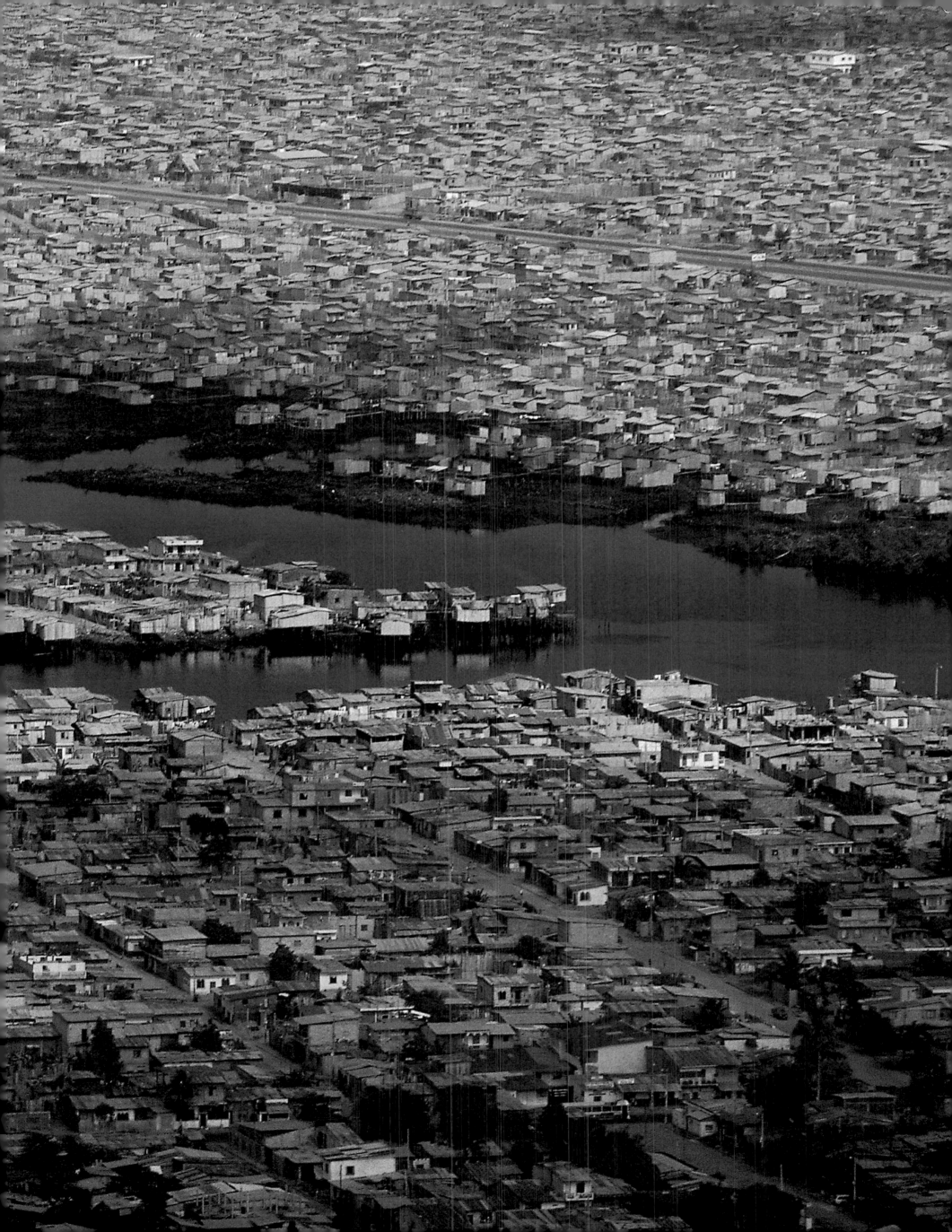

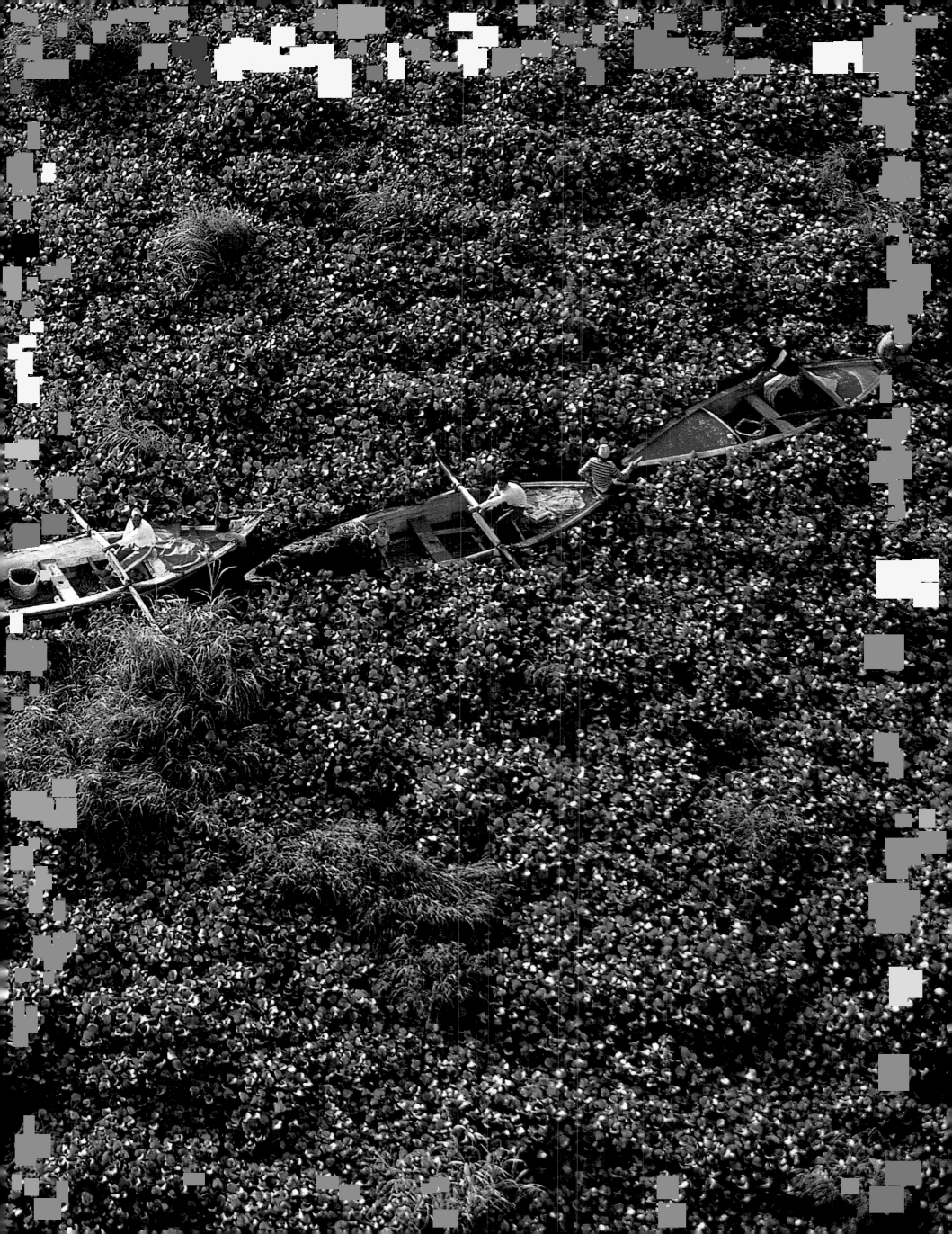

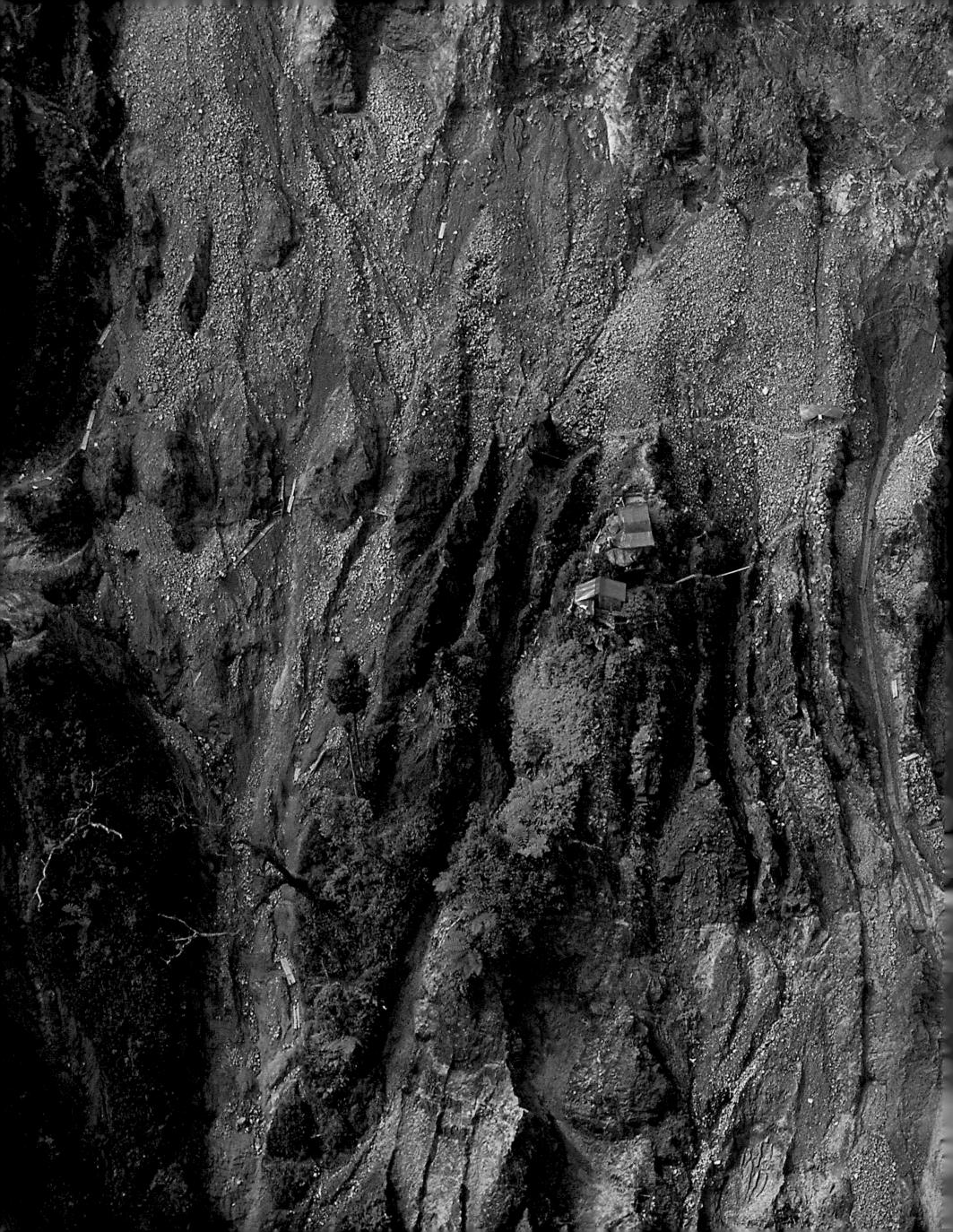

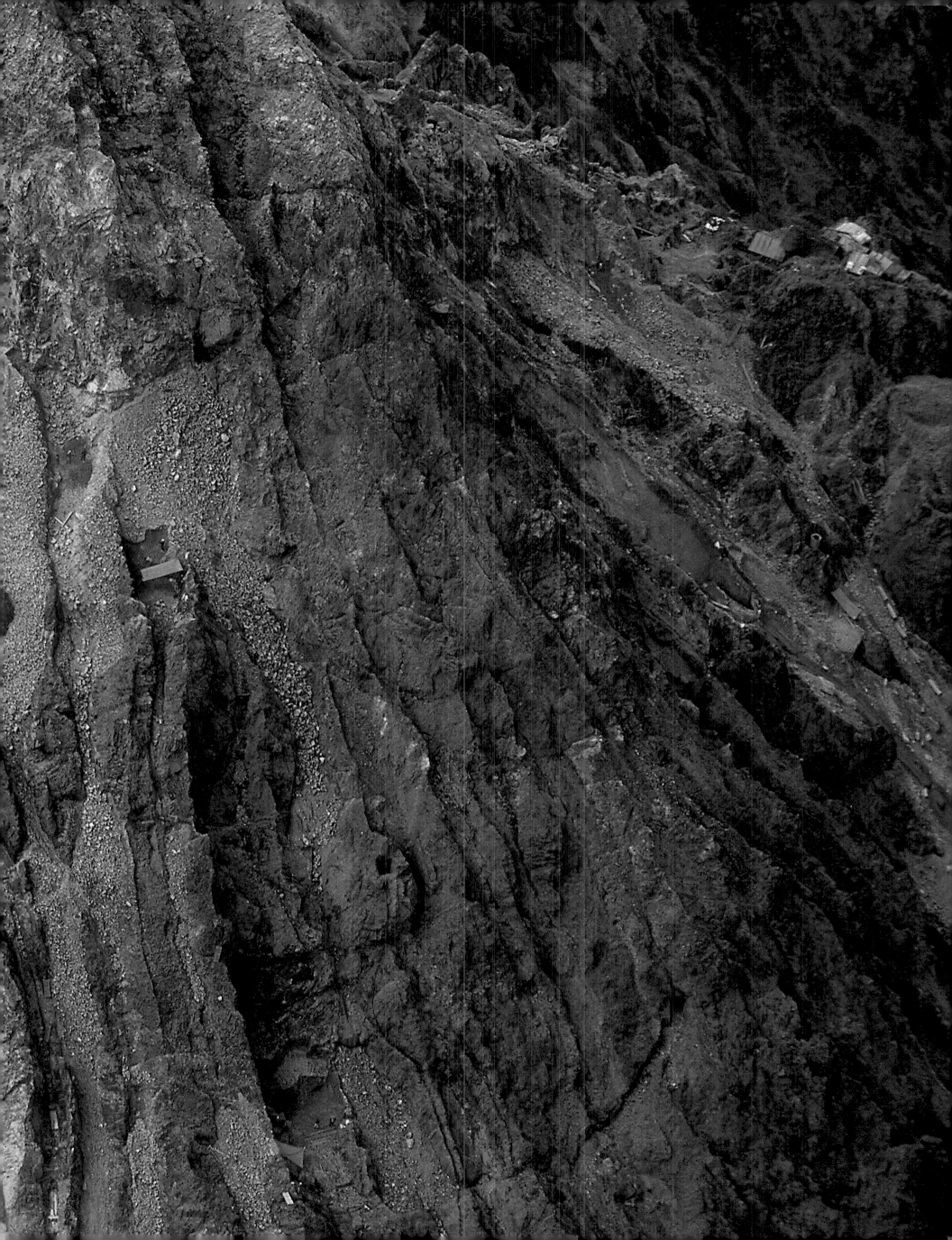

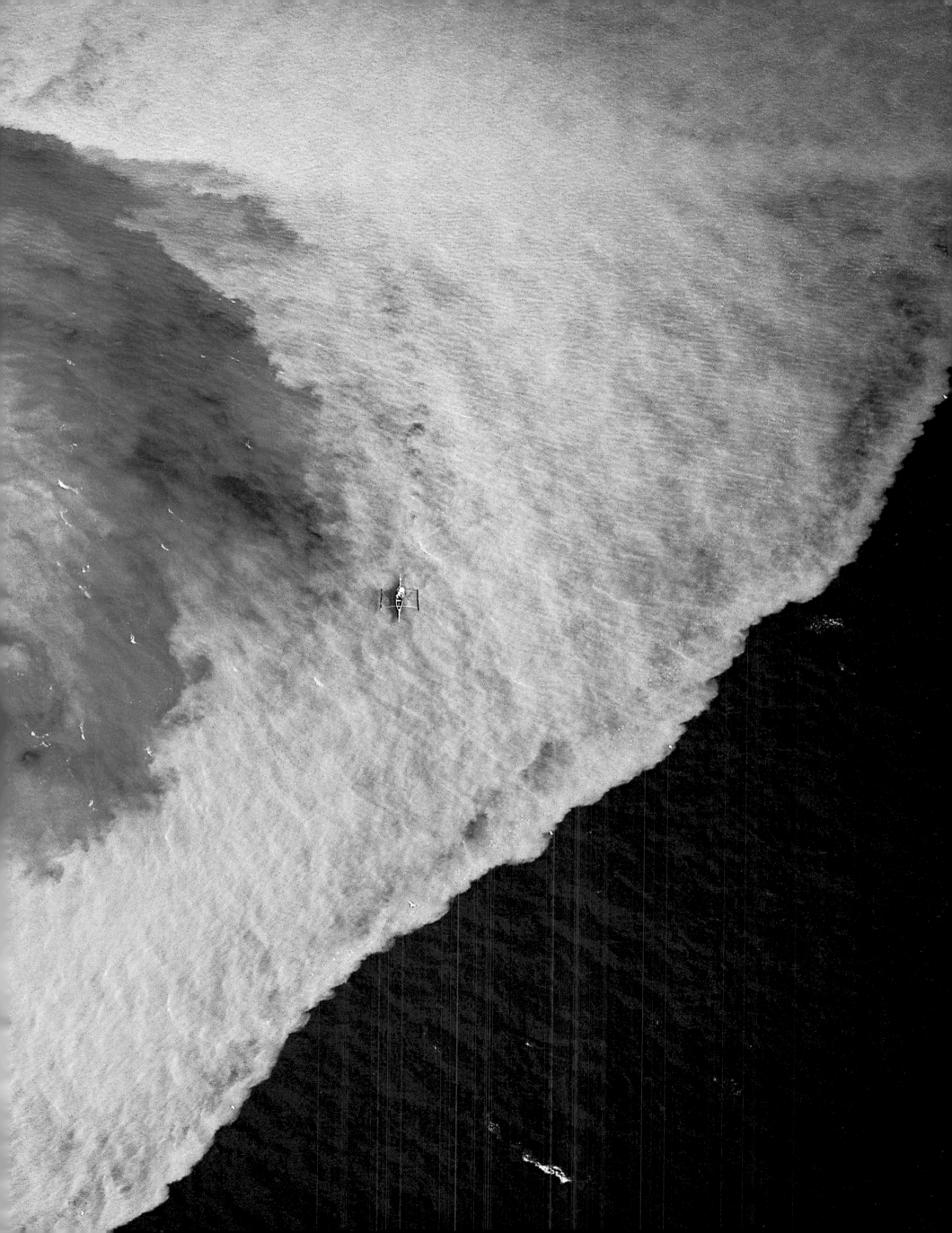

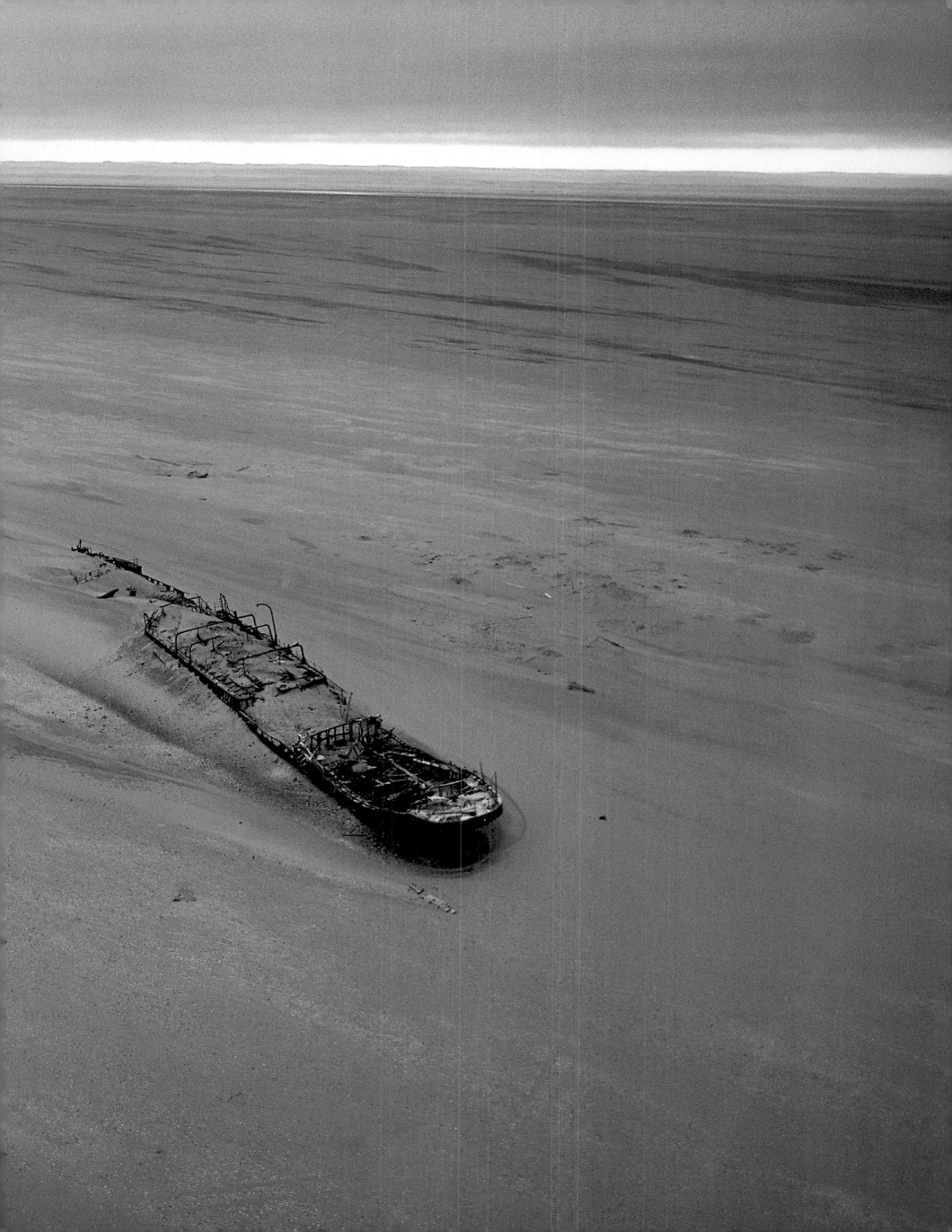

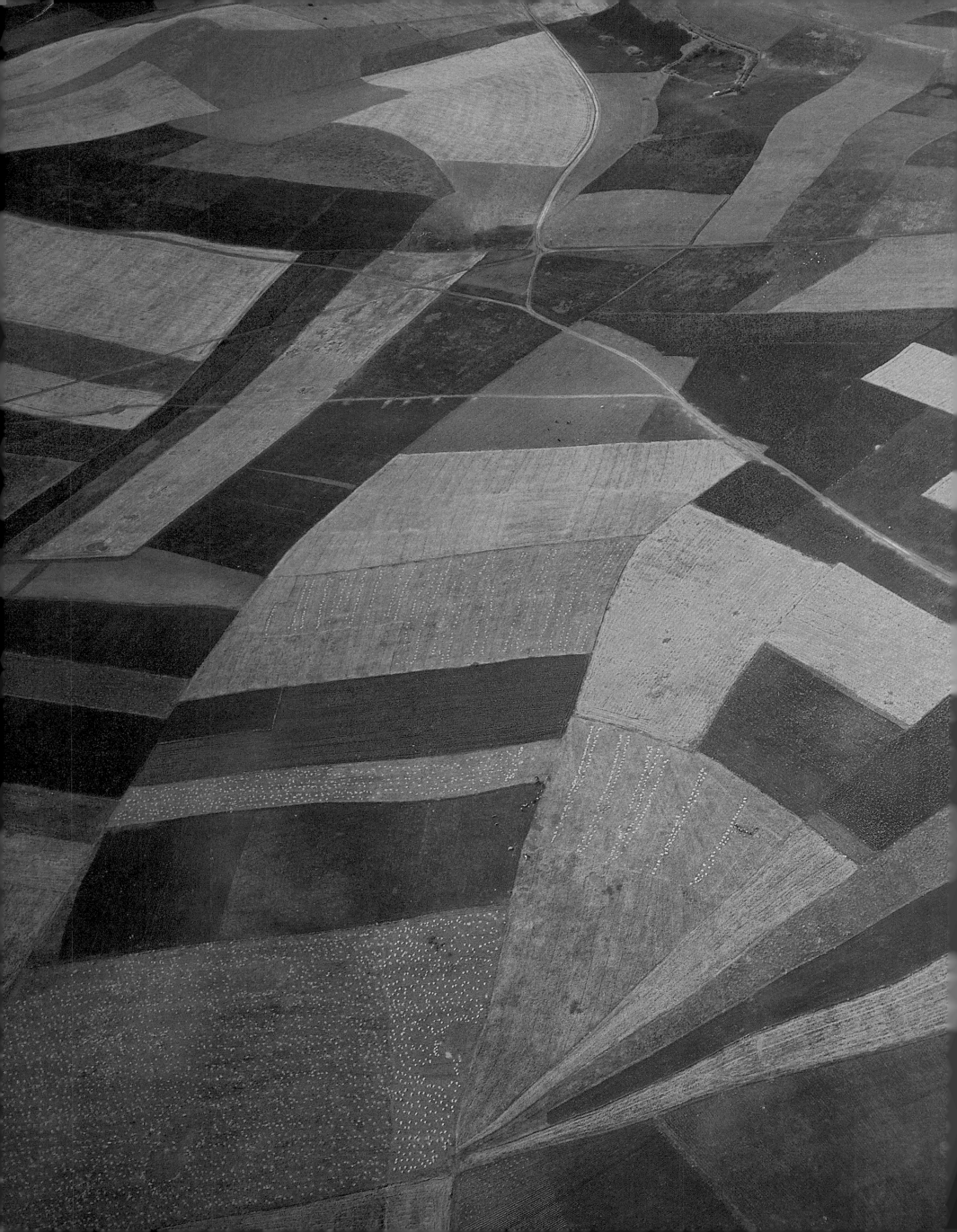

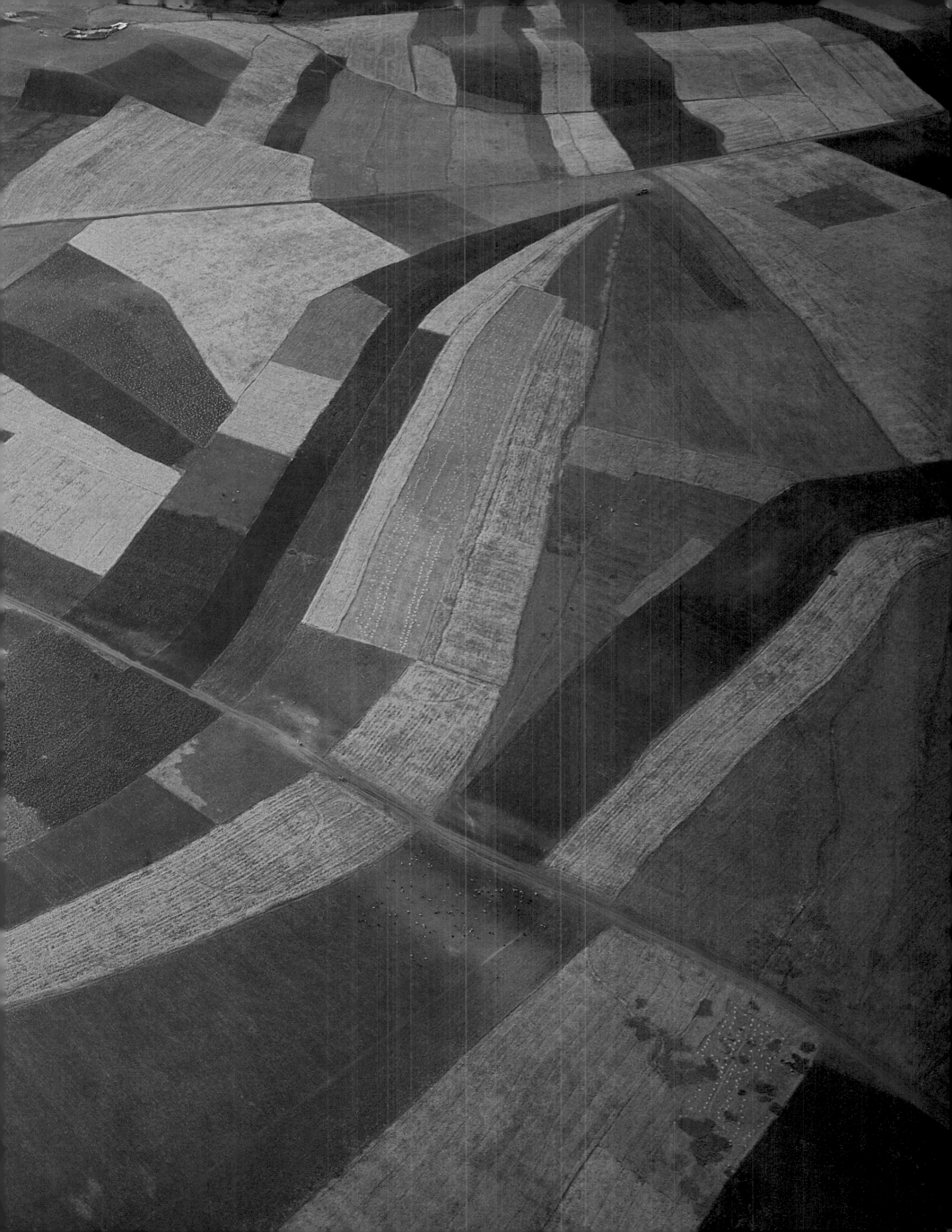

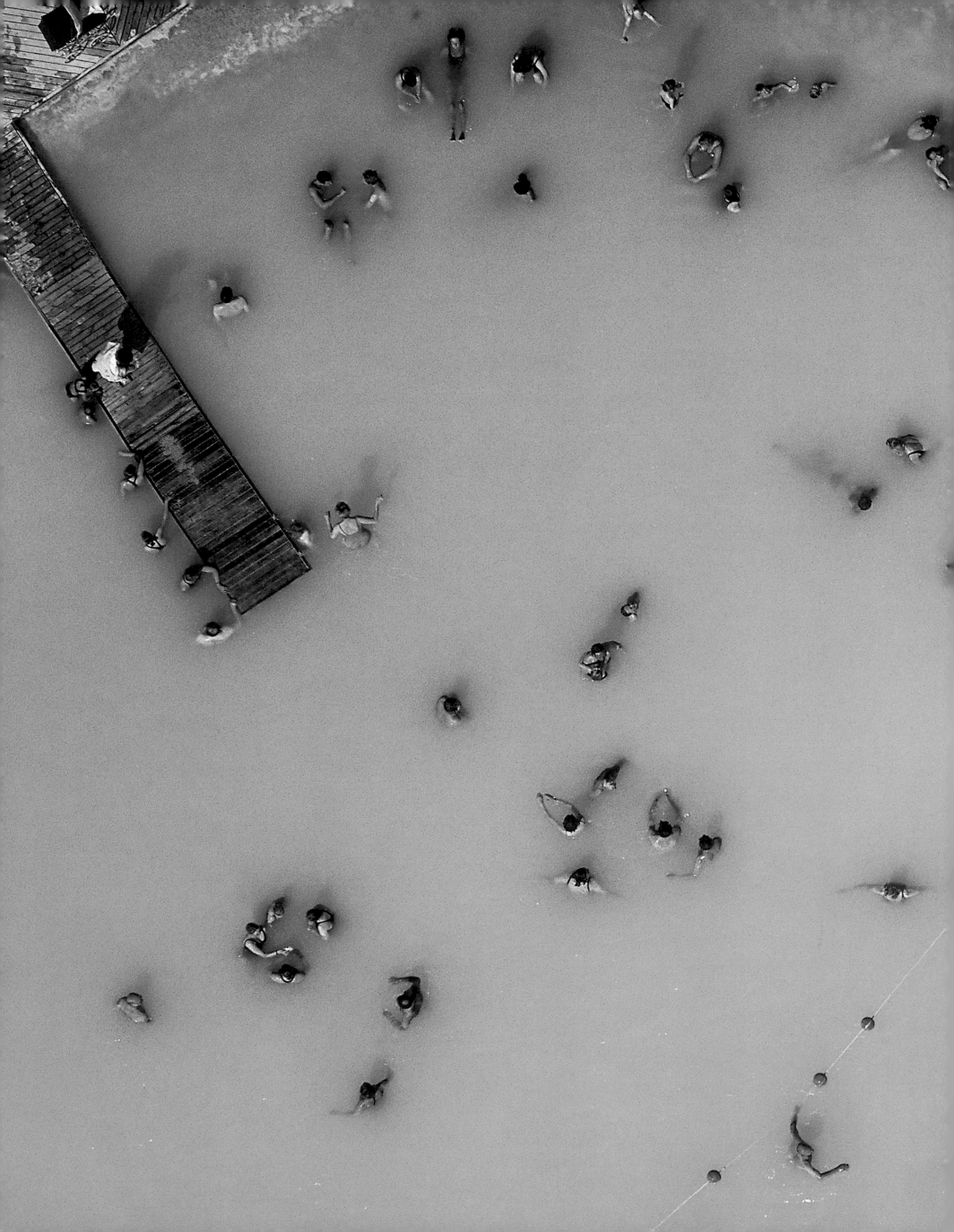

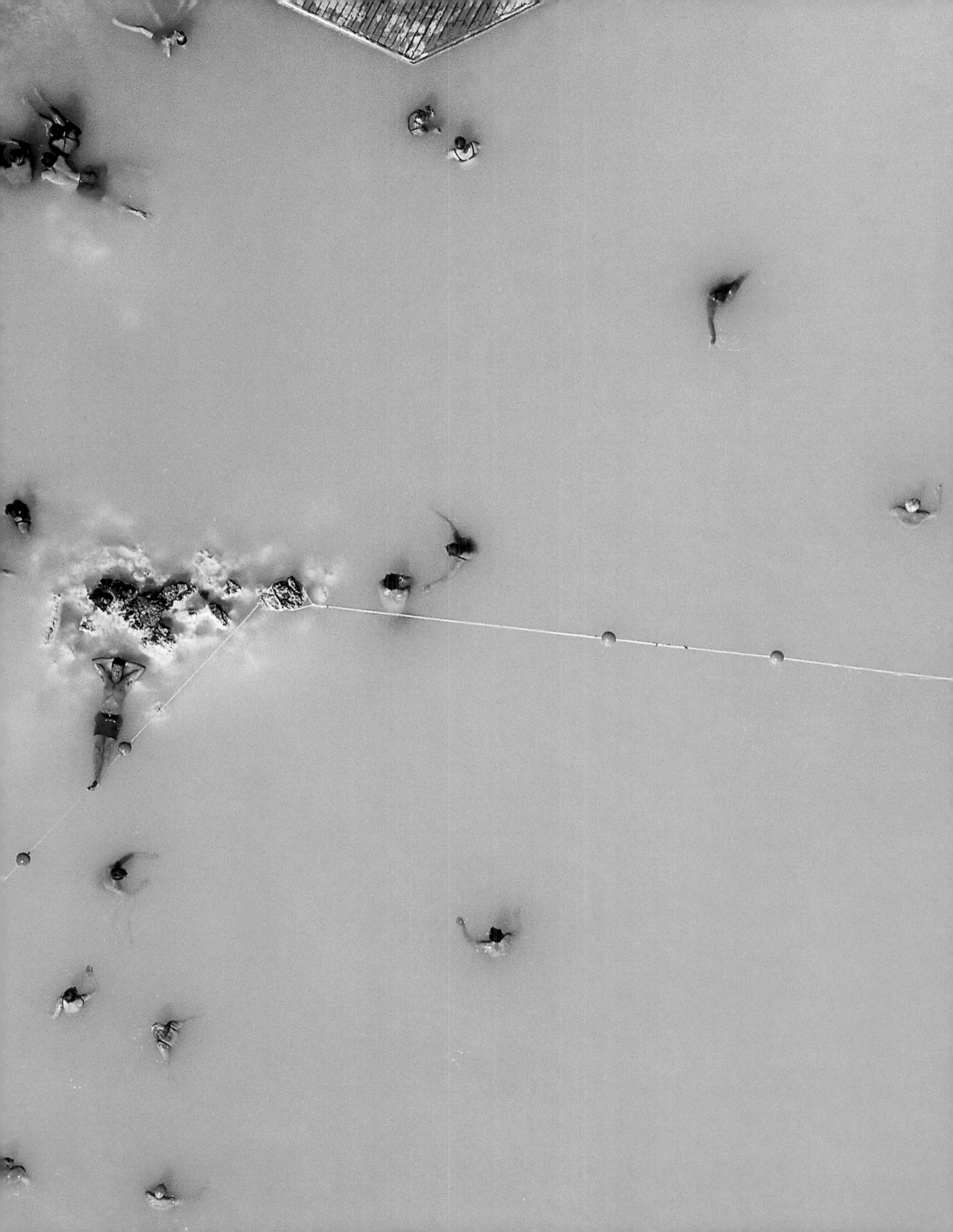

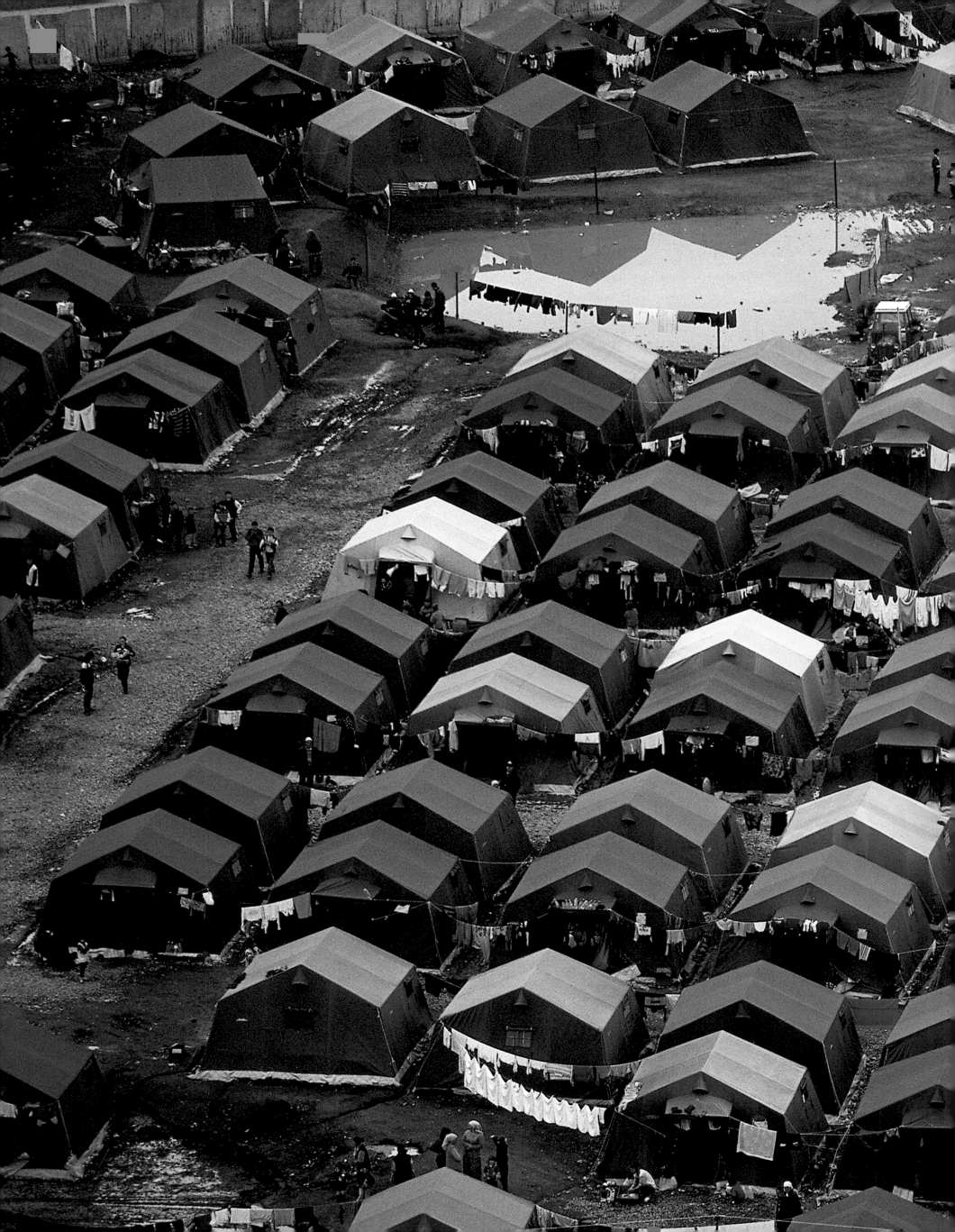

RENEWABLE ENERGY

*The problem of the exhaustion of energy sources has become a
problem of overabundance. The waste emissions created by oil and coal combustion now
surpass the natural absorptive capacities of the earth. However, other forms of energy exist:
the energy of the sun is channeled through solar panels and that of the wind through
windmills. They are not damaging to the environment and, in time, will become
less expensive than the energy we now use.*

In 1953, when the U.S. Atomic Energy Commission published consultant and mathematician Palmer Putnam's first economic prognoses for world energy consumption, he himself probably had no doubts about his findings. Putnam calculated that the number of people (i.e., users of energy) would reach 3.5 billion by the turn of the millennium, that the global market price for coal would continue to climb, and that oil reserves of an estimated 85 billion tons would become markedly scarce.

Putnam completely miscalculated. Today more than 6 billion people live on the planet, coal costs exactly what it did fifty years ago, and the original total estimated oil reserves have long since been burned up. Contrary to his estimate, the earth still contains—absurdly, apparently—200 billion tons of easily extractable oil.

His miscalculations put Putnam in the best company. In 1914 the U.S. Bureau of Mines had estimated that domestic oil supplies would suffice for only another ten years. And in the early 1970s, before the first oil crisis, the global think tank the Club of Rome alarmed the world by reporting that shortly after the year 2000 raw materials, including coal, oil, and natural gas, would become scarce. Computer simulations saw humanity running up against the "limits of growth," causing food and industrial production to break down worldwide. In reality,

more food and industrial goods are produced today than ever before in history.

The constantly recurring anxiety about a failure of energy resources is understandable. After all, nothing in industrial society can operate without a secure supply of energy. Oil is far and away the most important and most precious international economic commodity. But anyone who believes that humanity is heading for an energy crisis is overlooking two crucial factors.

The first of these is human inventiveness. Thanks to countless technical engineering breakthroughs, the industrial nations have learned to make more efficient use of energy—to produce more using fewer raw materials. To produce the same quantity of industrial goods, only half as much energy is required today as forty years ago.

And second, fossil-fuel reserves continue to be underestimated. As soon as energy becomes scarce and expensive, geologists start seeking it with greater exactitude. In the meantime, using modern seismic exploratory methods, they are finding deposits in places that no one had ever considered before. Most oil and natural-gas sources that have recently been discovered lie far out to sea under the ocean floor—where extraction was still unthinkable just a few years ago. This is the reason that the amount of known reserves climbs every year, although energy is being used in greater quantities.

That explains why, off the coasts of West Africa and Brazil and in the Gulf of Mexico, a real gold rush has broken out. Sea maps of these regions look like spiderwebs. The ocean floor is crisscrossed with an endless interweaving of oil and gas pipelines. Above the surface the nonstop hum of helicopters is heard as they fly service crews and scientists to their places of employment.

The Shell company's oil platform Ursa, one of the largest drilling stations in the world, is anchored in the Gulf of Mexico at an ocean depth of more than 3,300 feet (1,000 m), where it pumps 115,000 barrels of oil out of the ground daily. Drilling is no longer restricted to a straight vertical as in earlier times, but

WHEAT HARVEST NEAR MATHURA,
Uttar Pradesh, India
(N 27°21' E 77°51')
The state of Uttar Pradesh is located in the country's most fertile region, blessed with alluvial terrain that is permanently irrigated by the waters of the Ganges and its many tributaries, which are fed by the Himalayan snows. The climate of this state, which is marked by mild winters and hot, humid summers, also contributes to making it one of the greatest agricultural regions of the country. Wheat, a major local crop for domestic sale, as shown here near Mathura, is harvested manually by women at the end of the dry season. With a production of 74 million tons in 2000 (13 percent of the world harvest), India is the world's second-largest producer, between China and the United States. Since 1960 the world consumption of grains, intended for human consumption and livestock, has more than doubled. However, it represents less than 440 pounds (200 kg) per capita per year in India (mainly in the form of rice), whereas each American consumes, indirectly, the equivalent of 1,980 pounds (900 kg) of grains each year, in the form of animal products (meat and dairy).

also extend sideways as far as 6 miles (10 km). The entire undersea infrastructure, consisting of pipes, pumping stations, and distribution stations, was installed by remote-control robots. Now oil companies are planning to build to depths of more than 4,900 feet (1,500 m). Special chemical tools on the sea floor will separate water, oil, and natural gas so that only the desired parts are raised and the rest is reburied. A new generation of robots will work autonomously at extreme depths and will communicate with the drilling station only when problems arise. In addition, engineers are searching for new methods that will allow for up to half of an oil field to be exploited; now yield is only at one-third.

The international energy agency estimates that thanks to such new technologies, oil production can increase easily to 115 million barrels a day by the year 2020 from the current level of 80 million barrels. This doesn't appear to be a problem, as today's *known* oil reserves would last for 40 years at the current rate of consumption. Gas reserves would last 60 years, coal reserves 230 years. If new drilling locations are included, which until now were difficult and expensive to open up, as well as deep-lying oil fields, oil shales, and oil sands, supplies would not be depleted for another thousand years.

But the problem of energy is by no means solved by the enormous supply. Quite the contrary: today it is clear that the largest problem facing humanity is not the finite supply but rather its sheer endless wealth. Because of the vast quantities of cheap coal, oil, and gas, more is burnt and wasted than the environment can tolerate. Instead of wells drying up, we are faced with drowning in their spillage.

The main waste product of any combustion, carbon dioxide, is stored naturally in the atmosphere. That system worked well for a long time, because the planet's air mantle can tolerate large amounts—up to 12 million tons a year, according to climatologists. Plants turn carbon dioxide into organic sub-

stances, sea organisms build it into calcareous shells, and thus free the atmosphere from its excess burden. But because humans pump 26 million, rather than 2 million, tons of carbon dioxide into the air each year, combustion gas has been accumulating in the atmosphere since the dawn of industrialization—intensifying the natural greenhouse effect and throwing the world climate increasingly out of balance.

The chief culprits are the inhabitants of industrialized nations. Although they make up only 20 percent of the world's population, they consume two-thirds of the world's energy. The unacceptable lifestyle we all pursue is typified in the example of an average resident of central Europe, who drives to work in the morning, buys groceries in the supermarket, and flies off on vacation every year. A European's daily food consumption alone reflects 3 liters of oil in hidden energy: this energy is required to produce and process the food and deliver it to the end consumer.

The average German consumes a total of about 1,325 gallons (5,000 liters) of oil per year—enough to fill 14 bathtubs. The burnt oil creates more than 10 tons of carbon dioxide. This is five times the amount an average, climate-friendly world resident should be allowed, but it is still only half the amount of waste created by the average American.

By contrast, the typical citizen of a poor developing country, such as a farmer in Bangladesh, has virtually no influence on the world's climate. Compared with a European or American, the Bangladeshi farmer functions almost like a solar vehicle. His farm work is manual labor, the most important "machines" are draft animals that consume only grass, which is basically solar energy captured by plants. The farmer and his family consume only what they grow or catch in their fields and rivers. Their house is built of bamboo and jute sticks, the roof is covered with straw, and a wood fire burns under the cooking pot. A Bangladeshi farmer cannot afford the use of fossil fuels such as gas or coal. He creates only an average of 440 pounds (200 kg) of carbon dioxide each year.

As energy-efficient and pro-environmental as the forced modesty of a Bangladeshi's life might be, it can hardly serve as a model. Developing countries model themselves on the industrial nations, who live on a far different scale. But what will happen when every Indian owns a refrigerator and all Chinese drive cars—when these individuals do exactly what citizens of industrialized nations have always taken for granted?

PETROLEUM LAKES NEAR AL BURGAN,
Al Khiran, Kuwait
(N 28°58' E 47°56')
This desolate landscape shows one aspect of crisis following the Persian Gulf War, begun after the Iraqi invasion of Kuwait on August 2, 1990. In the course of the war, 300 million tons of oil were burned, one-tenth of annual global consumption. The Middle East holds two-thirds of the world's oil and one-third of the world's natural gas supply. The exploitation of petroleum destroys land through drilling and causes pollution during transport, refinery, and consumption. The final stage creates the most serious damage to the environment. It occurs on the scale of enormous urban regions in which automotive transport continues to pose growing problems for human health. On the global scale the byproducts of gasoline combustion play a major role in the modification of the chemical composition of the atmosphere and the disturbance of the planet's climates.

pp. 338–39
VILLAGE OF
KOH PANNYI,
Phang Nga Bay,
Thailand
(N 8°12' W 98°35')

The jagged west coast of Thailand has a series of bays bordered by many islands in the Andaman Sea. The largest of these islands is Phuket, situated off the coast of the Malay Peninsula. Formerly an arid region, the Phang Nga Bay was created 18,000 years ago when the great glaciers melted, and the receding waters uncovered only the peaks of the chalky mountains, which soon grew tropical vegetation. The bay was declared a marine park in 1981. A similar landscape with peaked karsts is found in other areas of Southeast Asia, such as the Ha Long Bay in Vietnam and the city of Guilin in China. Protected from monsoons by one of the slopes of the mountain, Koh Pannyi is a village floating on bamboo shoots, whose 400 inhabitants live mostly from traditional fishing. It is estimated that approximately 95 percent of all fishermen live in developing nations, of which 85 percent are Asian, producing one-third of all fish products in the world.

pp. 340–41
PEASANT WORKING
HIS FIELD,
Lassithi Prefecture,
Crete, Greece
(N 35°09' E 25°35')

Crete's hilly, rocky terrain creates problems for agriculture and also makes access to the fields difficult. The donkey, a traditional mode of travel, transport, and towing, is the animal best suited to the topography of the island. It remains widely used today, as in this fertile plain of the Lassithi plateau. The local climate, considered one of the healthiest and gentlest in Europe, no doubt favors the exceptional longevity of the inhabitants of Crete. Yet the virtues of the Cretan diet, in which olives and olive oil reign supreme, surely also play a role. Cretans, however, are not the only group of people who commonly live a full century; the Vilcabamba Valley in Ecuador also has many centenarians. Medical progress and improved health conditions around the world are gradually extending the average human life expectancy, which now stands at 66 years. But the duration of life on earth remains very uneven: in Japan and Canada, people on average live to the age of 80, whereas in the least advanced countries three out of four persons die before 50.

pp. 342–43
STORM OVER
AMAZONIAN RAIN
FOREST NEAR TEFÉ,
state of Amazonas,
Brazil
(S 3°32' W 64°53')

The Amazonian rain forest covers 63 percent of Brazil's land area. The Amazon is the most extensive tropical forest ecosystem in the world, covering 1.4 million square miles (3.7 million km²), comprising one-third of the tropical forests in the world. These forests cover only 8% of the world's land, but they shelter 90% of its biological heritage, making them the richest regions of the globe. The Amazon itself hold 10 percent of the total 1.7 million living species on the entire planet that have been classified. The count of animal and vegetable life forms on the planet, however, is far from complete, especially in tropical regions. It is estimated that 12.5 million species are yet to be discovered. This research is of primary interest to the pharmaceutical industry; in fact, more than half of all medicines used today contain as an active ingredient a natural substance extracted from plants or animals. Everyday nearly 78 square miles (200 km²) of forest disappear forever from the face of the earth, taking with them an inestimable number of species whose secrets will never be known.

pp. 344–45
GROUNDED BOAT,
Aral Sea, Aralsk region,
Kazakhstan
(N46°39' E61°11')

In the early years of the twentieth century, when the Aral Sea in Kazakhstan covered an area of 26,000 square miles (66,500 km²), it was the world's fourth-largest inland body of water. After the construction in the 1960s of a vast irrigation network for the cultivation of cotton in the region, the flow of the Amu Darya and Syr Darya rivers, which feed the Aral Sea, diminished to a disturbing degree. The sea lost 50 percent of its area and 75 percent of its water volume, and its shores shranks 40 to 50 miles (60 to 80 km)—leaving behind the hulls of small boats that had once fished its waters. As a direct consequence of water diminution, the salinity of the Aral Sea has continually increased in the course of the

past thirty years, today reaching about 10 ounces per quart (30 grams per liter), three times its original salt concentration, causing the disappearance of more than 20 species of fish. Salts carried by the winds burn all vegetation within a radius of hundreds of miles, contributing to the desertification of the environment. The example of the Aral Sea, although among the best-known examples, is not unique: 230,000 square miles (600,000 km²) of irrigated land all over the world, 75 percent of it in Asia, have excessive salt, which reduces their agricultural productivity.

pp. 346–47
DOGON VILLAGE
NEAR BANDIAGARA,
Mali
(N 14°23' W 3°39')

The Dogon have lived in northeastern Mali for more than five centuries. They are sedentary farmers who originally fled to the region bordering the cliff of Bandiagara, near Mopti, in order to escape Islam. Their villages are made up of walled residences, each of which houses one family. Built of banco (a mixture of earth, straw, and rice chaff), the homes are rectangular in shape and without windows, and they feature terrace roofs used for drying harvests. Each residence has several seed lofts for storing grain reserves, raised on stones, usually cylindrical, and covered with cone-shaped straw roofs. The Dogon, who number as many as 300,000, are known for their artisanry as well as their animist practices. The wealth of traditional Dogon culture led to the inclusion of the cliff of Bandiagara on the UNESCO list of world heritage sites in 1989.

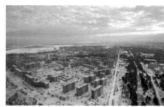

pp. 348–49
ABANDONED CITY
OF PRIPIAT,
near the nuclear power
plant at Chernobyl,
Ukraine
(N 51°21' E 30°09')

The April 1986 explosion of a reactor at the Chernobyl power plant in Ukraine (at that time part of the Soviet Union) caused the worst civilian nuclear catastrophe of all time. A radioactive cloud escaped from the destroyed reactor and contaminated wide expanses in a spotted pattern, not only in Ukraine but also in Belorus and nearby Russia. The 120 closest neighboring localities, including Pripiat (2 miles from the epicenter, population 50,000), were evacuated, although not until some time after the accident. The cloud, pushed by winds, spread over Europe. Today the exact number of victims is not certain, but it is estimated that several million people suffer from illnesses linked to the radiation, such as cancers and immune deficiencies. In December 2000 the last reactor of the power station was shut down, in exchange for Western aid of $2.3 billion for the construction of two other nuclear stations. The nuclear industry has yet to solve the problem of disposing of highly radioactive, long-lasting waste products, generated by 433 reactors in 32 countries, which are accumulating in stockpiling centers.

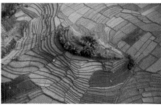

pp. 350–51
ISLET IN THE TER-
RACED RICE FIELDS
OF BALI,
Indonesia
(S 8°34' E 115°13')

The Balinese, organized into *subaks* (farming cooperatives), have exploited the volcanic landscape and the approximately 150 waterways of their island by erecting a vast irrigation system, allowing them to practice rice cultivation. Water retained in the hills is directed into the terraced fields through a network of canals. Rice is considered by the Indonesian farmers to be a gift of the gods. Temples are erected in the middle of the rice fields and, at each stage in the harvest, offerings are made in honor of Dewi Sri, the goddess of rice. The introduction of a new rapidly growing variety of rice in 1976 has increased the number of annual harvests from two to three, and today Indonesia is the third-leading producer of rice in the world, after China and India. In 2000 Indonesia produced 51 million tons, 8 percent of the total world production.

Captions to the photographs on pages 352 to 367 can be found on the foldout to the right of the following chapter

captions 338–351 ↓ captions 352–367 ↓

(N 51°21' W 30°09')

(N 46°39' E 61°11')

(N 40°45' W 73°59')

(N 8°12' W 98°35')

(S 3°32' W 64°53')

(N 28°58' E 47°56')

(N 14°23' W 3°39')

(N 35°09' E 25°35')

(S 8°34' E 115°13')

(N 63°54' W 22°25")

(N 7°04' E 125°36')

(N 42°03' E 20°22')

(N 32°33' W 6°36')

(N 6°52' E 126°03')

(S 26°42' W 15°14')

(N 27°21' E 77°51')

(S 1°52' E 36°17')

(N 26°21' E 72°45')

pp. 312–13
COLD MINING
NEAR DAVAO,
island of Mindanao,
Philippines
(N 7°04' E 125°36')

Gold prospectors in Mindanao occupy precarious shelters of branches and cisterns clinging to the sides of mountains. The slopes, endlessly mined over the years, are made fragile by the network of mining tunnels, which often collapse under the torrential downpours of monsoons, killing many miners. This precious metal is often extracted by means of rudimentary tools, such as hammers or scissors, at a rate of 88 pounds (40 kg) per day. Since prehistoric times 150,000 tons of gold have been mined across the entire globe, one-third of which was used for the fabrication of objects, one-third was hoarded by governments, and the remainder was lost. Today almost 2,500 tons are extracted each year throughout the world, primarily in South Africa (20%), the United States (15%), and Australia (13%).

pp. 314–315
DISCHARGE FROM
GOLD MINE ON THE
SHORE OF MINDANAO,
Philippines
(N 6°52' E 126°03')

Exploitation of gold deposits on the island of Mindanao in the southern Philippines provides an important economic resource for the country, which now produces an average of 8 tons of gold per year. However, the refuse and sediments from the washing and sorting operations are discharged daily into the rivers and ocean. These discharges darken the waters and endanger marine flora and fauna both along the shore and out at sea, particularly the coral polyps that depend upon light for survival. Chemical products such as mercury and hydrochloric acid used for cleansing and refining the gold particles are also discharged into the water, adding their toxicity to the effects of this marine pollution. Damage from mining operations has also affected Hungary's Tisza River, which in January 2000 was contaminated by cyanide (used in the extraction process) escaping from a Romanian gold mine.

pp. 316–17
BOAT RUN AGROUND
ON THE BEACH
NEAR LUDERITZ,
Namibia
(S 26°42' E 15°14')

The Benguela Current, moves north from the Antarctic and follows the coast of Namibia, where beaches alternate with reefs and shallows. The current causes a strong tide, violent turbulence, and a thick fog that conceals the contours of the coast. It is a passage feared by navigators sailing by on the way to the Cape of Good Hope, at the southern tip of Africa. Since 1846 Portuguese seafarers have called the shores "the sands of hell," and the northern part of the coast was given the evocative name Skeleton Coast in 1933. The rusted wreckage of boats as well as airplanes and all-terrain vehicles, along with skeletal remains of cetaceans (aquatic mammals such as whales) and even humans, are strewn along this melancholy shoreline. The wreckage is sometimes mired in the sand hundreds of yards from the water, as seen here near the city of Lüderitz, testifying to the violence of shipwreck. Although advancing rescue technology allows more lives to be saved than fifty years ago, the cost paid on the seas around the globe has been heavy: at least 65 fishing boats disappear daily around the world, and each week two large vessels are shipwrecked.

pp. 318–19
AGRICULTURAL
LANDSCAPE
BETWEEN AL MASSIRA
DAM AND RABAT,
Morocco
(N 32°33' W 6°36')

Modern Moroccan agriculture, based essentially on intensive production of cereals (such as wheat, barley, and corn), depends on irrigation because of the arid and semi-arid climate that characterizes most of the territory. Richer in streams and rivers than the other Maghreb countries, Morocco has been building large dams that now enable it to irrigate a total of 3.2 million acres (1.3 million hectares). The dams' combined storage capacity, which was about 3 billion cubic yards (2.3 billion m³) in 1967, was close to 11 billion cubic yards (15 billion m³) by 2001 for 97 dams. The country's irrigation satisfies 90 percent of total water demand. Although new dams are planned, the gradual silting up of reservoirs is already depriving the country of 65 million cubic yards (50 million m³) of stockpiling capacity each year (or potential irrigation of 12,000 acres). The problem

is inspiring soil restoration measures to combat erosion (caused by severe rainy periods on excessively dried-up slopes). It will remain a problem, nevertheless, for the coming decades.

pp. 320–21
CRYSTALLINE
FORMATION ON
LAKE MAGADI,
Kenya
(N 63°54' W 22°25')

The result of a tear in the earth's crust 40 million years before the Common Era, the Great Rift Valley extends for 4,000 miles (6,400 km) in eastern Africa. Bordered by high volcanic plateaus, this vast collapsed recess, a series of depressions from the Red Sea to Mozambique, contains a string of large lakes (including Turkana, Victoria, and Tanganyika) and Lake Magadi, the southernmost lake in Kenya. Fed by rains that wash the neighboring volcanic slopes and carry mineral salts, Magadi's water has a high salt content. In places its surface is marbled with licks, crystallized salt deposits mixed with briny water. Although inhospitable, this environment is not without life; millions of lesser flamingos gather to nourish themselves on the microalgae, shrimp, and other shellfish that proliferate in the waters of the lake.

pp. 322–23
BLUE LAGOON,
near Grindavík,
Reykjanes Peninsula,
Iceland
(N 63°54' W 22°25')

The volcanic region of Reykjanes Peninsula, Iceland, has numerous natural hot springs. The Blue Lagoon (Bláa Lónið, in the Icelandic language) is an artificial lake fed by the surplus water drawn from the geothermic power station at Svartsengi. Captured at 6,560 feet (2,000 m) below ground, the water is raised to 464° F (240° C) by the molten magma and reaches the surface at a temperature of 158° F (70° C), at which point it is used to heat neighboring cities. Rich in mineral salts and organic matter, the hot waters (about 104° F, or 40° C) of the Blue Lagoon are known for their curative properties in the treatment of skin ailments. The use of geothermy, a renewable, clean, and inexpensive energy source, is relatively recent, but it is being used with growing frequency. In 1960 less than 25 percent of the Icelandic population benefited from this source of heat, whereas today it meets the needs of 85 percent and provides heating for pools and greenhouses.

pp. 324–25
REFUGEE CAMP
NORTHWEST
OF KUKES,
near Tirana, Albania
(N 42°08' E 20°22')

Kosovo, a province of Serbia, is home to a population that is 90 percent Albanian. In late March 1999, in response to Serbia's long-standing policy to "ethnically cleanse" the region of all Albanians, NATO (North American Treaty Organization) began a military action of intense bombing against Serbia. The Serbian police and army responded by systematically forcing the exodus of hundreds of thousands of Kosovars, a process of removal that had already been underway. Accepted under emergency measures by bordering countries, the refugees were encamped in canvas tents. In the past 50 years more than 50 million people in the world have been victims of forced exile. During the 1990s the number of civil wars increased dramatically. Iran and Pakistan have received 3.5 million Afghans who have fled their homeland because of a series of conflicts since 1979—the latest is the NATO-backed bombing by U.S. and British forces in response to the terrorist attacks on the United States on September 11, 2001.

pp. 326–27
DRAWING IN THE YARD
OF A VILLAGE HOUSE,
west of Jodhpur,
Rajasthan, India
(N 26°21' E 72°45')

In the Indian state of Rajasthan, the walls and yards of houses are often adorned with decorative motifs drawn in chalk or by means of other mineral substances. This tradition is nearly 5,000 years old and is most firmly rooted in rural areas. The drawings, which are made by women, are usually of two types: either geometric figures, known as *mandana*, or depictions of people and animals, called *thapa*. They are renewed in time for holiday celebrations, displayed on the walls and the ground, and covered with a mixture of mud and cow manure. They not only personalize each home in an aesthetic manner but also serve an important social function: they testify to the prosperity of the residents and are believed to bring happiness and good luck. Only homes in mourning, which lasts a full year, abstain from these decorations.

The greatest cause for concern is the serious situation in China, the most populous country in the world, whose economy in the past years has been booming like nowhere else on earth. Already China stands second only to the United States in energy consumption, even though a Chinese citizen lives 6.5 times more energy-efficiently than an American.

But despite the fast-growing demand, the country is hardly at a loss for energy: buried on its own territory are roughly 1 trillion tons of coal, 100 billion tons of oil, and 2 trillion cubic feet (60 billion m³) of gas. Even if the economy grows at the high rate of 4 percent per year, and today's inefficient technologies remain in place, this would be enough to last for at least 300 years.

Today more than 70 percent of Chinese electricity comes from coal; the rise of 6 to 7 percent in demand will presumably be covered largely by coal as well. But this is an especially environmentally harmful fuel. With the highest carbon content, coal, when burned, produces more harmful carbon dioxide per unit of energy than oil and far more than natural gas.

One alternative is water energy, which could theoretically allow China to cover all of its demand for electricity. But the example of the Three Gorges Dam shows that mammoth projects based on renewable energy sources can be realized only at enormous environmental and social costs. The turbines on the Yangtze River promise one day to operate the largest power station in the world, with a capacity of 15 large nuclear power plants. But before the energy flows, 1 million people will be relocated by force, and thousands of square miles of fertile land will be flooded.

An even more dramatic rise in energy consumption will result if the worldwide automobile epidemic engulfs China. Cars make up the single fastest-growing item in the global energy balance sheet. Today 740 million cars are moving over the planet—15 times more than in 1945. Each year they pump about 3.5 billion tons of carbon dioxide into the atmosphere.

With fewer than 10 cars per 1,000 persons, China today is practically non-motorized. In crowded metropolitan areas of Shanghai, Guangzhou, or Beijing, even this traffic density is enough for a perpetual traffic jam. We can hardly imagine what would happen if as many Chinese as Americans were to drive cars: the number of automobiles worldwide would jump at once by 1 billion, more than doubling.

Developing countries pay an especially high price for automobile use. From Cairo to Karachi, internal combustion engines are the main source of air pollution in the overflowing urban centers. In addition, the demand for oil creates a dangerous dependence on the fluctuating world price. Most developing countries are dependent on oil imports, and the largest reserves lie in notorious crisis zones such as the Middle East, Russia, and the southern former Soviet states bordering the Caspian Sea.

Energy imports are not only expensive for the poor countries of the world. The Cato Institute, an American think tank, estimated that in the past the United States has spent between $30 and $60 billion annually to maintain a military presence in the Middle East, solely to secure oil imports worth only $10 billion. In other words, for each dollar of Arabian oil, Americans pay three to six times more in hidden defense costs.

This dependence can best be ended through smart, efficient technology. Engineers have built houses that do not depend on externally supplied energy; cars that can drive 60 miles (100 km) on half a gallon (2 liters) of oil or even none at all; or lighting systems that save over 90 percent and create more pleasant light. Even though such technology is only beginning to be used, countries such as Germany and Denmark have increased their gross domestic product for years through reduced energy consumption.

Until now, of course, rising demands of consumers have lowered energy savings. Washing machines, fluorescent light tubes, and cars become more efficient all the time, but energy use increases because people wash more, light up the cities at night, drive heavier, faster cars, and keep bringing new, high-consuming equipment into the household. Nevertheless, technicians think that every industrialized nation could easily function with a quarter of the energy it currently uses. Some experts even think a long-term factor of 10 could be achieved in energy savings. The U.S. Energy Commission believes that American households could save between 50 and 94 percent of energy without sacrificing any comfort.

Until this type of demand for energy decreases, it will not make sense to tap more intensively into the still expensive but clean and environmentally friendly regenerative sources. Today they contribute 14 percent to the global supply, the largest portion coming from water power and organic substances—two forms of energy that have been tested for a long time and whose prices are unbeatable. Wind power supplies 0.04 percent, solar energy only 0.009 percent.

Wind power, however, is not to be underestimated. It has just achieved profitability, and in Denmark wind power already supplies 9 percent of electricity. Windmills are easy to install, quickly upgraded, and within just three months make up the energy that was required to build them. Solar plants still lag far behind in capacity, but their long-term growth potential is gigantic, because the supply is virtually limitless.

Efficiency and renewable resources also constitute the only chance for developing countries to develop an independent energy supply. These countries waste a great deal of energy: for each kilogram of oil equivalent they obtain a mere $3.4 of purchasing power; in Western Europe this figure is $5.6. If developing countries were to operate as efficiently as their industrialized counterparts, they could reduce energy demand by 40 percent and save $120 billion. This would be a lifesaver for countries such as Ethiopia, Mali, and Pakistan, which spend more than half of their proceeds from exports on energy imports.

The energy supply model of the industrialized nations will rarely work in developing countries. The globally active energy firms, which control the whole process from extraction to

end user, have oriented their strategies and prices to the needs of rich countries. Developing countries, still on their way to joining the industrialized world order, have neither the infrastructure nor the purchasing power.

In Tanzania, for example, 97 percent of the country's domestically produced energy is used in its cities. In the countryside, where the majority of Tanzanians still reside, there is no pipeline network; generators and diesel oil for smaller power plants are usually far too expensive. The only possibility of developing the land, therefore, is to use natural resources that for the most part are available in sufficient supply, such as water, wind, organic substances, and sun.

Renewable energy can thus be recommended not only for its friendliness to the environment but also for economic reasons. It is in any case cheaper than nuclear energy, which has become too expensive to use more widely. Despite enormous government subsidies and research funds, nuclear energy was never able to satisfy more than 6 percent of the world's energy demand. Including hidden expenses, nuclear energy costs about twice as much as the electricity from coal or natural-gas power stations. This does not include uncertain costs for disposal of durable nuclear waste, or for the consequences of potential accidents. Considering the abundance of fossil fuels, and the ever-cheaper alternative sources, nuclear energy seems to be the only current type that has no future.

Humanity finds itself confronted with a completely different problem from what had been expected for decades. The specter of an energy crisis no longer terrifies anyone. It will be possible to respond to the needs of the growing world population for a long time to come with fossil fuels, buried deep in the earth for millions of years, and with energy sources that will be renewed as long as the sun shines on our planet. The techniques for exploiting solar energy already exist. We must seize the chance to use it, as soon as possible.

Reiner Klingholz

SPIRE OF THE CHRYSLER BUILDING,
New York, United States
(N 40°45' W 73°59')
In the heart of the borough of Manhattan, in New York City, rises the Chrysler Building. The spire, made up of a series of superimposed steel arches, reflects the rays of the sun by day and is illuminated at night. The architect William Van Alen designed this Art Deco building on the orders of the automobile magnate Walter P. Chrysler. At 77 stories and 1,050 feet (319 m) high, it was the tallest building in New York when it opened in 1930; but it was quickly dethroned in 1931 by the Empire State Building, which is 1,250 feet (381 m) tall. The Chrysler still counts among the city's forty tallest skyscrapers, all of which are above 655 feet (200 m) in height. The demographic and economic growth of the world's megalopolises inspires buildings of ever-growing height.

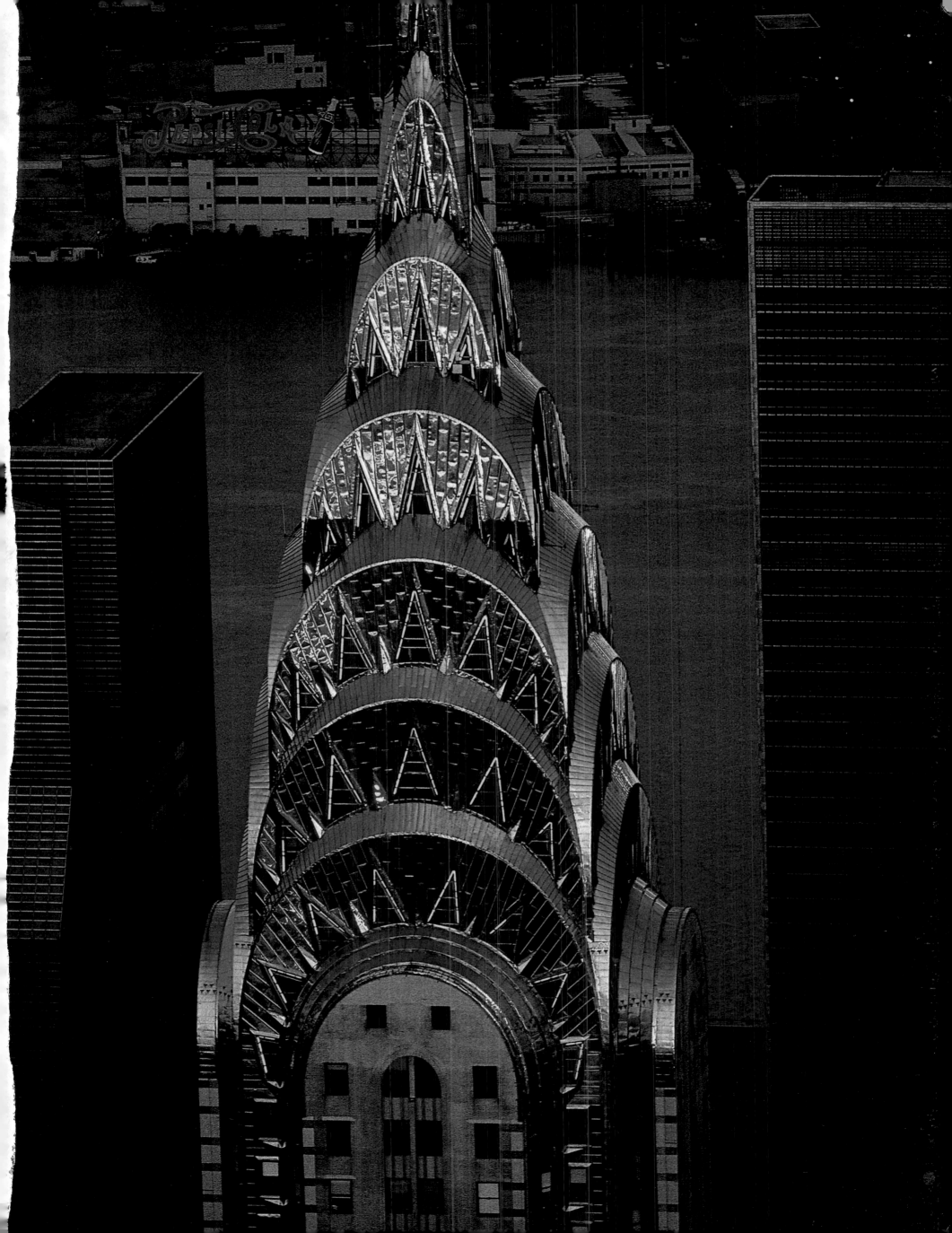

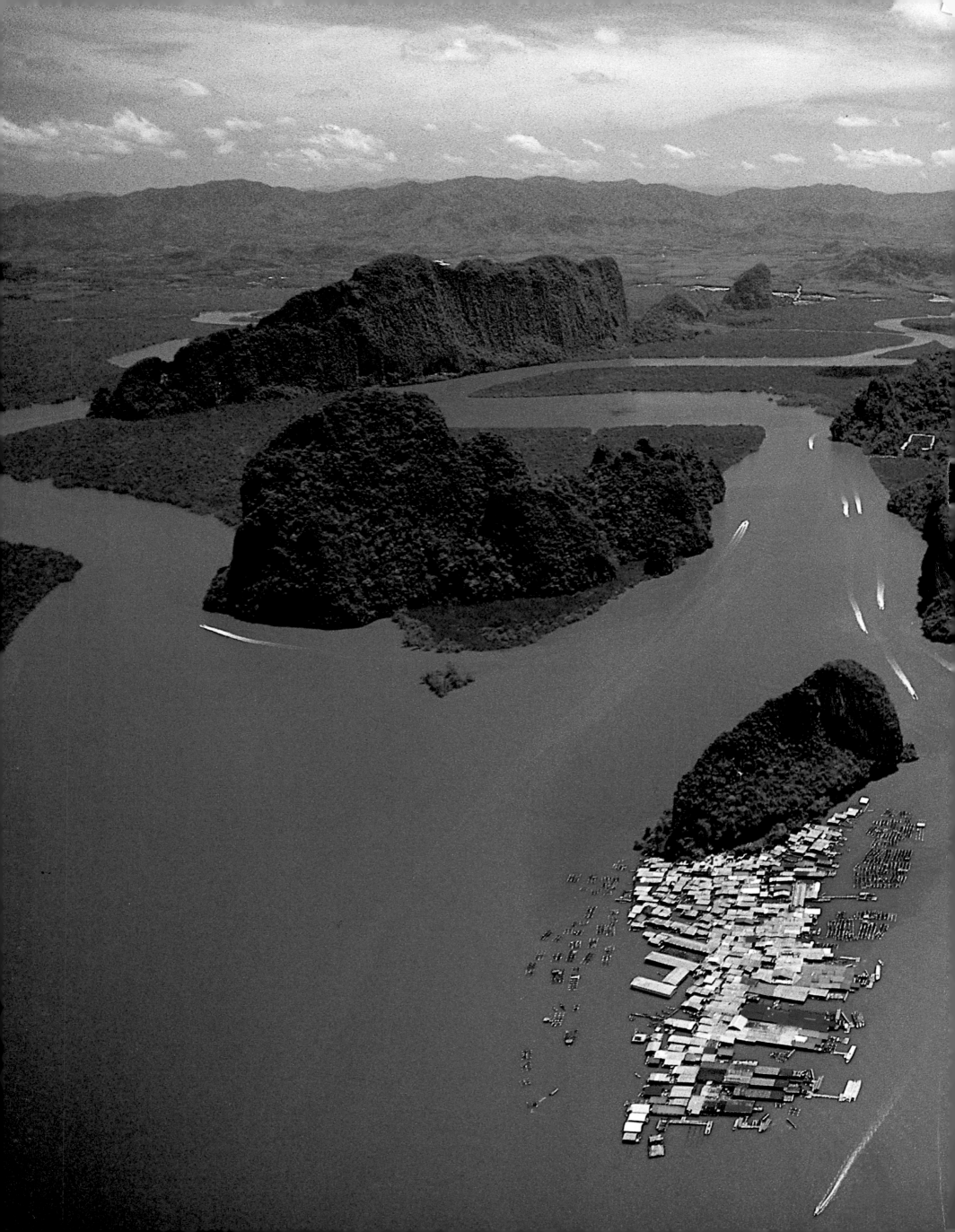

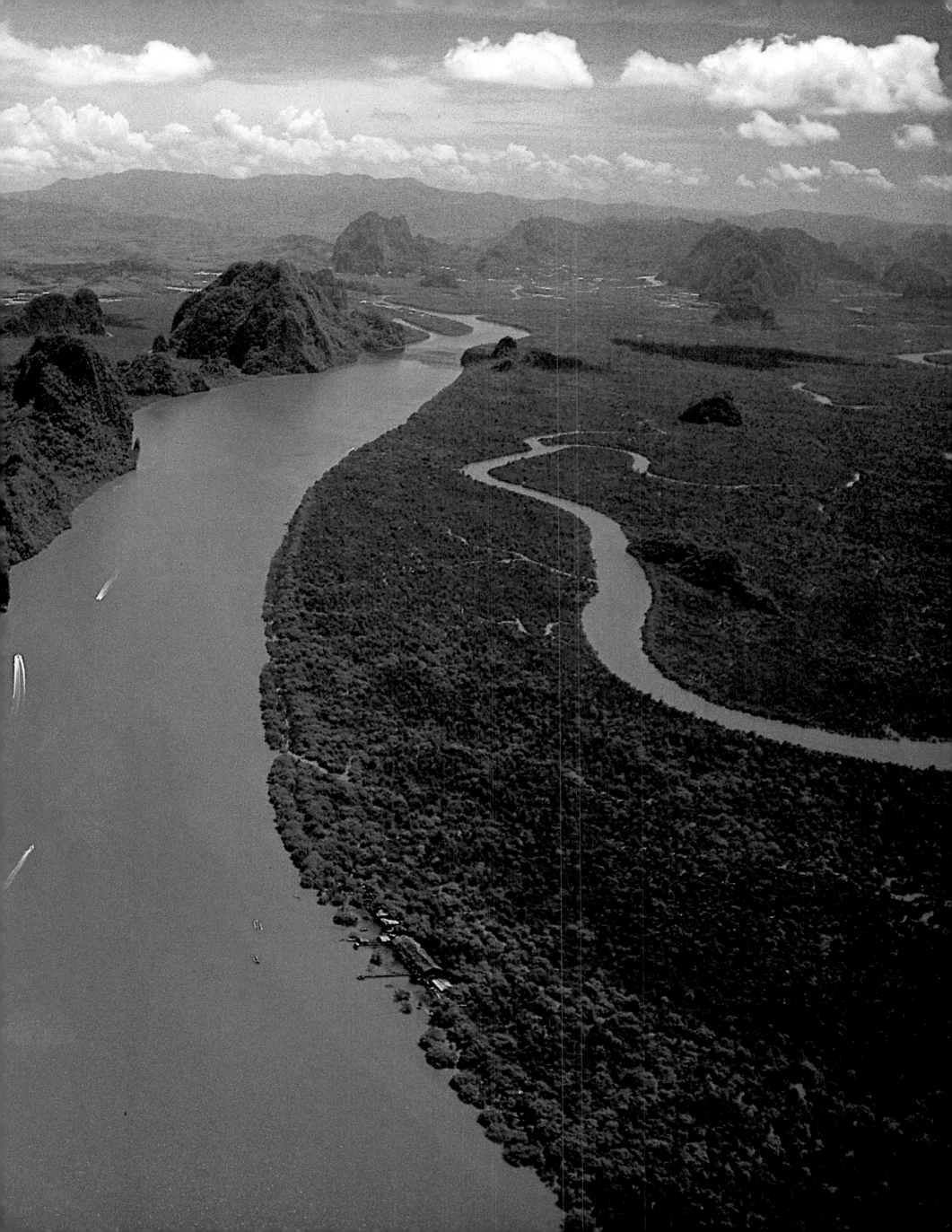

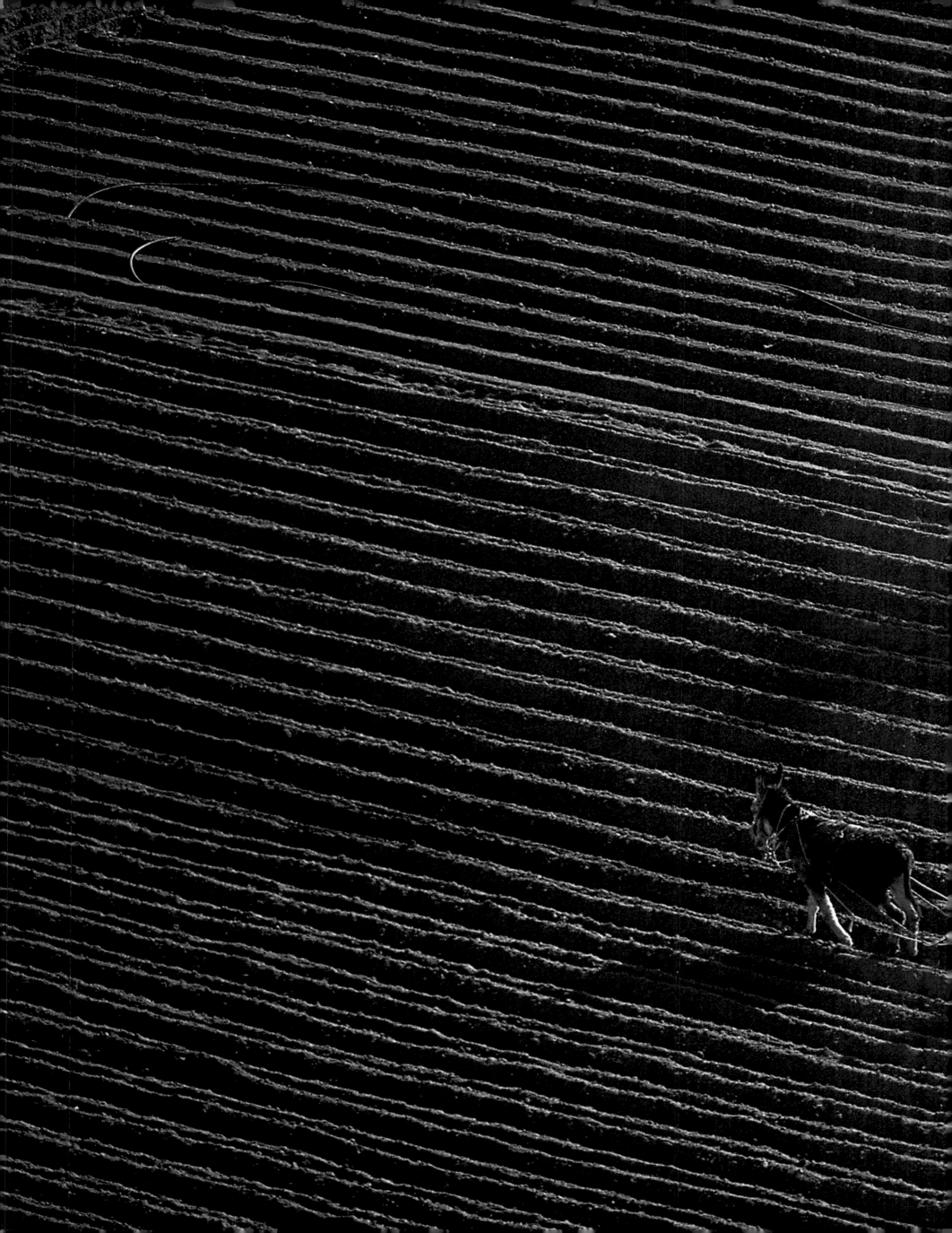

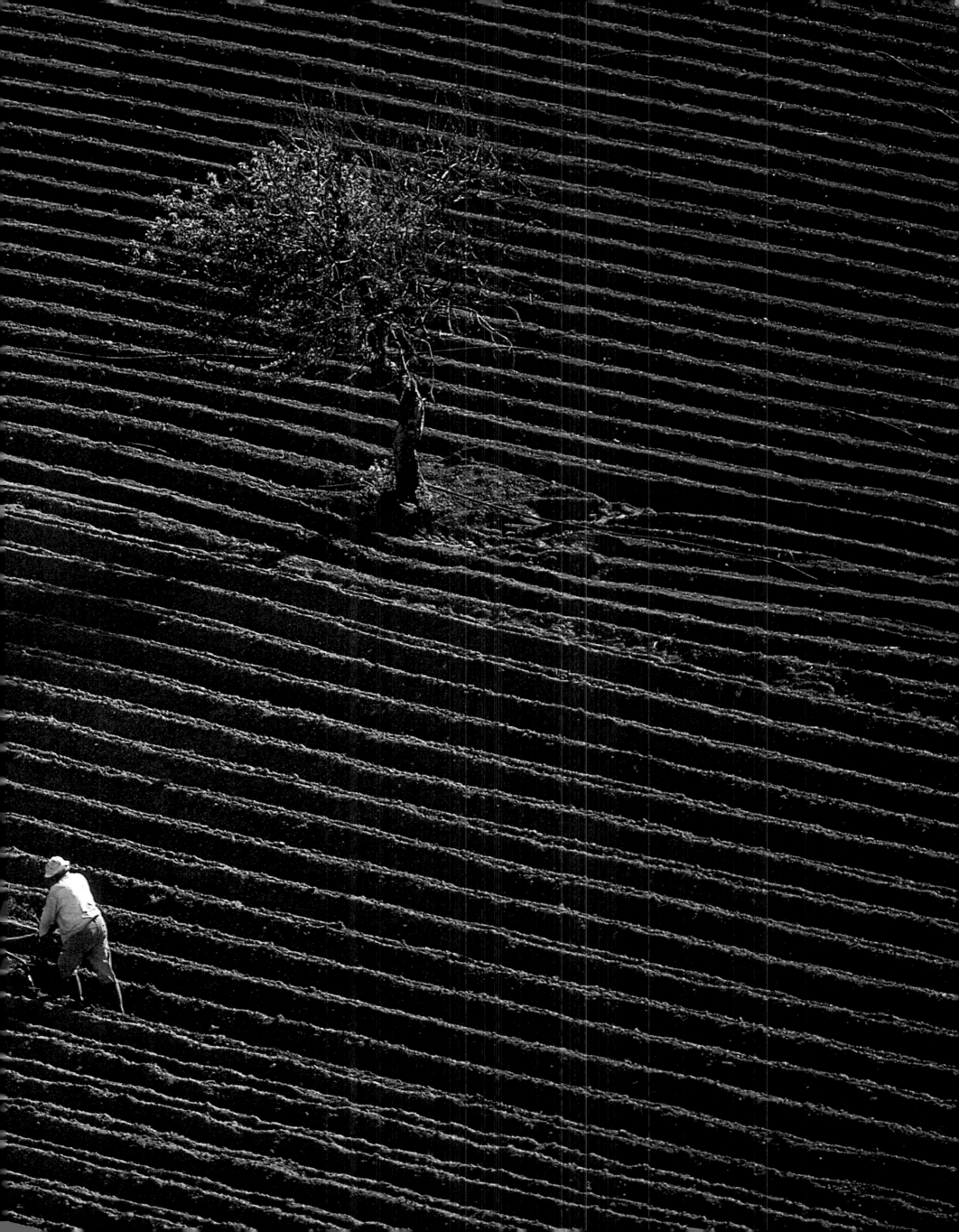

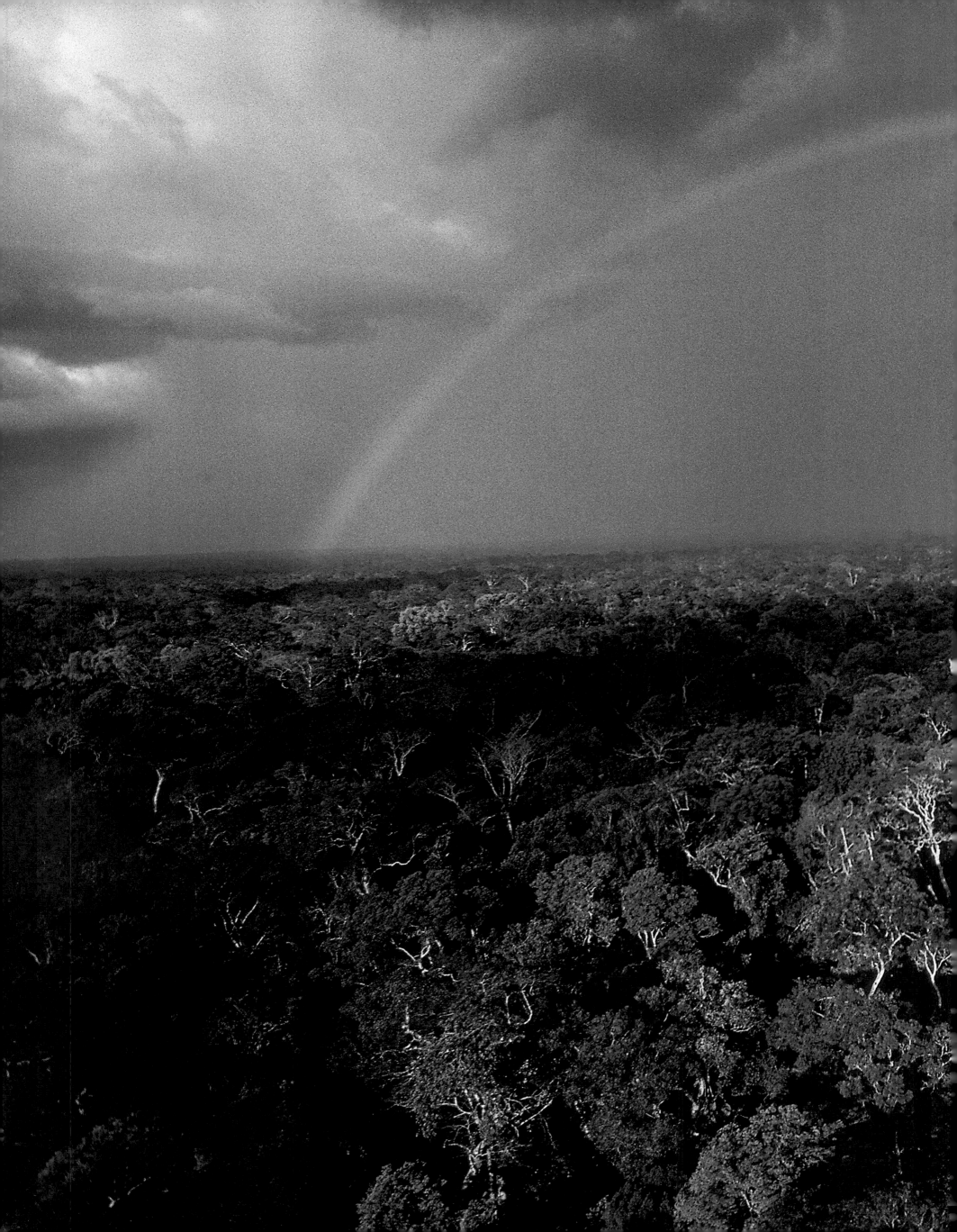

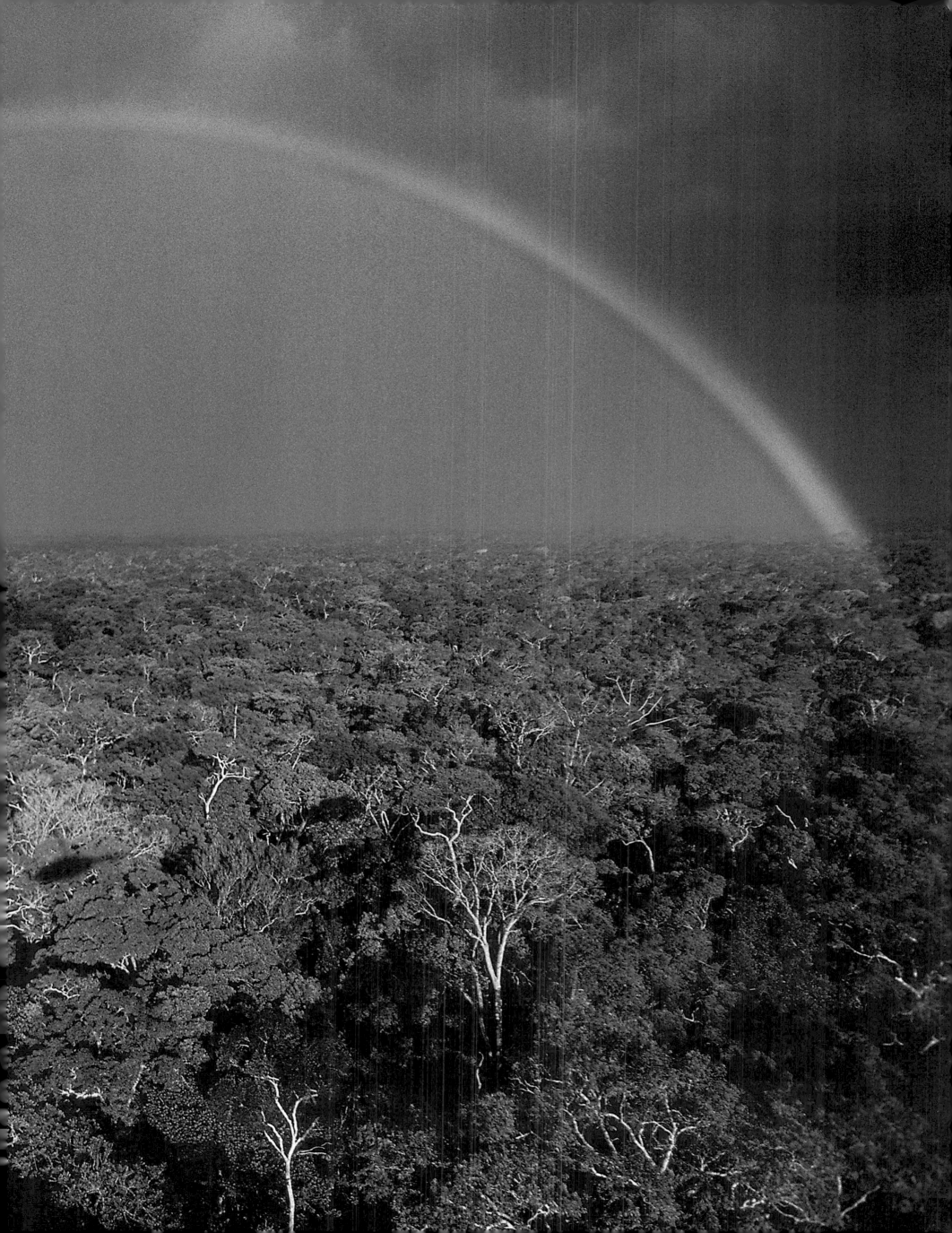

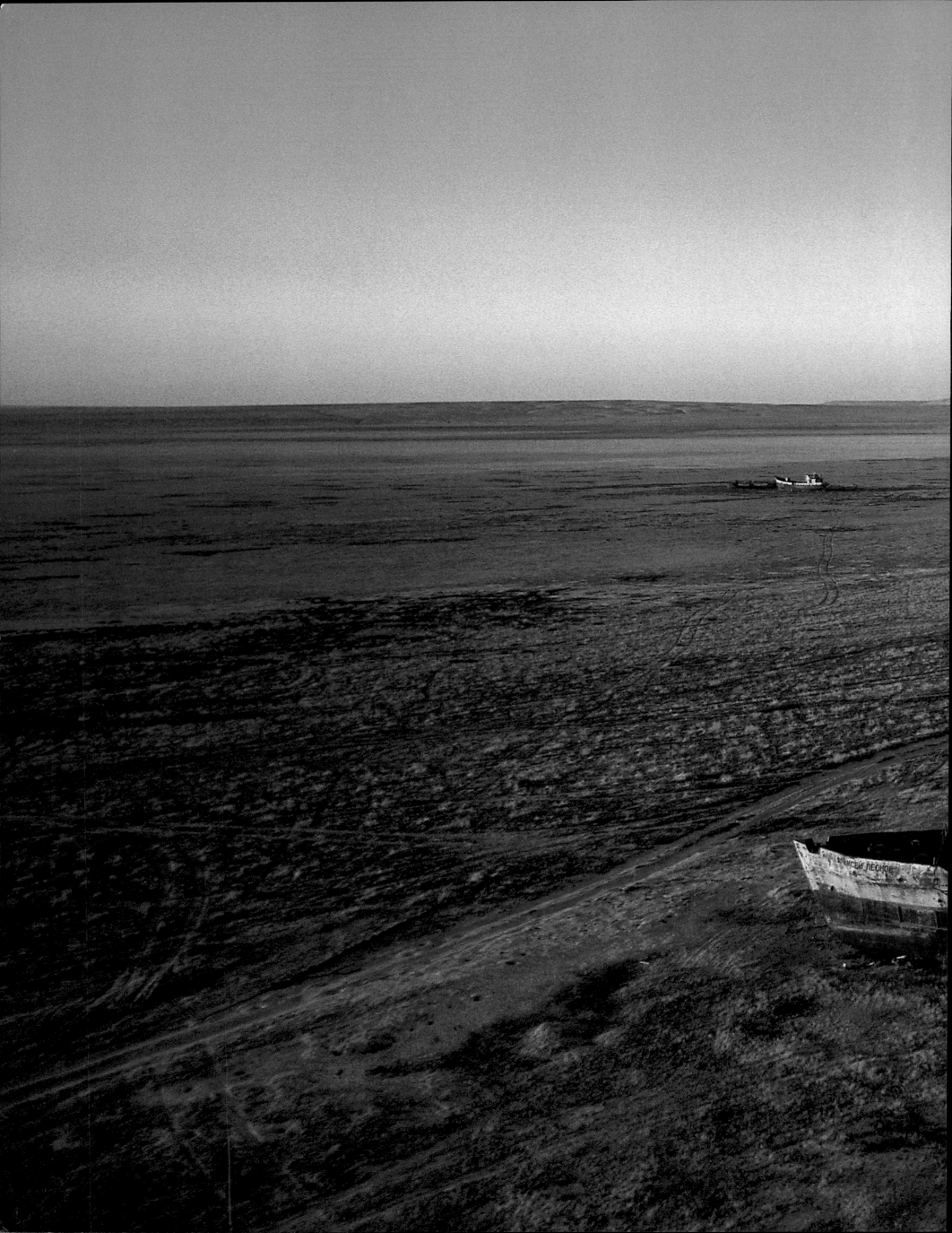

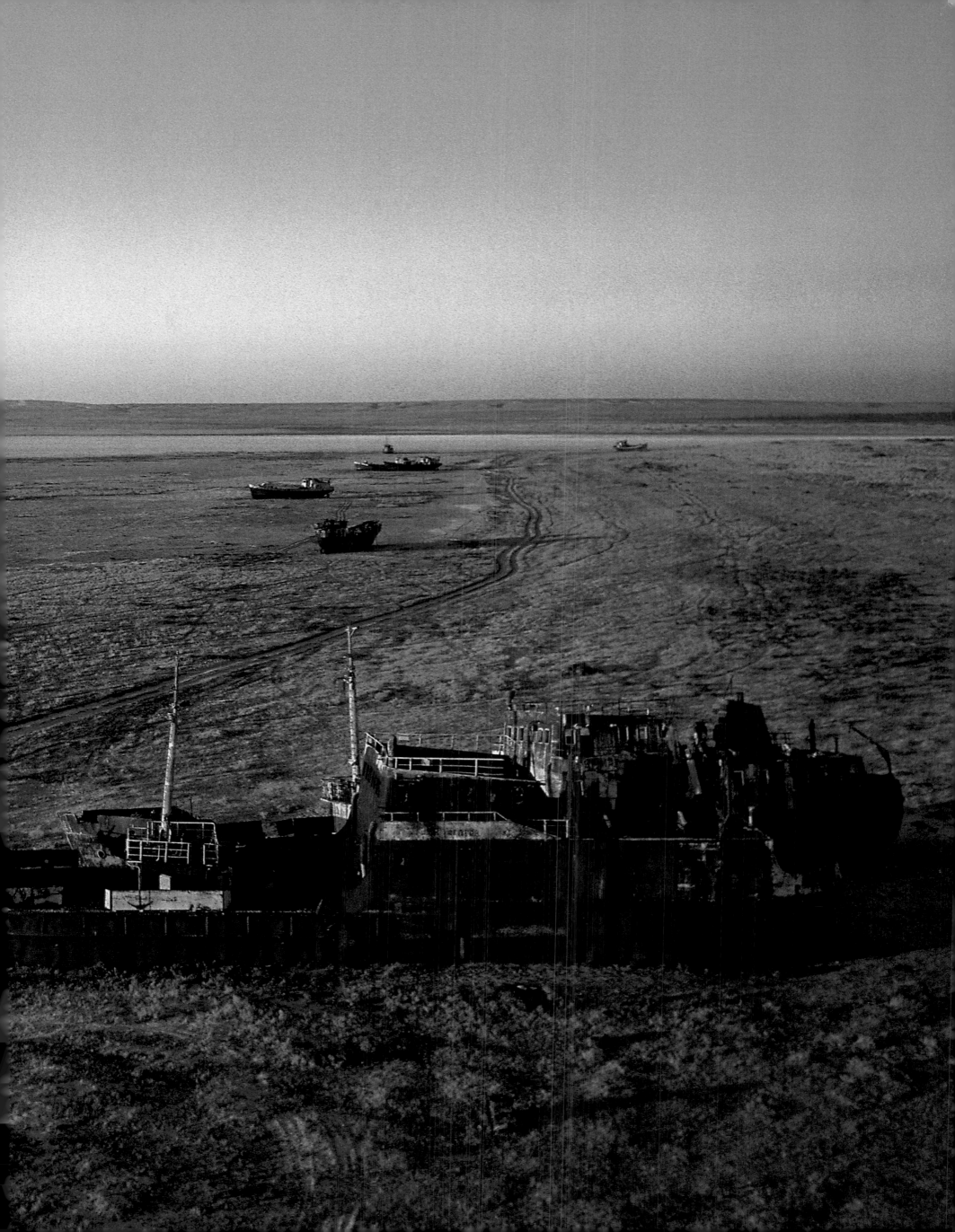

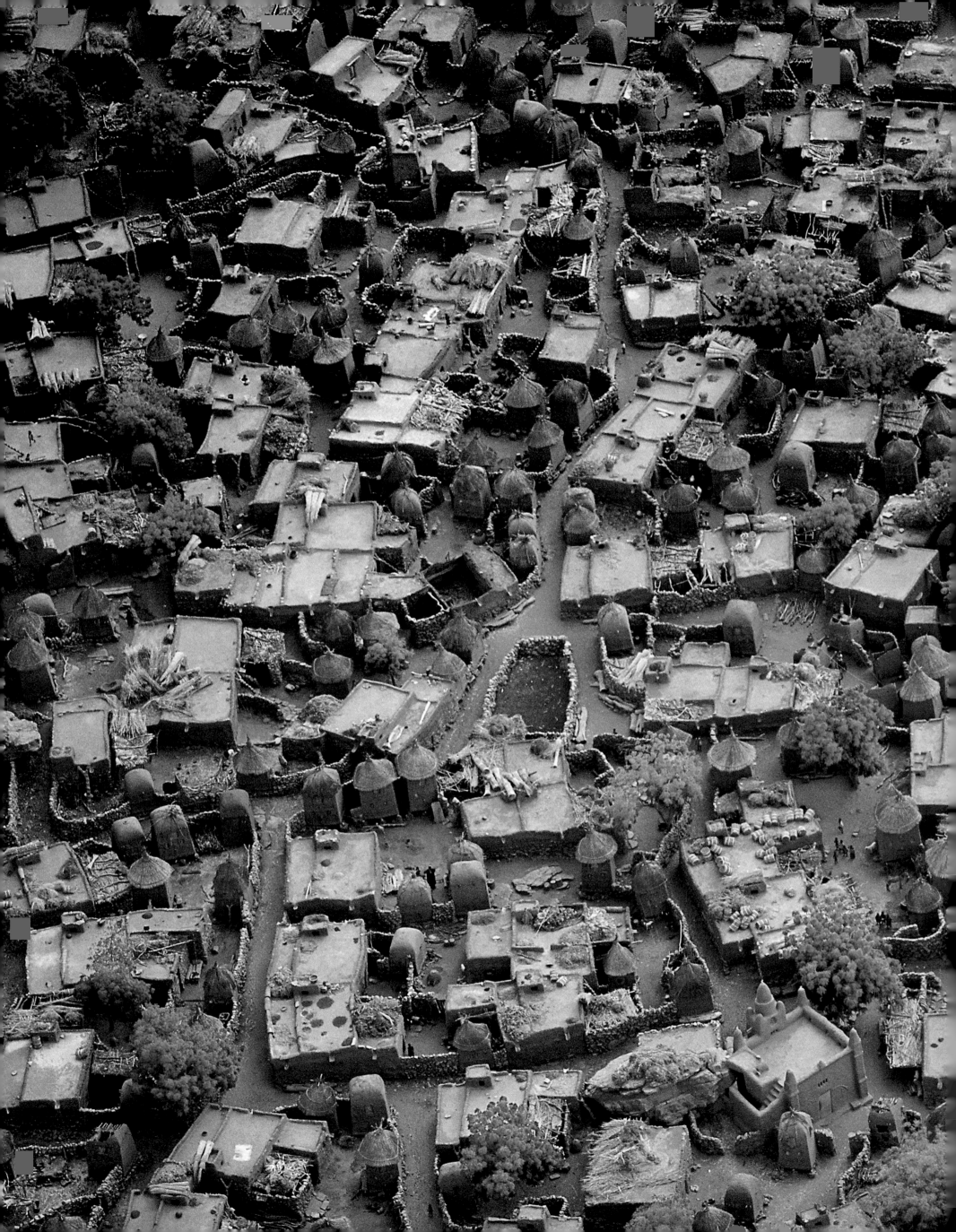

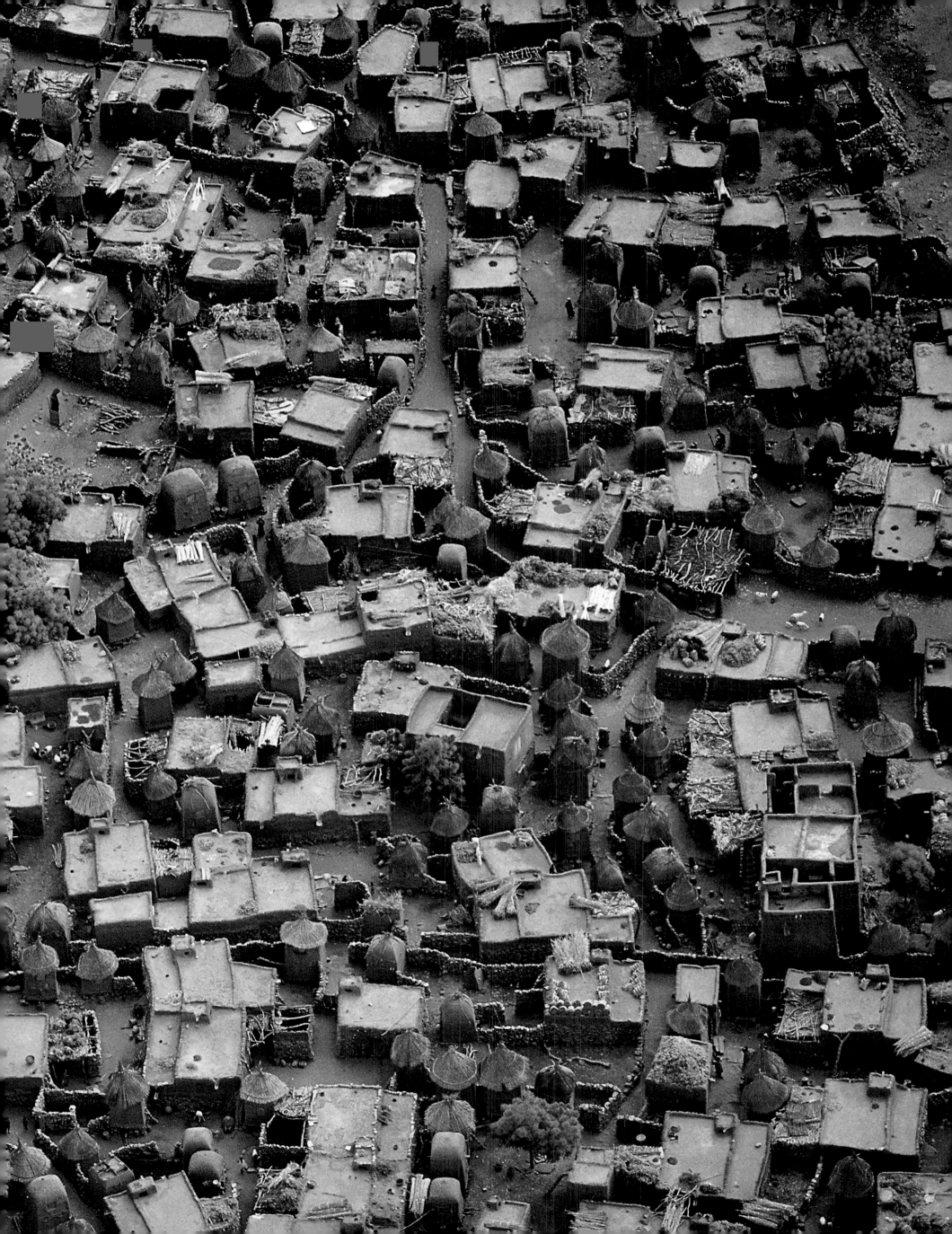

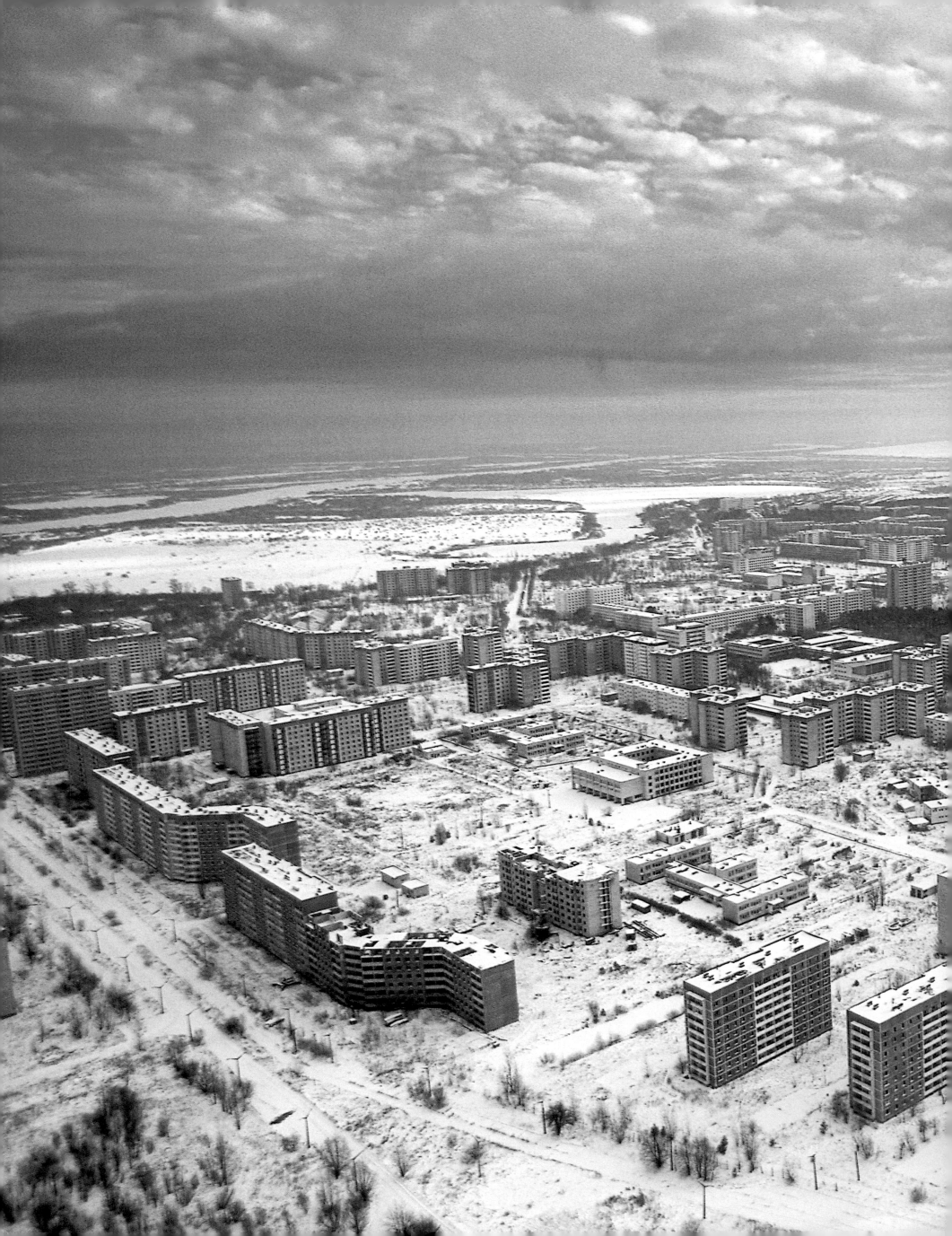

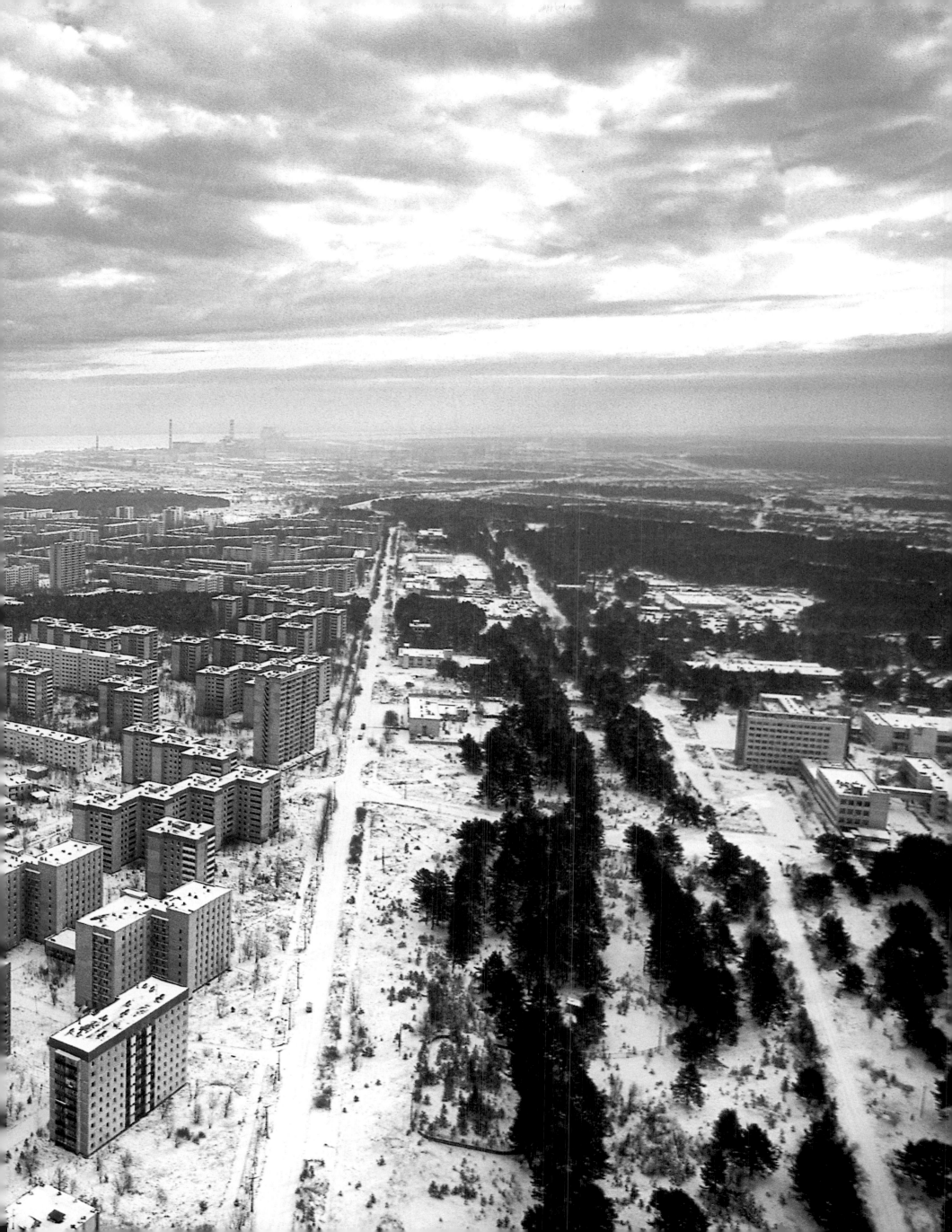

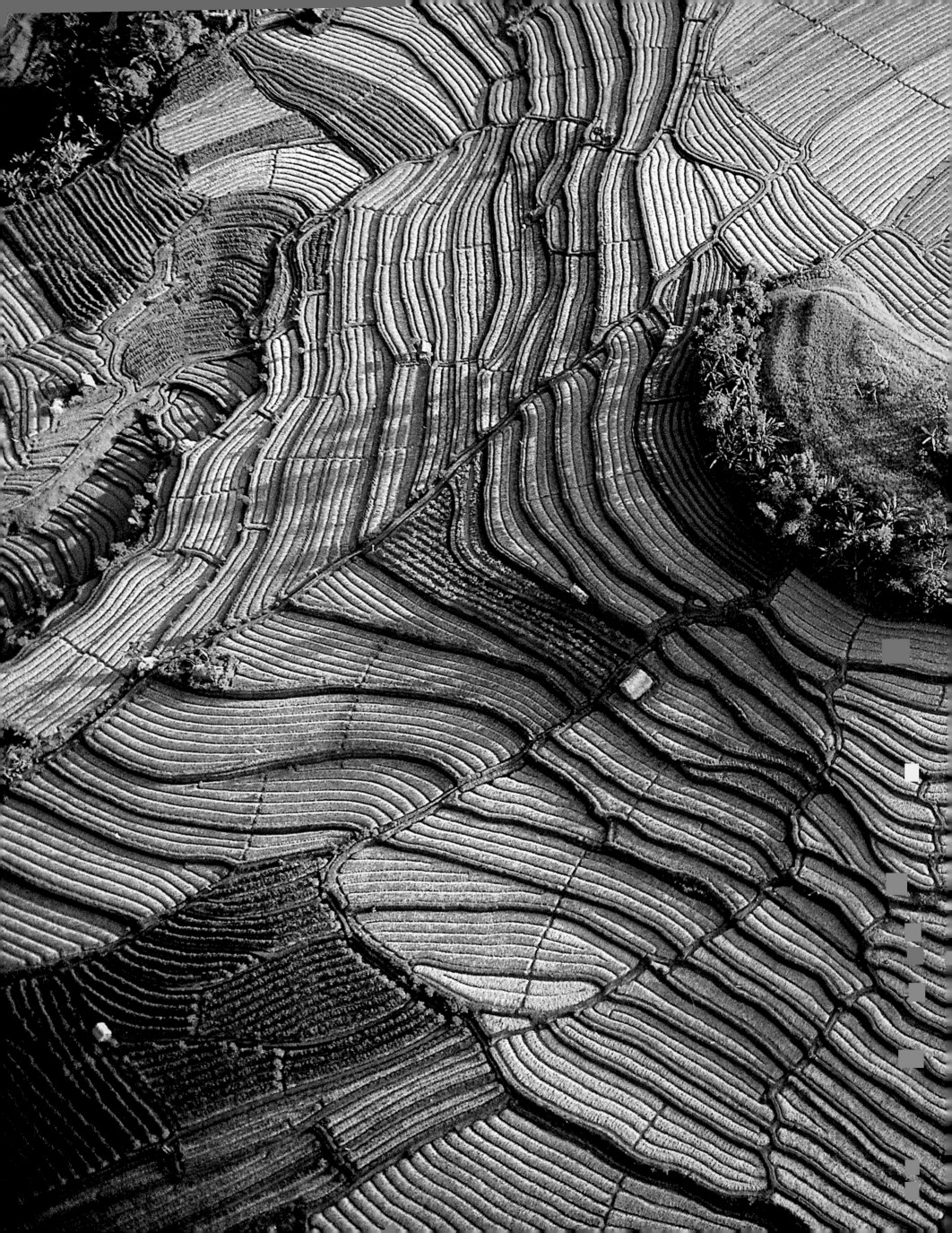

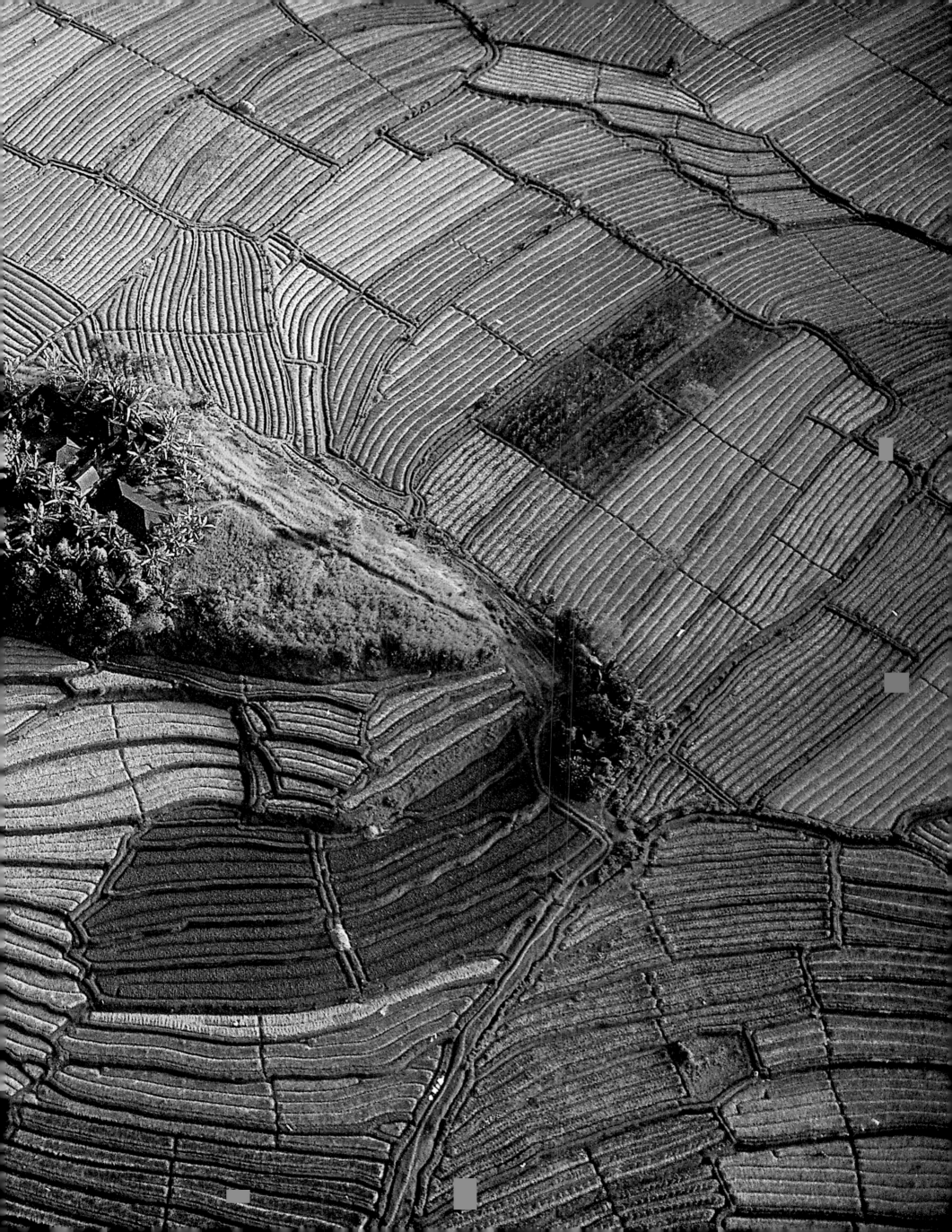

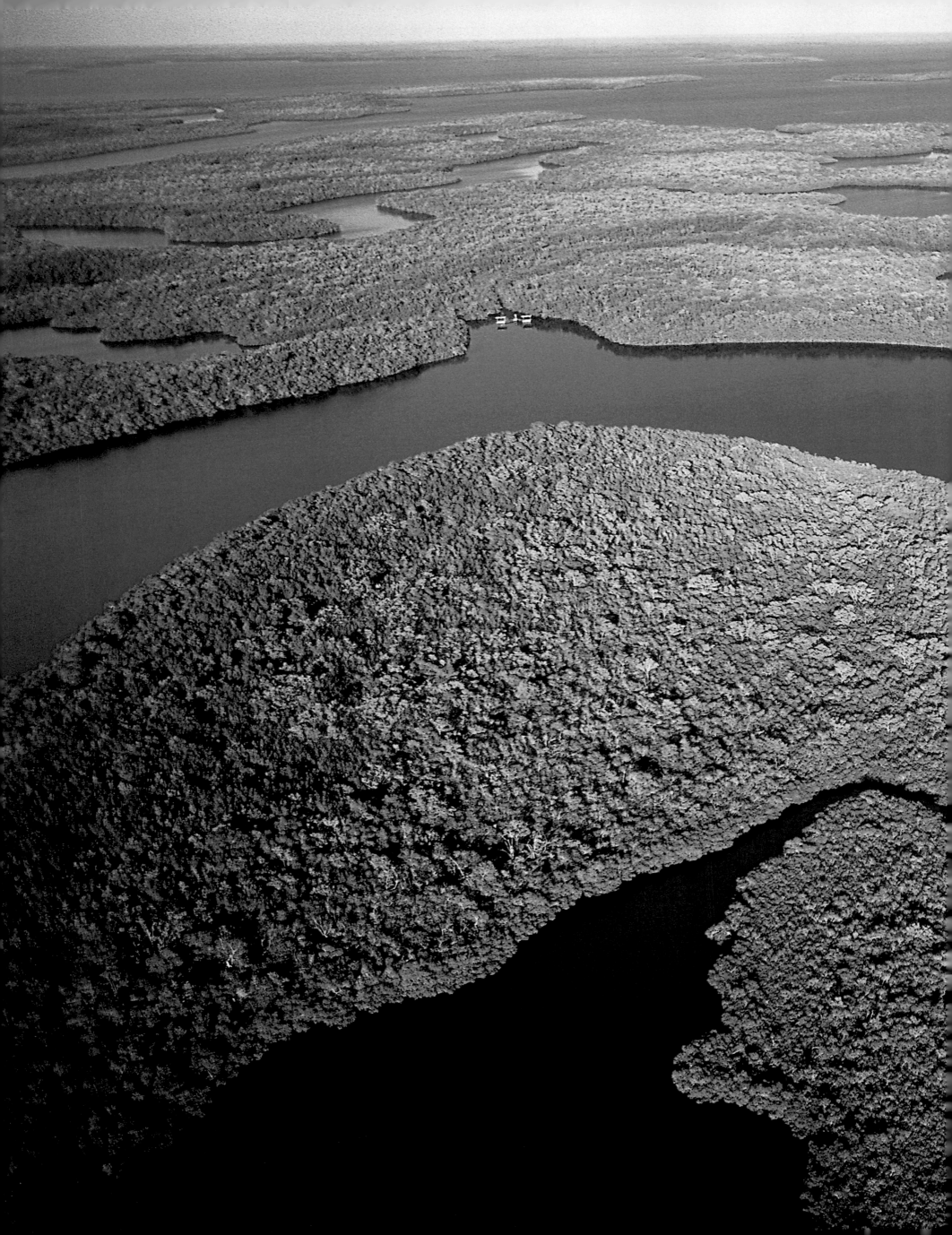

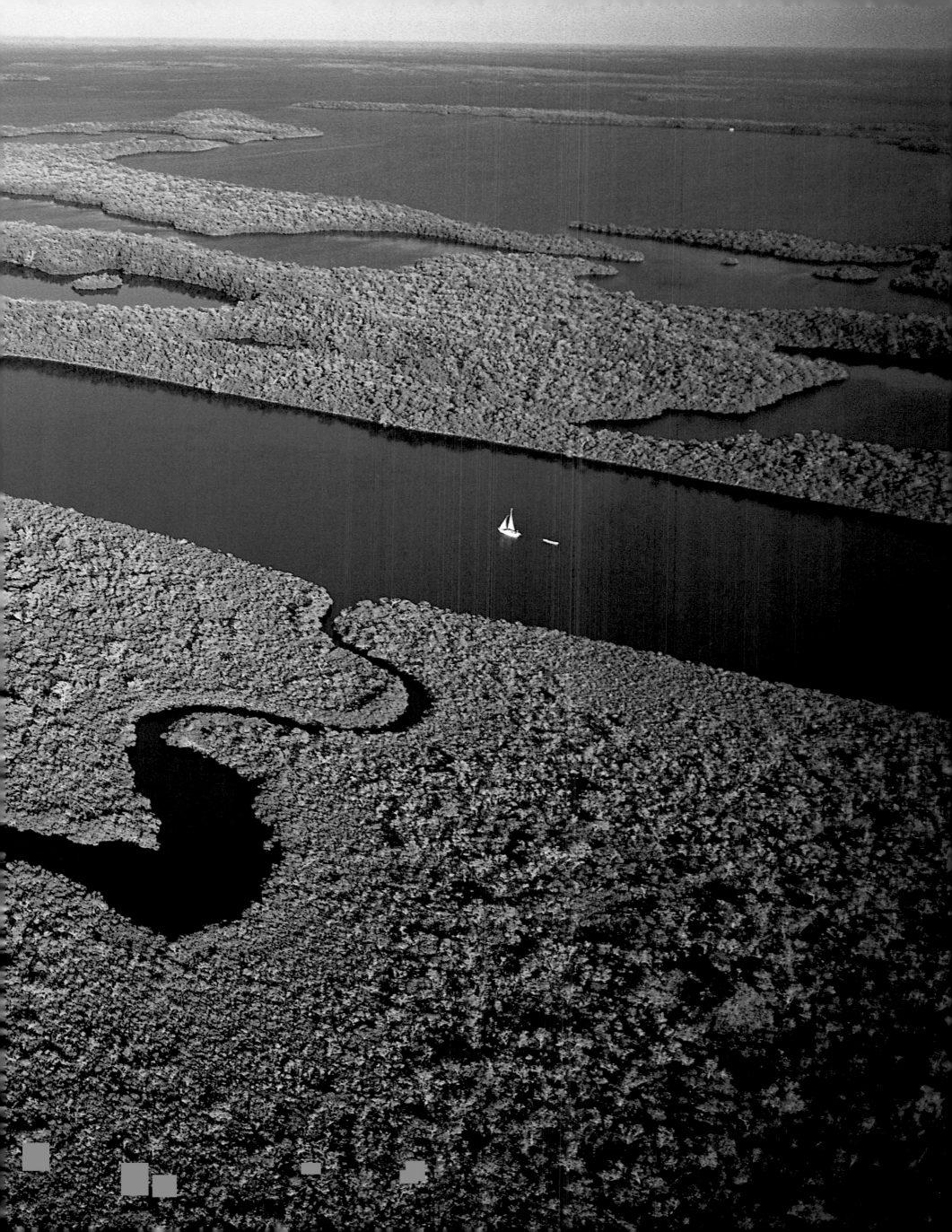

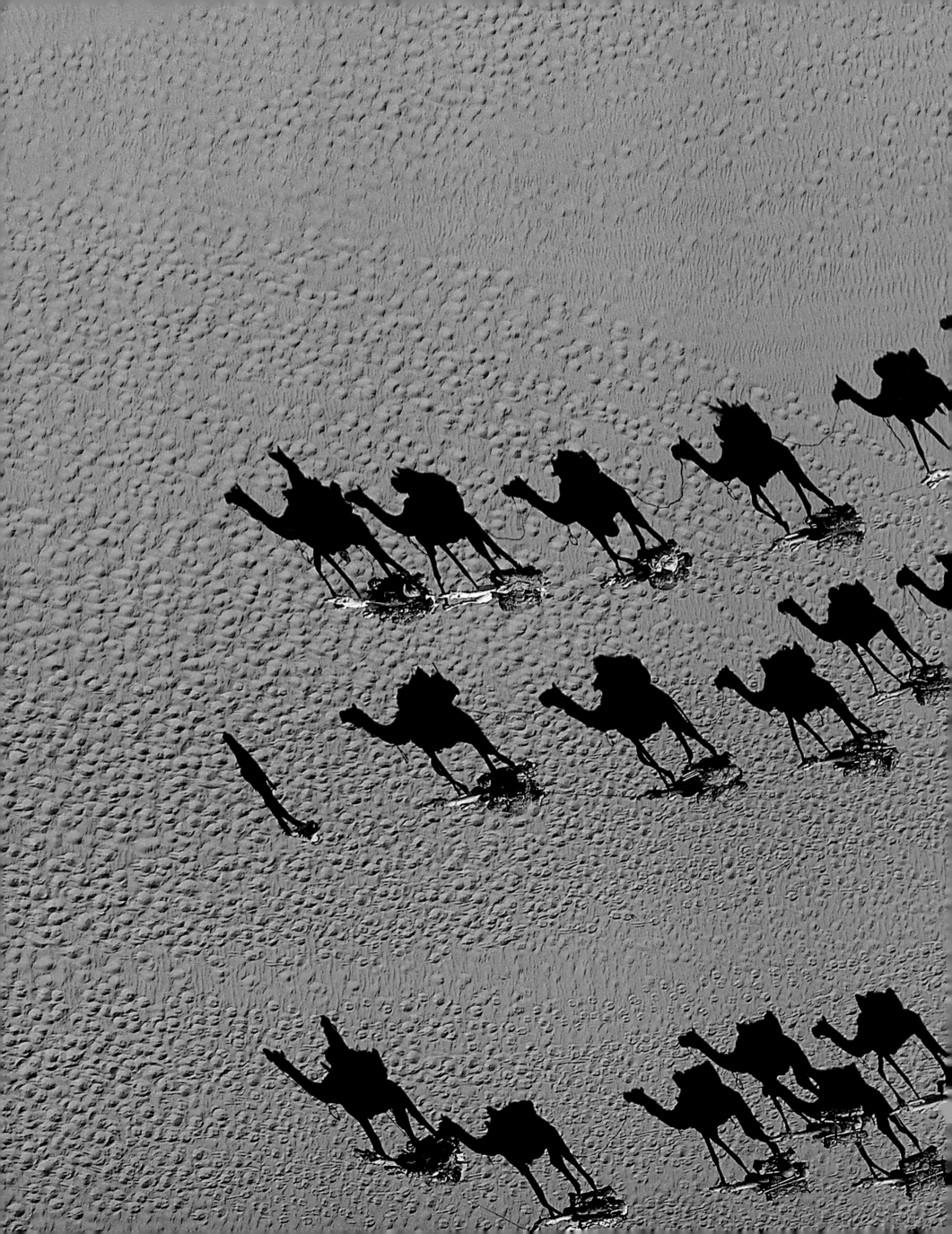

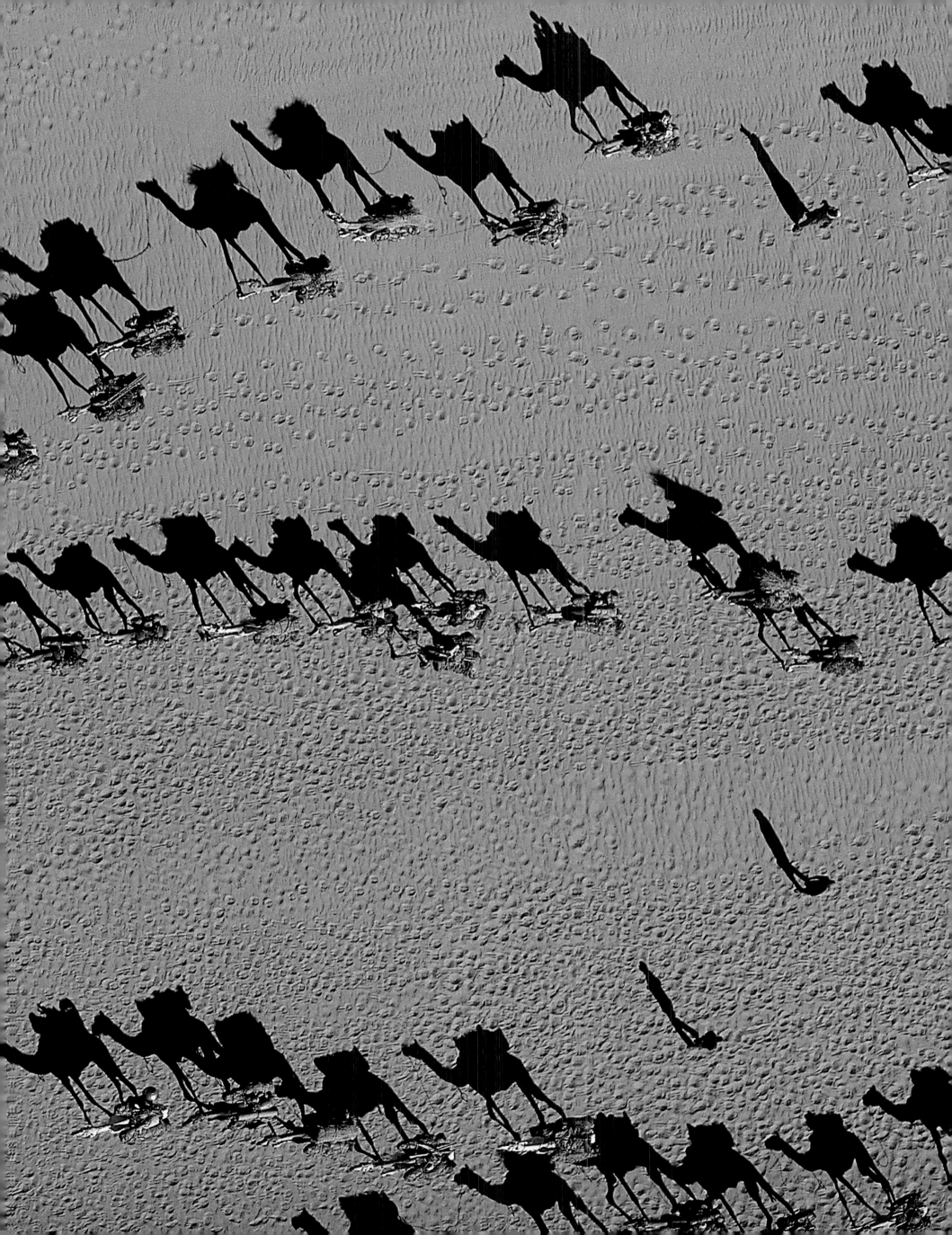

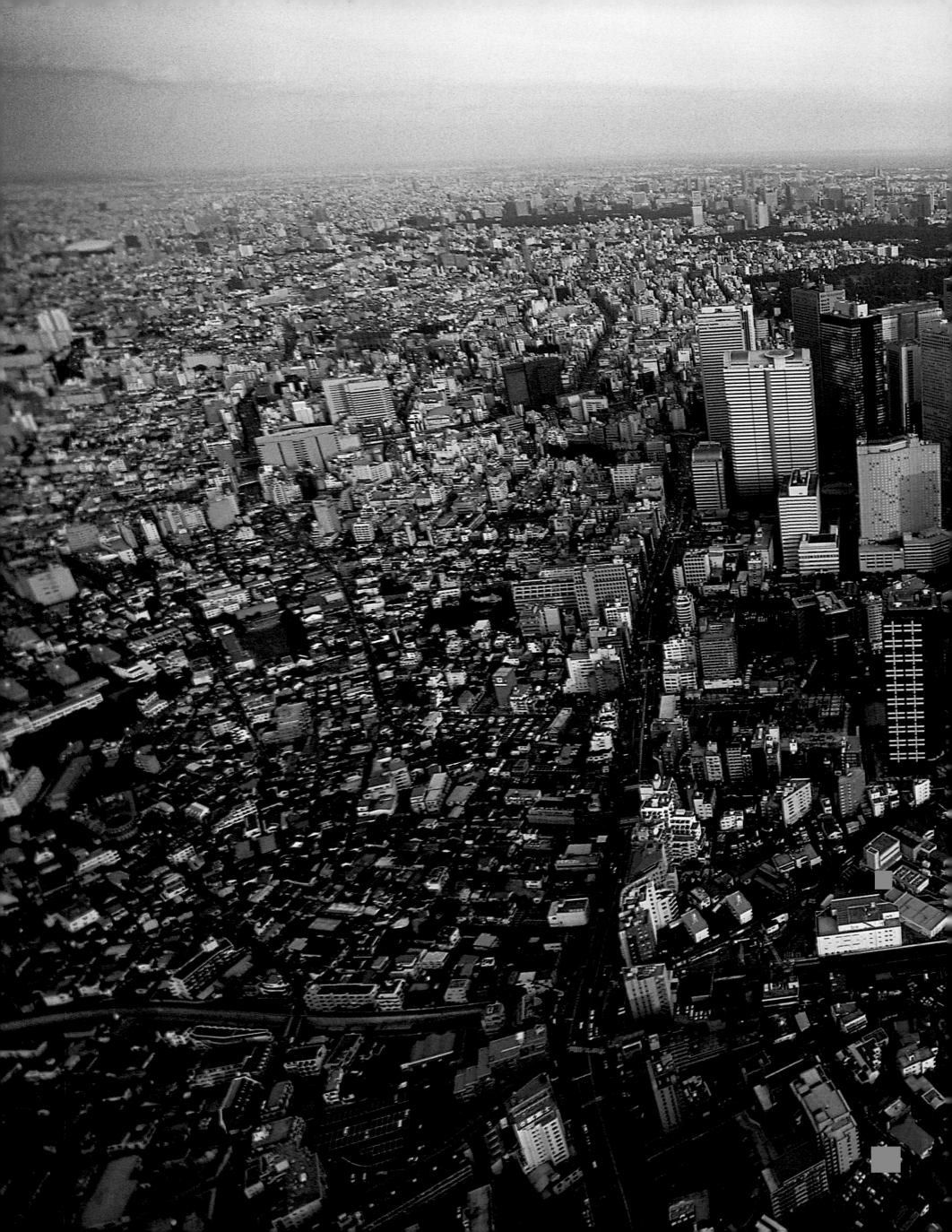

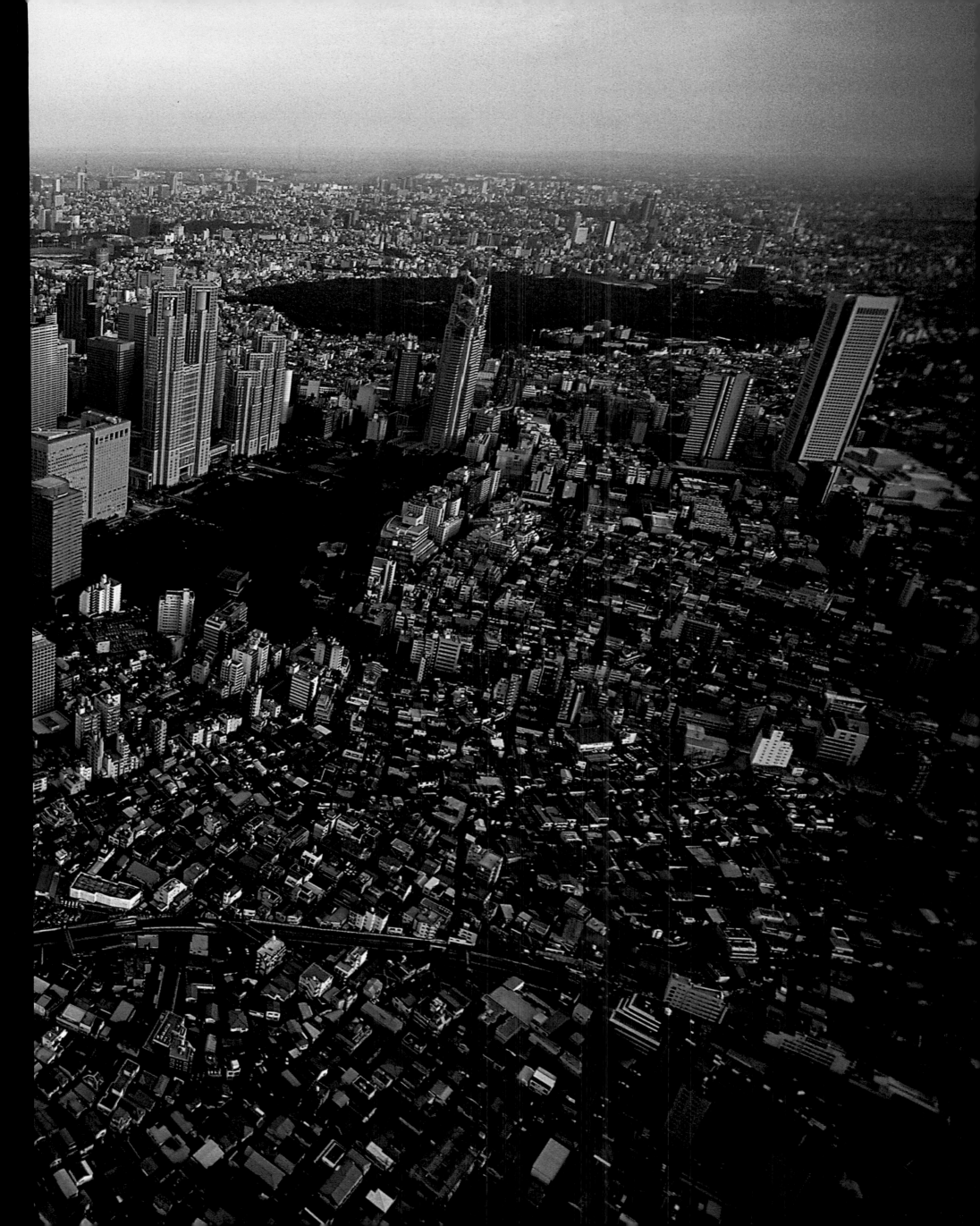

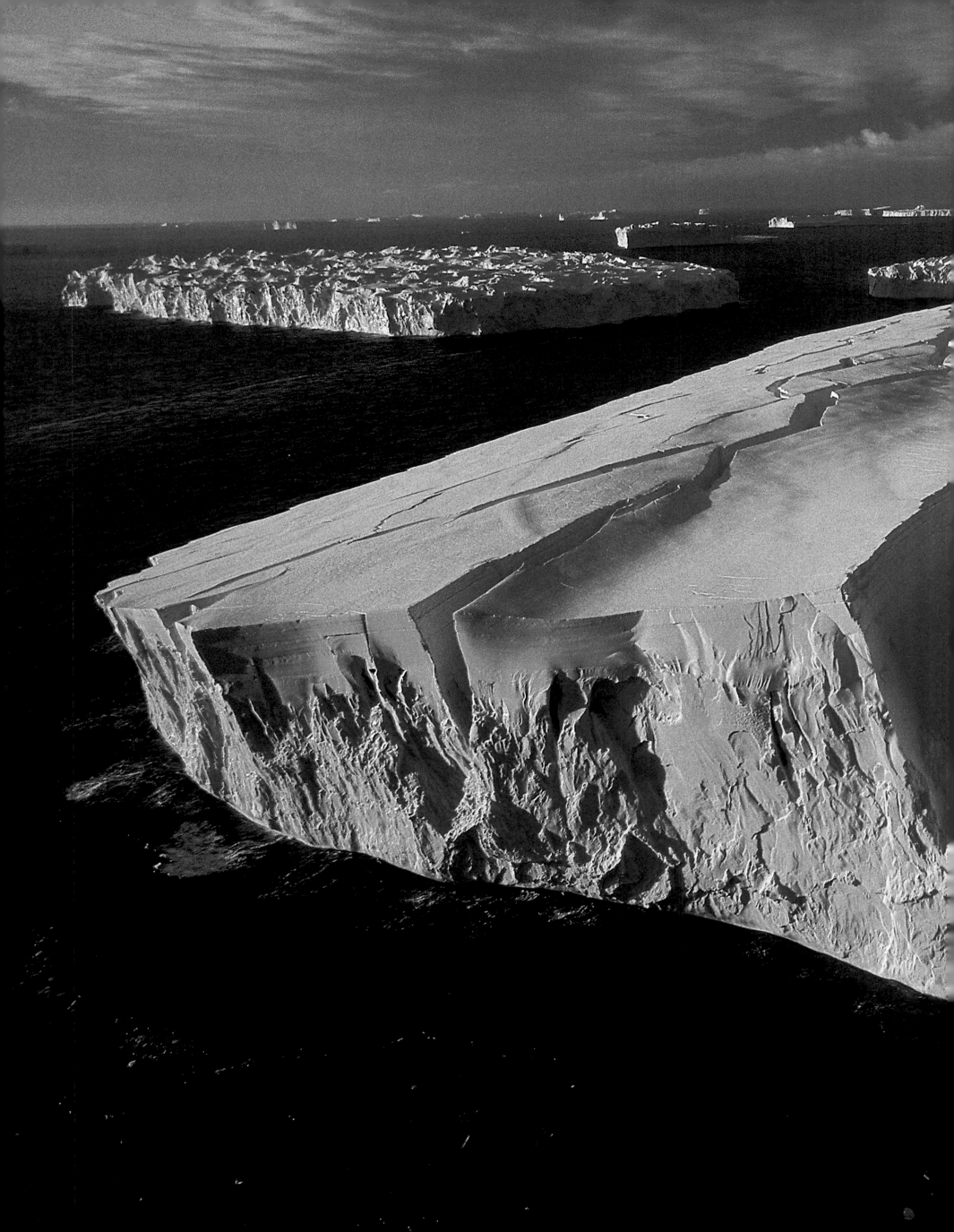

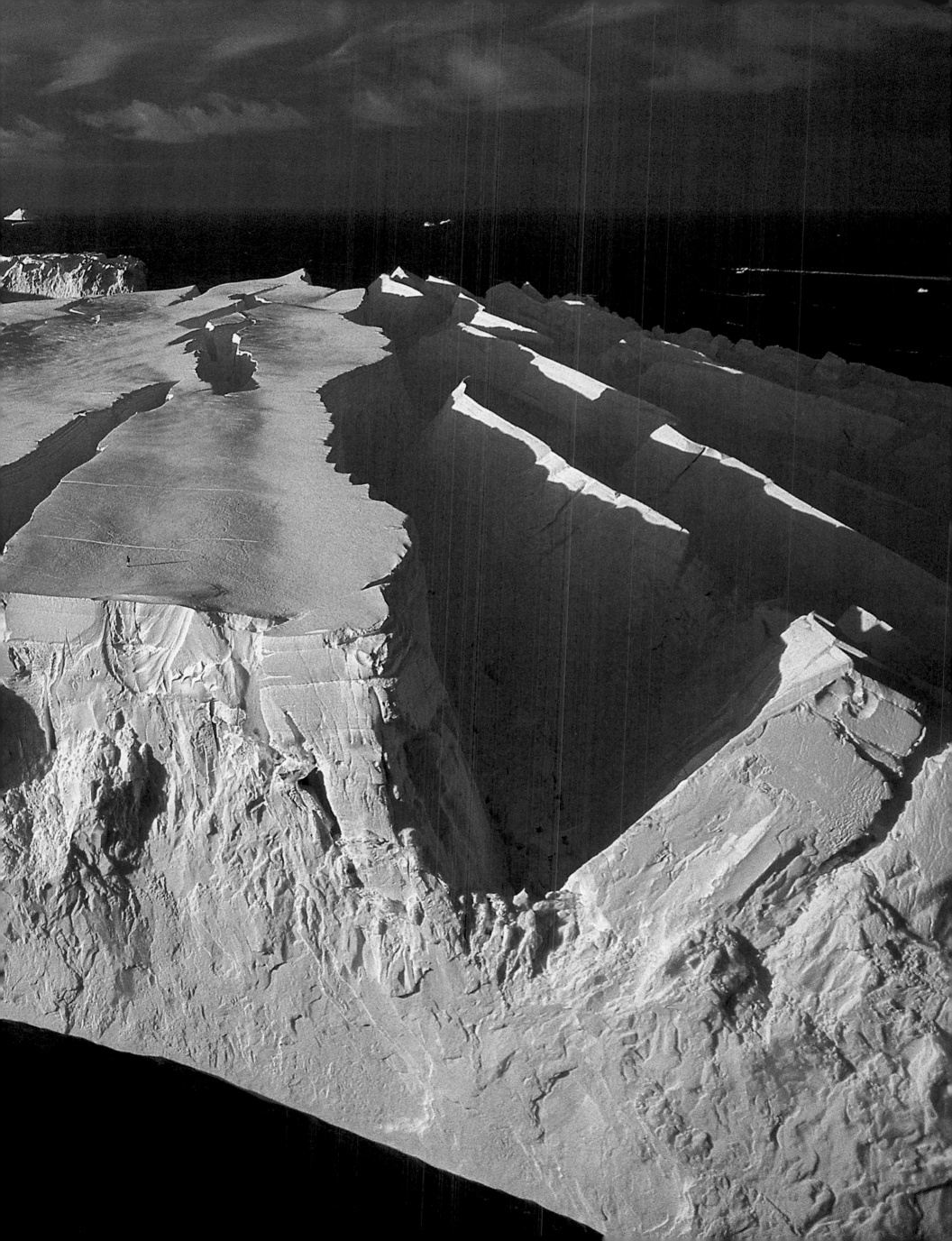

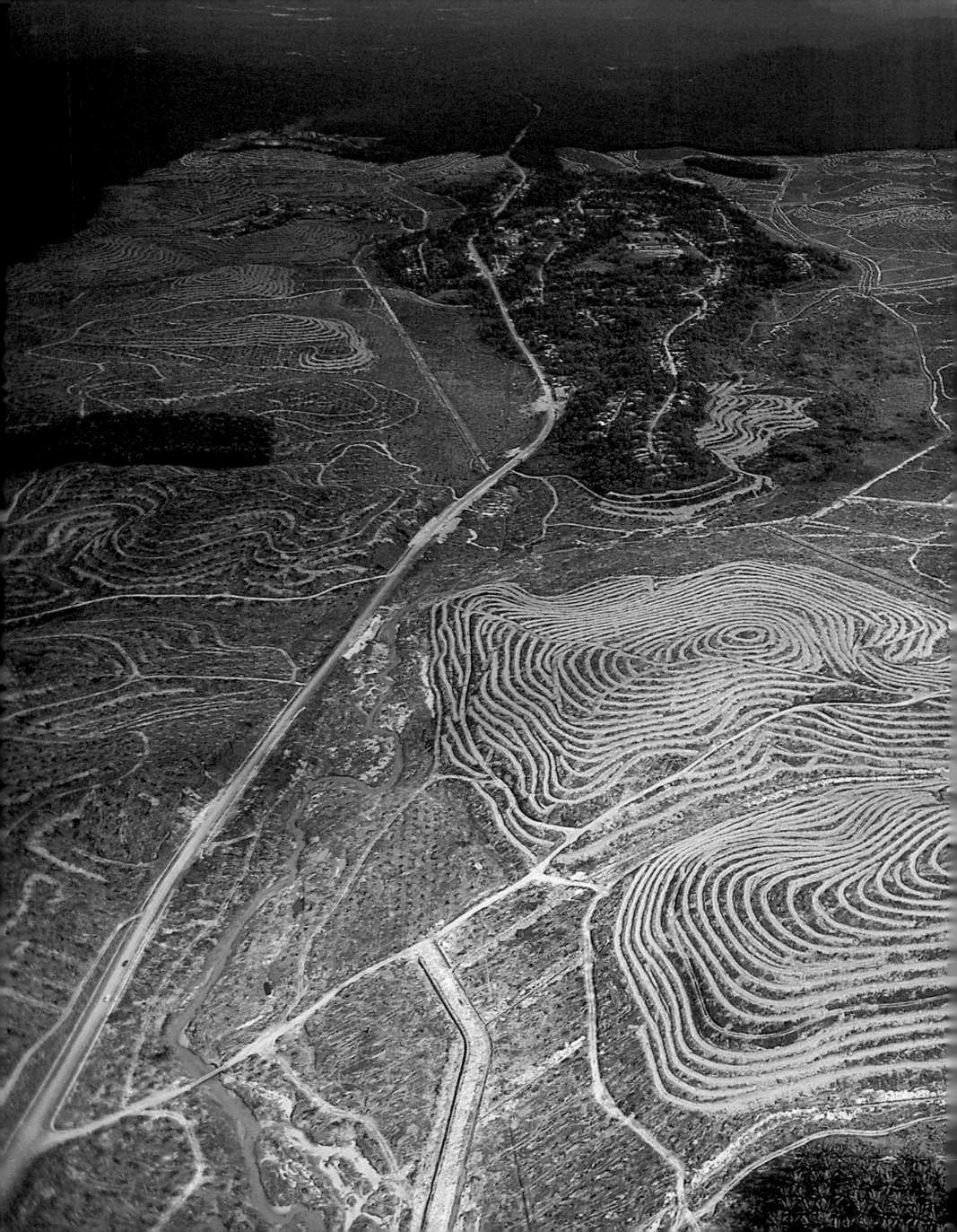

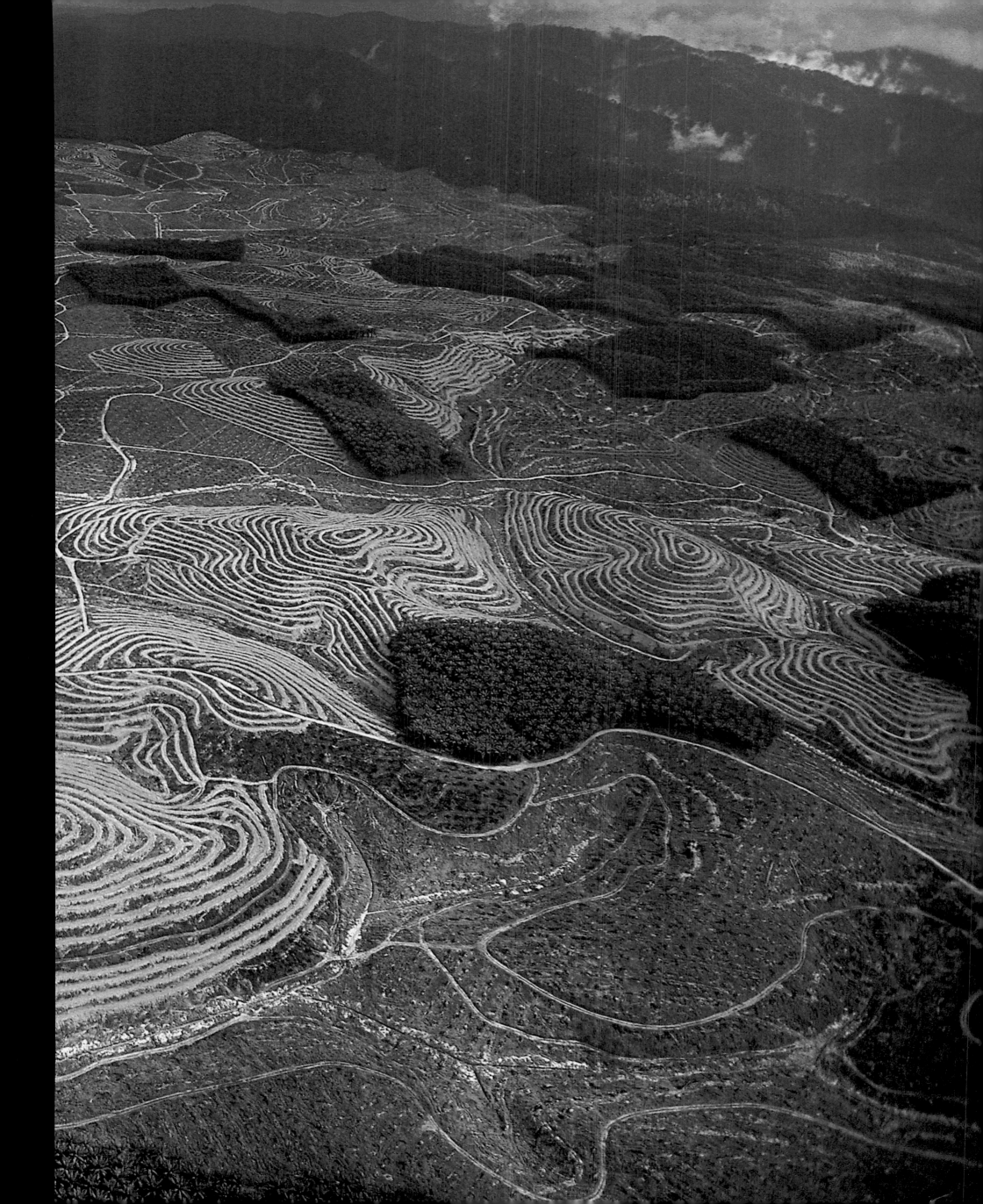

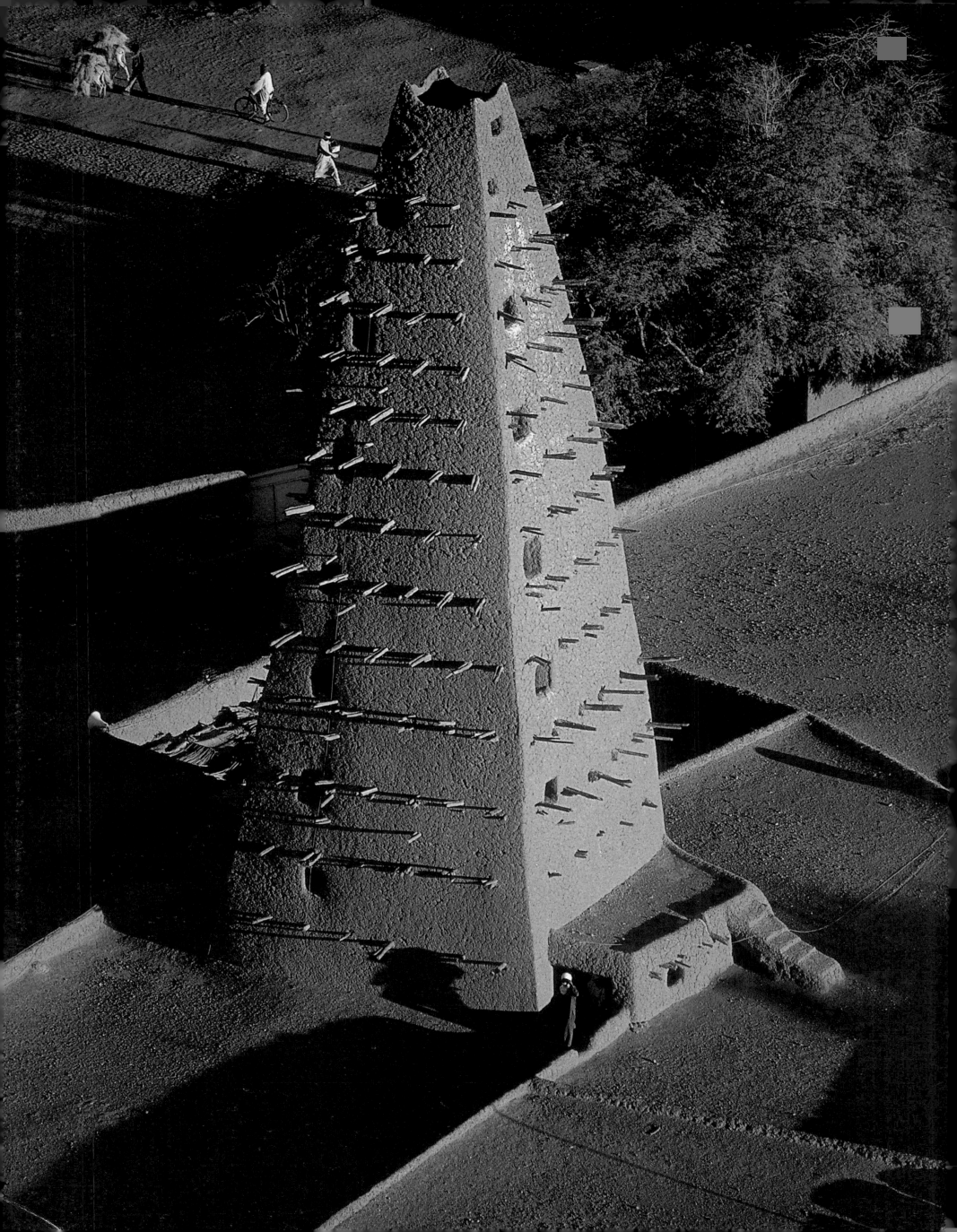

TOWARD A SUSTAINABLE DEVELOPMENT

How will we respond to the formidable challenges of our time? As the world population grows,
the need for food, energy, and goods escalates. The phenomenal wealth of developed countries
is based upon the impoverishment and pollution of the earth's environment and grave economic
and geopolitical imbalances. It is essential that we find a way to make humans more attentive
to the earth as well as to all of the earth's residents, present and future. This is the aim of
sustainable development, and it is the responsibility of every individual.

Neil Armstrong's first step on the moon in July 1969 was far less important, in the final analysis, than the view he had of the earth as a small, fragile blue sphere. A new understanding arose that the earth's resources must be managed sparingly. But the transition from awareness to the enactment of solutions will require a more minute and precise approach. This book reveals the great variety of landscapes and diversity of forms, the great jumble of human and natural activity, and the omnipresent force of human intervention that threatens the balance of the biosphere.

Concerns about the environment changed considerably between 1972, the date of the first United Nations Conference on the Human Environment at Stockholm, and 1992, the year of the Earth Summit in Rio de Janeiro. Experts at Stockholm

stated that a new "eco-development" must be conceived, and delegates from the Club of Rome think tank warned that economic growth had its limits; but those voices went unheeded. The first concern in the 1970s was to limit concentrated industrial pollution, often by means of dilution. In 1974, for instance, a European directive called for coal-burning electric power plants to be equipped with high smokestacks, to send the pollution farther away. Entire continents have been affected by the acid rain that derives from those tall smokestacks.

The next concern to arise was low-intensity sources of pollution, whose cumulative effects could be just as serious. These included high-yield agriculture, which endangers water quality and organic equilibrium; automobile traffic, which degrades air quality in cities and contributes to the greenhouse effect; and households, which produce garbage. The new trend was to *individualize* pollution. As time progressed, the preservation of the ozone layer and the prevention of climatic change grew to be crucial issues, and the environmental stakes became global. Today a major issue is pollution with long-term effects that will harm future generations, such as radioactive waste.

Thus, in twenty years, we have observed a three-part, large-scale change in scale: individualization, globalization, and long term. We have needed to profoundly reorganize our modes of operation.

With the growing concern about consumption and behavior of individuals, we cannot simply station a policeman behind

MINARET OF THE GREAT MOSQUE OF AGADEZ,
Niger
(N 16°58' E 7°59')
The Great Mosque of Agadez, at the foot of the Aïr Mountains at the center of Niger, was built in the sixteenth century when the city was at the height of its power. This dried-earth building in the "Sudanese" style is crowned with a pyramidal minaret that is 90 feet (27 m) high, bristling with thirteen rows of stakes that reinforce the fragile structure and serve as scaffolding for the periodic restoration of its surface. Agadez, known as the "gate to the desert," is the last major settlement before the Sahara and an important commercial center. It stands at the intersection of important trans-Saharan caravan routes. It is one of the holy cities of Islam, and its population is predominantly Muslim, as is 99 percent of Niger. At the dawn of the third millennium, Islam has more than 1.1 billion followers worldwide, the second-largest religion in the world.

each "polluter"; we must also alter the behavior of consumers, design goods and services to reduce their impact on the environment and on the use of resources, make use of clean technologies, prevent emerging problems, and develop systems for managing the environment. The environmental effectiveness of the economy and of society has become a priority.

Such considerations have led to proposals for a new development model called "sustainable development," which is based on three pillars: social equity, economic efficiency, and preservation of the environment and natural resources. This new type of development was first put forward by IUCN–The World Conservation Union and other environmental organizations in the early 1980s. In 1987 the World Commission on Environment and Development (WCED), chaired by Norwegian Prime Minister Gro Harlem Brundtland, presented a report stating the importance of "a form of development that meets the needs of the present without compromising the ability of future generations to meet their own needs"; the Brundtland Commission also called for an international conference to discuss possible measures. The United Nations Conference on Environment and Development (UNCED), or Earth Summit, took place in Rio de Janeiro in June 1992.

The framework adopted at the Earth Summit has proved hard to implement, however, raising problems that are at once ethical and political, methodological and operational. It is illusory to think that environmental solutions and policies could be devised in which everyone would emerge a winner. It is also hard to make difficult political decisions when scientific and philosophical uncertainty remains, as seen in issues such as climatic change and genetic engineering.

Sustainable development is about striking a balance between contradictory interests. The first opposition is between today's population and future generations. By depleting petroleum reserves or deposits of precious metals today, or accumulating pollution in the atmosphere, we are storing up a legacy of problems for future generations—this challenges the very concept of "progress." The second conflict is between rich and poor; in general, the countries of the northern hemisphere and of the southern hemisphere. The third conflict is between human beings and nature and other living creatures. The victor, in international policy and in economics, is the rule of force. For example, to stabilize the build-up of greenhouse gases in the atmosphere, we ought to be reducing current emission levels by half, from 1 ton of carbon emitted per capita to 1,100 pounds (500 kg). Latin America and China are at about this average level, and the rest of Asia and Africa stand at half that figure. The Europeans reach four times that level, and the North Americans 11 times.

The "ecological footprint" measures the human impact on the environment by calculating what we use of nature. For any defined population, it shows how much productive land and water is occupied to produce all the resources that are consumed and to take in all the waste that is made. This indicator shows that the area of consumed land is contantly growing, at a rate of 2.5 percent per year—in a space whose surface is limited. Experts in the area of sustainable development have determined that the "available space" per person is about 5 acres, or 2 hectares (a figured reached by dividing the almost 13 billion hectares of biologically productive land on the earth—only one-quarter of the planet's surface—by the global population of 6 billion). At some time in the 1970s humanity as a whole passed the point at which it lived within the global regenerative capacity of the earth. However, of course, the ecological footprints of different nations vary drastically: the average American consumes six times this "share," and a European three times, whereas half the people on earth are below this threshold.

INTERCHANGE BETWEEN THE 5 AND 110 FREEWAYS,
Los Angeles, United States
(N 34°02' W 118°16')
Los Angeles, in Southern California, is the second-largest city in the United States in population and area. Los Angeles is a shipping, industrial, communication, and financial center for the western United States and much of the Pacific Basin, and the motion-picture capital of the nation, if not the world. The Los Angeles metropolitan area encompasses 34,000 square miles (88,000 km²) and is connected by a freeway system, which is increasingly unable to accommodate the growing traffic. The tremendous number of vehicles, coupled with the geographic position of the city, creates unhealthily high levels of smog. A light-rail system and bus transporation do little to alleviate the highway congestion. One-quarter of the energy produced globally is absorbed by the transport sector. Transportation accounts for half of world petroleum consumption, which has expanded sevenfold in fifty years. This sector is responsible for nearly a fourth of carbon dioxide emissions and is thus among the chief sources of greenhouse gas emissions, which lead in turn to global warming. It is possible, however, that the petroleum era may be coming to a close, succeeded by the age of hydrogen, a clean fuel extracted from water, which can be used in engines equipped with a fuel-driven battery.

pp. 378–79
PERITO MORENO GLACIER,
Santa Cruz, Argentina
(S 50°27' W 73°10')

Created in 1937, Los Glaciares National Park is located in southern Patagonia, near the border of Chile. This protected zone, declared a UNESCO world heritage site in 1981, contains 13 glaciers that originated from the continental glacial covering of Patagonia, the largest in the world after Antarctica and Greenland. With a frontal width of 2.5 miles (4 km) and a height of 147 feet (60 m), Perito Moreno extends for 32 miles (52 km) and moves along one of the arms of Lake Argentino, dragging rock debris torn from the banks in its wake, which erodes and shapes the landscape. Every three or four years, at the confluence of the two arms of the lake, the glacier interrupts the water's flow. The growing pressure of the water against the ice barrier ends up breaking it, producing an explosion that can be heard from several miles away. Glaciers and ice caps make up 9 percent of the earth's land surface. Global warming could melt the ice, raising the level of the oceans by 3 to 35 inches (9 to 88 cm) before the end of the century and drowning the fertile shore areas.

pp. 380–81
CONFLUENCE OF THE RIO URUGUAY AND A TRIBUTARY,
Misiones, Argentina
(S 27°15' W 54°03')

Drastically cleared to make way for farming, the Argentine tropical forest is today a less effective defense against erosion than it was in the past. Heavy rains falling in the province of Misiones (79 inches, or 2,000 mm, per year) wash the soil and carry off significant quantities of ferruginous earth into the Río Uruguay, turning the waters a dark, reddish ocher. Swollen by tributaries bearing vegetal debris, the Río Uruguay (1,000 miles, or 1,612 km, long) empties into the Atlantic Ocean in the area of the Río de la Plata—forming the earth's largest estuary (125 miles, or 200 km, wide)—where the river dumps the sediment it has carried. The sediment accumulates in the access channels to the port of Buenos Aires, which must be dredged regularly to remain navigable. Deposits built up at the mouths of rivers can change landscapes by forming deltas or extending land into the sea.

pp. 382–83
SANDBANK ON THE COAST OF WHITSUNDAY ISLAND,
Queensland, Australia
(S 20°17' E 148°59')

Innumerable coral islets and continental islands are sprinkled over the narrow corridor separating the coasts of Queensland, in northeastern Australia, from the Great Barrier Reef about 20 miles (30 km) offshore. Ten thousand years ago, before sea level had risen after the last ice age, the continental islands of today were still hills bordering the continental Australian plateau. Among them, Whitsunday Island, 43 square miles (109 km²) in area, is the largest of the 74 islands that make up the archipelago of the same name, baptized by British navigator James Cook, who discovered the islands in 1770 on Whitsunday (the Sunday of Pentecost). As seen here on Whitehaven beach, the islands' shoreline is marked by the exceptional whiteness of its sand, made up of coral sediment. This site is part of Great Barrier Marine Park, which receives more than 2 million visitors each year. Tourism, tightly regulated, has only a slight impact on this sensitive site, unlike the repeated, unexplained invasions of crown-of-thorns starfish, a marine species that has damaged close to 20 percent of the reefs in the past thirty years.

pp. 384–85
HEART IN VOH,
New Caledonia, France
(S 20°57' E 164°41')

A mangrove swamp is an amphibious tree formation common to muddy tropical coastlines with fluctuating tides. It consists of various halophytes (plants that can develop in a saline environment) and a predominance of mangroves. These swamps are found on four continents, covering a total area of 65,000 square miles (170,000 km²), or nearly 25 percent of the world's coastal areas. This represents only half of the original range, because these fragile swamps have been continually reduced by the overexploitation of resources, agricultural and urban expansion, and pollution. The mangrove remains indispensable to sea fauna and the equilibrium of the shoreline. New Caledonia, a group of Pacific islands covering 7,000 square miles (18,575 km²), has 80 square miles (200 km²)

of a fairly low (25 to 33 feet, or 8 to 10 m) but very dense mangrove swamp, primarily on the west coast of the largest island, Grande Terre. At certain spots in the interior that are not reached by seawater except at high tides, vegetation gives way to bare, oversalted stretches called "tannes," such as this one near the city of Voh, where nature has carved this clearing in the form of a heart.

pp. 386–87
URANIUM MINE IN KAKADU NATIONAL PARK,
Northern Territory, Australia
(S 12°41' E 132°53')

Kakadu National Park is a rich source of uranium, making up 10 percent of the world's resources. It is divided into three plots in aboriginal territory, Ranger, Jabiluka, and Koongarra, which are enclosed in the protected park (a UNESCO world heritage site since 1981) but are statutorily excluded. The plan to open a mine on Jabiluka has caused controversy concerning the pollution risks, and the Mirrar aborigenes, traditional proprietors of these sacred lands, are stringently opposed, mobilizing international public opinion. Only Ranger is authorized for mining. In this waste zone, large sprinklers water the marsh banks to increase evaporation and reduce the risk of dust build-up, leaving sulfate deposits. Australia also has two other large deposits of uranium, and in 2000 the country produced more than 20 percent of the uranium extracted in the world (34,400 tons). Uranium provices fuel for the world's nuclear sites, divided primarily between the United States, France, and Japan.

pp. 388–89
COTTON FABRICS DRYING IN THE SUN IN JAIPUR,
Rajasthan. India
(N 26°55' W 75°49')

The state of Rajasthan in northeastern India is an important center of textile production, renowned for centuries for the crafts of dyeing and printing on cotton and silk fabrics. This activity is primarily practiced by the Chhipa, a community of dyers and painters who use ancestral techniques, decorating with wax and printing by stamping. Silkscreen printing, however, is increasingly used for larger-scale production, and chemical coloring is gradually replacing natural pigments. Craftsmen continue the multiple soakings to fix colors and dry their fabrics in the sun, as seen here in Jaipur, the state capital. The cottons and silks of Rajasthan have been exported since the Middle Ages to China, the Middle East, and Europe, and the international trade continues to flourish. Chhipa women perform this work: 32 percent of India's workforce is female, and this percentage is increasing. Recent decades have brought improved awareness of the rights of women throughout the world, but many countries are marked still by blatant inequalities between the sexes.

pp. 390–91
TOURIST IN A SWIMMING POOL IN PAMUKKALE,
Anatolia, Turkey
(N 37°58' E 29°19')

The city of Pamukkale in western Anatolia has warm-water springs that are rich in mineral salts, celebrated since antiquity for their curative properties. In 129 B.C. the Romans here established the city of Hierapolis. It suffered four earthquakes and was rebuilt several times, before it declined under the Byzantine Empire. Today the archaeological site of Hierapolis attracts many visitors. A hotel was built on the ruins of an ancient holy fountain; its pool, the bottom of which is littered with fragments of Roman columns, is a favorite with tourists. Hierapolis-Pamukkale was declared a world heritage site by UNESCO in 1988. Its landscape was distorted for a long time by the presence of numerous tourist facilities. The demolition of a number of hotels, planned since 1992, was carried out in late 2001.

Captions to the photographs on pages 392 to 407 can be found on the foldout to the right of the following chapter

captions 378–91 captions 392–407

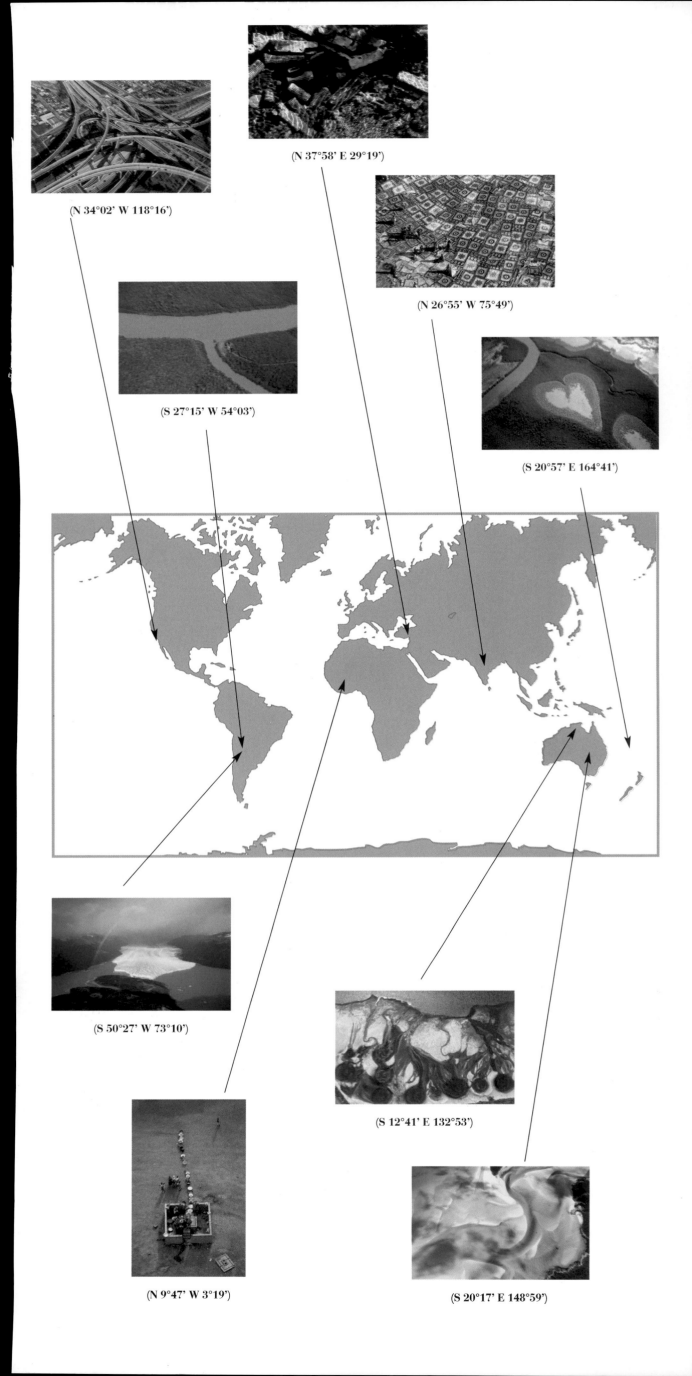

(N 34°02' W 118°16')

(N 37°58' E 29°19')

(N 26°55' W 75°49')

(S 27°15' W 54°03')

(S 20°57' E 164°41')

(S 50°27' W 73°10')

(S 12°41' E 132°53')

(N 9°47' W 3°19')

(S 20°17' E 148°59')

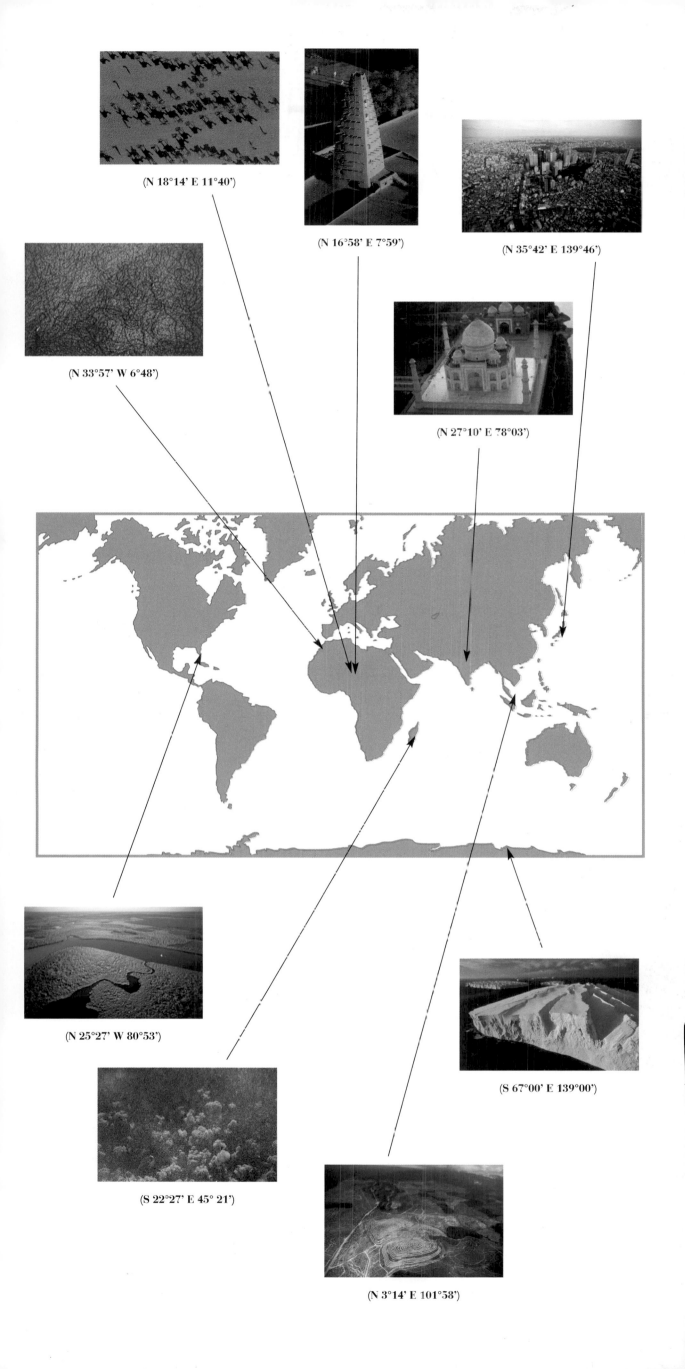

(N 18°14' E 11°40')

(N 16°58' E 7°59')

(N 35°42' E 139°46')

(N 33°57' W 6°48')

(N 27°10' E 78°03')

(N 25°27' W 80°53')

(S 67°00' E 139°00')

(S 22°27' E 45° 21')

(N 3°14' E 101°58')

**pp. 352–53
COWS IN A
SWAMPY RIVER,
Rabat, Morocco
(N 33°57' W 6°48')**

The region around the capital city, Rabat, like the whole northern area of Morocco's Atlantic coast, enjoys relatively abundant precipitation (as much as 300 inches, or 800 mm, per year). In this part of the country the November and March rains feed the rivers and cause major flooding. However, from May onward a warm, dry, southeast wind, the *chergui*, gradually dries out the riverbeds. The beds become swampy and are covered with a short-lived carpet of grasses and flowers, which attract a few cows that have drifted away from neighboring herds searching for food. Morocco's bovine livestock, made up largely of local breeds raised for both their milk and their meat, number more than 2.6 million. Far more numerous are the populations of goat (5.1 million) and sheep (17.3 million).

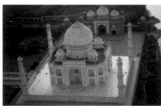

**pp. 354–55
TAJ MAHAL,
in Agra, Uttar
Pradesh, India
(N 27°10' E 78°03')**

The Taj Mahal was built between 1632 and 1653 on the orders of Mughal emperor Shah Jahan, as a memorial to his wife, Mumtaz Mahal. The total height of the tomb is 243 feet (74 m), and it overlooks the Yamuna River in Agra, in northern India. This white marble mausoleum, adorned with fine carvings and semiprecious stones, was created by 30 architects and 20,000 workers. The building was declared a UNESCO world heritage site in 1983. In 1993, 212 factories in Agra were shut down in order to preserve the structure's whiteness. India has 100 million Muslim inhabitants, making it the second-largest Muslim nation in the world after Indonesia. The country's majority religion is Hinduism, which is practiced by 80 percent of the population. The approximately 800 million Hindi in India represent nearly all of the world's devotees of this religion, which is the third-largest on earth.

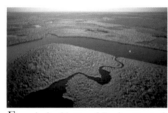

**pp. 356–57
MANGROVES IN
EVERGLADES
NATIONAL PARK,
Florida, United States
(N 25°27' W 80°53')**

Everglades National Park, situated at the extreme southern tip of Florida, stands at the point of convergence of the freshwater from Lake Okeechobee and the saltwater from the Gulf of Mexico. The Everglades are primarily made up of swamplands filled with mangroves, reduced by half in size by drainage and diking begun in 1880 to create greater urban and agricultural spaces. Since 1947 the 2,300 square miles (6,000 km²) of Everglades National Park have protected one-fifth of the original wet zone. Numerous and diverse fauna takes refuge there, particularly 40 species of mammals, including the endangered manatee, and 347 species of birds. The Everglades has been a Biosphere Reserve since 1976, a UNESCO world heritage site since 1979, and a wet zone of international importance since 1987. This fragile ecosystem, indispensable to the local economy, has deteriorated from the effects of agricultural pollution, hydraulic works, and several hurricanes, including Andrew in 1992. Since 1993 a major program has aimed to restore the quality and the natural cycle of its waters and to contain development of the neighboring urban zone of Miami (which has 6 million residents).

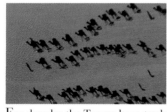

**pp. 358–59
DROMEDARY
CARAVANS NEAR FACHI,
Ténéré Desert, Niger
(N 18°14' E 11°40')**

For decades the Tuareg have traded salt by driving dromedary caravans over the 485 miles (785 km) between the city of Agadez and the Bilma salt marshes. The dromedaries, connected in single file, travel in convoys at a rate of 25 miles (40 km) per day, despite temperatures reaching 104° F (46° C) in the shade and loads of nearly 220 pounds (100 kg) per animal. Fachi, the only major town on the Azalaï (salt caravan) route, is an indispensable stop. Caravans, at one time made up of as many as 20,000 dromedaries, generally are limited today to 100 animals; they are gradually being replaced by trucks, each of which can carry as much merchandise as 250 dromedaries. The number of motor vehicles on the planet has risen from 40 million in 1945 to 680 million today. Although the number remains low in developing countries, this is where automobile use is growing the fastest. If the entire world had the same vehicular use as the United States, the total number of vehicles in earth would be 3 billion.

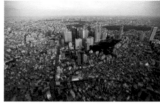

**pp. 360–61
SHINJUKU DISTRICT
OF TOKYO,
Japan
(N 35°42' E 139°46')**

In 1868 Edo, originally a fishing village built in the middle of a swamp, became Tokyo, the capital of the East. The city was devastated by an earthquake in 1923 and by bombing in 1945, both times to be reborn from the ashes. Extending over 43 miles (70 km) and holding a population of 28 million, the megalopolis of Tokyo (including surrounding areas such as Yokohama, Kawasaki, and Chiba) is today the largest metropolitan region in the world. It was not built according to an inclusive urban design and thus contains several centers, from which radiate different districts. Shinjuku, the business district, is predominantly made up of an impressive group of administrative buildings, including the city hall, a 798-foot-high (243 m) structure that was modeled after the cathedral of Notre Dame in Paris. In 1800 only London had more than 1 million inhabitants; today 326 urban areas have reached that number, including 180 in developing countries and 16 megalopolises that have more than 10 million. Urbanization has led to a tripling of the population living in cities since 1950.

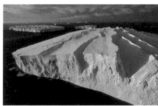

**pp. 362–63
ICEBERGS OFF THE
ADELIE COAST,
Antarctica (South Pole)
(S 67°00' E 139°00')**

These drifting icebergs recently detached from the glacial platforms of Antarctica, as can be seen from their flat shape and the ice strata that are still visible on their jagged sides. Like all 480 cubic miles (2,000 km³) of ice that detach every year from Antarctica, these icebergs will slowly be eroded by the winds and waves before disappearing. Antarctica is a place of extremes: temperatures reach as low as –94° F (–70° C), and winds reach speeds of 200 miles (300 km) an hour. The continent has an area of 5,500 square miles (14 million km²) and contains 90 percent of the ice and 70 percent of the freshwater reserves of the planet. Antarctica has been governed since 1959 by the Washington Treaty, which gives it international status and restricts its uses to scientific activities. The Russian station at Vostok has extracted, from a depth of 11,800 feet (3,623 m), chunks of ice that have made possible the reconstruction of more than 420,000 years of history of the climate and atmospheric composition. The atmosphere's current content of carbon dioxide—the main gas responsible for global warming—is higher than it has been for 160,000 years.

**pp. 364–65
PALM TREE
PLANTATION,
near Kuala Lumpur,
Malaysia
(N 3°14' E 101°58')**

Originally from West Africa, oil-producing palm trees were introduced to Malaysia in the 1970s in order to diversify the local agriculture, which relied almost exclusively on the hevea rubber tree crop. In thirty years the palm trees replaced the country's equatorial forest over an area of more than 10,500 square miles (27,000 km²), or 8 percent of the country, cultivated in terraces along the contours of hills to avoid erosion caused by streaming water. Malaysia provides half of the palm oil consumed in the world, making it the largest producer and exporter. Revenue from palm oil exports has doubled in ten years, exceeding $3.5 billion in 1999—short-term economic interests thus prevail over ecological concerns linked to the disappearance of the forest cover. Global production of palm oil has quadrupled in twenty years, and this oil has become the second most commonly used vegetable fat, after soybean oil. Used mainly for food, it is also found in soaps, cosmetics, and pharmaceuticals.

**pp. 366–67
LOCUT INFESTATION
OUTSIDE RANOHIRA,
near Fianarantsoa,
Madagascar
(S 22°27' E 45°21')**

Madagascar's cereal crops and pastures have been chronically destroyed for centuries by invasions of migratory locusts (*Locusta migratoria*) or red locusts (*Nomadacris septemfasciata*). Several miles in length and numbering as many as 50 billion insects, the hordes move at a rate of 25 miles (40 km) per day, laying waste to all vegetation in their path. To eradicate this scourge, authorities have resorted to massive spreading of insecticides by airplane or helicopter. However, toxicity to humans and the environment, as well as the development of resistance in harmful insects, have shown the limits of this procedure. A recently discovered natural pesticide made from mushrooms might provide an organic method of eliminating these swarms of locusts.

The United Nations Committee on Sustainable Development now seeks to reduce the polluting emissions and energy consumption in developed nations in the next twenty years by 75 percent, and by 90 percent within fifty years. This goal can be achieved only through the evolution of new technologies and superior social organization; it will require a multiplication of economic growth and consumption of non-renewable resources. Intermediate solutions, however, do exist. The International Energy Agency (IEA) estimates, for instance, that low-consumption compact fluorescent lightbulbs could reduce the carbon dioxide emissions of industrialized countries by more than 4 percent and are economically feasible.

Complex problems demand complex solutions, requiring cooperation and an understanding of how issues are interrelated. Urban sprawl, for instance, increases automobile traffic and atmospheric pollution and contributes to the greenhouse effect. The priority given to the automobile and the congestion that results from it lead to the building of highways that only worsen this urban expansion. To break this vicious cycle, to build the city of tomorrow more compactly, organized around public transportation, requires an urban plan that is shared by all public and private participants and is based on a coherent combination of planning activities, spatial organization, infrastructures, and fiscal considerations.

It is now ten years after the Earth Summit, and there is a call for the creation of a World Environmental Organization. Today the only way that people can voice their opinions on issues of global importance is through protests at the WTO (World Trade Organization) and G-8 meetings. How can we establish the environmental and social regulations that are demanded by the WTO? These global environmental policies must be equitable and must include sufficient aid for developing nations. Countries of the southern hemisphere fear they will be subjected to constraints to which the countries of the northern hemisphere are not themselves subjected. At the present time, for example, the United States will not commit to reducing its greenhouse gas emissions. Yet the environment is the basis for development in southern countries, and it must be protected. Water crises and desertification are huge problems that climatic change will no doubt aggravate. These problems rarely receive international attention; water, for instance, is not the subject of any international convention.

The industrial nations' promise, reiterated at Rio, to devote 0.7 percent of their gross national product to development aid has not been kept. In 1992 the figure was 0.35 percent, and it has since dropped to nearly 0.2 percent. The problem is not only quantitative. Southern hemisphere countries must also be given access to education and technology and be permitted to develop their own solutions.

Action by corporations, in particular multinational ones,

plays a role in the sustainability of development. For this reason, United Nations Secretary-General Kofi Annan proposed the Global Compact initiative in an address to the World Economic Forum (Davos) on January 31, 1999. He asked world business leaders to commit themselves to nine environmental, labor, and human rights principles. The Global Compact involves governments, companies, labor, and civil society organizations, and it is voluntary; it is not a substitute for governmental action. However, the Global Reporting Initiative (GRI) provides accountability that will ensure that commitments are, in fact, matched by actual performance. GRI, launched in the fall of 1997, provides a standardized report on the sustainable development practiced by corporations.

These necessary initiatives will remain ineffectual if consumers and investors do not support ecologically sound products and corporations. Sustainable development can offer economic and industrial opportunities. "Eco-industries"—industries relating to the environment, water treatment, waste treatment—form a new business sector. Many industries, however, focus on downstream treatment of pollution rather than true prevention and the creation of ecological products and services. Each service must be designed to reduce pollution and the use of resources throughout the entire cycle of a product's lifetime, from raw materials to the treatment and conversion of wastes.

The new economy will be one of service or rental. For example, manufacturers of photocopiers would sell photocopies, not the copiers themselves; the machines, made available to companies, would remain the property of the manufacturer. Thus, it would be in the manufacturer's self-interest to design reliable and economical models, which is not always the case when these models are made for sale, and to manage the life cycle of the machines in the most effective possible way from an environmental perspective. This approach diverts investment toward the user, employment toward upkeep and maintenance. Some production, such as agriculture, tourism, and goods based on local resources, presents obvious reasons to preserve the environment.

The true key resides in each of us. We must restore coherence among our diverse aspirations—ecological, social, and economic. People must renew their bonds with nature. Citizens must be sensitized and informed and take part in the decisions that concern them. This process of collective mobilization is integrated into what we call "governance": a process in which the political decision makers, the economic sector, and civil society all cooperate. Consumers must have ecologically responsible products to make good use of their purchasing power. Investors must have access to the information about corporations' behavior in matters of sustainable development.

But we must wonder whether the lack of coherence is

derived from the structure of our brain, composed of a left hemisphere, the seat of logic and abstraction, and of a right hemisphere, for concrete thought and images. Humanity's success may be based on the supremacy of the left hemisphere, but this success has its limits when abstraction and ideologies develop to the detriment of the perception of concrete problems. It is to be hoped that the power of the images in this book, addressed to our right hemisphere, will restore the equilibrium that is essential to the survival of humanity. The twenty-first century will then be witness to an eco-citizenship that can finally pacify the violence done to humanity and to nature.

Christian Brodhag

HYDRAULIC DRILLING STATION IN A VILLAGE NEAR DOROPO, Côte d'Ivoire
(N 9°47' W 3°19')

Throughout Africa the task of collecting water is assigned to women, as seen here near the regions of Doropo and Bouna, in northern Côte d'Ivoire. Hydraulic drilling stations, equipped with pumps that are usually manual, are gradually replacing the traditional village wells, and containers of plastic, enameled metal, or aluminum are supplanting *canaris* (large terracotta jugs) and gourds for transporting the precious resource. The water of these pits is more sanitary than that of traditional wells, 70 percent of which is unfit for drinking. Today 20 percent of the world population is without drinkable water. In Africa this is true for two out of five people, but more than half of the population in rural areas have no access to clean water. Illnesses from unhealthy water are the major cause of infant mortality in developing nations: diarrhea kills 2.2 million children below the age of five. In Africa and Asia improved access to clean drinking water will be one of the major challenges of the coming decades, as their populations grow.

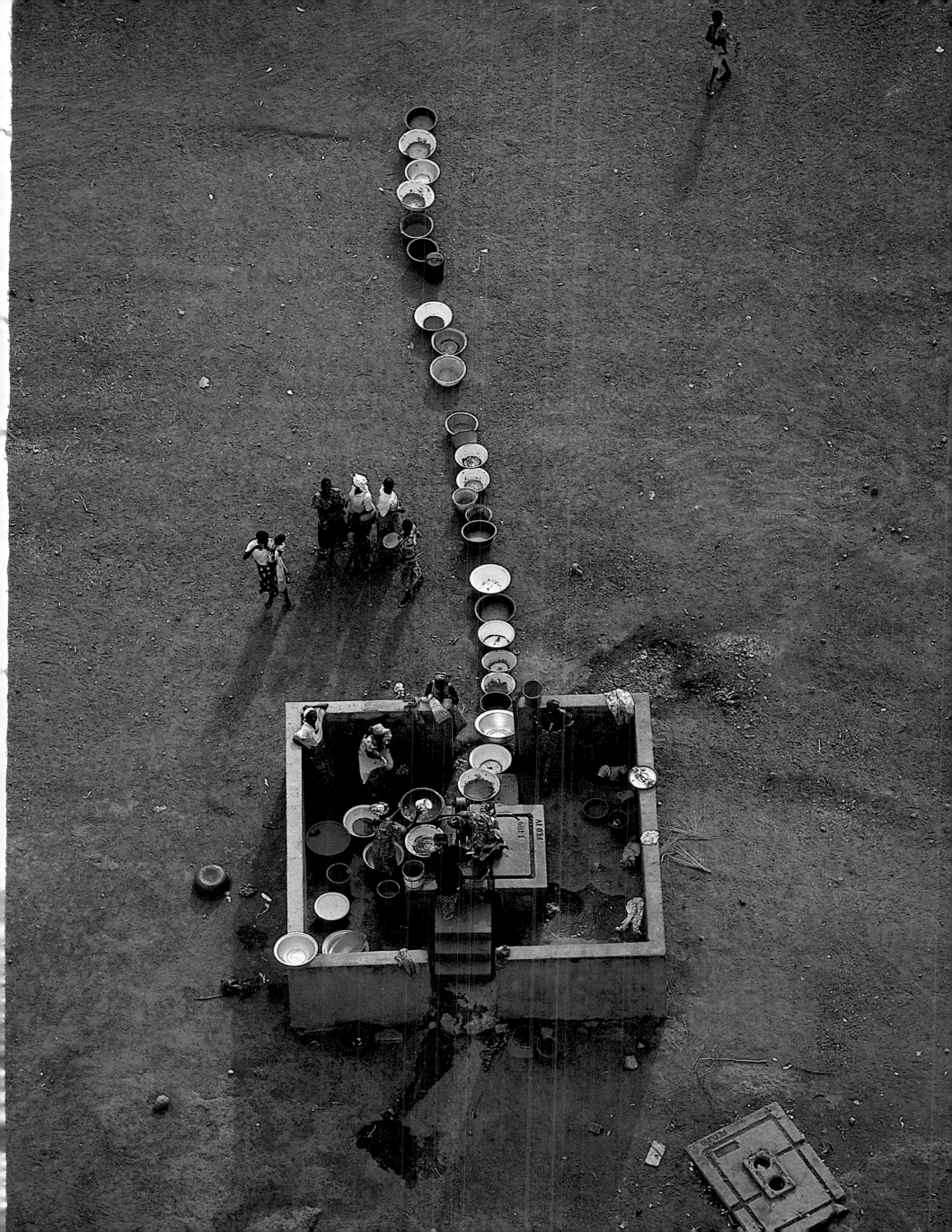

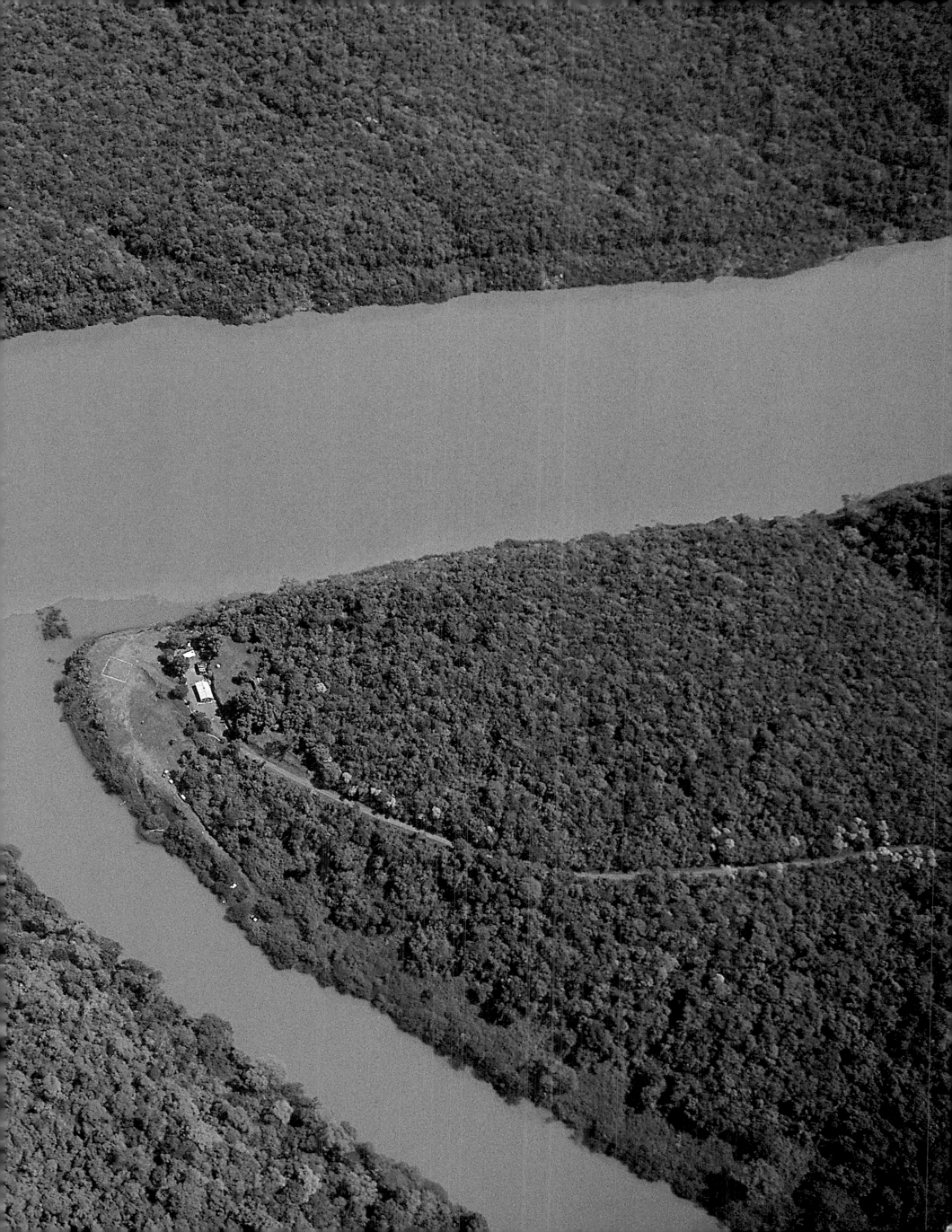

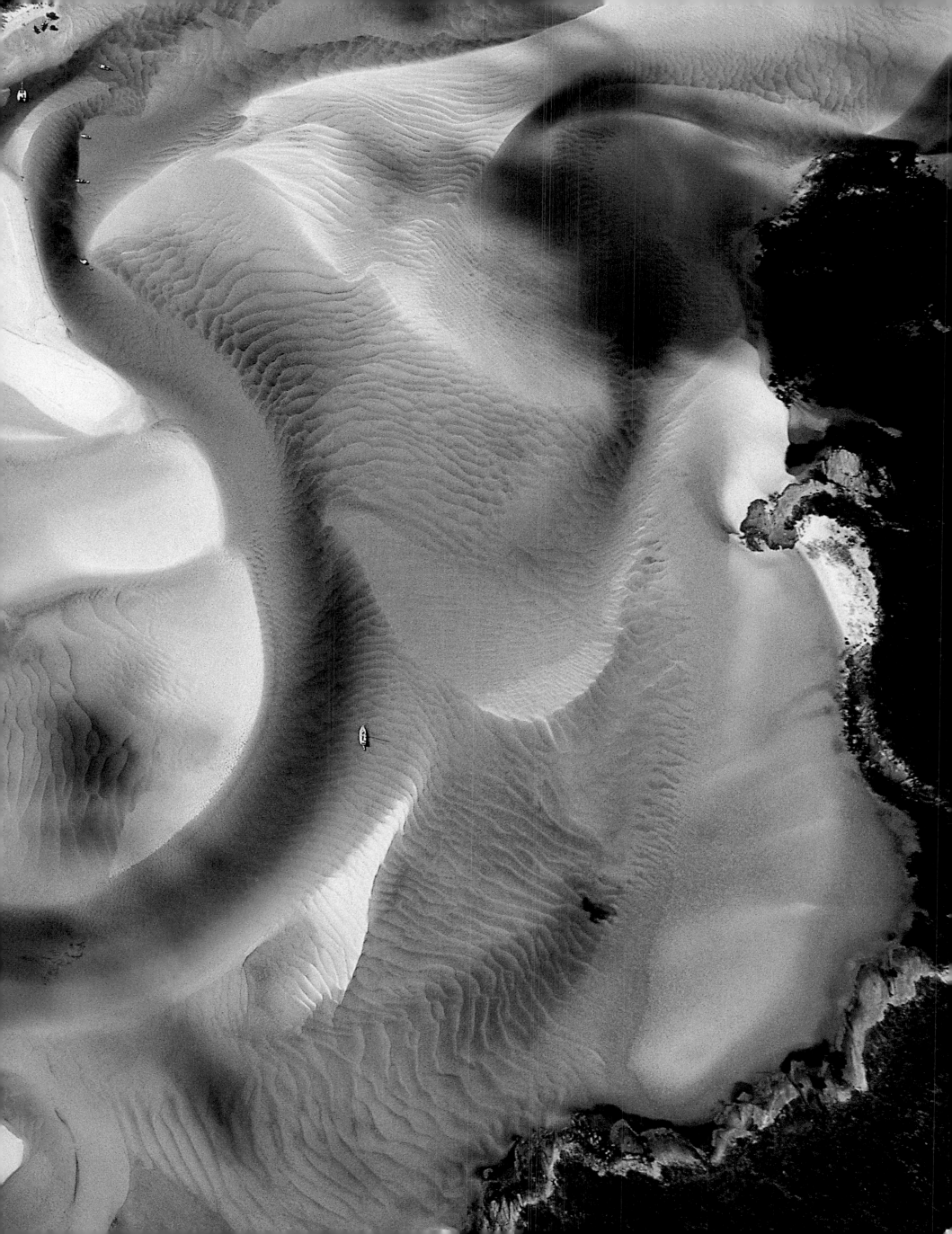

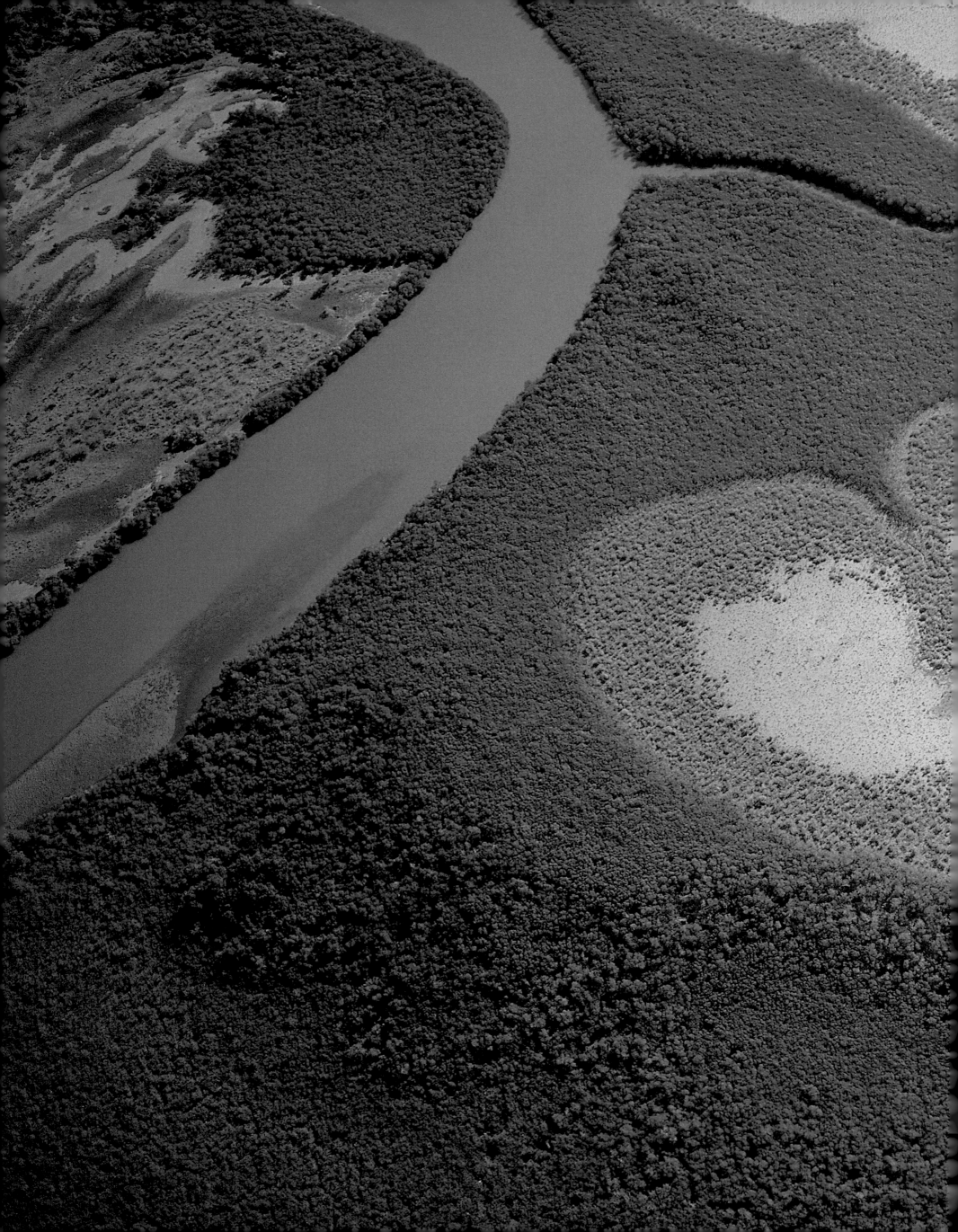

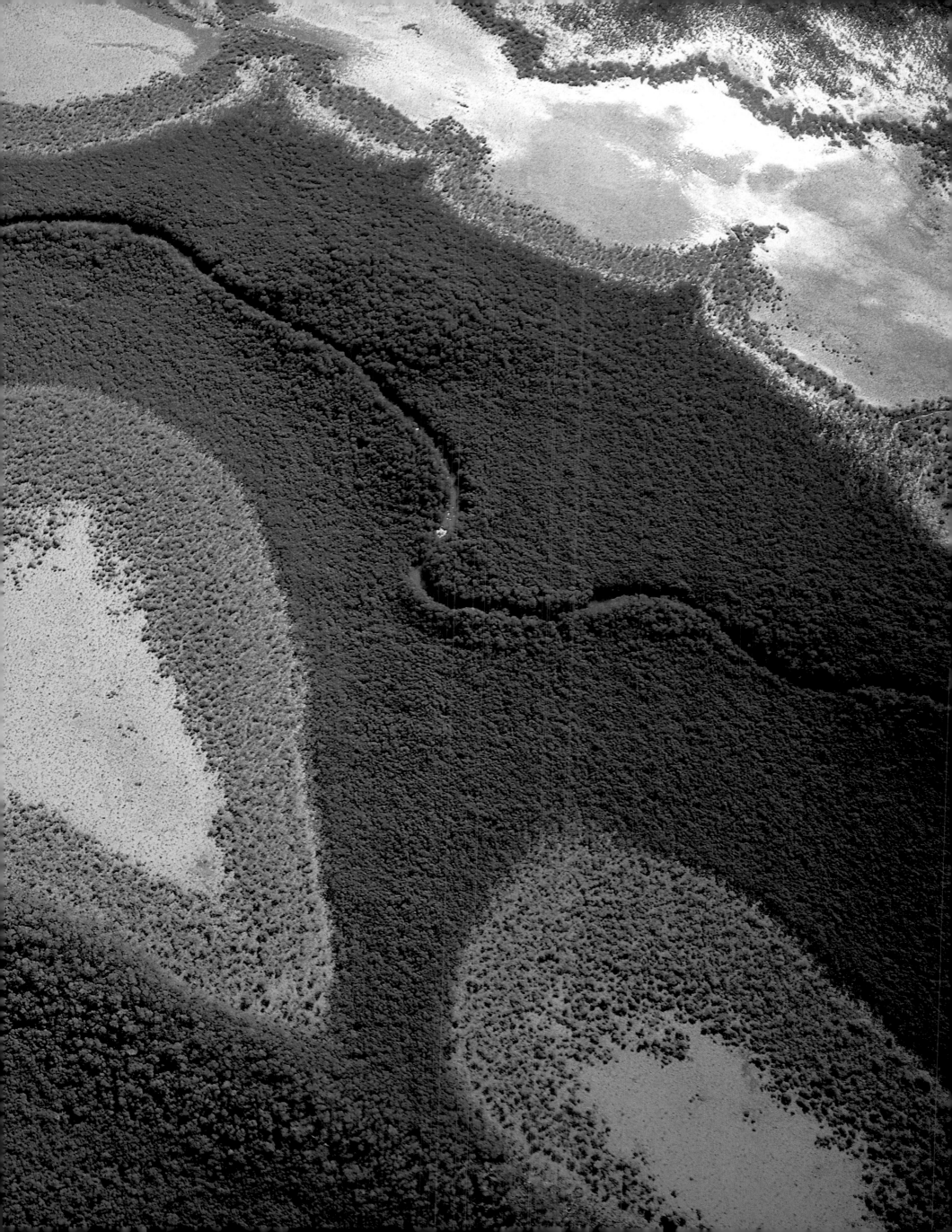

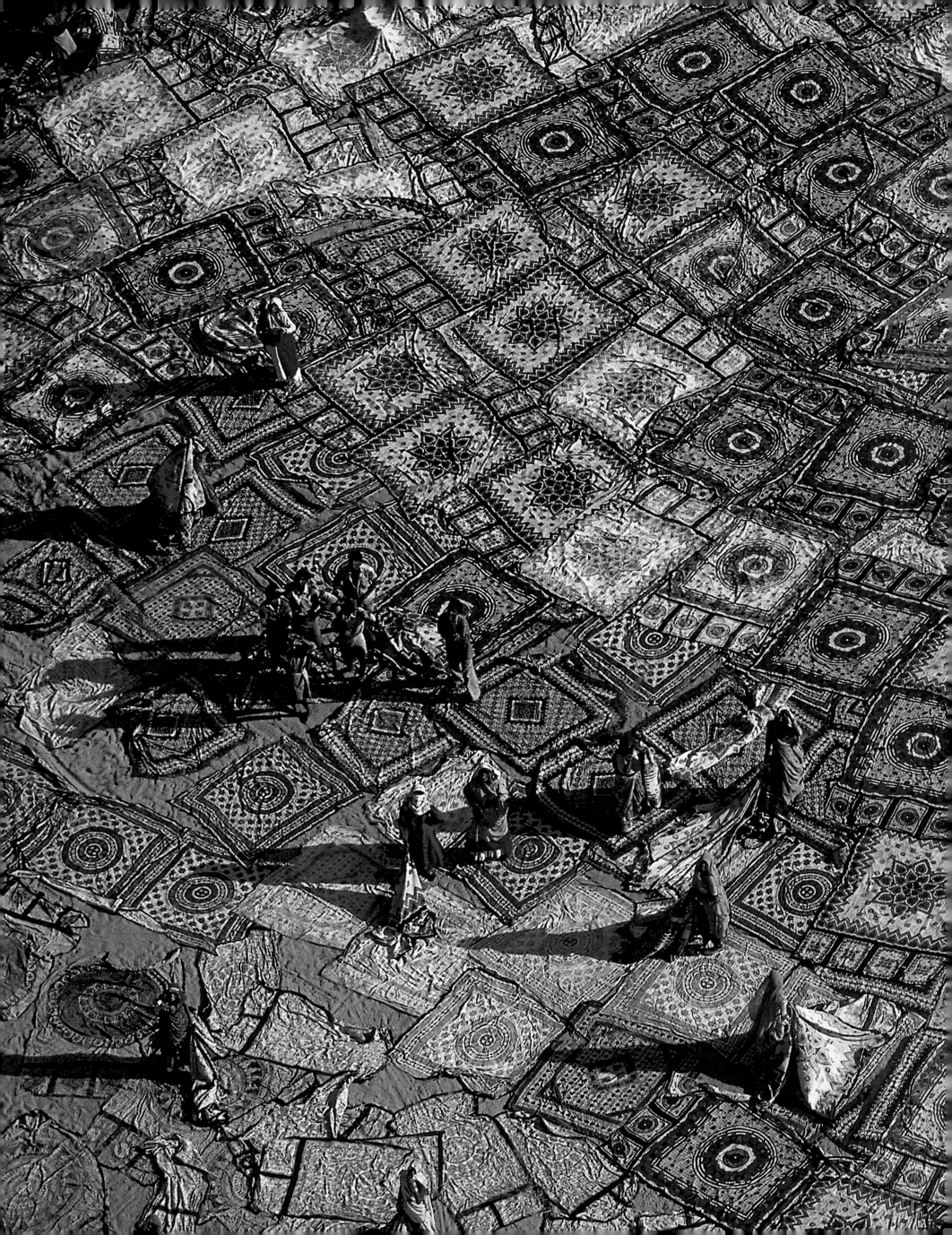

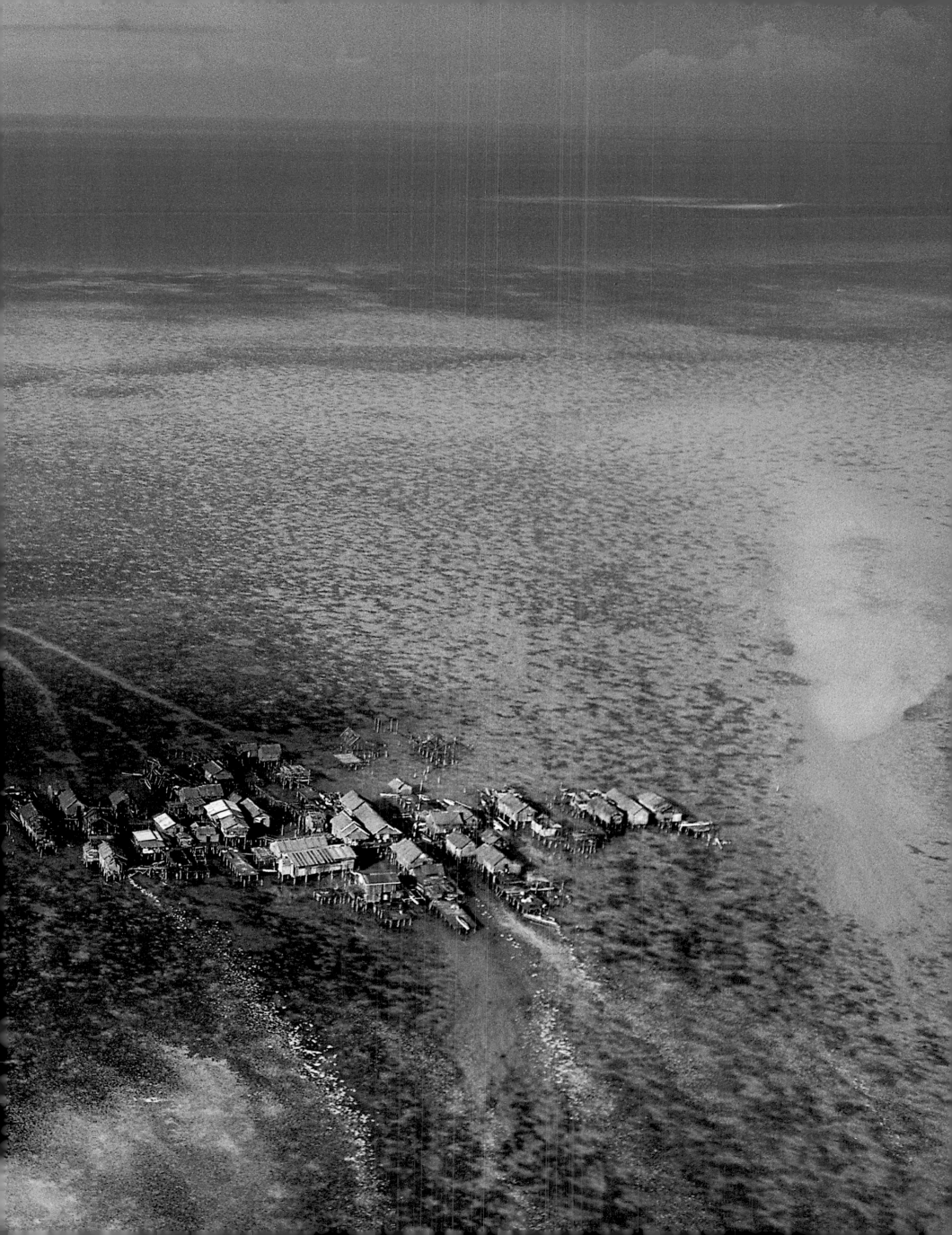

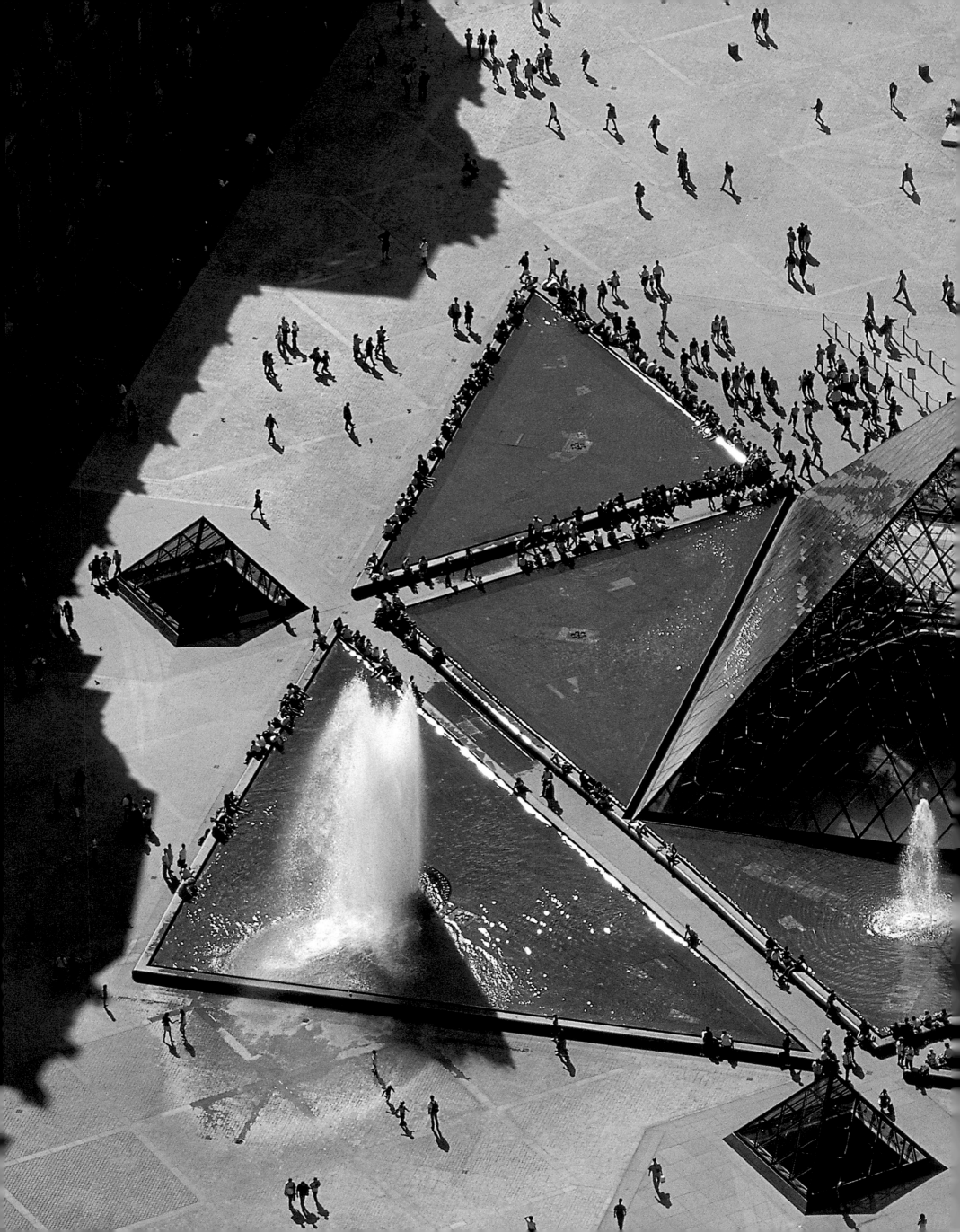

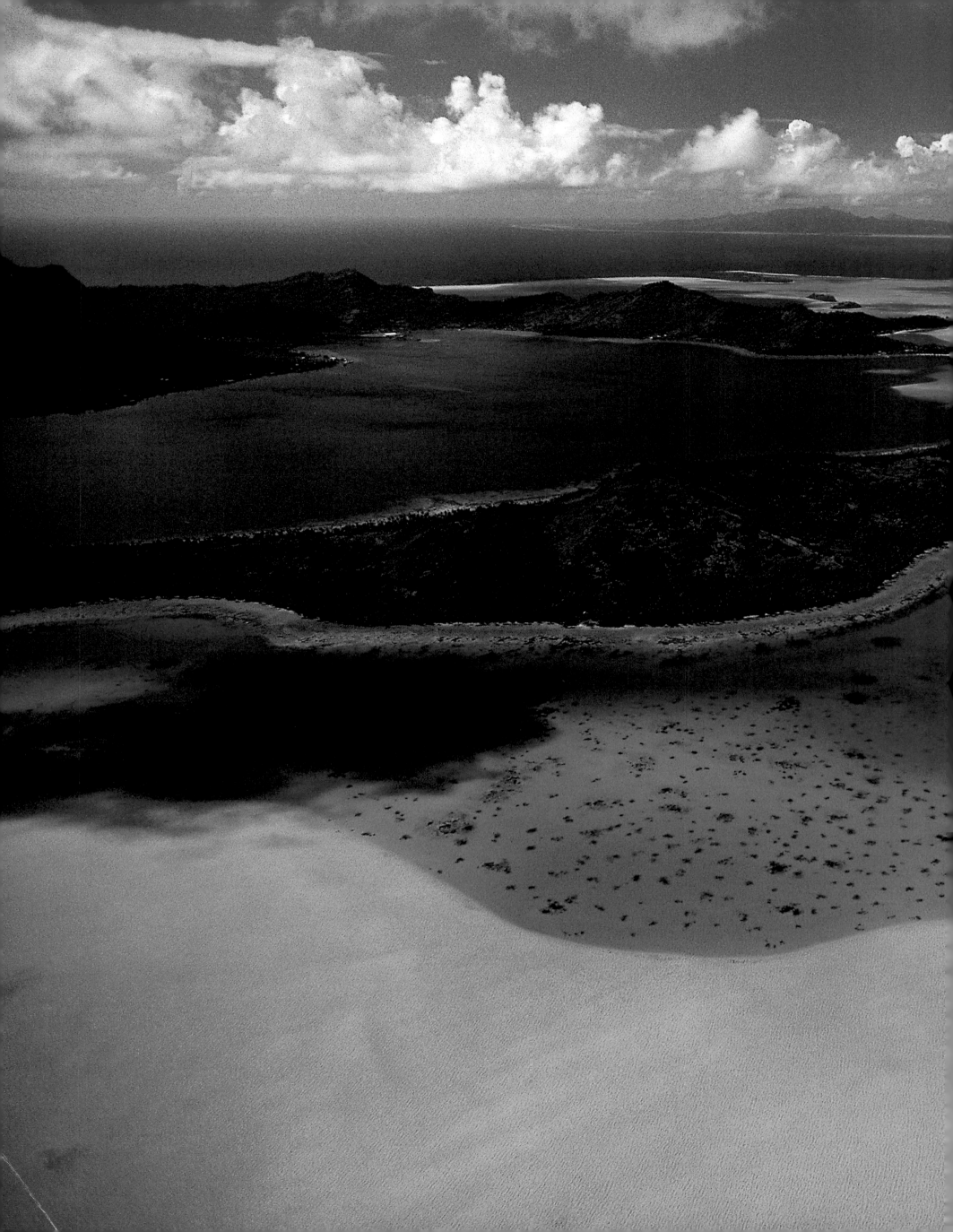

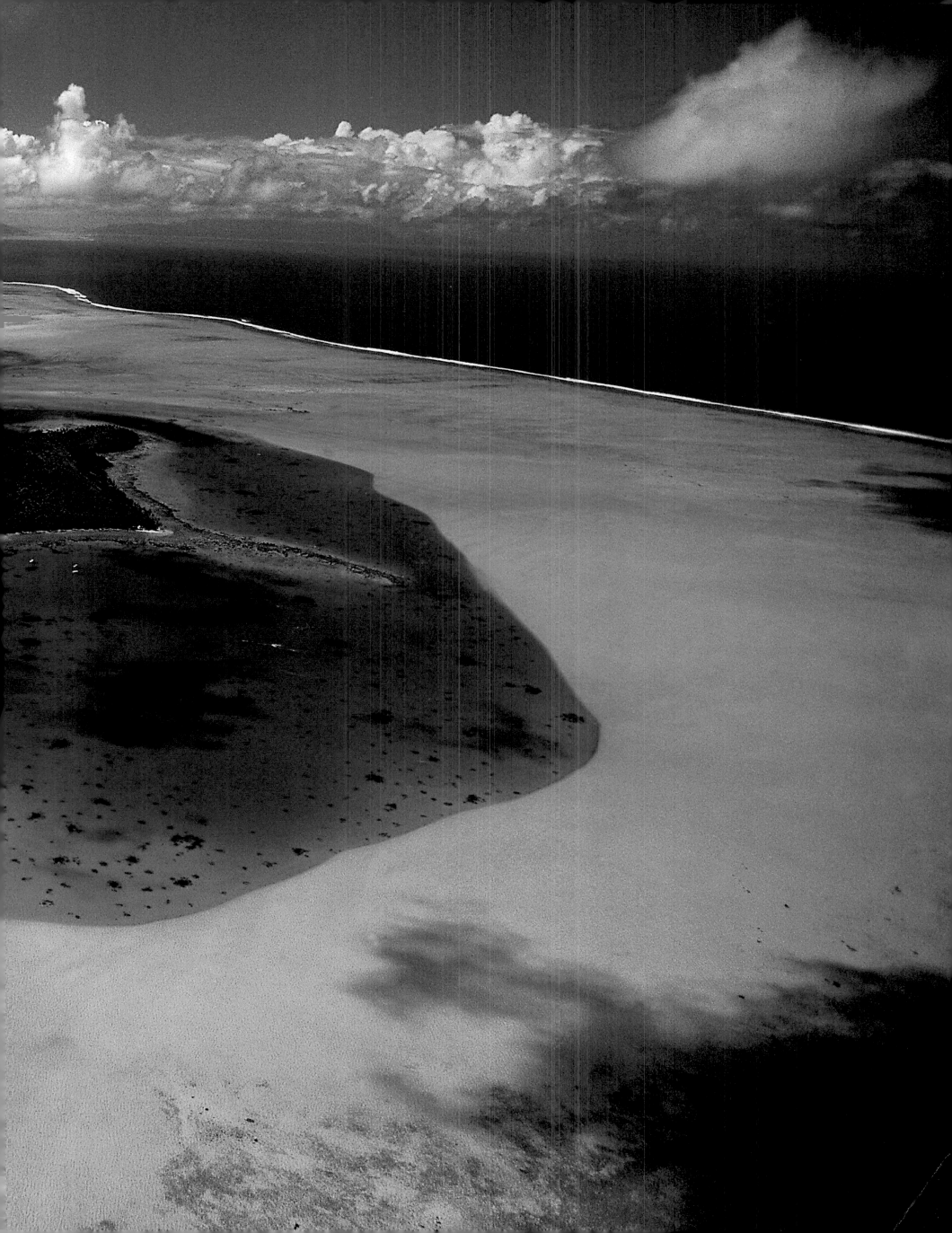

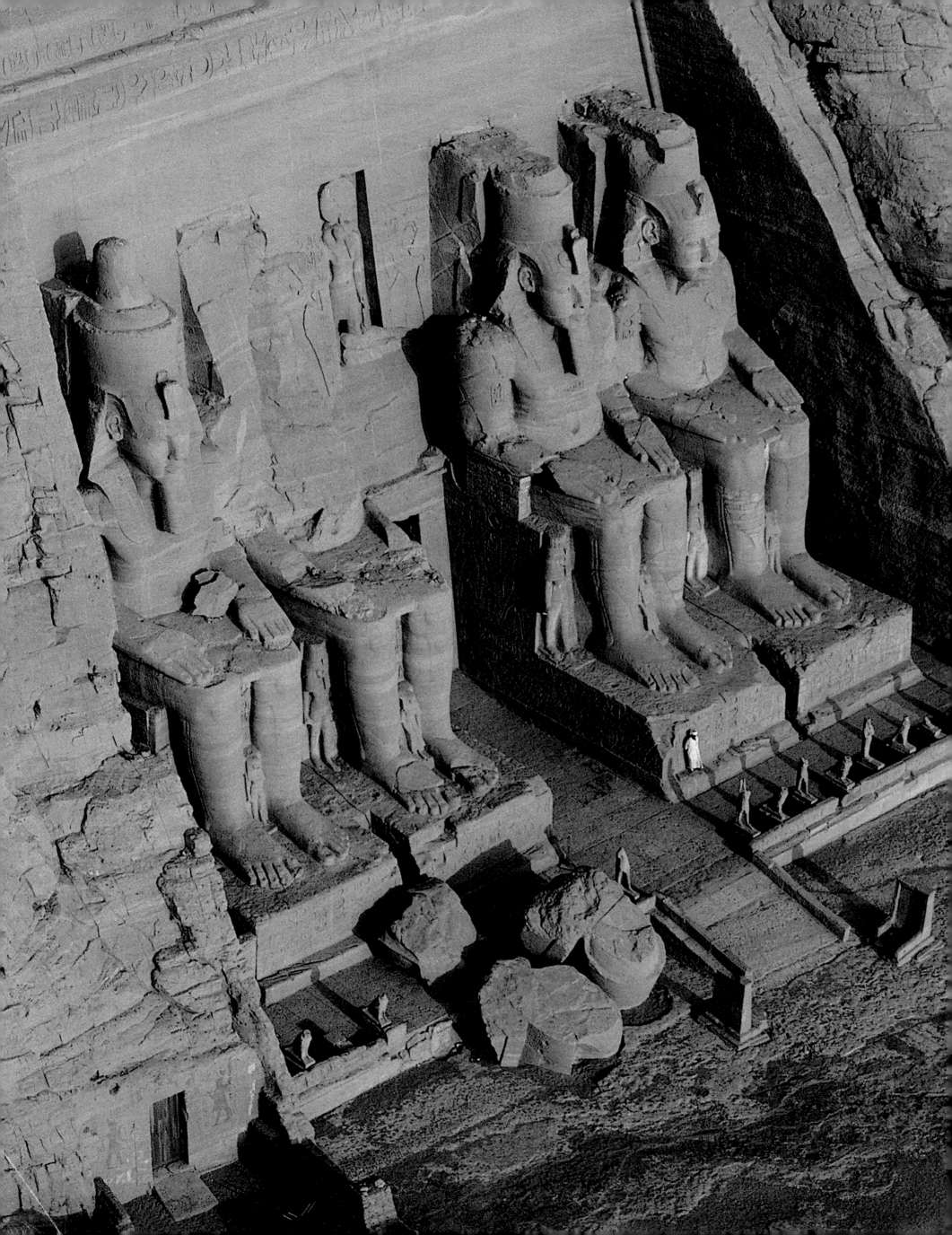

WHAT DO WE DO?

Economic growth, contrary to what many think, cannot solve all of our problems.
While the economy worldwide increased sixfold in the past fifty years, the ecological situation
deteriorated considerably. Global warming, the major problem in the decades to come,
can be halted only by a radical change in modes of production, life, and thought.
What must change, in other words, is industrial society itself.

Superficial changes will not save our beleaguered planet. Industrial society itself must change, along with the worldview that underlies it and rationalizes its policies. This worldview holds that economic growth and increasingly international trade provide a solution to just about every problem that we face today, whether it be poverty, unemployment, ill health, malnutrition, crime, or drug addiction. The implication is that money provides a veritable panacea to all our problems.

The fact that every one of these problems has grown considerably worse in the last fifty years—even though during this period economic growth has increased by six times and world trade by more than eighteen times—does not seem to lead people to question this incredibly naive assumption.[1]

In general terms economic growth by its very nature must necessarily give rise to a new organization of matter, which we can refer to as the technosphere, the world of human artifacts, or the surrogate world, which is rapidly supplanting the natural world. As the former expands, so must the latter correspondingly contract, and yet it is on the latter that we ultimately depend for our livelihood and indeed for our very survival. As readers of this book will already have realized, we have reached a point where the impact of the surrogate world on the real world cannot be allowed to increase any further. On the contrary it must be reduced, and reduced quite substantially.

This must clearly be so if we are to bring to an end the destruction of our forests, the compaction, erosion, desertification, and salinization of our agricultural lands, the draining of our wetlands, the systematic chemicalization of our land, rivers, seas, groundwaters, the food we eat, the water we drink, and the air we breathe—all of which trends are increasing rapidly and are, in effect, totally out of control. Even more out of control is by far and away the most daunting problem that humanity has ever faced: global warming.[2] It is so serious that, if it were allowed to proceed at the current rate, our planet would be made largely uninhabitable, possibly by the end of this century, but almost certainly before the end of the next. Global warming has been almost entirely caused by our industrial activities over the past 200 years. One can even say that the moment we learned how to mobilize the energy contained in fossil fuels, in the context of a market economy, we were condemned to global warming, and this in itself provides an indictment of the very principle of the industrial society that we are so proud of having brought into being. We have been warned that no more than a one degree change in temperature is tolerable if we wish to avoid the climatic discontinuities such as droughts, storms, floods, and sea level rises that would make life much more difficult for us on this planet. However, the Intergovernmental Panel on Climate Change, made up of 2,000 climatologists, states in its Third Assessment Report that we can expect up to a 10.4° F (5.8° C) change by the end of this century and a sea-level rise of up to 88 cms—enough to affect a significant proportion of the world's agricultural lands.[3]

But the situation could be far worse, for the IPCC's forecasts are based on a mathematical model that fails to take into account a number of important factors that its scientists found it difficult to quantify with any sort of credibility. Among them is the fact that our forests (which contain 400 billion tons of carbon) and our soils (which contain 1,600 billion tons, more than twice as much as is contained in the atmosphere itself) are being seriously degraded—the forests mainly by the logging activities of increasingly powerful logging companies and by forest fires, which are often lit by

ABU SIMBEL,
Nile Valley, Egypt
(N 22°22' E 31°38')
The archaeological site of Abu Simbel consists of two monumental temples of pink sandstone, built during the reign of Ramesses II (c. 1279–1213 B.C.). The facade of the larger one, facing toward the rising sun, holds four statues of the pharaoh that are 65 feet (20 m) tall and weigh 1,200 tons. The face of one of the giants has lain at his feet ever since an earthquake that occurred more than 3,000 years ago. In 1954 the decision to build the Aswan High Dam on the Nile threatened to bury the site under the waters of the reservoir lake. Upon the initiative of UNESCO, fifty nations—eager to reconcile the demands of development with historical heritage—united behind an arduous project. Four and a half years of hard work beginning in 1963, mobilizing 900 workers and more than $40 million, were required to break down the temples into more than a thousand blocks and then rebuild them identically, 200 (60 m) feet higher on an artificial cliff supported by a concrete vault. Since 1979 Abu Simbel has been one of the 721 UNESCO world heritage sites.

developers, and the soils by large-scale industrial agriculture, whose impact on the often very vulnerable soils of the tropics can turn reasonable agricultural land into dust in a matter of decades.

However, the Hadley Centre of the British Meteorological Office has now built a model that takes these factors into account, and this has led its climate scientists to estimate that the world's average temperature could increase by up to 15.8° F (8.8° C). This would create climatic conditions that have not prevailed for some 45 million years—conditions in which it would be extremely difficult for humans to survive. This model does not even take into account other important factors such as the probable release, as temperatures rise, of carbon from the permafrost and tundra in the Arctic and from that contained in the methyl hydrates in the shallow waters of the Continental Shelf. Something pretty drastic has to be done, and so far nothing of any consequence has either been done or even seriously contemplated. Even the very weak Kyoto Protocol, which has been further watered down at the more recent meeting at Bonn, over which so much fuss is being made, would make very little difference.[4]

Clearly the first thing required is the rapid phasing out of fossil fuels and their partial replacement by renewable energies. I say partial because it is unlikely that renewables would be able to replace oil completely, which means that, whether we like it or not, we must learn to make do with less energy. But even that is not enough—it also means preserving the sinks (which take CO_2 from the atmosphere and convert it into organic material through photosynthesis), such as the forests, and the rest of the terrestrial vegetation, the soil, and of course the oceans, which still absorb vast amounts of carbon dioxide. If we do not, as temperatures rise these spaces will not only cease to act as sinks but will actually become sources of carbon dioxide, which could thereby give rise to an unstoppable, runaway process of climatic destabilization.[5]

Of course, as long as the global economy continues and the world is dominated by powerful transnational corporations that are only interested in maximizing their immediate profits, the requisite measures will be extremely difficult to undertake.

For instance, the sheer political power of the oil industry makes it very difficult to phase out oil and replace it with sources of renewable energy. In the United States, which is the biggest consumer of oil in the world, the energy plan recommended by President Bush in the fall of 2001 cut expenditure on renewables by 27%, while increasing funding for research into coal technology by 813%.[6] Investment in energy efficiency is reduced by 7%,[7] suggesting that the maximization of oil sales even has precedence over increasing the efficiency and competitiveness of American industry, which the Bush administration claims is an economic priority. In Britain the situation is not much better: spending on research and development in renewable energy has fallen by 81% from 1987 to 1998. The government has recently agreed to spend more money on renewables, but the sum proposed is pitifully small.

Even if a more responsible government were to come to power it would be very difficult to pass a law to force the oil industry to disinvest in oil and invest instead in renewables. Let us not forget that in joining the World Trade Organization (WTO) a country gives up much of its sovereignty to what is in effect a world government: the WTO has its own legislature because it can pass laws, its own executive because it can implement these laws, and its own judiciary because it can penalize those countries that violate the laws. What is more, the WTO is not only concerned with trade, as we shall see, but with virtually all aspects of government, and its overriding priority is to assure that nothing is allowed to interfere with the immediate interests of the corporations that control it.

Hence, not surprisingly, an attempt to phase out fossil fuels would run afoul of a number of WTO regulations, such as that on Process and Products Methods (PPMs),[8] which makes it unlawful for governments to discriminate against different production methods used by various corporations so long as the final products are judged to be the same. Worse still, and in accordance with the General Agreement on Trade in Services (GATS), the entire energy production and distribution process is to be privatized. What is more, the U.S. administration proposes to introduce the new concept of technological neutrality, which it is almost sure to succeed in doing. This will mean that corporations must be granted access to markets for the services they provide, regardless of the technologies used for these services.[9] This means that what is true of production processes is now true of the provision of services as well, and this would clearly make it illegal to force any country to replace oil by renewable sources of energy and thus to prevent the fossil-fuel industry from maximizing the production of fossil fuels—to hell with climate change!

The world powers have also declared to hell with the climatically essential task of saving the world's tropical forests. The Brazilian government's most recent infrastructure development plan, "Avança Brasil," will lead to the annihilation of 40% of the climatically critical Amazonian rainforests; the plan has been approved by not only the Brazilian government but also the World Bank.[10] Four huge American logging companies—International Paper, Weyerhauser, Boise Cascade, and Georgia Pacific—aggressively lobbied President Clinton to support the ATL Initiative (known by its critics as the "Free Logging Agreement") at the WTO Ministerial Conference in Seattle in November 1999. This initiative would have made it illegal for loggers to be denied access to any source of timber or to any market for the sale of their products; tariffs on wood and wood products would have been eliminated; "performance requirements" would no longer have been allowed, freeing loggers from following sustainable forestry practices; and eco-labeling would have been outlawed.[11] In other words, the protection of the world's remaining forests—as essential as they are for climatic and other ecological reasons—would have been made illegal. The Seattle meeting proved to be a fiasco (for the corporations), and the Free Logging Agreement never became law, but at the fall 2001 WTO meeting in Doha, Qatar, it was put back on the agenda. The director general of the United Nations Environment Programme (UNEP) stated that only a miracle could save our tropical forests.

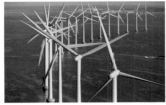

pp. 418–19
MIDDELGRUNDEN
OFFSHORE WIND
FARM,
near Copenhagen,
Denmark
(N 55°40' E 12°38')

Since late 2000, the world's largest offshore wind farm to date has stood in the Øresund strait, which separates Denmark from Sweden. Its 20 turbines, each equipped with a rotor 250 feet (76 m) in diameter, standing 210 feet (64 m) above the water, form an arc with a length of 2.1 miles (3.4 km). With 40 megawatts of power, the farm produces 89,000 MW annually (about 3 percent of the electricity consumption of Copenhagen). In 2030 Denmark plans to satisfy 50 percent of its electricity needs by means of wind energy (as opposed to 10 percent today). Although renewable forms of energy still only make up 2 percent of the primary energy used worldwide, the ecological advantages are attracting great interest. Thanks to technical progress, which has reduced the noise created by wind farms (installed about one-third of a mile, or 500 m, from residential areas), resistance is fading. And with a 30 percent average annual growth rate in the past four years, the wind farm seems to be here to stay.

pp. 420–21
TEMPLE SOUTH OF
TOKYO,
island of Honshu, Japan
(N 35°42' E 139°46')

If one had to sum up Japanese spirituality in a single word, it would have to be "syncretism." Syncretism of indigenous beliefs, animist and polytheistic, and the monotheistic doctrines imported from abroad; syncretism of Shinto, Buddhism and its many sects, Confucianism, and, to a lesser extent, Christianity, which has more than 1 million followers among the 127 million Japanese. In the course of a day, the Japanese are just as likely to stop in to meditate at a Shinto sanctuary as at a Buddhist temple or a chapel, all of which are found in close proximity. Conscious of this diversity, they often claim, jokingly, that their country has 300 million faithful: Shintoist at birth because it is a cult of life, Christian when they marry because of the pomp of its ritual, and Buddhist at death because of its gentle approach to the destiny of the soul.

pp. 422–423
TREES DOWNED
BY STORM IN THE
FOREST OF THE
VOSGES MOUNTAINS,
France
(N 48°39' E 7°14')

On December 26, 1999, the department of the Vosges awoke to find 348 of its 515 communities without electric power, 10 percent of its forests leveled. railway traffic totally at a stop, and 60,000 telephone lines cut. The most severe damage occurred in the Lorraine region, after the storm cut across France causing 79 deaths—an event without precedent in France in recent centuries. Violent winds (up to 105 mph in Paris) cut down more than 300 million trees throughout the country, equivalent to three years of harvests for state forests (of which 70 percent is sold). The National Forest Service, which set out to replace these woods, now plans to emphasize forests that are more resistant by nature, without endangering the timber industry, by favoring biological diversity (more adaptive and diverse species) and avoiding systematic alignment. From this viewpoint, not all of the consequences of the catastrophe will prove negative.

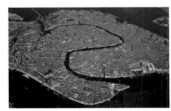

pp. 424–25
PANORAMIC VIEW
OF VENICE,
Veneto, Italy
(N 45°35' E 12°34')

Venice is not one island, but an archipelago of 118 islands separated by 200 canals that are crossed by more than 400 bridges. The Grand Canal, the "most beautiful street in the world," forms the city's main artery; its banks are lined by the finest palaces erected in medieval and Renaissance times by members of the Venetian aristocracy, along with the principal churches. Structures such as these, along with Piazza San Marco, the Palazzo Ducale, or the theater of La Fenice, epitomize the exceptional career of La Serenissima, the "Most Serene Republic." Venice owed its glory above all to its dominance of the sea; since the year 1000, the city sought to impose its maritime power, commercially as well as politically, through a network of trading centers. Maritime powers ruled the world up to the seventeenth century, when the continental powers came to the fore. Some expect the twenty-first century to see the return of great sea powers. Europe, the United States, and Japan, for commercial reasons and because of the concentration of populations alongside seas and oceans.

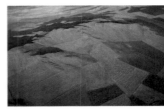

pp. 426–27
FARM LANDSCAPE
BETWEEN ANKARA
AND HATTOUSA,
Anatolia, Turkey
(N 40°00' E 33°35')

The farms on the Anatolian plateau north of the Ankara–Sivas line are in the region most favored in terms of natural conditions because it is the highest and best watered. The landscape is striking for its orderly, well-tended fields, its clearly traced furrows, and its diversified plantings both of grain (wheat and barley) and sugar beets. It typifies Turkey's strong agricultural development in the course of the last decades of the twentieth century, which was made possible by the extension of cultivated areas, the increase in mechanization, and the appearance of regions of monoculture and huge farms, which allowed the country to break the vicious cycle of food dependence and become an exporter of agricultural produce. The increasing intervention of man and machine in nature cannot conceal the zones that resisted monoculture, where many small farms subsist. They mark the countryside with trees and shrubs that, here and there, interrupt its symmetry.

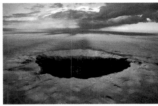

pp. 428–29
BARRINGER CRATER,
near Flagstaff, northern
Arizona, United States
(N 35°02' W 111°01')

All that is missing from this lunar landscape are the astronauts. In fact, NASA uses this site for training because the topography closely resembles the that of the moon. The crater interrupts the rocky, desertlike flatness that stretches out around Winslow, Arizona, in the American Southwest. This cosmic scar, discovered in 1871, is 558 feet (170 m) deep and three-quarters of a mile (1.2 km) in diameter. It is the point of impact of a meteorite that collided with the earth 25,000 years ago at a speed of 39,000 miles per hour (64,000 km/h). In the early twentieth century, geologist Daniel Barringer first pronounced this meteorite origin, but his hypothesis was hotly contested because there are also abundant volcanic craters in the area. The examination of meteorite collisions on earth is assisted by remote-detection satellites, but they still are not able to detect those at the bottom of the ocean. Indeed, we know the surface of Venus or Mars better than the depths of our own planet.

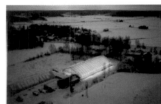

pp. 430–31
ILLUMINATED
GREENHOUSE
NEAR SAUVO,
Varsinais-Suomi
region, Finland
(N 60°18' E 22°36')

Finland occupies the most northern position in Europe, with a quarter of its territory located above the Arctic Circle. At such high latitudes agriculture faces natural challenges; in winter, night lasts uninterrupted for nearly two months in the north, while in the south the the sun does not appear for more than six hours daily. In this premature twilight the snow is scattered with gleams from greenhouses, where the daily duration of photosynthesis is extended by artificial lighting, as here near Sauvo, in the southwestern part of the country. Finland manages to thus produce 35,500 tons of tomatoes per year; but its greatest field of exploitation remains timber. It exploits pine and birch forests that cover 70 percent of its land and provide more than one-third of its export revenues. Residue from the timber industry and waste from cutting trees serve as fuel, an important source of renewable energy that has covered 20 percent of the country's energy consumption and 10 percent of its electricity consumption in the year 2000.

Captions to the photographs on pages 432 to
447 can be found on the foldout to the right of
the following chapter

captions 418–431 captions 432–447
 ↓

(N 35°02' W 111°01')

(N 60°18' E 22°36')

(N 55°40' E 12°38')

(N 35°42' E 139°46')

(N 50°23' E 02°42')

(N 47°04' E 12°42')

(N 48°39' E 7°14')

(N 40°00' E 33°35')

(N 46°42' W 117°12')

(N 48°52' E 2°20')

(N 6°07' E 121°81')

(N 64°18' W 21°08')

(N 43°27' E 4°34')

(S 16°30' W 151°44')

(N 22°22' E 31°38')

(S 2°59' E 38°31')

(S 13°00' E 132°30')

(S 18°45' E 22°45')

pp. 392–93
VILLAGE ON STILTS
IN TONGKIL,
Samales islands,
Philippines
(N 6°07' E 121°81')

The southern Philippines, particularly the Sulu Archipelago that shelters the Samales Group, is the home of the Badjaos. Known as "Sea Gypsies," they fish and harvest shellfish and pearl oysters, and they live in villages on stilts. A channel carved out of the coral reef allows them to reach the high sea. The Badjaos belong to a Muslim minority, the Moros, who make up only 4 percent of the Philippine population and are concentrated mostly in the southern part of the country. In this predominantly Catholic country, these populations feel marginalized and disfavored. Separatist religious conflicts have caused 120,000 deaths since the early 1970s, led by various protest movements that use Islam as a lever to free themselves from the pressure of the Philippine government. They include the extremist group Abu Sayyaf, responsible for several kidnappings of hostages for ransom, including in Jolo in July 2000. As elsewhere in the world, this guerrilla movement, which mixes economic and religious motives, hurts development in the region.

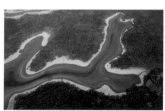

pp. 394–95
KAKADU
NATIONAL PARK,
Northern Territory,
Australia
(S 13°00' E 132°30')

Kakadu National Park in the Northern Territory has an area of nearly 7,800 square miles (20,000 km²), making it one of the largest parks in Australia. It was declared a world heritage site by UNESCO in 1981 because of its cultural importance, including aboriginal cave paintings, as well as its natural landscape. The grassy plains in the north are watered by the Alligator Rivers and are flooded each year by the October rains. Rich in flora and fauna, Kakadu is home to numerous species of plants and animals that are indigenous to the country. Because Australia separated from the rest of the world 150 million years ago, many species developed there and on neighboring islands that do not exist on any other continent; these species include the monotremes (the platypus and echidna, egg-laying mammals) and most of the marsupials (including the kangaroo and koala).

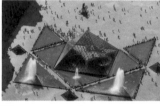

pp. 396–97
PYRAMID OF
THE LOUVRE,
Paris, France
(N 48°52' E 2°20')

This great translucent pyramid, 71 feet (21.7 m) high, was erected in 1988 in the heart of the Palais du Louvre in Paris, one of the largest museums in the world. The pyramid, which sits atop the reception area, is composed of 673 diamond-shaped and triangular glass panes, mounted on a metallic framework weighing more than 95 tons—a true technological marvel. The pyramid, however, is only the most apparent element among the renovations made to the museum in a large-scale restructuring project led by the American architect I. M. Pei. This contemporary structure, set off by a cluster of historic buildings that served as the residence of the kings of France, has become the symbol of the Louvre Museum. The museum, with a collection of 30,000 works of art, had more than 6 million visitors in 2000.

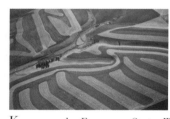

pp. 398–99
FARMING NEAR
PULLMAN,
Washington,
United States
(N 46°42' W 117°12')

Known as the Evergreen State, Washington has been raising wheat for decades, striving to adapt the grain in order to protect a soil made fragile by the erosive agricultural practices of earlier times. The development of "agrobusiness," an alliance of agriculture, industry, science, and financial investments, encourages technological innovations aimed at improving productivity and helps keep the United States the leading exporter of cereals (about 35 percent of the total) as well as corn (40 percent) and soya (nearly half of world production). The use of biotechnologies, especially in the production of corn and soya, has led to the creation of varieties that are resistant to parasites and herbicides that are believed to increase yield. Although these genetically modified organisms (GMO) are still the subject of prohibitions and sharp controversy all over the world, notably because of the limited knowledge of their effects on health and the environment, their cultivation is widespread in Argentina, Canada, and especially the United States, where half of all soya is genetically modified.

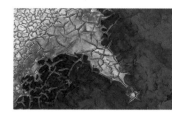

pp. 400–401
CRACKED MUD IN
THE CAMARGUE,
Bouches-du-Rhône,
France
(N 43°27' E 4°34')

Before it reaches the Mediterranean, the Rhône River (500 miles, or 812 km, long) divides into two arms that form a delta of 190 square miles (750 km²), known as the Camargue. This vast humid area is primarily made up of alluvial deposits, and 40 percent of it is covered by swamps and ponds of brackish water. Some of these swamps, known as *baisses* (depressions), dry up in the summer, revealing a muddy soil that cracks and is covered with saline deposits. Part of the Camargue was declared a nature preserve in 1927 for its varied fauna, particularly birds. Humans have also taken advantage of the riches of this natural setting: rice cultivation, winemaking, fishing, and husbandry of horses and bulls are all carried out on the delta. More than 40 square miles (100 km²) of salt marshes have been exploited from which more than 1 million tons of salt are exported annually.

pp. 402–403
LECHWE IN THE
OKAVANGO DELTA,
Botswana
(S 18°45' E 22°45')

Two million years ago the Okavango River flowed into the Limpopo and emptied into the Indian Ocean, but the faults created by tectonic movement diverted the river from its original course. The "river that never finds the sea" now ends in Botswana, in a vast interior delta of 9,300 square miles (15,000 km²) at the entrance of the Kalahari Desert. This labyrinth of swamps is home to 400 species of birds, 95 reptiles and amphibians, 70 fish, and 40 large mammals. Hidden in the islets of vegetation where they find food and protection from predators, lechwe (*Kobus leche*)—an antelope typical of swampy environments—exist in abundance in the waters of the Okavango Delta. Since 1996 the Okavango Delta has been protected by the Ramsar Agreement, which concerns 1,075 wet zones of international importance throughout the world.

pp. 404–405
BORA BORA,
Polynesia
(S 16°30' W 151°44')

The archipelago of the Leeward Islands (or "îles Sous-le-Vent") in French Polynesia, an overseas French territory since 1946, includes this island of 15 square miles (38 km²), whose name means "first born" in Polynesian. It is made up of the emerged portion of the crater of a 7-million-year-old volcano and surrounded by a coral barrier reef. Motus, small coral islands with beaches and vegetation that consists mainly of coconut trees, have developed along the reef. The lagoon's only opening to the sea is Teavanui Pass, which is deep enough to allow cargo and warships to enter. All of the coral formations of the planet cover only 110,000 square miles (284,000 km²) of sea territory (the equivalent of about half of the state of Texas) in intertropical regions where the water temperature favors their growth. Limited in extent, these areas still contain a remarkable biological diversity: about 100,000 plant and animal species have been classified, out of an estimated total of 2 million. More than 50 percent of the world's coral reefs (80 percent in the most populous zones) have deteriorated from the impact of human activity.

pp. 406–407
ATHI RIVER DRIED UP,
western area of Tsavo
National Park, Kenya
(S 2°59' E 38°31')

Like most Kenyan waterways, the Athi River, which crosses Tsavo National Park, is not permanent. Yet during droughts, the Masaai herdsmen still lead their herds of cows and goats into the dried-up bed of this river to allow the animals to drink from the chance water puddles that remain in rocky basins. In retreating, the waters of the river revealed their work, a surprising fresco resulting from the deposit of different types of granular sand, according to their density and shape. The 15,000 Masaai are semi-nomadic herdsmen, who depend for subsistence entirely on what they raise. They cover the long distances between Kenya and Tanzania seeking water sources and pastures for their herds. According to local belief, the livestock was given to the people by Enkai, the creator of the world. Kenyan governmental programs today are encouraging the Masaai to adopt agriculture and settle in one area.

One of the most important problems facing us is how we will feed ourselves under a regime of climate change. What is certain is that modern industrial agriculture is no longer an option. We need to grow a wide diversity of crops, and varieties of each crop, because we do not know which ones will prove resistant to the parasites and pathogens that, as temperatures rise, we are likely to inherit from tropical areas and elsewhere. Nor do we know which ones will survive the heat waves, storms, floods, and droughts to come. It would be best to concentrate on traditional varieties that often provide very high yields without the aid of off-farm inputs, such as artificial fertilizers, and require minimal irrigation. We also need to maximize self-sufficiency by drastically cutting down on imports and exports and concentrating on feeding local people. The U.S. corn belt and much of Australia are likely to be vulnerable to climate change. This would also minimize transport and the pollution and greenhouse gas emissions to which it gives rise. As much food as possible must be stocked by the individual farm, the village, the region, and the nation itself, in order to tide people over during the various crises that will occur because of climate change.

However, any one of these essential changes would be violently opposed by transnational corporations and the governments and international agencies that they control, and it would violate at least one WTO regulation if not more. To increase crop diversity would be very difficult, because the WTO and other international agencies actively promote monoculture, and on as big a scale as possible; to return to traditional varieties would be very difficult, although the protection of the remaining traditional varieties is called for by the Convention on Biological Diversity, because the WTO Trade Related Intellectual Property Rights (TRIPS) legalized the patenting of indigenous knowledge and whatever traditional crops have come from it.[12]

For a country to produce its food locally and seek to achieve self-sufficiency is the most difficult thing of all to achieve. Indeed, the WTO and the corporations that control it, as Agnes Bertrand points out, are at war with self-sufficiency. For them it is the number one enemy. If every country were to become self-sufficient, as was largely the case long ago, there would be no international trade and no transnational corporations. The path to self-sufficiency contravenes any number of WTO regulations: the "National Treatment" regulation forces countries to treat foreign corporations and their products the same as domestic ones; another regulation forbids "quantitative import and export controls"; the Agreement on Agriculture (AOA) forces countries to open up their markets to highly subsidized American and European food, which provides impossible competition for small farmers, who in countries such as India have little more than a few acres at their disposal.[13] Most small farmers—about 500 million in India alone—are condemned sooner or later to seek refuge in the burgeoning city slums.

Another AOA provision forces countries to export their food even when they are suffering from serious food shortages. It also forbids setting up food stocks to help people through serious food shortages. Outrageous as this may seem, it is seen as a means of diverting funds that should be used to repay debts to Western banks. Faced with a food shortage, the governments of developing nations are thereby forced to buy food on the open market, and given the great volatility of prices in the global economy, this could often be way beyond their means.

However, what makes it still more difficult to create the conditions in which we could feed ourselves under a regime of climate change is Article 23.3 of the GATS, which is based on Chapter 11 of NAFTA, the free-trade agreement between the United States, Canada, and Mexico. This gives a corporation the right to take legal proceedings against a country that dares pass a law preventing it, for health or environmental reasons, from making an investment in or exporting a specific product to the country in question. The corporation can now force the government of the country in question to rescind the regulation and compensate it for the profits which, on its own estimation, it would have made if the regulation had never been passed.[14]

A number of such cases have already taken place. The most famous one was brought by the Ethyl Corporation, a U.S.-based chemical company, against the Canadian government, which it sued for 250 million dollars for banning the sale of one of its products—MMT, an additive to gasoline that is a known neurotoxin and

PINGVELLIR FAULT EAST OF REYKJAVIK,
Iceland
(N 64°18' W 21°08')
Iceland is situated at the emergence of the mid-Atlantic submarine dorsal and thus stands at the junction of two tectonic plates. The island is distended by the force of the volcanic action of this rift, which, through the production of magma, is driving Europe and North America apart at an average rate of nearly one inch (2 cm) per year. The narrow road bordering the cracks of the rock, shattered by enormous tectonic stresses, is like a house built at the water's edge. It reflects the customary hardiness of human societies, and a surprising faith in nature. The motion of the earth's plates will continue far longer than the life span of ten generations. The rhythm of human life differs fundamentally from that of the movements of our earth.

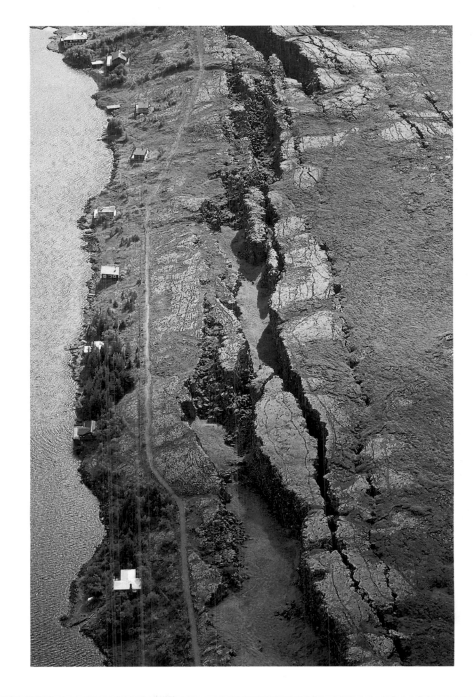

can cause brain damage. The Canadian government, fearing that it would lose the case, paid the Ethyl Corporation $13 million for damages and withdrew its ban on MMT.[15]

There is no reason to suppose that we would obtain a different decision if a government sought to pass a regulation that would stop the creation of some vast new coalmine; or a development plan that would annihilate a huge area of tropical forests (such as the Avança Brasil plan); or a vast export-oriented agricultural project such as the "Vision 2020" plan for Andhra Pradesh, India, which would create a 600-square-mile plantation to grow genetically modified crops for export, driving millions of small farmers off their land into the nearest slums—a project that the British government has been irresponsible enough to support financially. It will be hard to prevent any large-scale commercial project that will further reduce our ability to feed ourselves in the difficult conditions that lie ahead.

The most important step, then, in a campaign to save our planet must be to phase out the global economy—in this way massively reducing the power of the corporations that control it and that prevent us from taking the necessary action. This may sound utopian, and maybe it is; but is it not equally utopian to suppose that our increasingly unstable global economy, which struggles from crisis to crisis, creating poverty and misery on an unprecedented scale, has a chance of surviving for very long?

The ultimate answer, as suggested at the beginning of this chapter, is to change the industrial system itself and return to a largely rural, community-based society, in which economic activities are conducted on a much smaller scale and cater as much as possible to the local economy. Mahatma Gandhi's vision for India was that of a nation of loosely organized village republics. Switzerland was originally similar to this: almost all power resided with its rural communes, in which real participatory democracy prevailed, while the cantons (states) were loose alliances created by the communes largely for purposes of defense; the confederate government itself had very little power.

This is clearly the way to minimize the impact of our activities on what remains of the natural environment, and it is certainly the only way that we can possibly hope to bring climate change under control. I am also sure it would provide a much more human and more satisfying life than that facing the bulk of humanity who would otherwise be condemned—even without climate change—to the sordid, dehumanizing life of the city slums. Let us remember that the choice for most people today is not between the village and the city itself but between the village and the slum. If we take into account climate change the choice is between having a future and not having one.

Edward Goldsmith

NOTES

1. From an address by Renato Ruggiero, former director-general of the WTO, "A New Partnership for a New Century: Sustainable Global Development in a Global Age," presented at Bellerive/Globe International Conference, "Policing the Global Economy," Geneva, March 23, 1998.

2. *The Ecologist Report*, "Climate Change: Time to Act," special insert in *The Ecologist* (London: November 2001).

3. The Intergovernmental Panel on Climate Change (IPCC), Third Assessment Report, 2001.

4. United Nations Kyoto Protocol, October 1997; United Nations Bonn Agreement, July 2001.

5. Peter Bunyard, "How Climate Change Could Spiral Out of Control," in Simon Retallack, ed., *Climate Crisis: The Ecologist, Special Issue*, vol. 29, no. 2 (London: March/April 1999), pp. 68–74.

6. *The Ecologist Report*, "Climate Change: Time to Act," special insert in *The Ecologist* (London: November 2001), p. 21.

7. *Ibid.*

8. Debi Barker and Jerry Mander, *Invisible Government—The World Trade Organization: Global Government for the New Millennium?* (San Francisco: The International Forum on Globalization, 1999), pp. 14–15.

9. Agnes Bertrand and Laurence Kalafatides, "OMC, Le Pouvoir Invisible," in *La Privatisation des Entrailles de la Terre* (Fayard, March 2002).

10. Penelope Jacquacu, "When Forward Is Backward," *The Ecologist*, vol. 31, no. 3 (London: March 22, 2001), pp. 58–59.

11. Victor Menotti, *Free Trade, Free Logging: How the World Trade Organization Undermines Global Forest Conservation* (San Francisco: The International Forum on Globalization, 1999), p. 12.

12. Barker and Mander, p. 31.

13. *Ibid.*, pp. 32–34.

14. *Ibid.*, p. 9.

15. *Ibid.*, p. 41.

NATIONAL MILITARY CEMETERY OF NOTRE DAME DE LORETTE,
near Ablain-Saint-Nazaire, Pas-de-Calais, France
(N 50°23' E 02°42')
Two major conflicts devastated Europe before the words of Victor Hugo (1802–1885) became a prophecy: "No more armies, no more frontiers, a single continental currency. . . . The day will come when you will lay down your arms." Before unifying in peace, Europe had to go through two world wars; WWI cost 8 million lives, and WWII cost 45 million. The Battle of Lorette, from October 1914 to October 1915, in which the French and Germans struggled for possession of the strategic plateau of Artois, shed the blood of more than 100,000 victims on the fields of northern France. This military cemetary commemorates the fallen: 20,000 crosses are aligned across 30 acres, and eight ossuaries hold more than 22,000 unknown soldiers. Hugo also said, "The day will come when the only battlefields will be markets open to commerce and minds open to ideas." That day has come, but it is a battle whose outcome remains uncertain.

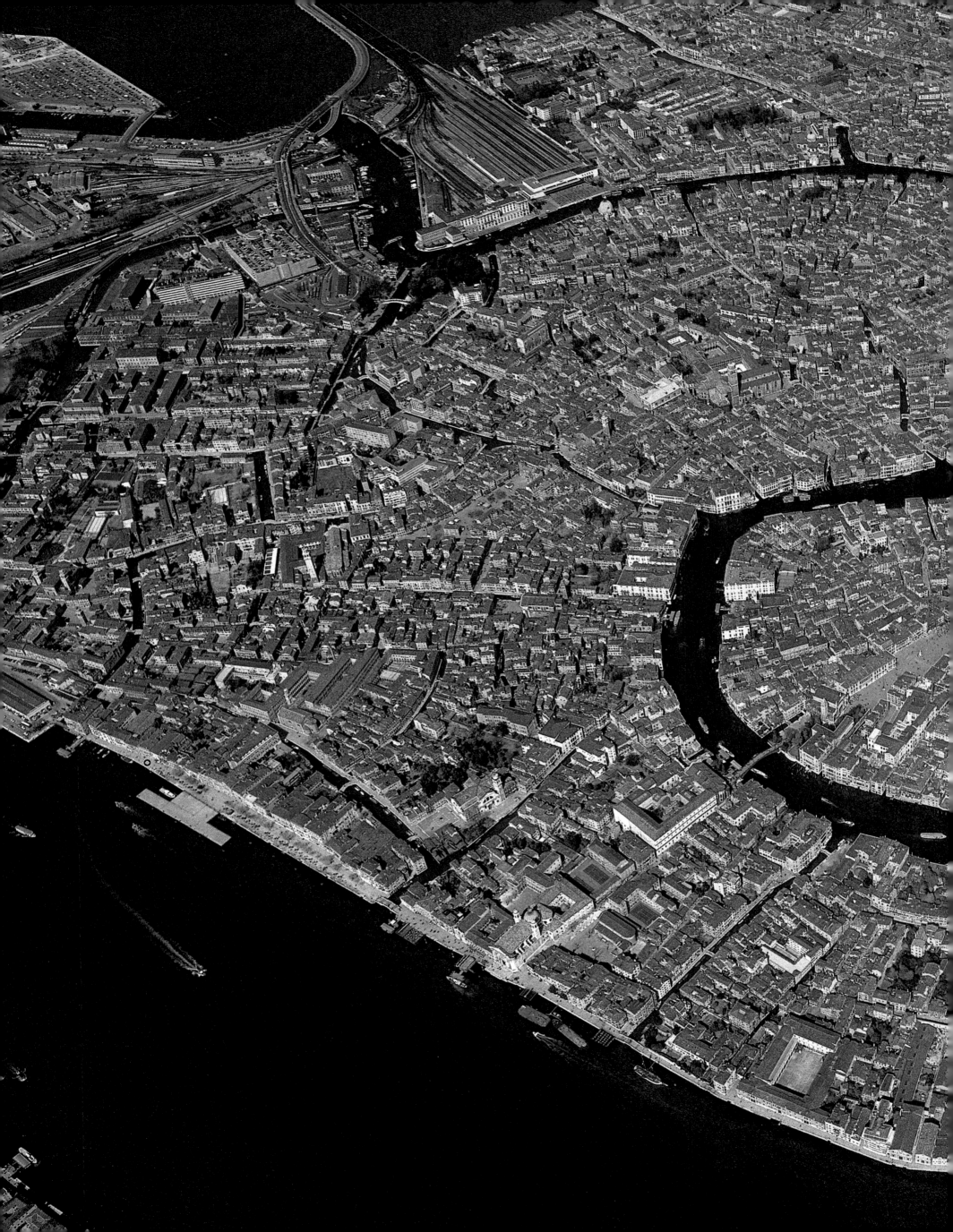

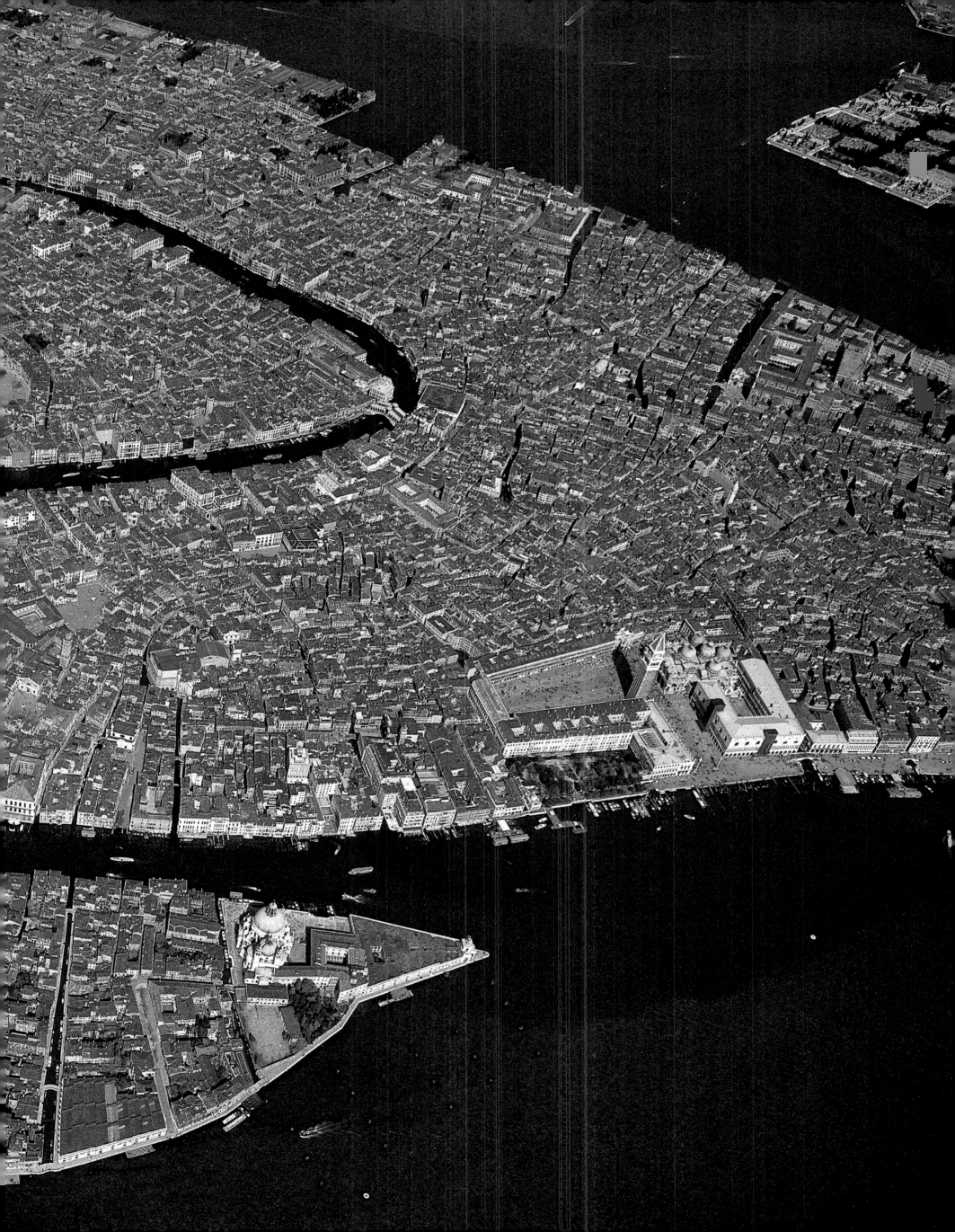

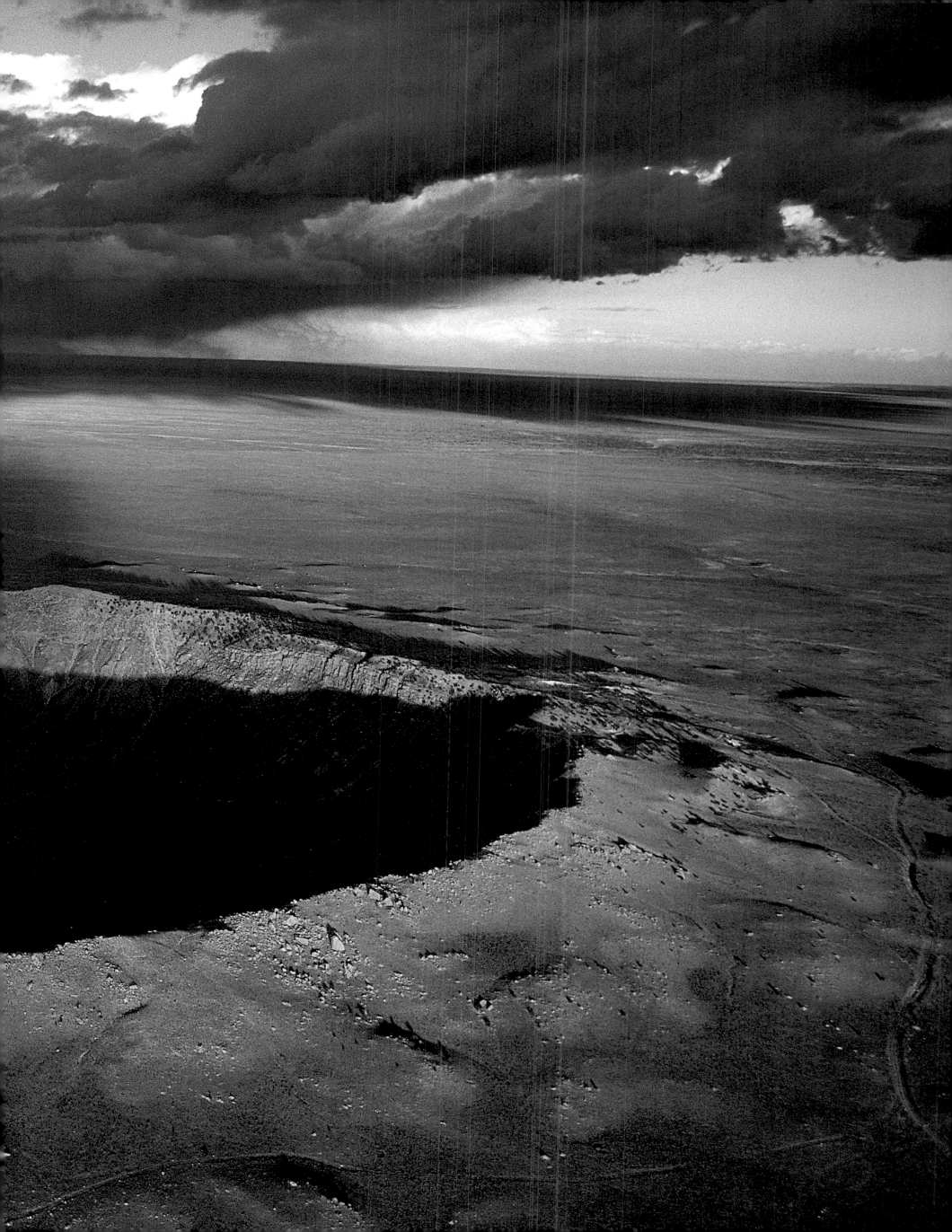

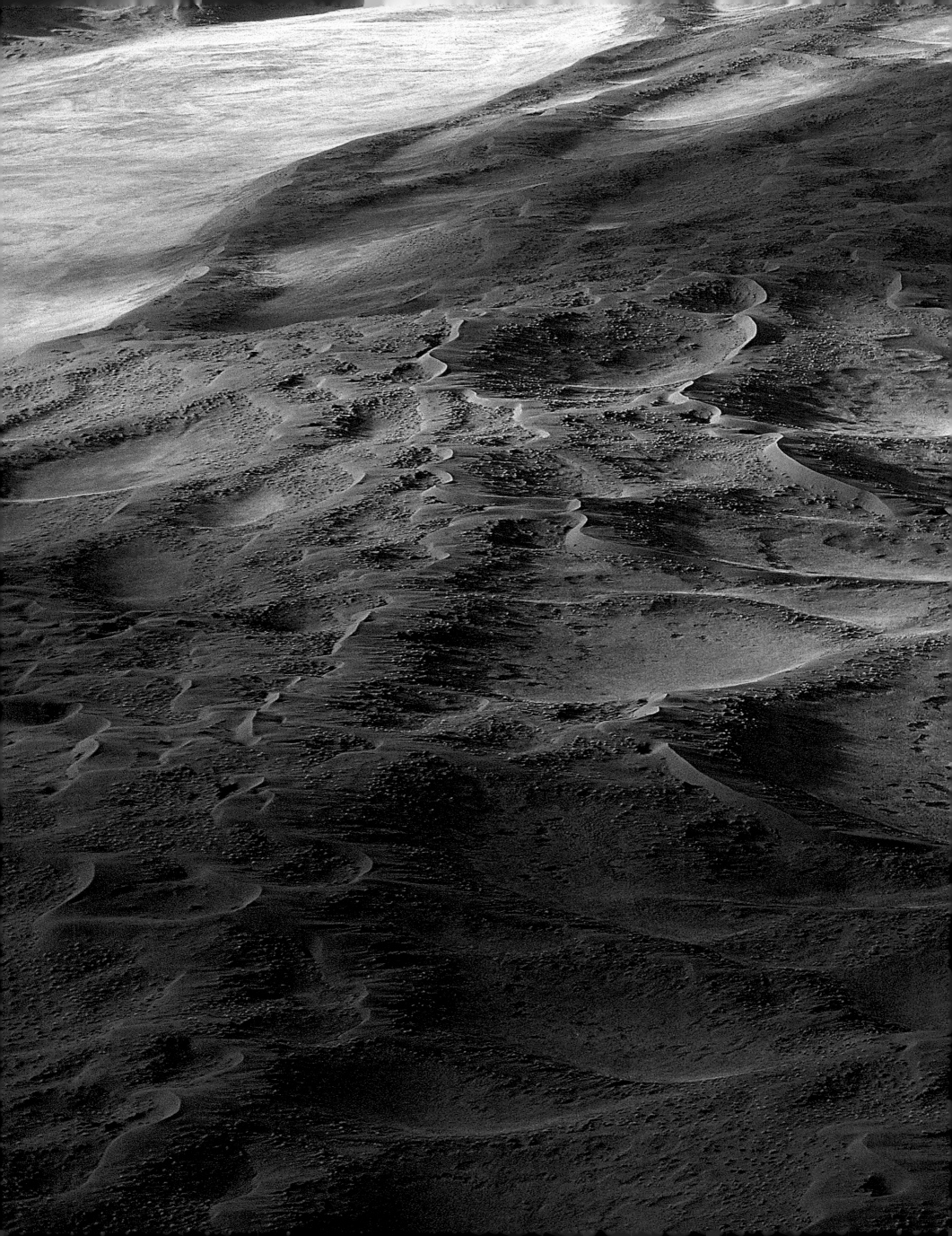

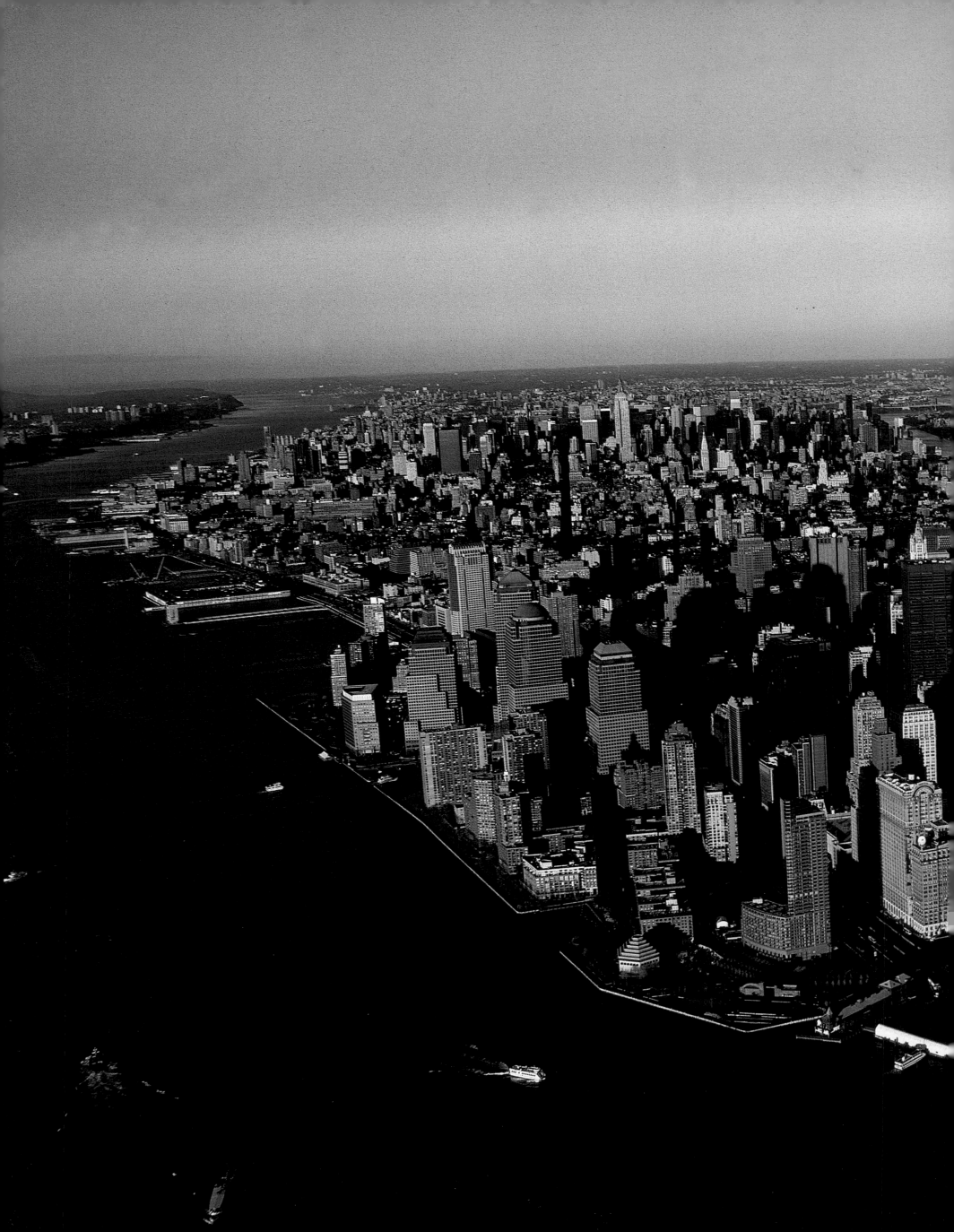

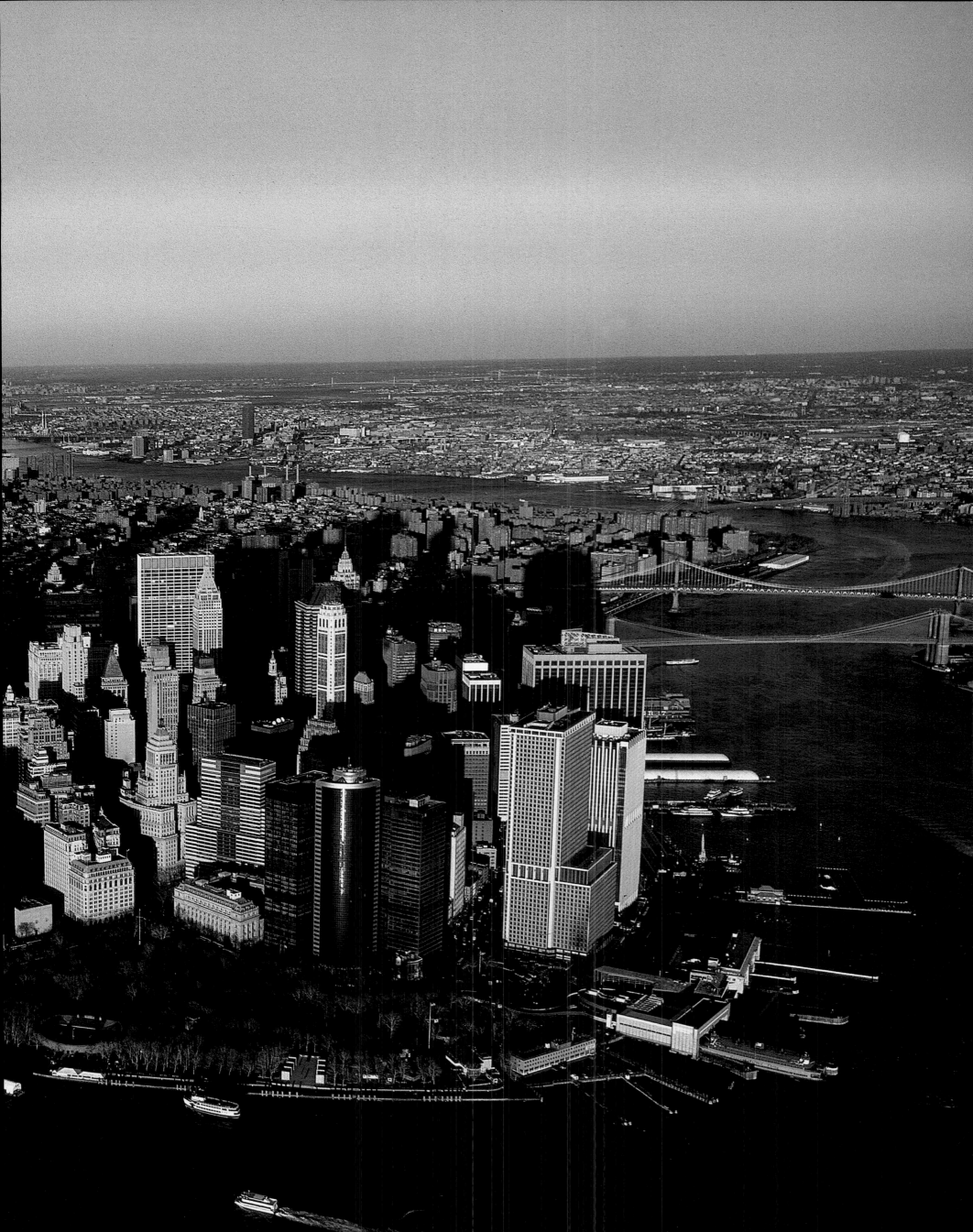

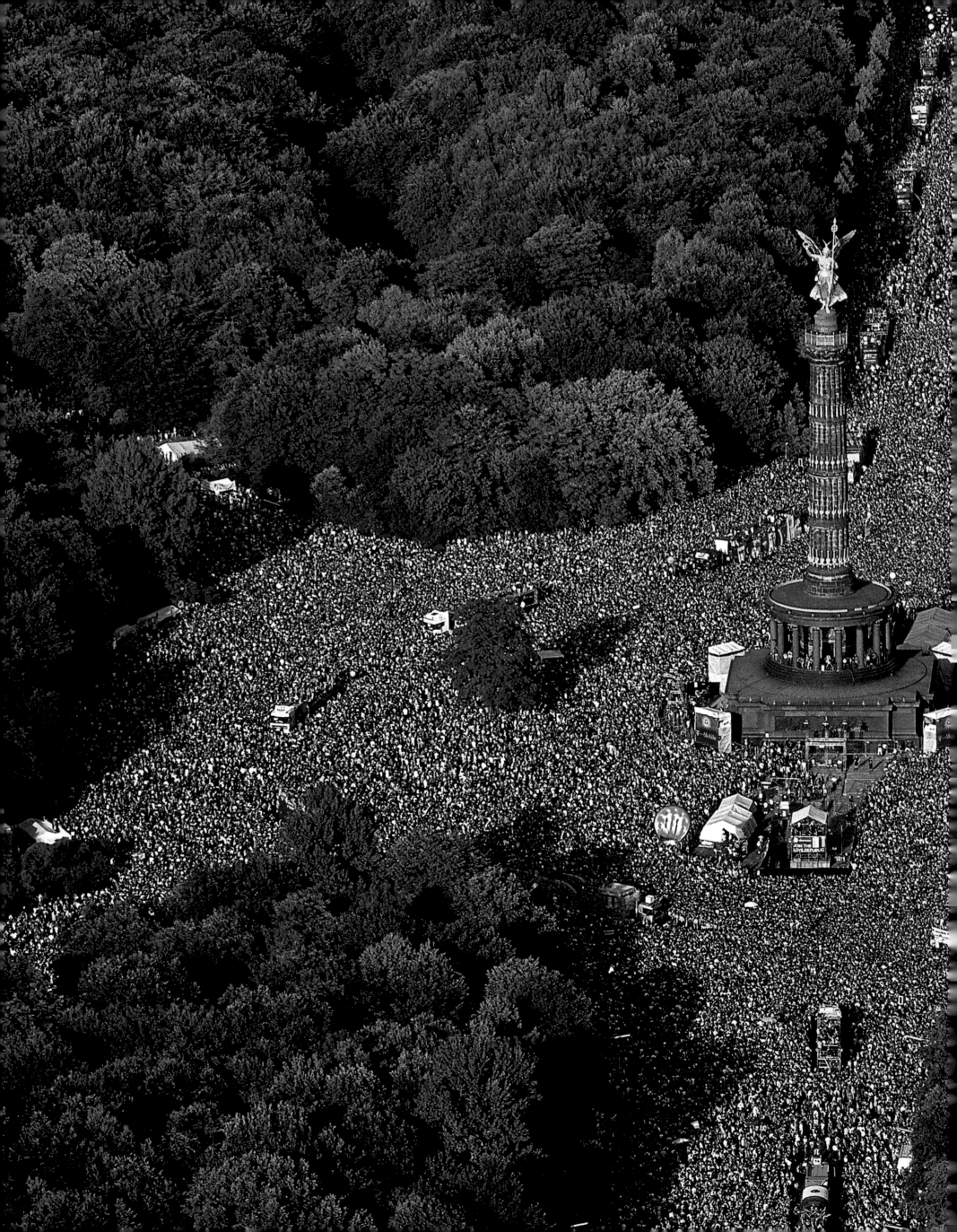

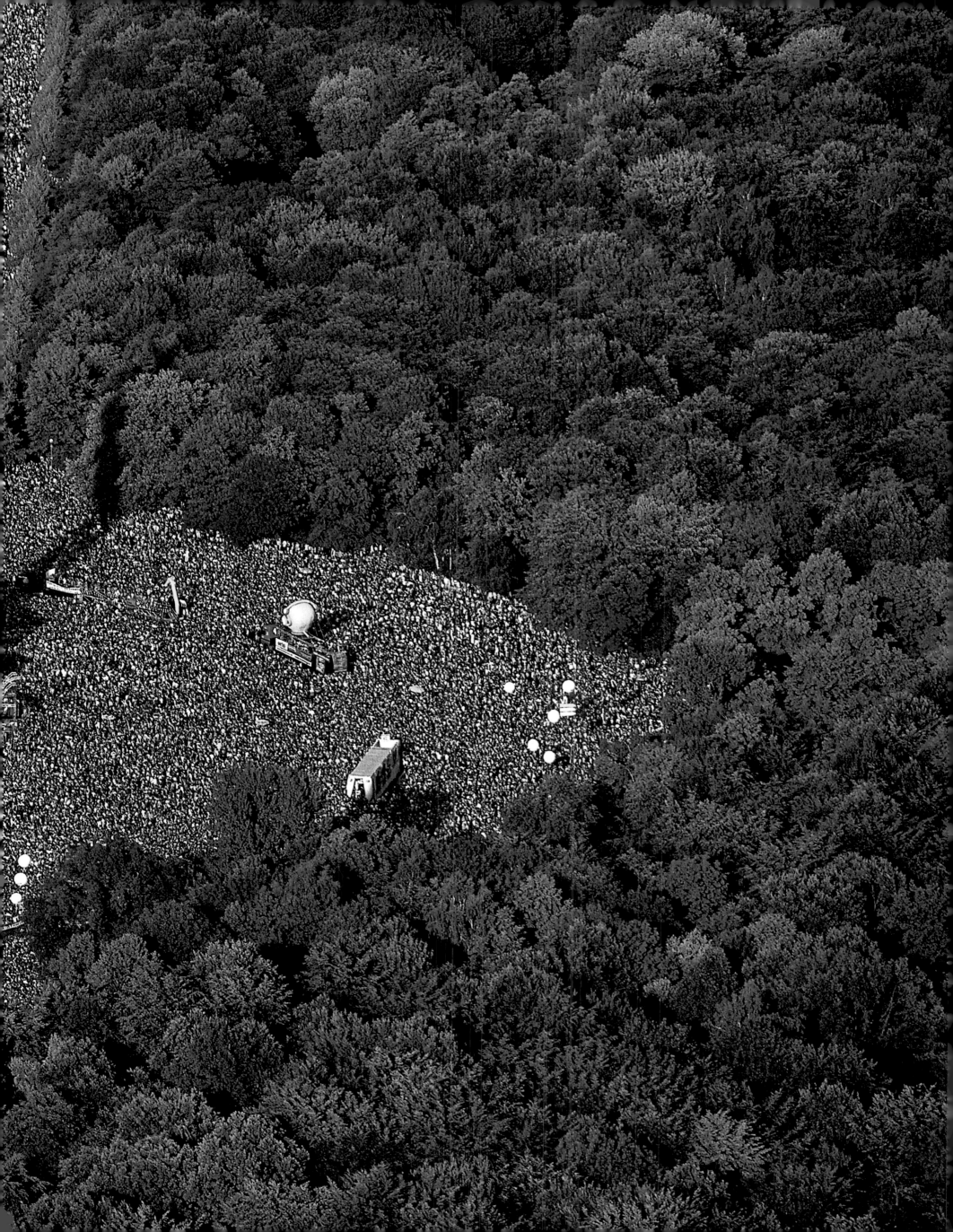

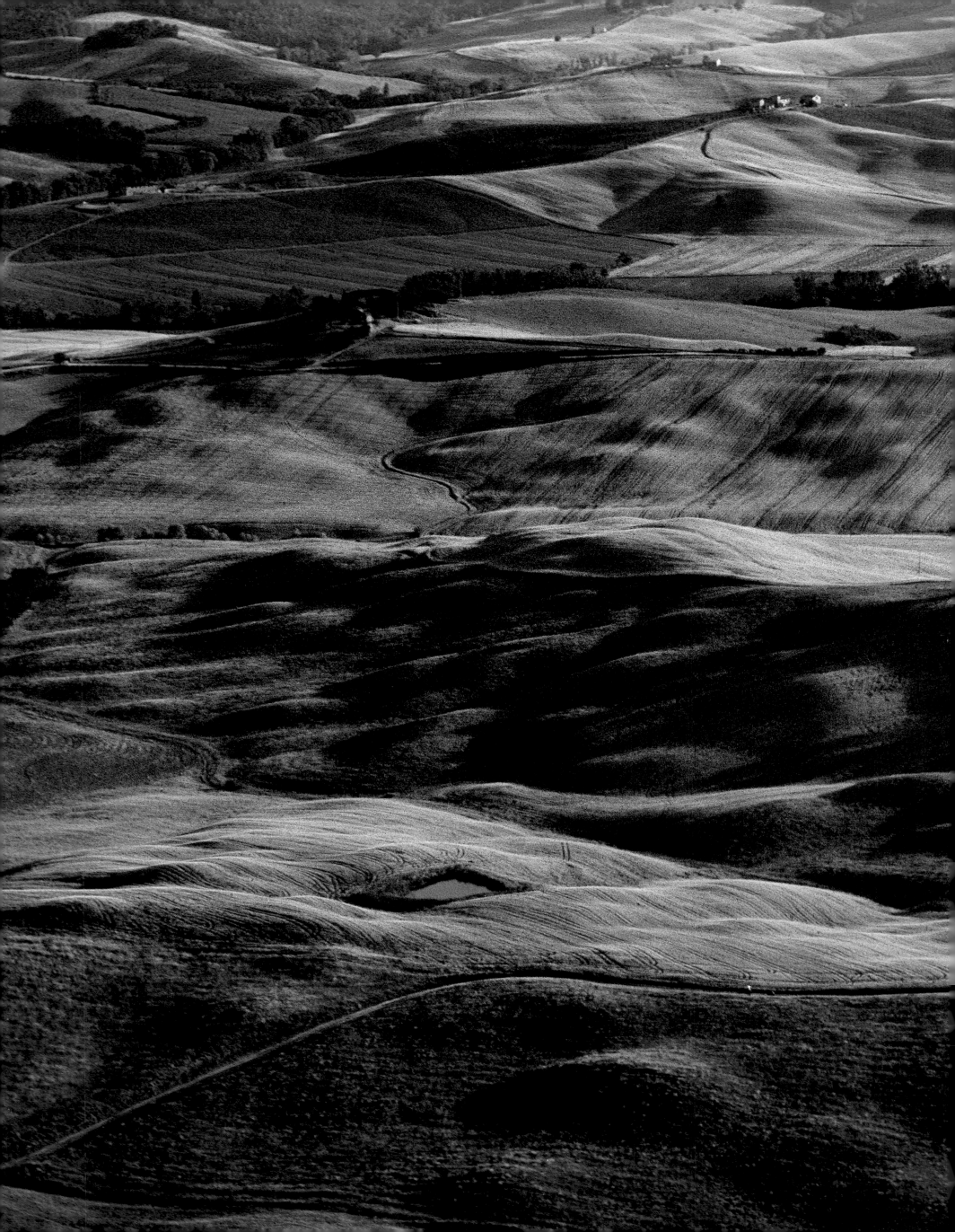

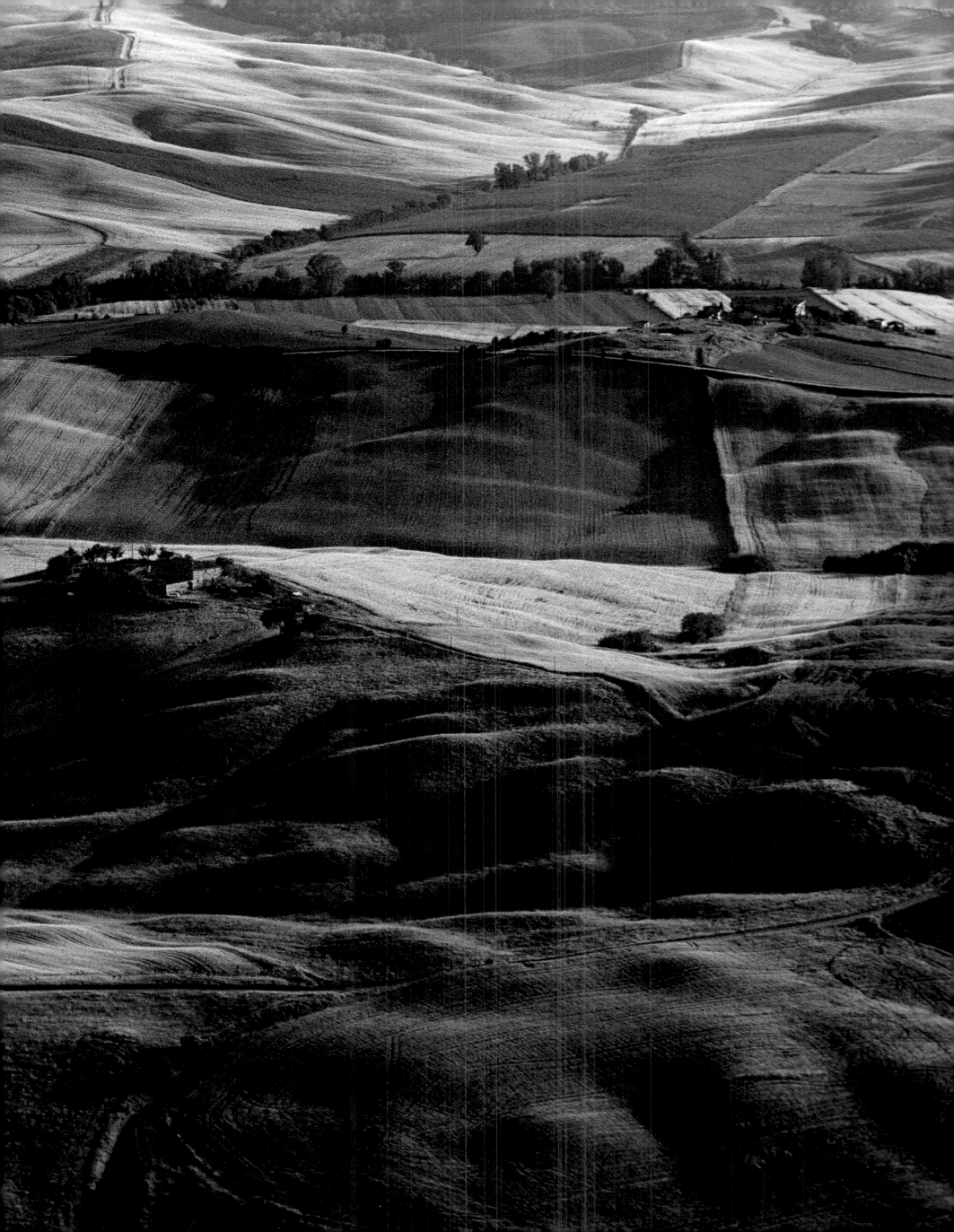

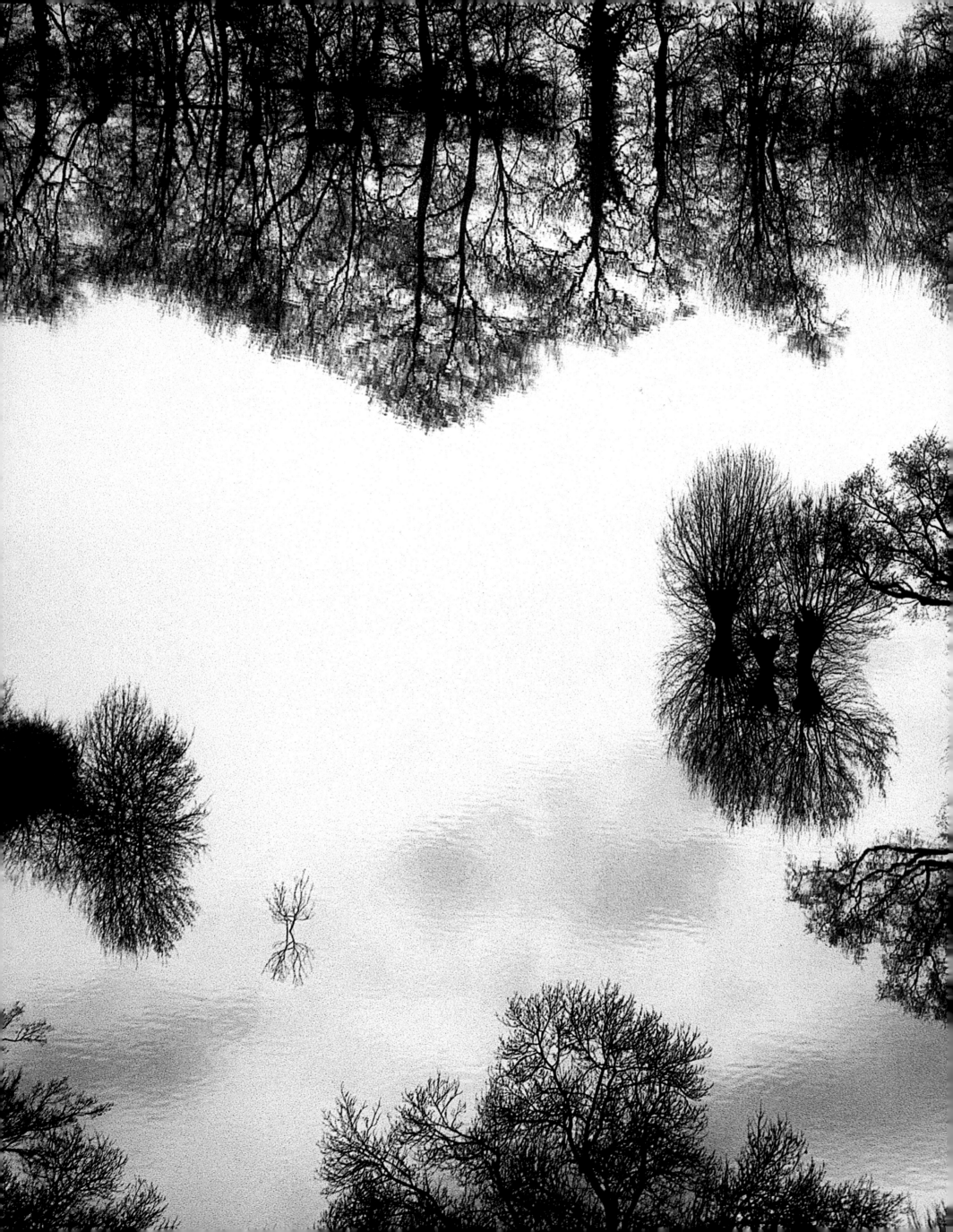

THE EARTH IN NUMBERS

- *The earth was born 4.5 billion years ago.*
- *Sea level was 230 to 295 feet (70 to 90 m) higher; temperature was 18°F (10°C) warmer.*
- *It took nature 180 million years to convert the atmosphere's carbon dioxide,*
 into underground reserves of fossil fuels (petroleum and coal).
- *The human being* (Homo sapiens) *appeared 150,000 years ago.*

ISOLATED SIGNS OF BROAD SIGNIFICANCE: SYMPTOMS OF A GLOBAL IMBALANCE

Description	Consequences
Industrial Accidents	
Feyzin, France, January 4, 1966, fire destroys a refinery in the Rhône-Alpes region	18 dead, 84 wounded
Seveso, Italy, July 10, 1976, dioxin leak from the Icmesa chemical plant	No human fatalities but 3,300 domestic animals died, and 70,000 heads of livestock had to be slaughtered.
Bhopal, India, December 2, 1984, pesticide gases escape from the American Union Carbide plant	3,000 to 6,000 dead; tens of thousands permanently disabled[1]
Chernobyl, Ukraine, April 26, 1986, accident in a nuclear reactor	At least 40 dead and about 2,000 cases of thyroid cancer[2]
Toulouse, France, September 21, 2001, explosion in the AZF chemical factory	30 dead more than 2,200 wounded; 10 to 15 billion francs' worth of damage
Oil Spills	
Torrey Canyon, **English Channel,** March 18, 1967	120,000 tons of unrefined petroleum released in the Channel
Amoco Cadiz, **English Channel,** March 16, 1978	250,000 tons of unrefined petroleum released on the coast of Brittany
Exxon Valdez, **Alaska,** March 25, 1989	37,000 tons of unrefined petroleum spilled along the Alaskan coastline
Usinsk, Russia, September 1994	65,000 tons of petroleum spilled on the ground, covering approximately 8,000 square miles (20,000 km²); billions of dollars' worth of damage
Erika, **eastern Atlantic Ocean,** December 12, 1999	10,000 tons of fuel spilled on the coast of Brittany

BOTTLE RACKS NEAR BRAUNSCHWEIG, Lower Saxony, Germany (N 52°20′ E 10°20′)

Not far from Braunschweig, in northern Germany, an avalanche of mineral water, beer, fruit juice, and carbonated drinks of all kinds is spread out in a grocery store's warehouse lot. Bottled water, estimated at a $22 billion market per year, leads all competitors in the world beverage industry. This most basic of bottled drinks is increasingly successful; world consumption is growing by 7 percent per year (15 percent in the Asian and Pacific region). One and a half million tons of plastic are used to contain the 89 billion liters of mineral water distributed in the world every year. Alcoholic drinks are still abused all over the world, a symptom of the despair and social malaise caused by poverty and unemployment. In Russia, alcoholism keeps male life expectancy at 59 years, as opposed to 72 for women.

Natural Catastrophes

El Niño, 1997, 1998, 1999, climatic disturbances in South America, Africa, southern Asia	Floods lasted for months on two-thirds of Bangladesh; mud slides destroyed millions of homes in China; Central America was devastated (see Hurricane Mitch, below); drought in Africa and Asia (causing famines and fires)
Forest fires in Indonesia, Malaysia, Brazil, Mexico, Philippines (and to a lesser extent in Australia, China, Colombia, Peru, Kenya, Rwanda, and Russia), 1997–98	More than 12.5 million acres burned; in Indonesia, 70 million people affected to various degrees;[3] more than $4.4 billion in damages;[4] 160 companies were found guilty of arson in October 1997
Hurricane Mitch, Central America, October 1998	9,745 dead, 96,000 homes destroyed, 2.5 million people helped through international assistance

A STRONG TENDENCY TO DIMINISH OUR COMMON ECOLOGICAL CAPITAL

In 1999 a quantity of oil nearly ten times the volume released from the tanker *Erika* spread throughout the marine environment:

- 257 incidents[5] occurred, spilling a total of 109,400 tons of unrefined petroleum.

Years	Millions of tons of unrefined petroleum released into natural environment	Number of incidents spilling more than 35,000 tons of unrefined petroleum
1960–1969	0.42	6
1970–1979	2.71	33
1980–1989	1.45	15
1990–1999	1.73	11
Total since 1960	**6.32**	**65**

- The number of natural[6] catastrophes—i.e., those directly attributable to weather or to earthquakes—increased fourfold in 40 years.
- The economic cost of these same natural catastrophes increased fortyfold during the same period.

Years	Number of natural catastrophes	Cost of these catastrophes ($ billions)
1950–1959	20	40
1960–1969	25	90
1970–1979	50	150
1980–1989	63	220
1990–1999	90	630

GLOBAL WARMING IS INCREASING INJURIES TO THE EARTH AND NOW REQUIRES A CONCERTED GLOBAL RESPONSE

- A little more than 300 years ago, the industries of the richest nations began to release CO_2 into the atmosphere millions of times faster than it had been stored underground.

- If no action is taken, temperatures could rise 10.8° F (6° C) by the year 2100, exposing humanity to the worst catastrophe in its entire history.
- The consequences of these climatic disturbances will be felt in economic and social as well as environmental terms.
- Today the atmosphere has the capacity to absorb only one-third of the CO_2 that we produce each year.

If prompt action is not taken, we can expect an acceleration of the greenhouse effect:

- World CO_2 emissions, the gas responsible for 70% of the greenhouse effect, have increased fourfold since 1950 and are continuing to grow.
- These emissions are the consequence of a fourfold growth in fossil-fuel consumption over the past 50 years; the consumption of oil has increased sevenfold.
- CO_2 emissions per capita are therefore increasing, growing from 3.3 tons per capita in 1990 to 4 tons per capita in 1996; e.g., a Mercedes sedan driving 10,000 miles (15,000 km) per year emits 5 tons.
- The production of wind energy, a renewable source, has grown tenfold from 1990 to 2000.
- According to the Intergovernmental Panel on Climate Change (IPCC, whose results are validated by all member states of the OECD before publication), we are capable of limiting the catastrophic consequences of global warming. To do so, we must stabilize the concentration of CO_2 in the atmosphere at the current level, and thus reduce CO_2 emissions by **50–70%** (in relation to the 1990 level).
- However, in the international Kyoto agreement of 1997, wealthy nations only agreed to reduce emissions by **5.4%** from the emission level of 1990. Even though this figure is very inadequate, many countries are still delaying ratification of the agreement and enactment of its measures.

The effort required by the residents of various countries to conform to an energy consumption level that respects the environment:

Country	Emissions of carbon equivalent kg/person/ year[7] (1998 basis)	Consumption per person above sustainable level
Inhabitant permitting a sustainable development	500	1 time (IPCC reference)
United States	6,250	13 times
Germany	3,333	7 times
France	2,272	4.5 times
Mexico	1,000	2 times
Mozambique	416	Less

- The United States, Japan, and the European Union produce more than 40% of world CO_2 emissions.
- At the opposite end of the spectrum, Bangladesh, with its 120 million inhabitants concentrated in 55,600 square miles (144,000 km²), slightly smaller than the state of Wisconsin, emits less greenhouse gas than the city of Chicago alone.[8]

A drastic reduction in energy consumption would limit the environmental risks that will occur with climatic change:
- Environmental and social costs of catastrophes attributed to climatic changes are estimated at $300 billion per year.
- Anticipated costs from climatic changes for the period 2000–2020 are estimated at $9.3 trillion, or $465 billion per year.

The first environmental refugees are about to exceed the number of political refugees:

Type of refugee	Number of refugees
Environmental refugees, Tuvalu, November 2001	10,000
Environmental refugees, Bangladesh, 2020	20 million
Refugees in the world since 1950	More than 50 million[9]
Refugees in the world in 2001	12 million[10]

• According to the United Nations Environment Programme, the energy consumption of the wealthy nations should be reduced by 90% in order to limit the catastrophes, which would mean conforming to an environmental "war economy."
• In fact, this massive effort would resemble the one successfully implemented by Great Britain, which achieved a 95% reduction in the use of motor vehicles,[11] while increasing the use of public transport by 78%, between 1938 and 1944.

THE ENERGY INDUSTRY REMAINS THE FOUNDATION FOR ALL HUMAN ACTIVITY, AND ITS CURRENT ORGANIZATION IS RESPONSIBLE FOR THE GREENHOUSE EFFECT:

• Energy demand is continually growing by 2% per year, and fossil fuels make up 89.6%, although 10 other possible energy sources[12] exist.
• World population has doubled since 1950.
• Global energy demand has increased more than fivefold.
• Today we consume in six weeks as much oil as was used in a year in 1950.
• Oil consumption is now at 67 million barrels per day.
• If consumption by the countries of the Organization for Economic Cooperation and Development (OECD, which includes 28 of the wealthiest nations in the world) continues to increase, world energy demand will increase by 65%,[13] which corresponds to a 70% increase in CO_2 emissions.
• Two-thirds of this increase will occur in developing countries, and 95% of this trend will concern fossil fuels, largely because of transportation, which today makes up 54% of oil consumption and 25% of greenhouse-gas emissions[14] (and more than 40% if consumption behavior does not change by 2010).

INEQUALITIES BETWEEN RICH AND POOR ARE INCREASING AS GLOBAL WEALTH GROWS

• The three richest families in the world have a fortune greater than the total gross domestic product (GDP) of the 48 poorest developing nations.
• 4% of the wealth of the 225 most wealthy families would provide access to basic needs and fundamental health care, education, and nutrition for the world.[16]

A debt—a tax levied on future generations—that grows more onerous
• The debts of poor countries derive primarily from imports of oil and arms.
• Foreign debts of developing countries have increased more than sixfold since 1970, reaching $2.8 trillion in 1999. This figure is only 5% of the debt of wealthy nations.
• Permanent members of the United Nations Security Council produce 81% of conventional arms exports.
• The price of a new nuclear submarine equals the annual budget of the 23 most underdeveloped countries.[15]

Debt is not the only cause of difficulty in developing nations, but it seriously aggravates problems by pushing countries to overexploit their natural resources.

• In the 1980s interest rates imposed on poor countries were four times higher than those imposed on wealthy countries.[16]
• In 1995 Mozambique spent 3.3% of its budget on health care, 7.9% on education, and 33% on debt payment.

• The total debt of the wealthy countries is 20 times that of the poor nations.

Country	Amount of national debt (in $ billions)[17]	Amount of public debt (in % of GDP)
Nicaragua, 1995	6.7	278%[18]
France, 2000	710	58%
United States, 2001	5,943	56%
Total, non-OECD countries	**1,115**	
Total, OECD countries	**22,293**	

Public assistance and investment are on the decline
• Direct foreign investment in developing countries has been cut in half since 1997.

Year	Direct foreign investment in developing countries as a percentage of total flow[19]
1997	43%
1998	30%
1999	23%
2000	21%

• Foreign aid for poor nations[20] given by member nations of the Development Assistance Committee of the OECD[21] represents an average of 0.22% of their gross national product (GNP), far below the 0.7% they had committed to pay at the Rio Summit in 1992.
• The World Bank notes that the rate of increase of revenue per capita for developing countries open to globalization has grown 3.5 times faster than that of countries that are not open.[22]

Development is not measured only in wealth, and it continues to progress
Wealth is only one of the means that enable people to live better. The United Nations Development Programme (UNDP) has created a Human Development Index (HDI), which measures the average level of development reached by a country as a function of criteria such as per capita income, life expectancy, and access to education.

• Between 1975 and 1999, the HDI shifted from a predominance of countries with low or medium development to a predominance of medium and high.[23]

Our apparent wealth is based on an economic growth whose indicators ignore the state of natural resources (for instance, deforestation of a country is entered as a "creation of value").

• Since the 1970s the earth's natural wealth has diminished by one-third because of human activity.[24] The increase in collective wealth has also decreased:

Type of country	Annual Growth of GDP per capita (in %)	
	1975–1990	1990–1999
Developing countries	2.3	3.2
Eastern Europe and former URSS countries	–	–3.4
OECD countries	2	1.5
World	**1.3**	**1.1**

• Vietnam and Pakistan have the same per capita GDP, but Vietnam has a human development index that is about 50% higher than that of Pakistan (in 1999).[25]

THE WORLD POPULATION CONTINUES TO GROW AND URBANIZE

• From a growth rate of 2% in 1975, or a doubling of world population every 35 years, the population growth rate has reached 1.2% today, or a doubling of the world population every 55 years.
• This change in the growth of the number of individuals could lead to a stabilization of world population at about 8 billion in 2040.
• If the earth were reduced to a village of 100 residents, 58 would be living in Asia, 14 in Africa, 10 in South America, 8 in Europe, 5 in North America, 4 in Russia, and 1 in Oceania.[26]

Year	Urban Population (in billions of people)	Urban population as a percentage of total population
1950	0.8	30%
2000	2.9	47%
2050	6.2[27]	70%

• The mortality rate among children below five years of age was almost cut in half between 1980 and 1998, from 123 to 75 per thousand.
• The world population of people aged 15 to 64 increased from 57% (2.595 billion) of the total population in 1980 to 71% (3.761 billion) in 1990.
• The total active population also increased between 1980 and 1999, from 45% (2.035 billion) to 49% (2.892 billion), as did the proportion of active women, from 39% to 41%.
• The proportion of working children aged 10 to 14 decreased from 20% to 12%.
• Between 1970 and 2000 life expectancy at birth rose from 60 to 67 years, and infant mortality (per 1,000 live births) decreased from 100 to 55 children.
• Between 1970 and 2000 the literacy rate among adults rose from 64% to 80%, secondary school attendance increased from 22% to 60%, and the number of children not attending school was reduced from about 380 million to 320 million.
• Individual income in developing countries was higher in 1998 than in 1975, and their per capita GDP rose from $1,200 to $2,250.

These results mask serious disparities in rates of change and in the levels reached by various regions and populations, especially differences between cities and rural areas and between men and women.

Blatant inequalities between men and women, rich and poor

• Everywhere in the world, the female population suffers more serious shortfalls, and women's situations improve more slowly. For instance, women's literacy rate is 10% below that of men, and female infant mortality is 10% higher than that of the male population.
• In 1995 an estimated 1.8 million women and girls were victims of prostitution.
• In Zambia, AIDS is causing a dramatic reduction in life expectancy, which has now fallen to 37 years.
• One-fifth of Zambians who are today older than 15 years of age will die prematurely, most during the next 3 to 10 years.

80% OF THE POPULATION LIVES IN DEVELOPING COUNTRIES—4.9 BILLION PEOPLE

Health

• 2.5 billion people (2 out of 5) have no adequate health supplies; 10% of the water used in developing countries has been treated.
• 1.1 billion people (1 out of 6) have no access to drinkable water.
• 0.5 billion people live in a state of water shortage in countries where water is removed at a rate that exceeds its renewal.
• One person out of five in the world has no access to modern medical services.
• 95% of people infected with AIDS (more than 35 million) live in developing countries.
• AIDS kills 6,000 people and infects 11,000 in Africa daily.
• 826 million people (1 out of 5) are malnourished.
• Women in poor countries are 200 times more likely to die of complications from pregnancy than those in wealthy countries.

Education

• 110 million children (1 out of 5) do not attend school.
• 900 million adults (1 out of 5) can neither read nor write; 98% of them are in developing countries, and two-thirds are women.

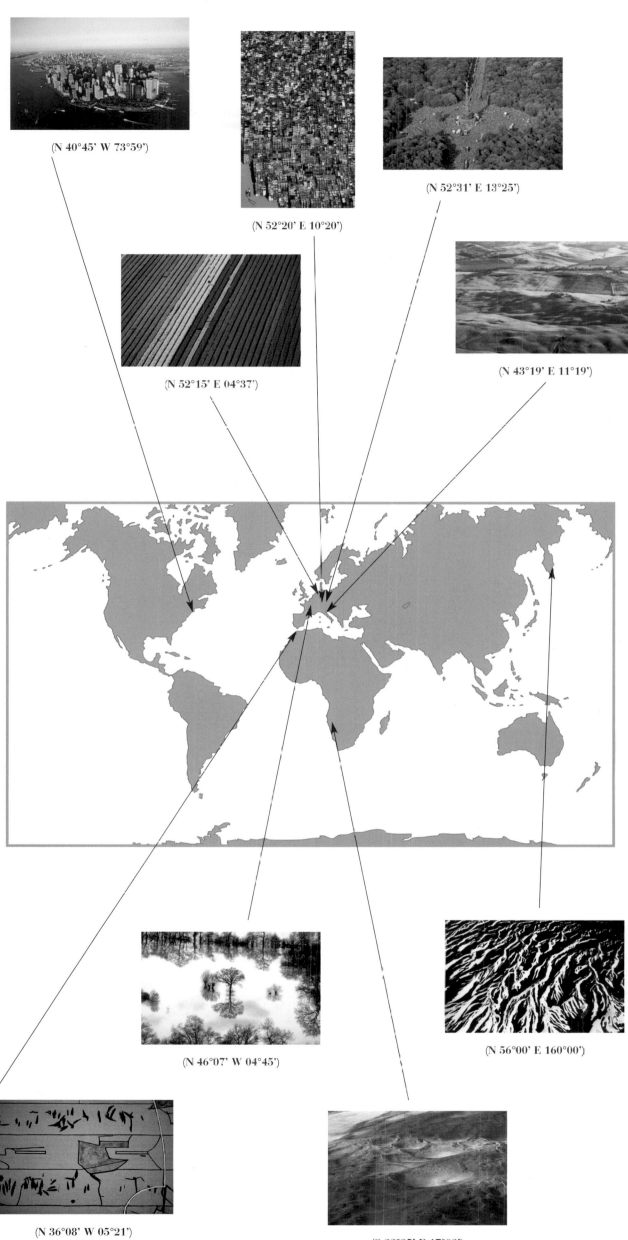

(N 40°45' W 73°59')

(N 52°20' E 10°20')

(N 52°31' E 13°25')

(N 52°15' E 04°37')

(N 43°19' E 11°19')

(N 46°07' W 04°45')

(N 56°00' E 160°00')

(N 36°08' W 05°21')

(S 22°35' E 17°02')

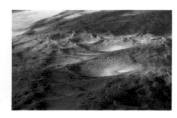

pp. 432–33
BEGINNING OF THE
NAMIB DESERT,
west of Gamsberg, region
of Windhoek, Namibia
(S 22°35' E 17°02')

The road linking Windhoek, Namibia's capital, to the beach re-
sort of Walvis Bay crosses the plateau of the Gamsberg, one of
Namibia's highest mountains at 7,650 feet (2,334 m). The Namib
Desert, formed 100 million years ago, is believed to be the world's
oldest. It consists largely of stony plains but also includes 13,260
square miles (34,000 km²) of sand dunes, which are the highest
on earth (984 feet, or 300 m). The Namib is also the only place
on earth inhabited by the *Welwitschia mirabilis* plant, specimens
of which are as old as 1,500 years. The fragile balance of this arid
ecosystem is preserved in part by two national parks, which oc-
cupy a total of 26,000 square miles (66,400 km²), one-fourth the
total area of the Namib.

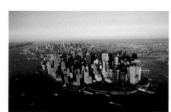

pp. 434–35
GROUND ZERO,
World Trade Center
disaster site, New York,
United States
(N 40°45' W 73°59')

Within months of the terrorist attacks of September 11, 2001,
which destroyed the World Trade Center, the remains of the twin
towers and the five other buildings in the complex have been
completely cleared, leaving a large void in the heart of Lower
Manhattan. More than 2,800 people died here; incredible acts of
heroism by firefighters and civilians prevented the loss of even
more lives. Both towers rose more than 1,360 feet (415 m), and
they were the tallest buildings in the world when they opened
in 1970–73. The complex provided a total of 10 million square
feet of office space, where 50,000 people worked, on an area
of 16 acres. Despite the tremendous loss, New York is recovering
strongly. The rebuilding of the district will be respectful of the
fact that the site is now a burial ground that must have a suitable
memorial.

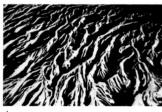

pp. 436–37
"LOVE PARADE" IN
TIERGARTEN PARK,
Berlin, Germany
(N 52°31' E 13°25')

In 1989 a Berlin disk jockey brought together 150 fans of elec-
tronic music for a modest party. Thirteen years later it has
become the "Love Parade," an enormous festival that draws a
million young people to dance to the rhythm of techno music.
The Berlin Love Parade is already being imitated in Paris,
Zurich, Geneva, and Newcastle. A Love Parade was planned for
Moscow in 2001, but the mayor's office canceled it, issuing a
statement that the festival would encourage debauchery and
that homosexuality was immoral. The mayor may have con-
fused the Love Parade with the Gay Pride Parade, for which he
also refused permission. In many countries homosexuality re-
mains a source of discrimination and violence.

pp. 438–39
SNOW-COVERED
FLANKS OF KRONOT-
SKAYA VOLCANO,
Kamchatka Peninsula,
Russia
(N 56°00' E 160°00')

At the eastern tip of Siberia, Kamchatka Peninsula spreads
over nearly 145,000 square miles (370,000 km²). This region of
Russia is ruled by nature, and humankind is barely present (the
population density is below 1 person per km²). The peninsula is
geologically very young (less than 1 million years) and includes
160 volcanoes, including 30 that remain active; they were
declared a UNESCO world heritage site in 1996. Kronotskaya
Volcano is one of the highest, at 11,570 feet (3,528 m). The 3,500
square miles (9,000 km²) of the Kronotsky Reserve are home to
several protected species: the Kamchatka brown bear, lynx, sable,
and fox. Facing Kamchatka across the Bering Strait, Alaska offers
a similar landscape. Twenty-six thousand years ago small groups
of people crossed the strait, at that time dry land, and gradually
populated all of the Americas. The Sioux, the Inca, and the
Guarani are all descendants of the people from Kamchatka.

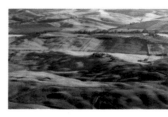

pp. 440–41
COUNTRYSIDE
AROUND SIENA,
Tuscany, Italy
(N 43°19' E 11°19')

Washed by the Tyrrhenian Sea, Tuscany in central Italy is one
of the loveliest regions of the entire peninsula. Tuscany owes
part of its fame to its hills, covered with vineyards, olive trees,
corn and barley fields, and punctuated with medieval villages.
Tuscans developed "ecotourism" at an early date. Local enter-
prises, especially artisans, now adhere to Social Accountability
8000 (SA 8000), an international standard based on the princi-
ples of human rights delineated in International Labour Organi-
zation Conventions, the U.N. Convention on the Rights of the
Child, and the Universal Declaration of Human Rights. SA8000
is a voluntary standard that ensures that economic development
occurs through the ethical sourcing of goods and services.

pp. 442–43
TREES AMID THE
WATERS NEAR
TAPONAS,
Rhône, France
(N 46°07' W 04°45')

In Taponas, in the Rhône region between the hills of Beaujolais
and the hundreds of ponds scattered among the swampy
Dombes area, the Saône River overflowed from March 20–23,
2001. This is a recurring natural phenomenon in the low-lying
zone, downhill from the confluence of the Saône and the Doubs
Rivers. Several areas in eastern and central France were sub-
merged in the spring of 2001. The series of floods were caused
by torrential rains that fell on a ground already gorged with
water and on underground water tables saturated by recent
rains. However, capricious climate was not alone responsible.
Human action also played its part with construction in flood-
prone areas, obstacles to water drainage (urban and transport
infrastructure), poor maintenance of rivers, and deforestation.

pp. 444–45
DETAILS OF THE
TARMAC OF THE
AERODOME AT
GIBRALTAR,
United Kingdom
(N 36°08' W 05°21')

On the tarmac of the Gibraltar airfield, at the southern tip of the
Iberian peninsula, geometric traces of signs and the repairs in the
asphalt create this strange piece of abstract art. The air-transport
sector, with 28 million jobs and an estimated value of $1.4
trillion, figures prominently in the world economy. It is vulnerable
to international insecurity, however, as was seen after the terrorist
attacks in the United States on September 11, 2001: companies
went bankrupt, and 120,000 jobs were lost. For the past ten
years, air traffic has shown an average regular growth of 6 percent
per year; 1.5 billion tickets were sold in 2000. If this trend con-
tinues, by 2010 some 20,000 planes will crowd the skies to trans-
port 2.3 billion travelers. To avoid the congestion of air space,
giant planes with as many as 600 seats are preparing for takeoff.

pp. 446–47
FIELDS OF TULIPS
NEAR LISSE,
near Amsterdam,
Netherlands
(N 52°15' E 04°37')

In April and May of every year, Holland briefly dons a multicol-
ored garb. Since the first flowering in 1594 of bulbs brought
back from the Ottoman Empire by the Austrian ambassador,
four centuries of selection have led to the development of more
than 800 varieties of tulip. On more than 50,000 acres (20,000
hectares), half devoted to tulips and one-quarter to lilies, the
Netherlands produce 65 percent of the world production of
flowering bulbs (or some 10 billion bulbs) and 59 percent of the
exports of cut flowers. Dutch agriculture, which employs 5 per-
cent of the active population, is one of the world's most intensive
and places the country third among world exporters of agricul-
tural produce (after the United States and France). But chemi-
cal products have caused a deterioration in the water; Holland is
thus beginning to use natural predators to protect its crops from
illness and harmful insects, especially in the horticultural sector.

Financial Poverty

- 2.8 billion people (47%) live on less than $1.75 per day.
- The 50 poorest countries' share in world trade declined from 4% to 2% in the past ten years (ending in 2000).

Children

- 33% of children under 5 years of age suffer from malnutrition.
- Diseases transmitted by air kill more than 25 million people per year, half of them children.
- More than 300,000 children in the world, of both sexes, are child soldiers; many are below 10 years of age.

Energy

- 2 billion people (1 out of 3) have no electricity.
- 96% of deaths caused by natural catastrophes take place in developing countries.

20% OF THE POPULATION LIVES IN DEVELOPED COUNTRIES—1.2 BILLION PEOPLE

The residents of these countries:
- represent 86% of private consumer expenditures
- have a 67% share of world trade ($7 trillion)
- consume 60% of total world energy
- eat 45% of the meat and fish consumed in the world
- own 87% of the vehicles in circulation in the world
- consume nearly 75% of available freshwater

In these wealthy countries:
- unemployment is at its all-time low, at about 4%
- total debt is 10 times higher than in poor countries
- 34 million people are underfed, 8 million are malnourished
- 15% of adults are illiterate (1998)
- 130 million people live in poverty (live on less than half of the per capita GDP; 1999)
- 1.5 million people are HIV-positive or infected with AIDS (2000)

Malnutrition is a problem of distribution not a problem of quantity

Some countries stockpile part of their grain production, while elsewhere the population is hungry.

World grains (wheat, rice, corn, barley, etc.) 2000–2001[28]	Quantities (in million tons)
Total production	1,444
Exported production	209
Stockpiled production	239

- About 40%[29] of grain produced is used to feed animals. Arable lands are a limited resource. As the number of inhabitants grows, so do ecological pressures: urbanization, desertification, floods, and so on.
In consequence, land for grain production per inhabitant has been reduced by half in 50 years. At this rate, widespread malnutrition from a lack of food worldwide could be reached quickly.
In the course of the past half-century in the world:
- the population has doubled
- the volume of fishing has increased fivefold
- meat production has increased fivefold
- soya production (mainly intended for feeding livestock) has increased sevenfold
- use of fertilizer has increased tenfold

THE MOST VITAL OF THE WORLD'S RESOURCES ARE BECOMING EXTINCT, ACCENTUATING IMBALANCES

Reduction of biodiversity

The disappearance of natural sites is causing a loss of biological diversity, one of the consequences of which is the reduction of local agricultural practices.

- Nearly half of the 17,000 nature reserves in the world are now used at least in part for farmland.
- In 2000, 24% of mammal species and 12% of bird species were threatened with extinction.
Life on earth is concentrated in the same small zones as the ones colonized by humankind: coastal areas (which contain mangrove forests in the tropical zone and coral in the marine zone) and wetlands (which today are subject to the most human pressure, to the detriment of tropical forests).

- More than half of **coral reefs** on the planet are potentially endangered.

Geographic zone	Percentage of coral reefs already destroyed[30]
Indian Ocean	59%
Middle East	35%
Southeast Asia	34%
Atlantic and Caribbean	22%
Pacific Ocean	7%

- Half of the **wetlands** originally on the planet have been destroyed.

Geographic zone	Percentage of wetlands already destroyed[31]
Oceania	70%
Europe and North America	60%
Asia	27%
South America	6%
Africa	2%

- Half of **mangrove** forests, essential to the life of 75% of commercial marine life species, have disappeared.
- Of the 50% remaining, half are still endangered, in part because awareness of their essential role has developed too late.
- **Natural tropical forests** are essential to world biodiversity, and yet deforestation is continuing at the same rapid rate, at about 37.5 million acres per year (equal to the total area of Florida).
- Between 1990 and 2000 deforestation accelerated: in ten years, the equivalent of the total area of California, Texas, Florida, and Washington has been lost.

Recent initiatives give some cause for hope for the preservation of this shared capital, such as the certification of forests with labels from the Forest Stewardship Council (FSC), begun in December 1995, or the World Commission on Forests and Sustainable Development (WCFSD), formed in 1995 under the aegis of the United Nations, permitting the protection of entire zones.[32]

Year	Remaining tropical forest surface (millions of acres)	Certified tropical forest surface (millions of acres)
1982	5,000	0
2002	4,250	11.57 (as of June 2001)[33]

- The rate of destruction of the forest has doubled between 1980 and the 1990s.[34]
The forest is not destroyed to nourish local populations but mainly to clear land for the cultivation of grains, in order to produce low-cost feed for the livestock of wealthy countries.

- Deforestation also increases the greenhouse effect and soil degradation.
- Deserts are advancing at the rate of 23,400 square miles (60,000 km²) per year (equal to the total area of the Benelux countries [Belgium, the Netherlands, and Luxembourg]).

Year	Deserts as percentage of total land surface[35]
1980	30%
2010	40%

- The seas are also in trouble: 75% of commercial species today are not being renewed, as a result of overfishing.

Water: a disappearing natural resource

- The water on earth is 97% saltwater; three-quarters of the 3% that is freshwater is immobilized in the form of ice or buried very deep.
- The only portion available for keeping humanity alive and sustaining our activities represents less than one-thousandth of the planet's water.

- In the twentieth century the number of humans has tripled, while consumption of freshwater has increased sixfold.[36]
- It is estimated that this consumption will increase by 4% to 8% per year if our management does not change. Agricultural water needs in developing countries could double every 20 years.
- It takes 1,500 tons of water to bring a ton of wheat to maturity, triple that for a ton of rice,[37] and 500 tons to build an automobile.

Use of freshwater in the world

- 70% for agriculture (irrigation, including the three-quarters that evaporates)
- 22% for industry
- 8% for domestic uses (including 50% lost in leakage in pipe networks)

Access to water is also a problem of distribution: whereas 15% of the world's freshwater resources are located in the Amazonian basin, which now has 0.3% of world population, some 60% of the world is in a situation of chronic water shortage.

Distribution of water availability in the world

Country	Consumption of drinking water, per day and per person	Excess consumption per person, beyond a sustainable level
Inhabitant permitting sustainable development	50 liters for essential needs (drinking, washing, toilet, food preparation, etc.)[38]	Multiple of 1 (WHO reference)
France	More than 212 quarts (200 liters)	Multiple of 4
U.S.	668 quarts (630 liters)	Multiple of 12
Least industrialized countries	Less than 21 quarts (20 liters)[39]	Below

Availability of water in the world is uneven, depending on region:
- most watered regions: 788 inches (20 m) of rainfall per year
- least watered regions: less than 8 inches (0.2 m) of rainfall per year

The quantity of available water per inhabitant has declined by more than 30% since 1970:

Year	Volume in cu. ft.(m³)
1950	561,000 (17,000)
1990	264,000 (8,000)
2001	257,400 (7,800)
Minimum necessary per person per year	33,000 (1,000)

If the current trend continues 1.5 billion people will not have a sufficient volume of water to live in 2025.
- In 1992 the Blue River, one of the two longest rivers in China, dried up for a few days as a result of irrigation; in 1997 it dried up for a few months.[40]
- Since 1950, 40 to 80 million people in the world have been displaced to make room for the building of reservoirs[41] and dams.

Oil: a disappearing natural resource

- 900 billion barrels have been consumed to date, from a stock that remains the same. American oil reserves are estimated at 115 billion barrels, and they are expected to run out by about 2010.[42]
- The portion of oil among primary energy sources will remain at 40% until 2020 and will then decline increasingly[43] in favor of other energy sources.
- The estimated remaining stockpile of fossil fuels (oil, gas, coal) would equal the energy of 11 days of sun[44] over the entire surface of the earth, which suggests excellent possibilities for solar energy (one of the most promising renewable energy sources).

Needs for primary energy are met by the following sources (1999 figures):

- Fossil fuels (oil, coal, natural gas): 89.6%
- Nuclear energy: 7.6%
- Renewable sources (hydraulic, solar, wind, geothermal, etc.): 2.8% (biomasses such as wood are difficult to quantify)

The energy market is dominated by a small number of corporations that share the deposits of oil, and these corporations in turn are owned by a small number of producing countries.[45] The governments, which are often shareholders in these companies, guarantors of their monopoly holdings, or suppliers of subsidies, discourage renewable energy sources and do not allow the consumer to know the true price of the energy he or she uses.

Subject of subsidies	Value of world subsidies in energy in 2000, in $ billions
Fossil fuels	200
Renewable fuels	10
Energy reserves	10 (including 80% for fossil fuels)
Nuclear energy	16

In consequence, the poorest countries, which often have excellent renewable energy sources, pay a high percentage of their revenues to acquire polluting energy.

"Globalization" Permits the Free Circulation of Goods, Information, People, and Currency; It Also Permits Greater Awareness within Civil Society

The free circulation of people helps tourism[46]

• Tourism (travel, whether for work or leisure) received $476 billion in the year 2000.
• The tourism industry worldwide saw a monetary increase of 4.5% between 1998 and 2000.

The beneficiaries, however, are not the most deprived, as the following tables show:

Tourism in the world

Rank	Attraction or site[47]	Millions of tickets
1	Disneyworld, Florida, U.S.	15.2
2	Disneyland, California, U.S.	13.4
3	Disneyland, Paris, France	12.5
4	Notre-Dame, Paris, France	12

Year	Millions of tourists	Proportion in Europe
2000	698	73%
2020	1,600[48]	—

• 78 million passports passed through the airport in Atlanta, Georgia, in 1999.
• 62 million passports went through Heathrow (England), in 1999.
These movements of population involve, primarily, an overconsumption of resources, which is the root cause of imbalances, particularly in developing countries. For the past few years the foundation has been laid for a sustainable form of tourism, respectful of local resources and populations.[49]

Growth of communication networks

The growth of the media can be measured by television networks and the internet, although they risk creating uniformity of sources of information.
• CNN has the widest international audience of any TV network: in 212 countries, via 23 satellites, CNN reaches 149 million homes all over the planet.
• China Central TV (CCTV) is the most watched international TV network: it reaches 84% of Chinese, 900 million people.
• The internet, by definition, is the most far-reaching network. The site msn.com, for example, potentially accessible to the entire world, received 10.5 billion visits in March 2000 (62% of them for messaging service).

The possibilities of access to networks of information and communication are not equal:

	Developing countries	World average	OECD countries
TV sets per 1,000 inhabitants (1990)	95	186	502
TV sets per 1,000 inhabitants[50] (1996–1998)	162 (+70%)	253 (+36%)	594 (+18%)

• Internet connections increased by 44% in 2000,[51] as 80 million new users signed on for the first time.

• 95.6% of computers linked to the internet go through member nations of the OECD,[52] and Hong Kong, Singapore, and Taiwan comprise more than half of the remaining 4.6%.
• This is based on a massive inequality of investments in information infrastructure between OECD countries ($115 per person) and other countries ($19 per person).[53]

A Cultural Revolution: The Rising Power of Civil Society

• The growing mobilization of citizens at summit conferences, organized by citizens' movements and facilitated by the new communication networks, gives hope that decision makers will become aware of the stakes of sustainable development.

Places and dates	Type of conference
Seattle, 12/19/99	WTO interministerial meeting
Quebec, 4/20/01	Third Summit of the Americas
Göteborg, Sweden, 6/15/01	European Union summit on sustainable development
Genoa, Italy, 7/21/01	G-8 Summit
Porto Alegre, Brazil, 2/1/02	Second World Social Forum
Davos-New York, 2/1/02	World Economic Forum

• Between 1974 and 2000 the number of democracies (countries holding elections with more than one party) in the world quadrupled from 30 to 120 countries.[54] Yet in these democracies, important decisions that affect society such as those concerning the greenhouse effect, fossil fuels, and nuclear energy, remain limited to a small circle of people.
• Since the 1992 Earth Summit in Rio de Janeiro, the number of countries following international treaties continues to increase. The 1992 summit was the first time that the problem of the destruction of natural resources and the consequences was recognized by the community of nations, in the northern hemisphere as well as the southern. Global warming, the loss of biodiversity, desertification, environmental catastrophes linked to industrial pollutants, scarcity of resources because of overfishing, soil deterioration, and exhaustion of water resources (leading to forecasts of risks of food shortages)[55] are all being taken into consideration gradually by political decision makers.
• International non-governmental organizations (NGOs) active in environmental, social, and humanitarian issues and civil rights are constantly growing, professionalizing, and working more and more with corporations to resolve common problems:
 • The Friends of the Earth (FOE) has 1 million members.
 • The World Wildlife Fund (WWF) has 5 million members, working since 1985 in 130 countries.
• Sustainable development has become a new strategic imperative for corporations, which are trying to respond to society's new concerns. This corporate effort takes the form of internal changes as well as membership in external organizations. Since the Rio Summit a number of professional associations have formed to increase environmental and social awareness in their fields. Society's new awareness is also expressed in the growing success of "fair trade" labels for products, allowing consumers to use their purchasing power to support fair trade with producers in developing nations:
• The number of fair-trade associations in Europe has grown from one, in January 1998, to 15 in May 2001. Fair-trade labels now exist in 17 countries in Europe and North America and Japan.
• The Max Havelaar Association was formed in the Netherlands in 1988 to ensure more equitable trade and profit sharing with small growers in developing nations. Products with the Max Havelaar label are now sold by the largest distribution chains, drastically increasing sales. (In France points of sale increased from 250 to 3,500 between January 1998 and May 2001, a growth of 1400% in three years.)

Consumer Society[56]

The expansion of the Western way of life seems to have passed the point of no return. But it leads to an impasse: according to UNEP, extending this model to all human beings would require the equivalent of 5.5 earths.

As a consequence of the growing consumption of goods, waste is accumulating. As consumers we generate indirect waste (industrial waste) and direct waste (household waste).
• In industrialized countries the volume of waste per inhabitant has tripled over the past 20 years.
• Each year 880 to 8,800 pounds (400 to 4,000 kg) of waste are dumped for every kilometer (0.6 mile) of coastline; 60 percent of this waste consists of plastics.
• In the process of degassing[57] ships release 2 million tons of hydrocarbons every year.[58] Recycling is subject to finite limits and is not applicable to all kinds of refuse.
• The least economical citizen is the American, who produces 1,584 pounds (720 kg) of household waste per year[59] (4.4 pounds, or 2 kg, per day).
• The average French citizen produces less, with an equivalent living standard.
• The largest dump in the world is located at Fresh Kills,[60] in the United States, with an area of 3,000 acres (the equivalent of 2,500 football fields) and a height of 17 stories. It receives 13,000 tons of solid waste per day, and it emits nearly 2,700 tons of methane daily.[61]

The "ecological fingerprint" is an index corresponding to the surface of the earth necessary for each person to meet needs of nutrition, consumption, and absorption of waste (water, air, soil):

Country	Ecological fingerprint: acres per inhabitant per year	Excess consumption per person, in relation to a sustainable situation
Inhabitant permitting a sustainable human development	5.25 acres	1 (UNEP reference)
Average U.S. citizen	32.25 acres	Multiple of 6
Average European citizen	15.75 acres	Multiple of 3

The economy remains bound to the removal of resources. When an economy grows, its consumption of natural resources increases proportionately.
• A severing of the link between standard of living and removal of resources would make it possible to cut the consumption of natural resources in industrialized counties by three-quarters between now and the year 2020, and by nine-tenths by the year 2050.

Parallel to this, financial initiatives are being organized to allow sustainable human development.
• Socially responsible investing increased 8% in the United States between 1999 and 2001: nearly 1 out of every 8 dollars under professional management is now invested using at least one of three strategies that define socially responsible investing: screening, shareowner advocacy, and community investment. This idea is gaining ground rapidly in Europe as well. Company shareholders are thus showing that they are no longer satisfied with mere financial profitability but also desire social and environmental profitability, which guarantees longer durability for their investments.

There Is Still Time . . . But We Can't Wait

Since the first Earth Summit in 1992, which brought together more than 150 countries, it has become even more certain that the entire world will suffer the consequences if countries continue to destroy resources for the sake of short-term benefits. Until today we have not known how to preserve collectively the common ecological capital of the world's natural resources. If literacy is a requirement for development of any kind, then the need for a true "development education" is essential as well, whether a country is rich or poor.

According to Amartya Sen, the Nobel Prize winner in economics in 1998, "a rethinking of the basic functioning of the marketplace has become urgent." In fact, the current price structure takes little note of environmental and social costs; for example, the retail price of a sack of grain does not take into account the costs required for purification of the water to make it usable, a cost borne by society. The shock of increasingly frequent crises have led

to the recent development of solutions, which are also adapted to chronic phenomena that are no less serious. We must support them.

Why so much indifference?

Because the majority of losses in the past 30 years are located in the countries of the southern hemisphere, which still seem quite far away—even if the consequences touch us directly.

Because our approach to the environment is still based on a vision inherited from the period when the planet's resources seemed inexhaustible.

Because we have a mistaken feeling of powerlessness when faced with the scope of the problem.

And yet we can all act: by reducing our superfluous consumption and putting pressure on corporations and governments to implement sustainable development, which would respond to the needs of everyone in the present without sacrificing future generations.

The first step is to make people aware and show them what is happening to the environment. This is what Yann Arthus-Bertrand seeks to do—to astonish and disturb. An awakening is required if we hope to hand down to our children a good quality of life.

Maximilien Rouer

NOTES

Each figure cited is documented by sources such as the World Bank, UNDP, UNEP, UNESCO, WWF, IUCN–World Conservation Union, Worldwatch Institute, OECD, FAO, INSEE (Institut National de la Statistique et des Etudes Economiques), WHO, UNICEF, Global Water Supply, United Nations, IPCC, World Meteorological Organization, and ADEME (Agence de l'Environnement et de la Maîtrise de l'Energie). In cases where two figures on the same topic differed, the more moderate value was cited.

1. www.bhopal.org

2. WHO; United Nations Scientific Committee on the Effects of Atomic Radiation (UNSCEAR), 2001.

3. www.unesco.org/courier/1998_08/fr/planete/txt1.htm

4. Figures from WWF (World Wildlife Foundation), EEPSEA (Economy and Environment Program for Southeast Asia).

5. *Oil Spill Intelligence Report* (published by Cutter Information Corp.)

6. Worldwatch Institute, *Vital Signs 2001: The Trends that Are Shaping Our Future* (New York: W. W. Norton & Company, 2001).

7. IPCC, 2001.

8. See Hervé Le Bras. pp 49–56.

9. UNHCR (United Nations High Commissioner for Refugees), Basic Facts, 2001 (www.unhcr.ch)

10. *Ibid.*

11. Internation Institute for Environment and Development (IIED).

12. Shell. UNESCO Conference. 9/13/01.

13. International Energy Agency

14. Dieke Peters, "A Sustainable Transport Convention for the New Europe," chapter 9 in Felix Dodds, ed., Earth Summit 2002: A New Deal (London: Earthscan, in association with UNED-UK, 2000).

15. Marilyn Waring, economist, New Zealand deputy.

16. UNDP

17. Express, Association for the Monetary Union of Europe, www.publicdebt.treas.gov

18. http://europa.eu.int/comm/external_relations /nicaragua/intro/index_fr.htm

19. *Foreign Policy*, Washington, D.C.

20. Aid to the poorest countries, granted by member countries of OECD.

21. OECD, press release of 12/12/2001.

22. World Bank

23. Human Development Report, UNDP, 2001.

24. Ecological Footprint, UNEP, WWF, 2000.

25. Human Development Report, UNDP, 2001.

26. Yves Paccalet, naturalist.

27. Extrapolations from Worldwatch Institute.

28. Soufflet Negoce (French milling company), http://195.200.108.83/expertises/redown/iaa-pdv0101creale.pdf

29. Source: FAO, www.fao.org/WAICENT/faoinfo /economic/giews/french/pa/pa9711/pa97/1106.htm

30. Worldwatch Institute, 2001

31. *Ibid.*

32. Principal source: FAO.

1990–2000: 385 million acres of forests, mainly tropical, were destroyed. During the 1990s, the loss of natural forests averaged 40.1 million acres per year, including 38 million acres in the tropics. In 2000, 149 countries participated in international initiatives to define and implement standards and indicators for the sustainable development of forests. Twenty-five countries in course of certification of the FSC (UNDP, 2001).

The total area of forests certified in the world reached 200 million acres by the end of 2000 (about 2% of total wooded areas on earth, but mainly in temperate zone countries). *The State of the World's Forests 2001*: www.fao .org/forestry/FO/SOFO/sofo-f.stm.

33. UNEP, WWF, FSC

34. FAO

35. UNEP

36. Global Environment Outlook 2000, UNEP.

37. See Bernard Fischesser and Marie-France Dupuis-Tate, pp. 169–176.

38. "Rapport de la Commission mondiale des barrages," November 2000.

39. Information brochure, Agence de l'Eau Seine-Normandie, 1998.

40. Cosgrove, European Technology Discussions, November 2001.

41. Dams and Development: Report of the World Dams Commission, November 2000.

42. "Quand le pétrole disparaîtra" ("When oil will disappear"), *Le Monde*, July 12, 2001.

43. *Ibid.*

44. "Fuel for Sustainable Development," report by Jurgen Maier, director of the German NGO Forum for Environment and Development.

45. Worldwatch Institute, 1992.

46. World Tourism Organization

47. World Tourism Organization

48. Frans de Man, member of the UN Study Group on Sustainable Tourism, UNDP.

49. Nina Rao, head of the Tourism Department, University of Delhi.

50. World Bank, Fighting Poverty, 2000–2001

51. *Foreign Policy*, Washington, D.C.

52. OECD

53. UNDP

54. U.S. Department of State, press briefing by Assistant Secretary Harold Koh, June 19, 2000 (archive of documents can be found at www.state.gov).

55. "Environnement et développement" ("Environment and Development"), report to the French prime minister by Laurence Tubiana, economist and counselor on the environment to the prime minister, April 2000.

56. *La société des consommateurs* is a book by Robert Rochefort, president of Centre de Recherche pour l'Etude et l'Observation des Conditions de Vie (CREDOC).

57. Degassing: cleaning out the tanks of an oil tanker to remove its hydrocarbon residues.

58. Bruno Rebelle, executive director of Greenpeace France.

59. OECD, 1999.

60. *Guinness Book of World Records*, 2001.

61. Methane (CH_4) is a greenhouse gas 20 times more efficient than CO_2.

THE STORY OF A BOOK

Aboard the Colibri: agile and easy to maneuver, the helicopter acts as a camera tripod.

© Raphaël Gaillarde/Gamma

"What about Sicily?"

This impatient question is addressed to Yann Arthus-Bertrand, who has just entered the office of the Altitude agency in his usual burst of energy. Sicily is no go, stubbornly hidden under clouds. A change in plans at the last minute made the more obliging Austria the subject of the last European report. For the coming weekend the forecast calls for clear skies over Finland. Good news, because that trip had already been put off twice. There's little time left to confirm airline tickets and an on-site helicopter rental. Not much time either for viewing the results of the last shoot. And still less for all the meetings crammed into the tight agenda of the photographer of *The Earth from the Air*.

An entire wall of the room is taken up by a vast world map bristling with blue arrows to indicate

Helicopter near Korhogo, Côte d'Ivoire.

countries already flown over, and red ones for those yet to be covered. It's not quite up to date, but it recalls six years of frantic work on *The Earth from the Air* project, struggles to obtain permission to fly through international air spaces, and globetrotting at the rate of two weeks of travel per month. The map testifies to the early stages of the saga, when each new blue arrow was a victory for the entire team. The photographer, who drives the project, confirms it: "The author of this book is the team."

After leaving for Kenya in 1978 with his wife, Anne, to study the behavior of a family of lions, Yann brought back a first book of photographs with text, the fruit of three patient years of daily observation. Seduced by this method of expressing his feelings for nature, which he practiced on every trip, he decided to become a photographer.

At the same time, using his pilot's license to finance his long African study, he carried tourists in

a hot-air balloon, offering a new way of discovering the Kenyan brush. He was soon won over himself to this other vision of reality that can discover a global expanse or a close-up, depending on the range.

With his confirmed preference for long-term projects, Yann gradually developed the plan that would draw together all these components. "The idea was to show what the earth looks like today," he says, "through pictures that could explain the world and alert people to important problems, current or future."

The goal of making a portrait of the planet in aerial photographs gradually took hold of him, but the scope of the task remained a stumbling block for his potential partners. Yet the photographer's enthusiasm, energy, and tenacity helped him convince several companies to sponsor this titanic effort that would require colossal resources (one hour in a helicopter costs between 800 and 3,200 euros). The blessings and support of UNESCO also helped, providing an effective door opener that also unlocked quite a few air spaces.

The fact is that in some sensitive countries, aerial photography is tantamount to espionage. So it took him three years to get permission to fly over India. But Yemen, Saudi Arabia, and China, for

instance, have never relented. "Not *yet*," Yann corrects, showing that for him perseverance overcomes resistance.

But flight permission is just the first of many obstacles. The next is to find, on the site, the means of flight (not easy in the Ténéré Desert), or else to bring it along, as he did for Easter Island. His preference is for the helicopter, a machine that can be manipulated, allowing every altitude and every angle.

"A helicopter is a wonderful instrument," the photographer confirms. "You take it up, bring it down, orient it easily to find the best frame—just like a crane or a mobile tripod." That depends, of course, on having an experienced pilot at the controls. "He has to be able to place the helicopter as I tell him to. The pilot is really situated between the picture and me, so he has to know aerial photography, he's got to be really good."

The pilot also has to know the area and its sights; it's too expensive to make a reconnaissance flight beforehand to size things up. So Yann and his team have to trust maps and tourist guidebooks, which fill dozens of shelves in the agency offices, and then trust in the pilot. In New Caledonia, it was the pilot who led Yann above the enigmatic heart of Voh, which became the emblem for the entire project. It is also necessary to trust in chance, never relaxing attention and having a good eye: 80 percent of the photographs were not planned in advance!

And the last, indispensable rule: good weather. Forecasts of Météo France Internationale have helped the team avoid many a disaster, but it's not unknown for a flight, after months of planning, to be cancelled at the last minute because of cloud cover.

In the air, in the tight cabin of the helicopter, the assistant juggles with the flight log and seven cameras equipped with different lenses, responding to Yann's demands as he hovers restlessly in the doorway. He's ready any minute to put on the red anorak that he always remembers to pack, so he can be put down, just long enough for a shot, on a monumental iceberg. Reduced to the status of a tiny red point, he will provide the scale of the immense scope of nature.

Back from an assignment, he identifies the pictures with the precious information noted during the flight. Between glass plating, filing, selection, numbering, archiving, it takes a long time to form

More than 2 million people visited the exhibition at the Luxembourg Gardens in Paris, the first in a long series of exhibitions.

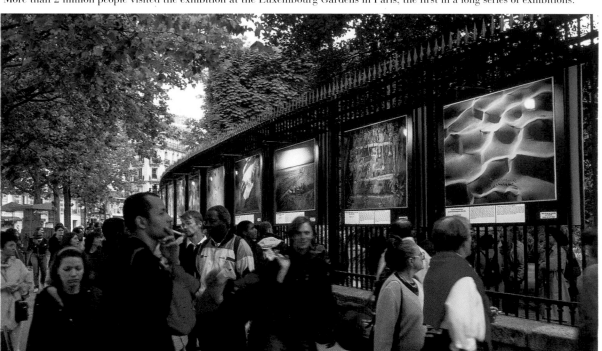

In Namibia, a Himba woman asks Yann to fly over her village.

a documentary archive. And sometimes, a *very* long time: approximately 10,000 photographs shot in India (90 percent of the work done there) have been blocked in the country since March 1999. Developed by the Indian army, then turned over to the authorities, they have never been returned.

This image database today has some 300,000 aerial views taken in more than 80 countries. Thanks to their geographic coordinates, it will be possible in a few years to record changes in the portrait of our ever evolving planet. For instance, the house at Keremma, in Brittany, since March 2000 no longer stands overlooking its fragile sand peninsula. Here and there, the face of the earth has already visibly changed. And the legends that accompany the images, providing material for thought, have already had to be updated between the first printing of the book and the present revised edition.

Earth from Above, as the author explains, is not only a collection of spectacular photographs: "A book is a goal, a direction, something that remains. It is an opportunity for a photographer, it keeps him from going off in all directions." And yet, he had to pursue multiple directions in order to build every chapter of the great story he wanted to report, the story of today's world. It is a reality that is at once historical, geographic, ecological, and human, a story that often cannot be read from the ground. An opening that, from the surface, looks like a wide valley, when viewed from higher up becomes a light scar on the earth's epidermis.

People are present in almost every photo in *Earth from Above*—if not physically, then through the traces they have left behind. Also, as their author explains, "Everyone seems at home in these photographs." We all consider ourselves, quite naturally, residents of the earth. It is a feeling of disconcerting simplicity, which no doubt contributed to the book's worldwide success and the touching meetings with people at the book signings and exhibitions that followed publication. "People came up to hug me out of gratitude, some of them crying with emotion," Yann recalls. One pregnant young woman had me dedicate a book to her future child. I had never had such contact with the public, and it was overwhelming."

An optimist, the photographer sees all of this as a sign that "today a global awareness is taking shape, the awareness that we all belong to the same unique planet and that it is being degraded." More than 1.5 million people all over the world, including 1.1 million in France, wanted to own this portrait of their planet in 400 pages (and more than 8 pounds), which has been translated into 14 languages including Hungarian, Slovakian, and Japanese.

"This success surprised and encouraged me, but it's also beyond me. No one expected it. It's impressive, moving, heartening. But it's more difficult, too, because you're constantly being sought

out. That gives you the chance to do it better yet, to have a stronger ethic and truly follow your path with greater independence." So the agency has outfitted itself with the dreamed-for addition to the panoply of the roving photographer—a helicopter, which is essential for the in-depth study of France that Yann wants to produce. Moreover, some countries that had previously been reluctant are ready to permit flights over their territory. China could become one of them sometime soon. And the team that accompanies the photographer today has been expanded to respond to new needs.

This great popularity with a public of all nationalities provided a unique opportunity to make the many admirers of our earth sensitive to the great ecological, economic, and human stakes of our century. This could be a major enterprise for the photographer, who, becoming a witness of his time, strives to give meaning to his work. It's up to every individual to decide what kind of earth we choose, every day, individually and collectively, to leave to

Above Mount Everest, at 16,500 feet, oxygen is necessary.

our children and to future generations. Each one of us, according to his or her own sensitivity, will react individually. The authors accommodate this kind of individual response in the sections between Yann's photographs in this new edition. Specialists here and elsewhere, they share their specific knowledge with the public at large, expounding their own viewpoints, in texts supported by examples, concerning the most disturbing ecological problems for the future of humankind.

When Yann decided to exhibit the photographs from *Earth from Above*, the idea was met with almost unanimous skepticism. Only the Senate in Paris provided space for the exhibition, at the Luxembourg Museum. The show was originally booked for a month and a half starting in May

2000, but it ran until December, attracting a flood of excited visitors, estimated at 2.5 million. The 150 large-format photographs of *Earth from Above* were then displayed on the fence of the Luxembourg Gardens, finally granting Yann's dearest wish: to share with everyone this voyage above the earth, to astonish and address the widest public. Likewise, the book, which was sold at an accessible price at the wish of photographer and publisher, was within reach of almost every purse, especially among buyers not usually drawn to this type of work. They were fascinated with the book and in turn bought it as gifts for others. "This book is no innocent gift. You receive it and then buy another to give to someone else," Yann observes.

Contrary to predictions, the prints exhibited on the Luxembourg Garden fence were not harmed. It was as if the beauty of the earth, by itself, had inspired respect. When the exhibition ended, the prints were auctioned off as a benefit for charities. And other prints, accompanied by a great global

Yann explains his flight over Madagascar to village children on the island.

map on the ground, on which visitors had fun covering the world in a few steps, set out in turn to tour the world. They were magically integrated into the main square of Copenhagen, Denmark, as well as in the port of Hamburg, Germany. By day as well as by night, people in Geneva admired a little corner of Mexico, while people of São Paulo discovered a sampling of Japan, and in Ankara they marveled at the Netherlands. Hosted by more than 50 cities in 22 countries, the exhibition has already attracted close to 30 million visitors, and it has been requested in St. Petersburg as well as Beijing. So let them prepare, in Beirut and Caracas, to offer a VIP welcome to the star of the event in person—the earth.

Anne Jankeliowitch

These distant and close-up shots reveal the making of a photograph in Côte d'Ivoire.

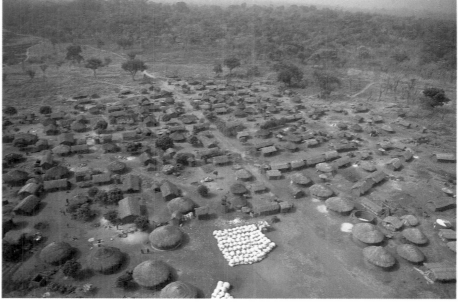

ACKNOWLEDGMENTS

UNESCO: Federico Mayor, Director-General; Pierre Lasserre, director, Ecological Sciences Division; Mireille Jardin, Jane Robertson, Josette Gainche, and Malcolm Hadley, Hélène Gosselin, Carlos Marques, Mr. Oudatchine, of the Office of Public Information; Francesco di Castri and Jeanne Barbière, environmental coordination; and Gérard Huber, who kindly supported our project within this organization

FUJIFILM: Masayuki Muneyuki, President; Toshiyuki "Todd" Hirai and Minoru "Mick" Uranaka, of Fujifilm Tokyo; Peter Samwell of Fujifilm Europe; and Doris Goertz, Ms. Develey, Marc Héraud, François Rychelewski, Bruno Baudry, Hervé Chanaud, Franck Portelance, Piotr Fedorowicz, Françoise Moumaneix, and Anissa Oger of Fujifilm France

CORBIS: Stephen B. Davis, Peter Howe, Malcolm Cross, Charles Mauzy, Marc Walsh, Vanessa Kramer, Susanna Harrison, Tana Wollen, and Vicky Whiley

Air France: François Brousse and Christine Micouleau and also Dominique Gimet, Mireille Queillé, and Bodo Ravoninjatovo

Eurocopter: Jean-François Bigay, Xavier Poupardin, Serge Durand, and Guislaine Cambournac

As we complete this final page, which brings back such wonderful memories from the four corners (!) of the world, we hope we have not forgotten any of you who have helped us to make this project a reality.

But if we have done so, please accept our sincerest apologies and our heartfelt thanks to all. We owe a special debt of gratitude to all the "anonymous" helpers on the sidelines who made their own quiet but important contribution to this foolhardy undertaking.

ALBANIA
ECPA, Lieutenant Colonel Aussavy
DICOD, Colonel Baptiste, Captain Maranzana, and Captain Saint Léger
SIRPA, Charles-Philippe d'Orléans
DETALAT, Captain Ludovic Janot
Crews of the French Air Force, Etienne Hoff, Cyril Vasquez, Olivier Ouakel José Trouille, Frédéric Le Mouillour, François Dughin, Christian Abgral, Patrice Comerier, Guillaume Maury, Franck Novak, pilots

ANTARCTICA
Institut Français pour la Recherche et la Technologie Polaires, Gérard Jugie
L'Astrolabe, Captain Gérard R.Daudon, Sd Captain Alain Gaston
Héli Union France, Bruno Fiorese, pilot
Augusto Leri and Mario Zucchelli, Progetto Antartida, Italy
Terra Nova

ARGENTINA
Jean-Louis Larivière, Ediciones Larivière
Mémé and Marina Larivière and Felipe C. Larivière
Dudú von Thielman
Virginia Taylor of Fernández Beschtedt
Commander Sergio Copertari, pilot; Emilio Yañez and Pedro Diamante, co-pilots;
Eduardo Benítez, mechanic
Squadron of the Federal Air Police, Commissioner Norberto Edgardo Gaudiero, Captain Roberto A. Ulloa, former governor of Salta Province
Oran Police, Salta Province, Commander Daniel D. Pérez
Military Geographic Institute
Commissioner Rodolfo E. Pantanali
Aerolíneas Argentinas

AUSTRIA
Heli travel, Hans Ostler

AUSTRALIA
Helen Hiscocks
Australian Tourism Commission, Kate Kenward, Gemma Tisdell, and Paul Gauger
Jairow Helicopters
Heliwork, Simon Eders

Thai Airways, Pascale Baret
Club Med organizations of Lindeman Island and Byron Bay Beach

BAHAMAS
Club Med organizations of Eleuthera, Paradise Island, and Columbus Isle

BANGLADESH
Hossain Kommol and Salahuddin Akbar, External Publicity Wing, Ministry of Foreign Affairs
His Excellency Tufail K. Haider, Bangladeshi ambassador in Paris, and Chowdhury Ikhtiar, first secretary
Her Excellency Renée Veyret, French ambassador in Dhaka
Mohamed Ali and Amjad Hussain of Biman Bangladesh Airlines and Mr. Vishawjeet
Mr. Nakada, Fujifilm, Singapore
Mr. Ezaher, Fujifilm laboratory, Dhaka
Mizanur Rahman, director; Rune Karlsson, pilot; and J. Eldon Gamble, technician, MAF Air Support
Muhinddin Rashida, Sheraton Hotel of Dhaka, Mr. Minto

BELGIUM
Wim Robberechts
SIDMAR Company

BOTSWANA
Maas Müller, Chobe Helicopter

BRAZIL
Governo do Mato Grosso do Norte e do Sul
Fundação Pantanal, Erasmo Machado Filho and Parcs Naturels Régionaux de France, Emmanuel Thévenin and Jean-Luc Sadorge
Fernando Lemos
His Excellency Mr. Pedreira, Brazilian ambassador to UNESCO
Dr. Iracema Alencar, Queiros, Instituto de Proteção Ambiental do Amazonas, and his son, Alexandro
Brasília Tourist Office
Luis Carlos Burti, Editions Burti
Carlos Marques, OPI Division, UNESCO
Ethel Leon, Anthea Communication
TV Globo
Golden Cross, José Augusto Wanderley and Juliana Marquès
Hotel Tropical at Manaus
VARIG

CANADA
Anne Zobenbuhler, Canadian Embassy, Paris, and Tourist Office
Barbara di Stefano and Laurent Beunier, Destination Québec
Cherry Kemp Kinnear, Nunavut Tourist Office
Huguette Parent and Chrystiane Galland, Air Canada

First Air
Vacances Air Transat
André Buteau, pilot, Essor Helicopters
Louis Drapeau, Canadian Helicopters
Canadian Airlines

CHINA
Hong Kong Tourist Office, Mr. Iskaros
Chinese Embassy, Paris, His Excellency Mr. Caifangbo, Li Beifen
French Embassy, Beijing, His Excellency Pierre Morel, French ambassador in Beijing
Shi Guangeng, Ministry of Foreign Affairs
Serge Nègre
Yan Layma

CÔTE D'IVOIRE
Vitrail & Architecture, Pierre Fakhoury
Hugues Moreau and pilots Jean-Pierre Artifoni and Philippe Nallet, Ivoiré Hélicopters
Patricia Kriton and Mr. Kesada, Air Afrique

DENMARK
Weldon Owen Publishing, the entire production team for "Over Europe"
Stine Norden

ECUADOR
Loup Langton and Pablo Corral Vega, Descubriendo Ecuador
Claude Lara, Ecuador Foreign Affairs Ministry
Mr. Galarza, Ecuadoran Consulate, France
Eliecer Cruz, Diego Bonilla, Robert Bensted-Smith, Galapagos National Park
Patrizia Schrank, Jennifer Stone, European Friends of Galapagos
Danilo Matamoros, Jaime and Cesar, Taxi Aero Inter Islas M.T.B.
Etienne Moine, Latitude 0°
Abdon Guerrero, San Cristobal airport

EGYPT
Rally of the Pharaohs,
"Fenouil," organizer; Bernard Seguy, Michel Beaujard, and Christian Thévenet, pilots

FINLAND
Heliwest Oy, Dick Lindhom

FRANCE
Dominique Voynet, Ministre de l'Aménagement du territoire et de l'environnement
Ministère de la Défense/SIRPA
Préfecture de Police de Paris, Philippe Massoni and Chantal Seltzer
Montblanc Hélicoptères, Franck Arrestier and Alexandre Antunes, pilots
Office du Tourisme de Corse, Xavier Olivieri
Comité Départemental du Tourisme d'Auvergne, Cécile da Costa
Conseil Général des Côtes d'Armor, Charles Josselin and Gilles Pellan
Conseil Général de Savoie, Jean-Marc Eysserick
Conseil Général de Haute-Savoie, Georges Pacquetet and Laurent Guette
Conseil Général des Alpes-Maritimes, Sylvie Grosgojeat and Cécile Alziary
Conseil Général des Yvelines, Franck Borotra, president, Christine Boutin, Pascal Angenault, and Odile Roussillon
CDT, départements de la Loire
Groupe Rémy Cointreau, Dominique Hériard-Dubreuil
Nicole Bru
Jacqueline Alexandre
Editions du Chêne, Philippe Pierrelee, artistic director
Hachette, Jean Arcache
Moët et Chandon/Rallye GTO, Jean Berchon and Philippe des Roys du Roure
Printemps de Cahors, Marie-Thérèse Perrin
Philippe Van Montagu
Willy Gonere, pilot of Colibri EC120
Airbus Industries, Marie-Noëlle Cabanié

La Nécropole nationale de Notre-Dame de Lorette; direction interdépartementale des Anciens combattants de Lille, Mr. Sfiotti
Domaine naturiste d'Arnouatehot, Jean-Philippe Pavié
SAF helicopters, Christophe Rosset, Hélifrance, Héli-Union, Europe Hélicoptère Bretagne, Héli Bretagne, Héli-Océan, Héli Rhone-Alpes, Hélicos Légers Services, Figari Aviation, Aéroservice, Héli air Monaco, Héli Perpignan, Ponair, Héli-inter, Héli Est.
Réunion: Office du Tourisme de La Réunion, René Barrien and Michèle Bernard
Jean-Marie Lavièvre, pilot, Hélicoptères Hélilagon
Noir Calédonia: Charles de Montesquieu, Jean-Michel Lebargy, Héli...
Bruno Civet, Hélicoc...
Etienne...
Antilles: Club...s, Boucaniers an Club Med de la Caravelle
Alain Fanchette, pilot
Polynesia: Club Med of Moorea

GERMANY
Stern, Tom Jacobi and Franck Müller-May
Heli-Charter-Gmbh, Günter Mahler

GREECE
Ministry of Culture, Athens
Eleni Méthodiou, Greek delegation to UNESCO
Greek Tourist Office
Club Med of Corfu Ipsos, Gregolimano, Helios Corfu, Kos, and Olympia
Olympic Airways INTERJET, Dimitrios Prokopis and Konstantinos Tsigkas, pilots, and Kimon Daniilidis
Meteorological Center, Athens

GUATEMALA & HONDURAS
Giovanni Herrera, director, and Mr. Carlos Llarena, pilot, Aerofoto, Guatemala City
Rafael Sagastume, STP villas, Guatemala City

ICELAND
Bergur Gislasson and Gisli Guestsson, Icephoto
Thyrluthjonustan Helicopters
Peter Samwell
Office National du Tourisme, Paris

INDIA
Indian Embassy in Paris, His Excellency Kanwal Sibal, ambassador; Rahul Chhabra, first secretary
S. K. Sofat, general, Air Brigade, Mr. Lal, Mr. Kadyan, and Vivianne Tourtet
Ministry of Foreign Affairs, Teki E. Prasad and Manjish Grover
N. K. Singh, office of the Prime Minister
Mr. Chidambaram, member of Parliament
Air Headquarters, S. I. Kumaran, Mr. Pande
Mandoza Air Charters, Atul Jaidka
Indian International Airways, Captain Sangha Pritvipalh
French Embassy in New Delhi, His Excellency Claude Blanchemaison, ambassador; François Xavier Reymond, first secretary

INDONESIA
TOTAL Balikpapan, Ananda Idris and Ilha Sutrisno
Mr. and Mrs. Didier Millet

IRELAND
Aer Lingus
Irish National Tourist Office
Captain David Courtney, Irish Rescue Helicopters
David Hayes, Westair Aviation Ltd.

ITALY
French Embassy in Rome, Michel Benard, press service
Heli Frioula, Greco Gianfranco, Fanzin Stefano, and Codicio Pierino

JAPAN
Press group Asahi Shimbun, Teizo
Umezu
Eu Japan Festival, Shuji Kogi and Robert
Delpire
Masako Sakata, IPI
NHK TV
Japan Broadcasting Corp.

JORDAN
Ms. Sharif, Anis Mouasher, Khaled Irani
and Khaldoun Kiwan, Royal Society for
Conservation of Nature
Royal Airforces
Riad Sawalha, Royal Jordanian
Regency Palace Hotel

KAZAKHSTAN
His Excellency Nourlan Danenov,
ambassador of Kazakhstan in Paris
His Excellency Alain Richard, French
ambassador in Almaty, and Josette Floch
Professor René Letolle
Heli Asie Air and pilot Mr. Anouar

KENYA
Universal Safari Tours of Nairobi, Patrix
Duffar
Transsafari, Irvin Rozental

KUWAIT
Kuwait Centre for Research and Studies,
President Abdullah Al Ghunaim, Dr.
Youssef
Kuwait National Commission for
UNESCO, Sulaiman Al Onaizi
Delegation of Kuwait to UNESCO, His
Excellency Dr. Al Salem, and Mr. Al
Baghly
Kuwait Airforces, Squadron 32, Major
Hussein Al-Mane, Captain Emad Al-
Momen
Kuwait Airways, Mr. Al Nafisy

MADAGASCAR
Riaz Barday and Normand Dicaire, pilot,
Air Marines
Sonja and Thierry Ranarivelo, Yersin
Racerlyn, pilot, Madagascar Helicopter
Jeff Guidez and Lisbeth

MALAYSIA
Club Med of Cherating

MALDIVES
Club Med of Faru

MALI
TSO, Rallye Dakar, Hubert Auriol
Daniel Legrand, Arpèges Conseil, and
Daniel Bouet, Cessna pilot

MAURITANIA
TSO, Rallye Paris-Dakar, Mr. Hubert
Auriol
Mr. Daniel Legrand, Arpèges Conseil,
and Mr. Daniel Bouet, pilot
Mr. Sidi Ould Kleib

MEXICO
EUROCOPTER, Antonio Barroeta
Orozco
Arturo Zavala
Club Med of Cancun, Sonora Bay,
Huatulco, and Ixtapa

MOROCCO
Royal Moroccan Gendarmerie
General El Kadiri and Colonel Hamid
Laanigri
François de Grossouvre

NAMIBIA
Ministry of Fisheries
Mission Française de Coopération, Jean-
Pierre Lahaye, Nicole Weill, Laurent
Billet, and Jean Paul
Namibian Tourist Friend, Almut
Steinmester

NEPAL
Embassy of Nepal in Paris
Terres d'Aventure, Patrick Oudin

Great Himalayan Adventures,
Ashok Basnyet
Royal Nepal Airways, J. B. Rana
Mandala Trekking, Jérôme Edou
Bhuda Air
Maison de la Chine, Patricia Tartour-
Jonathan, director; Colette Vaquier;
and Fabienne Leriche
Marina Tymen and Miranda Ford,
Cathay Pacific

NETHERLANDS
Paris Match
Franck Arrestier, pilot

NIGER
TSO, Rallye Paris-Dakar, Hubert Auriol
Daniel Legrand, Arpèges Conseil, and
Daniel Bouet, Cessna pilot

NORWAY
Airlift A.S., Ted Juliussen, pilot;
Henry Hogi; Arvid Auganaes,
and Nils Myklebust

OMAN
His Majesty the Sultan Quabous ben Saïd
al-Saïd
Ministry of Defense, John Miller
Villa d'Alésia, William Perkins and
Isabelle de Larrocha

PERU
Dr. Maria Reiche and Ana Maria
Cogorno-Reiche
Ministerio de Relaciones Exteriores, Juan
Manuel Tirado
Policía Nacional del Perú
Faucett Airline, Cecilia Raffo and Alfredo
Barnechea
Eduardo Corrales, Aero Condor

PHILIPPINES
Filipino Airforces
Seven Days in the Philippines, Editions
Millet, Jill Laidlaw

PORTUGAL
Club Med of Da Balaia

RUSSIA
Mr. Yuri Vorobiov, Vice Minister, and
Mr. Brachnikov, Emerkom
Mr. Nicolaï Alexiy Timochenxo,
Emerkom in Kamtchatka
Mr. Valery Blatov, Russian delegation to
UNESCO

**SAINT-VINCENT &
THE GRENADINES**
Paul Gravel, SVG Air
Jeanette Cadet, The Musique Company
David Linley
Ali Medjahed, baker
Alain Fanchette

SENEGAL
TSO, Rallye Paris-Dakar, Hubert Auriol
Daniel Legrand, Arpèges Conseil, and
Daniel Bouet, pilot
Club Med of Les Almadies
and Cap Skirring

SOMALILAND
His Royal Highness Sheikh Saud Al-
Thani of Qatar
Majdi Bustani, E. A. Paulson, and Mr.
Osama, office of His Royal Highness
Sheikh Saud Al-Thani
Fred Viljoen, pilot
Rachid J. Hussein, UNESCO-Peer,
Hargeisa, Somaliland
Nureldin Satti, UNESCO-Peer,
Nairobi, Kenya
Shadia Clot, correspondent
of the Sheikh in France
Waheed, Al Sadd travel agency, Qatar
Cécile and Karl,
Emirates Airlines, Paris

SOUTH AFRICA
SATOUR, Ms. Salomone
South African Airways,
Jean-Philippe de Ravel
Victoria Junction
Victoria Junction Hotel

SPAIN
His Excellency Jesus Ezquerra,
Spanish ambassador to UNESCO
Club Med of Don Miguel, Cadaquès,
Porto Petro, and Ibiza
Canaries: Tomás Azcarate y Bang,
Viceconsejeria de Medio Ambiente
Fernando Clavijo, Protección Civil
de las Islas Canarias
Jean-Pierre Sauvage and Gérard de
Bercegol, IBERIA
Elena Valdés and Marie Mar,
Spanish Tourist Office
Basque Country: Executive Office of
the Basque Government, Zuperia Bingen,
director; Concha Dorronsoro and
Nerea Antia, Press and Communication
Department of the Executive Office
of the Basque Government
Juan Carlos Aguirre Bilbao, chief,
Helicopter Unit, Basque Police
(Ertzaintza)

THAILAND
Royal Forest Department, Viroj
Pimanrojnagool, Pramo'e Kasemsap,
Tawee Nootong, Amon Achapet
NTC Intergroup Ltd., Ruhn Phiama
Pascale Baret, Thai Airways
Thailand National Tourist Office,
Juthaporn Rerngronasa and Watcharee,
Lucien Blacher, Satit Nilwong, and
Busatit Palacheewa
Fujifilm Bangkok, Mr. Supoj
Club Med of Phuket

TUNISIA
Zine Abidine Ben Ali, President of the
Republic
Office of the President of the Republic,
Abdelwahad Abdallah and Haj Ali
Air Force, Laouina air base, Colonel
Mustafa Hermi
Tunisian Embassy in Paris,
His Excellency Mr. Bousnina,
ambassador, and Mohamed Fendri
Tunisian National Tourst Office,
Raouf Jomni and Mamoud Khaznadar
Cérès Editions, Mr. Mohamed and
Karim Ben Smaïl
The Residence Hotel, Jean-Pierre Auriol
Basma-Hôtel Club Paladien,
Laurent Chauvin
Tunis Meteorological Center,
Mohammed Allouche

TURKEY
Turkish Airlines, Bulent Demirçi and
Nasan Erol
Mach'Air Helicopters, Ali Izmet Öztürk,
Segal Sahin, Karatas Gulsah
General Aviation, Vedat Seyhan and
Mr. Faruk, pilot
Club Med of Bodrum, Kusadasi, Palmiye,
Kemer, and Foca

UKRAINE
Alexandre Demianyuk, Secretary
General, UNESCO
A. V. Grebenyuk, director of the
administration of the area of Chernobyl
Rima Kiseliza, attaché,
Chornobylinterinform
Marie-Renée Tisné, Office of Protection
against Ionizing Rays

UNITED KINGDOM
England: Aeromega and
Mike Burns, pilot
David Linley
Philippe Achache
Environment Agency, Bob Davidson and
David Palmer
Press Office of Buckingham Palace
Scotland: Paula O'Farrel and Doug
Allsop of TOTAL OIL MARINE,
Aberdeen
Iain GRINDLAY and Rod de Lothian
Helicopters Ltd., Edinburgh
Gibraltar: ACS Company, Colonel
Purdom and Béatrice Quentin; ASO
Company, Etienne Lavigne; Franck
Arrestier

UNITED STATES
Wyoming: Yellowstone National Park,

Marsha Karle and Stacey Churchwell
Utah: Classic Helicopters
Montana: Carisch Helicopters, Mike
Carisch
California: Robin Petgrave, Bravo
Helicopters, Los Angeles, and pilots
Akiko K. Jones and Dennis Smith; Fred
London, Cornerstone Elementary School
Nevada: John Sullivan and pilots Aaron
Wainman and Matt Evans, Sundance
Helicopters, Las Vegas
Louisiana: Southwest Helicopters and
Steve Eckhardt
Arizona: Meteor Crater Enterprises Inc.,
Robyn Messerschmidt; Southwest
Helicopters and Jim McPhail
New York: Harry N. Abrams, Inc., Paul
Gottlieb and Eric Himmel; Liberty
Helicopters, Daniel Veranazza and Paul
Tramontana; Mike Renz, Analar
helicopters, John Tauranac
Florida: Rick Cook, Everglades National
Park; Rick and Todd, Bulldog
Helicopters, Orlando; Chuck and Diana,
Biscayne Helicopters, Miami; Club Med
of Sand Piper
Alaska: Philippe Bourseiller
Yves Carmagnole, pilot

UZBEKISTAN (not flown above)
Embassy of Uzbekistan in Paris, His
Excellency Mr. Mamagonov, ambassador,
and Djoura Dekhanov, first secretary
His Excellency Jean Claude Richard,
French ambassador in Uzbekistan, and
Jean Pierre Messiant, first secretary
René Cagnat and Natacha
Vincent Fourniau and Bruno Chauvel,
Institut Français d'Études sur l'Asie
Centrale (IFEAC)

VENEZUELA
Centro de Estudios y Desarrollo, Nelson
Prato Barbosa
Hoteles Intercontinental
Ultramar Express
Lagoven
Imparques
ICARO, Luis Gonzales

We also wish to thank the companies that
enabled us to work because of their
orders or through exchanges:

AEROSPATIALE, Patrice Kreis, Roger
Benguigui, and Mr. Cotinaud
AOM, Françoise Dubois-Siegmund,
Felicia Boisne-Noc, Christophe Cachera
BANQUE LOMBARD ODIER & CO.,
Thierry Lombard
CANON, Service Pro, Jean-Pierre Colly,
Guy d'Assonville, Jean-Claude Brouard,
Philippe Joachim, Raphaël Rimoux,
Bernard Thomas, and of course Daniel
Quint and Annie Rémy, who both helped
us so often throughout the project
CLUB MED, Philippe Bourguignon,
Henri de Bodinat, Sylvie Bourgeois,
Preben Vestdam, Christian Thévenet
CRIE, worldwide courier express, Jérôme
Lepert and his entire team
DIA SERVICES, Bernard Crepin
FONDATION TOTAL, Yves le Goff and
his assistant, Nathalie Guillerme
JANJAC, Jacques and Olivier Bigot, Jean-
François Bardy, and Michel Viard
KONICA, Dominique Brugière
MÉTÉO FRANCE, Mr. Foidart, Marie-
Claire Rullière, Alain Mazoyer, and all
the forecasters
RUSH LABO, Denis Cuisy, Philippe Ioli,
Christian Barreteau, Patrick Botté, and
all our friends in the lab
WORLD ECONOMIC FORUM OF
DAVOS, Dr. Klaus Schwab, Maryse
Zwick, and Agnès Stüder

THE STORY OF A PHOTO

The heart of Voh has become the symbol of an earth that is in urgent need of preservation. Because of The Earth from the Air, *this image has circled the world. Twelve years after his first photograph, Yann Arthus-Bertrand returned to fly above the famous mangrove marsh.*

Marsh of mangroves near Voh, New Caledonia. Photo IGN, 1982

Yann's first photograph of the heart of Voh, 1990

Heart of Voh, New Caledonia, February 2002

No, this clearing in the form of a heart was not drawn by humans, and the photograph is not a montage. Nature alone created this design in the forest of mangroves. Numerous readers have asked questions about this enigmatic apparition, in particular about its size. To satisfy their curiosity, Yann Arthus-Bertrand brought a second helicopter when he returned to the heart of Voh in 2002; in the new photograph, the whirl of the propeller creates a spot in the foliage. Returning to the heart of Voh, twelve years after he first captured it on film, was like making a pilgrimage to the subject of one of the first photos of *The Earth from the Air.* The photograph was not even planned from the start: during the flight, the pilot led Yann above the site, saying, "I'm going to show you something. . . ." This image, so resonant with its troubling message, became the symbol of the project. Between 1990 and 2002 the vegetation pushed back into the interior of the heart from where the salt had chased it over 10 acres. These tenuous gaps in vegetation correspond to slightly higher land, which is flooded less often by tides, and thus salt becomes concentrated there after the water evaporates. If the saline level continues to drop, the mangroves will completely close in on the heart. If salinization retakes the area, the heart will be reconstituted. Nature will decide. But perhaps it's necessary to return and see?

INDEX

The Earth from the Air Team, Altitude agency

Photo assistants: Franck Charel and Françoise Jacquot, who were there throughout this project,
and all the others who have helped me throughout these airborne years
Tristan Carné, Christophe Daguet, Stefan Christiansen, Pierre Cornevin, Olivier Jardon, Denis Lardat, Marc Lavaud,
Franck Lechenet, Olivier Looren, Antonio López Palazuelo, Erwan Sourget, and Sibylle d'Orgeval who recently joined us.
Coordination office:
Production coordination: Hélène de Bonis
Publishing coordination: Anne Jankéliowitch and Françoise Le Roché
Exhibition coordination: Catherine Arthus-Bertrand and Tiphanie Babinet
Production: Antoine Verdet, Catherine Quilichini, Gloria-Céleste Raad for Russia, Zhu Xiao Lin for China
Texts: Judith Klein, Hugues Demeude and PRODIG, geographic laboratory, Mesdames Marie-Françoise Courel
and Lydie Goeldner, Mr. Frédéric Bertrand
Iconographic research : Isabelle Lechenet, Ambre Mayen, Florence Frutoso, Claire Portaluppi
Pilot of the Colibri EC 120: Willy Gouere

I would also like to take this opportunity to express my gratitude to my friend Hervé de La Martinière, and to the entire team who
worked on this book, especially Benoit Nacci, the art director, whose kind support meant so much, Céline Moulard, Sébastien Raimondi,
Carole Daprey, Marianne Lassandro, Christel Durantin, Amaëlle Génot, Marie-Hélène Lafin, Jeanne Castoriano.
A final word of thanks to Quadrilaser and its team for the photo engraving, Kapp-Lahure-Jombart for the printing, and SIRC for the binding.

NEAR MAR DEL PLATA,
Buenos Aires, Argentina

All of the photographs were taken with Fuji VELVIA film (50 ASA).
Yann Arthus-Bertrand worked primarily with CANON EOS 1N cameras and CANON L series lenses.
Photographs were also taken with a PENTAX 645N and the panoramic FUJI GX 617.

The aerial photographs of Yann Arthus-Bertrand are distributed through the
Altitude agency: 30, rue des Favorites, 75015 Paris, France
e-mail: altitude@club-internet.fr
www.yannarthusbertrand.com

Printed in France